"PRIMITIVISM" IN 20TH CENTURY ART

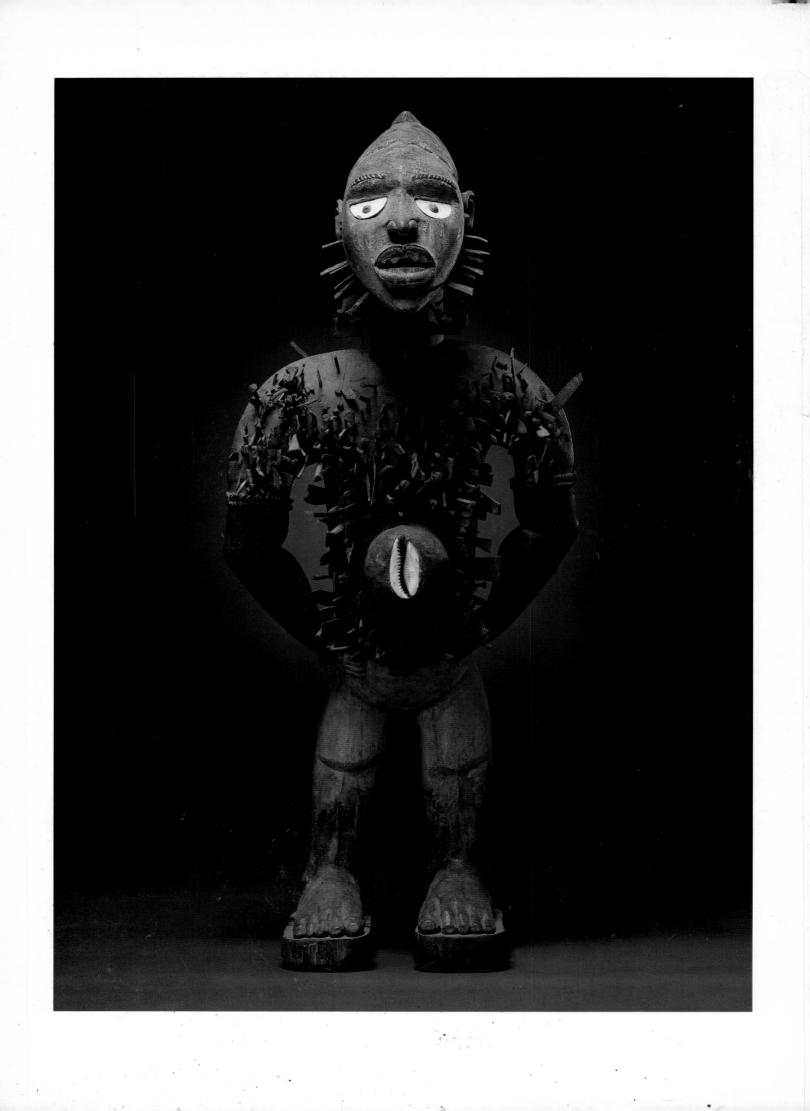

"PRIMITIVISM"
IN 20TH CENTURY ART

Affinity of the Tribal and the Modern

Edited by William Rubin

Volume I

The Museum of Modern Art, New York

Distributed by New York Graphic Society Books
Little, Brown and Company, Boston

"PRIMITIVISM" IN 20TH CENTURY ART
Affinity of the Tribal and the Modern

Published in conjunction with an exhibition of the same title shown at the following museums:

The Museum of Modern Art, New York
Detroit Institute of Arts
Dallas Museum of Art

The exhibition and its national tour are sponsored by Philip Morris Incorporated. Additional support has been provided by the National Endowment for the Arts.

This publication has been made possible by grants from Philip Morris Incorporated and The Eugene McDermott Foundation.

Designed by Steven Schoenfelder
Design assistant: Judy Smilow
Production by Tim McDonough
Production assistants: Ann Lucke and Carlo Pettorali
Typeset by Concept Typographic Services, New York
Printed and bound by Arnoldo Mondadori, Verona, Italy

The Museum of Modern Art
11 West 53 Street
New York, N.Y. 10019

Printed in Italy

Second printing, 1985

Frontispiece: Fetish figure. Yombe. Zaire or Cabinda. Wood, iron, shell, and mixed media, 46" (116.8 cm) high. The Detroit Institute of Arts; Founders Society Purchase, Eleanor Clay Ford Fund for African Art

DEDICATION

The Trustees and staff of The Museum of Modern Art are pleased to dedicate this book to Monroe Wheeler with great respect and affection. He has served the Museum in countless ways, initially as a member of the staff and subsequently as a Trustee. For five decades, he has generously shared with us his knowledge and taste, his love for all the arts, his enthusiasm for new ideas, and the extraordinary pleasure of his company. The dedication of these volumes is intended to honor his greatest contribution: the creation and direction of the Museum's publishing program. Under his guidance, pioneering publications from the Museum introduced a large international public to modern art and set new standards of art book production and content. The level of excellence which he established is a continuing inspiration as new volumes are added to the distinguished list Monroe Wheeler brought into being.

The influence on twentieth-century Western art of the traditional sculpture of African, Oceanic, and other peoples of the world's developing countries demonstrates the vitality that can result from cultural interaction. It is also a measure of the debt that modern culture owes these peoples.

At the outset of our century Western eyes were insensitive to the beauty, power, and subtlety of the tribal arts. But if the word "primitive" was until then used almost in a pejorative sense, it fell to the greatest and most innovative modern artists to give the word a sense both positive and vital—as when Picasso declared that "primitive sculpture has never been surpassed." Through their admiration for tribal art, and as a result of the inspiration they drew from it, modern art has been immeasurably enriched, and its public has been helped to appreciate a variety of great arts remote from its own traditions.

Philip Morris Incorporated is proud to sponsor what promises to be a landmark exploration of this artistic interaction. The idea of interchange between cultures is something we understand: we deal with people of all backgrounds in the United States, and in 170 other countries and territories.

We at Philip Morris have benefited from the contemporary art we have acquired and the exhibitions we have sponsored over the past quarter-century, ranging from Op and Pop art to the work of de Kooning, from American Indian art to textiles. They have stirred creative approaches throughout our company. We hope this exhibition will similarly inspire all who see it.

Hamish Maxwell
Chairman and Chief Executive Officer
Philip Morris Incorporated

CONTENTS

FOREWORD

In scope and concept, this publication and the exhibition it accompanies are among the most ambitious ever prepared by The Museum of Modern Art. However, they are very much in the tradition of this institution, recalling some of its earlier accomplishments. The Museum mounted major exhibitions concerned with the aesthetics of African and Oceanic art in 1935 and 1946 when other museums dealt with this material only in ethnographic terms. Over the years, this Museum has produced several exhibitions and catalogs which have proved historically important and influential, changing the ways we view the works presented, answering some prior questions and posing new ones. This book and exhibition belong in that select company.

This large and complex undertaking has required the good will and collaboration of a great many individuals and institutions. We are very grateful for their contributions, ranging from expert advice through the loans of crucial works, and these are specifically recognized in the extensive acknowledgments. However, the original conception for this project, its plan, and in large part its realization are the achievements of one person in particular: William Rubin, Director of the Department of Painting and Sculpture of the Museum. This book and this exhibition are impressive tributes to the breadth and quality of his imagination and scholarship, reflecting his dedication to the highest standards and his determination in pursuing them. The same commitment to excellence characterizes the work of the codirector of the exhibition, Kirk Varnedoe of the Institute of Fine Arts, New York University, whose knowledge and insight made him an ideal collaborator.

It was clear from its inception that this project would entail high costs for which special funding was essential. This required a corporate sponsor with the vision to recognize the purpose and significance of the exhibition and with faith in its own judgment as well as the Museum's that a very substantial commitment was warranted. We were most fortunate to find such a farsighted sponsor in Philip Morris Incorporated, which has long shown outstanding leadership in support of the arts. We owe our admiration as well as our warmest thanks to Hamish Maxwell, Chairman of the Board of Philip Morris, and to his immediate predecessor as Chairman, George Weissman, with whom this exhibition was first discussed. We also owe particular gratitude to Frank Saunders, Staff Vice President of Corporate Relations and Communications, and to Stephanie French, Manager of Cultural Affairs, for their early and perceptive interest in this project and for their unfailing cooperation. Our further appreciation is due the National Endowment for the Arts, which provided additional support, continuing its distinguished record of aiding important exhibitions.

To make this unusually extensive publication possible, a major grant was received from The Eugene McDermott Foundation. We are profoundly grateful to the Trustees of the Foundation and most especially to its President, Mrs. Eugene McDermott, who is also a knowledgeable collector of both modern and Primitive art. With her great generosity of spirit, Margaret McDermott combines unquestioned devotion to the Dallas Museum of Art with a longstanding, thoughtful interest in programs of The Museum of Modern Art for which we are most appreciative.

In conclusion, I thank all of these supporters not only for their financial assistance but just as warmly for the vital encouragement which their support gave us to persevere with this unusually challenging exhibition and publication. I hope that they will feel that the confidence they placed in this undertaking has been fully justified.

Richard E. Oldenburg
Director of the Museum

viii

PREFACES

It was an act of perspicacity and courage for Robert Goldwater to undertake a book on the vexing subject of modernist primitivism in the 1930s. At that time Picasso's *Les Demoiselles d'Avignon* was virtually unknown (it was acquired by the Museum in 1939, a year after Goldwater's *Primitivism in Modern Painting* appeared), and much of the artistic and documentary material on which our own book is based was inaccessible. The scholarly establishment treated art history then as if it had ended with Cézanne if not Courbet, and serious studies in modern art were few and far between. Yet Goldwater's book, revised in 1967 as *Primitivism in Modern Art*, remains and will remain the indispensable primer in the field.

That scholars today must take issue with some of Goldwater's conclusions does not diminish the stature of his seminal work. Nor is it surprising that we must revise a set of ideas about primitivism first formulated almost fifty years ago. The surprise is rather that any book on so central a subject in the history of modern art should have stood alone and unchallenged for so long. Indeed, Goldwater's rare, probably unique depth of knowledge in the fields of both modern and tribal art, together with the magisterial scholarly apparatus he brought into play, may well have discouraged or even intimidated later scholars.

I suspect, however, that there is more than this behind the fact that primitivism has been virtually the "invisible man" of art scholarship during the many decades since Goldwater's book was first published, years that have witnessed a phenomenal proliferation of studies on other aspects of twentieth-century art. It was not, of course, that the importance of tribal sculpture for modern artists went unnoticed. On the contrary, no history of modern art has been complete without ritual pieties on that score, usually anchored to *Les Demoiselles d'Avignon*—a variety of wrongheaded clichés that, if anything, often overstated the direct influence of the tribal sculptors. (Goldwater, the very personification of scholarly discretion, had himself understated it.)

Repetition of the familiar Sunday-supplement clichés amounted to a way of avoiding the real problems of subject. Like Ralph Ellison's "invisible man," primitivism was only metaphorically invisible, in the sense that no serious attention was paid it. No one was more guilty of this than the present author. Aside from a few facile generalities, the silence that I accorded primitivism in my *Dada and Surrealist Art* in the 1960s constitutes, I believe, my most serious error as an historian. That Marcel Jean's pioneering *History of Surrealist Painting*, which had appeared shortly before, had also paid scant attention to primitivism merely affirms the parable of the blind leading the blind. I had, as a young art historian, visited the home of the Surrealist Matta. But I never thought to relate his *personnages* to the New Ireland sculptures I saw there (as on pages 2 and 3); Matta himself had spoken of being inspired in the invention of his *personnages* by Giacometti's *Invisible Object* (p. 504) but had said nothing about tribal art. Today we know that the *Invisible Object* was itself influenced by Oceanic sculpture—and I have long since become much more circumspect in regard to what artists say, or don't say, about their art.

The few exchanges I had about tribal art with Picasso in the last years of his life altered all this. I was staggered to discover that his views on these sculptures were antipodal to the received ideas. (A clue to this had already appeared in Françoise Gilot's memoir, but I had overlooked it; subsequently, Malraux would report a conversation with Picasso very like my own.) In time, I decided that the entire question of primitivism had to be investigated anew. And what better way than by the exploration and research that an exhibition on the subject would occasion?

As in the case of our response to the paucity of both information and literature on the late work of Cézanne, an

extended book reflecting varied points of view seemed called for—something that would establish a working literature in the field. In the course of my own five-year investigation, I found that many of what seemed to me basic questions had never been asked (e.g., Why did the Cubists prefer African to Oceanic sculpture and the Surrealists the contrary?). Nor has the time available sufficed to answer satisfactorily some of the questions facing my collaborators and me. Hence, despite its size and ambition, this book should not be considered as aspiring to be definitive; it is best thought of as an opening to a new phase of scholarship in the subject.

William Rubin
Director of the Exhibition

Few aspects of modern art are as complex as primitivism, yet few reveal themselves so arrestingly in purely visual terms, simply by the juxtaposition of knowingly selected works of art. In counterpoint to the weight of words in these volumes, we should recall that modernist primitivism ultimately depends on the autonomous force of objects—and especially on the capacity of tribal art to transcend the intentions and conditions that first shaped it. This phenomenon not only testifies to the inventive power of tribal artists, humbling in its denial of Western presumptions linking human potential to technological progress. It also honors the modernist artists who, subverting their received traditions, forged a bond between intelligences otherwise divided by all the barriers of language, belief, and social structure. On the one hand, the power of art to surpass its cultural confines; on the other, the ability of a culture to see beyond, and revolutionize, its established art—in both cases, this exhibition and book rebut any notions of genetic or social determinism, and celebrate the unpredictable potential of human creativity wherever found.

Kirk Varnedoe
Codirector of the Exhibition

ACKNOWLEDGMENTS

The exhibition this book accompanies marks the first time in many years that The Museum of Modern Art has called upon ethnological museums for loans, and I must admit to having had some apprehension as to the reception of our often immoderate requests. In many cases we were asking these museums for their most outstanding objects—in connection with an exhibition that seemingly could not be further from the professional interests of anthropologists. I had been prepared for but limited interest, even for some resentment if not hostility. Much to my delight, we have received the most generous cooperation from these museums and have found, on the part of their directors and curators, genuine interest and much good will with regard to our project.

Because Paris was the cradle of twentieth-century vanguard art in general and modernist primitivism in particular, the Musée de l'Homme, known early in the century as the Musée d'Ethnographie du Trocadéro, was destined to play a central role in our exhibition. Its director, Dr. Jean Guiart, has been unstinting in his cooperation, and the Musée de l'Homme has emerged as our largest lender, agreeing to the loan of seventeen objects ranging from masks and figure sculptures to domestic utensils. While working with the Musée de l'Homme we have had constant recourse to the good offices of Francine Ndiaye, who is responsible for its African section. She has worked tirelessly to provide us with information and other assistance and has made excellent suggestions as to what we might seek out from her museum's vast reserves; her prompt response to our many inquiries—during a period of almost three years—went far beyond the call of any professional obligation. Very helpful to us in the Oceanic department of the Musée de l'Homme have been Marie-Claire

Bataille, François Lupu, charged with the collection of that department, and Catherine Krantz. Others associated with the Musée de l'Homme to whom we are indebted include Bernadette Robbe, Jean Jamin, Robert Liensol, and Marie-Noël Verger-Fèvre, as well as Monette Patisson and Muguette Dumont of the photographic archive, which has provided us with an immense amount of help both in documentary photography and materials for this book. Béatrice Coursier, previously a restorer for the Musée de l'Homme, has been of great help, putting certain objects from the Picasso estate and elsewhere in order for our exhibition and assisting in the preparation of the more delicate objects for shipment from Paris.

Also important as a lender of tribal objects has been the Musée des Arts Africains et Océaniens in Paris, whose director, Henri Marchal, had indicated at the very start of my researches an immense reservoir of good will toward our project, and whose curator of African art, Colette Noll, has been of frequent assistance in connection with different problems. Among other French museologists whom I wish to thank for help with tribal objects are Claude Seillier, Director of the Musée des Beaux-Arts et d'Archéologie of Boulogne-sur-Mer, which houses the pioneer collection of Eskimo art formed in the nineteenth century by Alphonse Pinart, and Henri Wytenhove, Curator of the Guerre collection of African art at the Musée des Beaux-Arts of Marseilles, and Philippe Chabert, Curator at the Musée d'Art Moderne, Troyes.

Needless to say, I am indebted to various other French scholars and experts, foremost among them two of the contributors of "background" chapters to this book, Jean-Louis

Paudrat, Professor at the University of Paris, and Philippe Peltier, Professor at the Ecole des Beaux-Arts in Orléans; the contribution of M. Peltier in particular far exceeded the information contained in his chapter, and I have had recourse to both for verification of important matters. Michel Leiris, no less a pioneer ethnologist than a poet and writer of distinction, has been most generous in giving his time and offering to answer our questions.

Ever since Derain's 1906 visit to the ethnological section of the British Museum, that institution has played an important role in the history of modern art. Its importance to British artists such as Epstein and Moore is, to be sure, well known. But it was also visited by many Paris artists and critics, and its important objects were widely known on the Continent through reproduction. Malcolm D. McLeod, Director of the Museum of Mankind, the anthropological division of the British Museum, could not have demonstrated greater interest in our project. An ethnologist whose private interest in modern art extends to contemporaries such as Frank Stella, he has participated in our project in a lively way, and I owe to him a number of suggestions of important objects in this book and in our exhibition; I also relish those occasions on which we have been able, at our leisure, to exchange ideas about the unique conjunction of our disciplines that inspired this exhibition. Generous loans from the Museum of Mankind include the great Austral Island figure of the god A'a (of which a much-impressed Picasso made himself a bronze replica). My thanks also to Graham Beal of the Sainsbury Centre for Visual Arts, University of East Anglia, Norwich, and to Lord and Lady Sainsbury for their generous assistance.

Taken as a group, the German ethnological museums, whose importance in the history of twentieth-century Expressionist painting can hardly be overestimated, have been unusually helpful in assisting us and generous in their lending. The tone was set by the Berlin Museum für Völkerkunde, where the director, Dr. Kurt Krieger, manifested immediate interest in the theme of the exhibition and a desire to do all he could to make it a success. Exemplary help was received on my visits to the Berlin museum from Dr. Horst Hartmann, Director of the Americas section, and Dr. Gerd Koch, Curator of Oceanic art, and, above all, from Dr. Angelika Rumpf, Curator of the African section, with whom I have conducted a lively dialogue on the subject of our exhibition. No less interested in our project, which I explored with them through photographic comparisons of proposed works, were Prof. Dr. J. Zwernemann, Director of the Hamburgisches Museum für Völkerkunde, and the curator there for the South Seas and Indonesia, Dr. Clara Wilpert. Their visible excitement in the theme of the project translated into the greatest generosity as regards loans, a generosity that included the twenty-four-foot Baining figure, one of the most extraordinary loans ever made by any museum. Dr. Wolfgang Haberland, now retired but then curator of the American department of that museum, also gave me a most kindly reception. To Dr. Herbert Ganslmayr, Director of the Übersee-Museum in Bremen, and Dr. Dieter Heintze, Curator of Australian and Oceanic ethnology in that museum, we are indebted both for advice and for their kindness in lending one of their rarest and most important objects. We are also indebted to Dr. Gisela Völger of the Rautenstrauch-Joest Museum in Cologne and to Dr. Karin von Welck for their interest and their kindness in lending.

In Switzerland, Dr. Gerhard Baer, Director of the Basel Museum für Völkerkunde, and Dr. Christian Kaufmann, Curator of Oceanic Art at that museum, were exemplary in their generosity, and we were much encouraged by their profound interest in our project. Dr. Eberhard Fischer of the Museum Rietberg in Zurich has shown no less enthusiasm and has lent generously from the collection of the museum. One of our most generous lenders has been the Musée Barbier-Müller of Geneva, whose Director, Jean Paul Barbier, a long-time personal friend, had much to do with my growing interest in tribal art over the last five years. He and his wife, Monique, have been unstinting in their help and encouragement with our project, and much of their assistance has materialized through the efforts of the museum's curator, Giselle Eberhard.

In Belgium, the Musée Royal de l'Afrique Centrale in Tervuren has lent important objects, and we are especially appreciative to its acting director, D. Thys van den Audenaerde, and to his associate, Huguette van Geluwe. The Etnografisch Museum of Antwerp is also lending one of its most important objects, and we have had outstanding cooperation on a number of accounts from its keeper, Dr. A. Claerhout, as well as from Frank Herreman. Other European museums from which we have borrowed tribal objects include the Tropenmuseum of Amsterdam, the Museum voor Land- en Volkenkunde, Rotterdam, the National Museum of Denmark, Copenhagen, the National Museum of Ireland, Dublin, and the Náprstkovo Muzeum, Prague.

Before turning to the many American anthropological and fine-arts museums that have lent tribal works, I want to thank two museums in the Pacific for their loans: the Bernice Pauahi Bishop Museum, Honolulu, and the Auckland Institute and Museum, Auckland, New Zealand. The director of the latter, Mr. G. S. Park, has truly made an extraordinary exception in permitting us to have the magnificent Caroline Islands sculpture of the goddess Kawe, which his museum has heretofore never lent.

We have received important loans from a variety of American museums, among them the Field Museum of Natural History in Chicago, whose Curator of Primitive Art and Melanesian Ethnology, Phillip Lewis, was very helpful, as was Miss Nina Cummings of the Photography Department; the National Museum of Natural History of the Smithsonian Institution, Washington, D.C.; the Lowie Museum of Anthropology of the University of California at Berkeley; the Thomas Burke Memorial Washington State Museum in Seattle; The University Museum of the University of Pennsylvania, Philadelphia; The Detroit Institute of Arts, whose Deputy Director, Michael Kan, has supported the project from its inception, and whose superb installation of tribal material first suggested to me that Detroit might wish to share this exhibition with us; the Indiana University Art Museum, Bloomington, which under the direction of Thomas Solley and the curatorship of Roy Sieber has developed a superb ethnological collection; the Seattle Art Museum; the Philadelphia Museum of Art; The Art Institute of Chicago (Richard Townsend, Curator); and in New York, the American Museum of Natural History and the Museum of the American Indian, Heye Foundation, and, last, but very far from least, The Michael C. Rockefeller Memorial Collection of The Metropolitan Museum of Art.

Douglas Newton, Chairman of the Department of Primitive Art at the Metropolitan, has been a consistent source of advice and good will, having vetted not only my introductory chapter but that of M. Peltier and having assisted us throughout in problems regarding Oceanic art history and tribal nomenclature. Susan Vogel, Curator of African Art in the Metropolitan, and Executive Director of the Center for African Art in New York, also vetted the introductory chapter and discussed it with me at great length, offering numerous recommendations, especially as regards delicate problems discussed in the notes; she also reviewed for us the chapter by M. Paudrat on the arrival of African art in the West. I have also depended very heavily for scholarly references and corrections on Leon Siroto, who not only reviewed the introductory chapter but contributed importantly to the discussions of the delicate problems of terminology dealt with particularly in that chapter. Jean Wagner, who pursued considerable independent research on our behalf, also spent many months establishing captions for the tribal works; she relied for advice in certain knotty problems on Douglas Newton for Oceanic questions and Leon Siroto for African ones. Inasmuch as recent scholarship has led to constant changing of traditional tribal attributions, the reader may be surprised to see some objects in this book appearing with unfamiliar tribal names in the captions. For the most part, I have accepted Siroto's emendations as regards African tribal names, but in a few cases I have retained, for the sake of communication with our nonspecialized readers, important traditional misattributions (e.g., Bambara rather than Bamana) simply because the objects in question continue to be known by collectors and the lay public under their familiar though less correct names. I owe an immense debt of gratitude to Mr. Siroto for the information he has provided, but he should not of course be held responsible for any errors in the captioning or in any other scholarly material in this book.

In addition to the museologists and scholars who have aided me in this undertaking, I have learned a great deal—and have been able to sharpen and test my eye—through a continuing dialogue with two artist-collectors of tribal art. The painter Willy Mestach, of Brussels, who is also one of our principal lenders, has been very generous in giving his time to the discussion of the finer points of African aesthetics and has put at my disposal texts and photographs that he has gathered over a period of many years. No doubt the most important of my artist contacts, however, has been my dialogue with Arman—fruit of a friendship that goes back a quarter of a century. It is very much through Arman's own collection, at first seen (figuratively speaking) only out of the corner of my eye, that I began to familiarize myself with African art. Though my discussions with Picasso were the immediate trigger to my involvement with the problem of modernist primitivism, Arman's willingness to pursue the implications of the subject with me, to further my education through visits with me to private collections and museums, helped provide the necessary background for this study.

A few dealer-collectors also have been of immense assistance. Foremost among these is certainly Jacques Kerchache. In the earliest phases of my investigation especially, he proposed objects for my consideration, put me in touch with collectors, recommended collections to visit. His photographic collection, developed during extensive travels, proved especially useful, as it was formulated on the principle of aesthetic quality rather than on those typological bases that normally govern the photo files of ethnological museums. Kerchache's taste in African objects has a particular propinquity with my own, and my discussions with him have been of immense help. I have also discussed the materials for this exhibition in ongoing dialogues with both Philippe Guimiot and Hélène Leloup, discussions from which I have not only learned a great deal, but which have afforded me constant pleasure.

Among the museums lending modern works are some that have made extraordinary exceptions both in number and in kind. We are profoundly indebted to Dominique Bozo and Germain Viatte of the Musée National d'Art Moderne of the Centre Georges Pompidou in Paris and to Michèle Richet, Marie-Laure Bernadac, and Hélène Seckel of the Musée Picasso, Paris; Michel Laclotte of the Musée d'Orsay, Paris, has exceptionally made a number of Gauguin's wood carvings available for the exhibition; and Dr. Leopold Reidemeister of the Brücke-Museum in Berlin, Dr. Martin Urban of the Ada und Emil Nolde Stiftung in Seebüll, and Alan Bowness of the Tate Gallery, London, must be mentioned for their special efforts on our behalf. Other museums lending modern works are the Kunstmuseum Bern; the Saarland-Museum, Saarbrücken; the Dansmuseet, Stockholm; and the Staatsgalerie, Stuttgart.

Among the American museum directors who have made very special efforts on our behalf are Edgar Peters Bowron of the North Carolina Museum of Art, Raleigh; Anne d'Harnoncourt of the Philadelphia Museum of Art; Arnold Jolles of the Seattle Art Museum; Thomas Messer (and Deputy Director Diane Waldman) of The Solomon R. Guggenheim Museum, New York; and John H. Neff of the Museum of Contemporary Art, Chicago. American museums lending modern works are the Albright-Knox Art Gallery, Buffalo; the Fogg Art Museum of Harvard University, Cambridge, Mass.; The Art Institute of Chicago; the Dallas Museum of Art; the Nelson-Atkins Museum of Art, Kansas City; the Sheldon Memorial Art Gallery, University of Nebraska, Lincoln; the Yale University Art Gallery, New Haven; The Metropolitan Museum of Art, New York; Vassar College Art Gallery, Poughkeepsie; the Art Gallery of Ontario, Toronto; the Munson-Williams-Proctor Institute, Utica; the Hirshhorn Museum and Sculpture Garden of the Smithsonian Institution of Washington, D.C.; and The Phillips Collection, Washington, D.C.

Among those who have been especially helpful in connection with loans of tribal objects are a number that I must single out for the special help they have given or the time and effort they have put into particular favors we have asked of them. Among these are Michel Leveau, John A. Friede, Mr. and Mrs. Pierre Matisse, Dr. Werner Muensterberger, and Claude Picasso. Hans Geissler, Roberto di Giacomo, Ben Heller, Henri Kamer, Pierre Lévy, Pierre Schneider, and Patricia Withofs have been instrumental in acquiring desired loans of tribal works.

In addition to those lenders of tribal objects whose assistance has already been noted in some other capacity, I want to express the Museum's gratitude to the following for loans: Dr. Edouard André, Rita Reinhardt Bedford, Jacques Blanckaert, Madame André Breton, Serge Brignoni, Dr. and Mrs. Sidney Clyman, Pierre Dartevelle, Philippe and Maryse

Dodier, Valerie Franklin, Murray and Barbara Frum, Marc and Denyse Ginzberg, Lawrence Gussman, the Erich Heckel Estate, Mr. and Mrs. Claude Laurens, Mr. and Mrs. Jacques Lazard, Robert and Jean-Jacques Lebel, the Fondation Olfert Dapper, Marie Matisse, Matta, Gertrud A. Mellon, Dominique de Menil, Mr. and Mrs. Herbert R. Molner, Mr. and Mrs. Alain de Monbrison, Carlo Monzino, Jack Naiman, Claude Picasso, Jacqueline Picasso, Marina Picasso, Paloma Picasso, Mr. and Mrs. Kelley Rollings, Mr. and Mrs. Milton Rosenthal, Mr. and Mrs. Gustave Schindler, Merton D. Simpson, Sheldon H. Solow, Mr. and Mrs. Saul Stanoff, Dorothea Tanning, George Terasaki, Pierre and Claude Vérité, Joy S. Weber, Raymond and Laura Wielgus, and a large number of private collectors who wish to remain anonymous.

For loans of modern works to our exhibition, we are indebted to Helena Benitez, Heinz Berggruen, the Galerie Beyeler in Basel, Sandra Davidson, Robert and Lynne Dean, Mr. and Mrs. A. E. Diamond, the Forum Gallery, New York, the Adolph and Esther Gottlieb Foundation, Inc., Bob Guccione and Kathy Keeton, Phyllis Hattis, Mr. and Mrs. Morton L. Janklow, Lee Krasner, the Galerie Louise Leiris, Donald Ludgin, Carmen Martinez and Vivianne Grimminger, The Henry Moore Foundation, Joshua and Leda Natkin, Jacqueline Picasso, Claude Picasso, Eva-Maria and Heinrich Rössner, Mary Rower, Italo Scanga, the Robert Schoelkopf Gallery, Mr. and Mrs. Joseph Shapiro, Sylvia and Joseph Slifka, Ruth and Frank Stanton, Dorothea Tanning, the Thyssen-Bornemisza Collection, Lugano, Mr. and Mrs. Burton Tremaine, Evelyne Wolf Walborsky, and Maya Picasso Widmaier, as well as a number of lenders who wish to remain anonymous. In addition to the lenders themselves, a number of individuals have been instrumental in obtaining loans of modern works and have helped us in other ways. Among these are William Acquavella, Ernst Beyeler, Robert T. Buck, Ann Garrould, Annette Giacometti, Sanford Hirsch, Maurice Jardot, Mr. and Mrs. Jan Krugier, Pierre Levai, Mary Lisa Palmer, Alain Tarica, and Eugene Thaw.

The mounting of a major exhibition such as this takes the efforts and energies of many more museum professionals than I can possibly thank here, but it begins with the support of the Museum's Director. Dick Oldenburg's faith in this exhibition and the manner in which that faith has translated into letters, meetings, discussions, and fund-raising have been exemplary—as have been the efforts in connection with the last (and most onerous) of those activities by Jack Limpert and his assistant Darryl Brown. The intricacies of planning and scheduling the exhibition and its tour have been in the experienced hands of Richard Palmer, Coordinator of Exhibitions. No one, of course, has had a more important role in the actual formulation of this exhibition than my codirector, Kirk Varnedoe of the Institute of Fine Arts, New York University. Apart from his three superb chapters in this book, he has been involved from the very beginning in the conception, planning, and installation of the show itself. He has also taken entirely upon himself the organization of its fourth section (Contemporary Explorations) and has assisted me with the editing of every chapter in this book. The pleasure I have derived from our continuing dialogue can only whet my appetite for future collaborations with him.

For the thousand things that must be done to assure the many loans to an exhibition of this amplitude, one is dependent on the resourcefulness of one's close associates. The enterprise, the efficacy, and the concern for detail evidenced by Laura Rosenstock, Assistant Curator, who has been responsible for the modern works in this exhibition, and Diane Farynyk, Curatorial Assistant, who has dealt with the tribal ones, are unmatched in my prior museological experience; both have labored after hours on countless occasions, juggling multiple duties involving this book as well as the exhibition. The research necessary for both the exhibition and the book—a research extending over four years—has naturally been extensive, and I think it safe to say that neither book nor exhibition could have been done without the expert research provided during this long period by Judith Cousins; her contribution has been invaluable.

The paperwork, telephone calls, cables, etc., that go into projects such as this are literally numbing, and in the face of this, the combination of professional efficacy and cheerfulness-under-pressure shown by my assistants, Ruth Priever and Lisa Farrington, merits my every ounce of appreciation. They have been ably helped by Alexandra Muzek. Julie Saul was of continuous assistance in acquiring photographs and straightening out captions. Louis Estrada, Erich Keel, and Aurel Scheibler solved the various foreign-language problems that arose.

The installation of the exhibition has been designed by Charles Froom in collaboration with Kirk Varnedoe and me and in association with Jerry Neuner of our own staff; over recent years "Chuck" has been responsible for major museum installations all over the world, and it is a pleasure to welcome him back to the museum where he began his career. The shipping, reception, and physical installation of the work involved in this exhibition have been especially challenging for a museum that has dealt heretofore almost solely with modern art, and our registrar, Eloise Ricciardelli, and her associate, Elizabeth Funghini, have faced up to this task with courage and knowledgeability. Likewise the special care required for this exhibition has put a particular weight on the Conservation Department, and Antoinette King, its director, and Patricia Houlihan and Terry Mahon have risen to the occasion.

Turning now to the production of this book, I must express my debt to Mac McCabe, who has had to take in hand, amongst his earliest charges as our Director of Publications, this most ambitious ever of MoMA's publications. He has organized his troops superbly, and his combination of managerial know-how and personal affability has kept the project rolling. The most complicated task in the production of this book has unquestionably been its design, and in this connection I can only marvel at the combination of inventiveness and speed with which, under great and constant pressure, Steve Schoenfelder has endowed a scholarly book with a beauty and clarity usually found only in luxury productions. I cannot imagine a smoother or a more pleasurable working relationship than the one I have enjoyed with him during the many months in which we developed the layout. He has been ably assisted by Judy Smilow. The editing of this entire book was in the expert hands of Francis Kloeppel (in collaboration with Holly Elliott and with editorial assistance from Alarik Skarstrom). Working with him has meant for me the renewal of intellectual pleasures and satisfactions of a type to which I have become accustomed in our past collaborations. The

color reproductions and the printing of the book have been the responsibility of Tim McDonough, who has spent months in Verona at the presses of Mondadori to insure the best possible results. Ann Lucke was the able production assistant who assured communication between our department and the members of the Publications staff. Frances Keech provided precious assistance in clearing permissions. Nancy Kranz has dealt ably with her foreign counterparts in establishing the foreign-language editions of this book.

We have made constant demands on Richard Tooke, Supervisor of Rights and Reproductions. Kate Keller and Mali Olatunji, photographers on Mr. Tooke's staff, and Mikki Carpenter of the Audio-Visual Archive have worked under great pressure to assist us.

The education program of seminars and lectures built around the book and exhibition have been in the expert hands of Philip Yenawine and Ann Sass. Luisa Kreisberg, Director of Public Information, and her able assistant Pam Sweeney have helped to make both exhibition and book known to the press, as has Sharon Zane.

The years of research that went into this book have necessitated calling on such a large number of people for help in providing information, photographs, checking historical facts, tracking down provenances, providing rare texts and periodicals, and a whole spectrum of other forms of assistance, that it would be impossible to name them all. I do feel it necessary, however, to mention the following individuals whose participation extended beyond any for which they may be footnoted in the text itself. They are Pierre Agoune, Gilles Artur, Martha Asher, Brigitte Baer, Marga Barr, G. Bauquier, Jean-Claude Bellier, Gaëlle Bernard, André Berne Joffroy, Gilbert Boudar, Louise Bourgeois (who kindly provided us with the typescript of the unpublished English version of a talk given by Robert Goldwater at Dakar in 1967), Michael Brenson, Jean Cambier, Ted Carpenter, John Cauman, John Cavaliero, Marianne Clouzot, Marie-Cécile Comerre, Elizabeth Cowling, Pierre Daix, Emile Deletaille, Nelia Dias, Gladys Fabre, Anne Fardoulis, Marie-France Fauvet-Berthelot, Jean Favière, Yves de Fontbrune, Helen Franc, Edward Fry (who was helpful in countless ways), Karlheinz Gabler, Danielle Gallois Duquette, Claude Duthuit, Lydia Gasman, John Golding, Max Granick, Wilder Green, John H. Hauberg, Jacques B. Hautelet, Gaston Havenon, Reinhold Hohl, Valerie Holman, Joi Colette Huckaby, Jean-Michel Huguenin, Geoffrey Ireland, Knud Jensen, Joop M. Joosten, David Josefowitz, Sam Josefowitz, Janet Kardon, Michel Kellermann, Raoul Lehuard, Brigitte Level, Yulla Lipchitz, Albert Loeb, Erle Loran, James Lord, Joan M. Lukach, George Sylvestre Lynch, Alex Maguy, Laurence Marceillac, Marilyn McCully, Franz Meyer, Roland de Montaigu, Nicole and Michel Morel-Révoil, Francis Naumann, Monique Nonne, Tamara Northern, Father G. Noury, Carol O'Biso, Michael Parke-Taylor, André-François Petit, Margaret Potter, Charles Ratton, Juliet Man Ray, Alfred Richet, Warren M. Robbins, Margit Rowell, Eleanore Saidenberg, Gert Schiff, Werner Schmalenbach, Annie Joly-Segalon, Gerard J. Soussan, James Specht, Werner Spies, Robert Stoppenbach, Robin Symes, Geneviève Taillade, Cecilia de Torres, Mary Jane Victor, Jeanine Warnod, Rose-Carol Washton Long, James Willis, and Lester Wunderman.

The course of our research has naturally led us to make unusual demands for help on various libraries, and among the many librarians whose names must be mentioned are Clive Phillpot, Janis Ekdahl, Daniel Pearl, Paula Baxter, and Rona Roob of our museum's own library; Allan D. Chapman, Virginia-Lee Webb, and Ross Day of the Robert Goldwater Library of the Metropolitan Museum; Sy Bran of the Columbia University Library; James Massaquoi of the library of the Institute of Fine Arts of New York University; and Margaret O'Bryant of the Alderman Library of the University of Virginia. In Europe we have received special help from Michael Doran, Librarian of the Courtauld Institute of Art, University of London; Suzanne Lemas, former Chief Librarian of the Fondation Jacques Doucet; Josué Seckel, Reference Librarian at the Bibliothèque Nationale, Paris; Monique Sévin, Chief Librarian of the Bibliothèque d'Art et d'Archéologie of the University of Paris; and Françoise Weill, Chief Curator of the library of the Musée de l'Homme.

While the many photographers whose work is reproduced in this volume are credited elsewhere in this book, there are a few whose efforts on our behalf went far beyond what might professionally be expected. They are Hélène Adant, Michel Appollot, Brassaï (Madame Brassaï was especially helpful in searching out very specialized material for us), Denise Colomb, André Koti, André Ostier, Edward Quinn, and Pierre Pitrou.

I am of course indebted to the authors of this book, whose names are listed on the contents page. Every one of them has made useful suggestions in regard to the exhibition. A few, however, have played a larger role in its planning: Rosalind Krauss has worked with Kirk Varnedoe and me on the educational program that accompanies the exhibition, Alan Wilkinson has regularly offered ideas and material, and Evan Maurer has made many contributions, acting in particular as an advisor on American Indian material. I am also deeply indebted to Barbara Braun, who has worked with me especially on questions relating to pre-Columbian art.

It is impossible to extend individual thanks to the full company of persons who have in one way or another helped to advance our project. Further, a number of them prefer no public acknowledgment of their kindness. But to all, named and unnamed, who have contributed to the realization of the exhibition and the book, I wish to express, on behalf of the Trustees of The Museum of Modern Art, our deepest gratitude.

W. R.

In these volumes, the notes to an essay immediately follow the text of the essay.

A page reference in parentheses is given for an illustration that does not fall on the page where it is mentioned or on the facing page. In the case of an illustrated tribal work that is owned or was owned by a modern artist, that artist's name is given in capital letters in the caption.

In captions, the dimensions of a work of art are given in inches and centimeters; height precedes width, which is followed, in the case of modern sculpture, by depth. Unless otherwise specified, drawings are works on paper, for which sheet size is given. For Primitive objects, the height does not include projecting feathers or fiber fringes. Names of ethnic groups appear without prefixes and are separated from the place of origin by a period.

Many of the works in this book are not included in the exhibition of the same title; a checklist for that exhibition is available from The Museum of Modern Art.

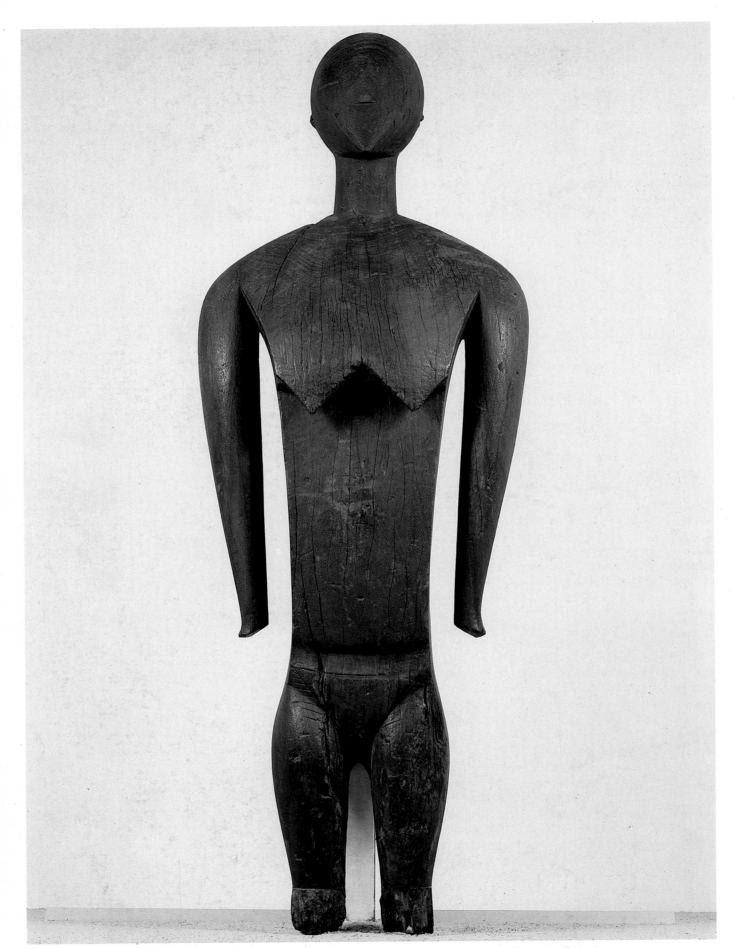

Figure (Goddess Kawe). Nukuoro, Caroline Islands. Wood, 7'1½" (217 cm) high. Auckland Institute and Museum, Auckland, New Zealand

MODERNIST PRIMITIVISM
AN INTRODUCTION

William Rubin

No pivotal topic in twentieth-century art has received less serious attention than primitivism—the interest of modern artists in tribal[1] art and culture, as revealed in their thought and work. The immense bibliography of modern art lists only two instructive books on the subject: the pioneering text by Robert Goldwater, first published almost half a century ago, and that of Jean Laude, written two decades ago, considerably more limited in scope, never translated from the French, and long out of print.[2] Neither author had access to certain important collections, that of Picasso among them, or to much significant documentation now available. The need for a scholarly literature consistent with the historical importance of the subject is reflected in the unusual scope of the present undertaking—though, at best, this book is but a beginning.

Upon reflection, it is perhaps not surprising that primitivism has received so little searching consideration, for intelligent discourse on the subject requires some familiarity with both of the arts whose intersection in modern Western culture accounts for the phenomenon. The studies of the two have traditionally remained separate. Until fairly recently, tribal objects were largely the preserve, at least in scholarly and museological terms, of ethnologists. Only since World War II has the discipline of art history turned its attention to this material; however, graduate-level programs in Primitive[3] art are still comparatively rare, and few of their students are also involved in modern studies. It should come as no surprise, therefore, that much of what historians of twentieth-century art have said about the intervention of tribal art in the unfolding of modernism is wrong. Not familiar with the chronology

of the arrival and diffusion of Primitive objects in the West, they have characteristically made unwarranted assumptions of influence. As an example, I cite the fact that none of the four types of masks proposed by eminent scholars as possible sources for *Les Demoiselles d'Avignon* could have been seen by Picasso in Paris as early as 1907 when he painted the picture.[4] On the other hand, few experts in the arts of the Primitive peoples have more than a glancing knowledge of modern art, and their occasional allusions to it sometimes betray a startling naiveté.[5]

The quite different kinds of illumination cast upon tribal objects by anthropologists and by art historians of African and Oceanic cultures are ultimately more complementary than contradictory. Both naturally focus on understanding tribal sculptures in the contexts in which they were created. Engaged with the history of primitivism, I have quite different aims; I want to understand the Primitive sculptures in terms of the Western context in which modern artists "discovered" them. The ethnologists' primary concern—the specific function and significance of each of these objects—is irrelevant to my topic, except insofar as these facts might have been known to the modern artists in question. Prior to the 1920s, however, at which time some Surrealists became *amateurs* of ethnology, artists did not generally know—nor evidently much care—about such matters. This is not to imply that they were uninterested in "meanings," but rather that the meanings which concerned them were the ones that could be apprehended through the objects themselves.[6] If I therefore accept as given a modernist perspective on these sculptures (which like any other perspective is by definition a bias), I shall nevertheless try to make a virtue of it, hoping that despite the necessarily

1

fragmentary character of our approach—whose primary purpose is the further illumination of modern art—it may nevertheless shed some new light even on the Primitive objects.

Discourse on our subject has suffered from some confusion as to the definition of primitivism. The word was first used in France in the nineteenth century, and formally entered French as a strictly art-historical term in the seven-volume *Nouveau Larousse illustré* published between 1897 and 1904: "*n.m. B.-arts. Imitation des primitifs.*"[7] Though the Larousse reference to "imitation" was both too extreme and too narrow, the sense of this definition as describing painting and sculpture influenced by earlier artists called "primitives" has since been accepted by art history; only the identity of the "primitives" has changed. The Larousse definition reflected a mid-nineteenth-century use of the term insofar as the "primitives" in question were primarily fourteenth- and fifteenth-century Italians and Flemings. But even before the appearance of the *Nouveau Larousse illustré*, artists had expanded the connotations of "primitive" to include not only the Romanesque and Byzantine, but a host of non-Western arts ranging from the Peruvian to the Javanese—with the sense of "primitivism" altering accordingly. Neither word, however, as yet evoked the tribal arts of Africa or Oceania. They would enter the definitions in question only in the twentieth century.

While primitivism began its life as a specifically art-historical term, some American dictionaries subsequently broadened its definition. It appears for the first time in Webster in 1934 as a "belief in the superiority of primitive life," which implies a "return to nature." Within this expanded framework, Webster's art-related definition is simply "the adherence to or reaction to that which is primitive."[8] This sense of the word was evidently firmly entrenched by 1938 when Goldwater used it in the title of *Primitivism in Modern Painting*. The general consistency of all these definitions of primitivism has not, however, prevented certain writers from confusing primitivism (a Western phenomenon) with the arts of Primitive peoples.[9] In view of this, we have drawn attention to the former's very particular art-historical meaning by enclosing it within quotation marks in the title of our book.

Nineteenth-century primitivist painters had appreciated pre-Renaissance Western styles for their "simplicity" and "sincerity"—which they saw in the absence of complex devices of illusionist lighting and perspective—and for their vigor and expressive power, qualities these artists missed in the official art of their own day, which was based on Classical and academic models. The more that bourgeois society prized the virtuosity and finesse of the salon styles, the more certain painters began to value the simple and naive, and even the rude and the raw—to the point that by the end of the nineteenth century, some primitivist artists had come to vaunt those non-Western arts they called "savage." Using this word admiringly, they employed it to describe virtually any art alien to the Greco-Roman line of Western realism that had been reaffirmed and systematized in the Renaissance. Given the present-day connotations of "primitive" and "savage," we may be surprised to discover what art these adjectives identified for late nineteenth-century artists. Van Gogh, for example, referred to the high court and theocratic styles of the ancient Egyptians and the Aztecs of Mexico as "primitive," and charac-

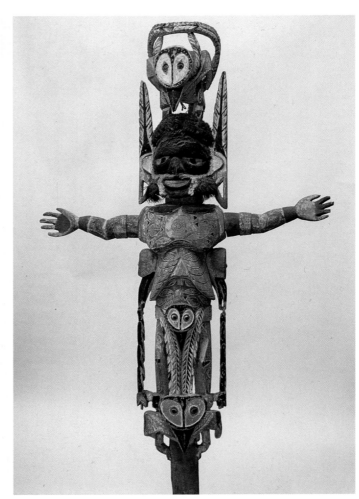

Malanggan figure. New Ireland. Painted wood, 52⅜" (133 cm) high. Collection SERGE BRIGNONI, Bern

terized even the Japanese masters he revered as "savage" artists. Gauguin used the words "primitive" and "savage" for styles as different as those of Persia, Egypt, India, Java, Cambodia, and Peru. A self-proclaimed "savage" himself, Gauguin later annexed the Polynesians to his already long list of "primitives," but he was less drawn to their art than to their religion and what remained of their life-style. Decades before African or Oceanic sculpture would become an issue for artists, the exotic arts defined as "primitive" by Gauguin's generation were being admired for many qualities that twentieth-century artists would prize in tribal art—above all, an expressive force deemed missing from the final phases of Western realism, which late nineteenth-century vanguard artists considered overattenuated and bloodless. With the exception of Gauguin's interest in Marquesan and Easter Island sculpture, however, no nineteenth-century artist demonstrated any serious artistic interest in tribal art, either Oceanic or African.[10] Our contemporary sense of Primitive art, largely synonymous with tribal objects, is a strictly twentieth-century definition.

The first decades of the twentieth century saw both a change in meaning and a shrinkage in the scope of what was considered Primitive art. With the "discovery" of African and Oceanic masks and figure sculptures by Matisse, Derain, Vlaminck, and Picasso in the years 1906–07, a strictly modernist interpretation of the term began. As the fulcrum of

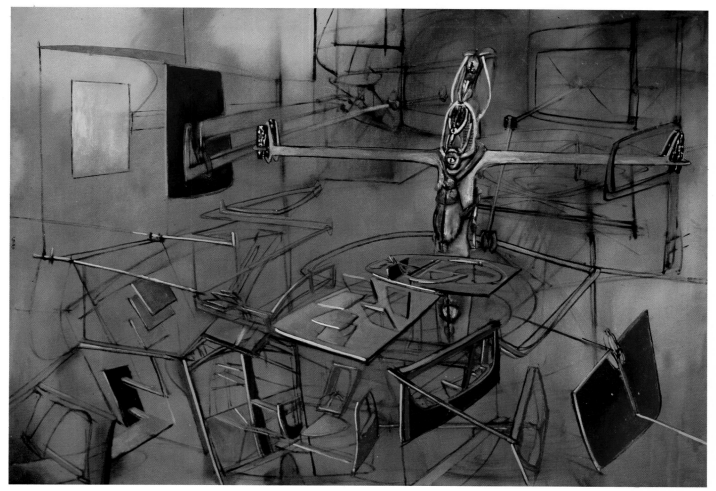

Matta. *A Grave Situation*. 1946. Oil on canvas, 55 x 77" (139.7 x 195.6 cm). Promised gift to the Museum of Contemporary Art, Chicago, from the Mary and Earle Ludgin Collection

meaning shifted toward tribal art, the older usages did not fall away immediately. "Primitive art" simply became increasingly identified, during the following quarter-century, with tribal objects. As far as vanguard artists of the beginning of the century were concerned, this meant largely African and Oceanic art, with a smattering (in Germany) of that of American Indians and Eskimos (which would become better known among Paris artists only in the twenties and thirties).

In Paris, the term "art nègre" (Negro art)[11] began to be used interchangeably with "primitive art." This seemingly narrowed the scope of meaning to something like tribal art.[12] But as a term that should have been reserved for African art alone, it was in fact so loosely employed that it universally identified Oceanic art as well. It was not until the 1920s that Japanese, Egyptian, Persian, Cambodian, and most other non-Western court styles ceased to be called Primitive, and the word came to be applied primarily to tribal art, for which it became the standard generic term.[13] In Goldwater's book, written the following decade, the "primitive" is synonymous with African and Oceanic art. To be sure, pre-Columbian court styles such as the Aztec, Olmec, and Incan continued to be called Primitive (and artists did not always distinguish between them and tribal art). But this was an inconsistency, and should now be recognized as such. In their style, character, and implications, the pre-Columbian court and theocratic arts of Mesoamerica and South America should be grouped with the Egyptian,

Javanese, Persian, and other styles that together with them had consituted the definition of the Primitive during the later nineteenth century.[14] The progressive change in the meaning of the word after 1906 was a function of a change in taste. Consistent with it, pre-Columbian court art enjoyed—except for Moore, the Mexican muralists, and, to a lesser extent, Giacometti—a relatively limited interest among early twentieth-century vanguard artists. Picasso was not unique in finding it too monumental, hieratic, and seemingly repetitious. The perceived inventiveness and variety of tribal art was much more in the spirit of the modernists' enterprise.[15]

The inventiveness just mentioned, which led in some African and Oceanic societies to an often astonishing artistic multiformity, constitutes one of the most important common denominators of tribal and modern art. Few remaining sculptures of the Dan people, to take perhaps the most startling example, are much more than a century old; yet the range of invention found in their work (pp. 4, 5) far outdistances that of court arts produced over much longer periods—even millennia of Ancient Egypt after the Old Kingdom.[16] And unlike Egyptian society, which placed a positive value upon the static as regards its imagery, the Dan not only explicitly appreciated diversity but recognized the value of a certain originality. As the fascinating study by the ethnologist P. J. L. Vandenhoute showed, the Dan were even willing "to recognize a superior social efficacity in [such originality]."[17] Although tribal sculp-

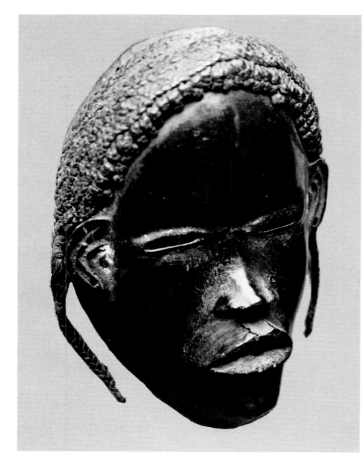

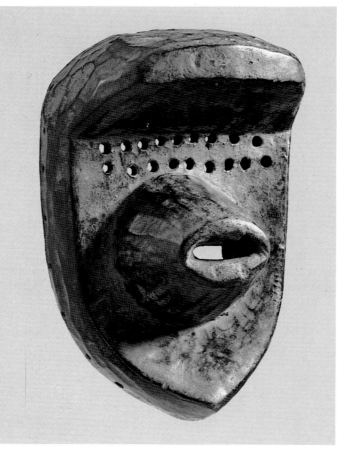

Mask. Dan. Ivory Coast or Liberia. Wood and fiber, c. 9″ (22.9 cm) high. Collection Charles Ratton, Paris

Mask. Dan. Ivory Coast or Liberia. Wood, 9⅞″ (25 cm) high. Private collection

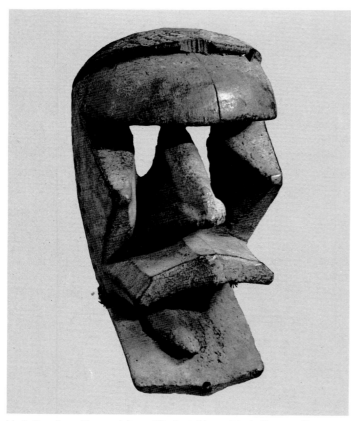

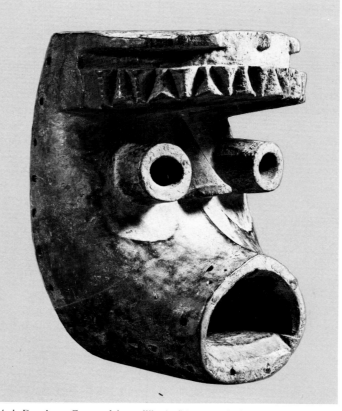

Mask. Dan. Ivory Coast or Liberia. Wood, 8⅝″ (22 cm) high. Private collection

Mask. Dan. Ivory Coast or Liberia. Wood, 9″ (22.9 cm) high. Private collection

tors were guided by established traditional types, the surviving works themselves attest that individual carvers had far more freedom in varying and developing these types than many commentators have assumed. This relative variety and flexibility, along with the concomitant incidence of change, distinguish their art from the more static, hieratic—and often monumental—styles of the court cultures in question (which for the sake of convenience I shall refer to generically as Archaic, in what amounts to but a slight broadening of that term's usual art-historical application).[18]

During the last two decades, the words Primitive and primitivism have been criticized by some commentators as ethnocentric and pejorative, but no other generic term proposed as a replacement for "primitive" has been found acceptable to such critics; none has even been proposed for "primitivism." That the derived term primitivism is ethnocentric is surely true—and logically so, for it refers not to the tribal arts in themselves, but to the Western interest in and reaction to them. Primitivism is thus an aspect of the history of modern art, not of tribal art. In this sense, the word is comparable to the French "japonisme," which refers not directly to the art and culture of Japan, but to the European fascination with it. The notion that "primitivism" is pejorative, however, can only result from a misunderstanding of the origin and use of the term, whose implications have been entirely affirmative.

Objections to the adjective "primitive," on the other hand, focus not unfairly on the pejorative implications of certain of its many meanings.[19] These have had no place, however, in its definition or use as an art-historical term. When Picasso, in the ultimate compliment, asserted that "primitive sculpture has never been surpassed,"[20] he saw nothing contradictory—and certainly nothing pejorative—in using the familiar if now-contested adjective "primitive" to identify the art. It is precisely the admiring sense with which he and his colleagues invested the word that has characterized its use in art writing. Employed in this restricted way, the word has a sense no less positive than that of any other aesthetic designations (including Gothic and Baroque, which were both coined as terms of opprobrium).[21] The "effective connotations" of "primitive" when "coupled with the word art," as Robert Goldwater concluded, are of "a term of praise."[22] As we are using the term Primitive essentially in an art-historical spirit, we have decided to insist upon this sense of its meaning by capitalizing its initial letter (except within quotation marks). All this does not mean that one would not happily use another generic term if a satisfactory one could be found.[23] And, to be sure, William Fagg, dean of British ethnologists of Africa, proposed that "tribal" be universally substituted for "primitive."[24] But the critics who object to "primitive," object with equal if not greater vehemence to "tribal."[25]

It is clear that art history is not the only discipline that has sought and failed to find a generic term for the Primitive that would satisfy critics. After struggling with the problem for some time, Claude Lévi-Strauss noted that "despite all its imperfections, and the deserved criticism it has received, it seems that *primitive*, in the absence of a better term, has definitely taken hold in the contemporary anthropological and sociological vocabulary." "The term *primitive*," he continued, "now seems safe from the confusion inherent in its

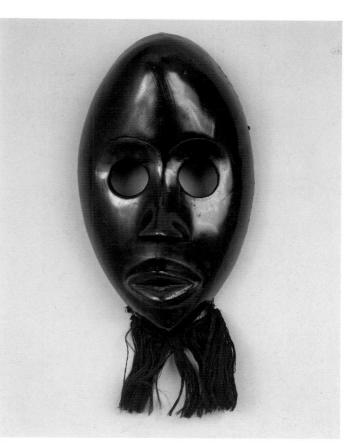

Mask. Dan. Ivory Coast or Liberia. Wood and fiber, 9" (22.9 cm) high. Private collection

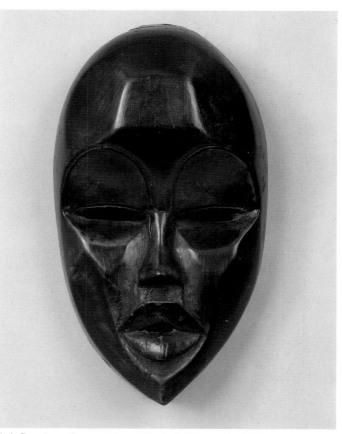

Mask. Dan. Ivory Coast or Liberia. Wood, 10¼" (26 cm) high. Private collection

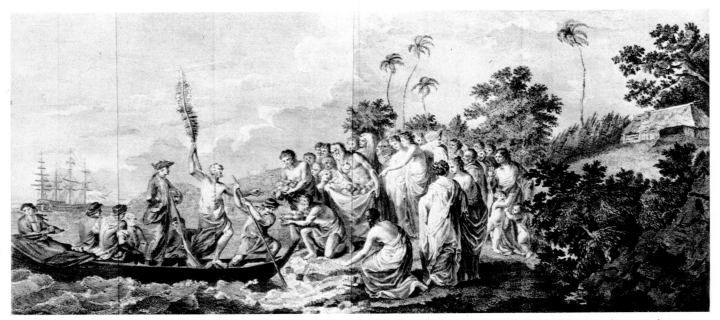

Robert Bénard. *The Arrival of Cook at the Tonga Islands*. Engraving. 18th century. The fusion of the "myth of the primitive" and the "myth of the antique" is seen in the costumes, postures, and facial types in this engraving, which was made for the French translation of the account of Captain James Cook's second Pacific voyage (1772–75). From a painting by William Hodges, who sailed with Cook, it shows Cook landing on one of the Tonga (or Friendly) Islands. Paris, Bibliothèque du Musée de l'Homme

etymological meaning and reinforced by an obsolete evolutionism." Lévi-Strauss then added a reminder hardly necessary for those who admire tribal art. "A primitive people," he insisted, "is not a backward or retarded people; indeed, it may possess, in one realm or another, a genius for invention or action that leaves the achievements of other peoples far behind."[26] This last was recognized by modern artists at the beginning of this century, well before the attitudes summarized by Lévi-Strauss were to characterize anthropological or art-historical thinking.

For the bourgeois public of the nineteenth century, however, if not for the art lovers of the twentieth, the adjective "primitive" certainly had a pejorative meaning. Indeed, that public considered any culture outside Europe, or any art outside the parameters of Beaux-Arts and salon styles—which meant all non-Western and some Western art—inherently inferior. (Even Ruskin opined that there was "no art in the whole of Africa, Asia or America.") To the extent that the "fetishes" of the tribal peoples were known at all, they were considered the untutored extravagances of barbarians. In fact, tribal objects were not then considered art at all. Gathered first in *cabinets de curiosités*, the masks and figure sculptures (along with other material) were increasingly preserved during the later nineteenth century in ethnographic museums, where no distinctions were made between art and artifact. As artifacts were considered indices of cultural progress, the increasing hold of Darwinian theories could only reinforce prejudices about tribal creations, whose makers were assigned the bottom rung of the cultural evolutionary ladder.

We shall explore in depth in our chapter on Gauguin a quite opposite Western view of the Primitive that had already begun to form in the eighteenth century, especially in France. But this affirmative attitude, of which Jean-Jacques Rousseau's Noble Savage is the best-known embodiment, involved only a segment of the small educated public. It remained, moreover, literary and philosophical in character—never comprehend-

ing the plastic arts. Antipodal to the popular view, it tended to idealize Primitive life, building upon it the image of an earthly paradise, inspired primarily by visions of Polynesia, especially Tahiti.[27] If we trace this attitude to its source in Montaigne's essay "On Cannibals," we see that from the start the writers in question were primarily interested in the Primitive as an instrument for criticizing their own societies, which they saw as deforming the innately admirable spirit of humankind that they assumed was still preserved in the island paradises.

Needless to say, most of these writers knew little of life in Polynesia or other distant lands, and the body of ideas they generated may be justly characterized as "the myth of the primitive." Indeed, even among those having firsthand contact with tribal peoples, the fantasy of the Primitive often overrode reality. The French explorer Bougainville, for example, one of the discoverers of Tahiti, saw evidence there of cannibalistic practices. But all of this is forgotten in this classic description of the island as "la Nouvelle Cythère," the New Cythera. By identifying Tahiti with the island of Greek mythology where, under the reign of Venus, humans lived in perpetual harmony, beauty, and love, Bougainville was equating the "myth of the primitive" with the already long-established but almost equally unreal "myth of the antique." It mattered little, however, that the affirmative view of the Primitive we have been describing had almost as little relation to reality as the negative one. The myth was from the start the operative factor, and until the third decade of the twentieth century, it had far more influence on artists and writers than did any facts of tribal life, of which, in any case, the first social scientists themselves knew but little.

This interest in the Primitive as a critical instrument—as a countercultural battering ram, in effect—persisted in a different form when early twentieth-century vanguard artists engendered a shift of focus from Primitive life to Primitive art. Modernism is unique as compared to the artistic attitudes of past societies in its essentially critical posture, and its primi-

tivism was to be consistent with this. Unlike earlier artists, whose work celebrated the collective, institutional values of their cultures, the pioneer modern artists criticized—at least implicitly—even when they celebrated. Renoir's *Boating Party,* for example, affirmed the importance of gaiety, pleasure, and informality, in short, the life of the senses. But by that very fact, it criticized the repressive and highly class-conscious conventions of contemporary Victorian morality. The Cubist artist's notion that there was something important to be learned from the sculpture of tribal peoples—an art whose appearance and assumptions were diametrically opposed to prevailing aesthetic canons—could only be taken by bourgeois culture as an attack upon its values.

That the modern artists' admiration for these tribal objects was widespread in the years 1907–14 is sufficiently (if not very well) documented in studio photographs, writings, reported remarks, and, of course, in their work itself. Artists such as Picasso, Matisse, Braque, and Brancusi were aware of the conceptual complexity and aesthetic subtlety of the best tribal art, which is only simple in the sense of its reductiveness—and not, as was popularly believed, in the sense of simple-mindedness.[28] That many today consider tribal sculpture to represent a major aspect of world art, that Fine Arts museums are increasingly devoting galleries, even entire wings to it, is a function of the triumph of vanguard art itself.[29] We owe to the voyagers, colonials, and ethnologists the arrival of these objects in the West. But we owe primarily to the convictions of the pioneer modern artists their promotion from the rank of curiosities and artifacts to that of major art, indeed, to the status of art at all.

Gauguin is rightly considered the starting point for the study of primitivism in modern art, but his role has tended to be vastly oversimplified and misunderstood, for his primitivism was more philosophic than aesthetic. Moreover, as we have observed, Gauguin had but a limited interest in the art of the Pacific peoples among whom he lived.[30] Whether a modified Marquesan Tiki on a hill (p. 193) or an enlarged Easter Island "talking board" used as a background for a portrait (p. 188), Polynesian works of art functioned for Gauguin more as symbols and decorative devices than as agents of influence on his style. There are, to be sure, a number of references to Polynesian art in his sculpture and a couple in his painting. But these are fewer and less central in his imagery than his allusions to non-Western high court styles such as the Egyptian, Persian, Cambodian, and Javanese, none of which we today call Primitive. Gauguin synthesized these diverse interests in an eclectic vision that can show contemporary Tahitian women standing in postures taken from Javanese sculptures (p. 178) or sitting in those adapted from Egyptian painting (p. 190). Such nontribal sources clearly had more effect on Gauguin's style than the Polynesian objects he occasionally cited. In view of the degradation and dissolution of Tahitian life that had resulted from French colonization, it would not be farfetched to consider Gauguin's visual account of his "island paradise" a somewhat desperate example of life imitating literature, in effect, a mimetic reenactment of the "myth of the primitive."

This myth was to persist to some degree in the early twentieth century in the art of the Fauves—as in Derain's *The*

Dance, completed 1906 (p. 217), with its admixture of exotic styles. To that extent, the Fauves—despite their collecting of tribal objects—represent in regard to primitivism, as in regard to style in general, more a synthesis of late nineteenth-century ideas than a radical departure. It was primarily with Picasso and the Cubists, whose works reflect a direct focus on both the expressive and plastic character of particular tribal objects, that primitivism entered its twentieth-century phase. More than the work of the Fauves, that of the Cubists endowed the name Primitive with a new, more concrete, more focused, and more aesthetically oriented connotation. As of the winter 1906–07, which witnessed the culmination of Fauvism, however, the sense of the Primitive still revolved around Archaic art. Derain's blocky *Crouching Man* of that time (p. 215) resembles pre-Columbian court or theocratic arts such as the Aztec more than it does any African or Oceanic sculpture he could have seen,[31] and Picasso's *Boy Leading a Horse,* painted early in 1906, contains an echo of Archaic Greek Kouroi, while his work of later 1906 and early 1907 reflects the artist's interest in Archaic sculpture from provincial centers in ancient Iberia (p. 251).

It is true that the Fauves had "discovered" African art in 1906, and had begun to acquire some sculptures, largely from curio dealers. But most of the pieces that first interested them, such as Vili and Yombe figurines (pp. 15, 214), Shira-Punu masks (p. 10), and the Egyptian-looking Gelede masks of the Yoruba (p. 10), were, not surprisingly, those African objects that as a result of their relative realism, most easily assimilated to the inherited definitions of the Primitive. It has been suggested that the stylized realism and figure types of Yombe sculpture were themselves somewhat influenced by early Western missionaries, and early anthropologists saw a relationship between Egyptian and West African styles;[32] given the orientalizing character of Shira-Punu masks, which aligns them directly with the exoticism of Gauguinesque taste, all these early choices are understandable. Indeed, we are hardly surprised to hear that when Matisse first showed Picasso an African carving in the fall of 1906, "he spoke," Picasso recalled, "about Egyptian art."[33]

To be sure, the choice of African (and Oceanic) objects in the Paris shops and at the flea market was still severely limited. Although some of the more unfamiliar-looking, more abstract objects, such as Kota reliquary figures (pp. 266, 270, 302), could nevertheless easily be found even before the turn of the century, we hear nothing of these in 1906, nor are they reflected in the work of vanguard artists at that moment. Only after the impact of Picasso's revolutionary *Demoiselles d'Avignon,* completed in late June or early July of 1907, did advanced taste begin to open to the more challenging tribal objects. If, at the height of Fauvism in 1906, the Primitive still designated Archaic court art and (secondarily) the more naturalistic African styles, by World War I the Cubists had not only changed its meaning to signify predominantly the art of Africa and Oceania, but had explored some of these cultures' most challenging and abstract forms. In the typically syncretistic manner of modern artists, however, influences of tribal art were sometimes mixed with those of exotic styles, popular arts, and aspects of earlier Western art. In the *Demoiselles,* for example, there are not only allusions to African and Oceanic sculpture, but to Archaic art (ancient Iberian), to Mannerism (El Greco), and to early modernism (Cézanne and

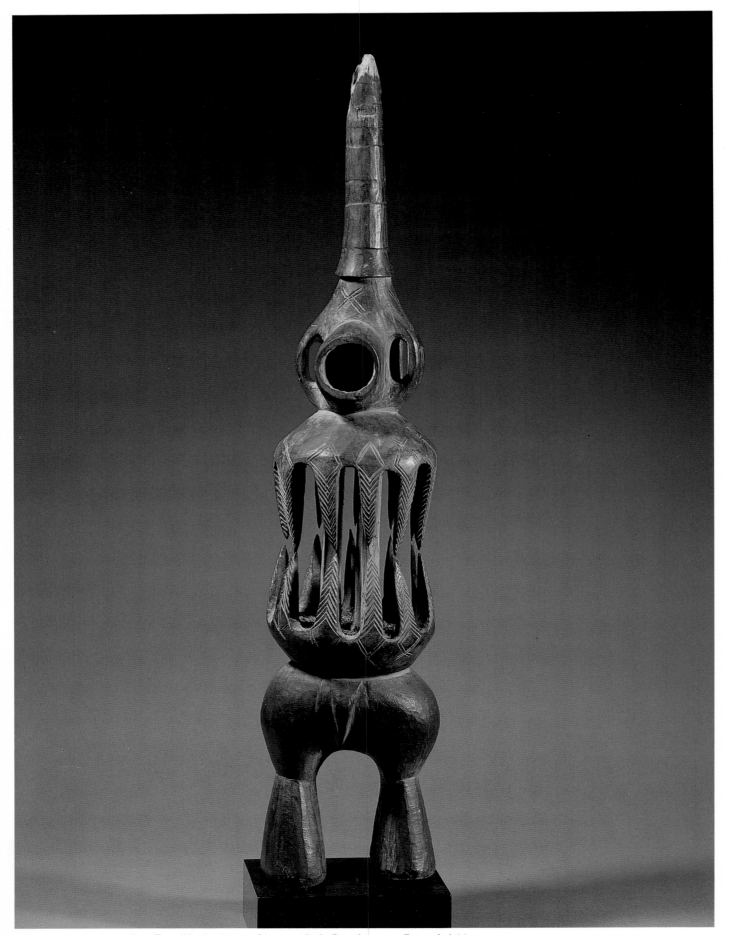

Figure (musical instrument). Pere. Zaire. Wood and iron, 31" (79.5 cm) high. City of Antwerp, Etnografisch Museum

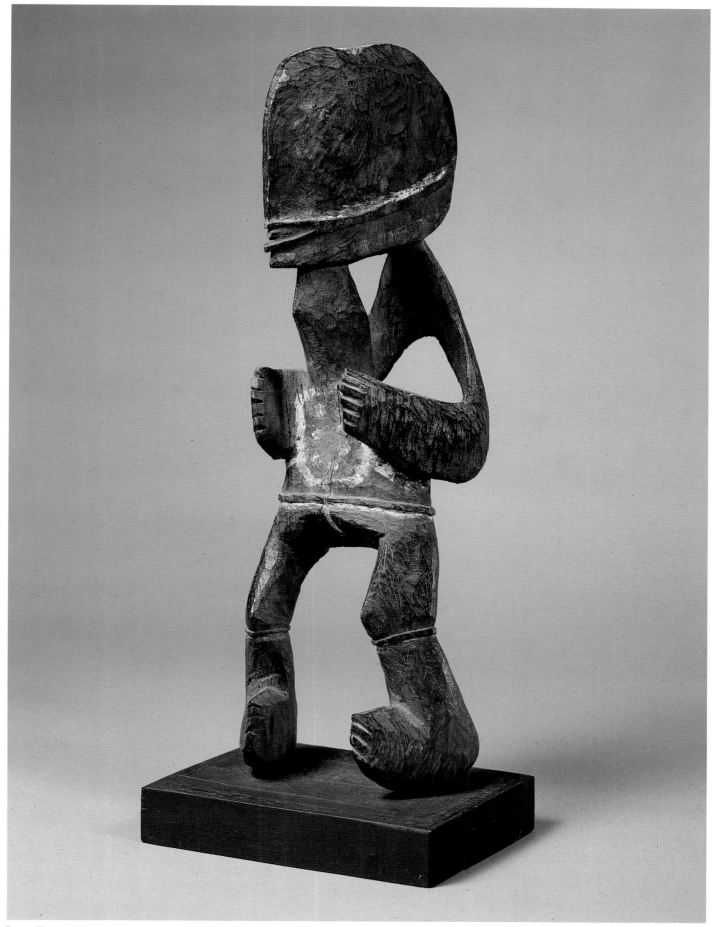

Figure. Torricelli Mountains, Papua New Guinea. Painted wood, 18½″ (47 cm) high. Collection SERGE BRIGNONI, Bern

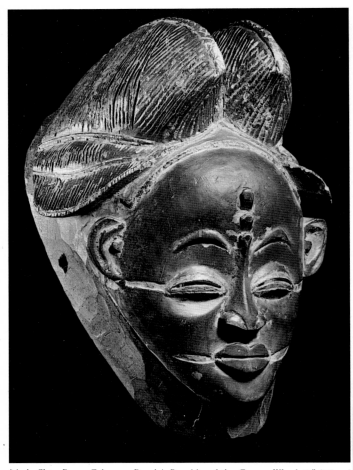

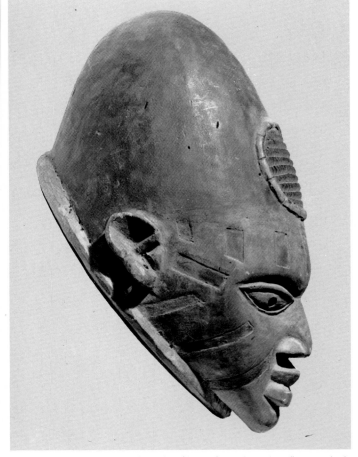

Mask. Shira-Punu. Gabon or People's Republic of the Congo. Wood, 11" (28 cm) high. Private collection, Paris. Formerly collection MAURICE DE VLAMINCK

Gelede mask. Yoruba. People's Republic of Benin. Painted wood, 6¾" (17 cm) high. Musée de l'Homme, Paris

Gauguin) among other sources. Therefore, we are not necessarily meeting with bad scholarship when writers attribute to individual modern works quite different and seemingly contradictory sources in Primitive art. Given the nature of modernist syncretism, such references are to be expected.

The kind of twentieth-century primitivism that relates to individual works of tribal art began to wane after World War II. Artists did not entirely stop collecting tribal sculpture or looking to it for ideas. But this object-to-object relationship has been largely displaced, especially in the last fifteen years, by a more tenuous, more elliptical, and, above all, more intellectualized primitivism, which takes its inspiration primarily from *ideas* about the way tribal objects functioned and about the societies from which they came. Prepared to some extent by Surrealist attitudes toward the Primitive, this "Conceptual primitivism"—which includes certain hybrid objects, Earthworks, Environments, Happenings (varieties of "shamanistic" theater) and other activities—draws its inspiration more from texts than works of art, from the writing of Bataille and Leiris, among others, and especially from the structuralism of Lévi-Strauss.

It is not by chance that I chose earlier to elucidate the meaning of primitivism by reference to "japonisme," for the vogue enjoyed by Japanese art in France during the later nineteenth

century played a role in the art of the Impressionists and Post-Impressionists comparable in both its superficial and profound aspects to that enjoyed by tribal art in the first half of the twentieth century. In both cases, that role has been as often exaggerated as underestimated. Modern art, we must remember, has drawn on a uniquely broad variety of sources. The growth of museums since the early nineteenth century and, even more, the documentary use of photography have made available a world of images that earlier artists could never have seen, culminating in the concept of Malraux's "Museum without Walls." This simultaneous accessibility of all historical sources, which sets the modern period off from any other, is encapsulated in the oeuvre of Picasso.

Among the myriad influences absorbed by modern artists, that of the Japanese printmakers (in the nineteenth century) and of the tribal sculptors (in the twentieth) stand apart in their depth and importance.[34] But just how great was that importance? The answer remains clouded, at least as regards tribal art, for the study of the problem is still in its infancy. Indeed, it will never be possible entirely to clarify the matter because of the difficulty of precising the nature of artistic transmission, and of recognizing, not to say measuring, the process. Yet if, on the one hand, we accept that tribal art was the most important non-Western influence on the history of twentieth-century art, we must certainly, on the other, dismiss the often-heard claims that "Negro art engendered

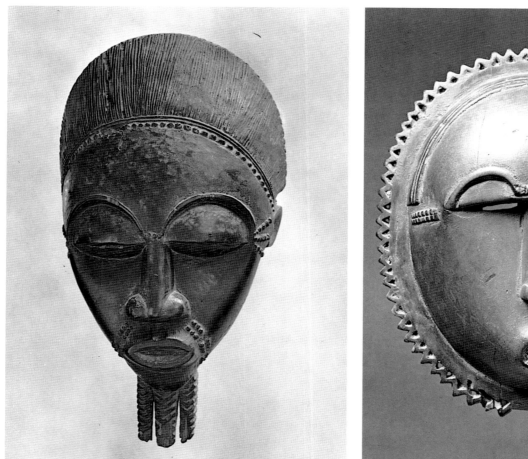

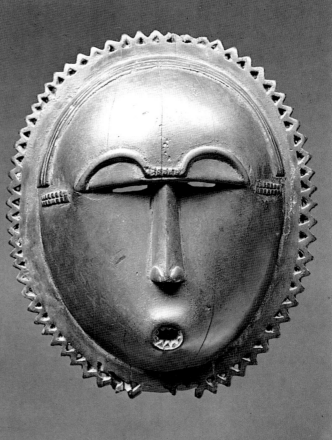

Mask. Baule. Ivory Coast. Painted wood, 13¾″ (34.9 cm) high. Private collection, New York

Mask. Yaure. Ivory Coast. Wood, 9″ (23 cm) high. Private collection

Cubism," or that "Primitive art changed the whole course of modern art." As we shall see, the changes in modern art at issue were already under way when vanguard artists first became aware of tribal art. In fact, they became interested in and began to collect Primitive objects only *because* their own explorations had suddenly made such objects relevant to their work. At the outset, then, the interest in tribal sculpture constituted an elective affinity.

The shift in the nature of modern art between 1906 and 1908 explains why "art nègre" was "discovered" by vanguard artists in Paris only then and not earlier. Tribal art was hardly, it should be remembered, a buried treasure. The Musée d'Ethnographie du Trocadéro (now the Musée de l'Homme), which opened to the public in 1882, had assembled a considerable collection of Oceanic as well as African objects well before the turn of the century. International expositions, such as those mounted in Paris in 1889 and 1900, contained didactic shows of tribal culture—indeed, entire tribal agglomerations—and a number of African and (to a lesser extent) Oceanic sculptures could be found in curio shops for decades before the modern artists took them up. Tribal art would have had no aesthetic relevance, however, for the fundamentally realistic painters of the Impressionist and Post-Impressionist generations, exception made for Gauguin. The "discovery" of African art, one must conclude, took place when, in terms of contemporary developments, it was needed. Earlier artists

had obviously purchased the occasional tribal work, as is illustrated in our photograph of the studio of Gustave Boulanger (p. 12), a nineteenth-century salon painter who traveled to North Africa with Gérôme. But such objects were merely colorful studio props. Serious aesthetic interest in them was precluded by prevailing artistic conventions.

This still leaves open, of course, the question of precisely what happened, within the evolution of modern art, that suddenly in 1906–07 led artists to be receptive to tribal art. No doubt there is more than one right answer, but the most important reason, I am convinced, had to do with a fundamental shift in the nature of most vanguard art from styles rooted in visual perception to others based on conceptualization. The styles of the Impressionsists and Post-Impressionists (again with the partial exception of Gauguin) derived from concentrated observation of the real world, and in certain respects, the acuity of the artists' vision led to effects of realism beyond those of older painters. To be sure, there is no such thing as purely perceptual painting; the data of the retina are known only through the mind. It suffices, however, that a painter such as Monet wanted to create an art as close to the truth of visual sensations as possible. This was less a concern of the Post-Impressionists, and for all Cézanne's emphasis on truth to his sensations *devant le motif*, his Bather compositions

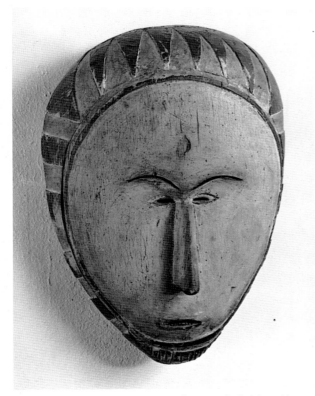

Mask. Fang. Gabon. Painted wood, 18⅞″ (48 cm) high. Musée National d'Art Moderne, Centre National d'Art et de Culture Georges Pompidou, Paris. Formerly collections MAURICE DE VLAMINCK, ANDRÉ DERAIN. Reproduced in color, page 213

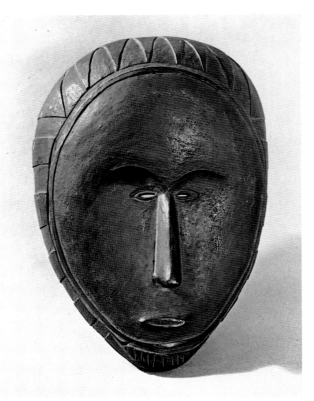

Fang Mask. Bronze cast by F. Rudier from the work reproduced at left, 16⅜ x 11½ x 5¾″ (41.5 x 29 x 14.5 cm). Musée des Arts Africains et Océaniens, Paris. Formerly collection Ambroise Vollard

Opposite: Mask. Fang. Gabon. Painted wood and fiber, 25″ (63.5 cm) high. Collection Gustave and Franyo Schindler, New York

Corner of the studio of Gustave Boulanger, Paris, c. 1880

It is usually said that artists discovered African tribal masks and figure sculptures around 1906. This is true as regards the aesthetic value of these objects, but nineteenth-century artists certainly possessed African materials among other studio props and souvenirs. Such objects could have come directly from West or Central African ports or perhaps through North African Islamic traders. Here, amidst the works of art, plaster casts, costumes, and other studio paraphernalia, is a mask (arrow), probably of the Bobo-Fing or Marka people.

in particular were not taken from nature but devised in the imagination, sometimes with the help of other art or of photographs.

It was Gauguin, however, who took the first important step toward a conceptual and thus more "synthetic," more highly stylized art. (We must keep in mind that the conceptualization of visual material is, in its turn, also a matter of degree; even in "hermetic" high Analytic Cubism, there are many perceptual components.) Gauguin by no means jettisoned the realism of Impressionism, but he was able to meld it, at least in his best pictures, with flat decorative effects and stylized forms whose antecedents were not in Western realism but in nonillusionistic arts as diverse as Egyptian, Medieval, Persian, Peruvian, and Breton (folk) painting and decorative arts (as well as the popular *images d'Epinal*), and in Cambodian, Javanese, and Polynesian sculpture. This was too much for Cézanne, who dismissed Gauguin as a maker of "Chinese" images.[35] It is not without a certain irony, therefore, that the culmination of the conceptualizing tendency in the first decades of the twentieth century, Picasso's and Braque's Cubism, should be based more

on the art of Cézanne than on anything else. But the Cubists' new conceptual reading of Cézanne was profoundly inflected by their experience of the Archaic, conceptual styles that Cézanne himself, still committed to visual perception, disdained—and even more, by their familiarity with tribal art, of whose existence he took no note.

The shift from the perceptual to the conceptual begun by Gauguin (though already signaled, to be sure, by Manet and reflected in the "japonisme" that took hold in the 1860s) gathered force in the first years of the twentieth century and became particularly emphatic in 1906, after the large Gauguin retrospective held at the Salon d'Automne. That year Vlaminck acquired the famous Fang mask (page opposite), soon sold to his friend Derain, which has since become the principal tribal icon of twentieth-century primitivism.[36] A great deal of fuss has been made about this mask, and an account of it has been mandatory in discussions of the subject. It became so famous, in fact, that the vanguard dealer Ambroise Vollard cast a bronze edition of it. There is something faintly ridiculous about all this. Quite apart from the poor quality of the mask, the paintings of Derain and Vlaminck show little or no reflection of it—or any other tribal art—in the immediately succeeding years.[37] Only with Picasso's inspiration by tribal art in *Les Demoiselles d'Avignon*—which represented a new plateau in the conceptualizing process he had begun in his Iberian period—was the real breakthrough signaled. The fame of this picture spread quickly through the little world of advanced artists in late 1907, and with it tribal art became an urgent issue.

The importance of Derain's Fang mask is to be found, I believe, in what the mask reveals about the situation immediately prior to the execution of the *Demoiselles*. Of primary importance is its relative realism, as compared to the marked abstraction and stylization in better and more authentic Fang masks such as Picasso and Braque (pp. 300, 307) acquired somewhat later, and particularly as compared to the masterpieces among Fang masks (right and p. 290). This atypical realism was a crucial factor in the Derain mask's rapid assimilation and popularity, which parallel the early vogue of Shira-Punu masks (of which Vlaminck's, p. 10, was at least a superb example) and of Vili and Yombe figurines (pp. 133, 141). Second, Derain's Fang is a mask of strictly mediocre quality— a type that was already being turned out in Gabon *en série* for sale by the turn of the century.[38] Hence its fame in those early years is also an index of how little good material was available at the beginning of the century.[39] Indeed, though such provenances as "Ex-Collection Derain" or "Ex-Collection Matisse"—often erroneous, as it turns out[40]—have a gilding effect in the marketplace, the majority of objects owned by all the major painters early in the century was in fact very mediocre as compared to the best examples of the same types we know today, most of which were brought out of Africa in later years. (Apart from a few objects of great historical importance, our exhibition contains only the best tribal works from these early artists' collections; however, some lesser ones are illustrated in this book for documentary reasons.)

The collections of the pioneer modernists were comparatively mediocre partly because of the paucity of fine Primitive sculptures on the market in those early years and partly because of the impecuniousness of the artists. (Juan Gris, for example, was particularly poor—and this may be

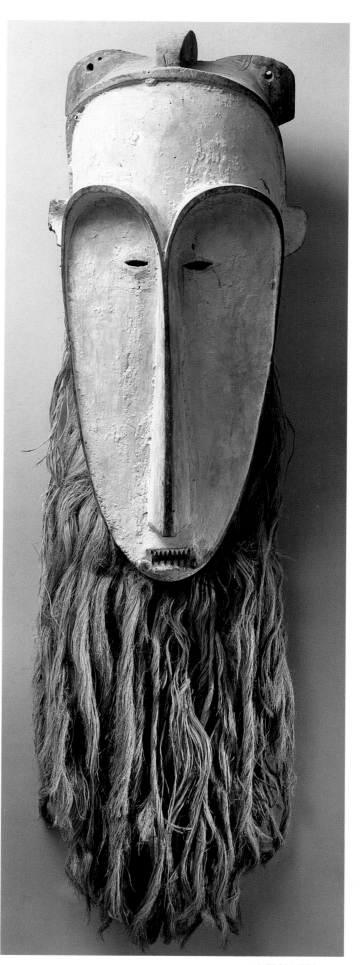

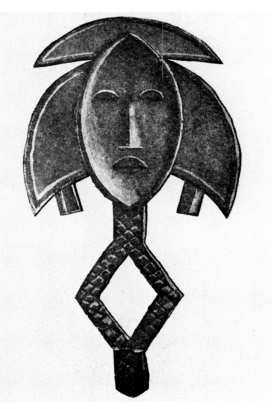

Juan Gris. *Reliquary Figure.* 1922. Cardboard. Destroyed

why he made a Kota reliquary for himself out of cardboard.) More important, this mediocrity reflected the fact that most of these modernists were not collectors at all, in the usual sense. Picasso is a case in point. I have had the opportunity to see in his studios—and later, in the collections of his heirs—almost seventy of the hundred or so Primitive objects Picasso possessed, and I am familiar with the best of the remaining ones through photographs. On average, Picasso's masks and figure sculptures were mediocre or worse; among the hundred-odd examples, there are only about half a dozen truly fine objects. These are offset not only by poor-quality carvings, but by some inauthentic[41] "tourist" works (made by tribal artists for sale rather than for ritual purposes). Indeed, the earliest visual document of Picasso's tribal art, a 1908 studio photograph (p. 299), shows a Yombe sculpture that was no doubt made to order for a European.[42]

Picasso could not have cared less. As he observed to me in regard to one mediocre example, "You don't need the masterpiece to get the idea." That is, of course, the point. A concept or component of style is entirely accessible in second-rate examples and even, as Picasso himself observed on that occasion, in fakes. (Virtually the entire collection of the Surrealist Wifredo Lam was, unbeknownst to him, made up of fakes.) Picasso was less a collector than an accumulator of objects, and he devoted more passion than care to their acquisition. ("Je ne suis pas collectionneur," he said, rolling the final *r* mercilessly to suggest disdain.) The collector tries to know a work in every aspect (the etymology of the word *connoisseur*) and savors it for itself. Of the major artists, Matisse was closest to this spirit of delectation. For Picasso, who usually did not even distinguish between African and Oceanic art, tribal

sculpture represented primarily an elective affinity and secondarily a substance to be cannibalized. To collect well, one must diligently search out and trail objects, study and compare them. Picasso had neither the time nor the patience for this. Apart from a few "chasses aux nègres"—as on his visit to Marseilles in 1912—most of his early Primitive sculptures, he told me, were acquired on Sunday strolls with Fernande through the flea market.[43] Unlike the serious collector, he might buy a mask simply because of the shape of the ears, or the profile of the nose, or because of an aspect of its overall stylization—or to amuse his friends.

Thus Picasso's mass of Primitive sculptures, far from constituting a private museum of tribal art, was distributed around the studio more or less on a par with other objects he found visually interesting, ranging from paintings, sculptures, and textiles to musical instruments (both tribal and modern), bibelots, souvenirs, and toys. Picasso held on to this material with fetishistic devotion throughout his life. The two African objects in the 1908 photograph, for example, had not been seen in his studio for well over half a century, but my assumption that he would never have parted with them was confirmed by their reappearance in his estate.

Picasso did in fact acquire a handful of truly fine tribal objects over the years, but not by dint of special effort. As the first Paris art dealers to handle "art nègre" established themselves, mostly between 1908 and the outbreak of World War I—Emile Heymann (Matisse's "négrier de la rue de Rennes"), already active in the 1880s, Joseph Brummer (of whom more below, pp. 143–44), and Paul Guillaume—better-quality objects gradually came to be concentrated in their hands, and they proposed purchases to Picasso.[44] Yet with the exception of a beautiful Marquesan Tiki (p. 283) and probably the finer of his two Grebo masks (p. 305), all Picasso's top-flight objects were acquired in the years following World War I, or even later, usually when such dealers in both modern and tribal art as Guillaume and Louis Carré offered them in exchange for his own work.

In view of the aims and spirit with which Picasso and other modernists approached tribal art, it is not surprising that their collections—if we can call them that—differed from those formed by the *amateurs* of "art nègre." Indeed, this disparity in taste—especially marked in the case of Picasso—is a revealing symptom. The issue is less a matter of quality than of character and style. We are struck not only by a divergence of emphasis as regards the tribal areas and types chosen by artists and collectors, but even more, by a not unrelated contrast in the nature and facture of the objects.[45] Certain kinds of Fang (p. 293), Kota (pp. 268, 270), Bambara (p. 272), and Senufo (pp. 130, 131) art were favored by both groups. But collectors consistently prized the "classic" Baule (p. 223), Guro (p. 419), Kuba, Luba, and Vili material (p. 214), while generally disdaining the abstract, transformative, and transmogrifying styles Picasso liked, as typified—if we limit ourselves to material readily available in Paris early in the century—by the work of the Baga (p. 276) and Grebo (pp. 20, 305). The "classic" African art favored by collectors (page opposite and pp. 10, 11, 38, 223) is largely that whose stylized realism closely relates it to the Archaic arts which had constituted the earlier, pre-Picasso connotation of "primitive."

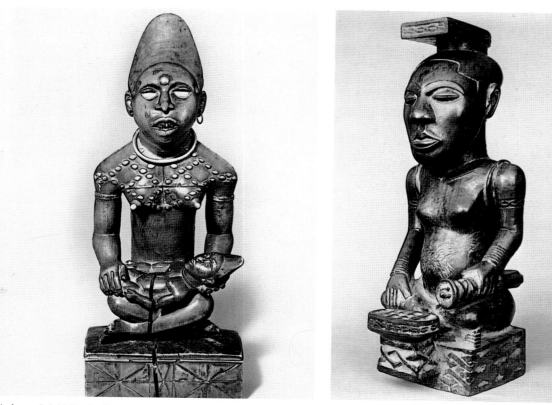

Mother and child. Yombe. Zaire. Wood, 12" (30.5 cm) high. Collection ARMAN, New York

Seated king. Kuba. Zaire. Wood, 21½" (54.5 cm) high. The Trustees of the British Museum, London

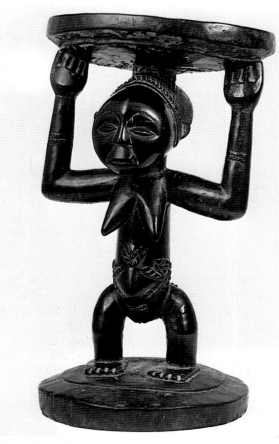

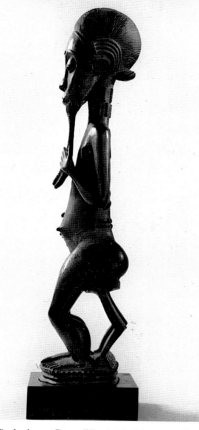

Stool. Luba. Zaire. Wood, 22½" (57.2 cm) high. Private collection

Figure. Baule. Ivory Coast. Wood, 23½" (59.7 cm) high. Private collection

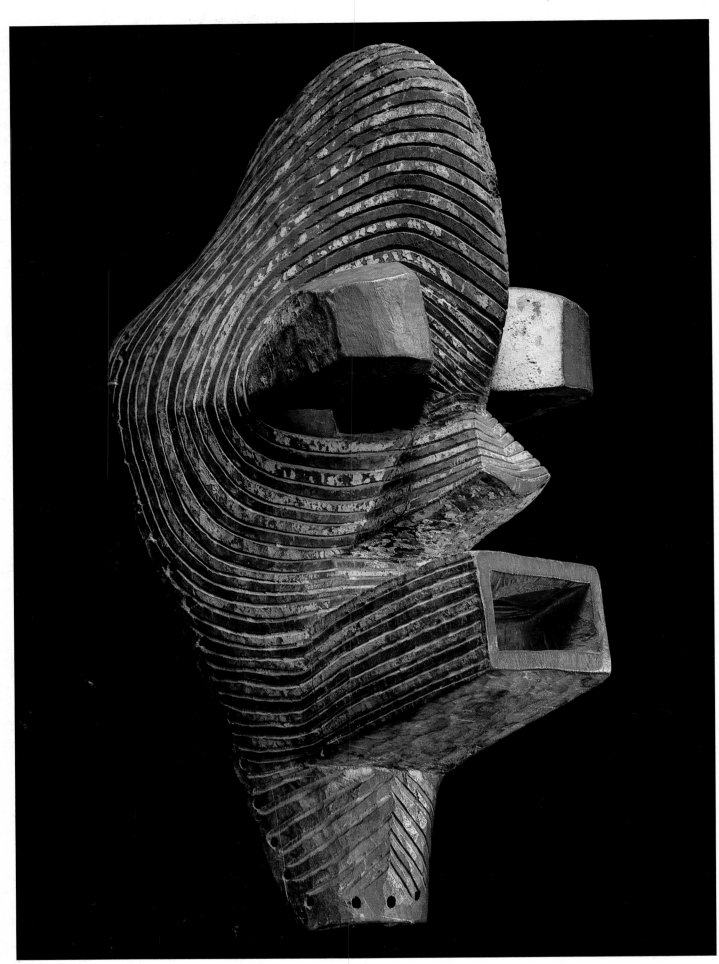

Many recent collectors, it is true, have been drawn to the imaginatively transformed, highly abstract Songye Kifwebe masks (left), which began to be available in France only some years after World War I. But these were not of interest to most collectors before 1950. Indeed, when such masks began appearing in some number in Paris late in the 1930s, they were looked upon askance, largely for the same reasons that *Les Demoiselles d'Avignon* (p. 240)—with which Kifwebe masks have some affinities—was considered ugly by the public for modern art when it first went on view in 1939.[46] It is precisely the change in taste during the last fifty years, which has promoted the *Demoiselles* to epic status, that is responsible for the present vogue of Kifwebe masks.

The "classic" taste in African art—as typified by that of Paul Guillaume and Charles Ratton, the two most important Parisian dealers in "art nègre"—is at odds with the choices made by Picasso, whose African carvings were generally less realistic and, above all, less "finished." He liked to see the traces of the "hand" of the sculptor, to be aware of the decision-making process. The Guillaume-Ratton taste,[47] which is more or less identical with a pervasive Franco-Belgian hierarchy of preferences, stresses highly refined, often intricate workmanship, beautifully polished or patinated surfaces, and a restrained, stylized realism, in contrast to the rawness, *non finito*, geometricity, and the emphasis on extremes of invention that not surprisingly motivated many vanguard artists' choices in tribal sculpture. (Some dealers and collectors have even gone so far as to remove the coarse and "unpleasant" surface that African objects acquired from ritual use, scraping them down to the natural wood and waxing them to resemble furniture.) The perpetuation of the "classic" taste accounts for the fact that some of the most extraordinary and inventive African objects, such as the finest Mumuye figures (p. 43) and Wurkun (initially called Waja) yoke masks (p. 146), are today less highly valued, despite their comparative rarity, than fine Baule masks and Luba caryatid stools;[48] it may also explain to some extent the marked preference of collectors for African over Oceanic sculpture and, within Oceania, for the Polynesian over the Melanesian.

That many collectors should sustain this "classic" taste, with its evident proximity to the *déjà vu* of Western and Middle Eastern culture, is in itself less surprising—given the unsureness of collectors and the taste-making of dealers—than that it should have been abetted by connoisseurs such as Guillaume, who was a major dealer in vanguard art, and Ratton, who was also conversant with that art. Indeed, so strong was this Franco-Belgian prejudice as to what was best in African art, that even a collector such as René Gaffé, whose choices in modern painting were among the most daring and perceptive in this century, was much more conservative in his acquisitions of tribal art. In his 1945 book on Congolese sculpture, for example, he reproduces largely the smoothly finished, relatively realistic types of Luba and Kuba objects (p. 15), while omitting the more inventive carvings of those same peoples (pp. 470, 485) and entirely overlooking the more daring and abstract Congolese masterpieces of the Songye, (pp. 72, 135) Bembe (p. 127), Pere (p. 8), Mbole (p. 526), and Zande (p. 173).[49]

No doubt Guillaume or Gaffé would have responded that

Kifwebe mask. Songye. Zaire. Painted wood, 24¾" (63 cm) high. Private collection

the "classic" styles they favored represented the best (i.e., in quality) that Africa offers. Not only do I think this not to be the case, but I suspect that their judgments masked an unconscious vestige of the old evolutionary bias that placed the more realistic typologies—those closer in character to Western art and hence also more accessible—at the top of the scale of values. If the sculpture typified by even such exquisite examples of "classic" African art as the Yaure, Baule (p. 11), and Guro masks (p. 419) and Hemba (p. 38) and Kuba (p. 15) figures we illustrate were all that continent's tribal art had to offer, Africa would have added much less than it actually did to the aesthetic vocabulary of world art.

The interest of artists has centered, not surprisingly, on those African carvings that have less in common (than the "classic" types) with the art of Western or Eastern cultures, and that therefore constituted, by definition, what—seen from the perspective of the whole history of art—is most distinctively African in African art.[50] As modern artists, beginning with the Cubists, were drawn more to the plastic idea the work embodied than to simple delectation, it mattered little to them that the examples of these more inventive types available early in the century were usually less than fine. By the thirties, however, it was possible to find masterpieces in these more abstract styles as well. But the "classic" taste was to remain the predominant sensibility in the collecting of African art, except among a few collectors who usually came to it by way of modern art itself.

That tribal art influenced Picasso and many of his colleagues in significant ways is beyond question. But that it caused no fundamental change in the direction of modern art is equally true. Picasso himself put it succinctly when he said: "The African sculptures that hang around...my studios are *more witnesses than models*."[51] That is, they more bore witness to his enterprise than served as starting points for his imagery. Like the Japanese prints that fascinated Manet and Degas, Primitive objects had less to do with redirecting the history of modern painting than with reinforcing and sanctioning developments already under way. Nevertheless, Picasso—who had an instinct for the *mot juste*—chose his words carefully, and his "more...than" construction must be looked at with care. Though more "witnesses" than "models," the sculptures were admittedly thus models to some extent. Hence, while first elected for their affinity to the artist's aims, once in the studio, the tribal objects took on a dual role, and exerted some influence.

Just how much and what kind of influence these objects exerted is, as noted, extremely difficult to gauge. In his classic text, Goldwater took a very conservative position on this question, to which Laude's book largely adhered. While arguing a "very considerable influence of the primitive on the modern"[52] in very general terms ("allusion and suggestion"), Goldwater insisted on the "extreme scarcity of the direct influence of primitive art forms" on twentieth-century art.[53] As our study will show, Goldwater substantially underestimated that aspect of the issue. Moreover, he considered most of the influence of tribal art to be poetic, philosophical, and psychological, granting it only a "very limited direct formal influence."[54] It was his view that Brancusi, for example, never adapted "specific forms of Negro sculpture, and...his work is

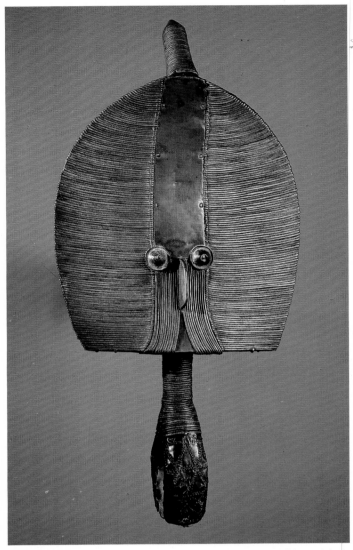

Reliquary figure. Hongwe. Gabon. Wood, brass, and copper, 20⅞" (53 cm) high. Private collection, Paris. Verso of this object reproduced page 352

never related to any particular tribal style." Yet the attitude, shape, and convex-concave structure of the head and the elongated form of the neck (as well as the obliquely projecting coiffure or "comb") of Brancusi's *Madame L. R.* (1914–18) seem to me unquestionably derived from Hongwe reliquary figures. Moreover, as Geist has shown, the peculiarly shaped mouth in the head that remains from the otherwise destroyed *First Step*, 1913, was almost certainly derived from a Bambara sculpture in the Trocadéro Museum (p. 349). Comparable examples can be adduced in the work of many artists whose primitivism was discussed by Goldwater only in general terms.

In the examples mentioned above, the juxtapositions of the modern and African works speak for themselves. But I am firmly of the opinion that there exists a whole body of other influences, *no less dependent on particular forms in individual tribal objects*, where a simple comparison of the modern and tribal works involved would not signal the relationship between them. Indeed, I consider it axiomatic that among modern artists who admired and collected tribal works, many of the most important and profound influences of "art nègre" on their

work are those that we do not recognize and will never know about. While artists of all periods have taken the shape of a head, the position of a body, or a particular pattern from the work of other artists, their assimilation of their colleagues' work often takes a more complicated, less recognizable form —all the more so in the twentieth century, given the degree of metamorphosis of visual raw materials in most modern styles.[55] By the time the plastic idea—borrowed knowingly or unconsciously—is fully digested and reemerges in the context of the borrower's very different style, it is often "invisible." The influence of tribal art is no exception to this principle.

Since *this* sort of direct influence is not recognizable through the juxtaposition of particular objects (at least without some guidance), the reader might well ask on what basis I postulate it. Apart from the testimony of a few artists, the answer lies in my sense of how the artistic mind operates, by what byways and indirect paths it achieves its goals. Fortunately, however, we can illustrate the effect of this group of influences through an ideal example in the work of Picasso: the role of one of his Grebo (Ivory Coast) masks[56] in the formulation of his sheet-metal *Guitar*, the first of his Cubist construction sculptures (p. 20). But we only know about this "invisible" case because, exceptionally, Picasso himself spoke about it—a kind of testimony that is rare among artists. A later example of such direct testimony by Henry Moore relates his *Moon Head*, 1964, to an illustration of a Mama mask (p. 610).

Picasso's *Guitar* does not directly resemble a Grebo mask. Its forms and syntax are demonstrably Cubist. Where, then, does the mask come in? The *Guitar* was made at a time (late 1912[57]) when the transparent, vestigially illusionistic planes of Picasso's high Analytic Cubist paintings of 1910–12 had given way, under the impact of collage, to images with larger, simpler and, above all, more opaque shapes. These shapes were less descriptions of the depicted objects than signs for them—the constituents of a conceptual language we now call Synthetic Cubism. At this point, Picasso decided to translate his ideas into three-dimensional reliefs and, in so doing, initiated a whole new form of sculpture which, instead of being carved or modeled, was *constructed* (largely out of materials new to art). In the process, Picasso replaced the more or less solid core or "monolith" common to carved and modeled sculpture since ancient times by "openwork" configurations such as characterize much of the best sculpture of our time.

Picasso had been drawn to African art in part because he found it "raisonnable"—that is, a result of the reasoning process—hence conceptual. In a Grebo mask, the paired projecting cylinders and parallel horizontal bars do not so much *resemble* eyes and mouth as *stand for* them ideographically; the same is true of the ornamented, upward-curving projection that often serves as the forehead. The reductive sign language of such African masks would have appealed to Picasso in any case. But one of the particular properties of Grebo masks especially relevant at this moment in Picasso's development is that the "face" from which the eyes, nose, and lips project is not a relieved three-dimensional form as in most other masks, but an uninflected flat panel, like the planes of the *Guitar*. Picasso drew particular attention to this aspect of Grebo masks in talking about them, but went on to say that the feature that most interested him was the cylindrical eye.

Picasso noted that while noses and lips are obviously pro-

jecting facial features, he had always thought of the eye as a receding, "hollow" feature in sculpture, especially as he treated more the "orbite"—the socket of the eye—than the eye itself; he recalled that as a young sculptor modeling in clay, he would form it by pressing in his thumb. Now, the Grebo sculptor, as he pointed out, had systematically indicated both the projecting *and* the receding features of the face by salient forms; this he could do because he was not illustrating a face but "re-presenting" it in ideographic language —a perfect example of what Picasso found "raisonnable" in tribal art.

As the artist recounted it (first to Kahnweiler and, later, in more detail, to me),[58] the solution for the representation of the sound-hole of the *Guitar*, a cylinder projecting from the flat back plane, came to him from Grebo masks. The front plane of the *Guitar*, though present at the bottom and on the right, is cut away in the center of the "instrument." The problem might be stated thus: how to signal a hole in a plane (the front of his *Guitar*) that does not literally exist? The solution was, as in the Grebo mask, to turn negative into positive and project the hole forward as a hollow cylinder. The very hollowness of Picasso's cylinder had already been anticipated in the circular rims painted on the front of the eye-cylinders by the Grebo artist[59]

Now this solution of Picasso's was entirely consistent with his other syntactical decisions in the making of the *Guitar*, not to say with the whole fabric of determinations that implemented Synthetic Cubism, all of which followed their own inner logic. It would be foolish, therefore, to overestimate the importance of this particular and limited intervention of tribal art even in an object that launched a sculptural revolution. Perhaps more important than its particular contribution to the *Guitar* is the way this intervention testifies to the underlying affinity between tribal and modern art on the level of conceptual form, and the evidence it gives of how certain kinds of modernist readings endowed tribal objects with a special resonance in the Cubist period. This particular "formalist" reading—and many readings of tribal objects by Picasso and other modernists were anything but formal—probably had nothing whatever to do with what the African artist was getting at, though, to be sure, we do not know what artistic intuitions motivated the artists who invented the Grebo style.[60] To insist that these sculptors usually functioned within a framework of religious needs and values says nothing that would not be largely true for certain Western styles, and still left them with the problem of plastic solutions—even though they had no concept for what such words mean.

A Grebo mask is not, moreover, an "openwork" sculpture, as has been pointed out more than once since Kahnweiler first referred to "transparency" in establishing the relationship between the objects. Interestingly enough, however, Africans *did* create such "see-through" sculptures, though they were not visible in Paris in 1912. I am referring here not primarily to the now fairly commonplace Senufo headdresses that have an affinity to certain of David Smith's "transparent" sculptures (p. 622); these large mask-superstructures remain in a single plane and, like the openwork New Ireland Malanggans (p. 54), were carved from a single block of wood. The much rarer and sometimes extraordinarily complex Bird headdresses of the Baga sculptors, however, were both carved and constructed additively from different pieces of wood, and their

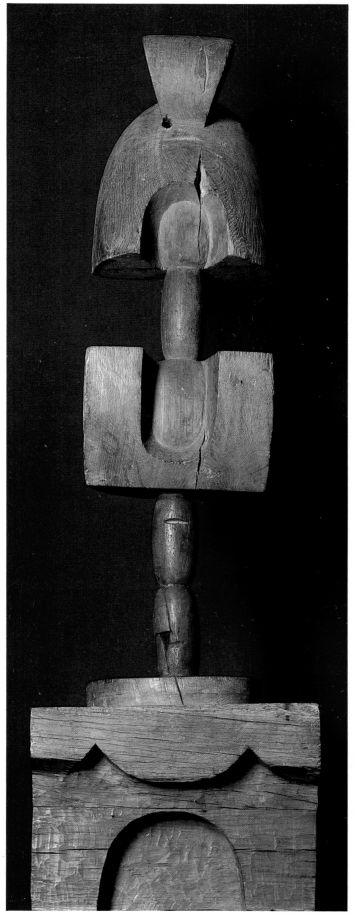

Constantin Brancusi. *Madame L.R.* 1914–18. Wood, c. 37" (94 cm) high. Private collection. For other reproductions of this work see page 353.

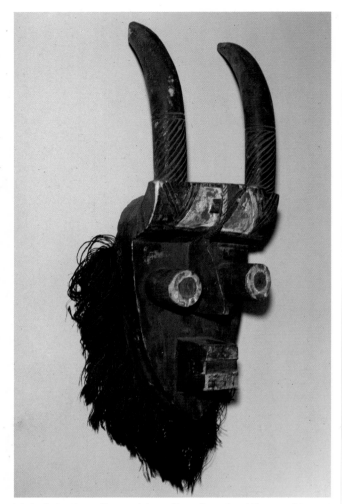

Mask. Grebo. Ivory Coast or Liberia. Painted wood and fiber, 25⅛" (64 cm) high. Musée Picasso, Paris. Formerly collection PABLO PICASSO

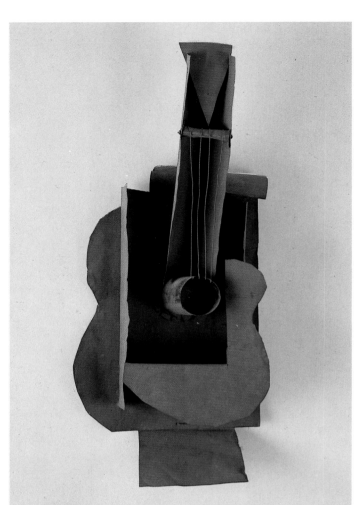

Pablo Picasso. *Guitar.* 1912. Sheet metal and wire, 30½ x 13¾ x 7⅝" (77.5 x 35 x 19.3 cm). The Museum of Modern Art, New York; gift of the artist. For another reproduction of this work see page 304.

spatially intricate openwork configurations, painted in gay decorative colors, recall the Synthetic Cubist constructions made by Baranoff-Rossiné and other Paris artists in the immediate wake of Picasso's discoveries (pp. 22, 23, 163). How the Baga Bird we illustrate would have interested Picasso in those years! But this *rara avis* and others of his tribe only made it to Paris in the 1930s.

Compared to some other Grebo masks, which began to be available at the turn of the century (Picasso would have seen the fine one that entered the Trocadéro in 1901, p. 260), the Picasso Grebo reproduced above is a routine work of art.[61] (Another, possibly acquired in 1912, is much finer; it is shown hanging on a wall of Picasso's apartment in a drawing of 1917, p. 305). Given what we know of Picasso's attitudes toward tribal objects, however, we should not be surprised that he prized it highly despite its mediocrity; after all, its "idea" is completely clear. It is instructive, nonetheless, to compare this lesser of Picasso's Grebo masks to one made by an inspired sculptor, such as that in the Metropolitan Museum.[62] The basic Grebo stylistic constituents—a "slat" nose without nostrils, cylindrical eyes, and parallel lips, all projecting at right angles from a generally flat panel—are common to both. And yet what a difference! The Metropolitan example is not only subtler in the proportioning and distribution of the common elements, and in its use of color, but in the very

slight convexity given the main panel. Moreover, it contains what may be a truly artistic leap of the imagination. Rather than representing the horns, the artist has absorbed their curve into the exquisite elongation of the panel, where they are present only inferentially. (The degree of this artistic "leap" would depend, of course, on such masks, unknown in the West, as might have mediated between horned Grebos like Picasso's and the Metropolitan example.)[63]

It is still sometimes said that traditional tribal art was a collective rather than an individual creation involving constant repetition of established formulae, to which the individual carver brought little beyond artisanal skill. My own experience with this art, on the contrary, has confirmed for me the assumption that good art is made only by gifted individuals. I am, in fact, struck by the differences rather than the similarities between tribal pieces of the same style (at least in types not standardized for European taste[64]), and especially by the uniqueness of those works I would call masterpieces. For example, of the dozen or so Grebo masks I have seen, no two are alike, though all include the basic constituents.[65] And the Metropolitan's, the finest of the group, is the least typical. The differences between these masks are just as marked as those between works by anonymous Western artists of the

Medieval schools in given regions—any particular school of Romanesque sculptors, for example. And the best work of both is distinguished by unique qualities of expressiveness and invention. That sculptures as fine as the Metropolitan's Grebo mask are, indeed, rare among Primitive objects, that the overwhelming bulk of tribal art is not very good, says nothing about it that would not be true of the production of any period, including—if not especially—our own.

While the birth of a very gifted artist is a rare thing in any civilization, only certain cultures provide a context for his or her flourishing. The fact, for example, that all African sculpture, good as well as bad, comes from but a portion of the tribally inhabited areas[66] does not mean that individuals with great artistic potential were not born in the other regions. Rather, the social and religious traditions there did not demand, or even permit, sculptural activity (although a high order of artistic realization was reached in some of those regions in other visual arts such as architecture and body painting).

The generally low quality level of most tribal art—at least that preserved in the West—has many explanations. In some traditions, for example, masks were made by all males, at least for certain rites, rather than being executed by trained artists.[67] More important, perhaps, is the fact that tribal art has not only suffered a much higher rate of extinction than Western art, but that its transportation to and preservation in the West have been largely haphazard. The loss begins with the limited durability of wood sculpture in a tropical climate; add to this the fact that many Primitive cultures jettisoned objects when they were desacralized—sometimes after being used only once. Such facts mean that most of the wooden tribal art preserved in Africa or the West is less than a century or so old, and therefore represents only the tail end of long and (since the colonial period) dissolving—or at least profoundly changing—traditions.[68] A certain number of African wood pieces are in fact much older; they remain either because they were preserved, like Egyptian wood sculpture, by being stored in dry, sub-Sahara regions (the Dogon figures attributed to the "Tellem"), or because reasons of religion or state ensured their conservation and protection.

While certain older pieces are very fine, the selection process that preserved even these was *not determined by aesthetic quality*. Indeed, it has been argued that many of the earliest African sculptures to arrive in Europe were "replacement pieces," hastily made by sculptors for a European, so that the community could avoid giving up a sacred object.[69] There was in operation, in fact, a kind of "negative selection," insofar as many important older pieces were destroyed as sacrilegious by the early missionaries.[70] The great bulk of the art made in Europe since the beginning of the Renaissance has also disappeared. But what remains has been preserved largely (though by no means entirely) on the basis of an ongoing collective judgment as to artistic value, which consensus functions as a winnowing process. For this process, a society seems to need not only gifted artists, but a concept of Fine Arts supported by an ongoing critical tradition which, in turn, requires a written language. Such discourse about sculpture as existed in African[71] and other preliterate tribal societies fell short of this.

Until the 1950s, the selection of such tribal art as has been preserved in the West was *primarily accidental* insofar as artistic quality is concerned. There are some masterpieces among the

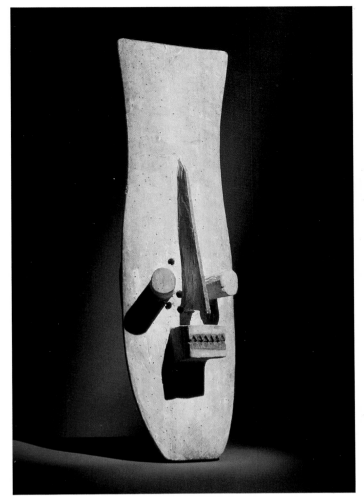

Mask. Grebo. Ivory Coast or Liberia. Painted wood, 27½" (69.9 cm) high. The Metropolitan Museum of Art, New York; The Michael C. Rockefeller Memorial Collection, bequest of Nelson A. Rockefeller

early Primitive objects brought back by seamen, travelers, and missionaries as curiosities. And here and there, they may have been chosen from among the myriad possibilities by individuals of developed artistic taste, though this was surely not generally the case. Nor is there any reason to imagine the operation of such taste in the choice of objects brought back as souvenirs by colonials (even though a few became students of the art of their regions). The situation improved somewhat in the case of the early ethnologists. But as ethnologists did not generally distinguish between art and artifact—indeed, some still reject aesthetic considerations as unscientific and thus alien to their discipline—the majority of objects they brought back have little or no artistic interest. These ethnologists were obliged to make choices, nonetheless, and because they were individuals of greater experience and sometimes evidently greater taste than the voyagers or colonials, the quality of what they sent back tended to be somewhat better. Certain ethnologists of recent generations possess considerable artistic culture, but in Africa and Oceania these men and women have been working with tribal cultures increasingly altered in varying degrees by colonialism and modern technology, with the result that the traditional art forms as practiced in recent decades tend to be exaggerated and base or to become academically frozen.[72] While fine older pieces can occasionally still be obtained in tribal regions,

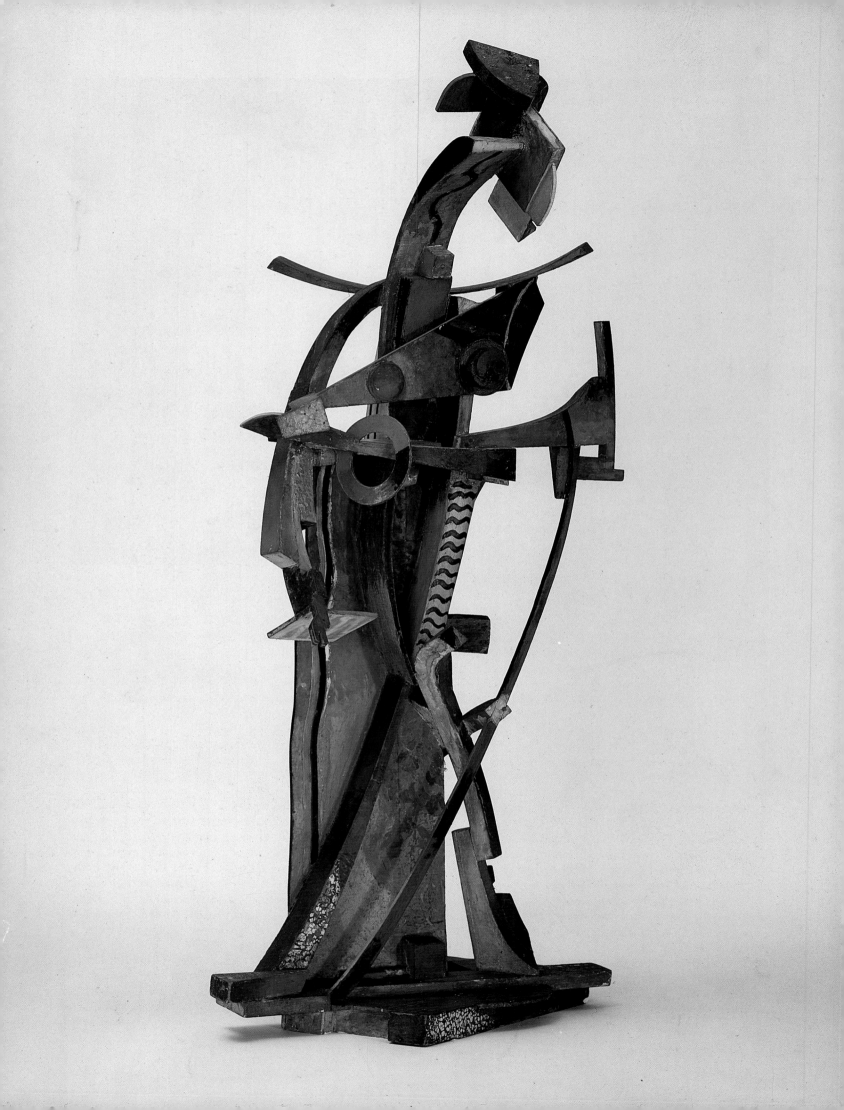

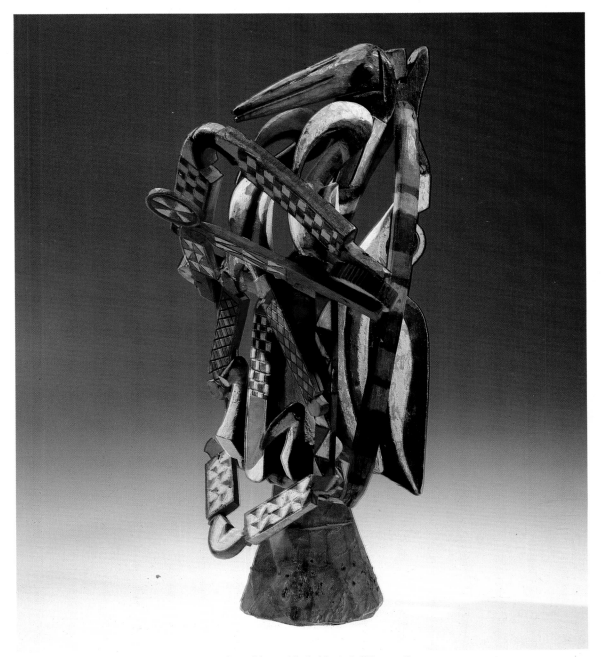

Above: Bird headdress. Baga. Guinea. Painted wood, 20½" (52 cm) high. Musée de l'Homme, Paris

Opposite: Vladimir Baranoff-Rossiné. *Symphony Number 1.* 1913. Polychrome wood and mixed media, 63¼ x 28½ x 25" (161.1 x 72.2 x 63.4 cm). The Museum of Modern Art, New York; Katia Granoff Fund

ethnological museums are generally in no financial position to compete for them.

One might imagine that the major dealers in tribal art who emerged in the years just before and after World War I, men of great taste such as Guillaume and Ratton, would have reversed the fundamentally accidental determination of those objects that would make their way to Western markets by traveling to tribal areas to buy work. But this was not the case. So far as I know, no dealer of Picasso's generation or the one that followed ever set foot in Africa.[73] Dealers exercised their taste by choosing for their stock from the best of what travelers, missionaries, colonials, and the "runners" they financed happened to bring back. It is true that a number of dealers who matured after World War II traveled widely in tribal areas and

brought to Europe some extraordinary work, including types of Primitive sculpture previously rare or unknown (pp. 43, 155). But by the 1970s, any long-term role they could have played was much diminished or rendered moot as the indigenous authorities themselves became conscious of the artistic value of older objects the collectivities possessed, and as the new-born nations in Africa and Oceania began to treat such art as national treasures.

If the "invisible" interventions of tribal objects in the history of modern art illustrated by Picasso's Grebo masks must remain largely hypotheses, there are more than enough quite recognizable ones to flesh out our definition of primitivism. The

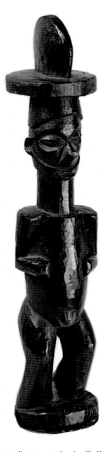

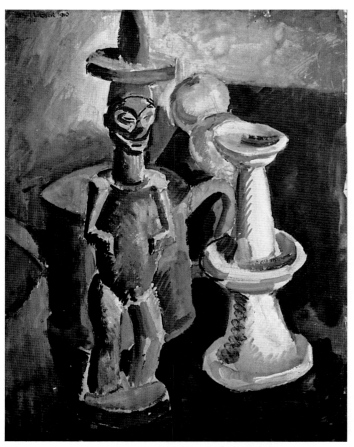

Figure. Yaka. Zaire. Wood, 10¼" (26 cm) high. Collection Joy S. Weber, New York. Formerly collection MAX WEBER

Above: Max Weber. *Congo Statuette* (also known as *African Sculpture*). 1910. Gouache on board, 13½ x 10½" (34.2 x 26.7 cm). Private collection, New York. Reproduced in color page 454

Opposite: Max Weber. *Interior with Women*. c. 1917. Oil on canvas, 18¼ x 23½" (46.3 x 59.7 cm). Forum Gallery, New York. Reproduced in color page 455

range of these may be illustrated by two early paintings of Max Weber.[74] In the first, Weber's 1910 Matissean still life, *Congo Statuette*, a small Yaka figure is quite realistically represented—which we can confirm by reference to the sculpture itself. As with the many outright depictions of tribal objects in German Expressionist paintings (pp. 388, 392), this image tells us of Weber's interest in the Primitive, but does not testify to any influence of tribal art on his style—at least directly. In this sense, the Primitive sculpture functions like any other still-life object. In Weber's Synthetic Cubist *Interior with Women*, c. 1917, however, African material is less depicted than absorbed into his now Cubist style, itself enriched by his recollections of Picasso's 1907–08 "African" paintings. The face of the woman seated in the center, to take but one example, is a synthesis of elements drawn from elongated concave Fang masks (p. 406) and from Kuba masks with conical eyes (p. 485).

The two paintings by Weber testify alternately to an interest in tribal art on the part of the painter and to an influence of it upon him. However, many suggestions of such direct influence made up to now, whether in texts or exhibitions (such as the ambitious one held in Munich at the time of the Olympic games),[75] are misleading simply because of the unlikelihood that the modern artist in question could have seen the particular tribal work proposed, even in reproduc-

tion. These examples involve, for the most part, presumed influences on modernist works of the earlier decades of the century, when many of the now-familiar types of tribal objects were not visible in the cities where the artists worked or traveled nor were reproduced (except, in some cases, in very rare and expensive ethnological publications that the pre-Surrealist generations—save for a few German artists—did not consult).

When such ahistorical juxtapositions are visually convincing, they illustrate *affinities* rather than *influences*. Affinities are far from unimportant, however, and in the long run, the multiplicity of them may tell us something more essential about twentieth-century art than do the far rarer instances of direct influence (which might be thought of as confirming the propinquity involved). The third section of the exhibition this book accompanies is entirely devoted to exploring the broad underlying affinity that relates much modern and tribal art. This may be said to parallel, as Picasso himself observed, the affinity of Italian Renaissance painting for the art of Classical antiquity[76]—even though (as was the case with the Cubists and tribal sculpture) the Renaissance painters actually were acquainted with little of that art. A proper distinction between influences and affinities is nonetheless as crucial to the study of modern art as it is to that of the Renaissance. But because tribal art has not until lately been treated as part of art history,

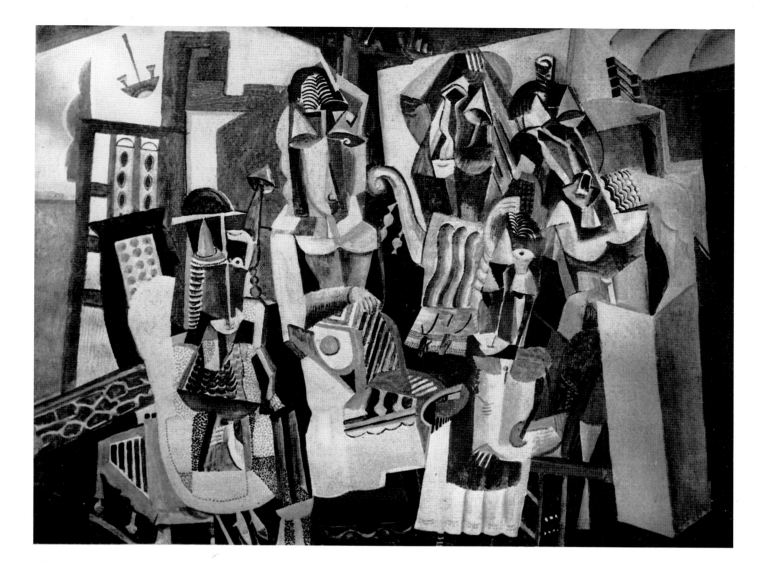

modernist scholars have repeatedly fallen into the kind of error that their counterparts in Renaissance art history would never make.

In order to dramatize the distinction between affinities and influences, I would like to juxtapose some works by Max Ernst with tribal objects to which they bear a striking resemblance. When we compare Ernst's *Bird-Head* to an African mask of the Tusyan people (pp. 26, 27), for example, we find among their common characteristics—apart from a general sense of the apparitional—such particulars as a flat rectangular head, straight horizontal mouth, small round eyes, and a bird's head projecting from the forehead. Let us also take Ernst's engraved stone sculpture, *Oval Bird*, of that same year (1934), comparing it to the Bird-Man relief from Easter Island in the British Museum (pp. 28, 29). Both *Oval Bird* and the Easter Island image are egglike in contour and depict a syncretistic birdman whose rounded forms echo the contour of the sculptural field.[77] The upper arm of both figures descends in a curve and the forearms project forward; both birdmen have a large round eye. Though the oversized hand of the Easter Island figure gives way in the Ernst stone to a second bird's head (birdmen with large hands are, however, found in other works by Ernst), and while the head of Ernst's *personnage* projects forward like that of the Easter Island relief, it is much less beaklike in form. Nevertheless, that form is almost exactly

matched in another Ernst bird head, also in an oval field, in the painting *Inside the Sight: The Egg* (p. 29).

One of the most celebrated of Polynesian objects, the Easter Island Bird-Man relief was collected in 1915 and acquired by the British Museum in 1920; it was reproduced in a number of publications beginning in 1919. Unlike his Cubist predecessors—and even more than most of his Surrealist colleagues—Ernst was a great *amateur* of ethnology and possessed a considerable library on the subject, probably including, both Maurer and Spies believe,[78] one or more of the early publications in which the Easter Island relief was reproduced. Hence we would be on reasonably solid ground in speaking here of an influence of the Bird-Man relief on his work. On the other hand, the resemblance between Ernst's *Bird-Head* and the Tusyan mask, striking as it is, is fortuitous, and must therefore be accounted a simple affinity. *Bird-Head* was sculpted in 1934, and no Tusyan masks appear to have arrived in Europe (nor were any reproduced) prior to World War II.

That such striking affinities can be found is partly accounted for by the fact that both modern and tribal artists work in a conceptual, ideographic manner, thus sharing certain problems and possibilities. In our own day it is easy to conceive of art-making in terms of problem-solving. But this was also substantially true for tribal artists, though their solutions were arrived at incrementally—as in much Western

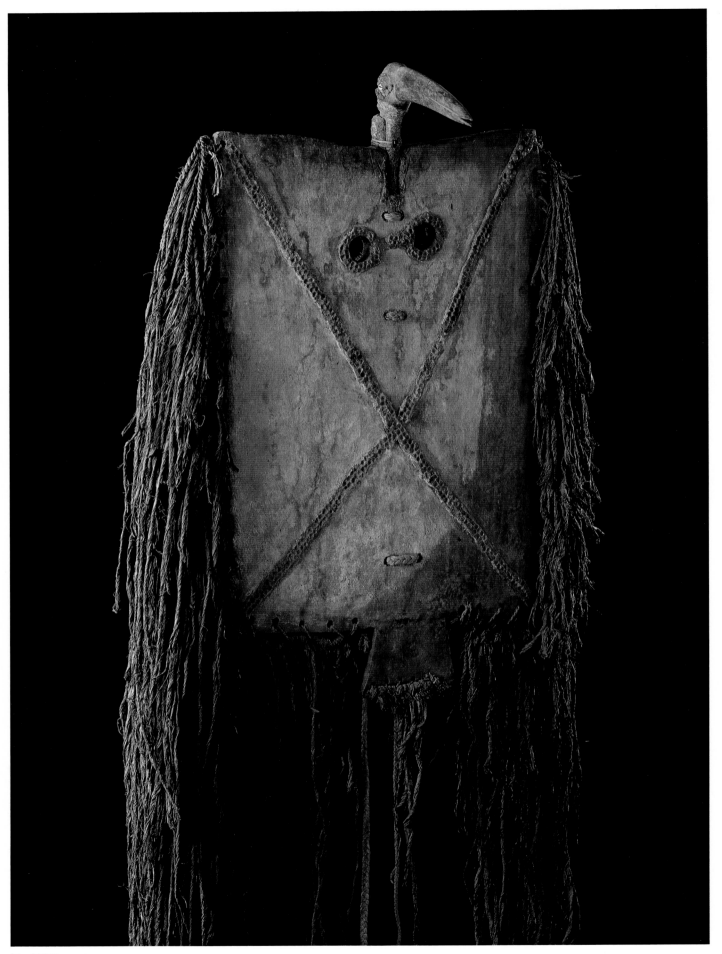

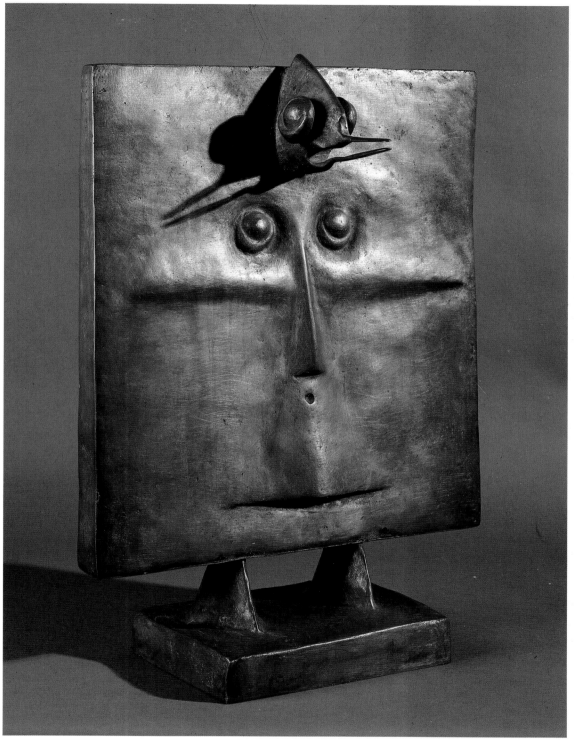

Above: Max Ernst. *Bird-Head*. 1934–35. Bronze (cast 1955), 20⅞ x 14¾ x 9⅛″ (53 x 37.5 x 23.2 cm). Galerie Beyeler, Basel

Opposite: Mask. Tusyan. Upper Volta. Wood, fiber, and seeds, 26⅜″ (67 cm) high. Musée Barbier-Müller, Geneva

Bird-Man relief. Easter Island. Painted stone, 14⅛" (36 cm) high. The Trustees of the British Museum, London

art—over a period of generations.[79] Ethnologists might argue that I am falsely attributing to the tribal artists a sense of Western art-making, that the tribal sculptor creating ritual objects for a cult had no consciousness whatever of aesthetic solutions. (The latter is simply their assumption, of course, based on the fact that many tribal cultures had no word for "art").[80] Even if this could be proven true, however, it would not contradict my contention insofar as the finding of artistic solutions is ultimately an intuitive rather than an intellectual activity. The art-making process everywhere has certain common denominators, and as the great ethnologist Robert Lowie quite rightly observed, "the aesthetic impulse is one of the irreducible components" of mankind.[81] The "art-ness" of the best tribal objects alone demonstrates that great artists were at work and that a variety of aesthetic solutions were arrived at, however little the artists themselves might have agreed with our description of the process. Now these solutions, insofar as they were to problems held in common—a sign for "nose," for example—were certainly likely to bear a resemblance to one another in ways that are independent of influences and traditions. Hence the similarity of tribal works from entirely unrelated regions, as in the head of a New Hebrides (Melanesia) fern sculpture and an African Lwalwa mask (p. 33). Is it so surprising, then, that Picasso's solution for the head of the upper right maiden in the *Demoiselles* should resemble a mask from the Etoumbi region of Africa (p. 263) of a type he could not have seen at the time?[82]

To say that Picasso's solution and that of the Etoumbi artist resemble each other is not, of course, to equate them. Quite apart from the fact that the Picasso head is painted and the

Etoumbi mask carved—so that a different set of artistic conventions apply—there are many aspects of the Picasso image that presuppose ontogenetically the whole phylogeny of Western art. Moreover, the aesthetic affinities between signifiers, such as they are, do not permit us to assume comparable relationships on the level of the signified. Thus Herbert Read was rightly criticized for attributing Expressionist anxiety (*angst*)—a peculiarly modern state of mind—to African sculpture.[83] And Picasso's reference to the exorcistic character of African art, which he said was created to make man "free," turned on a definition of freedom in terms of private psychological emancipation of a kind that would make no sense to a member of a tribal society.

The Easter Island Bird-Man relief probably influenced Max Ernst, while the Tusyan mask reflects only an affinity with his work: these are determinations that require a kind of scholarly investigation for which the facts are, unfortunately, unavailable in many instances. We cannot be sure, for example, when certain types of African sculpture first appeared in Paris or other centers. There is, however, a good deal we *can* discover by studying the relevant museum and early private collections, publications, dated photographs, and auction and sale catalogs.[84] The indispensable tool for the historian of twentieth-century primitivism—a chronological chart of the arrival of different types of tribal art in Europe—does not yet exist (though I have requested Jean-Louis Paudrat to create an incipient form of one for Africa, which we are publishing as an annex to his chapter on the arrival and diffusion of those

Max Ernst. *Oval Bird.* 1934. Stone, c. 12" (30.5 cm) high. Whereabouts unknown

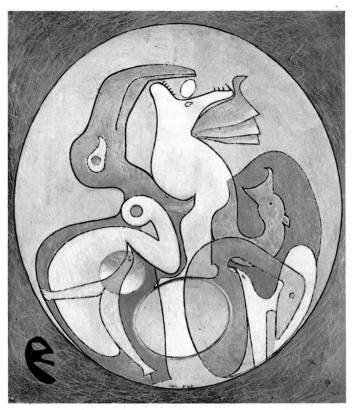

Max Ernst. *Inside the Sight: The Egg.* 1929. Oil on canvas, 39⅜ x 31⅞" (100 x 81 cm). Musée National d'Art Moderne, Centre National d'Art et de Culture Georges Pompidou, Paris

objects in the West).[85]

Even if we can be confident that a modern artist had access to particular tribal works, or reproductions of them, we cannot be absolutely sure—except when the artist himself avows it—that resemblances really reflect influences. The evidence is almost always circumstantial. That is, however, the nature of much art-historical evidence. Nowhere in any document of the period, for example, is it said that Raphael saw a particular ancient Roman sarcophagus illustrating the Death of Meleager. Yet the latter's resemblance to the composition of Raphael's *Entombment* (Borghese Gallery) is such that the influence of the sarcophagus on this picture is universally accepted by art historians.[86]

The problem of determining an influence based on circumstantial evidence is rendered all the more difficult in twentieth-century art because of the latter's very personal and highly metamorphic character. Moreover, aside from the German Expressionists, few artists simply quote works that interest them. We have a number of sketches by modern artists of tribal works, such as Henry Moore's study of an African Mumuye figure in the British Museum (p. 597) and Giacometti's drawings after Oceanic objects reproduced in *Cahiers d'art* or in museums (pp. 520, 521). But we rarely find the components of such sketches *directly* transported to the creative work of those artists. Picasso, to be sure, literally incorporated a wooden arm from Easter Island in his *Woman in a Long Dress*, treating it as an *objet trouvé* on the same level as the dressmaker's dummy used in the same sculpture (p. 330), but this is a "citation" of another order.

The study of influences leads us for the most part to situations where the resemblances between the tribal and modern objects are more elliptical than is the case with Ernst's avian imagery and the Easter Island relief. The relationship of Klee's *Mask of Fear* to the Zuni (American Indian) War God in the Museum für Völkerkunde, Berlin, is a case in point (pp. 30, 31). I am convinced that Klee's image contains a recollection, conscious or unconscious, of the Zuni sculpture. We know that Klee visited the Berlin Museum für Völkerkunde as early as 1906,[87] and no doubt revisited its collections on occasion during his subsequent Berlin sojourns in 1913, 1917, 1918, 1922, 1929, and 1930. We know from museum authorities that the Zuni sculpture, one of their most important American objects (acquired in 1880), was on display throughout that period, so the likelihood of Klee's having seen it is very strong.

A comparison between the two works illuminates a fascinating instance of modernist transformation. Though the Zuni carving is painted in decorative flat colors of a type we see frequently elsewhere in Klee's work, the somber monochromy of *Mask of Fear* is quite at odds with the Zuni sculpture—as are many other aspects of Klee's picture. Nevertheless, the similarities are striking, especially if we limit ourselves to the upper half of the Zuni figure (as in our diagram). Apart from the near oval form of the top of the head and, even more, the arrow projecting from it, one is struck by the similarly long, narrow noses of both

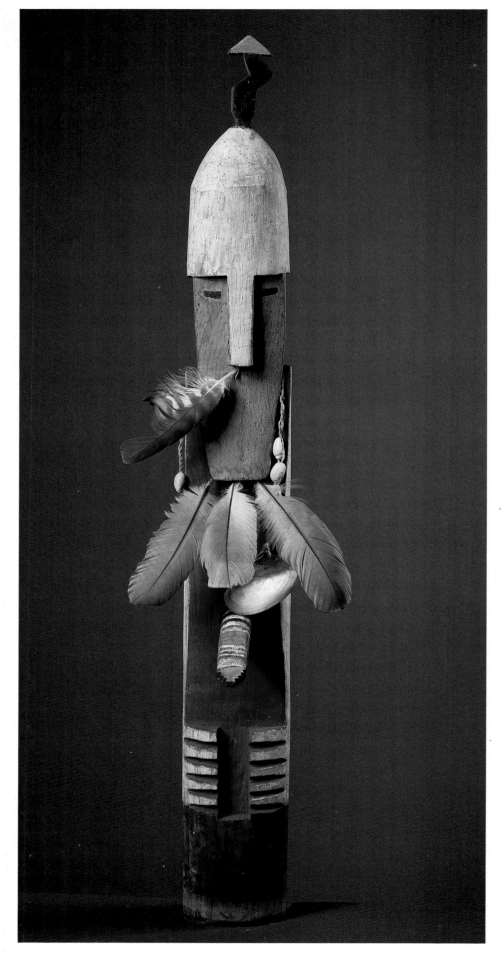

Figure (War God). Zuni. Arizona or New Mexico.
Painted wood and mixed media, 30½″ (77.5 cm)
high. Museum für Völkerkunde, Berlin

Opposite: Paul Klee. *Mask of Fear.* 1932. Oil on
burlap, 39½ x 22½″ (100.4 x 57.1 cm). The
Museum of Modern Art, New York; Nelson A.
Rockefeller Fund

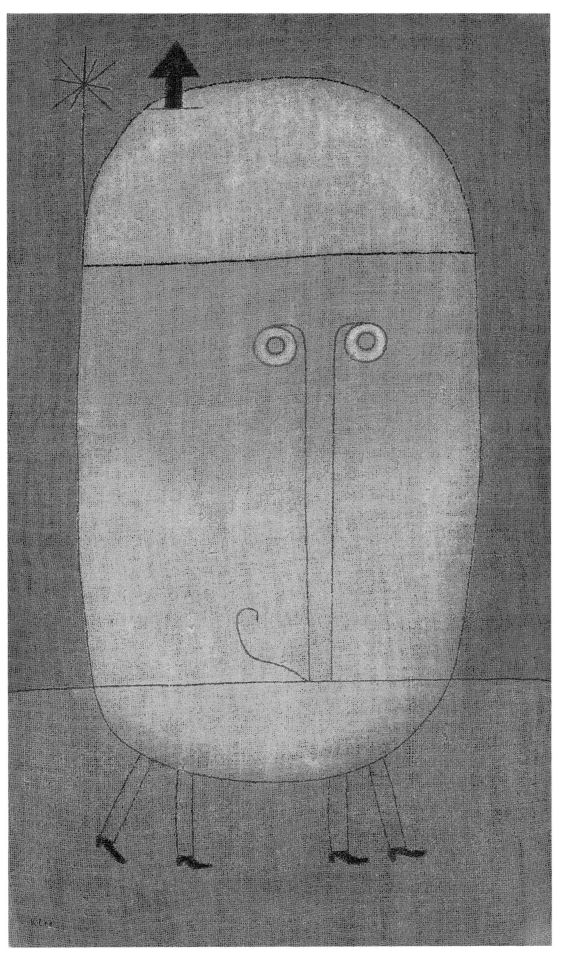

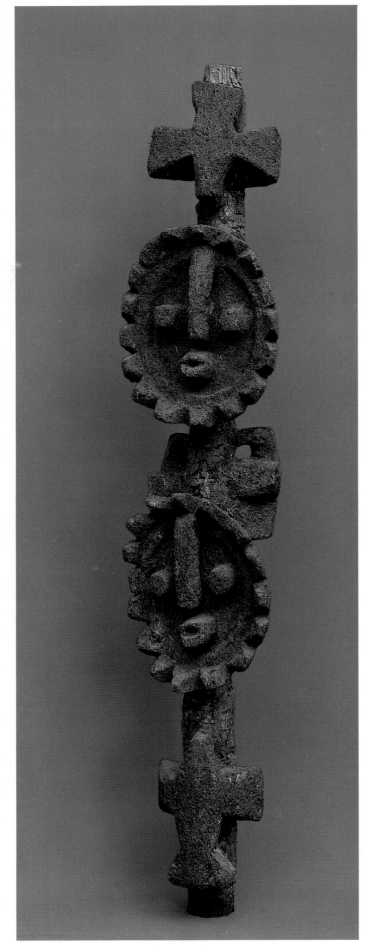

figures and the fact that neither has a mouth. Moreover, the horizontal line across the forehead of Klee's figure echoes the one that cuts across the War God at a similar point, while the lower horizontal in Klee's painting, which wittily serves as both the bottom of the nose and the horizon line (and could be said to imply a mouth) recalls the horizontal that demarcates the Zuni figure's chin. A far more subtle transformation was at work, I believe, as regards the feathers projecting from the chin of the War God, which probably inspired the curious multiple legs of Klee's *personnage*, while the arabesque indicating the latter's right nostril might well have been triggered by the feather projecting rightward from the nostril of the War God.

No doubt those familiar with tribal art find nothing unusual in feathers projecting from chins and nostrils, but I venture to say that the young Klee found this fascinating and therefore memorable, as he did especially the arrow projecting from the head. Whether he had the Zuni sculpture consciously in mind when he made *Mask of Fear* we cannot know, but it is of little importance insofar as Klee's configurations were always to some extent fished up by a process of automatic drawing from that area of the unconscious where "forgotten" imagery is stored.

The relationship between the Zuni sculpture and the Klee tells us more about the nature of artistic transmission, however, than merely the conversion of forms. The *Mask of Fear* was painted in 1932 on the eve of Hitler's assumption of power in Germany. The fascist bully-boys, among them the SS wearing their jagged "lightning" insignia, were already frightening people in the streets.[88] What could be more logical at such a moment than Klee's associating this to a War God crested by a zigzag arrow that for the Zuni represented a lightning bolt. Klee's fearful little man, creeping along the streets on caterpillar feet, has nevertheless got his antenna out and no doubt by this device senses the terror symbolized by the arrow, which is shown by Klee to be literally in (hence metaphorically on) his mind.[89]

The type of influence operating between the Zuni carving and the Klee falls more or less midway on a continuum bounded on one side by visually obvious relationships exemplified by the Easter Island and Ernstian birdmen, and on the other by "invisible" influences such as that of the Grebo masks on Picasso's *Guitar*. While we can be reasonably sure, I believe, of these three relationships, there are some cases of proposed influences where the absence of documentation for the parallels drawn renders the hypotheses—when at all convincing—more like good guesses. One of these was Reinhold Hohl's linking of Giacometti's plaster, *The Nose*, to a mask from the Baining people of New Britain in the Museum für Völkerkunde, Basel (pp. 34, 35).[90] This formerly hypothetical pairing, which new information, however, makes a virtual certainty, demonstrates a peculiarly interesting aspect of modernist responses to tribal works, a syndrome we might call "creative misreading." We know that Giacometti visited ethnographic museums, including the one in Basel, and such sculptures as his *Spoon Woman* were unquestionably inspired by tribal objects—in that case anthropomorphic rice spoons of the Dan and neighboring African peoples (pp. 508, 509). That *The Nose* echoed his experience of the Baining mask is

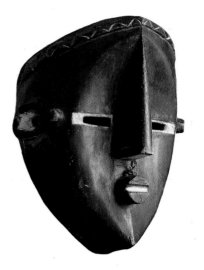

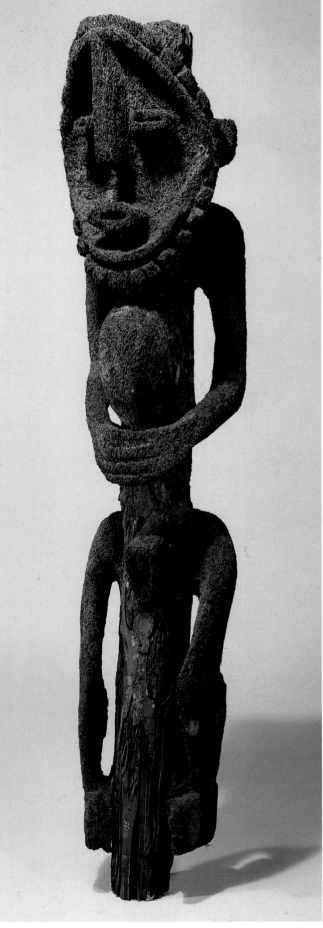

Above: Mask. Lwalwa. Zaire. Painted wood, 12″ (30.5 cm) high. Musée Barbier-Müller, Geneva

Left: Grade Society figure. Banks Islands, Vanuatu (formerly the New Hebrides). Tree fern, 6′1″ (185.5 cm) high. Museum für Völkerkunde, Basel

Right: Grade Society figure. Banks Islands, Vanuatu (formerly the New Hebrides). Tree fern, 71⅝″ (182 cm) high. Musée de l'Homme, Paris

Right: Helmet mask. Baining. New Britain. Painted bamboo, bark cloth, and feathers, 31½" (80 cm) high. Museum für Völkerkunde, Basel

Page opposite: Alberto Giacometti. *The Nose*. 1947. Metal, cord, and painted plaster, 32⅜ x 16⅝ x 16" (82 x 42 x 40.5 cm). The Alberto Giacometti Foundation, Kunstmuseum Basel

Below: Alberto Giacometti. *Head of a Man on a Rod* (detail). 1947. Plaster 23½" (59.7 cm) high. The Alberto Giacometti Foundation, Kunstmuseum Basel

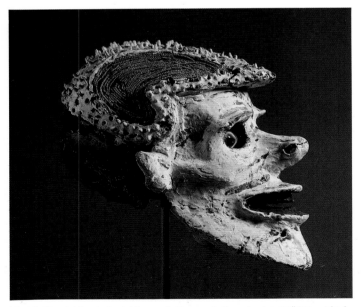

Modeled head. New Ireland. Human skull, wax, chalk, and paint, 6⅝" (17 cm) high. Museum für Völkerkunde, Basel

suggested by the comparably elongated noses (a motif not found elsewhere in Giacometti's work), the ornamental painting of both noses (a rare if not unique instance of this in Giacometti's sculpture), the presence of superstructures around the heads, and the resemblance of Giacometti's head—and especially a related one of the same year (above left)—to a painted skull from New Ireland exhibited along with the Baining mask in 1947, when *The Nose* was executed.[91] But Giacometti probably misread the Baining mask. For what we have been calling the nose of the mask is actually a megaphone and is, to that extent, its mouth;[92] indeed, the limning of a quite normal-size nose and nostrils is visible just above the megaphone. In the same way, the legs of the so-called "Dancing Figures" of Picasso's "African" period—which originated, as I shall demonstrate in a later chapter, in extrapolations of Kota reliquary figures (p. 268)—are derived from a perfectly understandable misreading of the lozenge supporting the reliquary figure's head as a pair of legs with knees bent outward. That this particular misreading was not unusual is testified to by Klee's *Idols* (p. 499), which is also clearly inspired by such reliquary figures.[93]

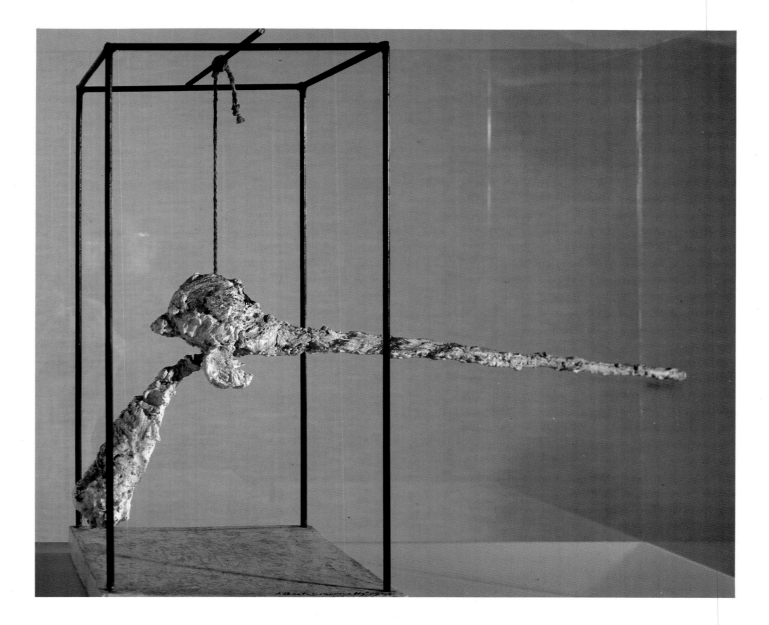

Of all the modernist misreadings of tribal works, the most common one interprets the sometimes rigid, frontal, symmetrical, and often awkward poses of many African figures as examples of Expressionism—as in Read's previously mentioned association of them to *angst*. Read attributed the "similarities" between modern and Primitive objects to the anxiety he postulated as their "common psychological condition."[94] This widespread misinterpretation, based upon an outmoded nineteenth-century interpretation of tribal life, no doubt somewhat accounts for the contemporary popularity of African art among certain artists, psychiatrists, and collectors. And it little matters, of course, if artists misinterpreted the objects in question if that misreading was of use to them. Nevertheless, in the interests of understanding the differences between tribal and modern art, we want to be aware that it *is* a misreading.

The distortions and exaggerations in modern Expressionist representations of the figure are functions, as Meyer Schapiro formulated it, of an "interior" or "felt" image of the body, as opposed to an optically perceived one.[95] (The feeling of the size of the bulge in our face when we have a toothache is much

greater than its actual dimensions.) This "felt" image, however, serves in Expressionist art as an index to a psychological rather than a somatic state. In Heckel's *Clown and Doll* (p. 37), for example, the sense of strain is communicated by typical Expressionist exaggeration of the terminals of the body—the head, hands, and feet—which are disproportionately large in relation to the torso. The effortfulness of dancing for the man—so opposite to the joy and grace in French representations of dancing—is the other side of the coin of the total abandon expressed by the angular distortions and weightlessness of the life-size doll with which he dances. Implicit in the Heckel picture is not only a general sense of malaise, but of an alienation of the sexes.[96]

It would not be difficult to misinterpret the Chamba figure illustrated here (p. 36) as embodying many of these same Expressionist themes. The immobile, frontal, and seemingly awkward posture of the body, with its enlarged hands, head, and feet (one turned in unanatomically), could be read as an image of strain; the overlarge penis as associating this strain to problems of sexuality; and the somewhat rounded open mouth as "vocalizing" anguish (as in the open mouth of

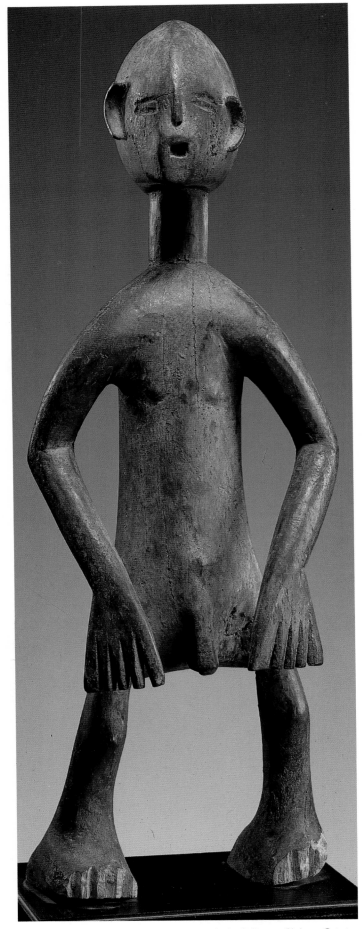

Munch's *The Shriek*, one of the principal Expressionist icons).

But anguish and alienation are in fact no more the content of the open-mouth convention in Chamba sculpture than in the Songye mask on page 16 or in the Ibibio mask we reproduce opposite, where the mouth is the focus of a patterning reminiscent (though far more regular than that) of the Munch. The emphasis on the sex in the Chamba figure, a common motif in tribal art is, by the same token, not a sign of sexual anxiety but of sexual identification and fertility. And the convention of frontality, which the Chamba shares with almost all other tribal art, expresses just the opposite of what Munch or Kirchner aimed at when, especially in their street scenes, they represented figures frontally. In the context of the mobile and molecular world of the modern street, the frontality of Munch's figures is a metaphor for anxiety and alienation on the public, social level (the characteristically modern sentiment of agoraphobia or *platzangst*). This frontality produces as unusual an image of modern man as a common one for Primitive (or Archaic) man. Tribal art expresses a collective rather than individual sentiment, alluding to the formalized and ritually ordered pattern of tribal life; as an artistic convention, frontality is thus in harmony with the structures of the artist's society, while the frontality of Munch's figures is at odds with the prevailing mobility and dynamism of modern life.

Darwin had described Primitive peoples as wholly unfree, in the grip of constant fear and trembling due to their inability truly to understand their universe. And it is this outmoded view that led to Read's thesis. For Darwin's assumptions to have been correct, however, Primitive man would have had to be without religious convictions. The rites in which tribal collectivities firmly put their faith, on the contrary, normally provided a substantial psychological security, as Lévi-Strauss observed;[97] it is precisely such security that Expressionist man finds lacking in the modern situation.[98] This does not mean, of course, that the order, symmetry, and frontality of tribal sculpture constitute a "picture" of tribal life, any more than does the stasis communicated by the far more rigid conventions of Egyptian sculpture. In both civilizations, as in any other, life was in fact subject to accident, change, and disturbance. Thus, what these sculptures communicate is less a picture of how things were than of how these societies perceived and valued them, how they ideally wanted things to be—a goal whose fulfillment was to be assured in part through the magical properties of the art objects themselves.

Those conventions of Chamba figures that encourage Expressionist misreadings are very common in African art, indeed, in tribal art in general. There are, moveover, some African objects that are even more markedly "expressionist" in character, such as the Montol healing-cult figure (right) and Pende "sickness mask" we illustrate (p. 264). While maintain-

Page opposite, top left: Healing cult figure. Montol. Nigeria. Wood, 14¾" (37.5 cm) high. Indiana University Art Museum, Bloomington; on loan from the Raymond and Laura Wielgus Collection

Page opposite, top right: Erich Heckel. *Clown and Doll*. 1912. Oil on canvas, 39⅜ x 27⅝" (100 x 70 cm). Destroyed

Page opposite, bottom left: Mask. Ibibio. Nigeria. Wood, 7⅞" (20 cm) high. Collection Jacques Kerchache, Paris

Page opposite, bottom right: Edvard Munch. *The Shriek*. 1895; signed 1896. Lithograph, printed in black, comp.: 13¹⁵⁄₁₆ x 10" (35.4 x 25.4 cm). The Museum of Modern Art, New York; Matthew T. Mellon Fund

Figure. Chamba. Nigeria. Wood, 22½" (57 cm) high. Collection Philippe Guimiot

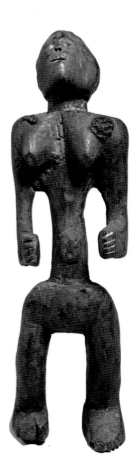

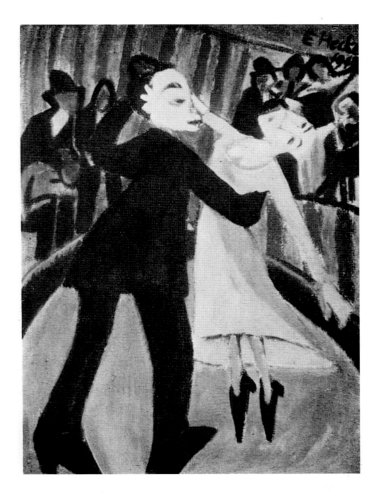

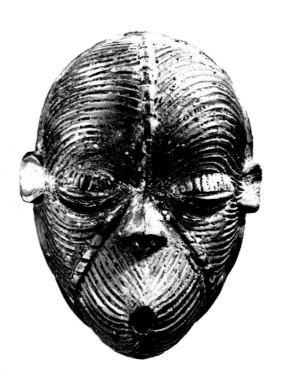

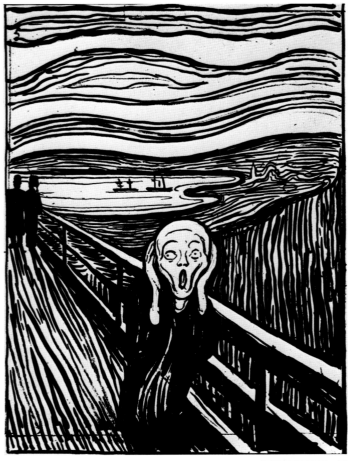

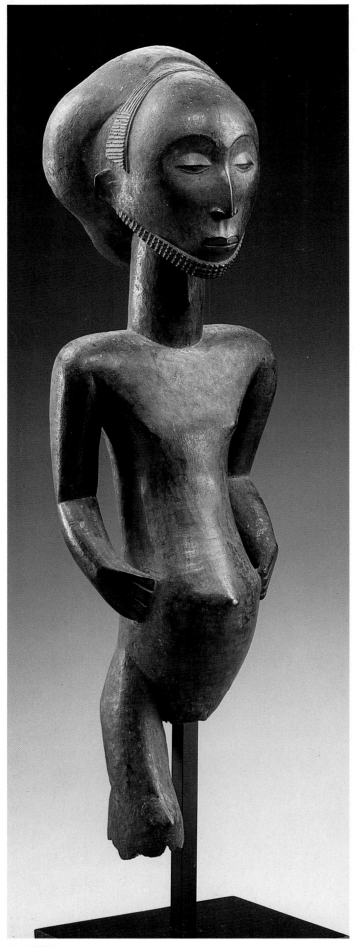

ing a conventionally symmetrical pose, the Montol sculptor seems to have wished through slight asymmetries (as in the hands and arms), and through a relative lack of articulation in the fashioning of the body, to create a sense of strain and awkwardness that is reinforced by the coarseness of the surface and, above all, by the upward tilt of the head and its pained expression. Unlike the Chamba sculpture, where Expressionist discomfort was not the intent of the artist, we may be dealing in the Montol piece with one of those rare Primitive works in which physical malaise was the intent of the depiction. To that extent, the almost paralytic posture of the Montol figure bears comparison with those in modern Expressionist works. There is a fundamental difference, however. The Montol work—if my reading is correct—is essentially realistic. As a religious specialist's accouterment used in curing, it may show a diseased figure. The kind of paralysis it suggests certainly existed in reality. Comparable figures in modern Expressionist art contain *distortions* of reality intended to communicate an inner state. The "distortions" of the asymmetrical Pende mask—which in some respects resembles the lower right figure of the *Demoiselles* (p. 264)—are not, as in the Picasso, an invented metaphor for a psychic state, but a depiction of a face in the advanced stages of such diseases as syphilis, *the model for which existed in reality* (though the image was subjected to characteristic Pende stylization).

There are, of course, many tribal works which (if, indeed, we do not misread them) deal with ferocity, horror, or fright, and express a certain violence—as in the face of the Ngumba (Cameroon Fang) reliquary figure and in the remarkably disquieting Makonde mask we reproduce. But unlike modern Expressionist works, in which such sentiments are generally identified with the psychic states of the figures represented, tribal expressions of this order appear outer-directed, in the sense that they are aimed at intimidating malevolent spirits and protecting reliquaries. Thus when we compare the Ngumba figure to the serene representation of the figure in Hemba statuary, the placidity of which is more typical of African art, we find that both works have far more in common, plastically and expressively, than the Ngumba work has with any Expressionist image of anger or fright.

The modernist tendency to interpret certain signs in tribal art in ways alien to Primitive cultures—to attribute to its signifiers twentieth-century signifieds—is only one of the many ways in which we respond to tribal art ethnocentrically. Underinterpretation is another. To the extent that certain modern artists (Matisse, for example) savored tribal objects purely for their plastic beauty, they detached them from the symbolic and thaumaturgic role central to their place in the matrix of Primitive culture. To be sure, some modern artists, beginning with Picasso and extending into our own day, have responded intuitively to the animistic aspects of most tribal art, though these artists soon abut the limits of their ethnological knowledge.[99]

Lack of familiarity with the cultural context of tribal objects is just one of many factors that condemn the modern artist to see them fragmentarily. More literal aspects of this fragmentariness include the fact that tribal objects often arrive in the West incomplete. A mask, for example, may be shorn of its fiber "beard" or headdress as well as other symbolic accouterments. Masks are seen, moreover, in isolation from the costumes (p. 549) of which they were a part. By the same

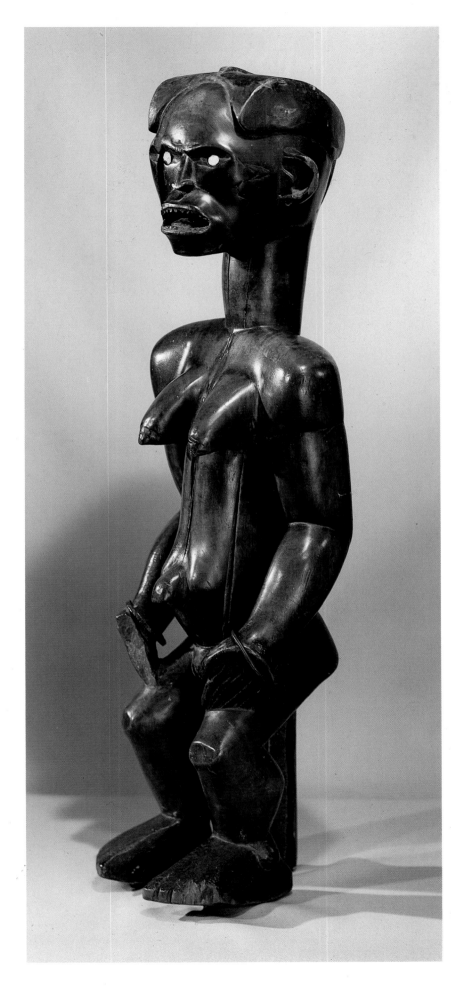

Above: Helmet mask. Makonde. Tanzania. Wood, 10½" (26.7 cm) high. Collection ARMAN, New York

Left: Reliquary figure. Ngumba. Cameroon. Wood, 26¾" (68 cm) high. Musée de l'Homme, Paris

Opposite: Figure. Hemba. Zaire. Wood, 26¾" (68 cm) high. Collection Jacques Blanckaert, Brussels

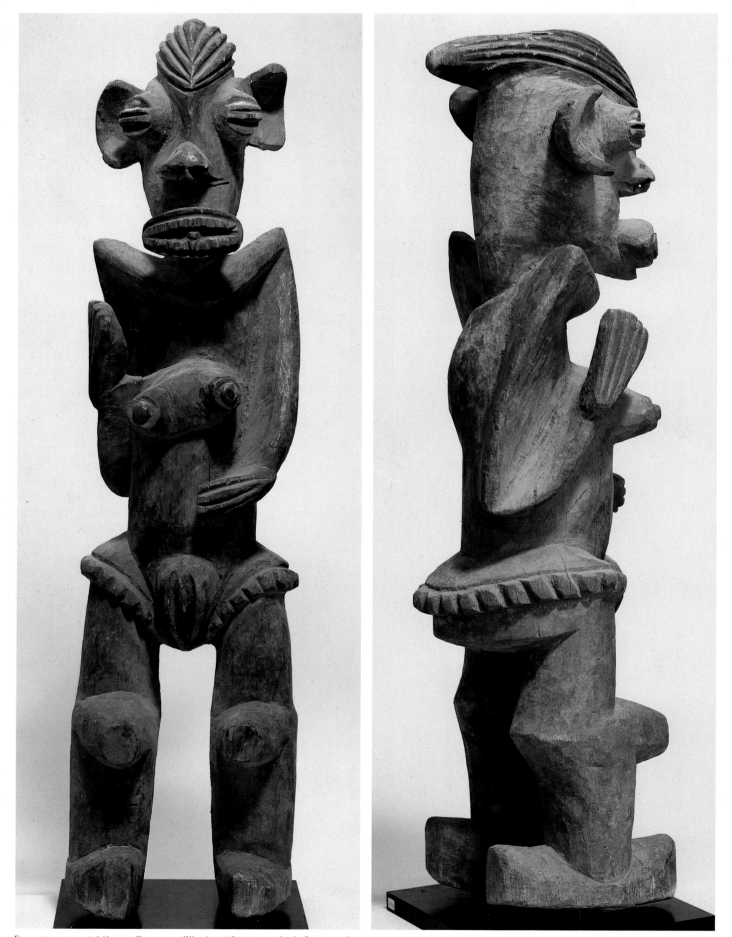

Figure (two views). Mfumte. Cameroon. Wood, 25½" (64.8 cm) high. Private collection

token, costumes are "fragments" of the dance, which is in turn a "fragment" of a more extended rite. Thompson observes, moreover, that many of the forms of African art were conceived to be seen in motion.[100] And while this is probably not true of most ritual figures, it does necessarily further distance us from some of the art that has most influenced modern painters and sculptors.

This general situation is hardly unique, however. We experience the entire history of past art in varying degrees fragmentarily and largely shorn of context. Few artists who appreciated Egyptian or Japanese art knew any more about its purpose or its cultural context than they did about that of Africa or Oceania. This ethnocentrism is a function nevertheless of one of modernism's greatest virtues: its unique approbation of the arts of other cultures. Ours is the *only* society that has prized a whole spectrum of arts of distant and alien cultures.[101] Its consequent appropriation of these arts has invested modernism with a particular vitality that is a product of cultural cross-fertilization.

In their collecting, the Cubist artists showed a marked preference for the art of Africa over that of Oceania. The Surrealists, for their part, were more enthusiastic about Oceanic objects (and those of the American Indians, Northwest Coast peoples, and Eskimos); in the "Surrealist Map of the World" (p. 556), Easter Island is represented almost as large as Africa. This broad and clearcut difference in preferences was perhaps inflected by the relative availability of objects from the two regions, but it stemmed primarily, I believe, from fundamental differences between Cubism and Surrealism. Cubism, like African art, was rooted—despite varying degrees of abstraction—in the concrete reality of the visible world; Surrealism, like much Oceanic art (at least in Melanesia), opted primarily for the world of the imagined, for the depiction of the fantastic rather than the visually derived.

The motivation for the Cubist and Surrealist choices becomes clear when we compare the insistent three-dimensionality of African carving—the measure of its concreteness and factualism—with the essentially pictorial structure of Melanesian, particularly New Guinean, sculpture. The latter's pictorialism is evident in the tendency of such sculpture-in-the-round to reveal itself satisfactorily from but a single point of view—usually either directly from the front or in absolute profile. We are struck by the relative flatness and "bodilessness" of certain Oceanic sculptures, our eye being drawn to the outer contours, or to the drawing or painting that ornaments the surface; we get little sense of the kind of tactile, sculptural mass that constitutes the essence of most African work. Many more Oceanic than African works are realized, moreover, in bark cloth (p. 547), mud (p. 636), or other "soft" sculptural materials, which in themselves are a measure of this pictorialism.

Whereas the best African sculpture is usually interesting from almost any angle—the Mfumte figure (opposite) virtually forces us around it—the pictorialism of Melanesian work often limits the perspective the viewer may profitably adopt. The front of the Abelam (Maprik) figure we reproduce (p. 42) reveals, for example, very little of the figure's articulation, or of the sculptor's sophistication; only a profile view makes visible such remarkably subtle artistic decisions as the

series of five minuscule descending steps that demarcate the bottom of the nose, the upper lip, lower lip, chin, and neck respectively, or the formal analogy between the ornament projecting from the figure's necklace and the shape of his penis.

Compare that decoratively painted Abelam figure now to the spare Mumuye carving from Nigeria with which it is paired (p. 43). Everything about the Mumuye figure is designed to make its three-dimensional plasticity impress us from whatever angle we look at it. The treatment of the arms is remarkable. Starting from the hands, they curve at once upward and backward around the column of the body, only to return again and join at the top of the torso so as almost to form an oval inscribed around a cylinder; the top of that oval, moreover, recalls the shape of the hoodlike coiffure that mysteriously shrouds the face. The African sculptor eschews the low relief and surface ornamentation that characterizes the Abelam figure. His forms are few, simple, and bold, and anything that would diminish the sense of sculptural mass is avoided. In fine African carving, the interior of the mass never seems plastically inert, as in much Egyptian sculpture and some other Archaic styles. Like the Archaic sculptor, the tribal artist takes frontality as a starting point—but unlike the former, he goes beyond it. He feels free to work against the grain of such formality, and manages to give to the shapes of the body a plastic liveness we rarely see in Archaic art, where sculpture in the round often suggests the joining of four reliefs, and the articulation of the figure seems directly derived from the surface drawing on the block of stone or wood with which the sculptor began.[102]

The unique possibilities of the planar/pictorial formula favored by Melanesian sculptors are nowhere more remarkably realized than in the New Guinea Highlands figure (p. 44), whose forms are cut from a narrow plank, so that while the sculpture has a front and back, it has no profile at all. Fascinating as is the sculptural contour "drawing" of this figure, much of its richness would be lost without its painting—the colorful concentric circles that articulate the head and abdomen, and are echoed in the semicircle of the support. There are few African pieces in which surface decoration and, above all, such pure play of color, enjoy so central a role, precisely because these properties would detract from the plasticity, the sense of sculptural mass, that the African carver is generally at pains to achieve. The New Guinea Highlands figure is remarkable not only for its high degree of abstraction, but for the autonomous nature of that abstraction; we would look primarily to the painting of recent decades—a Kenneth Noland *Tondo* (p. 45), for example—for a counterpart in the Western tradition to the flat concentric color pattern the artist has used for stomach and head. The nearest example I can find in other tribal art of such concentricity used as a symbol for a part of the body is a Yukon River Eskimo mask (p. 45)—and insofar as the Surrealists adored Eskimo as well as New Guinea objects, this kinship is perhaps not surprising.

The "colorism" of Melanesian art is not only a question of the literal use of color, or of the shaping of soft materials, but of the intricacies of carving—elaborate undercutting and complicated interpenetration of forms. Nowhere is this better embodied than in the monster that decorates a New Guinea hair ornament (p. 47) whose interlocking components recall the ornament of "Folk-Wandering" peoples of Eastern Europe. The equally small Mambwe figure from Zambia (p. 47),

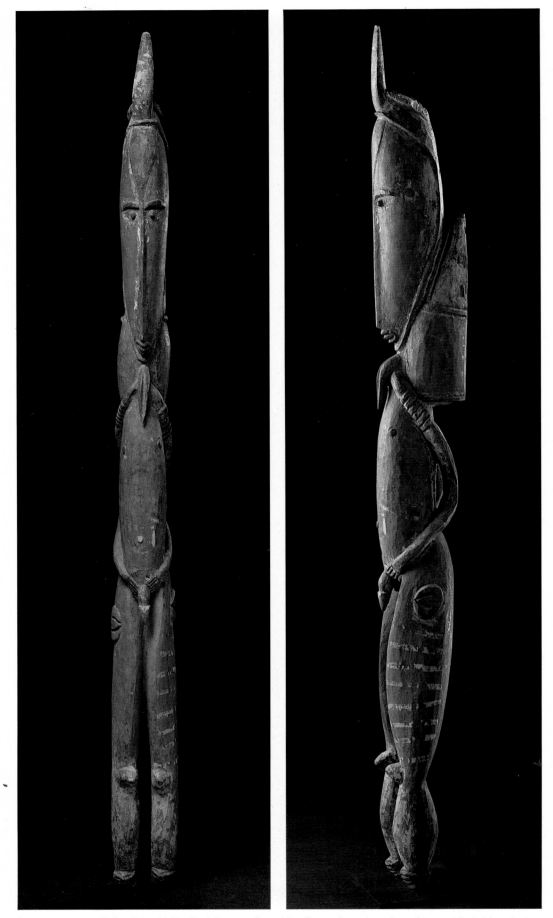

Figure (two views). Abelam (Maprik). East Sepik Province, Papua New Guinea. Painted wood, 53⅞" (137 cm) high. Musée Barbier-Müller, Geneva

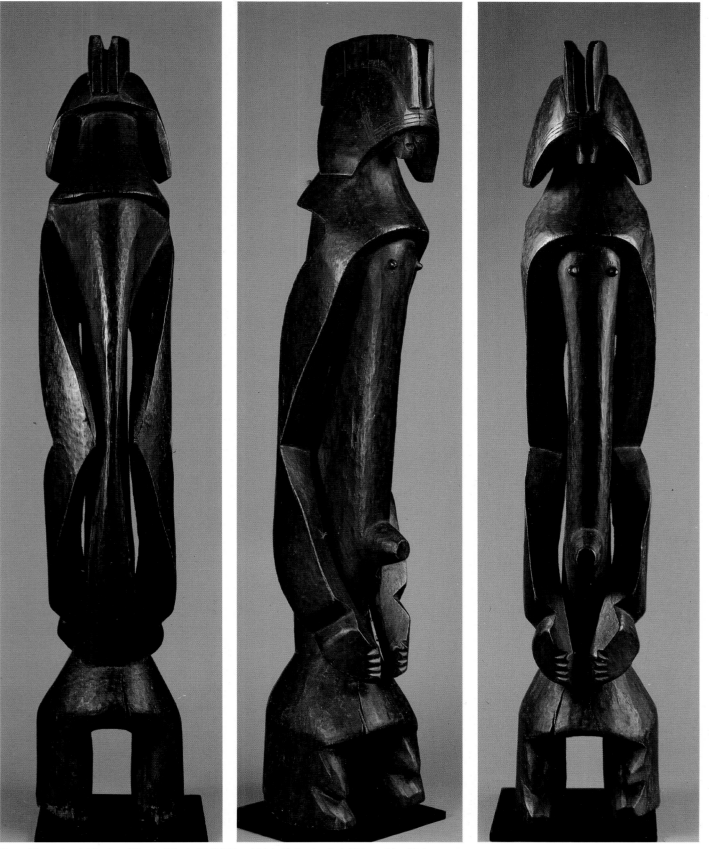

Figure (three views). Mumuye. Nigeria. Wood, 47¼″ (120 cm) high. Collection Jack Naiman, New York

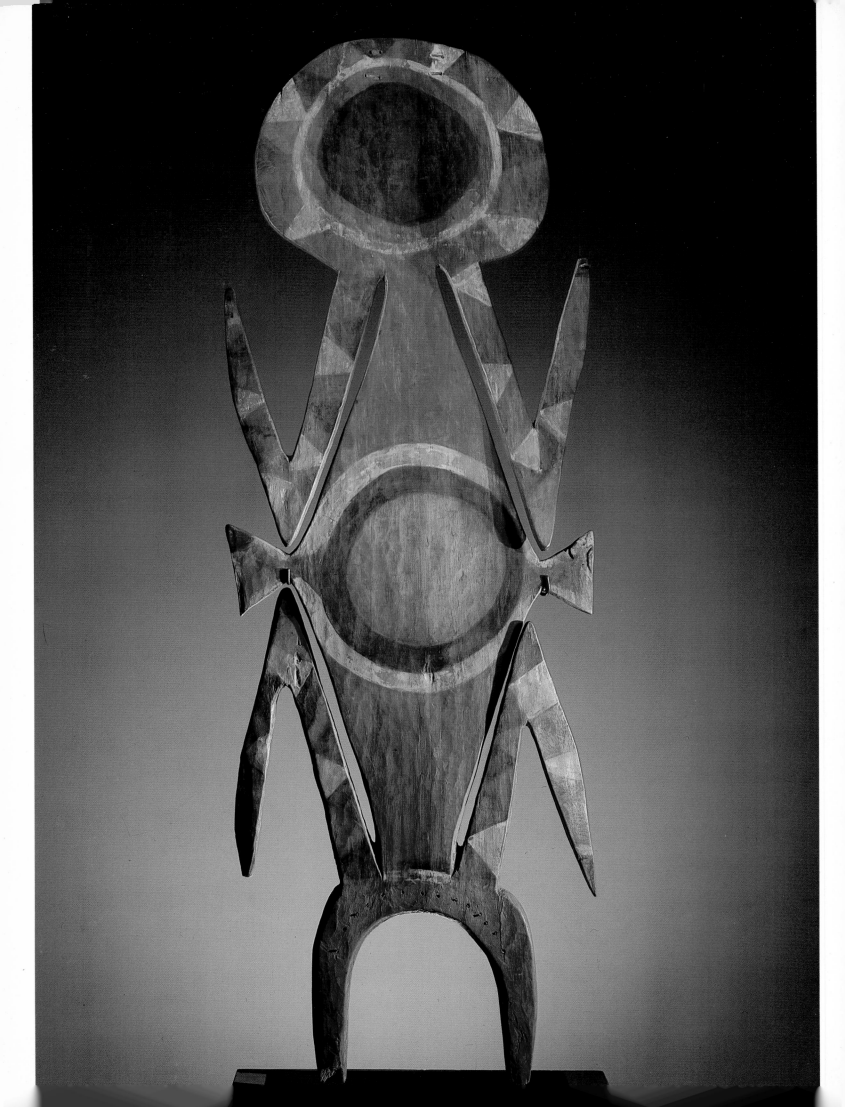

whose scar pattern is as severe and geometrical as its conception of the figure (reduced to torso, sex—or navel—and "head") is abstract and spare, provides a telling African foil for the hair ornament. As sculpture, the hair ornament may be said to revel in its miniaturization; the Mambwe carving, like many Zande figurines (p. 158), has such innate monumentality that it could be imagined to be a maquette for a large work by a modern sculptor.

If the Oceanic sculptors sacrificed mass by often working pictorially in a single plane, they gained the possibility of making the space in which their figures move play a role that it never does in African art. In the latter, the sculptor thinks only of the solid. Space is measured rather than shaped and, as in Classical art, it serves essentially as a foil to enhance the solids. But in Melanesian art, in particular, space becomes a full-fledged component of the artists' aesthetic. Consider, for

Above: Kenneth Noland. *Tondo*. 1961. Acrylic on canvas, 58½″ (148.6 cm) diameter. Collection Mr. and Mrs. A. E. Diamond, Toronto

Left: Figure. Eastern Highlands Province, Papua New Guinea. Painted wood, c. 59″ (150 cm) high. Private collection

Right: Mask. Eskimo. Lower Yukon River, Alaska. Wood, paint, and leather, 7¼″ (18.4 cm) high. National Museum of Natural History, E. W. Nelson Collection, Smithsonian Institution, Washington, D.C.

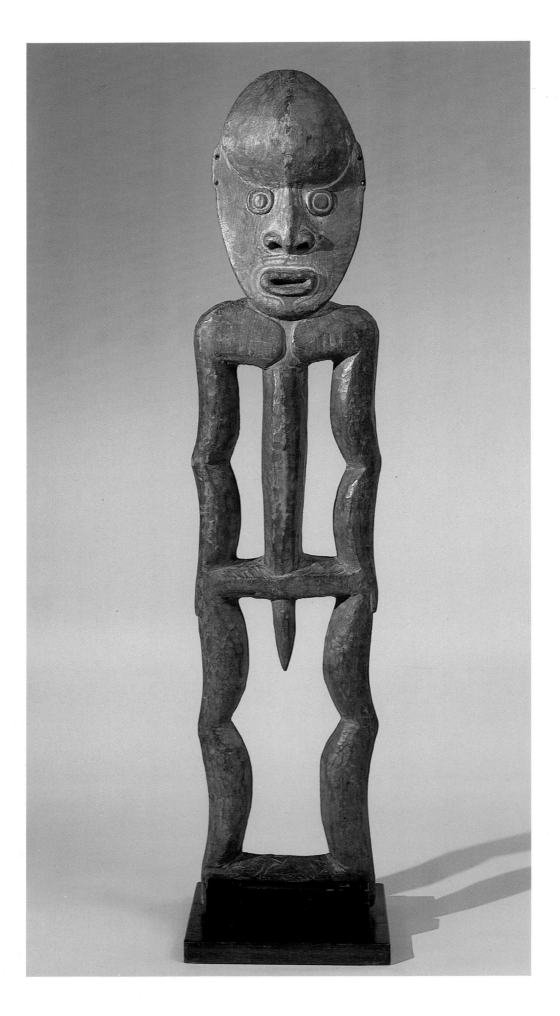

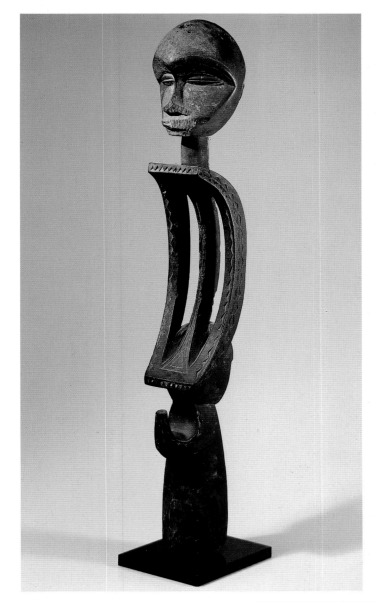

example, how the New Guinea Highlands sculptor exploits the narrow spaces between the bent arms and legs of the figure. Even more striking is the function of "reserved" spaces in the best of the Yipwon figures from the Karawari River region of New Guinea (p. 73). Here, the areas between the exquisitely curved "ribs" are as deeply felt as the tapered solids that define them. Regrettably, these figures, which are among the most remarkable inventions of the tribal artists, are so frequently badly broken or incomplete that few examples do justice to the sculptural idea involved.

The Iatmul (Sepik) figure reproduced on the page opposite is one of the most remarkable examples of the sophisticated use of such reserved or "negative" spaces. The spaces between the arms and the body, and especially the one bounded by the legs, haunches, and penis, have an autonomous aesthetic interest at least equal to that of the solid forms that demarcate them. The entire sculpture is conceived with an extraordinary economy that makes it especially appealing to modern taste, as exemplified by the continuation of the diminishing bulk of the torso into the pointed sex. It was not until the 1920s—as in some of the early works of Giacometti—that modern sculptors were able to exploit reserved spaces with such simplicity and inventiveness. Compare this Iatmul artist's conception now to the equally remarkable and spare solution for the body by an Eket sculptor from Nigeria. Typically for African art, the inventiveness here is not in the interplay of solid forms and shaped spaces, but in the movement through space of the solids themselves—the remarkable parallel arcs of the torso and arms, and the upward hook (of what may be the penis) that is played off against it.

The Wölfflinean generalization I have established between "tactile" African carving and "visual" or pictorial Oceanic—especially Melanesian—sculpture holds broadly speaking, I am convinced, for much of the three-dimensional work of both areas. But it *is* just a generalization, and there are numerous exceptions. In the figure of the goddess Kawe from Nukuoro, to take one example (Frontispiece), we find a sculptural plasticity worthy of Brancusi. Nor is such three-dimen-

Above: Figure. Eket. Nigeria. Wood, 28¾" (73 cm) high. Private collection, Paris

Opposite: Figure. Iatmul. East Sepik Province, Papua New Guinea. Wood and paint, 54⅜" (138 cm) high. Private collection

Right: Hair ornament (detail). Yuat River, East Sepik Province, Papua New Guinea. Painted wood, c. 20⅛" (51 cm) high, overall. Private collection

Far right: Figure. Mambwe. Zambia. Wood, 11⅞" (30 cm) high. Museum für Völkerkunde, Berlin

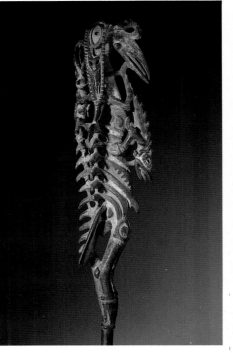

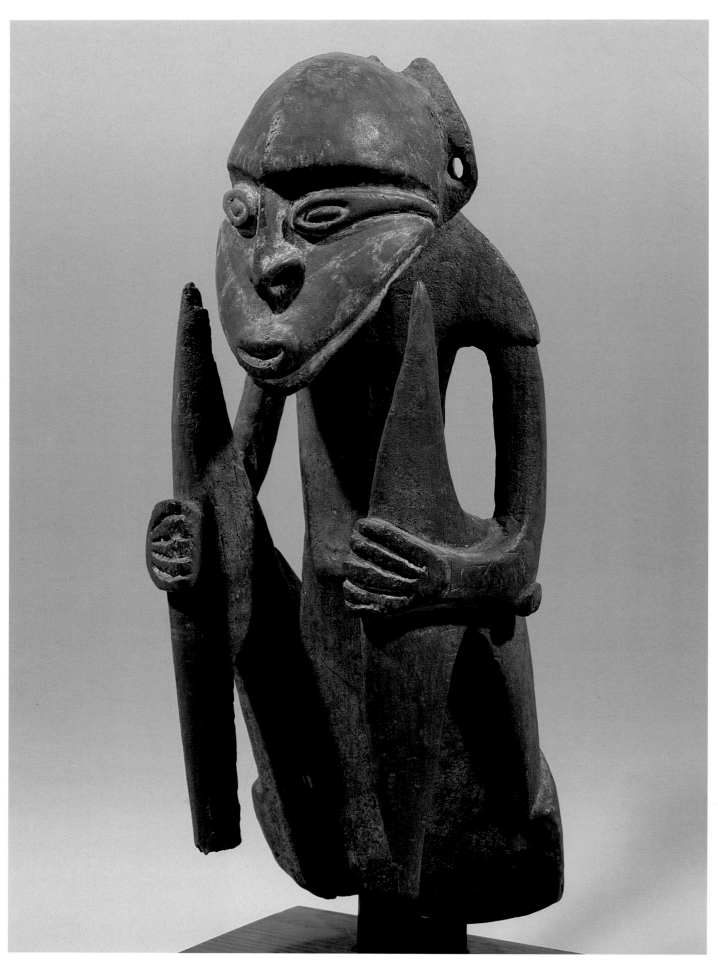

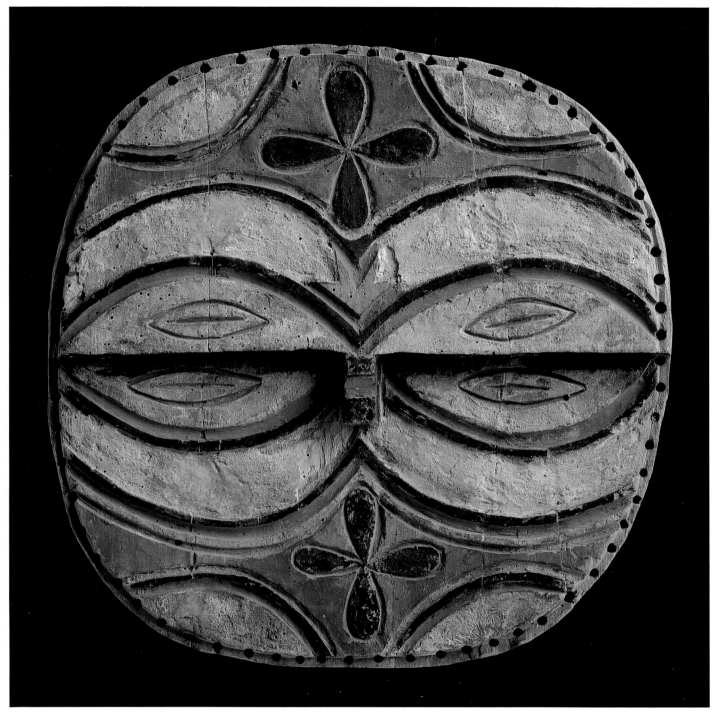

Above: Mask. Teke. People's Republic of the Congo. Painted wood, 13⅜" (34 cm) high. Musée Barbier-Müller, Geneva. Formerly collection ANDRÉ DERAIN

Left: Figure. East Sepik Province, Papua New Guinea. Wood, 17⅞" (45.5 cm) high. Musée Picasso, Paris. Formerly collection PABLO PICASSO

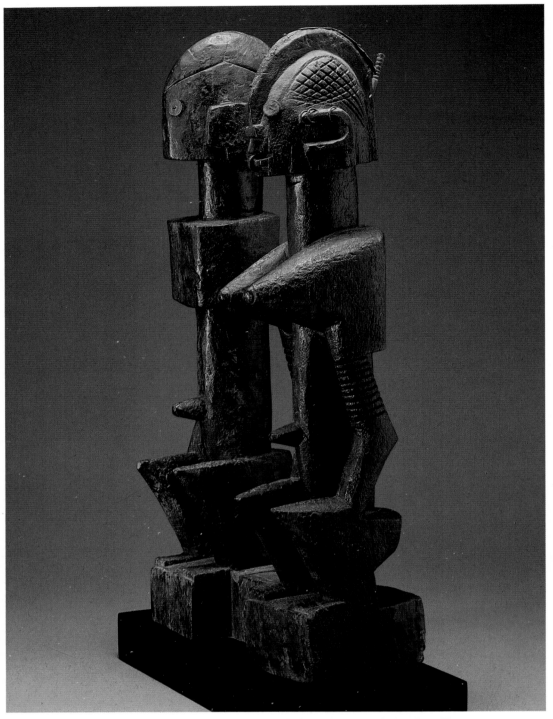

Seated couple. Dogon. Mali. Wood and iron, 22¾" (57.8 cm) high. Collection Murray and Barbara Frum, Toronto

sional displacement unique in Oceania, as witness Picasso's Sepik figure (p. 48) and the Tikis from Polynesia (pp. 283, 287). Conversely, the handsomely incised, colored Teke mask from the Congo (p. 49)—a mask that belonged to Derain—is unusual among African sculptures in its almost Oceanic pictoriality (I say "almost" because the particular geometry of the configuration remains resolutely African).

With the awareness we have formed of the differences between African and Oceanic sculpture, we can better situate

modern works in relation to them. The special affinity of the Cubists for African art can be readily understood by comparing a Dogon Couple with Lipchitz's *Seated Man*.[103] Like most African art (and early Cubist painting), the Lipchitz is monochromatic. Polychromy would have diminished, in both the African and modern works, the sense of the volumetric, the purely sculptural tactility. Moreover, despite the marked abstraction of the Lipchitz and Dogon pieces, both of which are reductively conceived in geometrical forms that emphasize straight lines, right angles, and simple curves, the constituents of the human body remain clearly identifiable. The

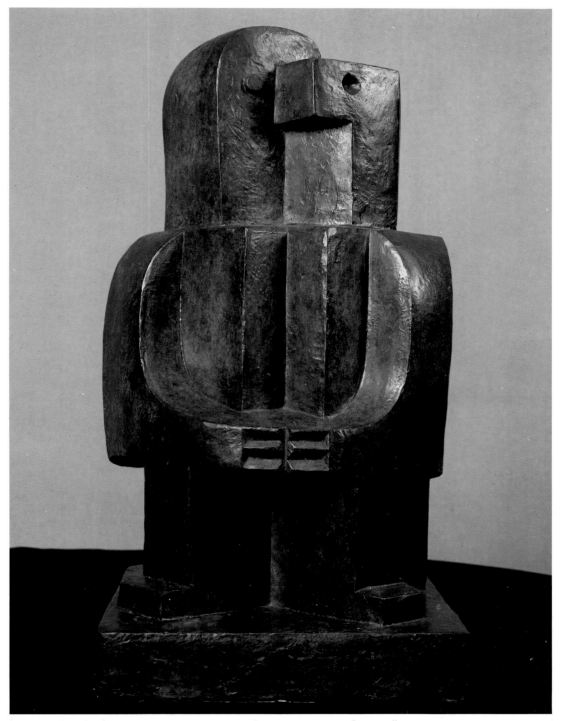

Jacques Lipchitz. *Seated Man*. 1922. Bronze, 20 x 10¼ x 10½" (50.8 x 26 x 26.7 cm). Private collection

parallelisms and symmetries common to these equally frontal objects demonstrate a propinquity in spirit: the positioning of the feet and hands, and the line across the shoulders in the Lipchitz, as against the lining up of the bent legs, the navels, and the heads in the Dogon. Neither work contains much sculptural "drawing." The incised lines of the hairdos and arm bracelets in the Dogon have the same geometrical simplicity as the hands of Lipchitz's figure, and the eyes in both are simple circles.

Though the Lipchitz bronze represents only a single figure, the opposition of curvilinear and rectilinear shapes within the

head recall the aesthetic contrasting of male and female in the Dogon: the woman's conical breasts against the "cube" of her husband's upper torso, or her curvilinear ear and coiffure-crest against the rectilinear ear and straight-edged hairline of the man. It is worth noting that Lipchitz's combination of round and straight-edged profiles within a single head was a Synthetic Cubist convention itself *originally derived from a confrontation of male and female forms.* Picasso had established it in his magisterial *Harlequin* of 1915, where the single figure was distilled and compressed from what had begun as a dancing couple (p. 53).

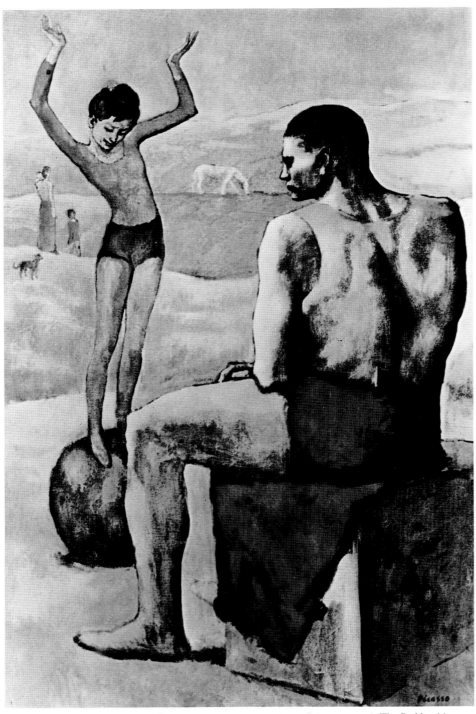

Pablo Picasso. *Young Acrobat on a Ball*. 1905. Oil on canvas, 57⅞ x 37½" (147 x 95 cm). The Pushkin Museum, Moscow

The elemental simplicity that led Picasso to identify the male with the rectilinear (and by extension with squares, rectangles, and cubes) and the female with the curvilinear (and by extension with arabesques, circles, and spheres) was entirely characteristic for him. (It is parodied in such *mots* of his as "If it's got a moustache, it's a man.") Moreover, this kind of reductive analogical thinking, which made Picasso especially receptive to African art, was typical for him well before he saw tribal art or shared in the creation of Cubism. In *Young Acrobat on a Ball* of 1905, for example, an analogy is already clearly stated between the male acrobat and the cube on which he sits, as it is between the young girl and the ball on which she balances.

Picasso's elementariness could easily be called banal. It is at the heart, nevertheless, of what gives his art a more popular appeal than that of the other great modernists. For only when the widest commonplace is amplified by the spirit of genius do we get the truly universal work of art. By the early twentieth century, modernism had become so complex and recondite that its potential audience was necessarily limited. The hyper-

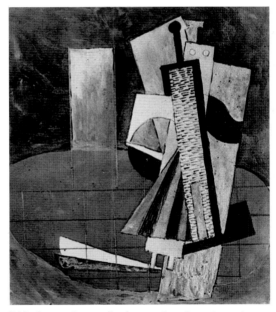

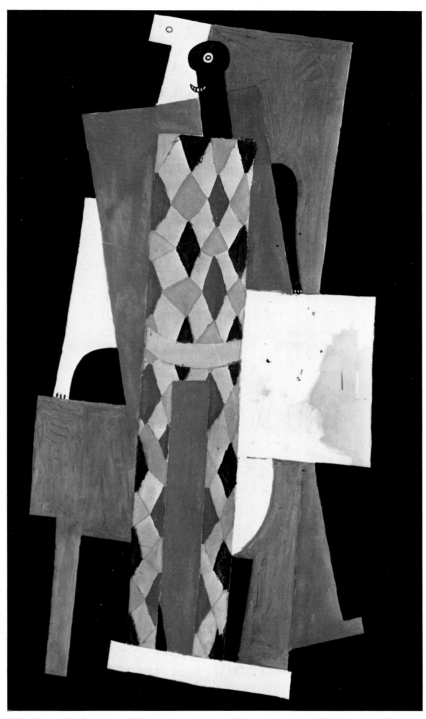

Pablo Picasso, *Dancing Couple*. 1915. Gouache and pencil, 5½ x 4¾" (14 x 12 cm). Collection Diane de Riaz, Val de l'Oise, France

Pablo Picasso, *Harlequin*. 1915. Oil on canvas, 72¼ x 41⅜" (183.5 x 105.1 cm). The Museum of Modern Art, New York; acquired through the Lillie P. Bliss Bequest

trophied sensibility celebrated in much Symbolist art—an important source of Picasso's Blue and early Rose periods—represented one extreme of this development. But by 1906, Picasso was ready to react against this, and his subsequent primitivism—first Iberian, then tribal—was the chosen vehicle. While tribal art continued to be relegated to the status of *curiosités* by the public of those years, it was eminently accessible to Picasso, who sympathized with its direct, simple, and reductive solutions. Picasso not only saw how these could be used as a purgative, but how they could help him build a

modern art that would share the quintessential and universal quality he recognized in tribal sculpture. The *Demoiselles* represented the climax of his eighteen-month struggle to break with the etiolated modernism of the Symbolist generations, and it was not by accident that Picasso's "Africanism" first appeared in it. The "elementalism" of the *Demoiselles* required cutting back through layers of inherited conventions to a set of plastic rudiments—an endeavor that Picasso associated with tribal art. But the *Demoiselles* implied more than just a return to basic formal building blocks; as we shall see (pp.

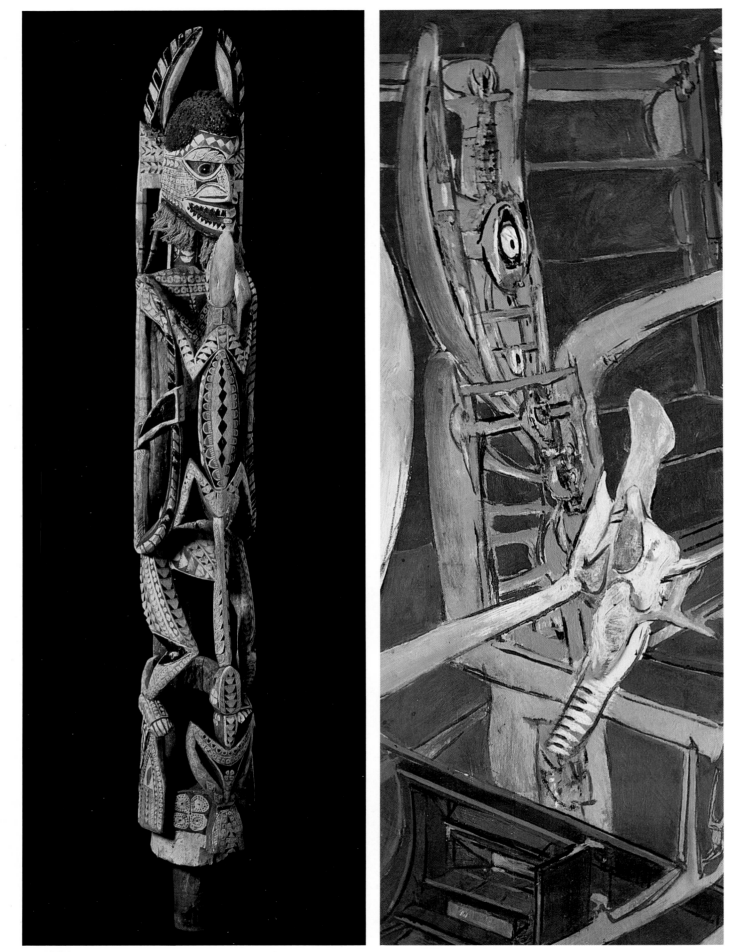

248–65), Picasso associated the return to fundamentals with the rediscovery of that direct magical affectiveness he knew to be the inherent power of the visual arts, an affectiveness with which the Western tradition had somehow lost contact. The "revelation" of this magic had come to him on his first visit to the Musée d'Ethnographie du Trocadéro.

The affinities that relate the Surrealist Matta's *A Grave Situation* (p. 3) to such typical Oceanic sculptures as the Malanggans of New Ireland (p. 2 and opposite) are at every point opposed to those linking the Lipchitz and Dogon works. The Malanggans are pictorial, i.e., "visual" rather than "tactile"; they share with the Matta a language of open forms and cursive "drawing" (e.g., silhouetting), both of which the Cubist and African artists eschew. Like Matta—but again unlike the African or Cubist sculptor—the New Ireland artist assigns an important role to color, at the cost of purely sculptural qualities.

The relationship between Matta's *personnages* and the Malanggan figures carries us beyond affinities into the realm of direct influences, however. Matta, like Ernst and other Surrealists, was an avid collector of these sculptures. And though the "cybernetic" structures of Matta's *personnages* give them a twentieth-century look, many aspects of them reflect his love for these tribal objects: the openwork structure of their anatomies, their rigid postures and "semaphoric" gestures, and their fierceness and aggressiveness. Like the Malanggans, Matta's figures are themselves attacked by monstrous animals.

As all tribal art—given its tendency to frontality and symmetry—is more "iconic" than "narrative," it is probably hazardous to distinguish between African and Oceanic art on the score of storytelling. Nevertheless, most Oceanic and all Northwest Coast sculpture (a special favorite of the Surrealists) seems to me to have a more visible if symbolic relation to narrative statement than African art. To this extent, we can understand why Cubism, which is an "iconic" art, would lead its makers to Africa, while Surrealism, which is a symbolically "storytelling" art, would lead its practitioners to Melanesia, Micronesia, and the Americas.

To put this in another form, I would hazard the generalization that, relatively speaking, Oceanic and Northwest Coast art leans toward the expression of myth, while that of Africa leans toward that of ritual. Whether ritual is abstracted from myth or, as some anthropologists feel, mythology is elaborated from ritual, need not concern us here, for simply in terms of the nature of the modes, we can say that ritual is more inherently "abstract" than myth. Thus, the more ritually oriented African work would again appeal to the Cubist, while the more mythic content of the Oceanic/American works would engage the Surrealist. This does not mean, to be sure, that mythical personages are wholly absent from African art; on the contrary, there are some examples of them.[104] Rather,

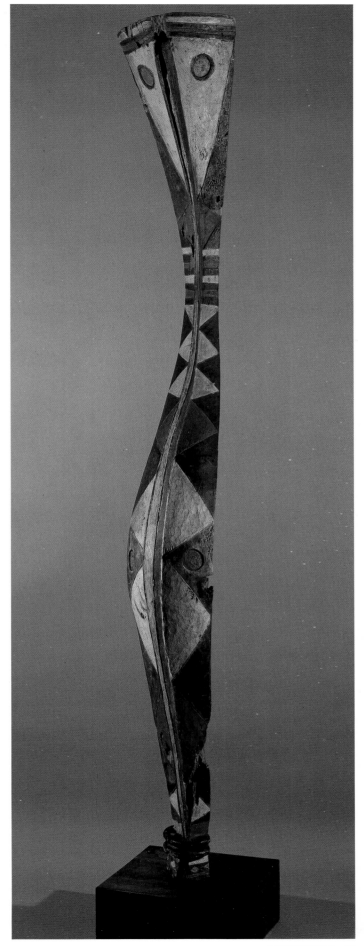

Opposite, far left: Malanggan figure. New Ireland. Painted wood and mixed media, 42½" (108 cm) high. Musée Barbier-Müller, Geneva

Opposite, left: Matta. *Wound Interrogation* (detail). 1948. Oil on canvas, 59 x 77" (149.9 x 195.6 cm). The Art Institute of Chicago; Mary and Earle Ludgin Collection. Entire painting reproduced page 582

Right: Serpent figure. Baga. Guinea. Painted wood, 8'2½" (250 cm) high, including base. Collection Mr. and Mrs. Jacques Lazard, Paris

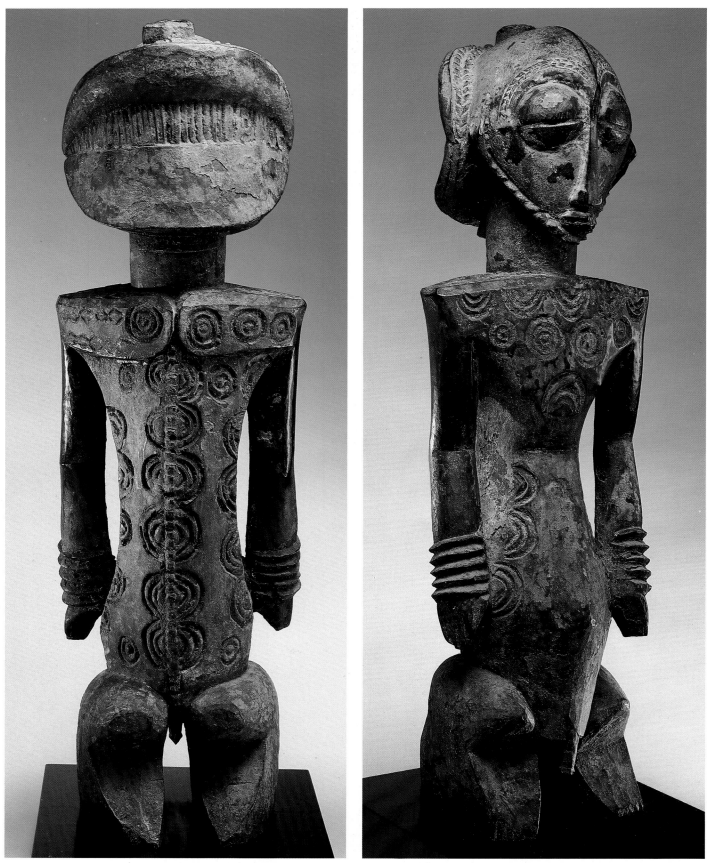

Figure (two views). Boyo. Zaire. Wood, 34" (86.4 cm) high. Collection Gustave and Franyo Schindler, New York

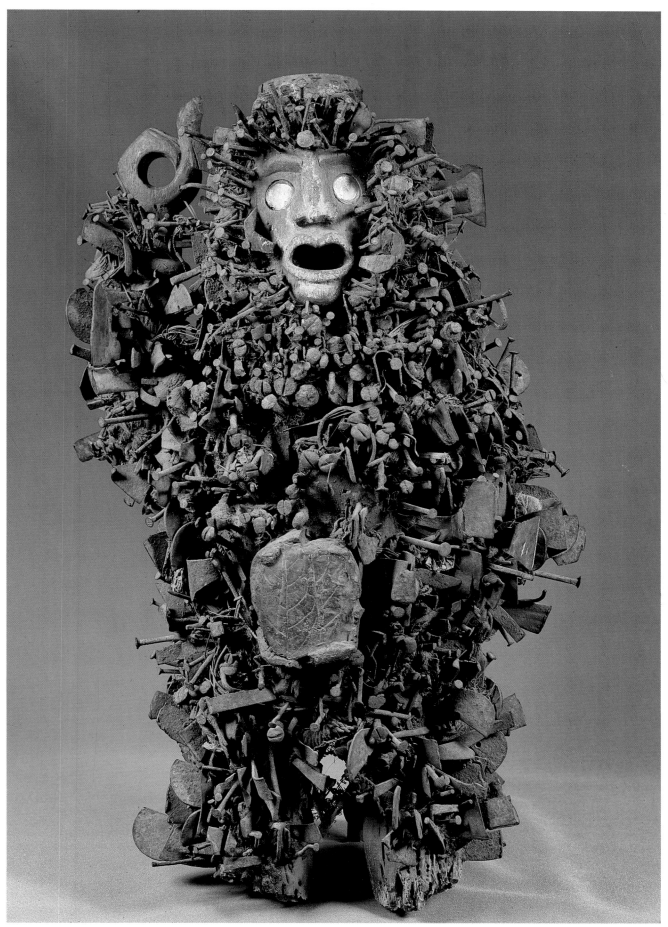

Fetish. Yombe. Zaire. Wood and mixed media, 23⅜" (59.5 cm) high. Musée Royal de l'Afrique Centrale, Tervuren, Belgium

Imunu figure. Namau. Gulf Province, Papua New Guinea. Wood, 21" (53.3 cm) high. Friede Collection, New York

Alexander Calder. *Apple Monster.* 1938. Painted apple branch and wire spring, 65 x 32 x 50½" (165 x 81.3 x 128.3cm). Private collection, New York

they appear in that art more in the spirit of the way they are called forth in liturgy than in the sequential storytelling manner of the myth, which—to the extent it can be accommodated in sculpture—leads to composite or totem-pole-like agglomerations such as are more common in Oceania and on the Northwest Coast than in Africa.[105]

The Surrealists preferred Oceanic to African art in part for its seemingly greater closeness to nature and its more varied, more aleatory use of natural materials. It is sometimes said that African art is Classic and Oceanic art Romantic, and although such generalizations can obscure as much as clarify, one could certainly agree that Melanesian art is more Romantic than that of Africa in the character of its identification with the world of nature. While there are numerous hybrids of men and animals among African masks and figure sculptures, they tend conceptually to be further removed, further abstracted from nature than the more ubiquitous monsters of the Melanesian peoples. Relative to many Oceanic arts, African sculpture could almost be characterized in terms of a prevailing anthropomorphism and anthropocentrism, both qualities of the Classic.[106] The New Guinea artist, on the other hand, tends to find his monsters more nearly "ready-made" in the very substance of nature. Nowhere in African art, for example, do we find anything comparable to the malevolent hybrid Imunus of the Papuan Gulf region, which are largely made up of branches or roots of trees. The result of this "natural selection" is an accident-accommodating, meandering, linear object, the near formlessness of whose contours is antipodal to

African aesthetic ideals.

But not to modern taste—especially that of the Surrealists, who particularly liked such objects. We see affinities to their structures, if not direct echoes of them, in the contouring of many works by Ernst and Miró, as well as later, in the work of Dubuffet (p. 637). But it is in the art of Calder, who was close to the Surrealists in the thirties, that one discovers what appears to be a direct influence of an Imunu. Calder, whose interest in tribal art began early,[107] had formed a fairly extensive collection of Primitive art by the later thirties. He was friendly with the dealer Pierre Loeb[108] who, aside from exhibiting such Surrealists as Giacometti and Miró, did much to advance the cause of tribal art from the South Seas in general and Papua in particular.[109] Calder's *Apple Monster,* 1938—largely formed from the branches of an apple tree—is an altogether unusual work in his oeuvre and responds directly, I believe, to the artist's fascination with an Imunu. Like the Imunus, whose "serendipitous" character was bound to appeal to vanguard taste, Calder's piece consists largely of found objects subjected to a minimum of alteration after their selection. Both Calder and the New Guinea artist divined the monster while it still lurked in the raw material of nature. Such seerlike prescience especially appealed to the Surrealists, who would have categorized both the Imunu and *Apple Monster* as "objets trouvés aidés."

The New Guinea object has, however, the mordant and truly hallucinatory quality of a work whose creator really believes in monsters. None of that malevolence is present in the Calder, which expresses rather a whimsical and decidedly unthreatening sense of the forces of nature. Like the monsters

in Klee and Miró, Calder's does not frighten us because neither he nor we still believe in monsters—at least in nature. For us, the truly monstrous emanates from man's mind—as was expressed so forcefully by Picasso's 1930s Minotaur (the beast-in-the-head instead of in-the-body), which is now stamped so indelibly on the modern psyche.

Most of the formal qualities shared by modern and tribal art may be traced to the widespread twentieth-century commitment to conceptual modes of imaging. Conceptualism opened a whole new world of possibilities, whose realizations led to such commonality as is shared by the pictographs of Klee's *Poster for Comedians* and an African bark-cloth painting from Zaire. The substitution of reductive signs for direct illustration offered the modern artist an opportunity to explore analogies of a type long familiar to tribal artists. And as the very nature of signs encourages economy, it is not surprising that both tribal and modern artists achieved a remarkable economy in their use.

In the Kwele mask illustrated on page 61, for example, the artist repeats virtually the same form in three vertical pairings anchored to a vertical axis. This signature shape is characteristic of Kwele sculpture. In isolation, it would probably be taken as an eye (the interpretation given by scholars), or perhaps a mouth. As a repeated sign, however, it acquires its identity through its location on the surface. Thus, in relation to the vertical axis, the same form may be read as alluding to eyes, nostrils, or mouth; in the same manner, the axis may be read as a nose. But the shape in question is not directly identifiable with any of these features, for it never sacrifices its autonomy as a sign to the purposes of representation. A similar ambiguity obtains in the Igbo Yam mask from Nigeria (p. 61). Although the eye is here clearly denoted as such (as is the curved form of the ceremonial yam-cutting knife attached on top almost as a surreal collage element), the face's three dowellike projections (whose symbolic significance is evidently unknown)[110] might be associated, as a result of their positioning, with forehead or nose, mouth, and chin—especially when viewed as circles from the front.[111] But again, as in the Kwele mask, the richness in the play of these forms depends on their suggestive indeterminacy, upon the fact that, despite the associations they tend to provoke, they cannot be equated with particular facial features. It is still sometimes said, to be sure, that everything in a Primitive work has a specific symbolic meaning. If this were true, it would indicate less freedom to develop the image in the making of it than seems clearly the case with tribal artists. Nor would it tell

Painted fabric (detail). Mangbetu(?). Zaire. Painted bark cloth, 57⅛" (145 cm) high, overall. Musée des Arts Africains et Océaniens, Paris

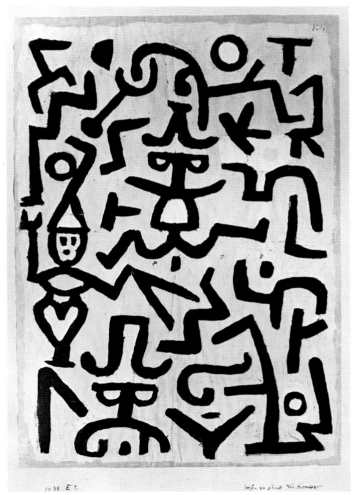

Paul Klee. *Poster for Comedians*. 1938. Colored paste, 19⅛ x 12⅝" (48.5 x 32 cm). Private collection, Switzerland

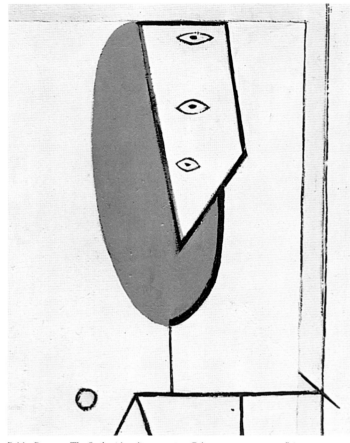

Pablo Picasso. *The Studio* (detail). 1927–28. Oil on canvas, 59 x 91" (149.9 x 231.2 cm). The Museum of Modern Art, New York; gift of Walter P. Chrysler, Jr.

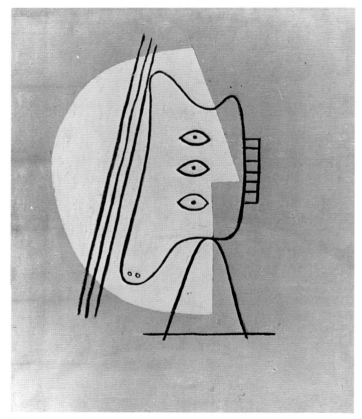

Pablo Picasso. *Head.* 1928. Oil on canvas, 28¾ x 23⅝" (73 x 60 cm). Collection Jacqueline Picasso, Mougins

us why, especially in a traditional society, many forms, such as the "dowel" component of the Yam masks, can apparently no longer be explained. Indeed, other such unreadable motifs are clearly metamorphoses of earlier, more literal forms, whose original identities have been lost in the course of time. The remarkable projecting screen of the abstract Jukun mask (p. 320), for example, seems to have evolved out of the horns of the Mama Buffalo masks (p. 610). Not only did the horns lose their identity as they turned into a perforated decorative oval, but the mask slipped downward from being worn on the top of the head (by the Mama) to an intermediate position between a cap and a face mask (as worn by the Jukun).[112]

The play of repeated motifs in the Kwele and Igbo masks is comparable to the reiteration of root signs that articulates the faces of many Picasso figures of the twenties and thirties. In *Head,* for example, an eyelike form is repeated three times vertically on the white profile of the face; it is handled in much the same manner in the head of the artist in *The Studio.* While this repeated sign is interpretable simply as a "third eye," we are in fact invited, as in the African masks, to associate it with differing facial features such as eyes, nostrils, and mouth by virtue of its location, though Picasso endows it with the same autonomy enjoyed by the African artists' forms. The "confusion" of anatomical features in tribal and modern works of this type also triggers fertile associations involving cross relationships between "projections" and "holes" in the human body that Freud dealt with in dream analysis.

In *Head,* the poetic possibilities of the resulting indeterminacy are further enriched by Picasso's having made the "eye" signs function in two systems at the same time. Even as they articulate the "geometrical" white profile head, they also participate in a more surreal, "biomorphic" head contoured by heavy black lines. Here, the projection of the teeth on the right and the nose on the lower left, in combination with the three lines that stand for hair, produce a vision so hallucinatory that the three eyes almost look natural. The convention of fusing two views of a head in a single image (usually a profile within a front view) was developed by Picasso out of possibilities inherent in Cubism. *Head* is unusual insofar as the two views are in two different styles, one "Classical," the other Surreal. By participating simultaneously in both views of the head, the motif of the stacked "eyes" locks together the two alien images of the configuration.

A single sign functioning simultaneously in two interlocking systems—an aspect also of the economy to which I have already alluded—is not unusual in modern art. In Klee's *Intentions* (p. 62), for example, the eye in the upper center belongs to a patternly series of discrete black pictographs that stand for figures, trees, animals, and houses, as well as less determinate forms, which are distributed evenly over the entire surface. But that lone and compositionally singular eye also functions in a second system, for it is the eye of a head whose outer contour is a large "C" form that sits on the upper torso of a centrally placed human figure. Lest we overlook this fellow, Klee marked his contour by a change in background color, while signaling the unique dual role of the eye by making it the only blue element in an otherwise red, green, and black picture.

The dual functioning of a sign, as in the Picasso and Klee pictures, is a possibility that did not escape tribal artists, and

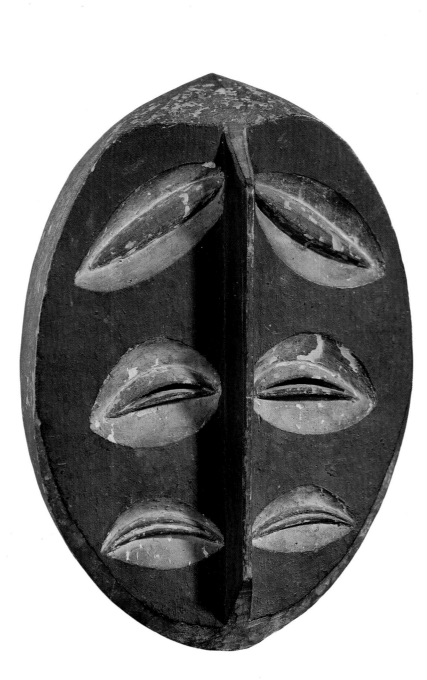

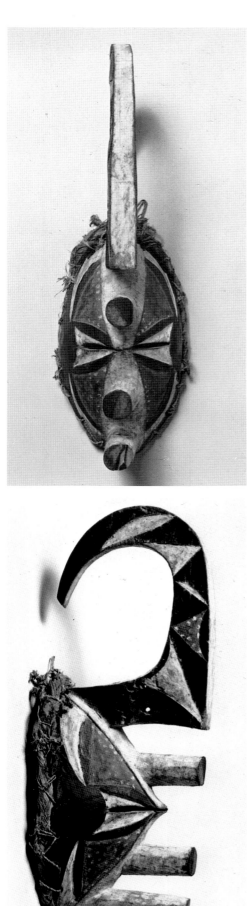

Above: Mask. Kwele. People's Republic of the Congo. Wood, 15″ (38 cm) high. Private collection, Paris

Right: Yam mask (two views). Igbo. Nigeria. Painted wood, 14⅝″ (37.2 cm) high. Collection Roy and Sophia Sieber, Bloomington

the patterning on the Asmat shield we reproduce (opposite) shows a comparable "wit" and economy. The little zigzag form with "hand" terminals that covers this shield is a sign for two joined arms.[113] But the portion of the same sign at the top of the shield has a dual role. As a result of its enclosure at once under a decorative "helmet" and inside the heavy contour that demarcates a face, it is made to read quite clearly as a nose and upper lip of an ancestor figure's head—in which new context its terminal "hand" serves rather to signify a "mouth." The level of sophistication in the analogical play of forms illustrated by this Asmat shield is not infrequently found in tribal objects. Comparable complexities of other kinds may be seen in the paired projections—the conical breasts and navels, the angular hands and knees—of a Dogon figure (p. 273); or the analogical play of circular motifs—as in the eyes, body ornament, and bracelets—of a Boyo sculpture (p. 56); or the seeming suspension of the upper torso in the Pere figure (p. 8); or the reciprocity between carving and surface painting in the handling of the double-triangle motif in a Baga serpent (p. 55); or the distribution pattern of progeny figures (sometimes substituted for anatomical features) over the face and body of the god A'a, in a sculpture from the Austral Islands (p. 331). The widespread resistance in the literature to analyzing tribal works in these aesthetic (as opposed to typological and statistical) terms is perhaps less the result of common assumptions that such compositional sophistication is alien to Primitive art than it is of an almost exclusive focus upon anthropological and iconographic problems on the part of those most involved with this art.[114]

The early twentieth-century emancipation from the restrictions of a perceptually based art encouraged a variety of aesthetic attributes that parallel those of tribal art. Not the least of these was the freedom to sacrifice the essentially naturalistic proportions to which European artists—however different their styles—had adhered from the Gothic period through Post-Impressionism (and even into the Fauvism of 1905–06). During those centuries, the proportion of the height to the width of the body, and the proportion of the head to the body's total height, varied only within distinct limits.[115] The change in favor of extreme ratios of proportion is anticipated in the latter part of 1906 in Picasso's "Iberian" style, in such pictures as *Two Women* (p. 248). But it is in 1907—in the *Demoiselles* (the lower right-hand figure particularly), and in Matisses such as *Le Luxe*—that freedom from the older conventions was definitively established. It was soon adapted by the German artists to a practice of "expressive disproportion." Their art tended, as Meyer Schapiro observed, to polarize into two figure types, as represented by the work of Lehmbruck and Barlach: tall, attenuated "dolichocephalic" figures and squat, "brachycephalic" ones respec-

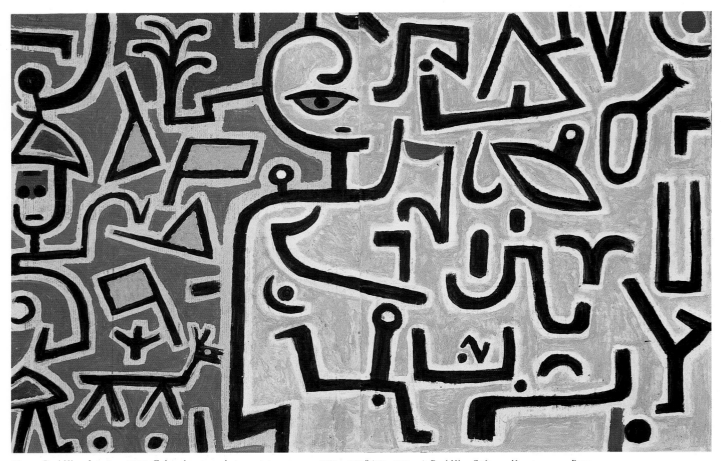

Above: Paul Klee. *Intentions*. 1938. Colored paste and newsprint on canvas, 29⅝ x 44⅛" (75 x 112 cm). Paul Klee-Stiftung, Kunstmuseum Bern

Right: Shield. Asmat. Lorenz River, Irian Jaya (formerly Netherlands New Guinea). Painted wood, 55" (39.7 cm) high. Friede Collection, New York

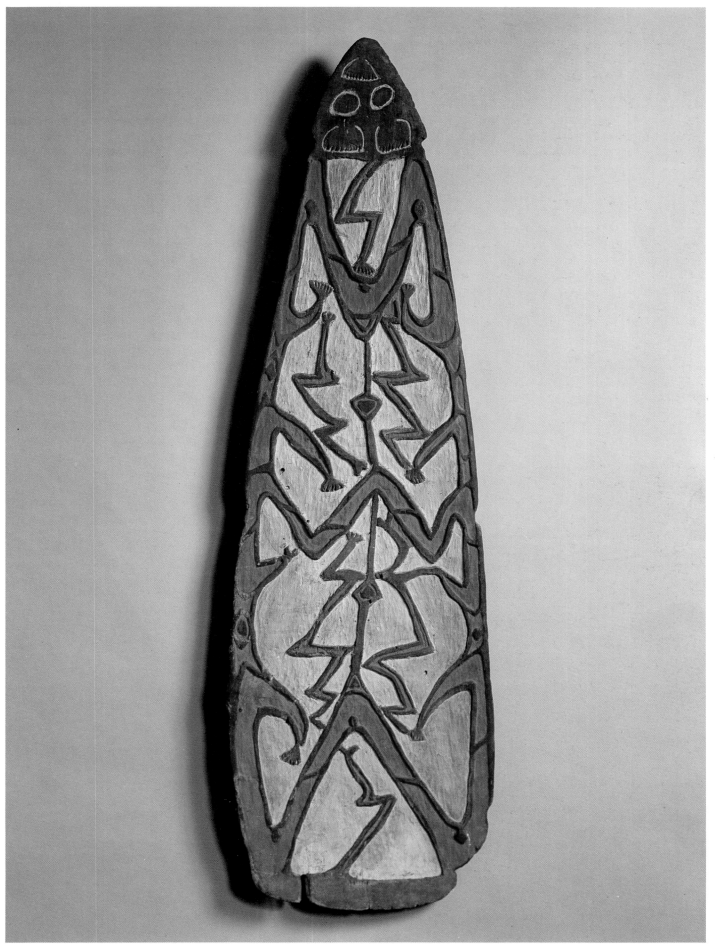

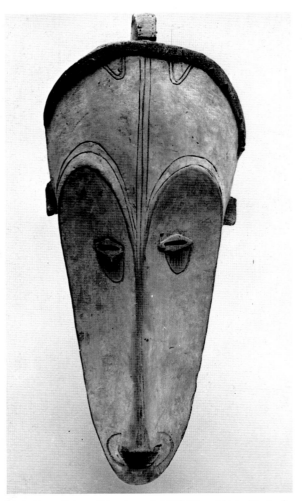

Mask. Fang. Gabon. Painted wood, 27½" (70 cm) high. Musée de l'Homme, Paris. Reproduced in color page 406

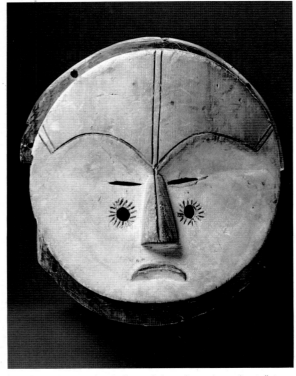

Helmet mask, Janus-faced. Fang. Gabon. Painted wood, 11¾" (29.8 cm) high. The Metropolitan Museum of Art, New York; The Michael C. Rockefeller Memorial Collection, bequest of Nelson A. Rockefeller

tively.[116] We see a comparable contrast in Fang masks that flatten the oval proportions of the human face into perfect circles or elongate them in the extreme.

The modernist tendency toward such a polarization could only have been reinforced by familiarity with the astonishing proportions of some tribal objects. Giacometti probably saw the extraordinarily attenuated Nyamwezi figure (illustrated opposite), a sculpture owned for decades, beginning in the thirties, by André Lefebvre, one of the great collectors of modern art. However, tribal material constituted only one of many possible precedents for his elongated figures. Giacometti was thoroughly familiar, for example, with the attenuated Etruscan figures at the Villa Giulia in Rome. And I suspect that as compared to Picasso's "broomstick" sculptures of 1931, both Primitive and Etruscan models probably functioned more as a reinforcement than an inspiration for the unusual proportions of Giacometti's later work.[117]

That Picasso should have made the first modern construction sculpture in the same year he invented collage, and that these interdependent developments should have been launched at a time when he was deeply involved with tribal art,[118] appear to me quite logical. The seeming simplicity and rawness of collage certainly constituted for Picasso a second primitivizing reaction, in this case against the hermeticism and *belle-peinture* of high Analytic Cubism. It paralleled that of six years earlier when he had overcome the late Symbolist refinement of his Blue and Rose Period paintings with the primitivism that culminated in the *Demoiselles*. In the spring of 1912, when Picasso glued a piece of oilcloth on his *Still Life with Chair Caning* and ordered an "endless" mariner's rope to go round it in place of a frame, he not only short-circuited the refined painterly language of high Analytic Cubism, but undercut its "classical" structure by introducing a mélange of materials previously considered incompatible with the Fine Arts. His subsequent application of the collage technique to constructed sculpture created the hybrid form known as "assemblage."

While Picasso's admixture of cloth and rope was unprecedented in the Western tradition, the principle of such mélanges was familiar to him in tribal sculptures whose makers often utilized cloth, raffia, string, bark, metal, mud, and found objects in conjunction with wood and other materials (as in fetishes and emblems, pp. 66 – 69, of which Apollinaire owned a notable example, p. 313, and masks, pp. 257, 261). Picasso's reliefs were constructed, moreover, to hang upon and project outward from the wall—which is precisely the way the European artists displayed their tribal masks. I do not want to imply this means that tribal objects were necessarily the primary inspiration of collage or assemblage, for the latter have other possible precedents, but given Picasso's deep involvement with tribal art in 1912, they had to have played an important role in his thinking.

Picasso's use of variegated materials did not lead to objects resembling tribal art. That was not his way. Picasso usually abstracted the principle involved, but used it to his own ends. However, the use of such materials in the hands of the Dadaists (Janco's *Mask*, p. 537) and Surrealists (Ernst's *Gay Dogs*, p. 574) reflected a conscious desire to evoke Primitive prototypes. The same is certainly true with regard to many

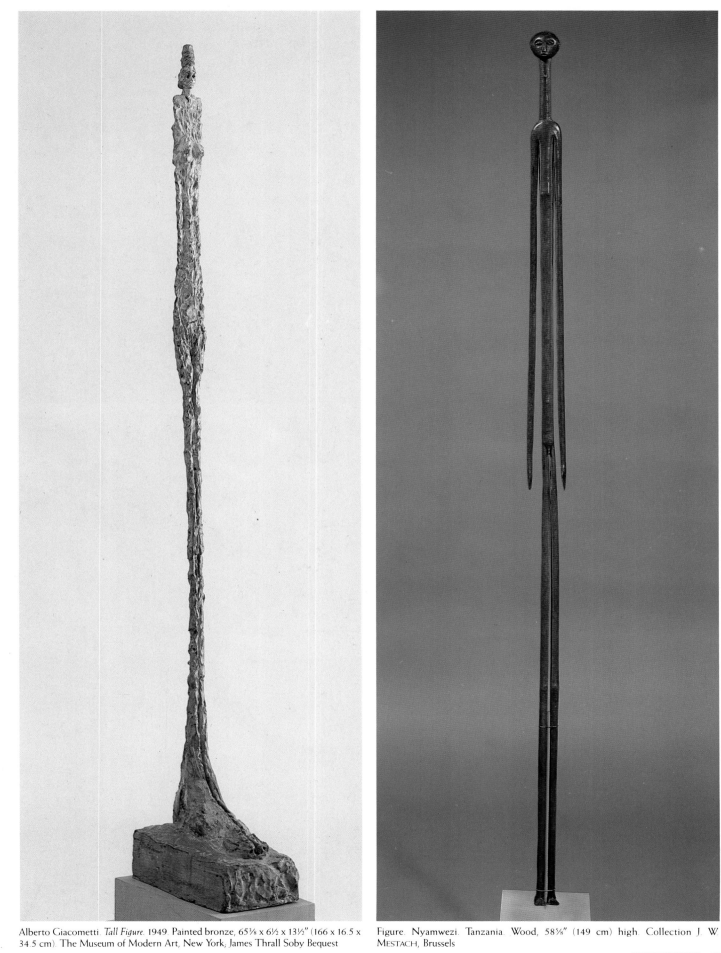

Alberto Giacometti. *Tall Figure*. 1949. Painted bronze, 65⅜ x 6½ x 13½″ (166 x 16.5 x 34.5 cm). The Museum of Modern Art, New York; James Thrall Soby Bequest

Figure. Nyamwezi. Tanzania. Wood, 58⅝″ (149 cm) high. Collection J. W. MESTACH, Brussels

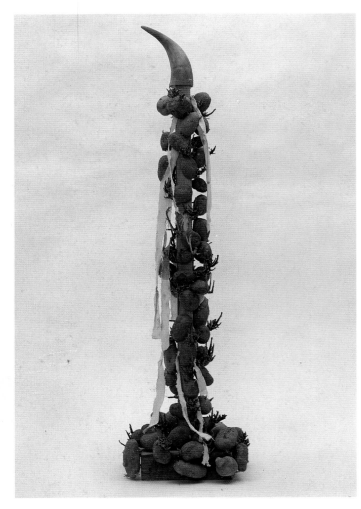

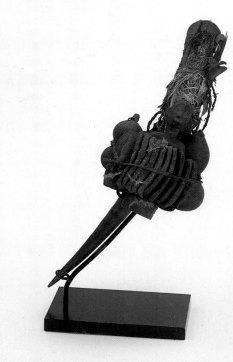

Top: Dog fetish. Vili. People's Republic of the Congo. Wood and mixed media, 31½" (80 cm) long. Museum für Völkerkunde, Berlin

Above: Fetish. Fon. People's Republic of Benin (formerly Dahomey). Horn, wood, and mixed media, 15" (38 cm) high. Collection Mr. and Mrs. Herbert R. Molner

Left: Italo Scanga. *Potato Famine #1.* 1979. Horn, potatoes, and mixed media, 52 x 12 x 8" (132.1 x 30.5 x 20.3 cm). Collection of the artist; courtesy Delahunty Gallery, New York

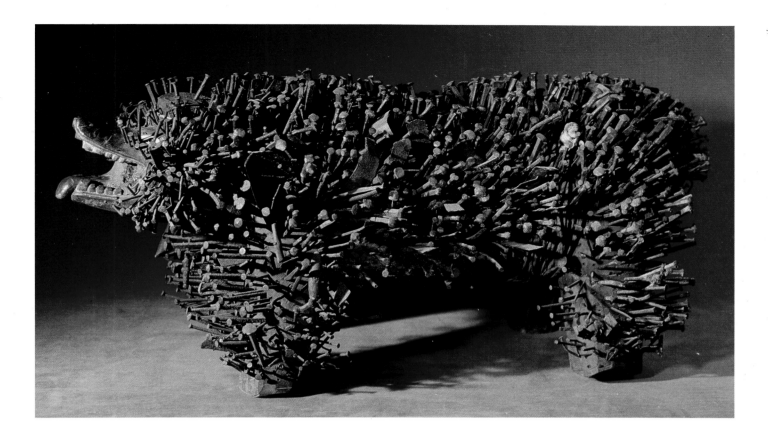

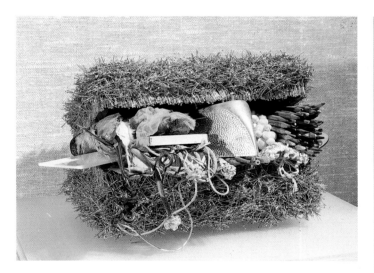

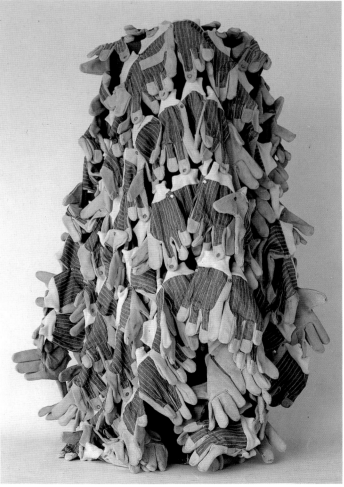

Top: Dog fetish. Vili. People's Republic of the Congo. Wood and mixed media, 34⅝"
(88 cm) long. Musée de l'Homme, Paris

Above: Lucas Samaras. *Box #1*. 1962. Mixed media, 9 x 16½ x 17" (22.8 x 41.9 x 43.2
cm). Collection Mr. and Mrs. Morton L. Janklow, New York

Right: Arman. *Cool Hands Blue*. 1977. Accumulation of gloves, 48 x 30" (121.9 x 76.1
cm). Collection of the artist

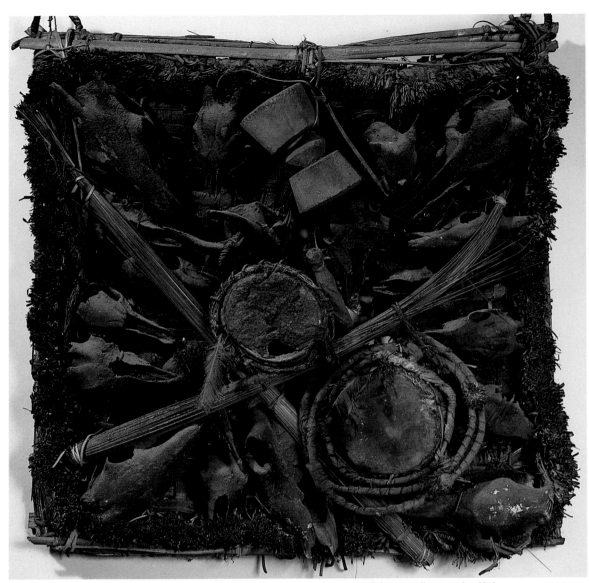

Ekpe Society emblem. Ejagham. Cameroon. Wood and mixed media, 35″ (88.9 cm) high. Private collection, New York

contemporary examples. Italo Scanga's *Potato Famine #1* recalls the Berlin Museum Dog Fetish in its cloth streamers (p. 66), while its inclusion of an animal horn reminds one of Fon (p. 66) and Songye (p. 135) fetishes. Conner's *Cross*, which may be compared to an assemblage-like Ejagham emblem, turns the tables on Christianity by recasting it in the animist spirit of the tribal religions (while also recalling fetishistic aspects of Christian devotion in ex-votos and the cult of relics).

African fetishes are generally collective in their ideology, and the significance of the components is clear to the initiates. The modern artist works with more private symbols. Lucas Samaras, for example, selects such strictly domestic material for *Box #1* (p. 67) that its "fetishism" turns inward in an almost Freudian way. Arman's *Cool Hands Blue* (p. 67) is consistent with the fetishistic principle operant in all his "Accumulations,"

the gloves having a particularly Freudian resonance (established in modern painting by de Chirico). Yet the configuration of the Arman, which is primarily indebted to "allover" painting, gives it a relatively formal appearance, closer to such "classic" nail fetishes as the Dog of the Musée de l'Homme (p. 67) than to the one in the Berlin Museum (p. 66). A longtime collector of African art, Arman feels a deep affinity with tribal art, but like most artist-collectors does not borrow from it directly. Yet his collecting of African art is no accident. "At the beginning of my interest in African art," he recalls,

I was attracted by artifacts covered with material and charged with magical powers. Such fetishes, which reflected a sense of the "accumulative," were somehow close to some of my own work in their allover multiplication of elements and the resultant power of suggestion. A long relationship with African sculpture as a collector

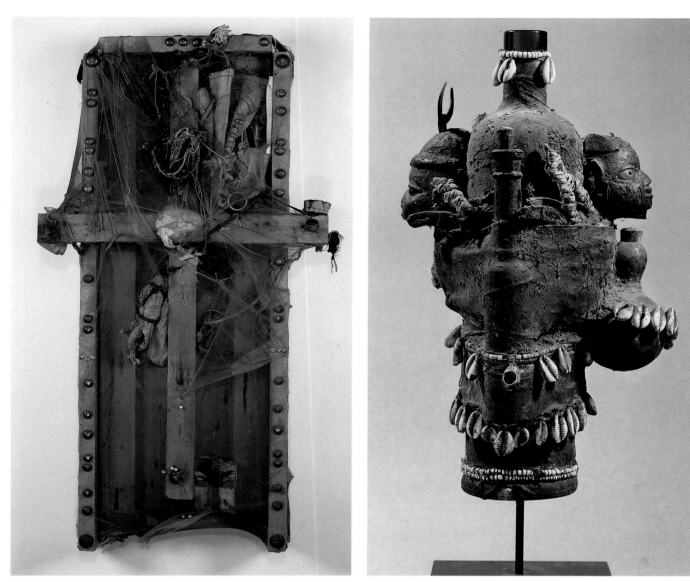

Bruce Conner. *Cross.* 1961. Wood, metal, and mixed media, 37 x 19½" (94 x 49.5 cm). Collection Robert and Lynne Dean, Los Angeles

Fetish. Fon. People's Republic of Benin (formerly Dahomey). "Suze" bottle and mixed media, 13⅝" (34.5 cm) high. Private collection, Paris

gave me a clearer understanding of what really good art should be.[119]

Since the early sixties, a number of younger artists have been making objects that elude even the more abstract formulations descending from Cubism, such as have governed the work of Arman, not to say that of Jackson Pollock, David Smith, and Anthony Caro. At first referred to as "specific objects," these nonfigural and semifigural Minimalist and Post-Minimalist creations were often charged with a profound poetry. Eva Hesse's *One More than One* (p. 70), for example, touches us in part through the anatomical and psychological allusiveness of its shapes and materials; its two concave hemispheres have been described as "an 'eyelike' inversion" of breasts, and the thin rubber tubes that descend from them as "tears."[120]

Most of the tribal objects discussed in this book are figural.

Even practical objects such as spoons, staffs, and musical instruments are mostly anthropomorphic, or informed by images of animals or monsters. Yet one also finds among the tribal peoples a number of "specific objects" that—in their configurations, materials, and distinctive poetry—have close affinities with the work of artists of Hesse's generation and the one following. The remarkable "soul-catcher" from the island of Pukapuka (p. 70), for example, shares the aleatoriness of the Hesse in the freely hanging cord to which its series of paired rings is attached, and it possesses a comparable oneiric poetry. It is said to have been used by the "sacred men" to catch the souls of those who offended them. An insect or bird flying through one of the trap's loops would be identified as the soul of the offender, who would then have to sue for its return. Before World War I, this object had already fascinated the

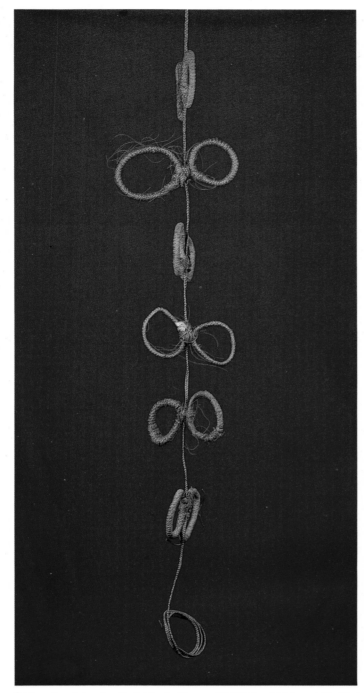

Soul-catcher. Pukapuka, Cook Islands. Fiber, c. 40″ (101.5 cm) high, variable. The Trustees of the British Museum, London

Eva Hesse. *One More than One*. 1967. Wood, plastic, papier-mâché, cord, and acrylic; box: 8 x 15 x 5″ (20.3 x 38.1 x 12.7 cm), work hung 5′ 5″ from floor with cords extending to and beyond floor. Collection Naomi Spector and Stephen Antonakos

Dada caricaturist and painter Marius de Zayas, who used it as an inspiration for his portrait of Stieglitz (p. 464).[121]

The "stick charts" from the Marshall Islands, which could be taken for contemporary sculptures, are sophisticated navigational maps indicating the reflection, refraction, and interaction of ocean swells in their passages toward and past the atolls. The skilled navigator could work out from a given swell pattern his probable position among the group of these low and strung-out islands, which were not visible for more than a few miles at sea. The remarkable lattice of straight and curved sticks represents a pattern of swells between particular

atolls—themselves indicated by small shells.

The unexpected poetry, beauty, and intellectual fascination of such tribal objects explain why many young artists have found inspiration in ethnological museums. Those wandering through the Museum of Natural History in New York, the Musée de l'Homme in Paris, the Museum für Völkerkunde in Berlin, or the Museum of Mankind (British Museum) in London are following paths beaten there early in the century by Max Weber, Pablo Picasso, Emil Nolde, and Henry Moore—even though they respond to different objects, and in different ways.

Stick chart. Marshall Islands. Wood, fiber, and shells, 22⅞" (58 cm) high. The Trustees of the British Museum, London

An undertaking such as this book, and the exhibition to which it is ancillary, must inevitably raise questions in the curator's mind as to its necessity—if for no other reason than its cost in time, effort, and money. Nor can the curator, though he has seen the works individually over the years in differing contexts, truly foresee the effect of bringing them together—the revelation, or lack thereof, that their confrontation may engender. Indeed, in a sense he organizes the exhibition to see what will happen. It would be disingenuous, nevertheless, to pretend that in proposing our exhibition I did not feel fairly certain that it would result in a significant correction of the received history of modern art, and draw to the attention of that art's very large public some unfamiliar but particularly relevant masterpieces from other cultures. There was also the thought that some modern works we know quite well might

seem all the richer for being seen from a new perspective. However presumptuous it may seem, all this lies within the realm of my expectations.

In the realm of my hopes, however, there is something less explicit, more difficult to verbalize. It is that the particular confrontation involved in our exhibition will not only help us better to understand our art, but in a very unique way, our humanity—if that is not saying the same thing. The vestiges of a discredited evolutionary myth still live in the recesses of our psyches. The vanguard modernists told us decades ago that the tribal peoples produced an art that often distilled great complexity into seemingly simple solutions. We should not therefore be surprised that anthropology has revealed a comparable complexity in their cultures.[122] I hope our effort will demonstrate that at least insofar as it pertains to works of the human spirit, the evolutionary prejudice is clearly absurd.

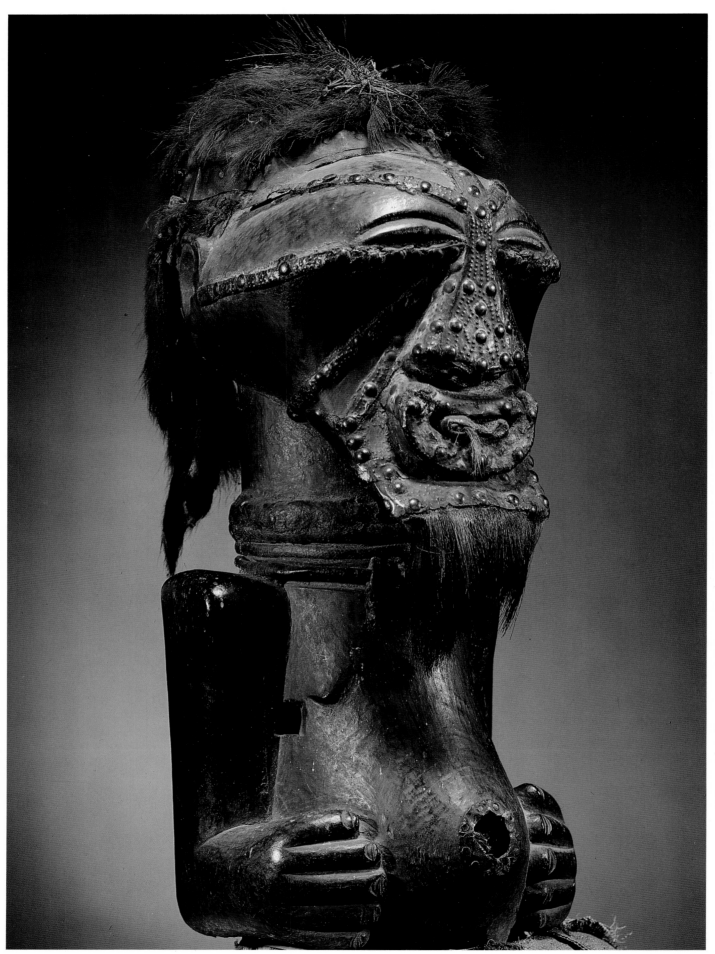

The various metamorphoses of Picasso's *Demoiselles d'Avignon* were but the visible symbols of the artist's search within his own psyche. This self-analysis, this peeling away of layers of consciousness, became associated with a search into the origins of man's way of picturing himself. Having retraced those steps through the Archaic in his Iberian studies, Picasso was prepared for the "revelation" of Primitive art at the Trocadéro Museum, which led him to the deeper, more primordial solution for which he was searching. At the Trocadéro, Picasso apprehended something of profound psychological significance that Gauguin had failed to discover in the South Seas.

That Picasso would call the *Demoiselles* his "first exorcism picture" suggests that he understood the very making of it as analogous to the kind of psycho-spiritual experiences or rites of passage for which he assumed the works in the Trocadéro were used. The particular kind of personal freedom he experienced in realizing the *Demoiselles*, a liberating power that he associated with the original function of the tribal objects he saw, would have been meaningless—as the anthropologists would be the first to insist—to tribal man. Yet there *is* a link; for what Picasso recognized in those sculptures was ultimately a part of himself, of his own psyche, and therefore a witness to the humanity he shared with their carvers. He also realized that the Western artistic tradition had lost much of the power either to address or to change the inner man revealed in those sculptures.

Like all great art, the finest tribal sculptures show images of man that transcend the particular lives and times of their makers. Nevertheless, the head of the African figure illustrated opposite this page has for us at first an almost shocking sense of psychological otherness, while the New Guinea carving reproduced here has a comparable otherness in terms of the way we understand our bodies. Nothing in Western (or Eastern) art prepares us for them. Yet they move us precisely because we *do* see something of ourselves in them—a part of ourselves that Western culture had been unwilling to admit, not to say image, before the twentieth century. If the otherness of the tribal images can broaden our humanity, it is because we have learned to recognize that otherness in ourselves. "Je," as Rimbaud realized, "est un autre."

I spoke earlier about Picasso's notion of the affinity of modern and tribal art as paralleling, in certain respects, the relationship between the arts of the Renaissance and Classical Greece. The analogy does not, however, capture the furthest reaches of implication in the affinity this book explores. For while the Italians of the fifteenth century were not in many significant ways, material or spiritual, advanced over the Greeks of the fifth century B.C., we, technologically speaking, are far beyond both, and with our consciousness of this we think of ourselves as having progressed light years beyond the tribal peoples. But insofar as art is a concrete index to the spiritual accomplishments of civilizations, the affinity of the tribal and the modern should give us pause.

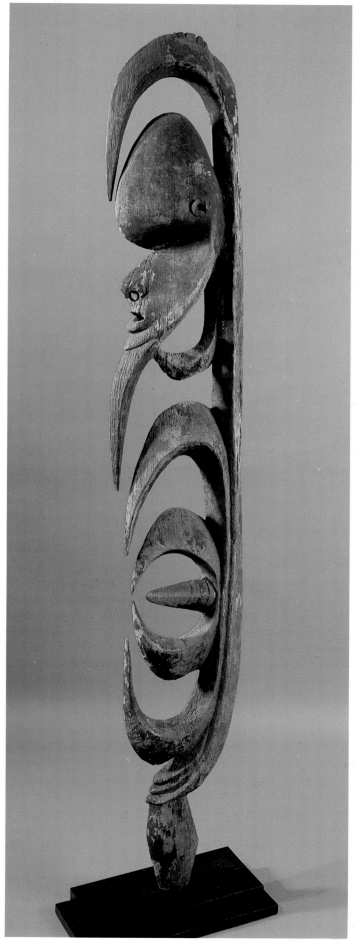

Opposite: Fetish figure (detail). Songye. Zaire. Wood and mixed media, 30¾" (78 cm) high, overall. Collection P. Dartevelle, Brussels

Right: Yipwon figure. Alamblak. Karawari River, East Sepik Province, Papua New Guinea. Wood, 7'½" (215 cm) high. Friede Collection, New York. Formerly collection MATTA

NOTES

1. During the past twenty years, the word "tribal" has been frequently used in preference to "primitive" in characterizing a wide variety of arts of more or less noncentralized societies with simple technologies. Both words are profoundly problematic; we use them reluctantly (and interchangeably) in this book to answer the need for a generalizing collective term for the art we are addressing. No adequate or generally agreed-upon substitutes for "tribal" and "primitive" have been proposed. Among some specialists, "tribal" has been used in preference to "primitive" because the latter is felt to contain too many negative Darwinian connotations (see discussion pp. 5–6). Others prefer "primitive" to "tribal" because many of the cultures commonly referred to as tribal (in Africa especially) are not tribal in the ethnological sense of the term.

Our use of "tribal" is obviously not anthropological in spirit. It corresponds roughly to Webster's (*New International Dictionary*, 2d ed.) third definition of "tribe"—as the word is used "more loosely": "Any aggregation of peoples, especially in a primitive or nomadic state, believed to be of common stock and acting under a more or less central authority, like that of a headman or chief." The word "tribal" should thus be understood as simply a conventional counter. The Africanist Leon Siroto observes:

"Tribal" in this connection would have to be no more than an arbitrary convention chosen to avoid the pitfalls of the term "primitive" as an expedient minimal designation in general discourse. It has been used so long and so widely that it seems to have gained significant acceptance.

Caution is indicated: many, if not most, of the peoples intended by the term do not form tribes in the stricter sense of the concept. They may speak the same languages and observe more or less the same customs, *but* they are not politically coordinated and have no pragmatic recognition or corporate identity. Moreover, a number of them, for these reasons, have disparate iconographies and practice markedly contrastive styles, tendencies that should caution against the notion that their art is *tribal* (i.e., ethnically unitary and distinctive)…Anthropologists tend to agree that tribal groups are more of a European creation than a fact of life. (Letter to W. R. of November 1983.)

Until the 1960s, "tribal" was still widely used by anthropologists to fill the need for a general term cutting across cultures and continents. Hence, for example, the collection of essays edited by Daniel Biebuyck for the University of California Press in 1969 was called *Tradition and Creativity in Tribal Art*. Today it might be titled differently; but the problem of nomenclature has not been solved. William Fagg has been the most eloquent proponent of the concept of "tribality in African art." This art, he insists, "is a product and a function of the tribal system," though he observes that "tribal is not a static concept, but a dynamic one" and that "tribal styles are subject to constant change" ("The African Artist" in Biebuyck, ed., p. 45).

African scholars (among others) have criticized "tribal" as "Eurocentric" (Ekpo Eyo, cited in the *New York Times*, October 12, 1980, p. 70), and their point is well taken, although the anathema cast on the word in Africa (it has literally been banned by one African parliament) probably responds in part to the political problem of melding unified nations and a national consciousness from ethnically diverse populations. That the "Eurocentrism" in question still exists—despite efforts to overcome it—is hardly surprising considering that the disciplines of art history and anthropology are themselves European inventions.

When addressing individual cultures, art historians can easily avoid such problematic terms as "tribal." But the need for a general term arises from the wish to allude to characteristics that appear (to some Western eyes, at least) similar in a variety of cultures in different parts of the world. The most up-to-date histories of world art still employ, if somewhat gingerly, the words "tribal" and "primitive" (e.g., Hugh Honour and John Fleming, *The Visual Arts: A History* [Englewood Cliffs, N.J., 1982], p. 547). Some anthropologists would argue that any perceived common characteristics implied in such use of the word "tribal" are fictions—which explains why the word has largely disappeared from anthropological literature. Even if true, however, this does not mean that it is inappropriate in the study of modernist primitivism. On the contrary, precisely because we are *not* directly addressing the cultures in question, but investigating *the ideas formed of them in the West* over the last hundred years, the use of the word "tribal"—which is a function of such ideas and the context in which they were formed—is not misleading. The word's ethnocentric drawbacks become, in effect, illuminating, for they characterize the nature of the primitivist perspective.

2. Goldwater's *Primitivism in Modern Painting* was first published in 1938; a revised and enlarged edition appeared in 1967 under the title *Primitivism in Modern Art* (New York: Random House, Vintage Books). Laude's *La Peinture française (1905–1914) et 'l'art nègre'* (Paris: Editions Klincksieck) appeared in 1968. These are the only completely serious general treatments of the subject in anything like reasonable wholeness. Charles Wentinck's lay-oriented *Modern and Primitive Art* (Oxford: Phaidon Press, 1979 [originally published in the Netherlands 1974 as *Moderne und Primitive Kunst*]) is an inadequate account which fails to distinguish satisfactorily between actual (or possible) historical influences and chance resemblances. Failure to make this crucial distinction also dogs the chapters on modernism and African and Oceanic art in the catalog *World Cultures and Modern Art. The Encounter of 19th and 20th Century European Art and Music with Asia, Africa, Oceania, Afro- and Indo-America* (Exhibition on the occasion of the games of the Twentieth Olympiad, Munich 1972) (Munich: Haus der Kunst, June 16–September 30, 1972). More valuable is the treatment of our subject as limited to modern sculpture in the catalog *Gauguin to Moore: Primitivism in Modern Sculpture*, by Alan Wilkinson (Toronto: Art Gallery of Ontario, November 7, 1981–January 3, 1982). To these books one might add Werner Schmalenbach, *Die Kunst der Primitiven als Anregungsquelle für die europäische Kunst bis 1900* (Cologne: DuMont-Schauberg, 1961), and his "Grundsätzliches zur primitiven Kunst," *Acta tropica* 15, no. 4 (1958), pp. 289–323.

3. As explained (above, pp. 5, 6, and below, note 19), we have retained the term "primitive" but have decided to capitalize it (except within quotation marks) in order to underline that aspect of its many meanings having to do with art-historical designation (as opposed to using it as a strictly descriptive term).

4. See below, pp. 260–65.

5. Symptomatic of this is the tendency of one of the leading authors on African art to characterize masks as "cubist" simply because they have rectilinear geometrical structures.

6. Anthropologists, especially those who consider the characterization of tribal objects *as art* irrelevant to their concerns, often write as if only the scientifically verifiable and verbalizable anthropological constituents of these objects have meaning. Art historians' interests naturally include the aesthetic and expressive potential of many of these objects. In general, artists usually consider only the direct apprehension of the latter as truly

meaningful. This is exemplified in a remark made to me by Picasso to this effect: "Everything I need to know about Africa is in those objects."

7. *Nouveau Larousse illustré*, 7 vols. and 1 suppl. (Paris: Librairie Larousse, 1897–1904), vol. 7, p. 32.

8. *Webster's New International Dictionary*, 2d ed., s.v. "primitivism."

9. Ekpo Eyo (*Two Thousand Years of Nigerian Art* [Lagos, 1977], p. 28) wrongly uses the word "primitivism" simply to characterize Europeans' use of the word "primitive" in relation to non-Western art. In regard to the same use, he stated (as quoted in the *New York Times*) that Western scholars "invented the notion of primitivism [*sic*] and spread it to wherever their influence reached."

10. This does not mean that they did not collect such art as "curiosités"; see below, pp. 11–12.

Beyond Gauguin's limited interest in Polynesian art (see below, note 30), he may also have owned two small African figures (see pp. 207–08, note 49).

11. This took place in the years preceding World War I.

The usual translation of "art nègre" as "Negro art," loses something of the pejorative flavor of the French "nègre" (as in "travail de nègre," for example). This connotation notwithstanding, many cultivated French still use the term "art nègre" although they might eschew the word "nègre" in other contexts.

12. It should be kept in mind that early in the century the term "art nègre" universally evoked the tribal art of Oceania as well as Africa. The same was true of the word "Negerkunst" and its variants. Both editions (1915 and 1920) of Carl Einstein's *Negerplastik* contain some examples of Oceanic art. The designation "art nègre" was used for the court art of the kingdom of Benin as well as for tribal styles.

13. In the period between the two World Wars, and for some time afterward, "primitive" was used in the titles of books and university courses and for classification in fine-arts museums (the forerunner of the Michael C. Rockefeller wing at the Metropolitan Museum was known as the Museum of Primitive Art, and the relevant department of the Metropolitan is still called the Department of Primitive Art). Until fairly recently the word was widely if sometimes reluctantly used by anthropologists as well (see citation from Lévi-Strauss, pp. 5–6). A collection of anthropological essays published by Oxford University Press in 1973 (Anthony Forge, ed.) was titled *Primitive Art and Society*.

14. Pre-Columbian civilization was (and still is) popularly identified by artists and others primarily with art from large-scale, complex, later-period theocratic societies of the Maya, Toltec, and Aztec in Mesoamerica and the Inca in Peru. These societies were characterized by a high degree of both specialization and social, economic, and political hierarchization, which are reflected in their monumental architecture and sculpture, which I would classify as more Archaic than Primitive in nature. Less known, but certainly not unknown to some artists, were many simpler pre-Columbian socio-cultural entities that did not have state-level government, monumental public works, written languages (which were, in any case, confined to the Maya), and other features of more complex societies. Notable among these were the Chrotega, Chiriqui, Chibcha, and many other chiefdoms that occupied the area between Mesoamerica and the northern Andes.

If, in terms of their art, the Maya, Toltec, Aztec, and Inca should be grouped with such cultures as the Cambodian or Egyptian, they present an exception insofar as the social and religious fabric of all the pre-Columbian cultures was marked by certain characteristics otherwise generally associated with Primitive rather than

court cultures. Since, however, modern artists knew little or nothing of this, and approached pre-Columbian cultures entirely through works of art (or their reproductions), these works entered modernism in the late nineteenth century not in the company of the tribal arts of Africa and Oceania (which were overlooked by artists at that time) but as Archaic arts, like those of the other court cultures such as the Egyptian that had passed for "primitive" to Gauguin and van Gogh. The "primitive" aspects of pre-Columbian technology, sociology, and communications account for the cultures' still being sometimes classified as Primitive in terms of their art (which, at the Metropolitan Museum and most others, is in the same department as African and Oceanic art).

Monumental Mesoamerican architecture and sculpture were visible in museums and world's fairs (the 1889 Paris Exposition Universelle had a reconstruction of an "Aztec House") and were of interest to artists generations before "art nègre" was known. Museum collections also contained a certain amount of material from the more remote, less centralized pre-Columbian regions, which art had somewhat more in common with tribal art. Yet how much of the latter was seen by artists, at least before the 1920s and 1930s, is open to question.

Pre-Columbian art unquestionably had an influence on modern art, but most of that influence was from the Archaic sculpture of the Aztec, Maya, Toltec, and Olmec cultures. After Gauguin and van Gogh, interest in it is largely associated with the generation of the 1930s (although, on a conceptual more than an aesthetic level, pre-Columbian civilizations have been of interest to recent artists). The measure of how deep or widespread this influence was will require a study that can satisfactorily distinguish demonstrable influences from simple affinities. Barbara Braun, with whom I have consulted on the organization of *"Primitivism" in Twentieth Century Art*, is presently at work on a book about pre-Columbian sources of modern art.

In addition to pre-Columbian objects, most natural history museums also possessed some specimens of the tribal arts of Mesoamerica and South America. Examples of these more recent objects are the Mundurucú trophy head that Nolde included in his painting *Masks* (pp. 378–79) and the Witoto mask illustrated on page 636.

15. Picasso seems to have had conflicting emotions about what he called "l'art aztèque," by which he meant the whole of pre-Columbian art as he knew it. My notes of conversations with him contain a reference to this art which I set down from memory as "boring, inflexible, too big…figures without invention." However, he praised the beauty of an "Aztec head" in a conversation with Brassaï (*Picasso and Company*, trans. Francis Price from the French *Conversations avec Picasso* [Garden City, N.Y.: Doubleday, 1966], p. 242). As recorded by Brassaï (for May 18, 1960), Picasso and he were looking at an album of his photographs. The chapter in the album entitled "Primitive Images," an "Aztec head," Brassaï tells us, "makes Picasso pause abruptly, and then he cries: 'That is as rich as the façade of a cathedral!'"

Picasso's feeling for the inventiveness of tribal art was a response to a reality—African and Oceanic art *is* more variegated and inventive than pre-Columbian art—as is evident if one compares visits to Mexico City's Museo Nacional de Antropologia and the Oceanic wing of Berlin's Museum für Völkerkunde, the two most beautiful and elaborate presentations of these respective arts that I know. But Picasso's attitude was also partly a matter of his perspective; hence my phrase "perceived inventiveness." What Picasso saw in the Trocadéro and the curio shops as the art

of "les nègres" was thought of by him as issuing, broadly speaking, from a single cultural entity, Africa, when in fact the variety of African styles is in part a function of an immense number of ethnic groups of different religions, languages, and traditions covering an area far more vast than Western Europe.

16. Note that I differentiate here between the Old Kingdom, on the one hand, and the Middle Kingdom and New Empire, on the other. Old Kingdom art strikes me as very rich in invention. Such "academicism" (as opposed to simple "Traditionalism") as one finds in Egyptian art becomes a factor only after that period. Invention, however, is a quantitative aspect of a work of art and has no necessary relation to quality. To find more invention in the work of Old Kingdom artists than subsequent ones is not to deny the quality of the many masterpieces that come down to us from the Middle Kingdom and New Empire.

17. "Classification stylistique du masque dan et guéré de la Côte d'Ivoire Occidentale (A.O.F.)," *Medelingen van het Rijksmuseum voor Volkenkunde, Leiden*, no. 4. (Leiden: E. J. Brill, 1948). This impressive study, though published in 1948, was based upon research done prior to World War II.

18. Goldwater (*Primitivism in Modern Art*, as in note 2, p. 150) quite rightly used "Archaic" to characterize the Iberian sculpture that interested Picasso and that subsequently "leads into the 'Negro' paintings." Picasso's interest in that sculpture was continuous with his even earlier interest in Egyptian art. The latter shares sufficient common denominators with certain non-Western court arts—at least as perceived by artists in the late nineteenth and early twentieth centuries—to warrant a global term; "Archaic," I believe, serves this purpose better than does any other adjective.

19. In the 1897–1904 *Nouveau Larousse illustré* (in which the word "primitivisme" made its first appearance, see p. 2 and note 7), "primitive" was given (as both adjective and noun) sixteen different definitions, ranging from the algebraic and geological to the historical and ecclesiastical (pp. 31–32). Two of the sixteen were pejorative in connotation, notably the one marked "ethnological": "Les peuples qui sont encore au degré le moins avancé de civilisation." The fine-arts definition, given as a noun, was simply: "Artistes, peintres ou sculpteurs qui ont précédé les maîtres de la grande époque."

20. In conversation with Sabartés in his studio at villa Les Voiliers, Royan, 1940. (See Jaime Sabartés, *Picasso, An Intimate Portrait*, trans. Angel Flores from the Spanish *Picasso, Retratos y Recuerdos* [New York, 1949], p. 213.)

21. "Gothic" was traditionally paired with "barbaric" in the classicist critique of Western art. Only in the nineteenth century did the word begin to attain respectability. The speed at which pejorative connotations can drop away from art-historical terms may be measured by the rapidity with which the designation "Impressionist" was accepted by the public and even the painters themselves, despite the fact, as Meyer Schapiro has observed, that it had pejorative connotations relating to artisanal house decoration ("peinture d'impression").

22. Robert Goldwater, "Judgments of Primitive Art, 1905–1965," in *Tradition and Creativity in Tribal Art*, ed. Biebuyck, p. 25.

23. Such candidates as "ethnic" and "indigenous" have been found to have so many art-historical and/or sociological drawbacks that no serious attempt has been made to substitute them for "primitive."

24. "The Dilemma Which Faces African Art," *The Listener*, September 13, 1951, pp. 413–15.

25. This is particularly true of African scholars, for the political reasons referred to in note 1.

26. *Structural Anthropology*, trans. C. Jacobsen and B. G. Schoepf (London, 1963), pp. 101–02.

27. Cf. below, Varnedoe, pp. 180–81.

28. "Simplicity" was an idea to which Picasso returned frequently in my discussions with him, sometimes in terms of his own work or (more often) that of other modern artists (e.g., Matisse) and on two occasions in connection with "art nègre." It was clear that what he meant by this was not just the absence of elaborate effects but an economy that implied the distillation of complexities. "Simplicity" was generally used in his conversation as an antonym for the type of complexity characteristic of nineteenth-century salon illusionism. Picasso's overall criticism of the received art of his youth was that artists had forgotten how to be simple. With Sabartés, as with me, he lauded Primitive artists for their simplicity. (See Sabartés, *Picasso, An Intimate Portrait*, e.g., note 20, p. 213.)

29. The Michael C. Rockefeller wing of the Metropolitan Museum is the classic instance of this. It depended directly upon Nelson Rockefeller's passion for tribal art, which had led to his earlier founding of the Museum of Primitive Art. This in turn depended on and followed from his taste for and involvement with twentieth-century art and his knowledge of the importance of tribal art for many modern artists.

30. With the (possible) exception of *There Is the Marae* (p. 193), no painting by Gauguin contains a direct reference to the art of Tahiti or the Marquesan Islands (the two areas of Polynesia in which he lived), though his pictures are replete with references to other non-Western art forms. The painting *Tehamana Has Many Parents* (p. 188) does contain enlarged script from Easter Island (which Gauguin never visited), and other forms of both Easter Island and Marquesan art are notable in his wood sculpture. But even there they are not the dominant influence.

31. Flam (p. 218) is in agreement with me on this. While there were no objects in the then Musée d'Ethnographie du Trocadéro that might have inspired *Crouching Man*, there were a number of pre-Columbian sculptures that Derain could have seen on his 1906 visit to the British Museum which have affinities with his piece. I reproduce one here.

Figure (the god Xochipilli). Aztec. Mexico. c. 1300–1521 A.D. Stone, 21⅝" (55 cm) high. The Trustees of the British Museum, London

32. For the influence of Portuguese Christian incursions on Congolese art, see Paul S. Wingert, *The Sculpture of Negro Africa* (New York: Columbia University Press, 1950), p. 54, and William Fagg

and Eliot Elisofon, *The Sculpture of Africa* (London: Thames and Hudson, 1958), p. 157.

Delafosse is among those who saw Baule sculpture as influenced by Egyptian art (through migrations and commercial exchange). His main publication is "Sur les traces probable de civilisation égyptienne et d'hommes de race blanche à la Côte d'Ivoire," *L'Anthropologie* vol. 2, 1900, pp. 431–51.

33. I cite Malraux here (*La Tête d'obsidienne* [Paris: Gallimard, 1974], p. 17], although Picasso also made this point to me, and doubtless to others. His meaning, at least in conversation with me, was not identical with what Malraux apprehended from this remark (see pp. 296, and 339 note 142).

34. I am speaking here, of course, of influences of non-Western and pre-Renaissance art. Despite its radical reaction against Renaissance-derived illusionism, modern painting is finally more informed by aspects of that art than by any other tradition. No matter how much a modern work may share with Egyptian, Romanesque, or Byzantine painting or with Primitive sculpture, the crucial difference between them is that the language that the modern style alters and simplifies *is* Western illusionism. The older styles are necessarily seen from the perspective formed by that intervening tradition.

35. Emile Bernard, *Souvenirs sur Paul Cézanne* (Paris, 1925), p. 31.

36. For discussions of this mask see Goldwater, *Primitivism in Modern Art*, pp. 86–87, 102 note 4, and Laude, *La Peinture française*, pp. 104–05, 109. In this volume it is discussed by Paudrat (p. 139), Flam (p. 214), and Bassani (p. 406).

37. Though I am myself among the many who repeated years ago the view of Golding according to which the head of one of the figures in Derain's *Bathers* of 1907 (p. 218) was influenced by African art, I have altered my opinion since becoming conversant with Primitive art. I am now in agreement with Flam (p. 219) that no Primitive influence is visible in this picture. Flam does see some influence of African masks in the Bather pictures of 1908 by both Vlaminck (p. 213) and Derain (p. 219). If so, it is slight indeed, and these are the only pictures by the artists in which the attribution of such an influence could be hazarded.

38. I have seen at least half a dozen masks virtually identical with the Vlaminck/Derain mask, and there must be more in commerce and in private collections. The Museum of Fine Arts, Columbus, Ohio, has mistakenly published its example as *the* Vlaminck/Derain mask; another is in the collection of the Etnografisch Museum of the city of Antwerp.

39. Apart from the poor quality Fang mask owned successively by Vlaminck and Derain, a general sense of the quality of objects available very early in the century can be gleaned by considering the Vili figure owned early by Matisse (p. 214), the four objects photographed in Picasso's studio in late 1908 (p. 299), Picasso's Kota reliquary guardian (p. 301, left), and his Baga figure (p. 276). We know that both Matisse and Picasso owned Punu masks relatively early; these and the Gelede masks owned by vanguard artists early in the first decade of the century probably represent their most notable acquisitions (as the average quality of such masks at that time was relatively high). Not until Brummer and Guillaume began to pay runners to gather objects for them did the general level of quality rise. Prior to that (except for a few of those works collected by ethnological expeditions) quality was a purely accidental affair.

40. A number of dealers and collectors have clearly attributed to tribal objects fictive provenances from the studios of major vanguard artists. This enhances the romance and interest surrounding the object and no doubt increases its value. All six of the objects described as "ex-collection Picasso" that I have tracked down (that is, those which

were not in his hands at the time of his death) have turned out to have no documentable connection with the artist. The same is true for some objects proposed to me as from the collection of Matisse. The Derain and Vlaminck situations are more difficult to deal with because at different moments in their lives both literally trafficked in tribal objects, buying sculptures for resale.

41. The question of "authenticity" is too complicated to deal with here at length, but the following formula is useful: An authentic object is one created by an artist for his own people and used for traditional purposes. Thus, works made by African or Oceanic artists for sale to outsiders such as sailors, colonials, or ethnologists would be defined as inauthentic. The problem begins when and if a question can be raised—because of the alteration of tribal life under the pressure of modern technology or Western social, political, and religious forms—as to the continuing integrity of the tradition itself.

42. See pp. 298–99 for the peculiarities of Picasso's Yombe object.

43. "La chasse aux oeuvres nègres devint un réel plaisir pour lui" (Fernande Olivier, *Picasso et ses amis* [Paris: Stock, 1933], p. 169).

44. One such proposal still exists—a letter from Heymann of 1909.

45. While African and Polynesian art is usually smoothly finished, Picasso had, comparatively speaking, a large number of objects with raw or crude surfaces.

46. Alfred Barr told me that at the time the *Demoiselles* was first shown, the reaction, except from vanguard artists, was far from generally favorable and that its acquisition was criticized by some members of The Museum of Modern Art community.

47. As Paudrat observes (p. 162), Ratton was more adventurous in his taste than Guillaume, but the parameters formed by the preferences of the two combined may nevertheless be generalized into a single, essentially "classic" taste.

48. By "value" I am here referring to the hierarchy of preferences that is finally reflected in the price of objects.

49. Cf. René Gaffé, *La Sculpture au Congo Belge* (Paris: Editions du Cercle d'Art, 1945). The measure of Gaffé's daring as a collector of modern art is his purchase, just one year after its execution in 1925, of Miró's *Birth of the World*. He had also once owned Picasso's *Girl with a Mandolin (Portrait of Fanny Tellier)* and Chagall's *I and the Village*.

50. This is nevertheless a different question from "What is most *characteristic* of African art?" The relatively naturalistic art of the Yoruba (a people of at least ten million) is far more *typical* of Africa than many of the styles that, in my view, most distinguish African art aesthetically from the styles of other major cultures.

51. Statement made to Florent Fels, in the course of successive conversations that led to the "interview" published by Fels (in *Les Nouvelles littéraires, artistiques et scientifiques*, no. 42, August 4, 1923, p. 2): "Je vous ai déjà dit que je ne pouvais plus rien dire de 'l'art nègre'... C'est qu'il m'est devenu trop familier, les statues africaines qui traînent un peu partout chez moi, sont plus des témoins que des exemples." For more on the context of this statement see below, p. 260 and p. 336, notes 63, 64.

52. Goldwater, *Primitivism in Modern Art*, p. xvi.

53. Ibid., p. xxi.

54. Ibid., p. 254.

55. It is not by chance, as I will show, that the tribal form of modernist primitivism begins simultaneously with the inception of radical metamorphosis in modernist formal structures (in the *Demoiselles* of 1907). Thus it is that the very process of conceptualizing common to both Primitive and twentieth-century art made the latter's debt to the former more difficult to identify.

56. These two masks, of a type previously identified

in the literature incorrectly as "Wobé," were probably both in Picasso's possession by the time he executed *Guitar*. The one illustrated on page 305 may have been purchased when Picasso and Braque scoured Marseilles for tribal objects in August 1912; the one on page 20 was no doubt acquired earlier (cf. pp. 305–07).

When I asked Picasso about "Wobé" masks at the time he gave *Guitar* to the Museum (I was prompted by Kahnweiler's observations on the subject in the article cited in note 58 below), the artist put off my question. Many months later he showed me a "Wobé" (Grebo) mask and both enlarged upon and (for me) clarified what Kahnweiler had evidently gotten from him somewhat confusedly. The essence of this conversation is contained in the main text below.

The mask Picasso showed me had cylindrical eyes, a beard, and horns. As I was at that time wholly inexperienced in African art, my visual "fix" on the mask was not very secure. Thus, I cannot be certain that it was the mask on page 20, but I think it was. This mask was then stored at the villa La Californie (which Picasso had bought in 1955), where Picasso's secretary Miguel was living. It was probably brought over to Le Mas Notre-Dame-de-Vie in Mougins (where Picasso lived from 1961 to his death) by Miguel on Picasso's instructions. The absence of such a mask in Notre-Dame-de-Vie may explain Picasso's reluctance to go into the subject when I first asked about it.

Claude Picasso has raised the question of whether the mask I saw was not a third Grebo mask in Picasso's possession. If so, it has not turned up. None are listed, at least as such, in the rough, incomplete, and often incorrect list of *objets de tiers* (objects in the studio by other hands than Picasso) drawn up after his death, which Claude Picasso consulted for me and a copy of which was generously made available to me by Lydia Gasman.

That the less good of Picasso's two Grebo masks (p. 20) was almost certainly the one he showed me means only that this was the one (of the two) Miguel happened to bring over. It does not imply a more important role for it than for the one on page 305 in regard to the *Guitar*. As the essentials of both masks are the same, and as Picasso was concerned with the concept rather than the particulars of such masks, we may treat the two masks as one for the purposes of discussing the *Guitar*.

57. Picasso's recollection of the date of *Guitar* fixed it in early 1912, prior to the execution of *Still Life with Chair Caning* (see this author's *Picasso in the Collection of The Museum of Modern Art*, exhibition catalog [New York: The Museum of Modern Art, 1972], pp. 74, 207–08 note 4. Since then, however, Edward Fry in a lecture ("Picasso's 1912 *Guitar*," paper delivered at the 65th annual meeting of the College Art Association of America, San Francisco, February 25–28, 1981) has made a convincing case for dating the first, cardboard version autumn 1912, with the translation into sheet metal perhaps executed only in early 1913. Fry is convinced, although without any real evidence, that the Grebo mask on page 305 was purchased in Marseilles in August 1912 (which may well have been the case) and that its acquisition triggered the making of *Guitar*. The problem with the latter idea is that Picasso almost certainly already possessed his other Grebo mask (the one on p. 20), and while the one on page 305 is finer, it does not contain any conceptual principle absent in the other; Picasso would also have been familiar with the Grebo in the Musée d'Ethnographie (p. 260) from the time of his first visits there in 1907.

58. Kahnweiler's article, published in English as "Negro Art and Cubism," *Horizon* London, 18, no. 108 (1948), p. 418, speaks of a "Wobé" mask in

Picasso's possession and relates it—particularly as regards the cylindrical eye—to the *Guitar*. He also saw the structure of such masks as having suggested Cubist "transparency," an idea he would later largely retract. When talking with Picasso, I observed that Kahnweiler had shown considerable visual perspicacity in connecting *Guitar* with such a mask. Picasso laughed, and said that *he* had in fact told Kahnweiler about it (a fact that Kahnweiler had omitted, perhaps for reasons of discretion).

59. Both of Picasso's Grebo masks have rims painted in this manner.

60. Goldwater (*Primitivism in Modern Art*, p. 161) suggests that the cylindrical eye "expresses the magical penetrating glance of the spirit symbolized by the mask or temporarily housed in it."

61. If this is, as I believe, the mask shown me by Picasso (see note 56), its routine quality was no obstacle to his interest in it or affection for it, which was evident in the manner in which he handled it and spoke about it.

62. Although Grebo masks were not rare early in the century (Oldman's catalog shows two for sale) and many of Picasso's friends, among them Kahnweiler (p. 301) and Apollinaire (p. 312) possessed examples, nothing quite like the Metropolitan's Grebo, in either quality or individual character, is documented to my knowledge.

63. The literature on Grebo masks (Leo Frobenius, *Masken und Geheimbünde Afrikas* [Halle, 1898] and Bernard Holas, *Tradition des Kru* [Paris, 1980] shows a considerable range of types but nothing that would seem to prepare one directly for the Metropolitan mask.

64. While some types of African art, such as the Fang mask illustrated on page 12 and discussed on page 13 and in note 38, were standardized as sale items, some element of standardization does enter into certain types of objects made even for cult purposes.

65. These include the cylindrical eyes, flat facial plane, parallel lips, and (usually) "slat" nose, but notably not the horns, which are variously curved, or present only by implication, or totally absent.

66. This area constitutes roughly a wide geographical band from west to east across central Africa. For a map of the sculptural regions, see Elsy Leuzinger, *Africa: The Art of the Negro Peoples*, 2d ed. (New York: Crown, 1967), foldout.

67. Africans, who lack a word meaning "art," would refer to these trained object-makers by artisanal terms such as smiths or carvers.

68. We know relatively little about African tribal art prior to the late nineteenth century, when colonialism began in earnest. Experts disagree as to the rate of change and the development of new forms before that time. Extremists even argue that the main body of what we take to be authentic tribal art was already influenced by the effects of contact with the West.

Africa being as large as it is, and having as many different religious and political forms as it had, the fate of precolonial traditions has differed radically from place to place. In certain coastal areas there was considerable contact long before the turn of this century. By contrast, in most rural areas traditional animistic religions and the art that accompanies them still flourish largely unchanged. In some of the latter, however, the maintenance of traditional forms has become more difficult in the face of increasing communications and the multiplication of Western influences. Some of the art produced under these conditions seems to me aesthetically sterile—though it is treated as fully authentic by some anthropologists, e.g., Simon Ottenberg, *Masked Rituals of the Afikpo: The Context of an African Art* (Seattle and London: University of Washington Press, 1975). My judgment that the masks reproduced in Ottenberg's book are

vastly inferior to older ones of the same types is not meant as a reflection on his lucid and informative text.

Those who deal with the question directly through the objects themselves, approaching them as art rather than as social and religious data, tend to find most such very recent objects "dead," that is, destitute of that expressive power and aesthetic conviction they find in earlier, "authentic" objects. For them, a Fang mask made in the 1950s—even if executed by a tribal sculptor and used for cult activities—is a lesser object. A Fang mask of the 1930s would be preferred because the religious faith and confidence of the Fang people remained unshaken at that time. Still more preferable—if such a mask exists—would be one that could be proven to antedate Western penetration of Fang territories.

It is my personal impression that most collectors of tribal art make rather too much of provenance (apart, of course, from the question of downright fakes, whether of European or of African or Oceanic origin), to the point where it often seems more important than aesthetic quality. Many very old, unquestionably "authentic" objects are of little or no artistic interest. Conversely, a great artist who emerged sufficiently early in the transitional period after contact with the West began would have been capable of making a great object, though it might have differed somewhat from traditional forms. An example of such an object is the Torres Strait mask obtained by Picasso in the 1920s. Whereas the traditional masks of this area were made of tortoise shell or wood (p. 108), this one (p. 315) has a metal underpinning that was probably merchant marine debris. This notwithstanding, it is an extraordinary work of art. And though dating from the colonial period, it derives, nevertheless, from a period when traditional life in the Torres Strait remained largely unchanged. A recent object in the style of the Torres Strait made by a New Guinea artist for sale in the tourist shops of Port Moresby would be something else again.

69. Cf. Jacques Kerchache, *Chefs-d'oeuvre de l'art africain*, exhibition catalog (Grenoble: Musée de Peinture et de Sculpture, November–December 1982), n.p.

70. Destruction of "heathen idols" by Christian missionaries took place continuously, though there was the occasional celebratory auto-da-fé, as for example the burning noted by Peltier, p. 100. Such objects as were preserved by missionaries were generally excepted in order to serve as examples to show the congregations at home the horrible superstitions that had been stamped out. The great Austral Islands figure (p. 331) is one of these.

In more recent times, missionaries have taken a more benevolent and even scholarly interest in tribal art. Father Francois Neyt is the author of numerous texts on Congolese art, most recently *Arts traditionnels et histoire au Zaïre: Cultures forestières et royaumes de la Savane* (Brussels: Société d'Arts Primitifs Institut Supérieur d'Archéologie et d'Histoire de l'Art in conjunction with the Université Catholique de Louvain, 1981). Father Joseph Cornet is author of a major text on the art of the Congo (*Art de l'Afrique noire au pays du fleuve Zaïre*, [Brussels: Arcade, 1972]) and is director of the National Museums of Zaire.

71. Contrary to what many believe—in part no doubt because tribal languages lack words for "art" in the Western, fine-arts sense—considerable discourse exists among these peoples regarding the quality and character of works of art. This has been the subject of recent scholarship by Robert Farris Thompson ("Yoruba Artistic Criticism," in *The Traditional Artist in African Societies*, ed. Warren L. d'Azevedo [Bloomington, 1979], pp. 19–61) and by Susan M. Vogel ("Baule and Yoruba Art Criticism: A Comparison," in *The Visual Arts,*

Plastic and Graphic, ed. Justine M. Cordwell [The Hague, Paris, New York: Mouton, 1979], pp. 309–25), from whom I have benefited from conversations on the subject.

This discourse should not be confused, however, with the formation of a cumulative, reflective, and self-referential body of critical writing such as exists in the West. In view of this, it is probably misleading to speak of Africans living in the traditional manner who discuss art, however sensitively, as "critics" (e.g., "Yoruba art critics are experts of strong mind...," Thompson, p. 19). Indeed, some of what is represented as African "art criticism" appears to me primarily responses to elicitations by Western scholars, and is probably colored by that fact.

72. I reproduce here an example of such an "exaggeration" of the Senufo style. It is a rhythm-pounder given to Picasso by Jean Leymarie in the 1960s. Compare this with the Senufo rhythm-pounders on pp. 130–31.

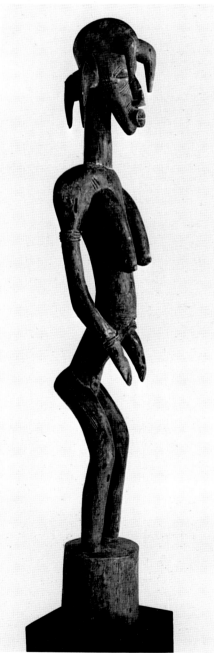

Rhythm pounder. Senufo. Ivory Coast. Wood, 45¼" (115 cm) high. Collection Jacqueline Picasso, Mougins. Given to Pablo Picasso by Jean Leymarie, c. 1962

73. Probably the earliest dealer to search personally for work in tribal areas was a man named Wirtz, who divided his time between Basel and New Guinea. Active in the period between the two World Wars, Wirtz sold a number of objects to the Museum für Völkerkunde of Basel.

74. I am indebted to Gail Levin for bringing these works to my attention. She discusses them in the context of American primitivism on pp. 454–55.

75. *World Cultures and Modern Art*, as in note 2 above.

76. In conversation with the author.

77. This would apply, in the case of the Easter Island stone, only to the surface that is relieved and painted (as in our reproduction). Unlike the stone engraved by Ernst, the Polynesian one is otherwise irregular in contour.

78. From Maurer and Spies in conversation with the author. The first association of the Easter Island stone and work of Max Ernst that I know is in Lucy Lippard's introductory essay "The Sculpture" for the exhibition catalog *Max Ernst: Sculpture and Recent Painting*, ed. Sam Hunter (New York: The Jewish Museum, March 3–April 17, 1966), pp. 38–39, where Ernst's untitled painted granite sculpture of 1934 and the Easter Island stone carving of a bird-headed man are reproduced across from each other without commentary in the text.

79. This is a universally shared assumption. We do not, however, possess enough tribal sculpture unquestionably predating colonial times—nor is that which we possess datable with sufficient accuracy—to know the extent to which tribal art altered over the centuries.

80. As noted above, there is—and no doubt was—discourse among tribal peoples regarding at least certain aesthetic aspects of cult objects. The proof, however, that tribal artists solved aesthetic problems is in the objects themselves. That the majority of artists merely imitated received ideas is true for all cultures, though this fact is ably "masked" by many recent Western artists. What certainly differs is the degree of consciousness of the artists that they are, in fact, solving aesthetic problems. But the solutions of genius in the plastic arts are all essentially instinctual, regardless of such intellectual superstructures as might be built around them after the fact by the artists themselves, other artists, or critics and art historians.

81. *Primitive Religion* (New York, 1924), p. 260.

82. For the history of this mask, see Leon Siroto, "A Mask from the Congo," *Man* 54, October 1954, pp. 149–50, and an unpublished memorandum on file in the collection of the Museum. See also below, pp. 262–63.

83. "Tribal Art and Modern Man" in *The Tenth Muse: Essays in Criticism* (London: Routledge and Kegan Paul, 1957). This essay originally appeared in *The New Republic*, September 1953.

84. This is probably—both for the history of tribal art and for modern art—the kind of study most needed. A beginning in this direction is represented by Marie-Noël Verger-Fèvre in a thesis written for Jean Laude: "Présentation des objets de Côte d'Ivoire dans les expositions universelles et coloniales de 1878 à 1937" (Université de Paris I, 1981–82), a specialized text detailing the arrival and dispersal of objects from the Ivory Coast.

85. See below, pp. 166–67.

86. Cf. Giovanni Becatti, "Raffaello e l'Antico" in *Raffaello: L'opera, le fonti, la fortuna*, ed. Mario Salmi (Novara, 1968), pp. 507–08. I am indebted to Creighton Gilbert for this reference.

87. In his diary entry for Saturday, April 14, 1906, Klee noted that he had visited the Museum of Ethnology ([Berlin] "Samstag, 14.4. Vormittags im Zoo. Nachmittags im Museum für Völkerkunde," in Felix Klee, ed., *Tagebücher von Paul Klee 1898–1918* [Cologne: M. DuMont Schauberg, 1957], p. 213).

88. In 1929 Hitler named Heinrich Himmler head of the SS, or Schutzstaffel, the Nazi party's black-shirted elite corps, which became increasingly active and increasingly ruthless. Its presence in the streets in 1932 was ubiquitous.

89. The arrow has, of course, in Klee's work a variety of symbolic meanings quite different from those explored here (see Mark Rosenthal, "Paul Klee and the Arrow" [Ph.D. diss., University of Iowa, 1979]). Mr. Rosenthal has pointed out to me that a number of titles of Klee's paintings of 1932 relate to the artist's anxiety about the rise of Hitler and the ubiquity of his legions, as for example the *Barbarian Captain* (coll. Felix Klee, Bern).

90. Both Giacometti works illustrated on pp. 34–35 in juxtaposition with the objects in the Basel Museum für Völkerkunde are to be found with these tribal sources in Reinhold Hohl, *Alberto Giacometti*, trans. H.-Ch. Tauxe and Eric Schoer (Lausanne: La Guilde du Livre et Clairefontaine, 1971; English and German editions, Stuttgart: Gerd Hatje, 1971), p. 295, documentary illustrations 61–62, 63–64; see also pp. 138, and 302, note 50.

91. My thanks to Dr. Christian Kaufmann of the Basel Museum für Völkerkunde for first having indicated to me the relationship between Giacometti's *Head of a Man on a Rod* and the modeled head from New Ireland, which I had overlooked in Hohl.

92. As explained to me by Dr. Kaufmann.

93. This relationship was first observed by James Smith Pierce, in "Paul Klee and Primitive Art" (Ph.D. diss., Harvard University, 1961; revised version, New York and London: Garland Publishing, 1976), pp. 42–43, 165.

94. Read, as in note 83.

95. Lectures, Columbia University. Schapiro also discussed Heckel's *Clown and Doll*, mentioned below.

96. A few years later, in an interesting example of "life imitating art," Oskar Kokoschka expressed his hurt and alienation over Alma Mahler's termination of their affair by accompanying himself around town with a made-to-order life-size doll designed to represent her. The metaphor, which expresses alienation from a woman by reducing her literally to an object, has a long literary history that goes back to the female mannikin created for Tristan by his artisans following his rejection by the White Iseult.

97. This is an underlying thesis of Lévi-Strauss's *Structural Anthropology*, esp. pt. 3, "Magic and Religion." It is "the cushioning of dreams" by which Primitive man "was protected—and to some extent released from bondage" (*Tristes Tropiques*, 1955, p. 513).

98. That is, the breakdown of stable, authentic communal beliefs, religious and social. The reaction of Impressionist and many twentieth-century French painters was to accept this atomization of society as an aspect of freedom, giving it a positive value in their art.

99. Few modern artists have been readers of ethnological books. Nolde and Kirchner seem to have consulted some of the specialized literature of their day, but Carl Einstein's *Negerplastik* (1915), which approached tribal sculpture from a purely aesthetic point of view, was of far greater interest to them. Max Ernst was exceptional in having read very widely in ethnology. Picasso, on the other hand, gleaned his impressions of the function of tribal objects in the Musée d'Ethnographie du Trocadéro from his imagination and from labels. Although Lydia Gasman suggests the contrary in her strongly argued dissertation "Mystery, Magic and Love in Picasso, 1925–1938" (Columbia University, 1981), pp. 476–82, Picasso surely did not read Mauss or other early twentieth-century French ethnologists. Indeed, scholarly literature, as he said to me with regard to art history, bored him. Moreover, his grasp of French in the crucial period (1907–08) was such that reading Mauss would have been beyond him. It is perfectly possible, nevertheless, that Picasso absorbed some much-generalized, watered-down versions of ethnological ideas through his passing contacts with Mécislas Golberg and J. Deniker, and to that extent Gasman has a point. The ideas of the French school of ethnologists could well have been "in the air" of some Paris vanguard studios in much the same way as what passed for "Existentialism"—a studio catchword in the New York of the late forties and fifties—was known to the Abstract Expressionists. Picasso's grasp of Primitive art was, however, unquestionably instinctive (see below, pp. 255 and 335, note 53).

100. This is the underlying thesis of Robert Farris Thompson's *African Art in Motion: Icon and Art in the Collection of Katherine Coryton White*, exhibition catalog (Washington, D.C., National Gallery of Art, and Los Angeles, Frederick S. Wight Art Gallery, University of California, 1974). See esp. pp. xii–xiv, 1–5, 47–48, 111–12, 117, 152, 154.

101. The modern West is not the first society to prize the art of other cultures, but is the first to prize cultures which (unlike Antiquity in its relation to the Renaissance) are not consonant with its own received traditions, and the first simultaneously to value a large number of alien cultures whose value systems are mutually contradictory.

102. Examples of unfinished Egyptian sculptures exist that show that the artist began by drawing profile and front views on the block of stone. Picasso made his *Caryatid Figure* (p. 289) in the same manner. African and Oceanic sculptors carved directly, without drawings, though they might score the main masses in the block.

103. At the time Lipchitz modeled *Seated Man*, he had already seen some geometrical Dogon figures in the Musée d'Ethnographie du Trocadéro, which owned and exhibited some Dogon material early in the century (see p. 273). The affinities I am discussing here, however, go beyond any such influences, and are of a more general order.

104. There is some difference of opinion among Africanists as to the prevalence of mythological figures in African sculpture. Most see "mythological figures" as representing a marginal aspect of its iconography. Leon Siroto argues that virtually all such figures are wrongly interpreted and that few if any of them are mythological.

105. Note that I distinguish here between totem figures and totem-pole-like configurations that could be storytelling structures without necessarily including actual tribal totems.

106. Susan Vogel carries the analogy between the sculpture of Africa and of classical antiquity even further than similar statements by Fagg ("The African Artist") and others. In "The Buli Master and Other Hands" (*Art in America*, no. 5, May 1980, pp. 132–42) she states: "Traditional African art . . . is in fact a classical art in its insistence upon order and conformity to tradition, and in its low regard for radical innovations and personal expression. . . African art's concern with controlled emotion, balance and proportion, and its general restraint, make it fundamentally classical." In *African Aesthetics* (Milan, forthcoming) she underlines the fact that African words for beauty used in connection with works of art have a moral connotation, as in the Greek *kalokagathia*, which means simultaneously the beautiful and the good. She also stresses "the cardinal value of moderation which underlies all African aesthetic systems," which is the counterpart of the Greek ideal of *sophrosyne*.

107. See below, Levin, p. 465.

108. For more on Pierre Loeb, see below, Peltier, pp. 111–12.

109. Loeb was responsible for financing important trips to Oceania, particularly Lake Sentani, by Jacques Viot.

110. I presume this because these characteristic projections of the "Yam" masks are not discussed in the

most specialized text on this material, Ottenberg's *Masked Rituals of the Afikpo*, as in note 68.

111. This type of mask would not have been so seen when danced, for it was worn on top of the head, like a cap.

112. The Jukun are often described as wearing these masks at an oblique angle, somewhere between a vertical face mask and the horizontal way the Mama masks were worn, that is, on the top of the head—which was probably the way their use began. The subject has been studied by the art historian Arnold Rubin; my gratitude to Roy Sieber for providing me photocopies of relevant passages from Rubin's doctoral thesis as well as other texts on Jukun masks.

We have reproduced the Berlin Jukun vertically (as if a face mask) rather than at an intermediate angle (the way it is installed in Berlin and is usually reproduced) in order to demonstrate the parallelism with Picasso's *Head*. (The manner in which tribal objects were originally meant to be seen was not a concern of modern artists.) However, there is evidence that at least some such Jukun masks were worn that way. Though I could not closely inspect the mask reproduced on page 320 because it was in a vitrine during my trips to Berlin, I was able to handle in the reserves another Jukun mask, of slightly inferior quality, which forms a pair with it. Putting on this mask, I discovered that the markings of interior wear line up exactly with the

eye-holes when the mask projects horizontally like a face mask.

113. Douglas Newton has provided me with this information, which comes from Adrian A. Gerbrands, ed., *The Asmat of New Guinea: The Journal of Michael Clark Rockefeller* (New York: The Museum of Primitive Art, 1967; distr. New York Graphic Society), p. 349.

114. This is true, regrettably, for the bulk of writing by art historians of Primitive art as well as, naturally, the work of anthropologists.

115. The extreme of these limits was set by Mannerist art, notably El Greco. The special popularity of El Greco in the first years of the century—he was singled out by such writers as Salmon, and the angularities and distortions of his work influenced Picasso in the Gosol work of 1906 and in the *Demoiselles*—reflects his proximity to primitivist concerns.

116. Kirk Varnedoe has pointed out that the typological treatment of human proportions was virtually parodied in Nazi "science," where the squat proportions of modern sculpture were compared with those of victims of elephantiasis (cf. Helmut Lehmann-Haupt, *Art under a Dictatorship* [New York, 1954], pp. 38–41).

117. It is quite impossible—nor should one even try—to sort out the many different influences fused in the refining fire of creative work in such a way as to assign them specific degrees of importance. My

own impression is that what I have called the "broomstick" sculptures—which Picasso actually whittled, according to Werner Spies, from the wood of picture stretchers—had an important meaning for Giacometti even though their influence would not be felt for many years. This type of Picasso carving (see William Rubin, ed., *Picasso: A Retrospective* [New York: The Museum of Modern Art, 1980], p. 284)—elliptically related to a motif in nature rather than devised wholly from the imagination as was Giacometti's art in 1931—subsequently provided, along with Cézanne, models for the artist's attenuated figures. If the latter were also as I believe—at least as regards their proportions—influenced by Archaic (Etruscan) and Primitive art, the same is probably also indirectly true of the Picasso figures, which were made at a time when his larger sculptures reflected his interest in Baga sculpture (see pp. 326–27).

118. See pp. 314–18.
119. Letter to W. R. September 1983.
120. Lucy Lippard, *Eva Hesse* (New York: New York University Press, 1976), p. 86.
121. See below, Levin, p. 464.
122. This is the burden of Lévi-Strauss's structuralist analysis of Primitive language, kinship patterns, and myth (see *Structural Anthropology*: the comparison of the workings of the "primitive" and modern mind on p. 230).

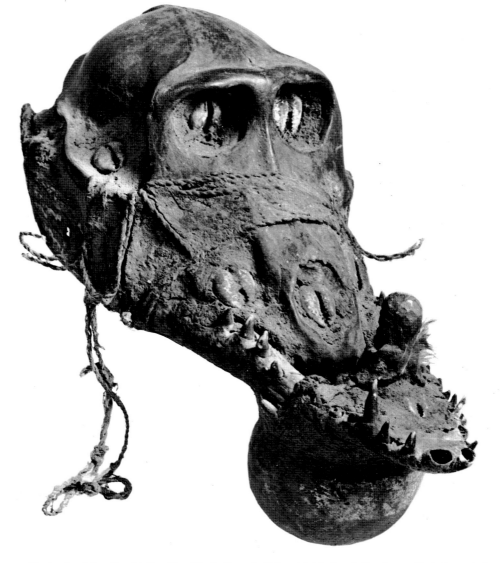

Monkey head. Fon. People's Republic of Benin (formerly Dahomey). Monkey skull and crocodile jawbone, shell, twine, and mixed media, 12″ (30.5 cm) long. Collection Mr. and Mrs. Herbert R. Molner

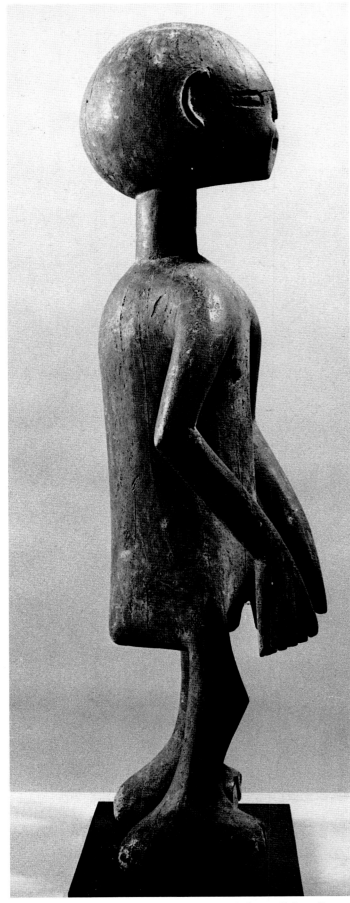

Figure. Chamba. Nigeria. Wood, 22½" (57 cm) high. Collection Philippe Guimiot.
For another view of this object in color see page 36.

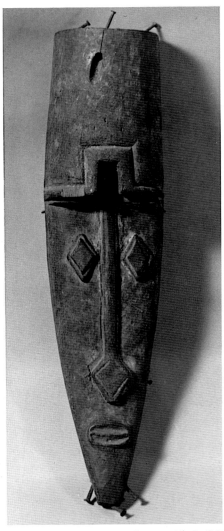

Mask. Kalabari Ijo. Nigeria. Wood, 15" (38.1 cm) high. Collection
Ernst Anspach, New York

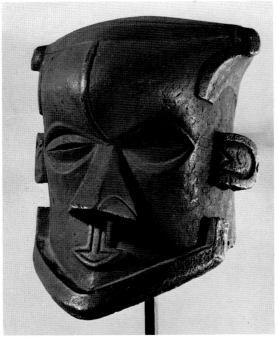

Mask. Kuba. Zaire. Wood, 13" (33 cm) high. Private collection,
New York

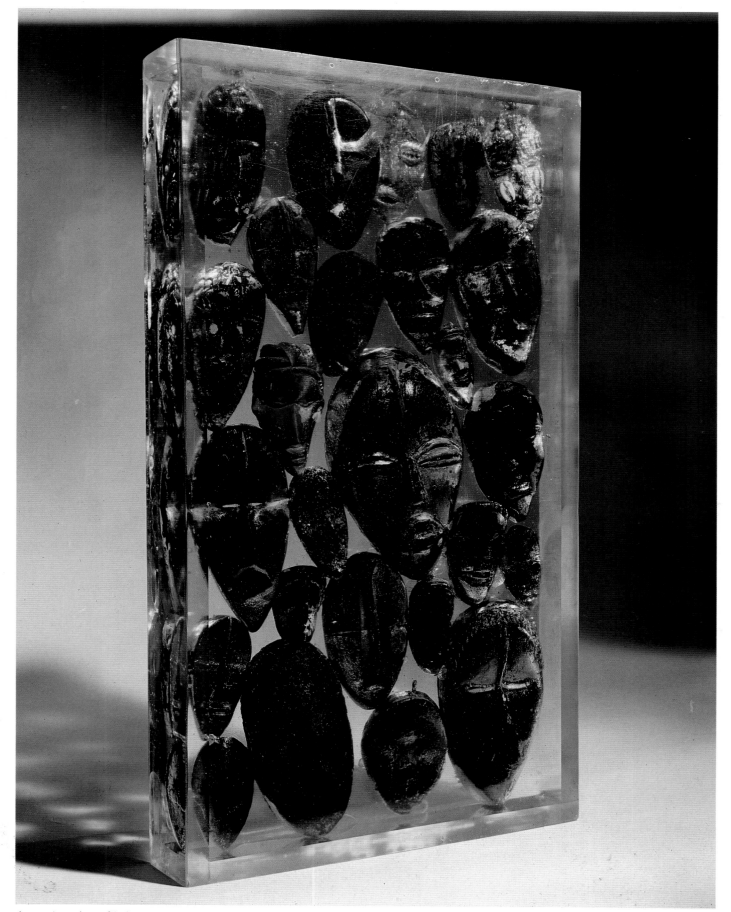

Arman. *Accumulation of Souls*. 1972. Dan masks embedded in polyester, 20½ x 11½ x 2⅝″ (52 x 29 x 6.5 cm). Private collection

"Surrealist Map of the World." Published in *Variétés,* 1929

THE ARRIVAL OF
TRIBAL OBJECTS IN
THE WEST

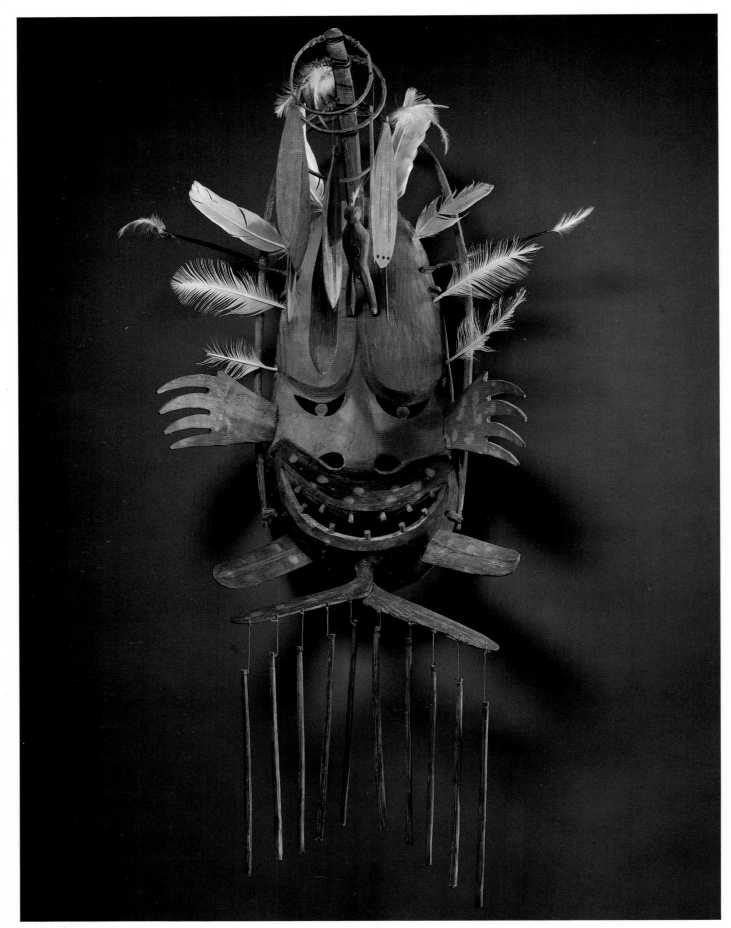

Mask. Eskimo. Kuskokwim River, Alaska. Painted wood, feathers, and leather, 45¼" (115 cm) high. The Metropolitan Museum of Art, New York; The Michael C. Rockefeller Memorial Collection, purchase, Nelson A. Rockefeller gift

FROM NORTH AMERICA

Christian F. Feest

The history of the collecting and appreciation of objects of North American Indian origin spans the entire period of Indian-White relations from first contact to the present day. It is inextricably connected with other aspects of interethnic relations, with incredulous speechlessness about a new world, and with old prejudices about faraway and foreign folks. Short of going to the New World itself or of gawking at live but often short-lived specimens of the native population brought to Europe, looking at some of the products of the indigenous peoples was still the least dangerous yet most immediate way of keeping in touch with the colonial enterprise (in case you belonged to a colonial power) or with the frontiers of an expanding world (in case you lived elsewhere).

North America, it should be remembered, was a second thought, considered only after Spain and Portugal had helped themselves to the more nutritious lower quarters of the hemisphere: It was fish and furs rather than gold and silver. Yet, the southern experience Europe had first had with the New World helped to shape its image and the expectations connected with it as a whole. The first and most permanent symbol of native Americans had its origin in Brazil before it spread to the north, and it was an artifact: the feather headdress. It appears on Hans Burgkmair's engravings of *The Triumph of Maximilian* (c. 1519, p. 86), where its wearers are still referred to as the "people of Calicut," and it makes those "Indians" more or less easily recognizable iconographically in sixteenth-century European art. Although oil portraits of Indians painted from life by professional artists do not appear until the mid-seventeenth century, Indian images representing a blend of a few facts with many preconceived ideas become important in European art much earlier as symbols both for plenty and the embodiment of evil.

The first shipment of native products sent by Cortes from Mexico (it was shortly followed by many more, yet only a few dozen of the items then sent have survived until today) included huge quantities of worked precious metals, objects encrusted with turquoise mosaic, native pictographic manuscripts, and above all featherwork of every description. When these objects were being displayed in 1520 in Brussels, they were seen and described by Albrecht Dürer, whose words have been consistently but erroneously interpreted as expressing aesthetic judgments when in fact he was being impressed by the sheer value of these things, their sometimes exotic raw materials, and their obvious craftsmanship.

When compared with these esoteric and eye-dazzling items from Mexico, the reputedly oldest surviving objects brought from Indian North America by Jacques Cartier in the 1530s were quite mundane and simple: two pairs of moccasins decorated with dyed porcupine quills. Because of their patently utilitarian nature, North American Indian artifacts never stood much of a chance to be confused with works of art in the European sense, even if their "subtle ingenuity" found just admiration.

Despite the fact that some ideas about Indians developed and spread across national boundaries, different national attitudes toward the people of the New World began to emerge. The enormous appetite for American things documented by the volume of early sixteenth-century publications on the New World in Germany foreshadowed the seemingly compensatory preoccupation with this subject matter by nations excluded for one reason or another from partaking in

Tupinamba Indians, Brazil. *People of Calicut* engraving by Hans Burgkmair, from *The Triumph of Maximilian I,* c. 1519

A less cordial reception was accorded the northern native group most frequently seen in Europe: Eskimos. Kayaks with their occupants, often whole families, were unceremoniously picked up in open waters by ships of Christian seafaring nations and brought home to be first interviewed about their native land and then displayed as self-confessed man-eaters to a grateful public. Of an Eskimo woman and child brought on a tour to Bavaria in 1566 (after the husband/father had been killed), two handbills announcing their appearance survive; a kayak once in the collection of the Elector of Bavaria, now in the ethnology museum of Munich, can be traced to another such interception in 1577. Live displays of Eskimos remained a common sight in Germany if we may judge from comments by a seventeenth-century German novelist about recurrent showings of "Greenlanders and Samoyeds," and from evidence documenting the practice well into the nineteenth century.

Given the fact that Florida remained the only permanent European colony in North America throughout the sixteenth century, it is not surprising to find the majority of North American objects in sixteenth-century princely or private collections attributed to Florida. Since the Holy Inquisition openly discouraged the collecting of presumably demon-infested native artifacts in the latter part of the sixteenth-century, Spain remains a fairly poor source for such items. Though similarly Catholic, Italy had much less of a problem in this respect; collectors like Giganti or Aldrovandi in Bologna proudly listed Floridian featherwork in their catalogs. The Elector of Bavaria owned a wooden idol from Florida, as did the Spanish collector Lastanosa, whose description of it

the colonial spoils. The emerging (at least stereotypic) French attitude of living and feasting with the Indians is equally well illustrated by the Brazilian Indian (Tupinamba) village erected in 1550 in Rouen on the occasion of the entry of King Henri II into that important port-of-entry for brazilwood. Within the limits set by actual power relationships, French royalty did not find it beneath their dignity to associate with Indians. In a similar vein, young Louis XIII when still dauphin befriended the Indian "Canada" brought in 1604 from the country sharing his name.

Mock battle between two Brazilian tribes held at the Tupinamba village erected for the entry of Henri II into Rouen, 1550

Eskimo woman and child who were displayed to the public during a tour through Bavaria in 1566. This handbill is the earliest surviving print illustrating Eskimos.

("so ugly that it cannot be described") makes it clear that it was not retained for aesthetic reasons. Rarity and curiosity remained the measures of ethnographic collection of the day.

The establishment of English, French, Dutch, and Swedish colonies along the Atlantic coast brought about a drastic increase in European-Indian contacts both in the New World and the Old, as well as a significant growth in the collecting of North American Indian ethnographic specimens. It did not materially alter (and in the long run even reinforced) European preconceptions about America's aboriginal inhabitants, nor did it change the basic reasons for collecting specimens of native manufacture. If they collected at all, colonial leaders would pay particular attention to potentially useful products or objects received in the course of official proceedings (such as bags made of "silk grass," shell money, boats, native arms, wampum belts); missionaries would concentrate on native religious paraphernalia and sometimes objects reflecting the Christian devotion of their new parishioners; and there were others who simply collected the wonderful and strange. Artistic quality was still not a major reason for acquiring objects;

the Virginian idol, for instance, brought back by the Reverend Alexander Whitaker (who had baptized Pocahontas) in 1615, was "ill favour'ly carved on a toadstool."

Nor did the ambivalent view of the Indian as noble or ignoble savage change. Pocahontas, Englished in dress and manners, was treated as some kind of tawny nobility and received by the Queen (p. 88); two other native Virginians, yet uncivilized, were almost concurrently being displayed as live zoological specimens at the zoo in St. James's Park in London (p. 88). While there is evidence of Indian influence on English fashion and tastes, the French nobility delighted in masquerading as "American kings" throughout the seventeenth and eighteenth centuries. In England, "playing Indians" may have been regarded as rather fit for children, as is indicated by a Virginian fur trader who in 1689 sent a native costume to a friend in England "for your boy to play with."

In England, the Crown apparently did not take a serious interest in collecting Indian objects. The early collections were all formed by private persons, such as Sir Walter Cope or John Tradescant (father and son). The Tradescant collection

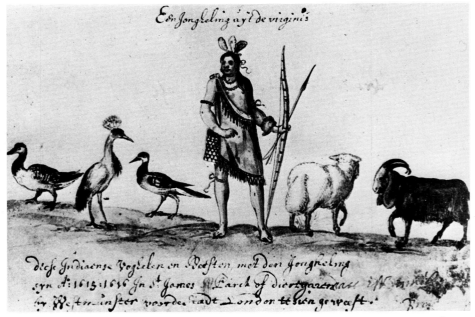

Pocahontas, daughter of Powhatan, dressed for her introduction to the Queen of England as Mrs. Rebecca Rolff

Eiakintomino, like Pocahontas an Indian from Coastal Virginia, was featured together with domestic and foreign animals at the zoo in St. James's Park while Pocahontas was introduced to the court as an Indian princess. Watercolor by Michael van Meer. University Library, Edinburgh

included "Powhatan's mantle" (surviving today in the Ashmolean Museum in Oxford and probably neither a mantle nor Powhatan's), which illustrates the growing tendency to collect memorabilia also in savage lands. In France and Scandinavia and later in the German principalities, however, the ruling houses played a prominent role as collectors of Indian artifacts. There were private collections in France, such as that of Nicolas-Claude Fabri de Peiresc (fragments of which survive in the Bibliothèque Sainte-Geneviève in Paris), but they were apparently dwarfed by those of the Crown. The private natural-history and ethnography collection of Ole Worm in Copenhagen was acquired by the Danish king in 1654, as was at a later date the collection of the Duke of Gottorp (including the early seventeenth-century Dutch collection of the physician Paludanus).

Some of these early and quite miscellaneous collections may not have been too much different from those existing among North American Indians of the same date. There is archaeological evidence at the site of the village of Patawomeke (south of Washington, D.C.) for the collecting of fossils (making it a logical precursor of the Smithsonian Institution), and all over coastal Virginia and Maryland the treasure houses of the native nobility contained things of value and of exotic and curious interest (such as the bed and washbasin sent to Powhatan by the King of England). And just as European colonial powers began to produce certain goods exclusively to meet native demands in the Indian trade, so did native artisans start to produce items for the incipient tourist trade. While this was apparently not readily recognized by the white customers, a case can be made that European aesthetics influenced the decoration and finish of elaborately carved wooden clubs evidently made for presentation, or of other articles specifically made for exchange. Aesthetics thus remained of secondary importance in the collecting of North American Indian specimens, but began to exert a likewise secondary influence on them.

Especially after the beginning of the eighteenth century, more and more Indian visitors came to Europe not as involuntary curiosities (although they still aroused much curiosity and in all likelihood more public interest than most collections, many of which were not public anyway), but as political emissaries of allied nations. This was particularly true of England, where the visit of the "Four Kings of Canada" (three Mohawks and a Mahican) in 1710 was the first of a series of similar events involving Cherokees, Creeks, and others. The Mohawks apparently made such an impression on the English that they became the name patrons of a "class of aristocratic ruffians who infested the streets of London" (not unlike the "Apache" would two centuries later in Paris). Whether this makes the English "Mohocks" the first precursors of the Italian "indiani metropolitani" (of 1977 vintage) or their kindred German "Stadtindianer" is open to question; it should be noted that the Mohawks in general (though not those visiting London) wore the roached hairstyle that became the model for contemporary "punk" fashion all over Europe.

Despite their dubious reputation, the Mohawks were well received in England, had a meeting with Queen Anne, and had their portraits painted by several artists. More and more professional artists (including Sir Joshua Reynolds) were thus exposed in their studios to live American Indians. Visitors like the "Four Kings" always found people in Europe who were

Burden strap with false moose-hair embroidery. One of the objects collected from the "Four Kings of Canada" who visited London in 1710. Mohawk. New York State. Hemp, quill, and moose hair, 1½" (4 cm) high. The Trustees of the British Museum, London

interested in items of native manufacture they had brought along. For those who were unable to go to America themselves, these were good opportunities to collect. Three items associated with the "Four Kings" in Sir Hans Sloane's huge collection ended up in the British Museum (just as the Tradescant collection had gone into Oxford's Ashmolean). In Sloane's collection, ethnography numbered only around four hundred items and was not even cataloged separately but under "Miscellanies." Slightly more than half of these were of North American origin, with an Eskimo attribution for a third of those provided with localities. The Sloane collection is typical for the majority of European collections (including those of scientific institutions such as the Royal Society's, started slightly before Sloane's) in (1) not being primarily a field collection, but being fed by field collectors, and (2) not being exclusively an American Indian collection. These agglomerations were more or less general collections in which specific public sentimental interests such as in Indians are not necessarily reflected.

Such sentimental interests are much more pronounced in field collections of Indian artifacts assembled by British army officers stationed along the frontier. Sir John Caldwell (his collection has recently been dispersed), who had his portrait painted showing himself dressed up in his Indian things, had been stationed in the Great Lakes area, just as was Arent Schuyler de Peyster (his collection, belonging to the King's Regiment, is still to be seen in Liverpool), who wrote a very funny and personal poem about his Indian friends.

The Indian interests of the French necessarily became more and more sentimental as their colonial possessions dwindled and chances for collecting decreased. But in literature these interests helped to propagate images of the Indians as models of a simpler, better, and happier life, or to portray moral institutions against which the vices and shortcomings of European civilization could be more clearly perceived. This is in basic agreement (but with a significantly different emphasis) with the thinking of British social and economic philosophers of the time, whose evolutionary schemes placed the American Indians at the earliest, primal, but also most primitive level ("In the beginning," it was said, "all the world was America"). That French interest in Indians continued after the loss of its North American possessions is illustrated by an early diorama-type display of Canadian Indian artifacts mounted by the Marquis de Sérent at Versailles for the education of the children of the royal family.

Besides prompting German emigration to America in the eighteenth century, the American Revolution caused a significant increase in the number of North American Indian collections in the German principalities. Hessian or Brunswick mercenaries frequently sent home the basis for future Indian collections in Germany. The attitude toward native Americans was one of friendly fascination. The German poet Seume, himself one of the mercenaries in America, is still quoted with a line from one of his poems dealing with Indians: "We savages," exclaims an indigenous Canadian, "are indeed better human beings." In a more distant perspective, the American Revolution was also responsible for American collections of Indian objects—beginning almost three centuries after the earliest European attempts of that kind.

Meanwhile, a different style of collecting was coming into being. The development of taxonomic systems of nature

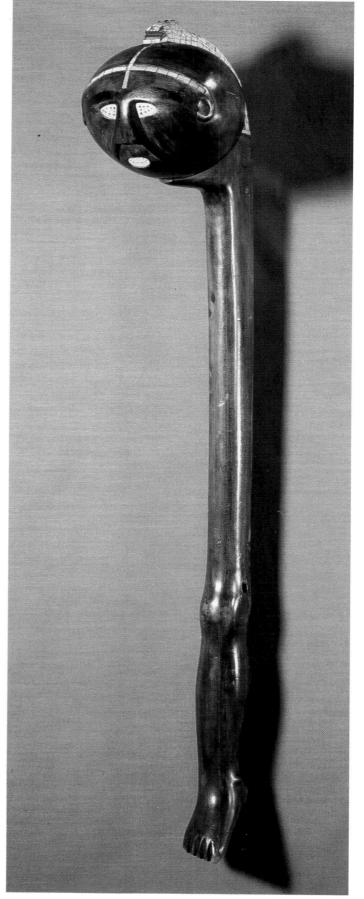

Club. Iroquois or Delaware. Northeastern United States. Wood, wampum inlay, 25¾" (66 cm) high. The National Museum of Denmark, Copenhagen, Department of Ethnography

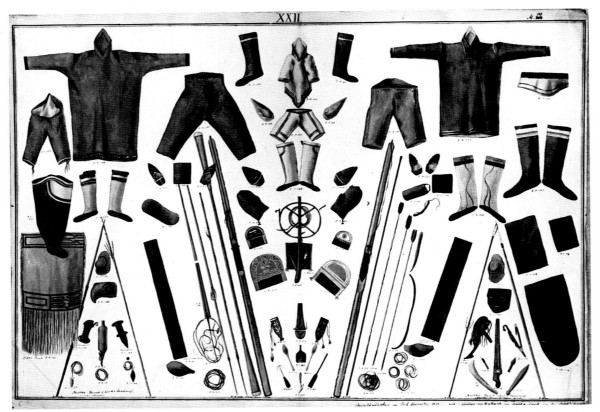

Northwest Coast Indian objects collected by Captain Cook in 1778 as displayed with Eskimo material from Greenland in the Imperial Ethnographic Museum in Vienna, 1838. Watercolor attributed to Thomas Ender

(such as Linnaeus') first paved the way for truly systematic collecting. The great eighteenth-century voyages of exploration created the opportunity to do this on a worldwide scale. The collecting of ethnographic specimens was more and more taken up by naturalists and influenced by their new approach to the problem. With the accompanying rise of the trade in natural-history specimens, the first regular market for ethnographic items developed in the latter part of the eighteenth-century. The name most commonly associated with voyages of exploration of this period (which finally turned traveling, formerly an art, into a science) and with the new collecting trends is that of James Cook. On the last of his three voyages, on which he was accompanied by numerous scientists from various European countries, Captain Cook visited the Northwest Coast of North America and caused the first large-scale dispersal of Indian arts and crafts from this area. While the majority of the collections were brought to England, some were given to Russian officers in Kamchatka (to be deposited later in Leningrad), and others were left in Cape Town. Captain King returned with some to his native Ireland; John Webber, the official artist of the last voyage, gave some to his father's native city of Bern. Traders sold material to Germany and Italy. A portion of the artifacts was deposited in the still badly disorganized new British Museum, but the majority went to the private museum of Sir Ashton Lever, which ultimately had to be sold at public auction in 1806. The fame of its Cook Voyage specimens caused great public interest at home and abroad. The Austrian emperor, for example, on this occasion had a sizable collection acquired for his natural-history collection, within which it formed the core for a new ethnographic collection.

After Cook's explorations and the contemporary French voyages to Oceania, other nations organized their own scientific voyages. In 1791–92, Admiral Alejandro Malaspina visited the Northwest Coast, which since Cook's visit had become a special economic attraction because of the sea-otter trade with China, and which Spain still claimed in extension of its Southwestern possessions. Malaspina's collection (now at the Museo de America in Madrid) was formed when Spain for the first time, in a flash of Enlightenment, also began to show serious interest in Mexican antiquities, and when through its control over the trans-Mississippi West, early Plains Indian material came into Spanish possession.

When the great Russian voyage of discovery led by Adam von Krusenstern (to be followed by others) touched the Pacific Northwest coast of North America in 1805 (a collection made on this occasion by G. H. von Langsdorff survives in Munich, the one by Lisiansky in Leningrad), it touched Russian territory, since after the middle of the eighteenth-century Russian eastward expansion through Siberia had crossed the Bering Strait and the Aleutian chain. Collections such as that of Baron von Asch (now in Göttingen) are approximately contemporaneous with those of Cook's third voyage, but reached Europe overland through Asia.

While the bulk of the Russian material from the Aleuts, Alaskan Eskimos, and Athabaskans ended up in Leningrad, other European collections received their share of it through non-Russians working in Russian service or through dynastic marriage. In the former category belongs the Helsinki collection of Arvid Etholén, Governor General of Russian America;

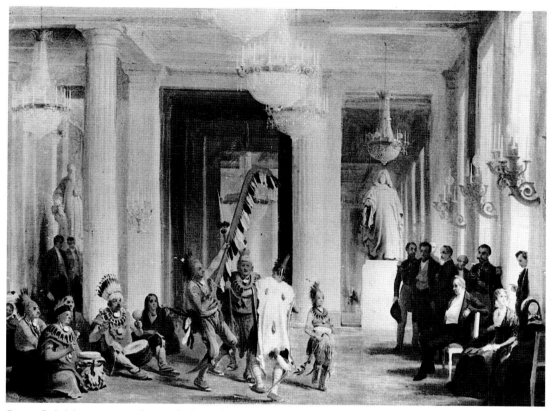

George Catlin's Iowa troupe performing for Louis Philippe at the Tuileries in 1845. Painting by Karl Girardet. Musée National du Château de Versailles

in the latter the one assembled by his predecessor, Colonel Kouprianoff, and now in Oldenburg. In general, the Russian collections—like the ethnographic reports to which they were related—show careful planning, including the use of questionnaires and checklists.

In its combination of daring feats, political implications, and scholarly endeavor, the transcontinental expedition of Lewis and Clark must be seen as analogous to other nations' voyages of discovery. It not only led to the establishment of one of the first American museums focusing on Indian artifacts, but also became a model for generations of European gentlemen travelers into the American West (whose other major inspiration was Alexander von Humboldt). Certainly one of the best prepared and most experienced in this group was Prince Maximilian of Wied, whose collections are now mainly in Berlin and Stuttgart. German interest in North America (and in Indians) remained pronounced throughout the nineteenth-century, partly because of increased emigration, and certainly was kept alive by an ever-increasing volume of trivial Indian novels influenced by James Fenimore Cooper as well as by French prototypes.

Just a year before Prince Maximilian, accompanied by Swiss painter Karl Bodmer, proceeded up the Missouri into the heart of Plains Indian country, an American lawyer-turned-painter by the name of George Catlin had been in the same area to start his project of documenting with canvas and brush the last days of a "vanishing race." What Catlin lacked in technical skill and quality as a painter he made up by enthusiasm and quantity. When the United States government displayed no interest in purchasing his "Indian Gallery," Catlin

moved to Europe, where he rightly felt his work (and anything relating to Indians) would be more warmly received. Accompanied by varying troupes of Indian performers (Ojibwa, Iowa), Catlin first conquered London and later Paris, where his pictures were shown at the Louvre and where King Louis Philippe commissioned him to paint a series of canvases relating to the French discovery of Louisiana. Like Bodmer and Catlin, many artists (European and American) of the nineteenth century traveled the West and spread (Plains) Indian images by their paintings, and some of them also collected. (Catlin even seems to have "improved" some of the pieces he had brought back from Indian country; as an artist he thought he knew better than the Indians—an attitude shared by bureaucrats, missionaries, and even some anthropologists.)

Systematic observations and systematic collecting laid the foundation for the establishment of anthropology as a scholarly discipline during the nineteenth century. While small, specialized ethnographic collections (usually containing American Indian material) existed either as part of universities (Göttingen, since the 1780s) or as separate entities within natural-history cabinets (Vienna, since 1806) or Kunstkammern (Berlin, since 1829), most European anthropology museums originated in the second half of the nineteenth century as departments of natural-history museums (like that of Paris) or even more general collections (like the British Museums). Berlin, where a separate anthropology museum was established in 1873, is an exception; most other museums separated

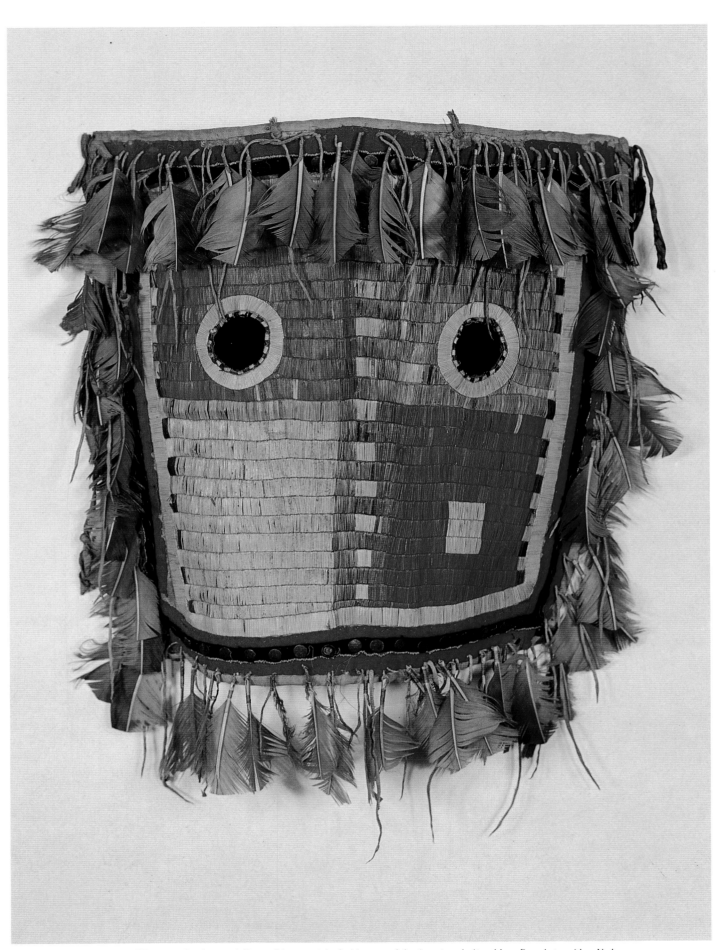

Mask for a horse. Cheyenne. Wyoming. Feathers and fiber, 21" (53.3 cm) high. Museum of the American Indian, Heye Foundation, New York

from their parent institutions (if ever) only during the twentieth century. Virtually all of them were public institutions financed and operated by the respective national governments, and many of them created the first jobs for anthropologists in their countries.

One should not conclude from this that all or even most of the collections acquired by the new museums were of a systematic and scientific nature. Very often, most of the funds had gone into the construction of prestigious-looking buildings and into salaries, and the growth of the collection was thus partly left to private sponsorship. Being frequently unable to raise the money for the purchase of systematic collections offered them by an increasing number of American field collectors, some museums had to be content with what travelers had found to be of curious interest and were now willing to dispose of free of charge. Such collections, of course, adequately mirror neither native cultures nor native aesthetics, but helped to shape the public's view.

Most European colonial powers were funding scientific expeditions primarily in their own colonial possessions, and even countries without colonies were more often looking into areas where colonies still might be established rather than supporting expeditions in the United States or Canada. Occasionally, a European might join an American expedition; H. F.

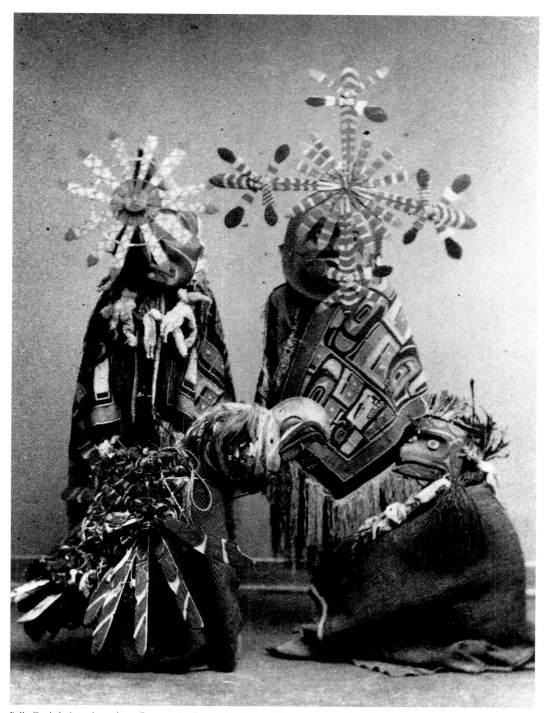

Bella Coola Indians, brought to Germany by Captain Jacobsen, performing a dance from the winter ceremonial cycle. Berlin, 1885

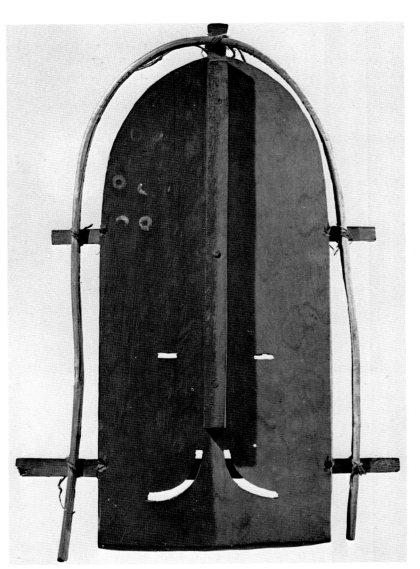

Mask, by Inuk Elio of Angmagssalik, East Greenland. 1934. Wood, 15" (38 cm) high. Musée de l'Homme, Paris

Mask. Eskimo. Kodiak Island, Alaska. Wood, 12⅝" (32.5 cm) high. Musée des Beaux-Arts et d'Archéologie, Boulogne-sur-Mer, Collection Pinart

C. Ten Kate, a Dutchman, teamed up with the Hemenway Expedition to the Southwest in 1887–88 (collections in Leiden and Rotterdam). Noteworthy among the French investigators of western North America is Alphonse Pinart, whose collection of Aleutian material assembled in 1871 (now in Boulogne-sur-Mer) had a strong impact on French artists, and who later went to southern California with Léon de Cessac (collections in Paris).

Scholarly collections may have helped the increase of knowledge, but they were not always spectacular. Less scholarly but at least fairly well documented and most of all vast were the collections assembled on the Northwest Coast and in the Arctic by the Norwegian ship captain Adrian Jacobsen for various German museums (most notably Berlin, but also Leipzig, Cologne and Lübeck), as well as for his native Oslo. In 1885, Jacobsen brought a Bella Coola troupe (p. 93) for a year-long visit to Germany, where the Indians not only danced but apparently also carved. German-born Franz Boas was attracted through these Bella Coola to the Northwest Coast; he became one of the founding fathers of professional

American anthropology and author of the influential book *Primitive Art.*

Despite the tremendous impact that the Bella Coola had on German audiences (the ladies especially fell for them), German (and European) notions about Indians remained closely linked to Plains Indian images. Museums could do little to set the balance right, but they were able to offer to an interested minority (which included artists) a broad spectrum of Native American tribal arts. By the outbreak of World War I, Berlin, for example, had acquired major collections from all cultural areas, including Southwestern material from Hopi Indian agent Thomas V. Keam, Californian basketry from Samuel Barrett and Wilcomb, or more recent Plains material from Clark Wissler. Berlin, it might be noted, had a zoo in which the compound housing a herd of American bison was carved in the style of Northwest Coast art.

By the turn of the century, however, heavy American field collecting—for the domestic museums recently established from coast to coast among native American societies suffering the shock of transition from independent nations to wards of a

foreign government—placed European museums at a disadvantage when it came to collecting American Indian material. Many museums were unable or thought it unnecessary to continue to purchase field collections or contemporary Indian products. Acquisitions were made from dealers like Webster or Oldman, who regularly published their catalogs, or from the heirs of nineteenth-century travelers. Private collecting of Indian artifacts was a fairly widespread activity everywhere in Europe, and some important collections were being formed especially between the two World Wars. The reasons for specifically collecting Indian material remained largely based on a romantic interest in Indian cultures and ways of life, with aesthetics playing a subordinate role. In the same vein must be seen the establishment of museums concentrating exclusively on Indian cultures. The first such institution in Europe seems to have been the Karl-May-Museum in Radebeul near Dresden, established (by a German squaw-man from Buffalo Bill's Show) in honor of the most popular German author of Indian fiction. Opening in 1928, it was founded just a dozen years after the Museum of the American Indian in New York.

The one area in North America where Europeans continued to collect in the field was the Arctic, especially Greenland, where the Danes had, of course, a stronghold. But the French also established an anthropological field station in East Greenland (active to this day), which also generated museum collections. Among these was a magnificent collection of the grotesquely distorted Angmassalik masks, one of which found admission into André Malraux's Imaginary Museum.

The "discovery" of American Indian art apparently occurred independently at about the same time in America and Europe. Just at the time when American painter John Sloan organized the first show of Southwestern Indian painting in New York, several books dealing for the first time with Indian-made objects as art appeared on the trade book market. But while the American approach was based on living arts and focused on the Southwest, the European approach was based on museum specimens and largely focused on the Northwest Coast. Leonhard Adam's *Nordwestamerikanische Indianerkunst* was a pathbreaking study of Northwest Coast art based on the Berlin collection. It was published in the 1920s almost simultaneously with a much less well conceived volume on Northwest Coast art by Fuhrmann, which is, however, noteworthy for its coverage of other European collections and for the fact that it was published by the Folkwang, a school and gallery of art and design in Essen.

At the time when most European anthropology museums had been established, cultural evolutionist theories had dominated the field, and very often the whole concept of displays reflected the idea of progressive development from "primitive" to "civilized." Even as mainstream anthropology turned away from this somewhat simplistic model (and museums generally followed suit a generation or two later), the more or less educated public didn't catch up as quickly with the new trends. Exotic largely remained synonymous with Primitive and/or Archaic. Undeterred by cultural relativism, artists searching for new old roots might find one ready solution in tribal arts and cultures. Still vital tribal cultures of Africa and Oceania clearly received preference over the nostalgic and romantic appeal of North American Indians. Despite the influence that existed, Indians remained a secondary love affair for European artists.

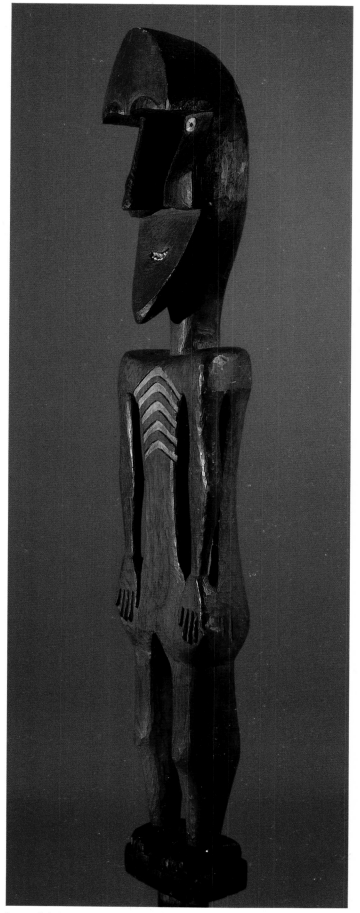

Figure. Salish. Washington. Painted wood, shell, and bone, 36" (91.4 cm) high. American Museum of Natural History, New York, Department of Anthropology

Blanket. Tlingit. Alaska. Dyed wool and cedar-bark fibers, 22" (55.9 cm) high. Museum of the American Indian, Heye Foundation, New York

Mask. Eskimo. Point Hope, Alaska. Wood, 7⅝" (19.6 cm) high. The National Museum of Denmark, Copenhagen, Department of Ethnography

Mask. Eskimo. Point Hope, Alaska. Wood, 8⅛" (20.8 cm) high. The National Museum of Denmark, Copenhagen, Department of Ethnography

Figure. Northwest Coast, British Columbia. Wood, 46¼" (117.5 cm) high. Museum für Völkerkunde, Berlin

Mask. Eskimo. Kodiak Island, Alaska. Painted wood, 23¾" (60.3 cm) high. National Museum of Natural History, Smithsonian Institution, Washington, D.C.

Helmet mask. Zuni. Arizona or New Mexico. Painted wood, feathers, and mixed media, 21" (53.3 cm) high. Collection Elaine Lustig Cohen and Arthur A. Cohen, New York

Mask. Eskimo. St. Michael, Alaska. Painted wood, feathers, and mixed media, 31½" (80 cm) long. Sheldon Jackson Museum, Sitka, Alaska

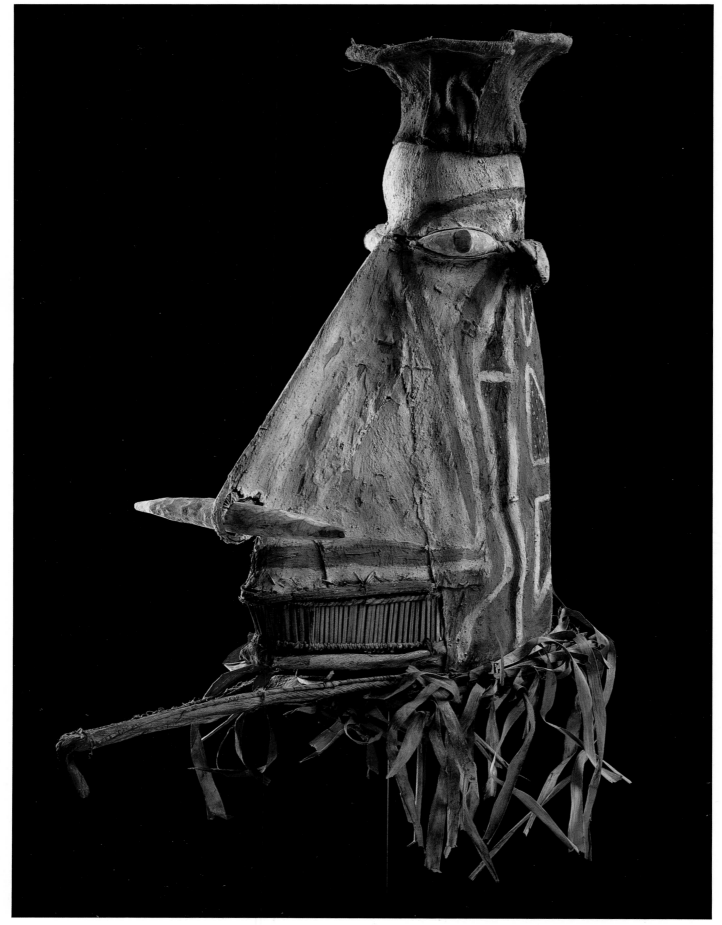

Mask. Witu Island, New Britain. Painted bark cloth and mixed media, 25¾" (65.4 cm) high. Musée Barbier-Müller, Geneva

FROM OCEANIA

Philippe Peltier

During the first Pacific crossing in 1521 Magellan encountered no islands. In the late sixteenth century, the Portuguese and Spaniards progressively discovered the islands of the Pacific, followed by the Dutch, who ousted these two rival nations by establishing the East India Company in the Philippines in 1602. Since such expeditions—including Tasman's in 1642 to New Zealand, where he was unable to land—did not produce their expected profits, they were abandoned for a century.

In the early eighteenth century, the publication of Renaissance voyages (often embellished), the progress of navigation, the interest taken by the century of the Enlightenment in the sciences, and the theory of a *terra australis* as counterbalancing the continents of the northern hemisphere—a theory reintroduced in France by Charles de Brosses—brought about a fresh upsurge in sea voyages, which, under the cover of scientific exploration, were no less concerned to discover new economic resources for the benefit of Europe. Thus John Byron in 1765, then two years later Samuel Wallis, Philip Carteret, and Bougainville, and finally Captain Cook during his three voyages between 1768 and 1779, while they did not find this mythical southern land, nevertheless established the map of the Pacific. But another myth was created.

The voyages of Cook and Bougainville were to serve as reference points in the debate carried on by the eighteenth-century *philosophes* over the natural state of man. Having read about these voyages, eighteenth-century minds retained only the passages on Polynesia. Bougainville, though somewhat reserved about the morality of the "savages," and Commerson, who accompanied him on his voyage, were to embellish the

reality on their return. Tahiti, called New Cythera by one, Utopia by the other, became an idyllic place where the nobility of the inhabitants, the simplicity of their customs, their worship of the love god, and their language recalled the *Georgics*.[1] Polynesia was regarded as the Aegean Sea of the Pacific, and painters represented the natives with the features of antiquity. Diderot contributed to the myth with his *Supplément au voyage de Bougainville*, as did Restif de la Bretonne, whose *La Découverte Australe* is a novel of initiation derived from Medieval fables, in which everything in these lands of the antipodes is the opposite of what it is in Europe.

But there was soon to be trouble in paradise. The Noble Savage possessed a childish, fickle character, which drove him to the worst excesses. Cook's death during a skirmish in Hawaii in 1779, and that of the Frenchman Marion de Fresne in New Zealand, gave rise to the image of the "ignoble savage."

Centering on man in his natural state, a state thought to be all the stronger given the inherent healthiness of nature, the attention of naturalist scholars was directed more to the customs and character of the savages than to their objects. In the illustrations of voyage narratives, these are never shown in the hands of the natives, but in separate plates. Despite the craze that they provoked in Europe, these objects were primarily "objects of curiosity." The aesthetic judgments brought to bear on them vary according to the observers. While some may admire the skill of the carving, for others they are simply crude objects comparable to those produced by sailors, and finally for still others they rival the products of antiquity that Europe was in the process of rediscovering through the efforts of Winckelmann.[2]

At the turn of the century, Europe was in search of its origins, and the Romantic period, obsessed by the tragic and sublime, was more fascinated by cannibals than by the ancient savage. It was to find in the world a mirror of its own development. For the French Ideologues of the Revolution and the Empire, the "savage," weakened by nature, knew only an undeveloped stage in which society was still in a state of immaturity. Objects, in both England and France, reflected this conception. Péron, who accompanied Baudin on a voyage to the southern hemisphere in 1800–04, compared the objects collected in New Guinea to those of the ancient civilizations of Western countries.[3]

The collections assembled by the explorers—no object from the sixteenth century seems to have survived, at least in French collections—were either to be dispersed in various European institutions or to remain in the hands of those who had collected them. Though Jauffret in France wished to set up a natural-history museum in which all the evidence of different civilizations would be represented, this overly Utopian project failed to see the light of day. The collections brought back by Bougainville and deposited in the library of the Order of Saint Geneviève in Paris were looted during the Revolution,[4] and those presented to Joséphine Bonaparte by Péron seem to have met the same fate.[5]

It was in England, through the efforts of Sir Ashton Lever, that the first museum to assemble a portion of the collections brought back by English voyagers was created. First established in Manchester, the Leverian Museum was to be transferred to London in 1775, before being dispersed in 1806 at public auction; a number of pieces were acquired by the Vienna Museum.[6]

These early collections were augmented by ships sailing the Pacific, where trade and evangelism soon reached a high level of activity. The first ships were the European and American whalers of the East Indian Marine Society, founded in 1799, and the objects they collected laid the foundations for the Peabody Museum in Salem. They made Hawaii their port of call and spread out all over Polynesia. Sailors fleeing the draconian discipline sometimes jumped ship on the more hospitable islands. The London Missionary Society had established itself in Polynesia by the end of the eighteenth century and in competition with Catholicism soon extended throughout the Pacific. Objects were brought back by the missionaries, both for purposes of edification and as proof of their work of "salvation." The number of conversions increased, and in Tahiti on February 15, 1815, and in Hawaii a few years later, "idols" were burned on pyres. Those that escaped the holocaust were sent to London and displayed in the Missionary Museum before being transferred to the British Museum in 1890. Other missionary museums were created at the time in Europe. One could point out other sources for the same period, first of all French, Prussian, and British scientific expeditions, as well as the warships of the Western powers engaged in protecting their nationals in the territories that they were beginning to annex, and finally the recruiting ships that furnished cheap manpower for the plantations.

In effect, at the same time that scientific voyages were going forward, adventurers and traders of all kinds were being drawn to the South Seas. The discovery of sandalwood in the Fiji Islands in 1804 was the starting signal for the pillage pursued in Hawaii in the 1820s, the New Hebrides in 1825,

and New Caledonia in 1840. Then sea cucumbers or *bêches-de-mer* were fished and exported to China. After 1850, the ease of communications with Europe encouraged a large influx of settlers. The copra trade grew steadily after 1868, and plantations were enlarged to the detriment of the natives, especially in Queensland, Fiji, New Caledonia, Tahiti, Hawaii, and Samoa. Around 1863, the demand for cheap labor for these plantations brought about the forced recruitment of the male populations of the New Hebrides, the Gilbert Islands, New Caledonia, and other places. Little by little, the islands lost whatever independence they may have had: missionaries, warehouses, and consuls played a leading role in the direction of their affairs (Hawaii, for example). Thus New Zealand and Fiji were annexed in 1840, and New Caledonia in 1853, but the Solomon Islands, Samoa, and the New Hebrides were later divided among different nations (1877 for the first, 1879 for the second, 1887 for the third). The Tonga Islands, after many civil wars, became a protectorate at the end of the century. The islands of Micronesia experienced various fates, but overall their annexation took place in the 1880s. New Guinea, which had not been subject to labor recruitment, was divided up: the western part was annexed by the Netherlands as early as 1828, the northeastern part by Germany in 1884, and, also in 1884, the southeastern part was made a British protectorate.

Thus a multitude of travelers, sailors, scholars, settlers, and adventurers brought back a few objects, or even more complete collections, along with geological, botanical, and zoological specimens, chiefly from Polynesia at the beginning of the century. But no ethnological museum was ready to receive these collections. They ended up either in the collections of curiosities belonging to the king, the aristocrats, or the scholars who had financed the expedition, or in museums of natural history. The first endowed museums were likely to be in ports and capitals: for example, in France, the museum of Boulogne, the Musée d'Histoire Naturelle in Caen, which received the Dumont d'Urville collections, the Musée des Médailles of the Bibliothèque Nationale in Paris, and also the Musée de la Marine, installed in 1850, which inherited the royal collections.[7]

It was only in the last third of the nineteenth century, at the time when Europe was beginning its colonial expansion, that ethnological museums increased in number.[8] Oceanic objects often constituted their initial collections, as in Vienna and Copenhagen, and at Harvard. One should not, however, overlook the role of the Expositions Universelles, which were regularly to celebrate industrial progress and display the products of the colonies. One could also see Oceanic works there, as in London in 1851 and Paris in 1855, where the paintings of Australian aborigines were exhibited.[9]

Thus, in January 1878, the Musée des Missions Ethnographiques opened in Paris, exhibiting a collection of Hawaiian pieces owned by Ballieu, then French consul in Honolulu. This museum was the precursor of the Musée d'Ethnographie de Paris, which was created in the same year under the direction of E. Hamy, but did not open its doors until 1882 (pp. 102, 258).

At the 1878 Exposition Universelle in Paris, three ways of interpreting the Primitive arts took shape, as represented by

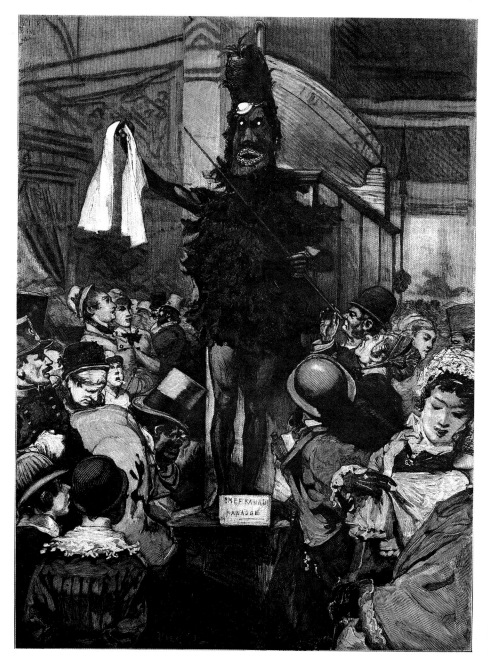

A mannequin wearing a mask of a Kanaka chief (New Caledonia). Exposition Universelle, Paris, 1878. Engraving after a drawing by M. Vierge, published in *Le Monde illustré*, December 14, 1878

three different locations: the Palais des Sciences Anthropologiques, the colonial pavilions, and finally the "Exposition des Arts Anciens" in the new Palais du Trocadéro.

In the first, the objects were displayed next to skulls and chipped stones from prehistoric periods. Weapons, chiefly from New Caledonia and New Zealand, were presented in the form of trophies to which were added two Korwar figures from Netherlands New Guinea, jade Tikis from New Zealand, and objects from the Tonga Islands.[10] It was a feeble representation dominated by weapons, which, collected in great numbers throughout the Pacific, made it possible, along with the objects from daily life, to classify societies—from the least developed, represented by Australia, to the most aristocratic, those of western Polynesia.

In the colonial pavilions, the objects were more numerous. England and France showed products from Australia and New Zealand, French Polynesia and New Caledonia, respectively.

But pieces from New Guinea turned up in the British section, from the Gilbert and Solomon Islands in the French, sometimes under false attributions. Each object was assigned to an established category based on European products and placed in proximity to them: a mask from New Caledonia found itself classified as a "knickknack," while the few sculptures were mingled with "implements of ordinary usage."[11] Indigenous objects were used to demonstrate the value of Western products and the progress of colonization.

The most representative display was assembled in the "Exposition des Arts Anciens." The history painter Jean-Léon Gérôme had been put in charge of a section devoted to the "ethnography of peoples foreign to Europe." Polynesia was represented by Tikis from Tahiti, axes from the Cook Islands, clubs from the Marquesas, and—the most admired of all—a boat from New Zealand. Melanesia was shown by sculptures from the Solomon Islands, a mask and ceremonial axes from

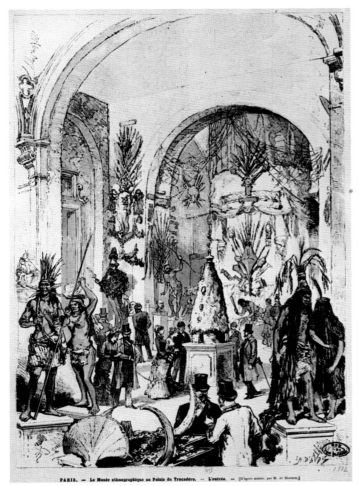

Installation of the entrance hall of the new Musée d'Ethnographie, Palais du Trocadéro, Paris, 1882. Engraving after a drawing by de Haenon, published in *Le Monde illustré*, May 16, 1882

New Caledonia, objects from Geelvink Bay in Netherlands New Guinea, and, in the midst of weapon trophies, some "bowls, plates, and headdresses." But all that the critics remembered of this "childish and barbaric, naive and frightful" art was "the splendor of its wood...the finish, the workmanship, the frequent search for ornamentation," which established a connection between these objects and the arts of the Orient.[12] Thus the ornamental aspects were more noticed than the sculptural ones. Already in 1869, when Racinet had published his book *L'Ornement polychrome*, one plate had reproduced motifs inspired by the arts of Oceania and the sculptures of New Zealand. The latter were the most represented and the most prized, because they carried to their extreme a system of interlacings that had nothing to do with an imitative design, but came from pure imagination and was therefore perceived as entirely decorative.[13]

At this Exposition Universelle, the objects were there primarily to demonstrate an origin and a state of civilization. Official painting, governed by a rehearsed ideal of beauty and truth, devoted itself, in the classical tradition, to the study of physiognomy and character when it put "peoples foreign to Europe" on display. In 1886, Rochet was to proclaim that "History painting will be ethnographic or nothing," and he dreamed of a museum that, unlike the Musée d'Ethnographie, would only show human types in all their anthropological truth.[14] Thus the objects to be exhibited and studied, in

preference to sculpture, were masks taken as portraits of savages, both as they were and as they imagined themselves to be. It was in this sense that they were represented on the warrior mannequins at the Musée d'Artillerie des Invalides, which was reorganized for the 1878 Exposition.[15]

The representation of the islands was very unequal in the kind of objects and number of objects involved. It depended on provincial collections, private collections, and colonial agencies, which played a fundamental role in the dispersal. Each country obtained objects from its own colonies on a preferential basis.

Thus in 1878 in Toulouse, the Maison Saves, a firm established in New Caledonia, sold "objects of curiosity." Likewise Le Mescam in these years collected objects from New Caledonia (masks, a door lintel) and the New Hebrides (including a carved tree-fern and some modeled skulls), which in 1895 he left to the museum in Le Havre, Braque's native city. In 1857, the Maison Godeffroy of Hamburg set up its first warehouses in Samoa, then in 1874 in the Bismarck Archipelago, and its ships sailing the Pacific brought back objects some of which were to form the basis for its private museum, set up in 1881. The Hernsheim firm established itself in 1876 in New Ireland and gave to the Berlin Museum some masks that are among the oldest in its collections.[16]

But museums were not the only beneficiaries of gifts and auctions. The Bertin Collection, exhibited at the Trocadéro in 1878 and sold in Paris in 1887, is a case in point. In addition to objects from Tahiti, Bertin owned an important group of pieces from German and Netherlands New Guinea. A catalog was published for the sale—a relatively rare occurrence in France, which shows a growing interest in exotic objects. The collection was purchased by several buyers, including Hamy, director of the Musée d'Ethnographie, and Heyman, the dealer in the Rue de Rennes where Matisse bought his first piece of African sculpture. One can suppose that even at this early date several antique dealers were selling exotic objects to collectors who were not necessarily connected with anthropology: Bertin was a wholesale jeweler.[17]

In April 1882, the halls of the Musée d'Ethnographie in Paris were opened to the public. Its collections were made up of certain objects that had figured in the 1878 Exposition, including those displayed by England and the Netherlands, and others gathered by the Laglaize and Raffray expedition to the northeast coast of New Guinea and by Bourdil on the southeast coast. Weapons, displayed in the form of trophies, still predominated, and represented the principal islands of the Pacific. Only Polynesia and New Caledonia were illustrated by more complete series. Then in 1884 the Higginson Collection from the New Hebrides, which included large sculptures, was arranged in the entrance hall of the Musée d'Ethnographie. It was to be completed in 1890 by a portion of the François Collection, after an exhibition at the Orangerie of the Musée d'Histoire Naturelle. With these two collections, Paris at this time owned the most complete ensemble from the New Hebrides, in which sculptures, masks, drums, grade-society figures, and mortuary statues were all represented.[18] In 1887, the acquisition of the Bertin Collection, given to the museum by Roland Bonaparte, made it possible to display pieces from German and Netherlands New Guinea.[19] Following a visit to the Colonial Exposition in Amsterdam in 1883, Prince Bonaparte bought a number of

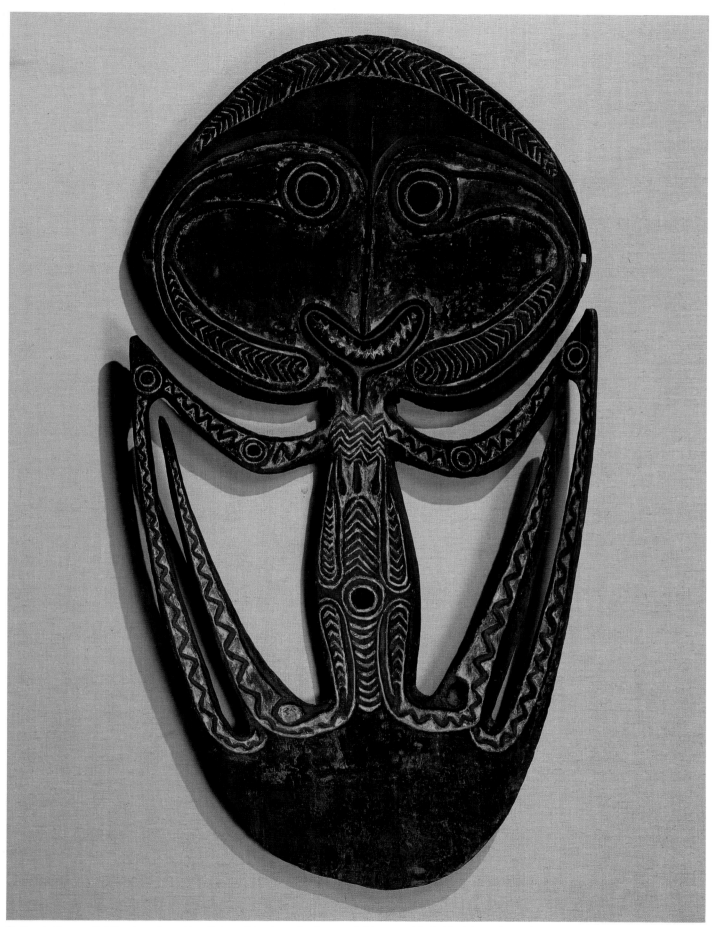

Skull rack. Kerewa. Gulf Province, Papua New Guinea. Painted wood and rattan, 56″ (142.2 cm) high. The Metropolitan Museum of Art, New York; The Michael C. Rockefeller Memorial Collection, gift of Nelson A. Rockefeller

The Kanaka Village (New Caledonia), Exposition Universelle, Paris, 1889. Engraving after a drawing by Louis Tinayre, published in *Le Monde illustré*, June 27, 1889

objects from Netherlands New Guinea, especially from Geelvink Bay, where a permanent warehouse had been set up in 1882.[20] In 1886, during the Colonial Exposition in London, the first large Tapa masks from the Gulf of Papua were shown. New Zealand was represented by an important group of objects from the Buller Collection, and a memorial exhibition was dedicated to Captain Cook.

In Germany, following the official taking over of New Guinea and the Bismarck Archipelago in 1884 by the Deutsche Neu-Guinea Compagnie, the trade department charged with their administration, an exhibition of pieces collected by this agency opened in Berlin.[21] This still largely unknown region of the world soon became the site of important expeditions. The Russian Miklouho-Macklay, who was the first to sojourn on the northern coast of New Guinea, assembled collections there that were exhibited in St. Petersburg in 1886 The cities of the Hanseatic League, Berlin, Leipzig, which in 1885 bought a part of the Godeffroy Museum, as well as Dresden, all received collections from the most heavily colonized points: Palau, the Carolines, New Ireland, and New Britain. The stone carvings from New Ireland seem to have attracted particular attention. Only the northeast part of New Guinea was represented: the exploration of the interior was slow and difficult, and objects came chiefly from the coast and the islands. The rhythm of scientific expeditions slowed down after 1895[22] The objects collected by d'Albertis, who had been the first to go up the Fly River in 1876, were exhibited by the Museo Etnografico in Rome. From the Gulf of Papua to the Massim region, a considerable number of objects arrived in British museums, such as the Pitt-Rivers, set up at Oxford in 1884, or Cambridge, which received objects from the Torres Strait Expedition of 1888.

Museums in Budapest were enriched by collections from the Néprajzi Mission, which were exhibited in 1896, the collection of Lajos Biró, formed between 1896 and 1902 in New Guinea and the Bismarck Archipelago, and finally by Count Rodolfe Festetics, who in 1895–96 went around the world on his private yacht.[23]

This brief survey gives an idea of the range of the Melanesian collections, which completed the older ones from Polynesia, a range extended in the field by an increase in objects due to the introduction of new wealth and of iron.[24]

Publications multiplied in the years 1880–95. These publications mark important dates in which two interpretations of the Primitive arts come face to face. Haddon, following an evolutionist line, considers only the motifs, their transformation and magical character, and takes no interest in the objects as such. Gross substitutes an interpretation of objects in their social context for the interpretation of their signs, and thus makes it possible to take all the forms of production into account.

During this period in France, colonial expansion in Africa and Indochina was to hold the public's attention. At the 1889 Exposition, Tahitian and New Caledonian dwellings were reconstructed in the "native villages" offered to visitors on the Champ de Mars in Paris. For the first time Oceanic objects were viewed in their proper setting. But they were part of a "never-never land," and aroused a feeling of strangeness: it was exoticism that predominated, or the dream of an early world,

Easter Island. Drawing by Pierre Loti, dedicated to Sarah Bernhardt, January 7, 1872

of a return to the childhood of civilizations, of an Eden forever lost. It was an exoticism that derived from a syncretism and an "aesthetic of the different."[25] From Louise Michel to Gauguin, a hearkening to myths of the Stone Age takes precedence over forms. Loti is in search of a lost civilization embodied in Easter Island, already a *memento mori* of the Pacific for Captain Cook as well.[26] Exotic decoration was all the rage: Sarah Bernhardt, for example, constructed a buffet with Maori sculptures that had been given to her in 1891 during her voyage around the world.

Following the 1889 Exposition, the Musée d'Ethnographie in Paris was reorganized. The Oceanic collections, cramped for space on the stair landings, were moved to a new hall in 1892. But the museum's sorry financial state did not allow for the appointment of a new custodian. Despite its installation, the hall remained officially closed to the public until 1910.[27]

In France, unlike Germany and England, few objects were brought into collections. Certain Pacific islands underwent a sharp drop in population.[28] The source of objects dried up. The Society Islands were Westernized, but the missionaries who had banned the ancestral customs had copies of objects made. At the Exposition Universelle of 1900 in Paris, "curios," among other things, were shown in the colonial pavilions, especially in the one for Tahiti (p. 106).[29] Colonial expansion brought about an increase in the number of exhibitions and the creation of offices in the large provincial cities, where alongside commercial products some museums displayed

The Tahitian Pavilion, Exposition Universelle, Paris, 1900

objects that in certain cases might have caused one to wonder if they had not been fabricated on demand. Thus in Paris, after Marseilles and Bordeaux among others, the Colonial Office was transferred in 1901 to the Palais Royal, where a permanent museum was installed.[30]

On the other hand, there was a broader range of activity in England and Germany. German expeditions were resumed in 1905, sent out by the cities of Hamburg and Berlin. Better organization made it possible to collect a considerable amount of material in the western Pacific, including pieces from the interior of New Guinea. Thus the Hamburg expedition of 1910–11 brought back 6,667 objects to that city alone. Brigham, the director of the Honolulu museum, passing through Hamburg in 1913, found the museum closed (the collections, cramped for space, were in the process of being installed in a new building), but saw some of the Godeffroy material at the "dealer Umlauff"; in Berlin there was such an accumulation of objects that he judged it impossible to study them.[31] Scientific publications multiplied. Emil Stephan's book *Südseekunst*, published in 1907, marks an important date in the history of ideas. It treats as relative, for the first time, the concepts of fidelity to nature and stylization.

During the same journey, Brigham inspected the British collections in London, Oxford, and Cambridge, and paid visits to the collectors Fuller, Beasley, and Edge-Partington. Its maritime and colonial tradition had indeed designated Great Britain as the ideal country for collectors of Oceanic

art, and the market there was likewise more active. The dealers Webster and Oldman, the latter specializing in weapons, published catalogs. An analysis of them confirms that objects came from all regions of the Pacific, but with the British colonies, particularly New Zealand and the Gulf of Papua, being predominantly represented. Objects from Hawaii and French Polynesia are rare, and there are no objects from the interior of New Guinea; finally, shields and especially weapons are more numerous than sculptures.[32]

In the absence of sources, it is difficult to determine the number and nature of objects circulating in France at this time.[33] In the first collections made by artists and connoisseurs between 1906 and 1919, African objects outnumber Oceanic ones. It was the Fauves and Cubists in Paris, and the German Expressionists first in Dresden and later in Berlin, who were to see and collect them. Unlike the French, who, with the exception of Gauguin, had never gone to the Pacific, Germans such as Nolde and Pechstein accompanied two scientific expeditions in the years 1913–14.[34] Yet the example of Gauguin—a certain number of whose canvases and objects were kept by the ceramist Paco Durrio, a friend of Picasso, in his studio (canvases that he lent to the exhibition organized by the Salon d'Automne in 1906)—was to attract artists to Polynesia. If we are to believe the dealer Paul Guillaume, it was the painter Frank Burty Haviland who was the first to emphasize the architectural character of Tikis. As for Matisse, "when someone is in his studio, he lectures him and quotes Nietzsche

and Claudel, even mentioning Duccio, Cézanne, and the New Zealanders."[35] In 1907, Picasso acquired a Marquesan Tiki (p. 283), and two New Caledonian sculptures were hanging in his studio in 1908 (p. 299)[36] Vollard owned two large Marquesan Tikis, which adorned the cellar where he received painters and writers for dinner. Thus in France the first pieces noticed by artists were chiefly Polynesian. Determining what pieces were bought by Level, an early collector soon friendly with Picasso, Hessel, and perhaps Fénéon, both of whom worked at the Galerie Bernheim, is a more risky proposition. Only the first exhibitions and subsequent publications make it possible to construct a more complete picture.

In those years no handbook was devoted to Oceania, and the Oceanic hall of the Musée d'Ethnographie was officially closed until 1910, though it could be visited by special arrangement with the guards or curators (p. 335, note 49) and some objects could be seen in the large entrance hall devoted to Africa and Oceania. The Musée d'Artillerie, and until 1907 the Musée de la Marine in the Louvre, displayed a number of objects. The latter's collections were to be transferred to the Musée de Préhistoire in Saint-Germain-en-Laye, near Paris, where, beginning in 1910, they were reinstalled in the Salle des Comparaisons, except for a few Hawaiian pieces deposited in the Musée d'Ethnographie.[37] The museum's register nevertheless records a certain number of visits. Besides those of travelers and anthropologists, the most outstanding were those of František Kupka, who came in 1907 to copy motifs on Mexican stelae, and Robert Delaunay, who, accompanied by several other people, came on October 16, 1909, to see the Oceanic hall.[38]

The London collections, more than those in Germany, seem to have been the point of reference at the time. Thus when Elie Faure devoted a chapter to "the art of the tropics" in the second volume of his *Histoire générale de l'art*, all the objects reproduced belonged to the British Museum, whose *Handbook to the Ethnographical Collection*, published in 1910, was to serve as a reference text for the first lovers of Primitive art.[39] Though this catalog is dispassionately ethnographical, Elie Faure, taking up once more a view that had persisted since the eighteenth century, describes the art of Oceania, the Aegean Sea of the Orient, as a violent—even distorted—art, heightened by colors that harmonize with nature. He sees it as an art of line, of the decorative, pushed to its extreme in New Zealand, a country where, because of savagery and cannibalism, "a stubborn desire for balance and architectural rhythm" is in ferment, the germ of a more developed art whose prehistoric traces can also be found in the hieratic sculpture of Easter Island.[40]

This text is echoed in 1917 by Paul Guillaume's *Sculptures nègres*, published on the occasion of the exhibition of Primitive art that marked the opening of his gallery.[41] If Apollinaire in the foreword to the book declines any attempt at classification and interpretation as too risky in the absence of precise information on the origin and function of the objects, Paul Guillaume recalls the relation of the arts of Oceania to the Neolithic arts of Europe. The races of Oceania created "monstrous faces capable of arresting or repelling evil spirits. Everything for them is a subject for anxiety, and they are entirely preoccupied with driving away evil spirits. . . . Hence these grimacing faces placed at the door or at the top of their huts. The more hideous they are, the more powerful they are supposed to be."[42]

Between these two dates, two exhibitions in which Oceanic art was represented were held in Paris: one at the Galerie Levesque in June 1913, the other under the auspices of the "Lyre et Palette" association in November–December 1916. The first showed a piece from New Guinea, the second a Tiki from the Marquesas Islands, a "decorative sculpture," an idol, and a Kanaka mask[43] a feeble representation of Oceania, lost amid African objects. So it should come as no surprise that, in his 1917 catalog, which includes only four Marquesan objects as against twenty African ones, Paul Guillaume concludes that the forms of sculpture in Oceania are less diversified than African ones.

The exhibition at the Galerie Devambez in 1919 was organized by Paul Guillaume. Clouzot and Level wrote the preface to the catalog and published *Art nègre et art océanien*.[44] These publications make it possible to get a better idea of the state of the collections. Level had lent the exhibition fourteen Oceanic pieces of which seven were Polynesian (Hawaii,

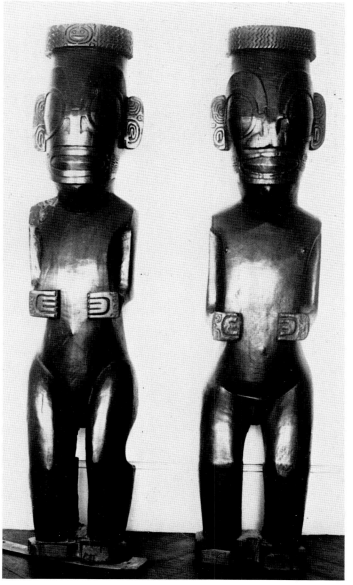

Two Tikis. Marquesas Islands. Wood. Private collection. Formerly collection Ambroise Vollard. Published in Apollinaire and Guillaume, *Sculptures nègres*, 1917

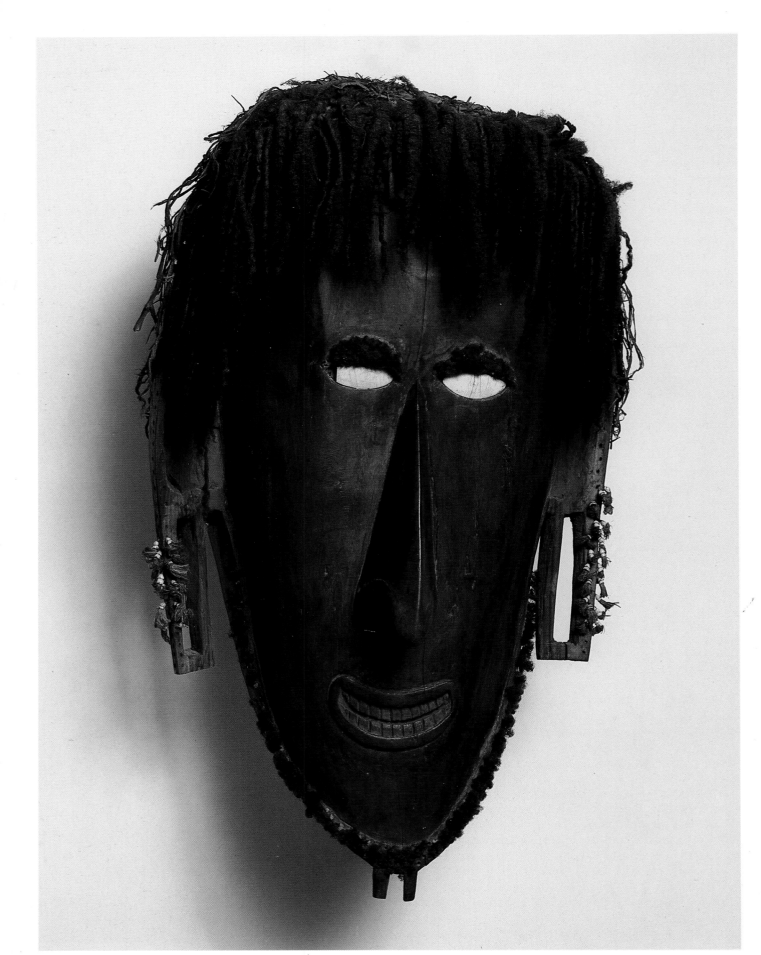

Mask. Saibai Island, Torres Strait, Papua New Guinea. Wood, shell, fiber, and human hair, 27¼" (69.3 cm) high. Friede Collection, New York

Easter Island, Marquesas Islands) and seven Melanesian (New Guinea, New Caledonia), to which were added a Tiki from Paul Guillaume's collection and a sculpture belonging to Léonce Rosenberg. Clouzot and Level set forth ideas quite far from those of Guillaume Apollinaire. While the latter rejected any analytic approach, their interpretation wavers between a judgment deduced from formal criteria and the Western view that sees the Melanesian as a being governed by spirits. They work out a classification of objects in terms of their plastic values—the more geometric pieces being the more esteemed—and the supposed state of savagery of the groups that produced them. At the very bottom of the scale lies Australia, which according to them is totally ignorant of art and whose sole display of genius would be the invention of the boomerang. Next comes the Bismarck Archipelago, whose pieces are judged more decorative; then New Caledonia and the New Hebrides, characterized by objects with "ample forms" but whose faces "of carved monsters grimace in an effort to frighten the unreal monster that issues from the imagination of the natives." Finally, Polynesia, whose "Marquesan Tiki, calmer and more serene, is a monster from the realm of the geometric." Polynesian art is placed at the top of the hierarchy by its forms, which seek "abstraction and a kind of absolute" and are compared to the works of young artists, among them Picasso, "an old adept of the Tiki."[45] They imply more strongly than Paul Guillaume that the achievement of Polynesian art is due to a race of Caucasian origin that migrated to these islands. This interpretation is also developed in Réal's book, published in 1922, on the art of Oceania and is in line with the scientific hypotheses of the time.[46]

It fell to Carl Einstein, in the wake of German aestheticians, to analyze works in accordance with their forms. His *Negerplastik*, published in Leipzig in 1915, is about African art, though it mistakenly contained some Oceanic pieces. Oceania is not, however, mentioned in the text. Some of the Oceanic objects were to disappear when the book was reissued in 1920.[47]

On the other hand, the books of von Sydow, one published in 1921 in Leipzig, the other in 1923 in Berlin, offer a more complete synthesis of the Primitive arts. He contrasts the art of Oceania with that of Africa for its decorative vitality, which transforms the surface of objects dedicated to the cult of the sun and of the dead into a system of lines and colors that introduce constant vibration.[48]

Through their different approaches, Clouzot and Level in France, Einstein with his connection to the French milieu, and von Sydow in Germany offer a reinterpretation of the Primitive arts that reflects the aesthetic concerns of the "isms" of the period. Attention seesawed between the Oceanic Primitive and the modern Primitive, and both were offered as models. From the twenties on, the fashion launched by Paul Guillaume at his Bal Nègre—where it seems that nothing Oceanic was represented—was African. Music, dance, and the recitation of stories did as much as objects to draw attention to their spirit.[49] It was a spirit that the Dadaists were to take up again in the course of their manifestations in Paris at the beginning of the twenties. Thus Tristan Tzara in 1917 published some translations of Maori songs that he declaimed

Tapa (detail). Tahiti, Society Islands. Painted bark cloth, 6'6¾" (200 cm) high, overall. Musée de l'Homme, Paris

Tapa. Tonga Islands. Painted bark cloth, 58½" (148.5 cm) high. Musée de l'Homme, Paris

Masks conceived by Louis Marcoussis for the Count de Beaumont's Bal Marin, 1928. Photograph by Marc Vaux. Published in *Variétés*, 1928

during Dada soirées in Zurich, following the example of manifestations in German Expressionist cabarets frequented by Arp and Ernst. This tradition was to be repeated at the Grand Palais in 1920, when Breton danced a Pilou-Pilou.[50] It was also in these years that the Dadaists began their collections. Ernst for his part had bought Tapas during the war; Breton had been encouraged in it by Apollinaire as early as 1916, and this passion was reinforced by reading the magazine *Dada* in 1917. But at this time they were seeking both Oceanic and African objects, although Breton said later that he was unmoved by African art, which he considered "too plastic." Eluard's collection in 1924 contained only "Negro wooden sculptures." Little by little they began to search more actively. Their collections were put together haphazardly from lucky finds and from trips, particularly to England and Holland. Breton was already stressing the *trouvaille* or chance find as a game, the idea of which he had taken over from Apollinaire.[51]

In 1922, the Colonial Exposition opened in Marseilles, and in 1923 the exhibition "Art indigène des colonies françaises" at the Musée des Arts Décoratifs. Clouzot and Level, along with Stéphen Chauvet, prepared the catalog for the exhibition at the Pavillon de Marsan, which repeated a classical orientation: the inspiration of the motifs of exotic products. The spectators' attention is drawn to weapons, utilitarian objects, and above all Tapas, which "achieve ravishing symphonies of color...and make of these fabrics some very decorative pieces."[52] The choice of everyday objects common to the two civilizations (bowls, combs, and vegetable fabrics) leads to a facile identification that makes the retranscription of the motifs possible without much transformation. In being offered as a model, Polynesian art, by its more geometric ornamentation, is rated more highly than Melanesian art, which is found to be too savage, more sexual, and more colorful, hence too shrill and distorted. In this venture even the Tiki god, reproduced on so many of the objects, is reduced to a decorative theme. Nevertheless Oceanic sculpture benefits from a comparison with Western art in its more contemporary manifestations. While for Clouzot and Level in 1919 "the abstraction of the Tiki is a limited application and formal model for the more advanced experiments of artists,"[53] in 1923 they regard a stylized head on a New Hebrides weapon as "an achievement to make the most complete [*intégral*] Cubist turn pale."[54]

The Clouzot and Level text is accompanied by illustrations. New names appear in the list of lenders: in addition to Marcoussis, Picasso, Level, Hessel, Fénéon, and Guillaume, we find Morris, a dealer established in Montmartre since before the war, Ruppaley, a former teacher who along with the artists had been one of the first to collect Primitive art objects, Angel Zarraga, who owned only a small number of Oceanic pieces, and finally G. Lecerf and Prudhome.

Nineteen twenty-six marks an important date. Two exhibitions, one under the aegis of the Surrealists in France, the other at the Flechtheim Gallery in Germany, offered Oceanic objects exclusively.

The Galerie Surréaliste, directed by Roland Tual, opened in March 1926 with an exhibition of Man Ray's "pictures and objects from the islands." The cover of the catalog was illustrated with a Man Ray photograph entitled *The Moon Shines on the Island of Nias*, in which a Nias sculpture from Breton's collection is projected onto a lunar landscape.[55] Though Polynesia was represented by twenty-one objects, including seven from the Marquesas, a larger place was reserved for Melanesia with almost all the principal islands being illustrated by an object. In this ensemble, New Guinea stands out with eight objects and New Ireland with five. Along with Easter Island, this was to be the region whose art the Surrealists admired most and collected with special enthusiasm. The works exhibited belonged to Ruppaley, Level, Morris, Delouis, Eluard, and Tual, as well as two collections designated by the initials L.A. and N.S. If the initials L.A. are transparent (Louis Aragon), ought we to read N.S. as a printer's error for the name of Nancy Cunard, who was in contact with the Group of 24 and was to have an affair with Aragon shortly thereafter? Together they hunted for objects in British ports on two trips, and when Nancy Cunard opened her publishing house in Paris in 1928, the shop was to be decorated with objects from Africa and the South Seas. Tual, a friend of Max Jacob since 1921, began right after the war, despite his meager resources, a collection that was to be one of the most important and which was to be sold in 1930 (p. 113).[56]

The second exhibition opened at the Flechtheim gallery in Berlin under the title "Südseeplastiken." It was also to appear at the Kunstmuseum in Zurich, before being mounted at the Flechtheim gallery in Düsseldorf. It contained 184 pieces almost exclusively from the former German colonies lost as a result of World War I (New Guinea as well as the Bismarck Archipelago and Bougainville), forming the personal collection of Flechtheim, whose gallery dealt in objects from the South Seas as well as modern art. Carl Einstein wrote the preface to the catalog. Relying on the writings of German anthropologists, he goes back to a regional classification and a sociological explanation. He describes the Oceanic world as divided into many communities, each having its own images and demons. Only the worship of the ghosts of ancestors unites them. Motifs and figures are interwoven on objects to recount myths, fables, and the struggles of demons, demons from whom man also draws protection through the intermediary of the totem. Images are dominated by death: the skull is often shown on bodies "transformed into ornamental skeletons."[57] But the violence of these images also comes, as von Sydow remarks, from the fact that the figures are tightly imprisoned by a grillwork.

Mrs. Pierre Loeb seated in the family apartment, Rue Desbordes-Valmore, Paris, 1929

Thus in these years, and especially in France, it was the art of eastern Melanesia that prevailed. As Zervos remarked in 1927, "What happened twenty years ago with Negro sculpture is what is happening at present with Melanesian and pre-Columbian art, from which we do not require direct inspiration but feelings of affinity."[58] With fashion helping along, the number of collections increased. In France, the intelligentsia that was to give financial support to Surrealist pictorial movements, or to the "return to order" in painting, integrated this new form of art into its collections, and followed the example of dealers by displaying modern paintings and exotic objects side by side. Count Etienne de Beaumont organized a Bal Marin, with masks designed by Marcoussis that presented a synthesis of Oceanic and African forms. Madeleine Rousseau, who was both an enthusiast for Oceanic art and an agent, advised Girardin in his purchases of African and Oceanic objects (his collection of paintings was to form the basis for the Musée d'Art Moderne de la Ville de Paris). Between 1927 and 1930, the locations where exhibitions were held shifted and new ideas emerged. The number of auctions increased from 1928 on, especially in Paris where such activity was intense at the time, to reach its height in the years just before the economic crisis. Several books that appeared were aimed at an audience of art lovers. L'Art chez les peuples primitifs by A. Basler, published in 1929, summed up the ideas that had been developed over the previous years, with the author attempting a syn-

thesis in order to explain the process of creation.[59] He is suspicious of Freud's theories, then being developed by von Sydow, and inclines toward the psychology of the perception of space, growing out of the works of Otto Rank and Salomon Reinach, who compare the vision of savages with that of children, "whose sense of reality is less optical than tactile"[60] (an analysis put forth in France in 1930 by Luquet in L'Art primitif, where he expounded his theory of "visual and intellectual realism"[61]). For Basler, art corresponds to a magic naturalism that the experiments of Gauguin and Picasso were unable to match, since their art lacks that "original truth" that is the soul of religious art. Painters would not only have taken back from the Primitive arts a formal system, but also a creative process that their rationalism no longer permitted them to attain; placed on a par with the child, the savage possesses a logic of his own, forever lost in the Western world.

Basler reproduces objects belonging to various collectors: Tual, Bondy, a German painter who was a member of Matisse's Académie and exhibited with the "Group du Dôme," and finally Chauvet, a French physician who was to publish two books, one devoted to Easter Island, the other entitled Art indigène de Nouvelle-Guinée (1930), the first work on this region to appear in France with numerous illustrations; his collection, a very important one, was further enriched by some of the pieces brought back by Count Festetics.

In that same year, 1929, the March-April issue of Cahiers

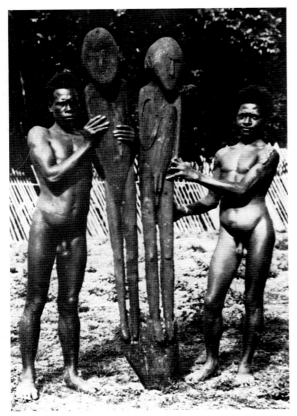

Double figure. Lake Sentani, Irian Jaya (formerly Netherlands New Guinea). Wood, 69½" (176 cm) high. Australian National Gallery, Canberra. Formerly collection JACOB EPSTEIN. Field photograph by Jacques Viot, 1929

d'art, edited by Zervos, was entirely devoted to Oceanic art[62] For the first time, a complete panorama of the arts of the Pacific, or at least what was known of them, was presented. Polynesia retained its leading position. Except for a foreword by Tristan Tzara and one by Zervos, as well as two articles by von Sydow and Fischer, the regional studies were written by specialists, curators of museums (Eichhorn, Speiser, Wölfel), a collector (Chauvet), and Monseigneur Jaussen, who was bishop of Tahiti. All trends in ideas are upheld, from the psychoanalytic interpretation (expounded in an article about von Sydow) to the ethnological. In his introductory text, Christian Zervos disputes Basler and defends the idea that the art of Oceania is the expression of a visionary imagination close to modern art. Beyond the study of form, it is the graphic signs that emerge from the darkness of time that lie at the heart of Oceanic art; the most obvious examples of these signs are to be found on Easter Island, for which Monseigneur Jaussen's article provides an explanatory table. These illustrations inspired Max Ernst at the time (pp. 29, 560), and were reflected in the paintings of Miró. Poncetton and Portier repeated this view in their book *La Décoration: Océanie.*[63] Little by little, through objects and their extrapolation in Surrealist canvases, the demons became more familiar, and the art of Oceania took on a character of universality.

Cahiers d'art and the Poncetton and Portier book reproduced numerous objects. They came from large museums (Berlin, Basel), but also from private collectors: Breton, Eluard, Tzara, Flechtheim, Fénéon, Tual, Delouis (a dealer in Chinese art who had gone over to Primitive art), Ascher (a former painter who had become a picture dealer and whose

gallery was then located in Montparnasse), and finally Carré and Ratton, then among the most active dealers in Paris (Ratton was to buy back several pieces from the Flechtheim Collection), and Pierre Loeb, whose Tapas from Lake Sentani (p. 114) were reproduced for the first time. Loeb, a dealer for the Surrealist painters, also sold Oceanic objects.[64] His private collection (p. 111) was one of the most important of the period. One day he offered Picasso an arm from Easter Island (p. 330), and it was at his gallery that many artists were able to live on familiar terms with the art of the Pacific. He sent Jacques Viot, who had already wandered around in the Pacific, to collect objects in New Guinea in 1929. Viot took a special interest in the art of Lake Sentani, hitherto almost unknown in France, and brought back Tapas and sculptures. On his return, he published an article, an excerpt from a book, in the first issue of the magazine *Le Surréalisme au service de la révolution,* in which, repeating d'Albertis's expression, he described New Guinea as an enchanted castle, but the title, "N'encombrez pas les colonies" (Don't Overcrowd the Colonies), was also an allusion to the government's colonial policy and to the Exposition that was to take place in 1931, with which the Surrealists were at odds.[65]

Three exhibitions opened in Paris in 1930. The first was organized by Tzara and Charles Ratton (the latter prepared the catalog) at the Galerie Pigalle, the second was held at the Galerie de la Renaissance, Rue Royale, and the third at the Galerie Mettler, where a few pieces from Easter Island were displayed.[66] These three exhibitions mark an important turning point: they were the last in the private sector before the economic crisis of the thirties; on the other hand, they presented for the first time in France a complete panorama of the arts of Oceania accessible at the time; finally, it was the first time that an exhibition at the Galerie de la Renaissance, which devoted itself especially to painters of the "return to order," had presented the art of Oceania. But the press paid scant attention to the show. These were also the first exhibitions to draw on the resources of a large number of collectors, some of whom are mentioned for the first time. The first contained 138 objects from Oceania and British colonies, especially New Zealand and the southern coast of New Guinea. The objects came from the Loeb, Ratton, Tzara, Mettler, Ascher, and Chauvet collections. The second showed 180 pieces, in which even the art of the Solomons, largely unknown except for a few canoe prows and Kapkaps, was represented by thirteen objects. The number of pieces shown was divided equally between Melanesia and Polynesia. Though the lenders were the same as at the Galerie Pigalle, these names appear: Lavachery, director of the Musée du Cinquantenaire in Brussels, a former lawyer whose passion for objects had led him into anthropology; Chardenet; Lamart; the woman journalist Titaÿna; the painter Lhote; the lawyer Pomaret; the print dealer Le Veel; the two Stora brothers, dealers in tapestries and Medieval objects, the younger of whom was interested in Primitive art; Yvon Helf, a specialist in old silver; the writer Paul Morand alongside Stéphen Chauvet; Louis Carré; Edouard and Pierre Loeb; Poncetton, the associate of the expert Portier for whom he wrote catalog entries; Félix Fénéon; and finally Bela Hein, a former journalist who kept an antique shop in Paris. These were primarily dealers and a few collectors who were exhibiting, and one may wonder if the chief purpose of these exhibitions was not

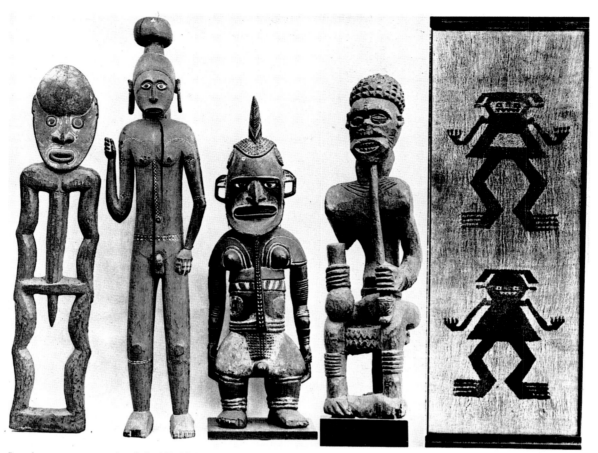

Page from an auction catalog, Roland Tual Sale, Paris, February 1930

the commercial one of promoting an art hitherto reserved for a small coterie. But the economic crisis was to jeopardize this trend.

No Surrealist lent any objects to these exhibitions (Tzara, who organized the exhibition at the Galerie Pigalle, had long since broken with the movement, although he stayed in touch with some of its members). Of course, Breton and Eluard, while they kept a portion of their finds, exchanged or sold some pieces. But their choice of objects was governed by particular criteria. In 1929, a special issue of the Belgian magazine *Variétés* was devoted to the "position of Surrealism." It included an article by Eluard on the "savage arts," an article already in embryo in his notebooks in 1927,[67] and a map of the world (p. 556) on which, contrary to the usual mode of representation, Oceania occupies the center. The size of each country depends on the interest it arouses. Among the more important regions are the Bismarck Archipelago and Easter Island, followed by New Guinea, New Zealand and the New Hebrides, Hawaii and the Marquesas. The Solomon Islands are reduced in size and New Caledonia is absent: Breton found its art too distorted. In the art of Oceania Breton saw "the triumph of the dualism of perception and representation." This attraction to dualism is reflected in his choice of certain objects that in his eyes were its realization. He enthusiastically collected Kapkaps, images of the "synthesis of the concrete and the abstract," and Uli figures from New Ireland, interpreted as figures of hermaphrodites or again sculptures of birdmen from Easter Island (pp. 556, 558, 559), a place he saw as the "modern Athens of Oceania."

In 1931, the Colonial Exposition opened. Some rooms in the new Musée des Colonies were reserved for the "Art of the Pacific." They showed a mixture of old pieces and modern ones created for the occasion. The New Hebrides room displayed for the first time since the war an important group of modeled objects from Malekula. Because of their technique, their colors, their large mortuary effigies and masks, these objects were to occupy as important a place among collectors as works from the Sepik region. A number of Surrealists responded to this Colonial Exposition with an exhibition of their own, organized by Aragon, Thirion, and Sadoul, then members of the Communist Party. Aragon and Eluard, with the help of Tanguy, set up the room where, among other things, some New Ireland sculptures from Aragon's collection, and perhaps Eluard's, were displayed.[68]

In this decade of the thirties, the separation between the Surrealists, on one side, and collectors and painters committed to more traditional paths, on the other, became one of rigid opposition. The Primitive arts were the stakes in an interpretation of the arts of the West: Was painting to be governed by the unconscious or by "classical formalism"? Emmanuel Berl condemned the cult of fetishes as a "manifestation of aesthetic Satanism."[69] In Germany, the 1933 exhibition at the Kunstgewerbe Museum in Berlin, of which Hans Purrmann gives an account,[70] was to be the last before Primitive art was once again included in the "history of savages" and consigned to the Hitlerian category of the "degenerate arts," for which it had served as a model.

The economic crisis, which produced much hardship in

PL. VII

Melanesian masks offered for sale at auction by André Breton and Paul Eluard, July 1931

France, also brought about an interruption. Sales, though they had increased in previous years, now fell off. The pieces put up for auction followed the direction of taste. In 1919, Tapas and rarer objects from the Marquesas and Tahiti were among the more expensive items in the few auctions that took place. Their number began to grow in 1928. The Walter Bondy Collection, consisting of fifty objects from New Guinea, the Bismarck Archipelago, New Caledonia, the Marquesas, Easter Island, and New Zealand, was one of the finest ensembles sold in these years. Another memorable auction was held in 1929, without the collector's name, and the Tual Collection was sold in 1930 (p. 113); it consisted of 119 Oceanic objects, including a tortoise-shell mask from the Torres Strait. Finally, in 1931, there was an auction organized by Ratton, in which there figured an object that was subsequently acquired by Picasso (p. 48).[71] In London, however, sales continued with a strong representation of objects from New Zealand and New Guinea. The last large auction of this

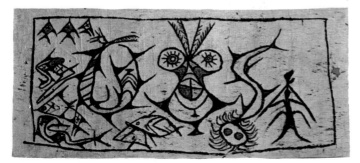

Tapa. Lake Sentani, Irian Jaya (formerly Netherlands New Guinea). Painted bark cloth, 22½" (57.1 cm) high. Collection Dorothea Tanning, New York. Formerly collection MAX ERNST

period was that of the Breton-Eluard Collection, organized by Ratton in July 1931. The cover of the catalog broke with tradition by its typography and by the substitution of the words "sculpture from Oceania, Africa, and America" for "primitive arts," a change that by its reduction of the semantic field sought to introduce these objects into a "universal museum." The sale consisted of 149 Oceanic objects, including numerous Kapkaps and masks from New Ireland. But it did not have the expected results. Certain objects were to be offered again at the shop that Breton opened in 1937 at the sign of the "Gradiva." Eluard handed over his collection to Roland Penrose in 1938.[72]

In search of a new clientele, the dealers Charles Ratton and Louis Carré organized exhibitions in New York. In 1934 Ratton presented his collection of Oceanic objects at the Pierre Matisse Gallery, and in 1936 he showed "American, Oceanic and African." In his introduction to the catalog, Robert Goldwater distinguished Oceanic art from African by its decorative qualities and especially its variety of forms, in which birds and humans were intermingled, achieving the creation of a "paranoiac image" well before the Surrealists.[73]

These years of crisis in France coincide with the reorganization of the Musée d'Ethnographie du Trocadéro. As early as 1929, under the efficient direction of Paul Rivet, assisted by Georges-Henri Rivière, the displays were remodeled. Beginning in these years, exhibitions organized by artistic circles were to give way to ethnological exhibits, "chance encounters" to the study of ritual and the sacred.[74] The important exhibition in 1934 entitled "La Danse sacrée" was an example of this new orientation, one virtually shared by the staff of the magazine Documents, founded and published by Bataille, and of which Georges-Henri Rivière was to be one of the most active participants. Documents insisted on the importance of transgression and sacrifice and was thus opposed to the idealism of the Surrealists.[75] Louis Clarke, in the fifth issue, had an article on the art of the Solomon Islands, then almost unknown in France, and Bataille, in the seventh issue, analyzed Luquet's book on New Caledonian art. He was, however, less interested in the art of New Caledonia than in the idea of a "psychological realism" articulated by Luquet, which allowed him to demonstrate the consistency of children's drawings. Having become a world center with ties to intellectual circles, the Musée d'Ethnographie was to organize an important series of exhibitions and receive a number of collections. In 1933, it displayed the collection of Tapas assembled by Jacques Viot. These Tapas had already been present in the Amsterdam collections, but a new interpretation of this system of small figures, half fish, half insect, in an imaginary landscape that is sometimes distorted to produce a system of lines covering the whole surface, was made in the light of Surrealist painting. In 1934, a room devoted to the Marquesas Islands was reorganized to receive a donation of objects described by Michel Leiris in an article in Cahiers d'art.[76] In the same year, the von der Heydt Collection was installed in the rooms.[77] Replete with pieces from New Guinea and the Bismarcks, it filled certain gaps that twenty years of inactivity had created in the collections. It was completed by a collection from the New Hebrides assembled in 1934 by the geographer Aubert de la Rüe during an official expedition. Then in 1935 an Easter Island exhibition was held; it was repeated in Brussels in 1936. These exhibitions displayed the results of the Franco-Belgian

Oceanic art exhibited at the Pierre Matisse Gallery, New York, 1934; objects furnished by Charles Ratton

scientific expedition led by A. Métraux and Lavachery. Finally, in 1938, the Musée d'Ethnographie, renamed the Musée de l'Homme, exhibited in its new premises the works gathered by the expedition aboard the *La Korrigane* in the Pacific. Thanks to this collection, it owns an important number of pieces chiefly from Melanesia.[78]

This phenomenon can also be seen in England. In 1935, the exhibition "The Art of Primitive Peoples" opened at the Burlington Fine Arts Club. The pieces exhibited came from New Zealand, the Fiji Islands, the Solomons, the Massim region, and New Guinea; some had been gathered by the anthropologist Gregory Bateson. The catalog is ethnological, and each piece is placed in its economic and social context.[79] This same orientation appears the following year in Raymond Firth's *Art and Life in New Guinea*.[80] In June of the next year an exhibition of three hundred objects from the Moyne Collection opened in Grosvenor Place; it contained pieces from the Fly River, the Eilanden River (Asmat), and the Ramu River.

In the United States, Oceanic objects (including some from New Guinea, New Zealand, and New Ireland) were shown at the California Midwinter International Exposition, San Francisco, in 1895. An exhibition, "Oceanic and African Art," containing only a few Polynesian pieces, opened in 1934 at the Fogg Museum of Harvard. A 1939 exhibition at the Peabody Museum in Salem again showed Polynesian collections in which a large part was given over to objects of everyday use. And in the same year, for the Golden Gate International Exposition in San Francisco, a section was devoted to Oceania. Its purpose was to establish in the eyes of the public the notion that the productions of this region were on a par with those of Europe and other parts of the world.

The Surrealists, remaining faithful to Breton, shunned out of principle this too-didactic world. To the ethnographic view, they opposed a vision of the marvelous; to scientific classifications, other categories that demonstrated their absurdity. Oceanic objects were thus displaced, and they jostled American objects, readymades, mathematical objects, and interpreted *objets trouvés* in the "Exposition d'Objets Surréalistes" at the Galerie Charles Ratton in 1936.[81] In the same year, at the international Surrealist exhibition in London, objects from the Sepik region (New Guinea), borrowed from the University Museum of Archaeology and Anthropology at Cambridge, were displayed, as well as photographs of pieces that the organizers had not been able to obtain. At neither of these exhibitions, however, were all of the Surrealist collections on view. Max Ernst, Paalen, Tanguy, and others owned objects that were never shown.

Objects collected during the La Korrigane expedition, 1934–35, in New Guinea. Field photograph by van de Broek. Musée de l'Homme, Paris

The early sea voyagers brought back only a few objects. Objects began to arrive in large quantities only when Europe embarked on its colonial expansion, and at that time they served as evidence of conquest. Displayed in museums, Expositions Universelles, and private collections, they demonstrated the lives and customs of the natives. They pointed to the existence of another world. The French Surrealists, by celebrating the *trouvaille* or lucky find, highlighted that system of displacements wherein objects take on all the more meaning from being looked at. Divided between the studies of anthropologists and artists, they have been first of all the initiators of a fantastic realm whose history begins with the first crossings of the Pacific and is not over yet.

—Translated from the French by John Shepley

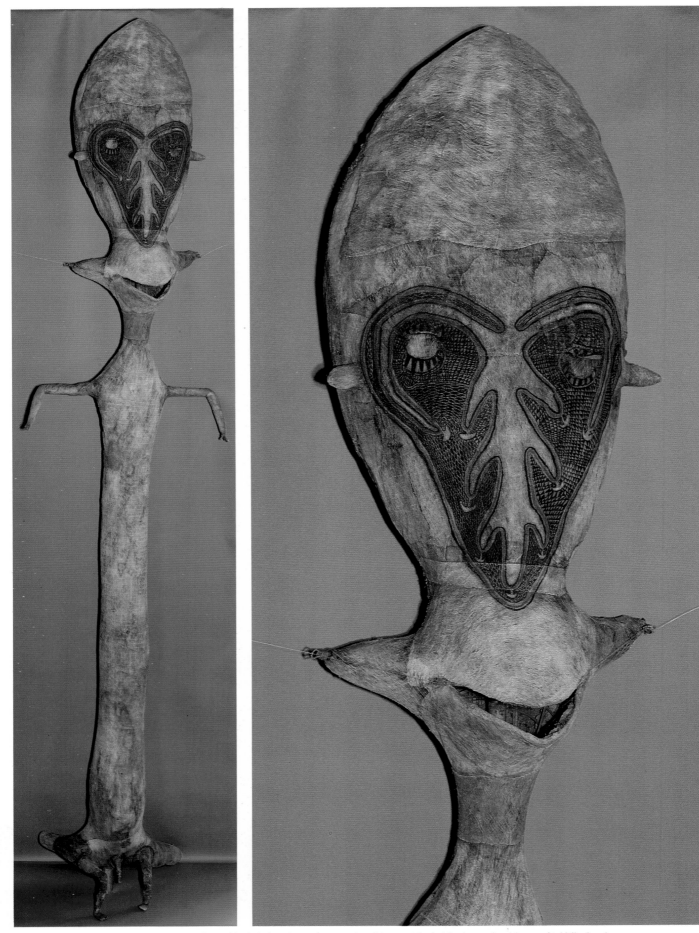

Headdress (and detail). Baining. New Britain. Painted barkcloth and cane frame, 23′ 7½″ (720 cm) high. Hamburgisches Museum für Völkerkunde

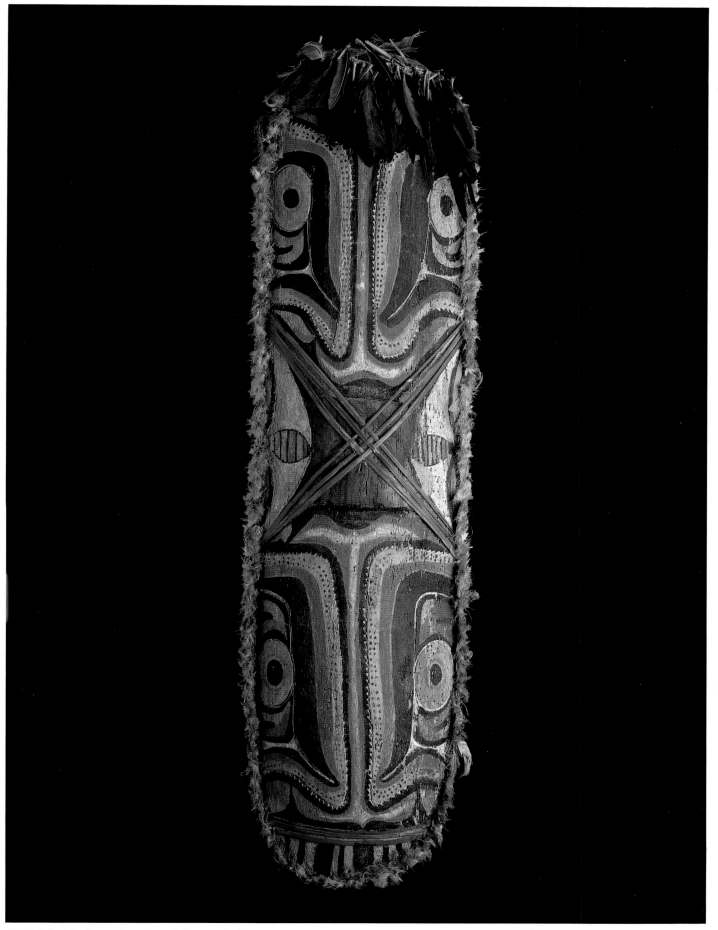

Shield. Sulka. New Britain. Painted wood, fiber, and feathers, 47⅝" (121 cm) high. Musée Barbier-Müller, Geneva

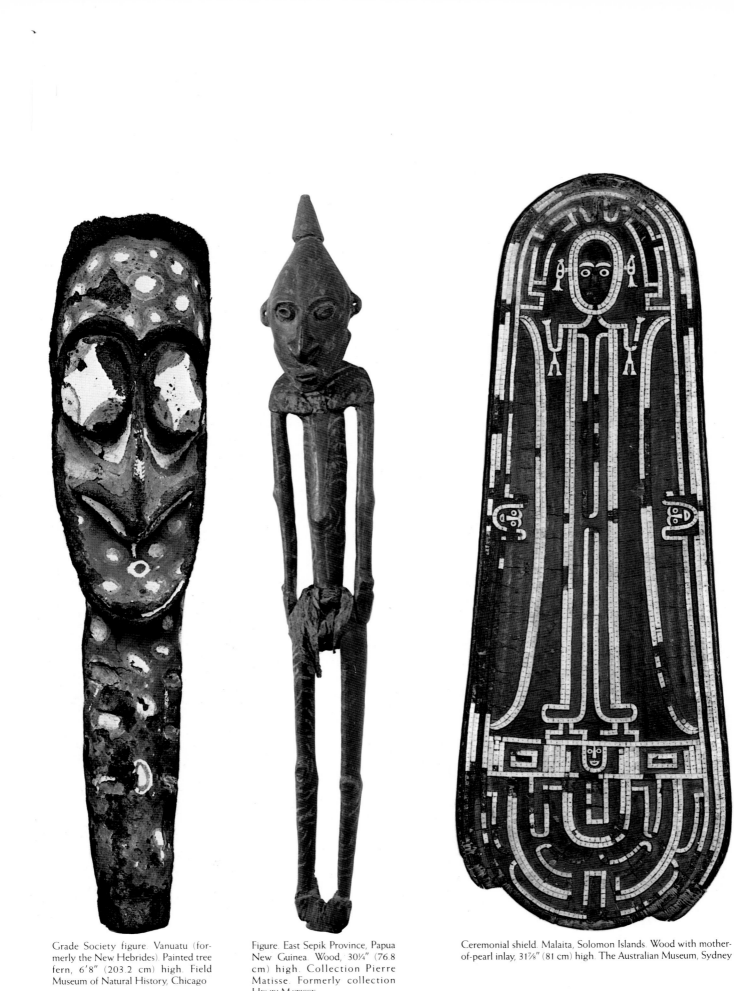

Grade Society figure. Vanuatu (formerly the New Hebrides). Painted tree fern, 6'8" (203.2 cm) high. Field Museum of Natural History, Chicago

Figure. East Sepik Province, Papua New Guinea. Wood, 30¼" (76.8 cm) high. Collection Pierre Matisse. Formerly collection HENRI MATISSE

Ceremonial shield. Malaita, Solomon Islands. Wood with mother-of-pearl inlay, 31⅞" (81 cm) high. The Australian Museum, Sydney

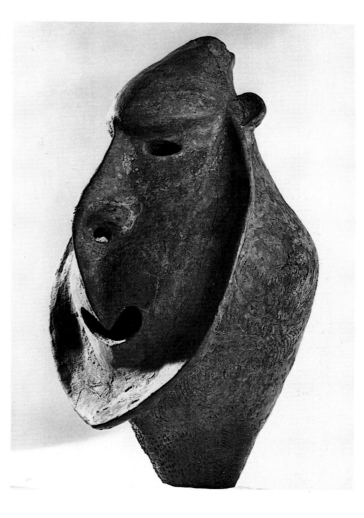

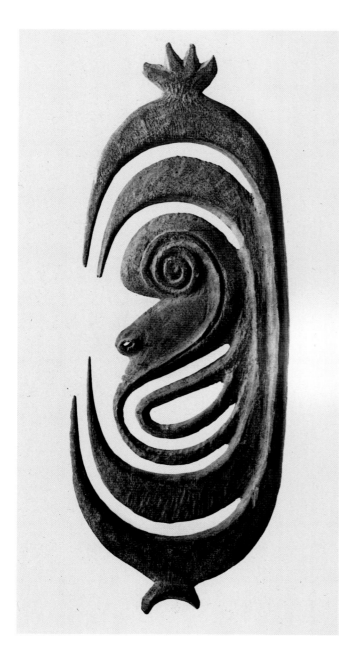

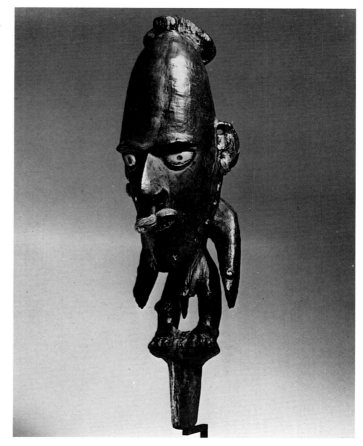

Above: Hunting charm. Alamblak. Karawari River, East Sepik Province, Papua New Guinea. Wood, 12½" (31.8 cm) high. National Museum of Natural History, Smithsonian Institution, Washington, D.C.

Above right: Head. Kwoma. East Sepik Province, Papua New Guinea. Terra-cotta, 16½" (42 cm) high. Private collection, New York

Right: Figure for a sacred flute. Biwat. East Sepik Province, Papua New Guinea. Painted wood, shell, and fiber, 18" (45.8 cm) high. Friede Collection, New York

NOTES

This text would not have seen the light of day without the valued assistance of Françoise Girard, Marie-Claire Bataille-Benguigui, and Jean Jamin of the Musée de l'Homme, of Rosalind Krauss, Judith Cousins, and Jean-Louis Paudrat, of Michel Leiris, Jean Laude, and Charles Ratton. To these, and to Douglas Newton for his most helpful critical reading of the text, I wish to extend my sincere thanks.

1. See de Commerson, "Post-scriptum sur les îles de la Nouvelle-Cythère ou Tayti," published first in the *Mercure de France* in November 1769, then in the *Décade philosophique* of 30 Messidor, year IV, vol. 18, pp. 133–42.

2. B. Smith's *European Vision and the South Pacific, 1768–1850* (Oxford University Press, 1960), gives an analysis of these changes in attitude toward the Pacific, based particularly on English sources.

3. On this subject, see J. Copans and J. Jamin, *Aux origines de l'anthropologie française* (Paris: Le Sycomore, n.d.), and G. Stocking, "French Anthropology in 1800," *Isis* 65, no. 180, 1964, pp. 134–50.

4. The navigation logbooks of the Bougainville expedition have recently been published by Etienne Taillemite. They contain maps, plates, and drawings: *Bougainville et ses compagnons autour du monde* (Paris: Imprimerie Nationale, 1977), 2 vols.

5. All the objects were not gathered by Péron: 160 were offered to him by the naval surgeon Georges Bass, who had settled in Sydney and received them from navigators. The book by Copans and Jamin, op. cit., gives a list of objects according to Péron's manuscript, preserved in Le Havre.

6. The collections of Captain Cook and his companions, the accounts of whose voyages have been many times republished, were dispersed in numerous European museums. A. Kaeppler has meticulously cataloged them. See A. Kaeppler, *Artificial Curiosities: An Exposition of Native Manufactures Collected on the Three Pacific Voyages of Captain Cook* (Honolulu: Bishop Museum Press, 1978), and *Cook Voyage Artifacts in Leningrad, Berne and Florence Museums* (Honolulu: Bishop Museum Press, 1978).

7. The Caen collections were published by E. Deslomchamps, "Note sur les Collections Ethnographiques de Musée de Caen et sur deux haches en pierre polie provenant de la Colombie," in *Annuaire de Musée d'Histoire Naturelle de Caen*, 1884. At this date, completed by the Vieillard, Marc, and Deplanches Collection, it owned a representative ensemble from the Pacific: for New Zealand, a Tiki, a plank from a canoe; for Tahiti, a fly whisk; ornaments, clubs, tortoise-shell crowns, and earrings for the Marquesas; weapons and Tapas from the Tongas and the Carolines; some rare earrings from New Britain and New Ireland; a "crocodile" from the Solomons; masks, sculptures, stone weapons, and bamboos from New Caledonia; bird sculptures and weapons from Netherlands New Guinea; finally a tortoise-shell mask from the Torres Strait and weapons from Australia. The Musée de la Marine of the Louvre was made up of objects from various voyagers, including Dumont d'Urville et d'Entrecasteaux, as well as objects deposited there by Louis Philippe that were given to him by the missionaries Pompallier and Douare and the Scandinavian antiquary Rafn. Melanesia was represented by 253 pieces, Micronesia by 38, and Polynesia by 447. One could mention, among other things, a drum and a mask from the New Hebrides, sculptures from New Caledonia, "idols" from New Guinea, a small sculpture from the Solomons and an important one from the Gambier Archipelago, sculptures, feathered boxes, and jades from New Zealand, and finally a feathered mask from Hawaii and some carved fly-whisk handles from Tahiti.

8. On the growth of ethnographic museums, see R. Goldwater, *Primitivism in Modern Art* (New York: 2d ed., 1967), especially the first part.

9. The Musée d'Ethnographie du Trocadéro acquired its first Australian paintings in 1935. In the nineteenth century, searchers' attention was turned more to paintings on sand or in caves than to paintings on tree bark. R. B. Smyth, in his book *The Aborigines of Victoria* (London: 1878), was one of the first to analyze one of them. Smyth notes, however, that "the native artist was not a wild black. He had observed the customs of the whites" (p. 286). In the 1890s Baldwin Spencer had been one of the first, crossing the Arnhem Land, to collect bark paintings.

10. *Catalogue spécial de l'Exposition des Sciences Anthropologiques* (Paris: Imprimerie Nationale, 1878). The objects come from the Musée de Caen, the Musée des Colonies du Palais de l'Industrie on the Champs-Elysées (this museum was created after the Exposition Universelle of 1855; it apparently never published a catalog, and the museum fell into desuetude in the 1890s), the Bordeaux museum, as well as the Rivière Collection in Paris and the Seidler in Nantes, and finally the Royal College of Surgeons in London. One might also consult the *Actes du Congrès des Sciences Ethnographiques* (Paris: Imprimerie Nationale, 1878).

11. Each country published a catalog. For France, see *Catalogue des produits des colonies françaises* (Paris: Challamel, 1878). The list of exhibitors, reproduced in the catalogs, consists of both colonials and commercial firms.

12. Liesville, *Coup d'oeil général sur l'Exposition Historique de l'Art Ancien*, Palais du Trocadéro (Paris: Honoré Champion, 1879), pp. 82ff. It gives a list of members of the "admission and classification committee" and of "exhibitors".

13. A. Racinet, *L'Ornement polychrome, Art ancien et asiatique, Moyen-Age, Renaissance, XVII, XVIII, XIX siècle: Recueil historique et préhistorique avec des notes explicatives* (Paris: Firmin Didot, 1869), 2 vols. This work was reissued in 1885–86 and 1888.

14. C. Rochet, *Traité d'anatomie d'anthropologie et d'ethnographie appliquées aux Beaux-Arts* (Paris: Renouard, 1886). Rochet taught anatomy at the Ecole des Beaux-Arts in Paris. Among other things, he was responsible for the imperishable statue of Charlemagne that adorns the parvis of the Cathedral of Paris. He judged the ethnographic museum created by his "learned colleague and excellent friend Doctor Hamy...to contain too many rags and worthless things" (p. 250).

15. The Galerie d'Ethnographie des Invalides in Paris displayed a complete series of mannequins whose costumes retraced the history of battle gear. The gallery underwent several successive alterations, but the "savages" were always on view for purposes of comparison. The gallery was dismantled in 1917, and the remaining objects (ornaments, weapons, etc.), as well as the mannequins, were given to the Musée d'Ethnographie.

16. On the Maison Saves, see G. Astre, "Théophile et Alexis Saves, négociants toulousains en Nouvelle Calédonie et collecteurs d'objets d'Histoire Naturelle et d'Ethnographie à la fin du XIX siècle," in *Journal de la Société des Océanistes*, no. 18, December 1962, p. 108. The Maison Saves published a few catalogs of which only a few examples survive. The Le Mescam Collection was published by G. Lennier, *Description de la collection ethnographique océanienne qu'a offert à la Ville du Havre M. Le Mescam, négociant de Nouméa: Notes d'Ethnographie Océanienne* (Le Havre: Museum d'Histoire Naturelle, 1886). The Maison Godeffroy of Hamburg published an ethnographic magazine, and J. D. Schmeltz and R. Krause published the catalog of the collections: *Die Ethnographisch-Anthropologische Abteilung des Museum Godeffroy in Hamburg: Ein Beitrag zur Kunde der Südseevölker* (Hamburg: Friederichsen, 1881). On the New Ireland collections in Berlin, see K. Helfrich,

Malanggan I (Berlin: Museum für Völkerkunde, 1973).

17. We do not possess at the present time any biographical information on Bertin, and the places where he bought his collection are unknown to us, but one can assume that as a dealer in diamonds he frequented Amsterdam and Antwerp, cities in which objects from many non-French possessions in the Pacific could be found. He was born near Paris in 1821, and his collection was dispersed in the year of his death. The statement of the sale was unearthed by M.-C. Bataille of the Musée de l'Homme in Paris. A copy of it is on file in the Oceanic department. In addition to Hamy (who was purchasing for the Musée d'Ethnographie with funds donated by Prince Roland Bonaparte) and Heyman, objects were bought by, among others, Jonchery, Besnard, Pieret, Edwards, Dounelle (or Daunelle), and Klein, names of which otherwise we have found no trace.

18. The Oceanic collections were installed on the entrance landings. Mannequins wore "ornaments," and the more valuable objects were placed in glass cases. The New Caledonian mask is not the oldest in the present collections of the Musée de l'Homme, but rather the one that Rochas offered to the Société d'Anthropologie in 1861 and which belonged to its museum set up in the Latin Quarter. An article published in *La Nature*, June-September 1882, interprets the objects as rebuses, "for example, in a staff surmounted by a bear, the length of the staff was marked with the footprints of this plantigrade, the whole signifying that the owner of the staff was called 'Bear-that-climbs.'" This interpretation is not far from the kind later applied by Jarry or certain Symbolists.

19. Prince Roland Bonaparte, who was later president of the Société de Géographie, became deeply interested in the 1880s in New Guinea and hoped that France would annex a part of it. He published *Les Derniers Voyages des Néerlandais à la Nouvelle Guinée Hollandaise* (Versailles: 1885), and *Notices sur la Nouvelle Guinée* (Paris: 1887). He owned an important collection of objects, chiefly weapons. A generous patron, he gave the Musée d'Ethnographie several collections, including part of Bertin's, which consisted of 297 objects of all kinds.

20. On this exhibition, see *Catalogue de la Section Néerlandaise à l'Exposition Internationale Coloniale et d'Exportation Générale tenue du 1 mars au 31 octobre 1883 à Amsterdam* (Leiden: Brill, 1883). New Guinea was represented primarily by everyday objects from the Utrecht museum, and by Korwars. The Australian section displayed mostly weapons.

21. See O. Finsch, "Die Ethnologische Ausstellung der Neu-Guinea Compagnie in Königlischen Museen für Völkerkunde," in *Original Mittheilungen aus der Ethnologischen Abtheilung der Königlischen Museen zu Berlin*, Jahr I, Heft 2.3, 1886, pp. 92–100, and *Katalog der Ethnologischen Sammlungen der Neu-Guinea Compagnie ausgestellt in Königlischen Museum für Völkerkunde* (Berlin: Otto van Holten, 1886).

22. The general state of the collections was described by K. Bahnson, "Ueber Ethnographischen Museen," in *Mittheilungen der Anthropologischen Gesellschaft in Wien*, Band XVIII, 1888, pp. 109ff. See also W. M. T. Brigham, "Report of a Journey around the World Undertaken to Examine Various Ethnological Collections," in *Occasional Papers of the Berenice Pauahi Bishop Museum*, Honolulu, vol. 1, no. 1, 1898, pp. 1–72. He cites a few private collections and draws up a rapid inventory of the collections he saw in various European and American museums.

23. See T. Bodrogi, *L'Art de l'Océanie* (Paris: Grund, 1961) for the French edition. Count Festetics de Tolna kept his collection on his estate near Paris at the beginning of the century. He published two books of memoirs about his travels in the Pacific, in which he tells how he acquired certain objects.

24. It seems, for example, that the introduction of

traditional currency fabricated in Europe as early as the years 1875–80 had as a repercussion an increase in such objects as Malanggans in New Ireland, which arrived in considerable numbers in the museums. Likewise the use of iron, traditionally unknown in the Pacific, not only made possible a more rapid production but also an increase in size for certain objects.

25. V. Segalen, *Essais sur l'exotisme: Une Esthétique du divers* (Montpellier: Fata Morgana, 1978). Segalen is also the author of an essay on Gauguin, who died a few days before Segalen arrived in Tahiti, and of a book, *Les Immémoriaux*, which like Gauguin's *Noa Noa* is a revival of the myth about Tahiti. On exoticism and painting see J. Laude, *La Peinture française (1905–1914) et "l'art nègre"* (Paris: Klincksieck, 1968).

26. In 1898, an adaptation of Loti's early novel *Le Mariage de Loti* was staged under the title *L'Ile du rêve.* The plot of this verse play, set to music by Reynaldo Hahn, is the tormented love between a ship captain and a beautiful Tahitian woman. Loti crossed the Pacific in 1872 while a midshipman on the *Flore.* On Easter Island he bought a number of objects, some of which are now in the Musée de l'Homme in Paris. The *Flore* brought back a stone head, which was exhibited at the Museum d'Histoire Naturelle, and later transferred to the Musée d'Ethnographie du Trocadéro.

Louise Michel, a painter at the Musée d'Ethnographie du Trocadéro. Louise Michel, an anarchist sent to the penal colony of New Caledonia for her part in the Paris Commune of 1871, published several books of memoirs about the Kanakas in the 1880s. One might wonder, in any case, if anarchist circles did not play an important role in the reevaluation of the Primitive arts; Félix Fénéon, among other things a champion of the Pointillists, was to own an important collection of Primitive art.

27. See "L'Inauguration du buste du Docteur Hamy et de la salle d'Océanie au Musée d'Ethnographie du Trocadéro," in *L'Anthropologie* XXI (1910), pp. 241–45. For the material and financial situation of the Musée d'Ethnographie at the beginning of the century, see Verneau, "Le Musée d'Ethnographie du Trocadéro," in *L'Anthropologie*, 1918–19, pp. 547–60.

28. This drop in population was principally due to epidemics of European origin, the traffic in cheap labor, and a psychological attitude brought on by the feeling of being trapped in a hopeless situation.

29. As early as the 1870s, it seems that certain regions of New Caledonia were specializing in the sale of objects to settlers and travelers. Other regions, for example the Cook Islands, the northern coast of New Guinea, and the New Hebrides, soon began fabricating "souvenirs." Father Colette had copies made in Papeete of tablets from Easter Island. A firm in Germany produced New Zealand jades, and some were re-exported to the Pacific, where they were sold by unscrupulous dealers as authentic pieces.

30. The Institut Colonial of Marseilles was founded by Heckel, a former colonel, in 1893. The institute was connected with the Chamber of Commerce, and its purpose was to study the resources of the colonies. It set up a museum that owned, among other things, some objects from New Caledonia and Australia. Colonial gardens were established at the same time as these institutes. A Kanaka hut was built in the one in Paris. As for the Musée des Colonies in Paris, it was reinstalled in the Palais Royal. If one is to believe Florent Fels, one could "there buy cheaply authentically Melanian works": F. Fels, "L'Art mélanien au Pavillon de Marsan," in *Nouvelles littéraires*, October 27, 1923, p. 4.

31. W. M. T. Brigham, "Report of a Journey around the World to Study Matters Relating to Museums, 1912," in *Occasional Papers of the Berenice Pauahi Bishop Museum*, 1913. The Berlin Museum was enriched in these years by the collection from the Sepik Expedition of 1910–12; see H. Kelm, *Kunst vom Sepik*

(Berlin: Museum für Völkerkunde, 1966–68), 3 vols. The Hamburg expedition has been the subject of a recent study by H. Fischer, *Die Hamburger Südsee Expedition: Uber Ethnographie und Kolonialismus* (Frankfurt am Main: Syndicat, 1981). Following the expedition, an enormous publication, continued after the war, was published under the direction of Thilenius.

32. Webster published his catalog from June 1895 to Autumn 1901, Oldman from December 1903 to January 1914. It was from the latter that Breton and Eluard bought a few objects after World War I. Edge-Partington published his collection at his own expense; cf. J. Edge-Partington, *Album of the Weapons, Tools, Ornaments, Articles of Dress of Natives of the Pacific Islands*, 3 vols., Manchester, 1890, a general work on many museums and private collections, in the United Kingdom and Australia, including his own. Fuller's collection was bought in its entirety by the Field Museum in Chicago.

33. Several dealers, including Heymann and Brummer, sold Primitive art objects in Paris. See the articles by J.-L. Paudrat and W. Rubin in this book. André Warnod, in what seem to be the first articles published about African art by an art critic, reproduces only pieces from Africa and Madagascar; see A. Warnod, "Curiosités esthétiques," in *Comoedia*, June 27, 1911, and January 2, 1912.

34. We might also mention the voyage of the Polish writer and painter Witkiewicz, who accompanied the anthropologist B. Malinowski in 1914 to the Pacific in the capacity of painter and photographer. In 1907, a group of German painters and philosophers calling themselves "the Brothers of the Sun" settled in New Guinea. But two of the brothers died, and the survivors, in pitiful condition, were repatriated to Europe.

35. See P. Guillaume, "Une Esthétique nouvelle, l'art nègre," in *Les Arts à Paris*, May 15, 1919, pp. 1–3. In this article, Guillaume gives a list of the first collectors. See also G. Apollinaire, "Quelques Artistes au travail," in *Mercure de France*, April 16, 1911, reprinted in Décaudin, *Oeuvres complètes* (Paris: Balland, 1966), p. 308.

36. See Kahnweiler, *Juan Gris* (London: 1947), note 104. The New Caledonian sculptures appear in a photograph that Gelett Burgess took in Picasso's studio in 1908; see *Pablo Picasso, A Retrospective* (New York: Museum of Modern Art, 1980), p. 87. For a more complete photograph of Picasso's tribal objects in 1908, see below, Rubin, p. 299.

37. On the collections of the Musée de la Marine, see note 7 above.

38. *Journal du Musée d'Ethnographie du Trocadéro*, 1899–1910, manuscript, Musée de l'Homme, Paris. The names of the persons accompanying Delaunay do not appear, but one can suspect the presence of Apollinaire, who was to devote an article to the Musée d'Ethnographie in *Paris-Journal*, July 18, 1914.

39. *British Museum Handbook to the Ethnographical Collection*, The Trustees, 1910 for the first edition.

40. E. Faure, *Histoire de l'art: L'Art médiéval* (Paris: Floury, 1912), especially pp. 137–66. The plates show objects from the Solomons, Hawaii, and Easter Island.

41. *Sculptures nègres, 24 photographies précédées d'un avertissement de Guillaume Apollinaire et d'un exposé de Paul Guillaume* (Paris: private edition limited to 63 copies). The book was published with the help, among others, of the collector Jacques Doucet and the University of Lausanne. On the relations between Apollinaire and Guillaume and the publication of this book, see J. Bouret, "Une Amitié esthétique au début du siècle: Apollinaire et Paul Guillaume, 1911–1918, d'après une correspondance inédite," in *Gazette des Beaux Arts* 68, no. 1223 (December 1970), pp. 373–99. A report on the exhibition at the Galerie Paul Guillaume, 108 Faubourg Saint-Honoré, was done by M. Le Chevrel, "Devant l'Atlantide," in *Le Gaulois*, December 18, 1917.

42. P. Guillaume, op. cit., 1917.

43. *Collections de Monsieur Charles Vignier*, Galerie Levesque, 109 Faubourg Saint-Honoré, May 16–June 15, 1913.

Lyre et Palette, 6 rue Huyghens, XIV°, Première exposition du 19 novembre au 5 décembre 1916. Kisling, Modigliani, Ortiz de Zarate, Picasso, sculptures nègres. A text by Guillaume Apollinaire introduces the "Negro sculptures." The Galerie Lyre et Palette was directed by Emile Lejeune, a painter of Swiss origin who published his memoirs in the *Tribune de Genève* from January to March 1964.

44. Clouzot and Level, *L'Art sauvage—Océanie, Afrique: Catalogue de la première exposition d'art nègre et d'art océanien organisé par Paul Guillaume*, May 10–31, 1919. Galerie Devambez. The catalog contains Apollinaire's text from the *Album nègre* of 1917. The exhibition displayed 147 objects.

Clouzot and Level, *L'Art nègre et l'art océanien* (Paris: Devambez, 1919). The plates, in addition to pieces from the British Museum and the Musée d'Ethnographie in Paris, show a Hawaiian sculpture, a Korwar, two New Caledonian masks, a stilt-step and some bone and wooden Tikis from the Marquesas, and two Easter Island statues from the Level Collection.

45. Clouzot and Level, op. cit., 1919, p. 22.

46. D. Réal, *La Décoration primitive: Océanie* (Paris: Calavas, 1922). The plates show objects from Indonesia and Oceania, and a few pieces from the Rupalley Collection.

47. C. Einstein *Negerplastik* (Leipzig: Die Weissen Bücher, 1915, for the first edition; Munich: Kurt Wolff, 1920, for the second). Oceanic objects are shown in plates 43, 81, 82, 85, 86, 87. The last two plates (nos. 107 and 111), showing a new Caledonian door post and a sculpture from New Ireland, disappear in the second edition.

48. E. von Sydow, *Exotische Kunst, Afrika und Ozeanien* (Leipzig: Von Klinkhardt und Biermann, 1921). The objects reproduced, from the Bismarck Archipelago and New Guinea, belonged to the museums of Leipzig and Dresden.

E. von Sydow, *Die Kunst der Naturvölker und der Vorzeit* (Berlin: Propyläen-Kunstgeschichte, 1923). The plates show objects from all of Oceania.

One ought also to mention two important books that deal with Primitive art in general: W. Hausenstein, *Klassiker und Barbaren* (Munich: 1923), and H. Kühn, *Die Kunst der Primitiven* (Munich: Delphin, 1923). For an analysis of this last book, see R. Goldwater, op. cit., pp. 30–31.

49. Paul Guillaume, in the fifth issue of his magazine *Les Arts à Paris*, gives an account of this evening event, which he had organized, along with comments by the press. See also Allard, "Fête nègre," in *Le Nouveau Spectateur*, no. 4 (June 25, 1919), which reproduces Fauconnet's costume designs.

50. G. Duthuit, "Cinématographe et fêtes," in *Action*, no. 4 (July 1920). This history of the Dada movement in France has been studied by M. Sanouillet, *Dada à Paris* (Paris: Pauvert, 1965). The Pilou-Pilou was the name given by the settlers to the dances of New Caledonia.

51. On Breton's years of formation, see M. Bonnet, *André Breton et la naissance de l'aventure surréaliste* (Paris: Corti, 1975). On Eluard, see J.-C. Gatteau, *Eluard et la peinture* (Ph.D. diss., Paris, 1980), and the catalog of the exhibition "Paul Eluard et ses amis peintres," Paris, Centre Georges Pompidou, November 14, 1982–January 17, 1983.

52. Clouzot and Level, *Exposition d'art indigène des colonies françaises*, Musée des Arts Décoratifs, Palais du Louvre, Pavillon de Marsan, November–December 1923, and S. Chauvet, *L'Art indigène des colonies françaises* (Paris: Maloine, 1924).

53. Clouzot and Level, op. cit., 1919, p. 9.

54. Clouzot and Level, op. cit., 1923, p. 22.

55. See catalog *Tableaux de Man Ray et objets des îles*, opening of the Galerie Surréaliste, 16 Rue Jacques Callot, March 26–April 10, 1926. The catalog

reproduces a "mask from New Mecklenburg," an "engraved stone from the Loyalty Islands," a "sculpture from Hawaii," and a "mask from New Guinea."

56. See below.
57. *Südseeplastiken*, exhibition, May 1926, Galerie Flechtheim, Berlin; June 1926, Kunsthaus, Zurich; August 1926, Galerie Flechtheim, Düsseldorf (Berlin: Das Kunstarchiv, 1926). Foreword by Carl Einstein. The catalog illustrates 29 of the 184 objects displayed. A translation, with illustrations, appeared in *Art and Archaeology* 1 (1927), pp. 125–28.
58. C. Zervos, "Introduction," in *Cahiers d'art*, no. 7–8, 1927, p. 229. The article is illustrated by a photograph of a mask from the Torres Strait in the Picasso Collection (p. 315).
59. A. Basler, *L'Art chez les peuples primitifs* (Paris: Librairie de France, 1929). The chapter on the Oceanic arts was reproduced in *Les Arts à Paris*, no. 6 (January 1929), pp. 19–24.
60. A. Basler, op. cit., 1929, p. 23.
61. Luquet, *L'Art primitif* (Paris: G. Doir, Bibliothèque d'Anthropologie, 1930). This problem of realism had already been debated for many years. Apart from Grosse's theories in Germany, the problem was broached in France following Breuil's prehistoric investigations and his controversy with S. Reinach. The question was: Logical realism or visual realism? The notion of logical realism, as is shown by Hamy's article on "La Figure humaine chez le sauvage et l'enfant" in *L'Anthropologie* 19, (1908), pp. 385–407, and Luquet's "Sur le caractère des figures humaines de l'art paléolithique" in *L'Anthropologie* 21 (1910), pp. 409–23, allows one to compare the art of indigenous peoples and the art of children. Luquet in 1930 was thus taking up again and developing ideas that had been at the center of a broad debate since the beginning of the century, not only in the milieu of prehistory and anthropology, but also in that of psychology, particularly child psychology.
62. *Cahiers d'art*, no. 2–3, 1929, 119 pp., 189 illustrations.
63. Portier and F. Poncetton, *La Décoration: Océanie* (Paris: Calavas, n.d. [1931]), 8 pp., 48 plates.
64. Pierre Loeb wrote a book of memoirs, *Voyages à travers la peinture* (Paris: Bordas, 1946), and an exhibition was dedicated to him. See *L'Aventure de Pierre Loeb—La Galerie Pierre, Paris, 1924–1964* (Musée d'Art Moderne de la Ville de Paris; Musée d'Ixelles, Brussels: 1979). Pages 103–10 deal with his collection of Primitive art.
65. J. Viot, "N'encombrez pas les colonies," in *Le Surréalisme au service de la révolution*, no. 1 (July 1930), pp. 43–45, and *Deposition de blanc* (Paris: Plon, 1932). This book is an anticolonial satire. Viot also published "La Baie de Geelwinck" in *Art vivant*, no. 147 (April 1931), pp. 172–73. This article is illustrated with photographs of the terrain.
66. Catalog of the *Exposition d'art africain et d'art océanien*, Paris, 1930, 29 pp., 15 fig., and the catalog *Exposition des arts de l'Océanie, 23 mai–6 juin 1930, à la Renaissance, 11 rue Royale*, 16 pp. There is a report on the Galerie Mettler exhibition by A. Sautier, "Une Collection d'art d'Océanie," in *Formes*, no. 2, 1930, p. 13. The article is illustrated by reproductions of two stone statues from Easter Island.
67. J.-C. Gatteau, op. cit., 1980, p. 244. At this time Eluard was planning a voyage to New Guinea. His trip around the world in 1924 remains, on the other hand, quite mysterious.
68. There is not much available information about this exhibition. A photograph of it was printed in *Le Surréalisme au service de la révolution*, no. 4 (December 1931), but its poor quality allows only an approximate identification. J.-C. Gatteau, op. cit., gives a few supplementary details about the organization of the exhibition but makes no reference to the objects.
69. E. Berl, "Conformismes freudiens," in *Formes*, no. 5 (May 1930), p. 3. See also W. Georges, "Le Crépuscule des idoles," in *Les Arts à Paris*, no. 17 (May 1930).
70. H. Purrmann, "Südseekunst," in *Kunst und Künstler*, 1933, p. 115. C. Zervos, in *Cahiers d'art*, wrote his "Reflexions sur la tentative d'esthétique dirigée du III Reich," in which he also developed his position on the role played by the Primitive arts in the painting of his time.
71. Between 1925 and 1939, forty auctions with catalogs in which Oceanic objects appeared were held in Paris. They represent about nine hundred pieces, some of which were put up for sale several times. The two last important prewar auctions were those of Frank Burty Haviland in 1936 and Vlaminck in 1937. The Level Collection went under the hammer in 1943. Those of Fénéon, Titaÿna, under an assumed name, Madeleine Rousseau, Paul Guillaume, and La Korrigane were dispersed after the war.
72. See Penrose, "Un Oeil de liberté," in *Paul Eluard et ses amis peintres*, op. cit., 1983.
73. R. Goldwater, "American, Oceanic and African," in catalog of exhibition at the Pierre Matisse Gallery, April 20–May 9, 1936.
74. For these ideas, developed by the Frenchman Mauss, and their application to sculpture, see R. Krauss's article on Giacometti in this volume.
75. On the *Documents* group and the Musée de l'Homme, see J. Clifford, "On Ethnographic Surrealism," in *Comparative Studies in Society and History* 23, no. 4 (October 1981), pp. 539–65, and J. Jamin, "Un Sacré Collège, ou les apprentis sorciers de la sociologie," in *Cahiers internationaux de sociologie* 68 (1980), pp. 5–30. On Surrealism see, among others, E. Maurer, "In Quest of the Myth: An Investigation of the Relationship between Surrealism and Primitivism" (Ph.D. diss., University of Pennsylvania, 1974), and E. Cowling, "An Other Culture," in *Dada and Surrealism Reviewed* (London: Arts Council of Great Britain, 1978), pp. 451–68.
76. M. Leiris, "L'Art des Iles Marquises," in *Cahiers d'art*, no. 5–8, 1934, pp. 185–92. The article, ethnographic in nature, discusses the invention of the Tiki.
77. The collection of the Swiss businessman von der Heydt was published by E. von Sydow, *Sammlung Baron Eduard von der Heydt* (Berlin: Bruno Cassirer, 1932). This publication nevertheless does not take account of the scope of the collection, which was deposited in the Musée de l'Homme and given after the war to Zurich, where it formed the core of the Rietberg Museum.
78. The La Korrigane expedition was organized by the Ganay and van den Broek families. Both families had connections with large industry, and Mme de Ganay took courses with Mauss in Paris.
79. *Catalogue of an Exhibition of the Art of Primitive Peoples* (London: Burlington Fine Arts Club, 1935), introduction by A.D. The exhibition contained 292 objects.
80. R. Firth, *Art and Life in New Guinea* (London: Studio Publications, 1936).
81. The objects displayed in this exhibition were a tortoise-shell mask from the Torres Strait in the Georges Salle Collection, a wicker mask from the Breton Collection, a wooden mask, an ancestor figure, and a headrest from New Guinea, a sculpture from New Ireland, a Tapa mask from New Britain from the Pierre Loeb Collection, a carved tree-fern mask from the New Hebrides, and an engraved pebble from the Loyalty Islands from the Eluard Collection.

Installation of Oceanic and modernist art at Galerie Pierre Loeb, Paris, 1949. From left to right: skull rack, East Sepik Province, Papua New Guinea; Alberto Giacometti, *The Hand*, 1947, bronze; Antonin Artaud, *Self-Portrait*, 1946, pencil; figure, probably East Sepik Province, Papua New Guinea; photograph of Vieira da Silva in her studio, Boulevard Saint-Jacques, by Denise Colomb; roof finial figure, New Caledonia; figure, probably East Sepik Province, Papua New Guinea; small photographs representing Pierre Loeb's mother and father; photograph of Pablo Picasso by Man Ray, 1933, with dedication from Picasso to Silvia and Pierre Loeb. Photograph by Denise Colomb

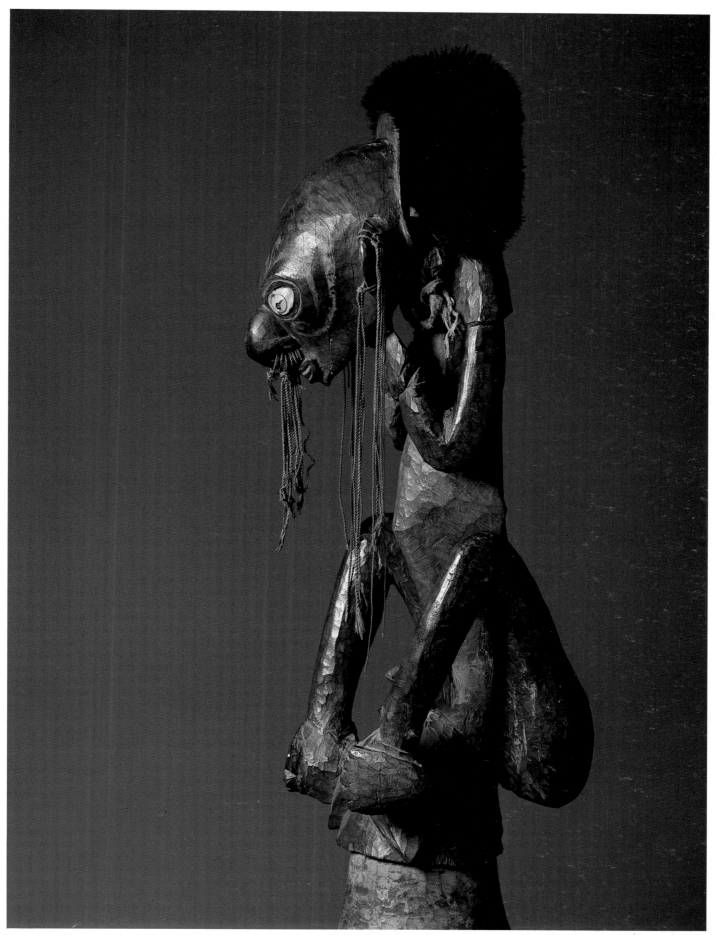

House finial figure. Biwat. East Sepik Province, Papua New Guinea. Wood, shell, fiber, and feathers, 48" (122 cm) high. Musée Barbier-Müller, Geneva

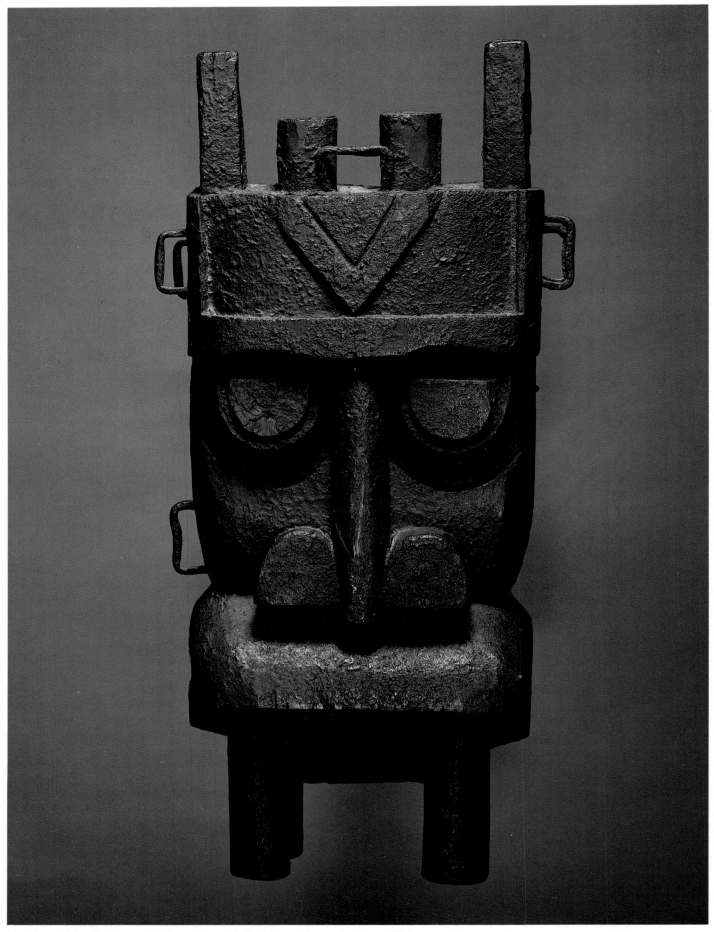

Headdress. Kalabari Ijo. Nigeria. Wood, 18½″ (47 cm) high. Collection Raymond and Laura Wielgus

FROM AFRICA

Jean-Louis Paudrat

Early in this century, when ethnographic specimens began to be perceived as objects of artistic importance, Paris more than any other city became the point of convergence for the propagation of ideas and activities that bestowed on African art an essential role in the formation of Western sensibility.

Over the centuries a variety of tribal objects had found their way into French collections, their number eventually augumented by the fervor of French colonialism (and its attendant scientific studies) after 1880. Only a few of the objects that arrived before the second half of the nineteenth century, however, found their way into public collections. Of those French "cabinets of wonders" set up in the Renaissance by a few princes and shipowners to contain "strange idols"[1] brought back from an Africa that Rabelais described as "always known for producing new and monstrous things,"[2] no material traces would seem to survive. Only five elaborate hunting horns, two eating implements, and a powder horn survive from the sixteenth-century Afro-Portuguese art produced by Sherbro, Edo, and Kongo ivory carvers. Anyi funerary pottery may very well have come from Africa at the end of Louis XIV's reign,[3] but there is no mention of it in the inventories. There are records, however, of a "statuette from the coast of Guinea,"[4] whose tribal origin is difficult to ascertain; it was sent during the eighteenth century to the Cabinet des Médailles of the Bibliothèque Royale. Just as in his *Recueil d'antiquités égyptiennes, étrusques, grecques et romaines* Comte de Caylus in 1756 had reproduced a Kulango bronze pendant,[5] so in *Les Monuments des arts du dessin chez les peuples tant anciens que modernes* Baron Denon, who had participated in Napoleon's Egyptian campaign, published an object whose source was equally remote from the banks of the Nile. Finally, during the first half of the nineteenth century, a few Akan gold powder boxes were placed in the Cabinet des Médailles.

Then, in 1850, the Musée Naval of the Louvre was established. This institution, according to the inventory drawn up in 1856,[6] owned close to five hundred objects sent by overseas companies operating under the protection of the navy: primarily weapons, agricultural tools, articles in leather and basketwork, headdresses, and musical instruments.

A few years later, in 1874, E.-T. Hamy, an assistant at the Museum d'Histoire Naturelle, conceived a plan "to bring together in a single museum the tribal objects scattered in various state establishments."[7] His proposal resembled those that had been put forward by Barthélemy as early as the late eighteenth century and by Jomard, curator of the Dépôt de Géographie in 1828.

The opening in Paris, on January 23, 1878, of the Musée Ethnographique des Missions Scientifiques—immediate ancestor of the museum that was to play such an important role in the evolution of Paris modernism—represented the first result of efforts by Dr. Hamy to convince the Ministry of Public Education of the need to endow the French capital with a scientific institution devoted to assembling and classifying in a comparative fashion the most representative specimens showing the evolution of the technics of mankind.

Distinct from those of the Musée Permanent des Colonies, which had been visible in the same building since the Exposition Universelle of 1855, the hastily assembled collections were displayed for six weeks in three rooms on the second floor of the Palais de l'Industrie on the Champs Elysées. Consisting essentially of artifacts from the ancient cultures of

Asia and the Americas, the exhibition set apart a smaller section for Oceania and Africa. For the latter, there were two displays from Gabon, arranged by Hamy with material collected by Alfred Marche during his second expedition (1875–78) to the Ogowe River. This was probably the first time that a Kota reliquary guardian figure could be seen in France.[8]

The success of this precursor of the Musée d'Ethnographie prompted Baron de Watteville, Director of Sciences and Letters, to open a "Hall of Voyages and Scientific Expeditions" at the Exposition Universelle of 1878; it contained more or less the same objects displayed at the Palais de l'Industrie. Meanwhile, an exhibition of "ethnographic objects of peoples outside Europe,"[9] meaning the Americas and Africa, was installed in the right wing of the Palais du Trocadéro. Here, too, the items from Alaska, Mexico, and Peru outnumbered those from Africa: a group of carved ivories from the Congo belonging to the merchant Conquy Senior, some weavings and weapons from Basutoland lent by Casalis, and a few small Asante objects. Finally, the African section at the Palais des Colonies, supplied chiefly by shipments from commercial warehouses in Gabon and the Gold Coast, was, except for garments and various objects for domestic use, limited to scales and weights to measure gold dust and some Akan trinkets, including a "fetish" from the Fante ruler of Assinie.

While the most conspicuous effect of the Exposition Universelle of 1878 was the strengthening in public opinion of the idea of France's colonial destiny in Africa, the science of ethnography was able at this moment to define with greater clarity its objectives in relation to expansion toward the interior of Africa. At the same time, the decision to create in Paris an ethnographic museum comparable to those already established in certain foreign countries was finally made. But

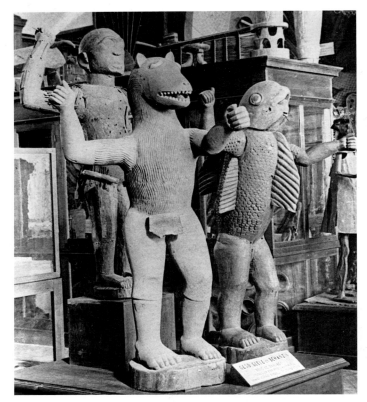

Three Fon figures as installed in the Musée d'Ethnographie du Trocadéro (now Musée de l'Homme), Paris, 1895

we must still note that the various manifestations of that decisive year were based on few African groups, those being for the most part along a few parts of the Atlantic coast. The gifts received by Dr. Hamy for the future museum, interesting as they were, were still few in number:[10] an Igbo Ikenga from Onitsha acquired from the dealer Bishoffeim after being bought at the Exposition Universelle; a few objects from the Western Sudan brought back by Soleillet from his journey to Ségou; and a statuette from the Guinea coast, brought to France in the eighteenth century and given by the Bibliothèque Nationale. One ought, however, to note that the Musée Permanent des Colonies, the Museum d'Histoire Naturelle, the Musée Naval du Louvre, the Musée d'Artillerie, and the Bibliothèque Nationale, as well as some learned societies (of geography, anthropology, and zoology) had collections in the same period that were somewhat more extensive, comprising weapons, fabrics, dress ornaments, musical instruments, domestic and ceremonial objects. Moreover, the "Musée Africain,"[11] installed in September 1879 for a few months in the lobby of the Théâtre du Châtelet, despite the confusion of its presentation, broadened the ethnic and material typologies to include objects from the central, eastern, and southern regions of the continent, as well as others with a "cultural purpose" ("African divinities" from the Bertin collection, "wooden mask used in religious celebrations, . . . sacrificial knives, various fetishes, idols, household gods, emblems of beauty" from the Bouvier collection).

The display at the Châtelet was, in its way, symptomatic of a tangible change in attitudes toward Africa. Adolphe Belot's play La Vénus noire, which was the pretext for the Châtelet display, followed faithfully, despite a few liberties, the account that the German naturalist Schweinfurth had given of his journey (1860–71) through the lands of the Shilluk, Dinka, Bongo, Zande, and Mangbetu.[12] His Im Herzen von Afrika, published as Au coeur d'Afrique in 1874 in eleven splendidly illustrated installments in the magazine Le Tour du monde, revealed to the French public that in the interior of the continent, free from both Christian and Islamic influences, there existed societies of a high level of culture, which had developed sophisticated music, poetry, and arts of decoration and architecture. But even as he evoked the pomp of the court life of the Mangbetu ruler, the author of the stage adaptation undertook to stress on his own the savagery of certain kinds of behavior that the audience was to understand had not yet been softened by the beneficent influence of Western civilization. Thus nourished by reports of the discovery of unknown lands, by descriptions of the strange customs of the societies encountered, and by stories of the adventures of intrepid explorers, the taste for exoticism was steadily whetted. But the transition from the fantastic to the more pragmatic realities represented by France's political and economic interests was constantly being introduced.

The sponsors of the Musée Africain—the geographical societies of Marseilles and Paris, the Zoological Society, the representatives of a number of Marseilles commercial firms established on the African coasts—profiting by the conclusions of the previous geographical congress, hoped to convince public opinion of the continuity they thought should exist between the sciences and their applications in the

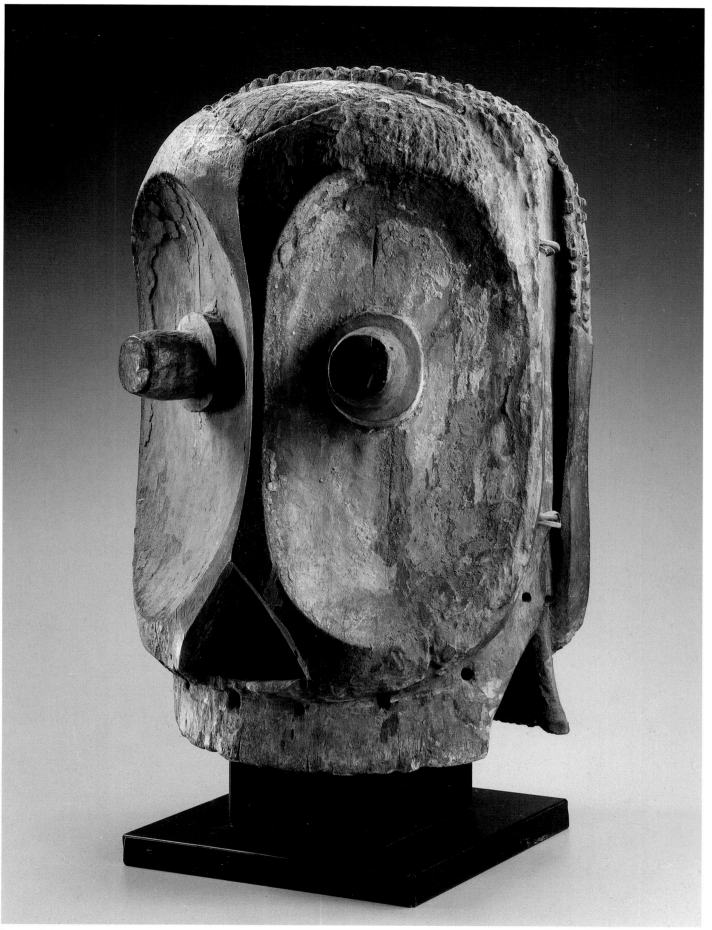

Janus mask. Bembe. Zaire. Painted wood, 23⅝″ (60 cm) high. Private collection

Kota reliquaries drawn by Riou after documents brought by Jacques de Brazza from the West African Expedition. Published in *Le Tour du monde*, 2e semestre, 1887

Kota objects, including reliquary figures, acquired by the Musée d'Ethnographie du Trocadéro (now Musée de l'Homme), Paris, between 1883 and 1886. Heliogravure published in *Le Tour du monde*, 2e semestre, 1888

conquest of new territories. Zoology, botany, and ethnography could help to provide better information about countries to be taken over, the dangers they concealed, the resources they offered, and any customs of their inhabitants that would be useful to know in order to subject them to the plans of the future colonial power. The Châtelet exhibition responded to this didactic purpose, one that the Musée d'Ethnographie was to assume on a larger scale. The collections of the naturalist Bouvier, sponsor of the Marche and Compiègne expeditions to Gabon, the Petit to Cabinda, the Lucan to Loango, etc., exemplified the benefits to be reaped from supporting the colonial cause.

It was to men like Charles Maunoir, secretary general of the Société de Géographie of Paris, and Edouard Charton, editor of *Le Tour du monde*, that the Minister of Public Education appealed, asking for their participation on the commission whose operations were to lead first to the designation of a repository for the collections assembled since 1878 and then to the opening to the public, in the exhibition rooms at the Trocadéro Palace, of the Musée d'Ethnographie itself on April 12, 1882.

From 1879 to 1886, which year was to see the entry into the museum's collections of some of the pieces gathered by the members of the West African expedition (1883–85), the prog-

ress of acquisitions seems to have been singularly slow. Still, the geographical and ethnic origins of the objects recorded during this period deserve to be mentioned. From the coast of West Africa, a Bijogo sculpture from the Bissagos Islands—then a Portuguese territory—arrived in 1881. In 1883 an Elek figure and a small Nimba bust of the Baga people of maritime Guinea, and five Igbo statuettes collected in the Niger delta by Commander Mattéi, general agent for the Compagnie Francaise d'Afrique Equatoriale, were acquired. From the Western Sudan, a Bambara antelope headdress was sent by Captain Archinard, and in 1885 there came a Nama mask of the same people, as well as a Malinke statuette acquired nearby by Dr. Bellamy. Finally, from Gabon came the guardian figure from a Kota reliquary collected by Guiral, then a member of the second expedition led by Pierre de Brazza.

The scientific booty of de Brazza's third expedition to Central Africa, called the West African Expedition, carried out under the aegis of the Ministry of Public Education, was presented to almost thirty thousand visitors, between July 1 and 15, 1886, in the Orangerie of the Jardin des Plantes, an outbuilding of the Museum d'Histoire Naturelle. From those regions where members of the expedition had begun setting up an administrative and political organization (Loango Coast and Kouilou-niari area, Teke plateau, the banks of the middle

and upper Ogowe, of the Alima and the Congo), 101 boxes containing the various natural-history and ethnographic specimens that had been collected arrived in the spring of 1886. Some had been gathered by the naturalist Jacques de Brazza and his assistant, Attilio Pecile, both having been hired for this purpose in 1883 by the Museum d'Histoire Naturelle. The rest had been assembled by a noncommissioned officer named Cholet, who sent from the Kouilou region "144 pieces including 24 of metalwork, 15 musical instruments, 5 smokers' articles, 38 objects of domestic use, and 15 fetishes," by the engineer Michaud (middle Ogowe), by Dr. Schwebisch, the expedition's physician, and by the naturalist Tholon (upper river). A few ethnographic specimens picked up more haphazardly by other agents of the expedition (Dolisie, Chavannes, Beauguillaume) completed the collection of Gabon-Congo pieces exhibited at the Jardin des Plantes.[13]

The *Notice sur les collections de la Mission Scientifique*,[14] drawn up for the occasion by Emile Rivière, clearly shows that despite the importance of the items that had been gathered, little was known about their purposes or use. At most the author relates the longitudinal stripes on the face of some "fetish" to the scarifications customarily practiced by the Teke, the side wings on the head of some other to the headdresses of Mbamba women, or the filling of eye sockets with bits of glass to a technique resembling that employed by the ancient Egyptians. These hasty considerations, like those repeated by Hamy in his lecture to the Société de Géographie, show that "customs and costumes, beliefs and myths, were scarcely touched upon"[15] by those who brought together the material evidence of them.

The dispersion of the exhibits at the end of their temporary presentations was carried out chiefly to the advantage of the Museum d'Histoire Naturelle, the geographical societies of Paris and Rome, and the Musée d'Ethnographie du Trocadéro. This last, which as early as 1884 had received from Schwebisch and Tholon three Kota reliquary figures, an Aduma mask, and two statuettes attributed to the Ondumbo, was enriched in 1886 by gifts from de Brazza and Pecile of three more reliquaries and a few Vili statuettes, a Hongwe reliquary from Pierre Michaud, and an important group of Vili and Kugni objects from Cholet. A display consisting of all the reliquary figures received since 1883 was shown in the African room in late 1886.[16]

In March 1887 the collection formed by the gem dealer Bertin over a period of almost thirty years was put up for auction.[17] Though it consisted mainly of objects from the Pacific islands, the catalog does mention a "club from Central Africa and Gabon." We may recall that at the time of the Musée Africain exhibition a glass case and an array of ethnographic specimens belonging to Bertin contained, in addition to some "clubs" and "staffs," a few "African divinities." Among the purchasers at the Bertin auction figure the names of Emile Heymann, who was to open a shop dealing in tribal and exotic objects on the Rue de Rennes in 1896, and that of Prince Roland Bonaparte, future president of the executive committee of the Société de Géographie, whose generosity made it possible for the Musée d'Ethnographie du Trocadéro to expand its Oceanic collection. It seems likely that the group of seven carved African objects, including two Chokwe ceremonial staffs, registered under Bonaparte's name in 1888, also came from the Bertin sale.

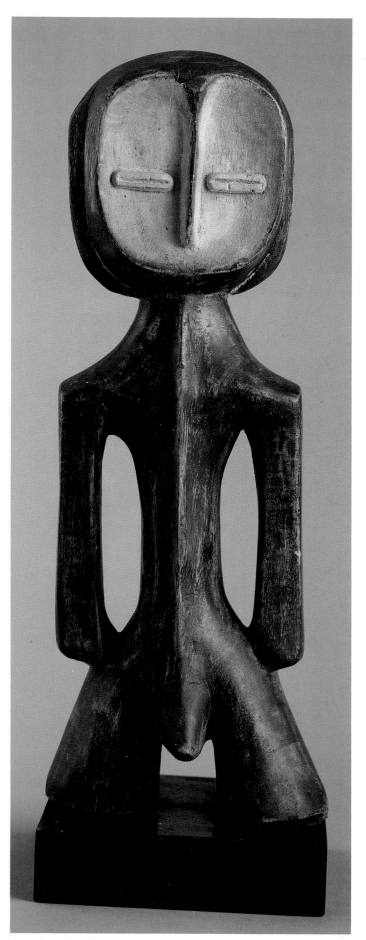

Janus figure. Lega. Zaire. Painted wood, 19¾" (50.2 cm) high. Private collection

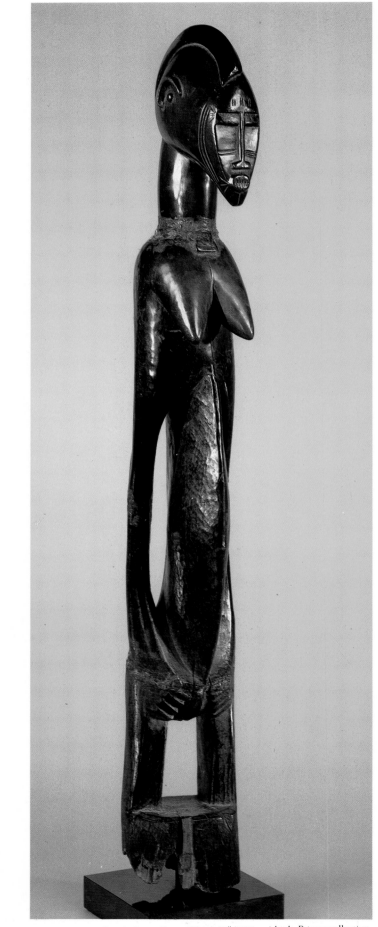

Rhythm pounder. Senufo. Ivory Coast. Wood, 38" (96.5 cm) high. Private collection

Even more than the previous one, the Exposition Universelle of 1889[18] was to attest to the wish of its organizers to popularize the colonial idea. France's economic development and political expansion were presented at the time as the result of three convergent factors: the reform of the educational system, the progress of the applied sciences, and the first successes of colonization. Thus, at the Palais des Arts Libéraux, in the large hall where the Ministry of Public Education celebrated the virtues of secular, democratic instruction, the contributions of the first "scientific" expeditions, which had gone to Africa under its sponsorship, were given particular importance. Alongside various documents relating to the successive stages of the administrative organization of Gabon-Congo, some of the more important objects brought back by the members of the West African Expedition were conspicuously displayed. At the Exposition du Travail et des Sciences Anthropologiques, the comparative perspective adopted was expressed partly by examples from East Africa (Roland Bonaparte collection) and southern Africa (Lombard collection). Furthermore, in the halls of the Palais Central des Colonies, where samples of products intended for importation by France were on display, each of the African sections exhibited a few objects judged to be representative of its land of origin. For the Sudan, there were Malinke and Bambara statuettes; for Guinea, a few Baga and Landuma sculptures; for the Gold Coast, some Anyi objects; for Dahomey, some Anago (Yoruba) masks and Fon sculptures; and for the colony of Gabon-Congo, forty-seven "fetishes" of various kinds.

Though the editor of the official catalog of the Palais Central notes explicitly that in relation to Anyi statuary it is possible to speak of "primitive art,"[19] and Pol-Neveux in the *Revue de l'Exposition Universelle*[20] insists on the refined art of sculpture among the Baga, and more generally compares the sincerity of the African sculptor to that of the anonymous artists who decorated the cathedrals, what prevails in the reports is the expression of an amused condescension for what looks merely crude, archaic, and childish.

The duplication in the Place des Invalides of a few dwellings claimed to be typical of Senegal, Gabon, or the Congo also caught the public's fancy. On the square of the "Pahouin" village, a few Okande, Aduma, or Vili tribesmen could be seen, performing dances or engaging in craftsmanship. Some of them would carve on demand exotic ivory souvenirs.

Simultaneously with the triumphant figure of the Engineer (Eiffel), glorified by the Exposition of 1889, there slowly rose that of the Colonial Officer, conqueror of the hinterlands, first organizer of the colony, pacifier, but also soldier of Christian Civilization combating the power of "fetishes" and the custom of human sacrifice.

The long and murderous campaign fought by France in Dahomey after 1877 to subjugate the kingdom of Abomey ended on January 25, 1894, with the capitulation of its ruler. Behanzin's surrender marked for one part of the French press the victory of faith, for the other of reason, over "degrading fetishism." The display at the Musée du Trocadéro of the symbols of power seized by Colonel Dodds in the holy city of Kana and the palace of Abomey was in some way proof of the civilizing action over heresies that were not only religious but political as well: the royal throne, four relief doors with

symbolic motifs, three allegorical statues said to be representations of the ancestor, the father, and the king himself (p. 126), to which were later added a metal effigy of the Fon thunder god (p. 322) and two monumental thrones. Still, the display of these trophies aroused comments that were not always scornful or arrogantly assured. For the columnist of *Le Monde illustré*, for example, they represented "the finest specimens of Negro industry," and, he added, "There is a considerable distance between these interesting figures and the crude fetishes of New Caledonia."[21] Likewise, Maurice Delafosse (in two articles in *La Nature*,[22] whose preservation for *L'Anthropologie* was ensured by René Verneau) objected to the term "fetish," which he deemed vulgar, and to the conventional opinion that Dahomeans were incapable of artistic feeling and devoid of any lofty religious belief. For the careful and honest observer that he was, these productions were historical documents, the ideographic annals of the kingdom. As such, they called for deciphering and interpretation. His words on Dahomean culture contrast strikingly with those that brought success to the patriotic play *Au Dahomey* at the Théâtre de la Porte Saint-Martin, or those describing the display of some 150 male and female warriors on the Champ de Mars.

Compared with the advances within the borders France inherited from the Berlin Conference of 1884–85 and the rise in the number of administrative and commercial agents in the territories France already controlled, additions to the African collections of the Musée d'Ethnographie were only moderate during the 1890s. If one excludes the kingdom of Dahomey (the acquisition of the Behanzin Treasure had been preceded by a few objects donated by the administrator d'Albéca in 1889, and in 1891 by the important objects assembled between 1886 and 1890 in Anago country by Edouard Foa) and lands under non-French colonization whose registered samples are numerically few), the entries for West Africa are limited to the Ivory Coast (a few examples of Anyi statuary, an Adjukru gold sword ornament, two masks, two statuettes, and a large Baule drum), the Sudan (two sculptures of the eastern Bambara of Ouassoulou and a Malinke figure), and Senegal (a Balante mask). From Gabon, the Congo, and Ubangi, however, there is comparatively greater movement of objects. From late 1889 to 1900 the museum acquired some forty anthropomorphic and zoomorphic "fetishes" ("Nkonde" with nails, with mirror, and with magical function): thirty-five Vili (p. 67) and one Woyo (Kongo); four Teke; one Ambete. In addition, it received three Vili masks, one Teke mask, and two reliquaries, Sango and Ondumbo; an Ambete bust; and, among the musical instruments, a Vili whistle and a large Yangere drum in the shape of a buffalo acquired from de Brazza in 1895. The only Fang sculpture to enter the museum before 1900 was obtained by purchase in 1898. Moreover, at the end of the nineteenth century the Trocadéro collections still did not include masks or figures from the Dogon. The same goes for Upper Volta (Mossi, Bobo, Bwa, Kurumba). The frontier areas of the west (Dan, Guere) and northeast (Senufo, Lobi) were not represented either. From Gabon and the Congo, one finds no carved specimens of the Kwele and Tsogo peoples, and the inventories contain no mention of Shira-Punu masks, Bembe statuettes, or Mboshi polychrome heads. Furthermore, the dispersion of bronzes and ivories from the court of Benin, which took place as early as 1897 in England,

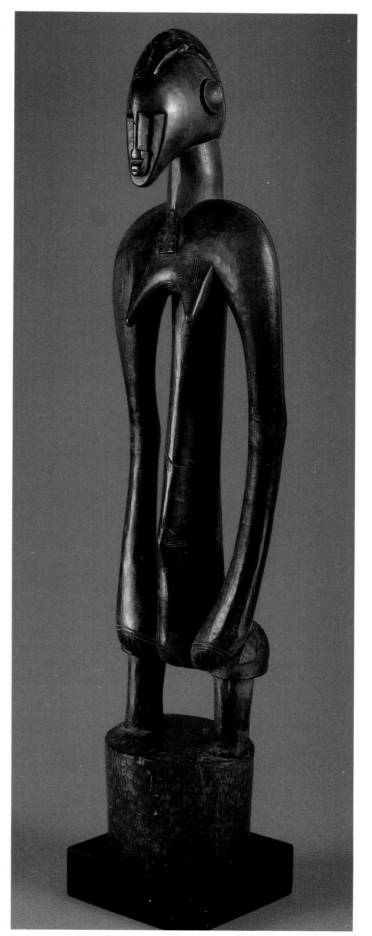

Rhythm pounder. Senufo. Ivory Coast. Wood, 36" (91.5 cm) high. Private collection

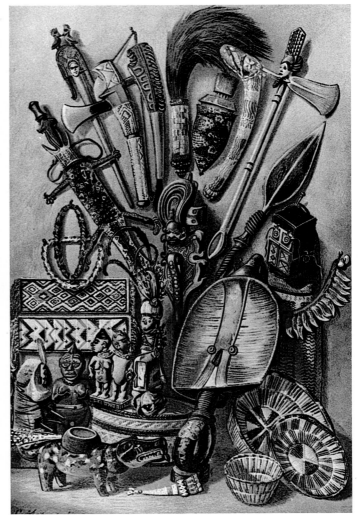

Two figures from the Sudan, West Africa, published as "Poupées fétiches des Nègres du Soudan" in *Bibliothèque illustrée de voyages autour du monde,* 1888

Engraving of African objects in Friedrich de Ratzel's *Völkerkunde,* vol. 1, Leipzig, 1885

did not lead to any acquisitions on the part of the Trocadéro museum. Similarly, no object from the Cameroon Grasslands or the eastern savannahs of the Belgian Congo, except perhaps for two Chokwe ceremonial staffs, appear at this time in the collections of this institution.

In 1900, after the closing of the Exposition Universelle, the organization committees of the Guinea and Ivory Coast sections would donate a few gifts to the Trocadéro, including a Nalu initiation mask of the Simo confraternity, some thirty Akan weights for measuring gold, a Baule monkey statue, four Anyi funerary terra-cottas, the much-reproduced Grebo mask from the Sassandra region (p. 260), and a wooden head (Uhunmwun-elao) from Benin, attributed to the Baule. To this should be added the Baule masks and statuettes donated personally by Clozel, secretary general of the Ivory Coast, and by Delafosse, then deputy administrator of that colony. It was Delafosse who formulated, in *L'Anthropologie* in 1900, on the basis of a comparison with some of his sculptures displayed at the Exposition, the hypothesis of the existence of "probable traces of Egyptian civilization and of men of the white race on the Ivory Coast."[23]

During the last quarter of the nineteenth century, French publications accorded, by and large, very little space to the illustration of African artifacts. One cannot, of course, deny

that *Le Tour du monde*—which had no competitor in this until the appearance in 1897 of *La Bibliothèque illustrée des voyages autour du monde*—published as accompaniment to its tales of exploration numerous engravings of the regions crossed and the activities of peoples encountered by the authors. But it must be admitted that while illustrations showing domestic tools, ornaments, finery, and musical instruments are fairly abundant, those reproducing religious objects or political symbols are much more rare. If we take, for example, the long report *Du Niger au Golfe de Guinée,* written by Binger about his expedition, which appeared in 1891 in *Le Tour du monde*[24] before being published in two volumes, we note that out of almost a hundred engravings, only six relate to masks and statuary. There are no French equivalents to *Artes Africanae* (1875)[25] by Schweinfurth, to the three volumes of *Völkerkunde* (1885–88)[26] by de Ratzel, or to *Die Masken und Geheimbünde Afrikas* (1898)[27] by Frobenius, who published no less than 130 masks representing all the known regions of Africa.

The extent of German documentation is obviously not unconnected with the richness of the public ethnographic collections on display in most of the large cities of that country. Berlin is only one example.[28] Although Bismarck's Germany

had been engaged in a policy of colonial expansion for only two years, the Berlin Museum für Völkerkunde housed almost ten thousand African tribal objects when it opened to the public in 1886. The collections were based primarily on specimens gathered on exploration expeditions led by such great German travelers as Barth to the central Sudan (1850–55), Rohlfs between Tripoli and the Guinea Coast (1867) and some time later in Abyssinia, Nachtigal to East Sudan (1868–74), and Schweinfurth in the Nile regions and on the banks of the Uele (1868–71). Under the firm direction of Adolf Bastian, the collections were later to be enriched by additional contributions. The members of the German Society for the Exploration of Equatorial Africa (its founder Bastian, Peschuel-Loesch, Gussfeldt) brought back, with valuable observations on the conditions of their use, an important number of Vili "fetishes," gathered between 1872 and 1876 on the Loango Coast.[29] Later some Chokwe,[30] Lunda, and Luba (p. 398) objects were sent by Homeyer and Pogge after the expedition that connected Luanda and Kimbundu (1875–76). The Austrian geologist O. Lenz, who explored the Ogowe in 1877 on behalf of the German branch of the International African Association, sent a Hongwe reliquary figure, along with some Kongo, Adumas, and Ilanda pieces. Finally, some Urhobo, Nupe, Tiv, Jukun, Mbum, and Baya objects were obtained in 1880 from Flegel, corresponding to the stops on his journey.

For the period extending from 1881 to 1899, marked by a significant growth in the Berlin collection, we can here mention only the most important acquisitions. Some Songye, Luba, Kuba, Lulua, and Ngombe (p. 399) works were obtained during three expeditions (1881–87) by Wissmann,

the German agent for the International Association of the Congo. As a consequence of the German annexation of the Cameroons in 1884, the soldiers and administrators in the new protectorate (Sand, Passavant, Zintgraff, Zenker, Conradt, and Conrau) sent back Duala, Kundu, Wute, Balong, Bafo, and Bangwa objects. In addition, from the Congo Basin, Lieutenant Mikic, then in the service of Leopold II, Buttner, Joest, and Visser collected Sundi and Kongo objects (especially Vili) for the museum.

In 1897, at first under the personal financial initiative of von Luschan, one of the two most important collections of works from Benin began to be assembled (p. 377). A few weeks after the pillage carried out by the British in the palace of the ruler of Benin (at the time of the punitive expedition sent in February 1897 to avenge the massacre of almost all the members of an apparently peaceful mission deemed unwelcome by the Oba's advisers), the official loot—close to one thousand bronze plaques that had originally adorned the wooden pillars of the palace—was put on sale in London by the Foreign Office. In addition, a large part of the spoils of war appropriated individually by soldiers in the expeditionary corps was soon put in circulation by enterprising dealers.[31] For those who were its first enthusiastic commentators and avid purchasers, however, this numerically considerable ensemble represented something quite other than a collection of curiosities. The perfect technical mastery of rare, precious, or durable materials, along with the talent of craftsmen skilled in giving realistic material form to the legitimation of the royal powers, was recognized, not without amazement, as a sign of the incontestable presence of a great art in Africa. As proof, there are the numerous scholarly writings that already by 1900

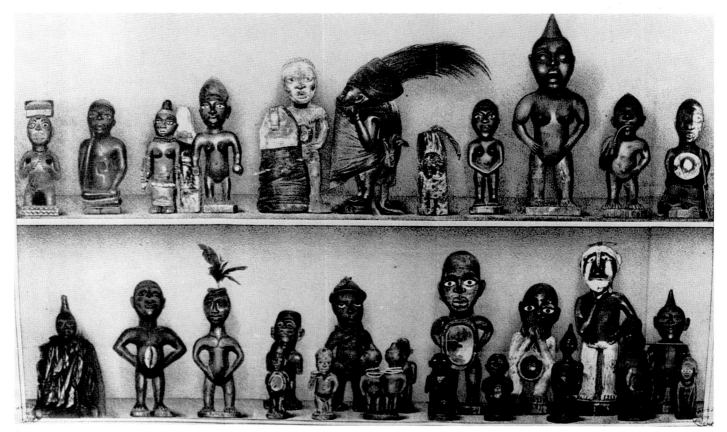

Figures from the Loango coast collected by Bastian, Peschuel-Loesch, and Gussfeldt. Published in A. Bastian, *Die Deutsche Expedition an der Loango-Küste*, 1874

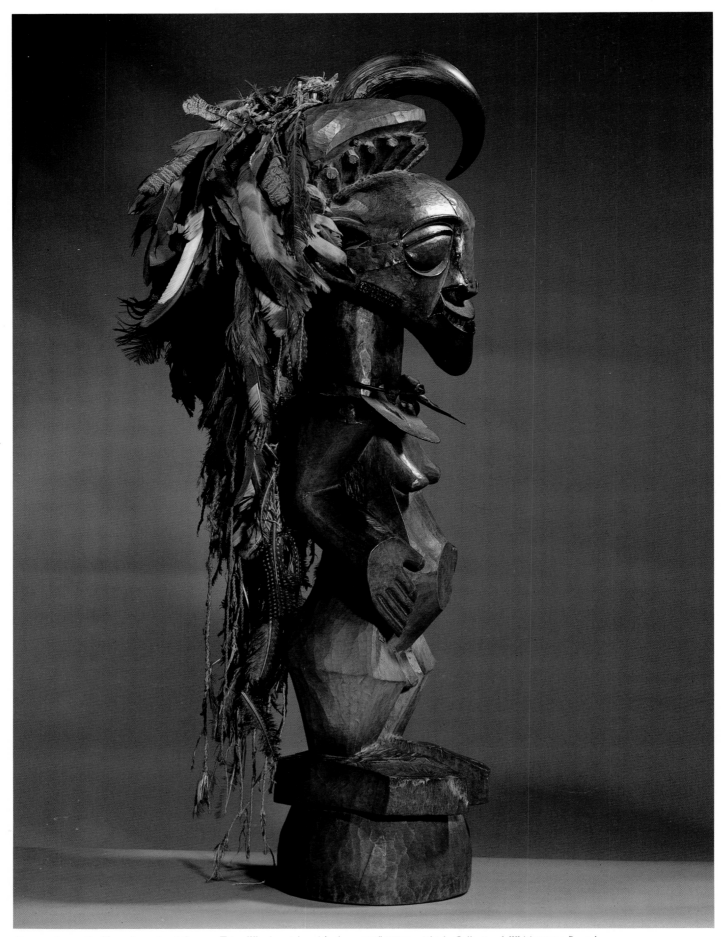

Above and opposite: Figure (two views). Songye. Zaire. Wood, metal, and feathers, 44¼" (112.5 cm) high. Collection J. W. MESTACH, Brussels

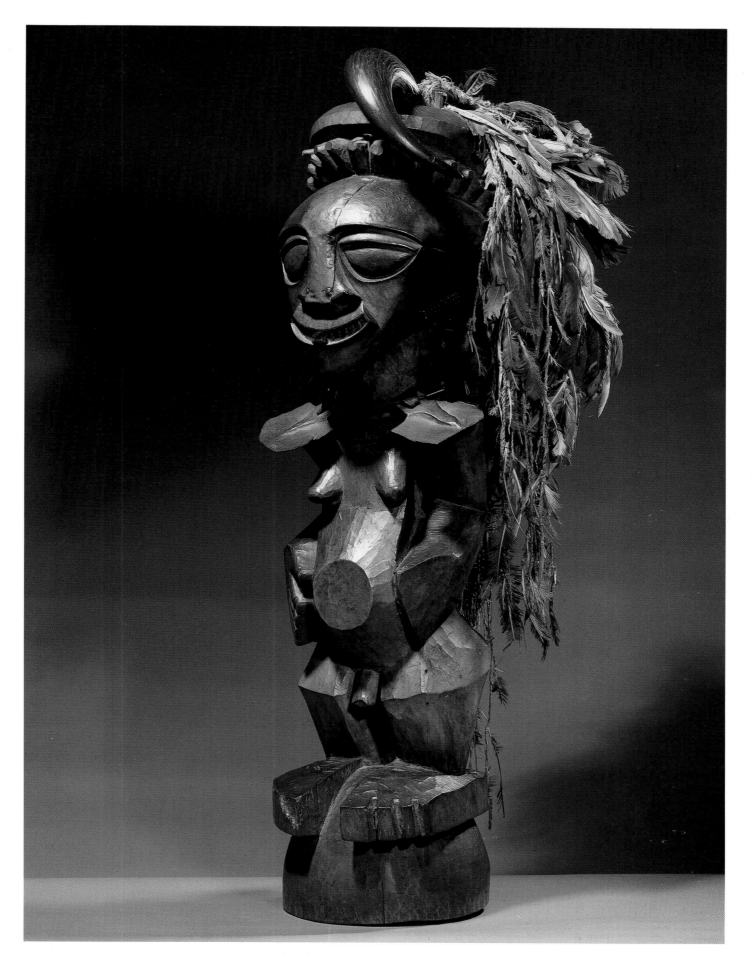

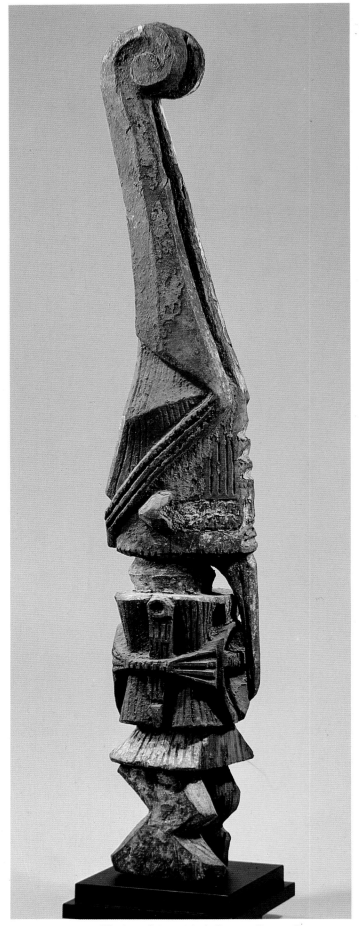

Figure. Igbo. Nigeria. Wood, 38⅝" (98 cm) high. Private collection, Paris

offer a partial description of it (Forbes, Pitt-Rivers, Roth, Read and Dalton in Great Britain; Carlsen, Brinkmann, Foy, von Hagen, and von Luschan in Germany; Heger in Austria; Peet in the United States). At the same time, among museums—not all of which were ethnographic—one sees the beginnings of a certain competition to obtain the most characteristic examples of this highly developed court art. Thus in the last three years of the century, the museums of Liverpool, Glasgow, Edinburgh, and the British Museum in Great Britain, those of Hamburg, Stuttgart, Vienna, Berlin, Munich, Leiden, and Copenhagen in continental Europe, and the Field Museum of Chicago in the United States were enriched, some by a few objects, others by impressive series. The role played by dealers in the diffusion of these works (Webster, Cutter, Stevens, Bey, and later Oldman in England, Umlauff in Hamburg, Opperse in Amsterdam) was unquestionably a decisive one. One has only to consult, for example, the auction catalogs published by W. D. Webster in order to be convinced: In the thirty-one issues published between 1895 and 1901, no less than 546 objects from Benin are described and illustrated.

Nevertheless, however gripping the confrontation between the West and the unexpected works of Benin may have been, it is hard to go along with William Fagg when he states that "this event was of incalculable importance for the first experiments of modern art" and that "it helped to create in favor of tribal art an atmosphere of consideration under the influence of which...the great innovative artists of Paris and Munich found a direct impulse."[32] While Derain may have visited the African section of the British Museum in 1906, it is difficult to believe that it was in the art of Benin that he recognized a "stupendous" power, "bewildering in expression."[33] And while the Blaue Reiter almanac includes a bronze plaque from that kingdom,[34] one cannot thereby conclude that a continuity would exist between the revelation in 1897 of this court art and the "discovery" by vanguard artists in 1906 of the tribal sculpture of Africa.

The British Museum came into existence in 1753 through the bequest of the enormous private collection of Sir Hans Sloane, a physician whose interest began in collecting natural-history specimens, but came to include books, manuscripts, coins, antiquities, works of art, and ethnographic objects.[35] Of the original 351 ethnographic items, only 29 were of African origin, including a Kongo textile and two ivory bracelets from Guinea; these were the first African objects in the British Museum. For the remainder of the eighteenth century the African collections increased slowly and with little conscious direction. Acquisitions depended largely on individual generosity and reflected the scientific and colonial interests of Great Britain. The most famous expedition of the period, that of Captain James Cook to the Pacific Islands, returned with many natural-history specimens and ethnographic objects that were added to the British Museum (as well as to many other European museums).

Two noteworthy additions to the African collection occurred during the first half of the nineteenth century. In 1819 T. E. Bowdich returned from his "Mission from Cape Coast Castle to Ashantee" in Ghana, and presented among examples of woodworking, metalworking, and textile arts "six

Installation view of Congolese objects at the Exposition Universelle, Brussels, 1897 (in what is now the Musée Royal de l'Afrique Centrale)

specimens of the goldsmith's work" earmarked for the British Museum by the Asante king. The other significant acquisitions of this period were the objects brought back by the ill-fated Niger expedition in 1843.

The entire ethnographic section expanded much more rapidly during the second half of the nineteenth century under the devoted keepership of Augustus Wollaston Franks. Additions to the African collection were made during this period by administrators and officials in Britain's colonial services. These included that of Sir Bartle Frere from South Africa (1877–80), Sir Harry Johnston from Nigeria (1885–87), Sir John Kirk from East Africa (1888), and J. T. Bent from Mashonaland (1893).

The early twentieth century was a time of continued collecting by self-taught anthropologists, travelers, colonial officials, and missionaries. From 1904 to 1910, the Museum purchased a major group of textiles and sculptures from Emil Torday, who explored what was then the Belgian Congo. The Museum continued to build up its holdings from East Africa through donations made by Sir Claud Hollis from Kenya (1908–10) and Sir Apolo Kagwa, the Katikiro of Uganda (1902). Objects from northern Nigeria were donated by Mr. and Mrs. Macleod Temple and by P. Amaury Talbot, who collected in southeastern Nigeria. During the 1920s the Museum added T. R. O. Mangin's collection of brass gold-weights from the Gold Coast, artifacts collected by H. S. Stannus from Nyasaland, and objects sent by the government of Tanganyika Territory to the British Empire Exhibition of 1924. In 1933 ethnography became an official Sub-Department, and Thomas Athol Joyce became Sub-Keeper. The holdings in East and South Africa were increased by H. J. Braunholtz's collecting of thousands of stone-age implements. The C. A. Beving collection of West African textiles came to

the museum in 1934, as did objects collected in the French Cameroons and the Anglo-Egyptian Sudan by Major and Mrs. P. H. G. Powell-Cotton. Their daughters collected and donated objects from Somaliland and Angola later in the decade.

There are few significant facts on record to show what attention may have been paid to tribal art by modern European artists and those around them between the early 1890s (by which time Gauguin may have owned two small African figures)[36] and 1905, the year generally—though, as we shall see, mistakenly—considered to mark the threshold of vanguard interest in "art nègre." A few unconvincing, sometimes contradictory, examples have been proposed. It has been suggested, for example, that James Ensor, having accomplished the most important part of his work, may have discovered the art of the Congo at the Exposition Universelle in Brussels in 1897,[37] and that the sculptures that the Belgian Symbolist Georges Minne exhibited with Les Vingt in 1890 may not have been unrelated to "the fetishes of savage tribes."[38] However, when Carlo Carrà, during his first stay in Paris in 1899, paid a visit to the Musée d'Ethnographie du Trocadéro, he noted only its mediocrity and insignificance.[39] Jacob Epstein, on the same premises in 1902, saw only a mass of Primitive sculptures, poorly displayed.[40] Moreover, there is nothing to show that Picasso or Matisse might have been especially sensitive to anything contained in the colonial pavilions at the Exposition Universelle of 1900.

For the period around the turn of the century (1897–1903), the absence of verified factual data cannot, however, justify the supposition that the recognition of Primitive art by modern artists was the result of a sudden chance encounter, as so

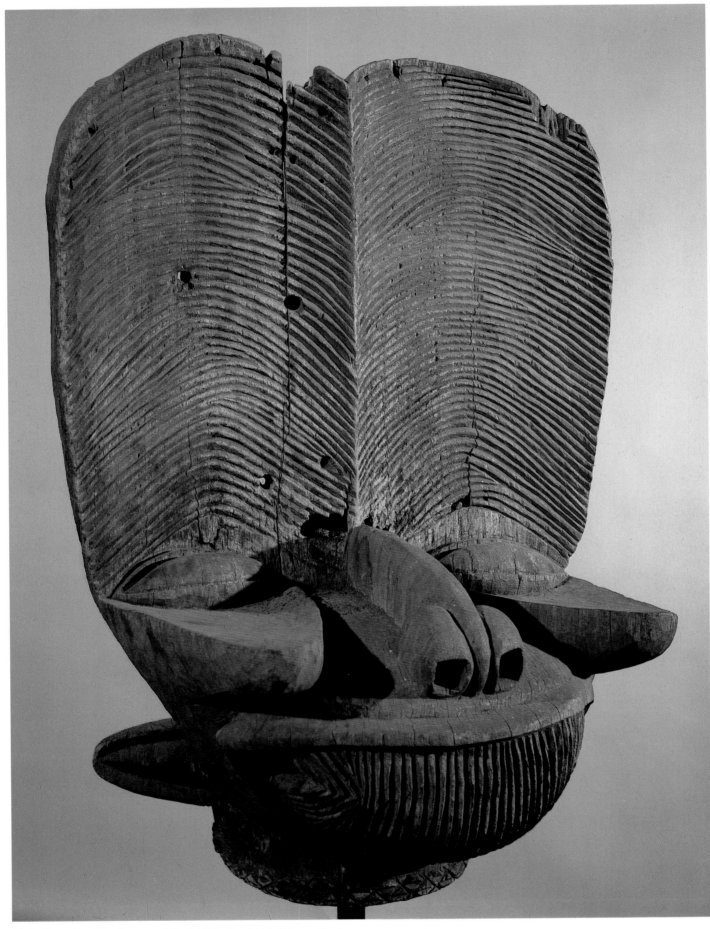

Mask. Eastern Bamileke. Cameroon. Wood, 30″ (76.2 cm) high. Private collection

many fond memorialists would have us believe. Just as one should not underestimate the historical conditions that make its emergence part of a process begun before the end of the nineteenth century, so one cannot rest content with sources quoted to verify that the confrontation, in the sense that we know it today, actually took place before the autumn of 1906.

None of the accounts of events most often assigned to the year 1904 is believable, much less corroborated by sufficient proofs: While Vlaminck, who can hardly be accused of wishing to dissemble the role he had attributed to himself as the discoverer of Negro art, himself places his discovery in 1905,[41] Goldwater, on the basis of a questionable piece of information from Kahnweiler, anticipates him by a year.[42] On the other hand, Goldwater is led to suppose that the first assembling of objects by Matisse would have "perhaps" taken place in 1904, and in any case "before 1906."[43] There are three accounts by the artist himself that conflict with these hypotheses. Furthermore, among the collections established by a few connoisseurs and whose beginnings have been said to go back to 1904, none seems really to have got started in that year. André Level, in a private communication received by Goldwater[44] in 1934, and later in his "memoirs," claims that it was in 1904 "that he was touched by grace in the presence of the first Negro sculptures he saw."[45] But this encounter, as he tells it, took place at Matisse's—which shifts the event to a later date, no earlier than 1906 and probably later. For his part, Jean Laude has suggested that Félix Fénéon would have begun collecting a few African objects "around 1904."[46] But the two editors of books on his criticism, Françoise Cachin[47] and Joan Halperin,[48] agree in transposing the earliest of his "art nègre" acquisitions to 1919. In fact, Fénéon probably began collecting earlier than 1919, but certainly not in the first years of the century. As Rubin observes (p. 285), Fénéon responded to Picasso's *Demoiselles* in 1907 as caricature, but recognized in it nothing African. Finally the testimony offered by Paul Guillaume[49] about his own discovery—in 1904, at a laundress's in Montmartre—of a Bobo-Dioulasso effigy, which he showed immediately thereafter to Apollinaire, is invalidated both by his age (he would have been only twelve and a half) and by the fact that he did not meet the poet until 1911.

The possibility can be more readily accepted that Braque, André Lhote, and Vlaminck acquired some African sculptures in 1905, *though there is absolutely no firm evidence of this*. During the summer, spent in the company of Manolo and the critic Maurice Raynal between Honfleur and Le Havre, Braque is supposed to have bought a Gabon mask from a sailor.[50] In July of the same year, Lhote is said to have paid three francs to a junk dealer in the Place Mériadeck in Bordeaux for what would seem from the description to have been a mask from the western Ivory Coast.[51] Finally—the story is often repeated—Vlaminck, probably at the end of the summer, in exchange for buying drinks for customers in a café in Argenteuil, carried off "Two Dahomey statuettes, daubed with red ocher, yellow ocher, and white, and another from the Ivory Coast, all black."[52] If there is some reason to doubt the date advanced by Vlaminck in laying claim to his discovery, it is even more difficult to go along with the painter when he specifies that it was in 1905 that he received from a friend of his father's "a large white mask and two superb statues from the Ivory Coast"[53] and that in the same year he sold the mask to his friend Derain (p. 213). In the two versions that he gives of

Advertisement for Emile Heymann's curiosity shop, Au Vieux Rouet, Paris, 1909

the facts,[54] Vlaminck stresses the proximity of the two episodes, even indicating in one that they were barely separated by a few days. Both versions agree on the reasons that led Vlaminck, quickly but regretfully, to get rid of an object whose grandeur and Primitive quality, as he says, perplexed and delighted him: He was overwhelmed at the time by financial problems. There is support for the statement that Derain took his acquisition to his studio in the Rue Tourlaque, and that it was there that Picasso and Matisse, "impressed," "disturbed and moved," saw it. These pieces of information would seem sufficient to place Vlaminck's acquisition of the Dahomey statuettes in 1906, very likely at the end of March, and his experience with the Ivory Coast works in the first two weeks of April. Derain had moved to the Rue Tourlaque on his return from London at the beginning of April, and the precarious economic situation weighing on Vlaminck and his family was to improve for a time after Vollard bought all the canvases in his studio from him in the latter half of April.[55]

As for the purchase at that time of a "Negro" object by Matisse, one notes that the information given by the artist himself to three different interlocutors—Pierre Courthion in 1941,[56] André Warnod in 1945,[57] and E. Tériade in 1952[58]—is consistent and complementary but for one variation. Without distorting these accounts, one can restate them as follows: On his way to pay a visit to Gertrude Stein in the Rue de Fleurus, Matisse noticed a "Negro" object in the window of Emile Heymann's shop of exotic curiosities at 87 Rue de Rennes, and bought it for a few francs. Upon arriving at the Stein apartment he showed it to Picasso, who while looking at it displayed a certain enthusiasm. The Courthion interview includes details that do not appear in the other two: Matisse emphasized that it was the first object he had bought, that it had cost fifty francs, and that it was the first object to which

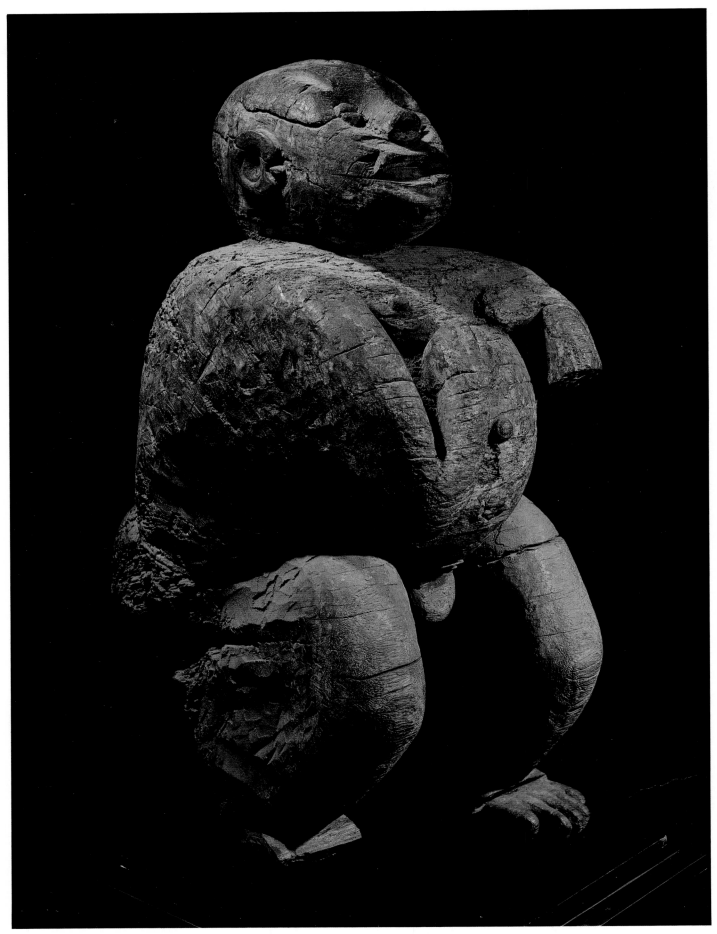

Figure. Mbembe. Nigeria. Wood, 29⅛" (74 cm) high. Private collection, Paris

Picasso paid any attention. According to Matisse, this was the decisive encounter that gave birth to a movement of interest in Primitive art, a movement Derain would only subsequently join by obtaining the large white mask from Vlaminck.

One difference, however, separates the three versions: To Courthion and Warnod, Matisse spoke of a statuette, to Tériade of a small head. (The often repeated variant, according to which the object would have been a mask, should be excluded altogether; this interpretation is the result of a bad translation into French of the Tériade interview, which was originally published in English.)[59]

Two indirect testimonies confirm and round out the report of the event: Despite an erroneous date, what Max Jacob told Georges Duthuit, the artist's son-in-law, is identical in substance.[60] For her part, Gertrude Stein specified the historical moment: It was after Picasso had finished her portrait—which places the event indisputably in the fall of 1906.[61]

In examining the various accounts[62] given by Max Jacob of the visit that he, Picasso, Apollinaire, and Salmon paid to Matisse's studio on the Quai Saint-Michel, obviously only a few days after what had just occurred at Gertrude Stein's, one notices that a statuette is always mentioned. Everything suggests that the "small head" of the Tériade version represents Matisse's focus of attention on part of a whole. In this sense, the parallel introduced by the artist between this statuette and the porphyry heads of the Egyptian collections in the Louvre can only be justified by what is common to the two terms of the comparison: namely, the treatment of the head.

The ambiguity of the Tériade version could have been dispelled had it been possible to obtain an accurate description of the object. Hitherto there has been reluctance to credit the only description so far given of it, probably because of the whimsical character generally attributed to the words of its author. Max Jacob speaks of "a little seated figure [bonhomme] sticking out its tongue."[63] Behind the seeming extravagance of the statement, however, an outline, a pose, and an attitude take shape, and a dimension is perceived. These are in perfect conformity with a Vili statuette found in that portion of Matisse's collection which, after the death of his daughter Marguerite, fell to her son (above right and p. 214). This is undoubtedly the sculpture mentioned in the numerous accounts that we have just recalled.

Matisse's encounter with the white mask at Derain's, on which Vlaminck insisted so much, must have come, like the visit to the Quai Saint-Michel studio, after the purchase of the Vili statuette. This does not necessarily imply, as Matisse believed, that Derain had bought the Fang mask after he himself had made the purchase of his statuette. Besides, while no proof exists that Picasso saw the mask in the spring at the Rue Tourlaque studio—indeed, it is highly unlikely—it is very hard to believe that he could have been unaware of its existence some six months later, at a time when his meetings with Matisse and Derain were becoming somewhat more frequent.

Thus, aside from some possible if unverifiable individual discoveries attributed to 1905 (those of Braque, Lhote, and Vlaminck), the encounter with African art was not actually embarked upon until the fall of 1906: The Fang mask and the Vili statuette were the catalysts for it, and Derain and Matisse together the instigators. Picasso no doubt saw some of these pieces between autumn 1906 and spring of the following year,

Figure. Vili. People's Republic of the Congo. Wood, 9⅜" (24 cm) high. Private collection. Formerly collection HENRI MATISSE. For another view of this object see page 214.

but only around June 1907 does he evince any real interest in tribal art. Different experiences would have prepared each of them for it: for Matisse, during the summer of 1905, his discussions with Maillol at Daniel de Monfreid's about works by Gauguin, and "it may have been Maillol who drew Matisse's attention to Negro sculpture";[64] for Derain, more directly, his visits to the Musée d'Ethnographie du Trocadéro in 1904 and to the African section of the British Museum in March 1906, not to mention his acquisition of the following month. For Picasso, it was probably the revelation of the Iberian sculptures from Osuna in the Louvre, in early 1906.

Whatever objects Picasso may have seen before that time, one should not risk underestimating the importance to him of his visit to the Trocadéro in late spring of 1907. For this new experience, without necessarily contradicting any previous ones, revealed to Picasso a meaning and a dimension of Primitive art of which he had hitherto been unaware. The account he gave of it thirty years later to André Malraux is highly enlightening in this respect.[65] As he entered the Trocadéro rooms alone, the repulsive atmosphere of the place prompted the wish to flee, and at the same time something irresistibly attracted him: "It was disgusting. The Flea Market. The smell....I wanted to get out of there. I didn't leave. I stayed. I stayed." He felt that "something was happening [to him]...that it was very important." He suddenly realized "why he was a painter." For unlike Derain, Matisse, and Braque, for whom "fetishes," "les nègres," were simply "good sculptures...like any other," he had discovered that these masks were first of all "magical things," "mediators," "intercessors" between man and the obscure forces of evil, just as potent as the "threatening spirits" present throughout the world, and "tools" and "weapons" with which to free oneself from the dangers and anxieties that burden humanity.

Without wishing to lessen the emotion felt by Picasso in this "frightful museum," it must nevertheless be admitted that it was based on a certain reality. In 1907, the African room (pp. 126, 322) was not, as one might imagine today, a large hall dedicated to the instruction of the public, where methodically classified, well-maintained, and accurately labeled collections were exhibited under good conditions for examination. It was much closer to being a very small and overcrowded depot where some of the most surprising productions ever conceived by the human spirit had been hastily laid out without rhyme or reason. Against the walls, "temporary" glassed-in cupboards had been built, some of them from the badly squared boards of packing cases. These cabinets tottered not only under the weight of the objects they contained, which were heaped together in such a way that one could hardly tell one from another, but even under that of various domestic tools jutting out from above them. These, in their turn, were mingled with weapons of all kinds and less bulky specimens arranged to form "wall trophies." From periphery to center, there was little room to move. One might stumble at every step: here against a life-size human statue, there against an overloaded display case.

Although the confusion that reigned in this place made any objective and well-informed evaluation difficult, it also narrowed any critical distance between this disparate, involuntarily unified ensemble and its surprised then subdued spectators, and a strange familiarity, due not merely to forced proximity, was established. One might well balk at the hybrid figures of this fantastic bestiary (p. 126), at the violence and pain evoked by these bodies, scarified or bristling with nails, at the fear inspired by the wild-looking faces of ghostly apparitions, at material that seemed animated by the irrational forces of sorcery.

And yet this universe, sometimes astonishing, always marked by the sacred, did not present effigies of a remote pantheon peopled with vengeful deities and demonic monsters. Seldom monumental or overwhelming, it combined instead chthonic spirits, living ancestors, beneficent images of maternity, and protective fetishes. As such it allowed one to perceive the intermingling of the sacred with man's experience, the intersection of ritual and daily life. It suggested another world, intermediary but credible, living and humanized. It was an invitation to the supernatural, but a supernatural in some way tamed.

What Picasso discovered at the Trocadéro, what penetrated him, may well have been of this order of awareness. At any rate, that was the lesson drawn for him by Christian Zervos, to whom he spoke of it. "The art of primitive peoples actually had an influence on Picasso only to the extent that it allowed him to obtain a vision of the world, suitable for modifying the appearance and character of his aesthetic experience, and offering him a new representation of the world in which experience and the supernatural overlap and compose by their interference as a single reality. It allows him to consider the objects that surround him, both in the combination of their forms and in their separate lives that associate them with the supernatural."[66]

In the last two months of 1906, after Cézanne's death and the second retrospective of Gauguin's work at the Salon d'Automne, what Matisse was inspired to call "the time of artistic cosmogonies"[67] opened for him and some of the artists he considered among the more advanced. The moment of "discovery" having passed, the taste for "les bois nègres" was confirmed, if not in the same way, at least with the same intensity for all of them. This can be seen in the acquisitions made by Matisse, Picasso, Braque, Vlaminck, and Derain between 1908 and 1914.

According to Kahnweiler, Matisse in 1908 owned "a collection of some twenty or so pieces of various origins."[68] André Level remembered seeing "in the artist's hands, some rather delicate objects, staffs with small, pronounced and well-executed heads"[69] at about the same time. If we accept Pierre Schneider's statement that Matisse only got rid of things that he had acquired late in life,[70] such as the South Malekula figure

African objects from the collection of HENRI MATISSE at the home of one of his heirs, Paris, 1976

Corner of Georges Braque's studio, Paris, c. 1914

(p. 333) that went to Picasso or the "Ethiopian" seat now in the Nice museum, we can try to reconstruct, on the basis of what is presently owned by his heirs, a collection of which a major part was probably assembled before World War I: Besides "two staffs," one Chokwe and the other Kongo with an anthropomorphic ivory top, there were three reliquary figures, two Tsogo and one Fang; some statuettes, three Vili (p. 141), one Bembe, and the one Bambara from the Segou district reproduced in 1917 by Paul Guillaume; a white Shira-Punu mask; a Pende mask (p. 239); a Luba cup-bearer; a hollowed-out Kuba head of questionable authenticity; and a female figure with outstretched arms (p. 229), judged by the editors of the catalog for the 1930 exhibition at the Galerie Pigalle, where it was shown, to be an ivory from the Lower Congo.

As for the objects collected by Braque in this period, the Fang mask and a curved harp from Gabon that appear in a 1911 photograph (p. 306)[71] need to be supplemented by the acquisitions probably made in the summer of 1912, which are to be seen in a more recent photo (above):[72] three Bambara statuettes, an effigy from the Lower Congo, and two sculptures that cannot be identified with any certainty. If one adds to this group—in addition to the Tsogo mask said to have been bought in 1905—a Dan object and a few Kuba textiles, one will probably have covered Braque's collection as it was at that time and as it was to remain. This is not nearly so extensive as the collection Picasso was to form, the integration of which Rubin discusses below (pp. 296–307).

Since we know that in addition to the mask he sold to Derain, Vlaminck sold Jos Hessel everything he had assembled since his Argenteuil discovery,[73] it is impossible to say what he may have acquired after 1908, either from junkshops in Montmartre or the Paris flea market, or indirectly in Marseilles through Derain, who spent the winter of 1908–09 in nearby Martigues.

Despite the continuous weeding-out to which Derain subjected his collection, which makes hazardous any speculation about its nature and extent before 1914, a photographic document of 1912–13[74] (p. 225) still shows the presence in his studio of three Fang masks, including the one bought from Vlaminck (p. 213), two reliquary figures from the same tribe, a Bambara antelope headdress, and a Senufo statue.

For the period between 1908 and 1914, many facts having to do with the present subject can be traced to, or at least are not unconnected with, the activities of a Hungarian sculptor who shortly after his arrival in Paris set himself up as an art dealer. Indeed, it was Joseph Brummer[75] who, beyond the small group of artists who were its first discoverers, contributed to the development of an interest in what was called "art nègre" and moreover ensured its diffusion before World War I in a fair number of Central European capitals.

After studying in Budapest at the School of Decorative Arts, with Rühmann in Munich, and Istvan Réti in Nagybanya, Brummer pursued in Paris, but without much diligence, the instruction offered by Rodin, Matisse, and some of the art academies in Montparnasse. When his funds ran out he took on all sorts of jobs in order to survive, but very soon, in the course of peddling Japanese prints on behalf of established dealers, he was able to obtain a few "Negro objects" from various secondhand shops, and these he offered to his more prosperous fellow students in the academy studios.

Having had a measure of success with these small deals, which he had begun to carry on from his wretched lodgings on the Rue Falguière, he invested his first profits, probably in 1909 but possibly the year before, in the renting of a shop at 6 Boulevard Raspail, where sculptures from Africa and Oceania appeared side by side with a few canvases by the Douanier Rousseau. Brummer's spectacular ability was completely evident when, between the two wars, he became one of the wealthiest and most reputable dealers in New York. But here we are concerned to show how, starting with a vast network of friendships contracted in the favorable climate before World

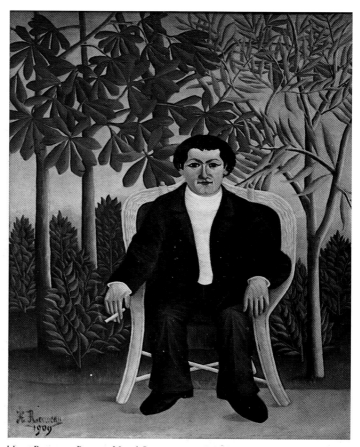

Henri Rousseau. *Portrait of Joseph Brummer.* 1909. Oil on canvas, 45¾ x 35⅛" (116 x 89 cm). Private collection, Switzerland

African objects from the collection of Guillaume Apollinaire, photographed in his library, c. 1954. For another photograph see page 312.

War I, when young artists from the United States and from all over Europe were questioning each other about the foundations of modern art, Brummer encouraged the confrontation with what constituted one of its essential sources.

The decisive role played at the time by the Stein circle has been rightly emphasized. We do not know whether Brummer was part of it or only remained on its outskirts. Be that as it may, he owed his enrollment in the academy that Matisse had opened in January 1908 at the prompting of Sarah Stein and the German painter Hans Purrmann to the latter, to whom he had been recommended by the American Max Weber, his fellow student at the Grande Chaumière. Directly or indirectly through Weber and Purrmann, he came to know many artists and critics who were to lend him support in his plans or whom he himself was to convert to his views. It appears that most of them were associated, in one way or another, with the Western destiny of "art nègre."

Max Weber, like Picasso, whose work and studio he knew, stated his conception of "primitivism" in relation to both African sculpture, examples of which he had seen very early in the Trocadéro collections,[76] and Rousseau's painting, which he admired for its genuinely modern truth. Weber thus made it possible for Brummer to meet the Douanier in March 1908. About the same time, the New Yorker Robert Coady became, also through Weber, a frequent visitor to the Douanier's studio. A few years later, he introduced to his Washington Square and Fifth Avenue galleries, and then to his magazine, *The Soil*, examples of African cultures, not only for their

artistic worth but also because their presentation might be an incentive to an egalitarian ideal on American "soil."[77] Another friend of Weber's with whom Brummer made contact was Patrick Henry Bruce, whose collection was sufficiently important in size and quality for the organizers of some of the more outstanding exhibitions of the 1920s and 1930s to ask for loans from it.[78] In addition, but whether through Weber or not there is no way of knowing, Brummer became friendly with the painter Frank Burty Haviland and was the source for the collection of African and Oceanic pieces that he was to begin acquiring in 1908.[79] On the other side, through Purrmann, Brummer came in contact with Karl Ernst Osthaus, a collector from Hagen, and with a young German writer named Carl Einstein, who, at his instigation, published the first book on the aesthetics of African art.[80] A group of "Germans" frequented the Dôme café in Montparnasse, and there one might have seen Brummer with Rudolf Levy, once his crony in the shop on the Boulevard Raspail, or with the Polish art critic Adolphe Basler, who was a habitué of the "musical evenings" given by Rousseau and who was to write a book entitled *Art among Primitive Peoples*, or with the Czech painter Walter Bondy and his sculptor compatriots Ernst Ascher and Bela Hein (these last three became dealers in African art, the first in Berlin and the other two in Paris).

While there would seem to be no proof that Brummer had known Guillaume Apollinaire before 1911, it nevertheless appears certain that their meeting should be assigned to the end of 1908, or at the latest the beginning of 1909. Also we should not exclude the hypothesis that Brummer, if not the first (who was probably Picasso) was at least one of the first to induce Apollinaire to begin collecting African sculpture.

Apollinaire had been introduced to Rousseau sometime between April 1906 and November 1907. Incidentally, we know from the special issue of *Les Soirées de Paris* devoted to the Douanier what the conditions were for the execution of the first version of the *Muse Inspiring the Poet*, which dates from 1909 but required Apollinaire to pose for the painter during November and December 1908, at a time when Brummer and Weber, who was preparing to return to the United States, were often at the Rue Perrel studio. We might also note that the first portrait to follow the *Muse* chronologically was that of Brummer (p. 143), painted before the spring of 1909 since it was going to be shown at the Indépendants. It is therefore hard to imagine that Brummer and Apollinaire had not been in contact as early as this period.

No precise date has yet been suggested for when Apollinaire began his collection of African art. The French editor of his complete works, who is moreover the author of an essay entitled "Guillaume Apollinaire devant l'art nègre,"[81] has no suggestions to offer on this point. His only remark about Apollinaire's move to 37 Rue Gros in Auteuil in 1910 is that he was beginning to take an interest in Negro art objects. As to who first supplied him with these objects, a few hypotheses have been put forward: One, for example, asserts that it was René Dupuy, a childhood friend and naval officer (hence familiar with seaports), who later, under the name René Dalize, became a contributor to *Les Soirées de Paris*.[82] This suggestion, which is not documented by its author, seems improbable. It relies on the evidence of Ensign Dupuy's voyages. These were interrupted by his resignation from the navy in 1907, and it is more than unlikely that Apollinaire had

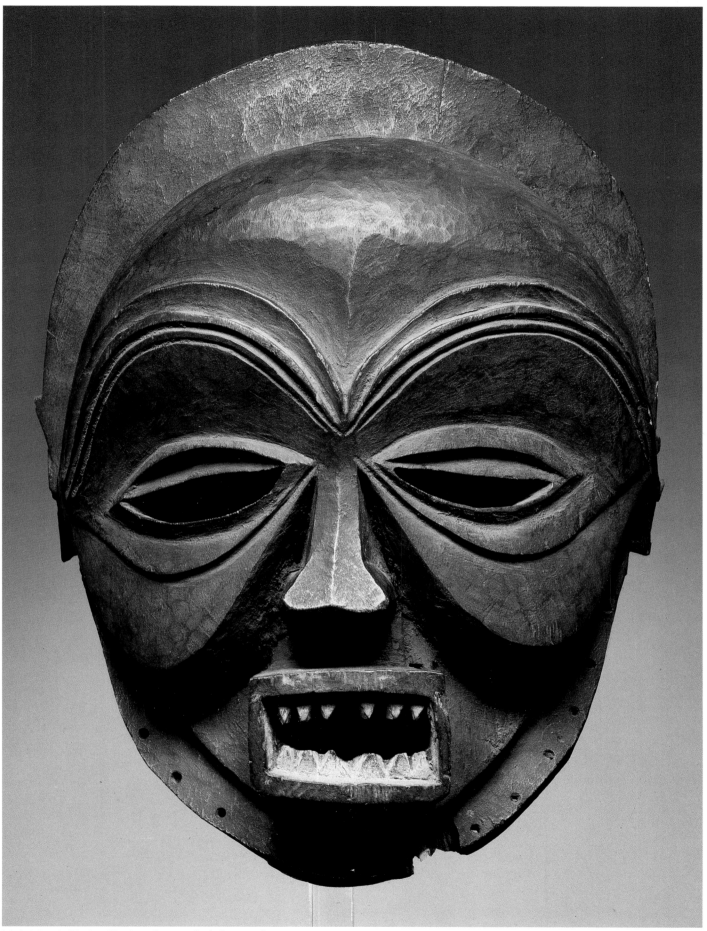

Mask. Mbunda. Zambia. Wood, 16⅞" (43 cm) high. Private collection

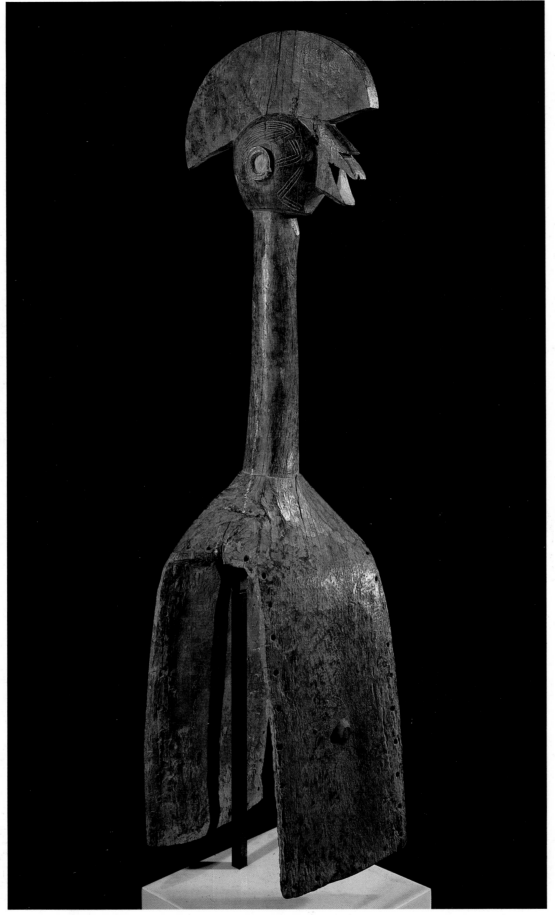

Mask. Wurkun. Nigeria. Wood, 68⅞" (175 cm) high. Private collection, Paris

already begun collecting African sculptures prior to that date. There is no supporting testimony, direct or indirect. According to Salmon, who often gave hospitality to the impecunious mariner during his shore leaves, the contents of Dupuy's trunk were limited to a few books and to equipment designed for smoking opium; the one exotic object was a pipe from Canton.

By contrast, it has been claimed that it was Félix Fénéon who "sold Apollinaire, around 1910, the first tribal objects that the poet bought."[83] Certainly Apollinaire had kept up friendly relations with Fénéon since at least 1904. But, as we have seen, the dates of Fénéon's own collecting are much disputed. Moreover, Fénéon, "around 1910," was working at Bernheim's gallery with Jos Hessel, who himself is also said to have been collecting since 1905. Thus, more solid proof is needed before we can accept this rather peremptory statement.

Mention has also been made of the existence of an early version, dating from 1907, of *Le Poète assassiné,* in which Picasso is called the "Bird of Benin" in reference to a Fon brass object owned by Apollinaire, in order to prove that the latter at this time had a work of African origin in his presence.[84] The fact is that the epithet assigned to Picasso appears only in the later manuscript, dated 1911.[85]

For my part, I must confess that I have no conclusive evidence to support my own hypothesis. It merely seems to me that it is more logical to assume that it was from Brummer that Apollinaire, in all likelihood in late 1909, either bought his first African sculptures or received them as gifts. The role of occasional scout that the *flâneur* of both banks of the Seine was to play for the dealer shortly thereafter would lead one to suppose that they shared common interests.

Even if the initiative could not be theirs alone, both Brummer and Apollinaire were to contribute to the diffusion of tribal art in the artistic circles of Prague before 1914.[86] African sculpture, however, had been present in Bohemia since the 1880s, if only through the tribal specimens collected by the naturalist Emil Holub in central and southern Africa between 1872 and 1879. At the end of the century, Albert Sachs, a German manufacturer of glass beads with a factory in northern Bohemia, who exported his products to Nigeria and the Gold Coast, had collected in a sort of glassware museum in Jablonec a group of African objects, some of which had been acquired by his representatives in Africa, while others had come from Webster and from Opperse in Amsterdam. In 1900 the writer Joe Hloucha, once having begun to assemble a large number of Japanese prints, had embarked on a remarkable collection of African sculptures. But it does not seem that Czech artists wanted to draw on these "national" resources.

Formed in opposition to the Mànes Alliance, the Plastic Artists Group (*Skupyna Vytvarny Umelcu*), founded in Prague in 1912, included some twenty-three painters, sculptors, graphic artists, and writers. Among them were the painter Josef Capek, his brother Karel the writer, the sculptor Otto Gutfreund, and, while preserving his independence but still close to their views, the art historian and collector Vincenc Kramar. Paralleling the activities of the group, the *Monthly Art Review (Umelecky Mesicnik)*,[87] created in October 1911, was edited until the spring of 1912 by Josef Capek. Not only the magazine but the exhibitions of the group made reference to

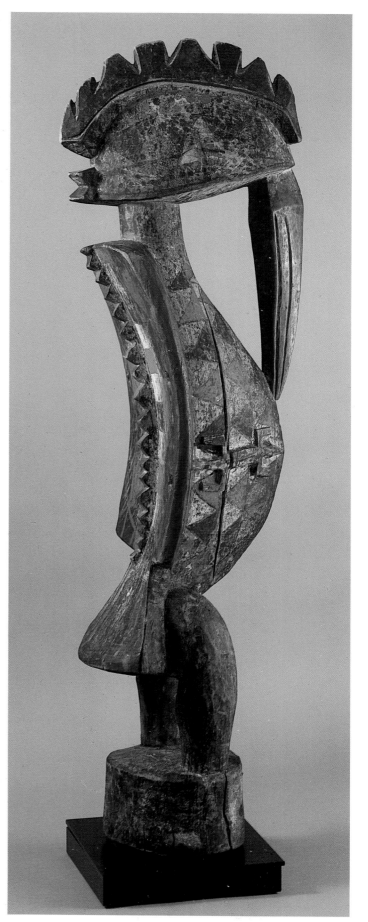

Bird figure. Senufo. Ivory Coast. Painted wood, 57" (144.8 cm) high. Private collection, St. Louis

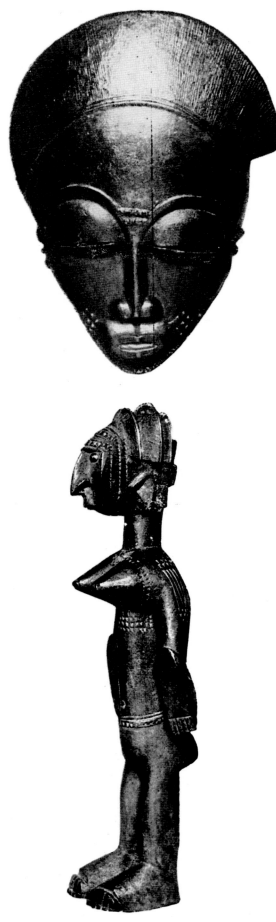

Baule mask and Bambara figure from the 1911 "Oriental Exhibition" at the House of Artists (Keleti Kiàllitàs a Müvészhàzban), Budapest

the "primitive" arts. Thus in the June 1913 issue of *Umelecky Mesicnik*, in connection with Gutfreund's "Plane and Surface," one of the most penetrating theoretical essays on modern sculpture published in that period, there appear eight photographs of "Negro" objects: Three of them are mentioned as belonging to Kahnweiler (a mask and a Bambara statuette as well as a small Baga sculpture) and all the others as coming from Brummer (a double figure from the Marquesas Islands and three statuettes—one Bambara, one Baule, and the third Teke—and a Fang head). In the October 1913 issue of the same magazine, two Senufo masks from Brummer's collection are reproduced. As for the exhibitions of the group, the third (May–June 1913) and fourth (January–March 1914), in addition to works by its members and by foreign artists, including Picasso, contained African sculptures.

If in Prague the idea of including tribal art in exhibitions of modern art most likely originated with Josef Capek, Gutfreund, Kramar, or even Emil Filla, it must be admitted that these men preserved close ties with a few Parisian artists and dealers who may have encouraged them to pursue this confrontation. Kramar, by reason of his purchases, was in contact with Kahnweiler, who, while not dealing in them, owned some pieces of African art. This is attested by documents published in the magazine and by photographs taken in 1913 in his apartment on the Rue George Sand (p. 301).[88] While we do not know what Gutfreund's connections in Paris were in 1909–10 when he was Bourdelle's pupil at the Grande Chaumière, there is more precise information concerning Josef Capek. Since the Capek family had received Apollinaire in Prague in March 1902, Josef and Karel had been exposed to the poet's literary and artistic preferences even before they went to Paris.[89] When Apollinaire, in his turn, entertained Josef Capek in 1910 and 1911, he acted as his mentor. Thus the young painter not only visited the Musée d'Ethnographie du Trocadéro but even took pains to photograph some of the objects that interested him: from West Africa, a Dogon statue (p. 273), one of those collected by Lieutenant Desplagnes on the Niger bend, and three heddle pulleys from looms. Later, in 1918, he was to publish an article on "Negro" sculpture in the magazine *Cerven* and in 1938 a book on Primitive art. These writings had their origin in these early encounters with the sculptures in the museum and those that he undoubtedly saw at Apollinaire's and in Brummer's shop.

It was probably in Brummer's homeland that, in 1911, the West's first exhibition took place in which the art of Africa and Oceania (among a variety of non-Western works) were presented as not only equaling those of the classical tradition in artistic value but even as the leaven for the renewal of contemporary sculpture and painting. The "Oriental Exhibition" ("*Keleti Kiàllitàs*") was held from April to May at the House of Artists in Budapest, under the aegis of Joszef Rippl-Ronai and Karoly Kernstock, both honorary members of this institution, which had opened in 1907 for artists of the Hungarian avant-garde. Alongside Persian miniatures, Japanese prints, and terra-cottas and bronzes of ancient China, Tibet, Cambodia, and India, there were sixteen Oceanic and African sculptures: six from New Guinea and ten from the Congo, the Sudan, and the Ivory Coast. Of these last, some had been lent by the writer and journalist Miklos Vitez, the others by the architect and decorator Lajos Kozma, who had acquired them during their travels in Western Europe. The catalog mentions

twenty Chinese works as coming from Brummer. We are therefore entitled to suspect that the latter had been one of the promoters, from Paris, of this historical event.

When, in an effort to describe the material presence of tribal art in Russia before World War I,[90] we examine Shchukin's collection or the illustrations in the book of Markov discussed below, we see that the origin of the objects acquired or the sources of the works reproduced are located exclusively outside the country. Certainly, for this period, there does not seem to have been any specialized trade in the sale of tribal objects in St. Petersburg or Moscow. The geographer and collector Anucin, for example, was supplied chiefly by the dealers Umlauff in Hamburg and Oldman in London. Nevertheless, many examples from the cultures of Africa had been appearing in the rooms of the Ethnographical Museum in the capital since the 1880s.

An article by Jakov Tugendhol'd on the French collection of Sergei Shchukin, published in the magazine *Apollon* in early 1914, points out that in part of Shchukin's mansion where some fifty works by Picasso were hung, there were also "some marvelous wooden sculptures from Madagascar and the Congo." There were at least seven of them. They had been purchased in Paris, probably betwen 1908 and 1912, and most likely from Brummer, or from Frank Burty Haviland through an intermediary. Four of them were later illustrated in *Negerplastik* in 1915.

It is to the intercession of the poet Mayakovski with the Commissariat under Lunacharski that we owe the publication of *The Art of the Negroes (Iskusstvo Negrov)* some five years after the death of its author, the painter, art theoretician, and founding member of the St. Petersburg Union of Youth (*Sojuz Molodezhi*) Vladimir Markov. In 1919, his companions V. D. Bubnova and L.I. Zerzeveev oversaw publication of the manuscript, which had been written in the last months of 1913 and the beginning of 1914, and of the photographs that Markov had personally taken during the summer of 1913 in the museums of Western Europe. If one excludes the plates reproduced from the *Annales du Musée du Congo belge* (1905), the book contains 117 original photographs corresponding to 72 objects, all belonging, with one exception, to the public ethnographic collections of Leipzig, Berlin, Kiel, Copenhagen, Oslo, Leiden, London, and Paris. The single exception, pertinent to this essay, is found in Markov's two photographs of a Bambara statuette belonging to Brummer. The illustrations clearly show that these are not "ethnographic specimens" dug out of glass showcases by Markov in order to

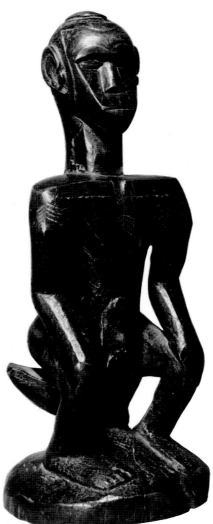

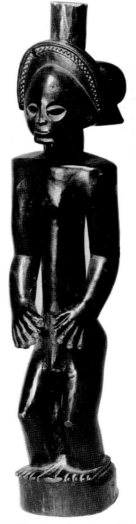

Figure. Bijogo. Bissagos Islands, Guinea-Bissau. Wood, 28" (71 cm) high. Náprstkovo Muzeum, Prague. Formerly collection Sergei Shchukin. Published in Carl Einstein, *Negerplastik*, 1915

Figure. Chokwe. Angola. Wood, 16½" (42 cm) high. The Pushkin Museum, Moscow. Formerly collection Sergei Shchukin. Published in Carl Einstein, *Negerplastik*, 1915. For another view of this object see page 479.

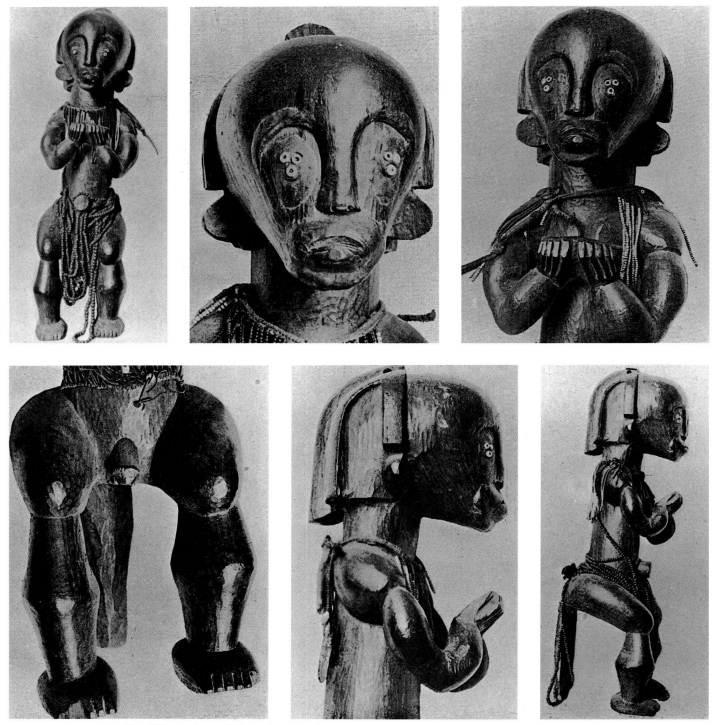

Reliquary figure (six views). Fang. Gabon or Equatorial Guinea. Photographed by Vladimir Markov (V. I. Matrei) at the Musée d'Ethnographie du Trocadéro (now Musée de l'Homme), Paris. Published in *Iskusstvo Negrov* (Art of the Negroes), 1919

take his photographs, but true works of art that he considered to be the finished results of plastic principles perfectly applied. As attentive to the singularity of structure unifying the diversity of forms as to the different ways by which the parts composing the object are articulated, Markov sometimes deliberately disregarded, either by displacing or removing them, any fetish material or attachments that threatened to disturb their intelligibility. This is not to say that he underestimated those details that are often judged to be fanciful or picturesque. On the contrary, they were to him true plastic symbols, whose relative meaning must be perceived both in relation to their integration in a uniform whole and with reference to their original usages, which they still suggest. Furthermore, the montage of photos corresponding to the same object similarly served the analytical endeavor that he pursued in Chapter 4 of his book. In *The Art of the Negroes*, at the same time that he explored the material achievement of plastic thought animating African sculpture, Markov, like Gutfreund and Einstein, theoretically defined some of the principles governing the sculpture of his time.

Since most larger cities in Germany possessed public ethnographic collections, and the commercial diffusion of "objects of curiosity" had existed in that country since the nineteenth century, Germany's vanguard artists, such as those of Die Brücke and Der Blaue Reiter, were able to discover close to their studios the exotic sources to which they were drawn. In light of this, it is surprising that the little Hungarian dealer on the Boulevard Raspail should have played even a secondary role in that country. Yet we know for sure that Brummer procured some African sculptures for the Ruhr collector Karl Ernst Osthaus, though it has yet to be proved that he was the source for the 1912 exhibition of "art nègre" that was organized in Hagen in the rooms of that rich patron's personal museum. But if we agree, on the one hand, that Carl Einstein's *Negerplastik* was a book of prime importance, not only for its priority in the history of ideas about the arts of Africa but also for the relevance of its analyses and the breadth of the illustrations it contains, and if, on the other hand, we consider that Brummer was both its instigator and the man who financed its publication, we can hardly limit him to the subordinate role of simple dealer in secondhand curiosities.

Carl Einstein,[91] during his studies in Berlin (1904–07), had discovered African sculpture in the rooms of the Museum für Völkerkunde. He was also in contact very early with the artistic avant-garde of his country. The criticisms he formulates in his work are aimed both at the evolutionist conceptions of the museographers and the exacerbated primitivism of the Expressionists. His perspective, sometimes taxed with being formalist, is otherwise. It is based on an extensive knowledge of *Kunstwissenschaft* and on what he saw, beginning in 1907, in the studios of artists during many visits to Paris. His friendship with Kahnweiler, which began in 1901, gave him the opportunity to meet, among others, Picasso, Braque, and Gris. Incidentally, as mentioned above, it was Purrmann who introduced him to the circle of habitués at the Dôme, and it was there that he met Brummer. There is no doubt that the originality and rigor of his remarks in the presence of Brummer's sculptures aroused the dealer's interest and enthusiasm. He offered Einstein not only the financial support necessary for the publication of his book[92] but also supplied him with most of the illustrations.

It seems likely that the publication of *Negerplastik* was delayed by some months because of the outbreak of hostilities between France and Germany. This leads one to suppose that Einstein had written his text and Brummer selected the illustrations during the first half of 1914. The first edition appeared in Leipzig in 1915, when Einstein was already in the army in Alsace. The only difference between this edition and the second, published in Munich in 1920, is in the number of plates (111 photos of 95 objects in the first, 108 of 92 in the second). Unfortunately, there are no captions in either edition to indicate the tribal attribution or the identity of the owners. True, Einstein never relies on specific examples in his analyses. A rapid perusal makes it clear, however, that the series of illustrations is not arbitrary. If one excludes the relatively small number of objects from the Berlin museum, those from the British Museum reproduced from the 1910 *Handbook*, and those of which no trace has been found in books and catalogs published since, it is safe to say that more than half of the sculptures presented in Einstein's book had been, at one time or another, in Brummer's hands.

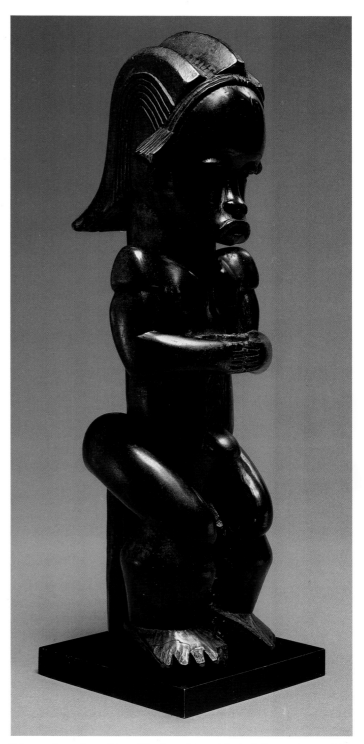

Reliquary figure. Fang. Gabon. Wood, 18⅛" (46 cm) high. Collection ARMAN, New York

In France, among the first to use what had become the commonplace expression "art nègre" in writing was the journalist and critic André Warnod, in a review in *Comoedia*, appearing under this title on January 2, 1912. Among the examples of this tribal art, which he claimed might soon replace Greek art in the training of young artists, were a mask and a Baule statuette, as well as a Fang head from the "Brummer collection." The previous year, in the same publication, Warnod had already presented a Malagasy funerary post belonging to "that intelligent and erudite antiquarian."

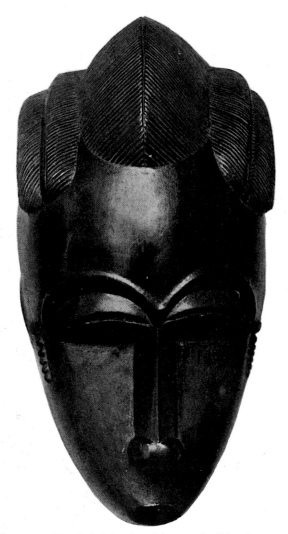

Mask. Baule. Ivory Coast. Included in the exhibition at the Galerie Levesque, Paris, 1913. Published in Carl Einstein, *Negerplastik*, 1915

The first exhibition in Paris in which African sculpture was explicitly referred to as such—though the exhibition was not exclusively devoted to it—took place at the Galeries Levesque from May 16 to June 15, 1913. It displayed the collections of Charles Vignier, which consisted of "sculptures, paintings, and ancient art objects from Asia, as well as a few pieces of Egyptian, Negro, and Aztec art." Vignier had begun as a Symbolist poet close to circles strongly influenced by the Japanese. His friend Fénéon invited him to contribute to the *Revue indépendant*. Later, Vignier's interest in the arts of the Far East led him to become a dealer in them, and his knowledge of the bronzes and ceramics of ancient China earned him the respect of the expert Sinologists of the Musée Guimet. At the same time, but on a smaller scale, Vignier was selling some sculptures from Africa and Oceania in a shop on the Rue Lamennais in Paris. At the end of the 1920s, as a friend and former employer of Georges-Henri Rivière, he was able to give the necessary encouragement to the reorganization of the Société des Amis du Musée d'Ethnographie du Trocadéro.

Some twenty African objects and a "fetish in blackened wood from New Guinea" are described under the heading "Art nègre" in the catalog of the Galeries Levesque. On the opposite page there is a single illustration: "a black wooden mask, with tattoos and tripartite hair treatment, from the

Ivory Coast." This mask would be reproduced in *Negerplastik*. At least four other objects exhibited at Roger Levesque's were also to be reproduced, judging by their descriptions in the catalog: the famous Kanioka "bound youth," now in the Rietberg Museum in Zurich; a Teke statuette, acquired very early by the University Museum in Philadelphia; a Dan beaked mask, and an antelope head of undetermined origin. The sculptures in Vignier's collection may well have been acquired from Brummer, but the reverse is equally plausible.

It was not one of Brummer's least merits to have urged a young employee of a rubber tire firm, at the beginning of the 1910s, to procure for him a few African objects. While the collaboration between the two did not last long, it was nevertheless decisive in orienting the career of Paul Guillaume, who was to be the most prestigious African art collector and dealer in the period between the two world wars. Indeed, Guillaume, an enthusiastic admirer of the traditional cultural products of African civilizations, was to contribute to the growing split between the ethnographic and museographic conceptions of his time, and to the appreciation shown by collectors—who because of him became more and more numerous—for the intrinsic qualities of African sculpture. His activities and writings testify to the wish to elevate what he considered to be the finest masks and statuettes produced by the "Dark Continent" to the rank of masterpieces of world art. Paul Guillaume's greatness resides in this conviction, even if in retrospect the "classical" taste that he imposed (see p. 17) seems to us far too selective when faced with the diversity of African styles.

Its anecdotal interest aside, the account that Brummer gave of his meeting in 1911 with Paul Guillaume deserves to be recalled in that it allows us to specify a few important facts.[93] Informed by Apollinaire of the presence of an African object of quality in the window of an automobile appliance store, Brummer negotiated its purchase from the young clerk and induced him to show him regularly the "fetishes" received by the clerk's firm through its colonial rubber supplies. Thus Guillaume, then twenty years old, came to sell him a number of these sculptures from Gabon and the Congo. It was while

View of Edward Steichen's installation of works by Braque and Picasso together with Primitive objects at "291," New York, 1914–15. Left to right: Pablo Picasso, *Bottle and Glass on a Table*, 1912; Kota reliquary figure; and wasp nest belonging to the artist Emil Zoler. Photograph by Alfred Stieglitz

offering them for Brummer's evaluation in the shop on the Boulevard Raspail that Guillaume undoubtedly made the acquaintance of Apollinaire, who, from that moment until his death, was to guide the young dealer through the shoals of the art world, and lend him constant support. Brummer's account is, moreover, confirmed by Basler.[94] The critic, accompanied by Frank Burty Haviland, paid a visit to Guillaume "before his military service, in an automobile garage, in one corner of which he stored Negro fetishes." It is conceivable that once his first transactions with Brummer were over, Guillaume, while keeping in touch with this experienced man who had so many contacts, had dreamed of going into business for himself. Thus, despite the allegations of the protagonist himself, the beginning of Paul Guillaume's career as an art dealer and collector cannot be placed earlier than 1911. The statement regarding his purported discovery of African art in 1904 is clearly refuted by the events described above, but also by Alice Halicka's version of these events.[95] She connects the presence of Marcoussis with the occasion of the purchases on the Rue Caulaincourt and places them "around 1910." If Guillaume's contacts with Marcoussis, like those with Basler and Frank Burty Haviland, were made, as is likely, through Brummer or Apollinaire, the young dealer could not have established them before 1911.

An anonymous article entitled "L'Art nègre," published in *Gil Blas* on October 8, 1912, announces the opening, anticipated for 1913, "of the first exhibition of tribal art, organized by a new society of collectors." Mention of the existence of this society suggests that it may have been the Société des Mélanophiles, founded at the instigation of Paul Guillaume. Alberto Savinio, who alludes to it in his memoirs, places its creation in 1913.[96] Although the announced exhibition did not take place after all, and although doubt persists as to the initial activities of this group of collectors, whose number and identity are moreover unknown, these facts are nevertheless convincing evidence of the dynamism already being displayed by Guillaume in the pursuit of his plans. He requested the suppliers of his former employer to ship Gabonese sculptures to his private address. And as early as 1912 he advertised in the colonial press for the purpose of extending the range of his stock. Endowed with a particularly keen spirit of enterprise, Guillaume was to benefit from the collaboration of Apollinaire and a wide circle of contacts. This is shown in more than one passage in the letters from the poet to the dealer.

The first exhibition in which African sculptures belonging to Guillaume were displayed took place outside France, and it was also the first time in the United States that this work was "shown solely from the point of view of art." Organized by Marius de Zayas, Stieglitz's associate, it was held at 291 Fifth Avenue in the famous little gallery of the Photo-Secession group. Eighteen objects from the Ivory Coast and Gabon were exhibited there from November 3 to December 8, 1914.[97] Despite the somewhat provocative title, "Statuary in Wood by African Savages: The Root of Modern Art," there was no *succès de scandale*, though the show received a great deal of often serious attention in the press. On the walls and pedestals of the gallery, these works from "the Land of Fright," in de Zayas's mythical expression, seemed altogether divested of their exotic flavor, despite Edward Steichen's abstract installation, which he thought might suggest "a background

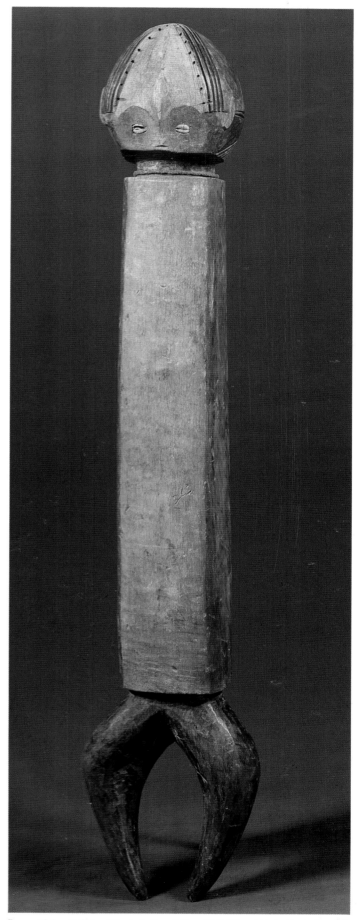

Figure. Ngbandi. Zaire. Wood, shell, and fiber, 31⅛" (79 cm) high. Musée Royal de l'Afrique Centrale, Tervuren, Belgium

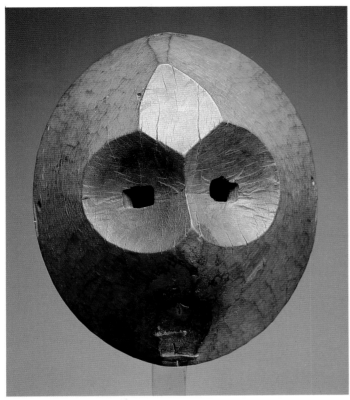

Mask. Nigeria (?). Wood, 8⅞" (22.5 cm) high. Private collection

of jungle drums."[98] The extracts from reviews published in October 1916 by *Camera Work* reveal that the critics, while sometimes hostile, were by no means indifferent to the art or the daring novelty of the occasion.

Thus Paul Guillaume, having only recently opened his first gallery on the Rue de Miromesnil in Paris, had already succeeded in imparting an international dimension to his operations. It may seem surprising that de Zayas had turned to Guillaume instead of to a recognized dealer like Brummer or even Frank Burty Haviland. His friendship with the latter's brother Paul Haviland[99] in the group around "291," and the fact that Frank at that very time was exhibiting some of his works there, ought to have directed him, one should think, toward this experienced collector, whom he most likely knew. We can only suppose that his chance meeting with Guillaume at Picabia's, which can be placed between May 16 and 25, 1914, had persuaded him to collaborate with this ardent champion of African art, who was, moreover, backed by Apollinaire's recommendation. De Zayas extolled Guillaume's disinterestedness concerning the sculptures that were entrusted for this first, so-called propaganda exhibition. But as early as November 14 of the same year, seventeen oils and watercolors were shipped by Guillaume from Le Havre to Stieglitz's address, including five canvases by de Chirico (among them, *Song of Love*, priced at four hundred francs). To this group of modern paintings, two "Bakoutas fetishes [Kota reliquary figures, p. 152] in copper and wood of the seventeenth century" were added at an asking price of three thousand francs.[100] And one suspects that this was not the last transatlantic shipment.

Knowing how much Paul Guillaume was driven by a proselyte's enthusiasm and zeal, one is surprised to note that no exhibition of tribal sculptures, which he was nevertheless

busily collecting, was organized in Paris before the end of 1916. Since he possessed both the material and the gallery, small as it was, before the war, one can only speculate on the reasons for postponing its presentation. On the one hand, perhaps, he respected an agreement with de Zayas by which the latter, who had had priority ("the first time...in this country or elsewhere") for the showing of African "art," would retain it for still some time. But there is no evidence for this. On the other hand, during the period immediately prior to the war, we can suppose that Guillaume feared the competition of the Exposition d'Art Indigène Africain, an event that was held for two months, from May to July 1914, under the sponsorship of a charitable organization, Le Souvenir Africain. The exposition had had the advantage of wide publicity in the religious and patriotic press. In the midst of a jumble of stuffed animals, works by the pupils of missionaries, and mediocre paintings constituting the prizes in a lottery, Apollinaire himself singled out "some marvelous idols, thrilling statues, infinitely valuable, carved by great anonymous artists."[101] It is possible that for the period between December 1914, when Apollinaire enlisted in the army, and August 1915, when he was recovering with difficulty from his wound, his absence discouraged Paul Guillaume from embarking on an undertaking for which he needed the help of his stalwart propagandist.

In the early winter of 1916, the Chilean painter Manuel Ortiz de Zarate suggested to his Genevan colleague Emile Lejeune,[102] who owned a studio at 6 Rue Huyghens in Montparnasse large enough to accommodate summer concerts, that he open his place to exhibitions as well. Ortiz and Kisling saw to the preparation of the first one. Thus, between November 19 and December 5, 1916, at the sign of the Lyre and Palette, there were displayed not only a few paintings by

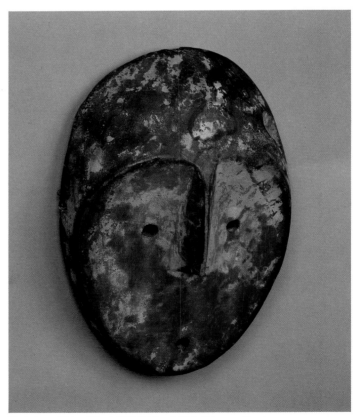

Mask. Lega. Zaire. Wood, 8⅝" (21.9 cm) high. Private collection

Mask. Djibete. Nigeria. Painted wood, 27⅞" (71 cm) high. Private collection

these artists but also an oil and a drawing by Matisse, two still lifes by Picasso, and no less than fourteen canvases by Modigliani. These last had been borrowed by Kisling from Paul Guillaume, who for the occasion added to this loan a group of "twenty-five Negro sculptures, fetishes from Africa and Oceania." A catalog was published, most likely at Guillaume's expense. In addition to brief descriptions of the works shown, it contained poems by Cendrars and Cocteau in homage to Satie and an unsigned note of a few lines entitled "Art nègre." Lejeune, in his memoirs, attributes the note to Guillaume. The editor of the Apollinaire-Guillaume correspondence, however, sees it as "the very first form of the poet's notices and declarations in favor of Negro art."[103] Be that as it may, this short text sums up some of the ideas that seem to have been shared by the writer and the dealer: that there is a crying need to extricate these sculptures from the compulsory framework of ethnographic museography in which their

beauty is flouted; and that their aesthetic value, even if appreciated by the most advanced artists of the moment, fails nevertheless to stand up in comparison with the masterpieces of earliest antiquity.

Because of the success, not merely *mondain*, of the Lyre and Palette exhibition, it constituted the point of departure in Paris for the vogue that "art nègre" was to enjoy well beyond artistic circles, and Paul Guillaume's convictions were thereby strengthened. Shortly afterward, he undertook an album of reproductions entitled *Sculptures nègres*. Apollinaire not only supplied the preface, "A propos de l'art des noirs," but also specific advice on the format of the volume. Apollinaire was to give him further help by drawing up the prospectus announcing its publication. *Sculptures nègres* came off the press in April 1917. In addition to Apollinaire's remarks and an "explanation" by Paul Guillaume, the album contains twenty-six reproductions of twenty-two African objects (from Guinea, the Ivory

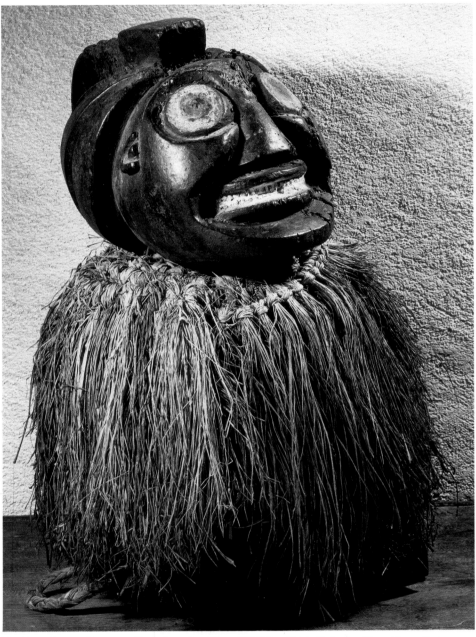

Headdress. Bamum. Cameroon. Painted wood and fiber, 11¾" (30 cm) high. Collection Pierre Harter, Paris

Coast, the Sudan, Gabon, and the Congo) and four from Polynesia. The identities of the collectors are mentioned for seventeen sculptures: Paul Guillaume—5; Ambroise Vollard—2; André Level—1; Jos Hessel—2; Alphonse Kann—2; Comte de Gouy—1; Bernard d'Hendecourt—1; Vlaminck—1; Matisse—1; and the Trocadéro museum for a Nimba of the Baga people. One notes that Apollinaire's name does not appear on this list; the reason is given in a note that he wrote to Guillaume: "Since I am signing the preface, it is better that my name not appear among the collectors."[104] This does not, however, entitle us to assume that all the objects whose ownership goes unacknowledged were therefore the property of the poet. The reluctance he expresses about the publication of his name can be perfectly well explained by his wish to preserve in the eyes of his colleagues an image of

independence and integrity, which would risk being compromised by too conspicuous a presence in the dealer's enterprises.

One might well consider that Apollinaire had transgressed in this direction in his contribution to *Sculptures nègres*. Indeed, if we compare two seemingly very similar texts, which nevertheless contain significant differences (the preface to the album and an article Apollinaire published in the *Mercure de France* for April 1, 1917), it is clear that the article was written before the preface. And what emerges from this comparison is the fact that the preface written for Guillaume constitutes not only a reduced but a distinctly obliging adaptation of the more ironical and aloof views expressed in the article concerning the developing taste for tribal art—an attitude well conveyed by the title of the column: "Mélanophilie ou mélanomanie."

This divergence in the real opinions of Apollinaire and Guillaume was not, however, to put an end to the collaboration between them.

Guillaume had probably already organized some important exhibitions (Larionov, Gontcharova, de Chirico, Picabia, Derain) at his locations on the Rue de Miromesnil and the Avenue de Villiers, but his fame was not truly established until after the opening of a new gallery in the prestigious Faubourg Saint-Honoré quarter in the autumn of 1917. The advertisements he placed in certain periodicals at that time reflect the goals he had chosen for himself: to show, along with a few important works by "Contemporary Masters" and the most representative examples of "the New Painting," a group of "Negro sculptures of the highest quality." These pieces of "great interest," all described as being from the "early period," were to be displayed, with a few works of antiquity, in a large glass showcase, thus constituting a permanent exhibition. Madeleine Le Chevrel, in an excited article that appeared in *Le Gaulois* on December 18, 1917, conjured up, in connection with the "Pahouin, Bahoulé, Bakoutos, and Upper Nigerian races" here exhibited, "the wreckage of the great submerged Atlantis."

As the war went on, the gallery at 108 Faubourg Saint-Honoré became one of the few active centers of Parisian artistic and literary life. During this period of exacerbated nationalism, it proved to be a favored spot where, except for the absence of what might otherwise have come from Germany, the echo of foreign avant-gardes made itself heard, and where, for example, the connections between Paris, New York, and Zurich were maintained. Vanguard painters, musicians, and writers thus rubbed shoulders at Paul Guillaume's. In the presence of his "Negro idols," some found the opportunity to display their talents. At the "evening of Poetry and Music" on November 13, 1917, after a statement by Apollinaire on certain novelties in sculpture, Satie played the score of *Parade* on the piano, and an actress read, in addition to a few poems by the author of *Calligrammes*, Cendrars's "Le Profond Aujourd'hui," and "Façon" and "André Derain" by an almost unknown young poet, André Breton.[105] In the program for this event, reproduced in facsimile, appears an envoi by Jean Cocteau to "Paul Guillaume, négrier." It concludes, "Negro art [thus] is not related to the deceptive flashes of childhood or madness, but to the noblest styles of human civilization." This must have proved to its recipient that his message had been understood.

It was Guillaume's hope that this "new spirit" stimulating the gallery and those who frequented it would be expressed in a publication to be devoted to "artistic and literary news of the arts and matters of interest." On March 15, 1918, between the Matisse/Picasso and the van Dongen shows, the first issue of a lavishly illustrated bulletin, *Les Arts à Paris*, appeared. Apollinaire was closely involved in the preparation of the first two issues. His biographers even try to claim that he "wrote an important part of it by himself." It is, however, proper to attribute to him only the authorship of the articles signed "Paracelse," "Docteur Passement," and "Louis Troëme." It was with this last pseudonym that he published a note, "Sculptures d'Afrique et d'Océanie,"[106] in which he seems to rally to Guillaume's views: "[Today] by taking an interest in fetishes, which all pertain to the religious passion that is the source of the purest art...artists [for whom] it is a question of renewing

their subjects and forms by turning their artistic attention to the principles of great art...strengthen their taste for it."

With Apollinaire's death in November 1918, Paul Guillaume's formative years may be said to end. And he embarked on the postwar period with decisive advantages: a now famous gallery, important holdings that had been enlarged during the "terrible years" by the absence of any true competition, a magazine that served to promote his enterprises, and an extensive network of contacts. Following the successful end of the war, he was furthermore to benefit from a favorable climate. The increased interest in Negro art he hoped to arouse was favored by a change in French attitudes toward Africans. The haughty disdain in which they had been held by the great majority was replaced, in part because of the courage the African troops had shown against the German enemy, by a certain curiosity about the customs of these people who had fought fiercely and were now joyful partners

Paul Guillaume, c. 1930

in the victory celebrations. In this upsurge of benevolent sympathy—not, however, untainted by condescension—Guillaume was able to seize the opportunity for a publicity and sales campaign that would play an important role in making "Negro" art fashionable.

The spacious premises of the Devambez gallery and publishing house on the Rue Malesherbes having been put at his disposal, he organized, with the help of Level, the Première Exposition d'Art Nègre et d'Art Océanien, held between May 10 and 31, 1919. Even though, properly speaking, the event was not a "first," the abundant comment it aroused and the throngs of people it attracted entitle it to be called unprecedented. Its catalog contains 150 entries. Of this number, two-thirds refer, explicitly and implicitly, to objects then held by Guillaume. Thirty-nine pieces were from the collection of

Figure. Zande. Zaire. Wood, 10¼" (26.1 cm) high. Collection Marc and Denyse Ginzberg, New York

Level. Eight sculptures were included presumably in recognition of the prestige of the lenders: the manufacturer Louis Delafon; the couturier and art patron Jacques Doucet; Georges Menier, painter and scion of a famous chocolate firm; Orientalist scholar Victor de Goloubew; art dealer Léonce Rosenberg; and Maurice Vlaminck. Though it is risky to rely on the often imprecise, sometimes fanciful designations printed in the catalog, we can nevertheless observe that with a few exceptions (Zande and Kuba objects from the Belgian Congo), the works came from territories under French colonial domination. One notes, besides, that a by no means negligible number of pieces fall not into the categories of masks and statuary but into what could be called the decorative arts: urns and bowls, combs and bracelets, spoons and seats, for example. Finally, we might add that the catalog, in addition to reprinting Apollinaire's preface to *Sculptures nègres*, contains a few sketchy reflections on "L'Art sauvage," which their authors, André Level and Henri Clouzot, later developed in numerous publications.

Guillaume provided an unexpected sequel to the successful recognition of this "new aesthetic," to which the show at the Galerie Devambez had contributed. During a memorable evening held at the Théâtre des Champs-Elysées that same May, he staged the first "Fête Nègre" for an audience made up of the Tout Paris. After listening to an opening statement in which the master of ceremonies sought to demonstrate that "the intelligence of modern man ought to become Negro," the spectators witnessed some choreographic and musical numbers whose subjects had been taken from the tales and legends

of Africa that Blaise Cendrars had recently compiled for his *Anthologie nègre*. It is difficult, in retrospect, to discern to what extent this manifestation was either naive didacticism or measured provocation. A pale imitation of an evening at the Cabaret Voltaire, an anticipation of *The Creation of the World*, a "spectacle of the Exposition Coloniale type, instructive and well-documented," "bamboola" burlesque—it was probably all of these at the same time. Be that as it may, the press gave it ample coverage, and Guillaume thereby gained further celebrity among "the elite of the eternal homeland of taste," as he was pleased to declare his nation.

While we may generally agree that these two events of 1919, the Devambez show and the "Fête Nègre," helped to transform an art that had once aroused the interest of only a small number of collectors into something of an object of fashion, should we thereby conclude that they mark the beginning of a disaffection among artists for the exotic arts, since the strength or renewal or rupture that they had ascribed to them now found itself in some way acclimated to current taste? We might well think so in considering, for example, the invocation nostalgically uttered by André Salmon in 1919: "The cannibal gods be praised who gave us the courage for salutary massacres."[107] Would not fashion, by appropriating for itself weapons that had been brandished against tradition, gradually blunt and polish them in order to turn them into symbols of a new academy? Indeed, Roger Allard, one of the most ardent champions of the Cubists, used the occasion of the Devambez show[108] precisely to stigmatize the attitude of those wealthy collectors who, manipulated by shrewd dealers, measured the quality of sculptures by their commercial value, not suspecting that they could be made to admire "imitation African sculptures." In any case, the new craze did not last the length of a whole Paris season.

Tribal art was nevertheless integrated with the furnishings and decor of the period (p. 483). Having earlier been a means of transgression for some, it ironically became, by reason of its worldly success, an element in the "return to order." Derain, close in this respect to the views of Guillaume, saw it as "the first of classicisms." From such views followed the question raised at the beginning of the 1920s: Should tribal art be admitted to the Louvre?

This was the central question in a survey conducted by Fénéon among "twenty ethnographers and explorers, artists and aestheticians, collectors and dealers." The results appeared between November 15 and December 15, 1920, in three issues of the *Bulletin de la vie artistique*, organ of the Galerie Bernheim-Jeune. A few short extracts will serve to indicate the state of the respondents' minds. For Salomon Reinach, curator of National Antiquities, the problem was not worth discussing, since "the wooden sculpture of the Negroes is hideous; to take pleasure in it would seem to be an aberration, when it is not simply a joke." In contrast, Lucie Cousturier, painter, writer, and close friend of Fénéon, thought that once "the Louvre welcomes Negro art, it will find in it, not its complement, but its principle." Jos Hessel, one of the first of its collectors and now a reputable picture dealer, was convinced that the instruction one could derive from the arts of Africa would be all the more effective if "a few very pure specimens" were displayed in that prestigious museum.

Charles Vignier expressed irony: Since the Louvre did not contain "Peruvian, Polynesian, Sudanese, or Dahomean works, this was sufficient reason [for its curators] to persist in this abstention. On the other hand, these works are in the British Museum, the Metropolitan in New York, the Fine Arts in Boston, and the University Museum in Philadelphia among others." Jean Guiffrey, curator of paintings at the incriminated Louvre, indeed thought that "it would be paradoxical to compare the stammerings of civilizations that have remained in their infancy, curious as they are, with the most perfect works of human genius." Léonce Rosenberg, who did not miss the opportunity to dispute his rival Paul Guillaume by insisting on the superiority of his own predilection, Oceanic art, nevertheless agreed that "only the ten best [African] pieces seen so far might occupy a small place in the Louvre." Finally, Guillaume himself suggested that things should not be rushed, "for at this moment there does not yet exist an official elite capable of choosing, with all the necessary discernment, pieces that are both the most significant and authentic, and that in themselves deserve final recognition."

A few months earlier, in April 1920, Florent Fels had solicited for his magazine *Action* the opinions of some well-known witnesses of the advent of tribal art. Along with Picasso, who paradoxically pretended to be unaware of it, and the harsh judgment expressed by Cocteau ("The Negro crisis has become as boring as Mallarmé's Japonisme"), Paul Guillaume was likewise outspoken: "Negro art is the fructifying seed of the spiritual twentieth century [and] it is this century's good fortune to have made the splendors of a statuary, whose reign is only beginning, to emerge from African antiquity."

Although tribal art was "in the air" at this period, no exhibition was organized in Paris between the one held at the Galerie Devambez and the one that took place at the Pavillon de Marsan at the end of 1923. During this period, curiosity was nevertheless fed by publications. A few books, but above all numerous articles, sought to restore to the arts of Africa their specific characteristics and, over and above their presence in artists' studios, their autonomy. The collector André Level, in association with Henri Clouzot, a specialist in European applied arts, proved to be especially prolific in this respect. In the last months of 1919, Editions Devambez published *L'Art nègre et l'art océanien*, the first book to appear in France in which an effort was made to relate the artistic value attributed to the works to the conception of their creators. Attentive to the forms of the objects they reproduce (some thirty, half belonging to Level and the others to Guillaume, Picasso, Louis Delafon, and the collections of the Trocadéro and the British Museum), the authors sometimes make observations that attest a loftiness of view comparable to Carl Einstein's. Thus: "The mode of expression of Negro masks never consists, so to speak, in a distortion of features, a grimace; they neither laugh nor cry. Their expression flows from their construction, from the accentuation of planes by large masses. It is from the play of lines that they derive their effects. Nothing is further from literature and more intrinsic to sculpture." We might note that Einstein himself is deliberately omitted from the references in the book; as a German, he was perhaps suspected of "trancendental metaphysics."

Because of the disparate sources used by Level and Clouzot, their most interesting remarks are embedded in a confused

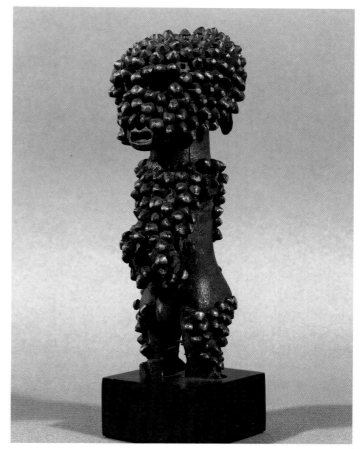

Figure. Songye. Zaire. Wood and metal, 8¼" (21 cm) high. Private collection.

mass of prejudices and preconceptions about "the Negro mentality." Basing their assertions on the writings—dated to say the least—of Arcin and Father Baudin, on lamentable statements by Professor Verneau, Hamy's successor as director of the Musée d'Ethnographie du Trocadéro, and on the no less mistaken analyses of Marius de Zayas,[109] they offer a number of absurdities about "the physiologically inferior cerebral development of the Africans," on Africans' supposed credulity. They quote Verneau with a certain respect to the effect that in Loango, nails are driven into the body of a fetish so that "the sensation it feels will make the request they have formulated penetrate more deeply into its memory."

It is clear that the book by Level and Clouzot is representative of the thinking of a period in which the stakes of colonization often made it impossible to extend cultural relativism, reserved for artifacts alone, to other facets of society. Between 1919 and 1923, some ten or so articles appeared under their double signature. The discovery at Tervuren, after the armistice, of the court arts of the eastern savannahs of the Belgian Congo, Clouzot's interest in the history of the applied arts, and Level's acquisitions in Antwerp from the importer H. Pareyn account for their numerous examinations devoted to the decoration of domestic objects and articles of dress.[110]

The publications of Level and Clouzot, the four portfolios on *La Décoration primitive* published by the Librairie des Arts Décoratifs in 1922–23, and the existence of such specialized private collections as Paul Rupalley's or even that of Captain Lepage, author of the volume on Africa in the above series, led François Carnot, president of the Union Central des Arts

Décoratifs, to organize in late 1923 an Exposition de l'Art Indigène des Colonies Françaises at the Pavillon de Marsan. It was to include "the most characteristic types of statuary, ornamental sculpture, jewelry, fabrics, everyday objects in wood, metal, or clay, musical instruments, basketwork, etc." The preparation of the event was assigned to a committee made up, in addition to Level, Clouzot, and Verneau, of Pierre Mille and Marius and Ary Leblond, journalists and writers close to colonial circles, and the administrator Delafosse, then a professor at the Ecole Colonial and director of the Economic Bureau of French West Africa.

One of the purposes governing the presentation of "native ornaments" was to present designers, craftsmen, and manufacturers with examples that they might be able to exploit. It was also an opportunity for the spokesmen for colonial power to step up their propaganda from a cultural and economic angle. The arrangement adopted was a geographical one: Each colony was represented by those of its products judged to be the most significant. Of the lenders who responded for Africa to the appeal by the curator of the Musée des Arts Décoratifs, six were institutions and forty-six were individuals. Among the latter were the artists Patrick Henry Bruce, Burty Haviland, Lhote, Georges de Miré, and Angel Zarraga; the writers Jean Giraudoux and Fénéon; the dealers and collectors Guillaume, Hein, Ernest Brummer (brother of Joseph), Vignier, Antony Moris, and Hessel; the private collectors Alphonse Kann, André Lefèvre, Paul Poiret, Madame Tachard, and Rupalley.

The number of objects put at the disposal of the organizing committee by collectors was considerable. For the Ivory Coast section alone,[111] for example, Guillaume lent seventy-nine, Hessel twenty-two, and Lhote eleven. As for Fénéon, he sent thirty heddle pulleys and fifteen masks.

One can easily imagine the interest aroused by the preparations for a systematic catalog of the objects exhibited. But the reluctance of some lenders to permit publication of photographs of their works, the huge number of entries (which probably far exceeded the expectations of the organizers), and the limited time available combined to abort its publication. Hence, to evaluate the contents of this exhibition, one must be satisfied with the hasty descriptions of it given by Dr. Stephen-Chauvet in a booklet published in 1924 and with the illustrations and the preface by Clouzot and Level, "La Leçon d'une exposition," in their album *Sculptures africaines et océaniennes* (1925). The exhibition at the Pavillon de Marsan, the first of such scope to be held in Paris, was a resounding success. Planned to run for two months, it had to be extended for four extra weeks. Alexandre in *La Renaissance des arts français*, Fels in *Nouvelles littéraires*, Janneau in the *Bulletin de la vie artistique*, and Tabarant in *L'Oeuvre*, among others, all wrote largely favorable comments about it.

Guillaume, who was not on the organizing committee and had nothing but distrust for the official champions of "pure" ethnography, set conditions for his contribution by asking assurances that "the artistic interest of the works will be neither impaired nor compromised" in the presentation. Chief lender to the exhibition, he had available, in the gallery he had just opened on the Rue La Boétie and in his apartment on the Avenue de Messine, the most extensive private collection existing at that time: close to five hundred "ancient" sculptures of African origin.[112] This figure, given by Guillaume himself,

seems believable, to judge by the size of his contribution to the exhibition at the Pavillon de Marsan.

Although Guillaume kept silent about the sources of his acquisitions, there is every reason to suppose that he made purchases from some of his colleagues, such as Brummer and Moris, and was supplied from abroad, from England in particular and probably from Belgium. Furthermore, the advertisements he placed in the literary and artistic press included offers to buy, as did his announcements in publications destined for the colonies. In the same way, at the Bréhant, a café frequented by officials on leave from the colonies, he used the message book for communications of this kind: "Paul Guillaume pays high prices for all pieces and collections of African origin."[113] In addition, we can be fairly sure that when he received, as he would declare ostentatiously, the emissaries of the Fama of Sassending or the son of Dinah Salifou, "king of the Bagas and the Nalous,"[114] he was actually welcoming some of his African suppliers.

The renown that Guillaume had achieved by the early 1920s owing to his success as a dealer and collector of both tribal and modern art was to increase when the nature and importance of the transactions that he had been conducting with the great American collector A. C. Barnes became known. Not only did he obtain for Barnes some masterpieces of modern painting, but he supplied him, in 1922 and 1923, with the core of the African sculpture collection assembled at Merion, Pennsylvania. In going through the series of issues of *Les Arts à Paris*, one quickly perceives that beginning in January 1923 the bulletin of the gallery on the Rue la Boétie was becoming in a sense the European organ of the Barnes Foundation, and Paul Guillaume its privileged if not exclusive correspondent. Seduced by the collector's philosophical, social, and aesthetic ideas, he made himself their mouthpiece in his magazine. In addition to texts by Barnes himself, we find there, for example, the didactic adaptation of his *Art in Painting* (1926) by Thomas Munro, the announcement of the publication of an article by John Dewey, who was, along with William James and George Santayana, one of his heroes, the translation of the charter of the Fleur de Lys Club of Philadelphia, which offered "a new education plan for Negroes," a reference to some issue of *Opportunity, Journal of Negro Life*, and even a photograph of "Paul Guillaume among the Negroes of New Jersey."

Primitive Negro Sculpture, a collaboration of Guillaume and Munro, then educational director at the Foundation, appeared in 1926. Forty-eight objects from the Ivory Coast, the western Sudan, Dahomey, Gabon, the French Congo, Belgian Congo, and Nigeria (a small Benin hip mask) are illustrated in it. All are from the collection in Merion; most of them had previously belonged to Guillaume. Three, however, had been in the possession of Marius de Zayas.[115] In 1923, in presenting "African Art at the Barnes Foundation" in *Les Arts à Paris*, Guillaume had specified, "In this collection...it will be noted that the epochs have been for the first time definitely fixed." In *Primitive Negro Sculpture*, the periods to which the objects are related are indeed mentioned: None is said to date from the twentieth century, and only two are attributed to the nineteenth. The famous Dogon couple is dated between the fifth and tenth centuries, and a Fang reliquary figure between the eighth and the tenth. Obviously there is no point in insisting on the extravagance of such claims.

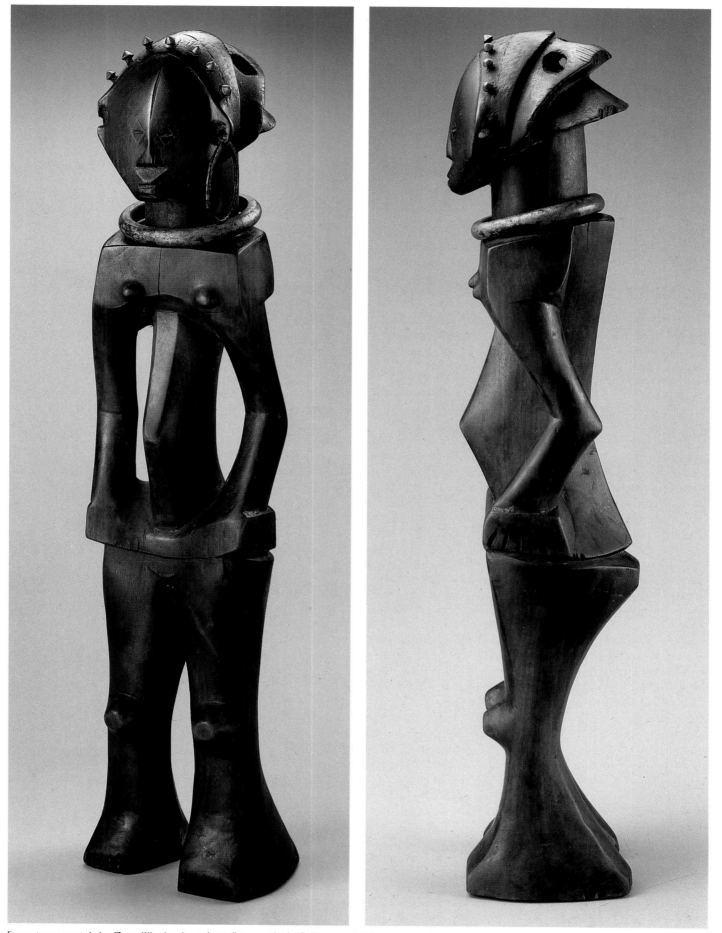

Figure (two views). Luba. Zaire. Wood and metal, 13¾″ (35 cm) high. Collection J. B. Hautelet, Brussels

Charles Ratton, c. 1935. Photograph. Archives C. Ratton–G. Ladrillère, Paris

A French translation, minus the third and fourth chapters, of the book by Guillaume and Munro was published in 1929. Its publication coincided with the Bernheim-Jeune gallery's presentation of the superb collection of paintings assembled by Guillaume, then at the height of his fame. He would have liked to give Paris the large museum of modern art that it still did not have, and add to it a museum of "art nègre." But his plans were to be thwarted by the officials of the Fine Arts and Education ministries, and this seems to have left him with a certain resentment. His enthusiasm in championing the artistic values of African works began to slacken somewhat. In May 1927 he had organized an important exhibition of his African sculptures for the Salon du Sud-est in Lyons. This was the last time he took the initiative. In the May 1930 issue of *Les Arts à Paris*, Waldemar George published, under the title "Le Crépuscule des idoles," an open letter that reflects Guillaume's opinion of the situation on the threshold of the 1930s. The pretext for the letter had been the "Exposition d'Art Africain et d'Art Océanien" at the Galerie du Théâtre Pigalle, in which a few of Guillaume's pieces were shown but without his having had anything to do with the arrangement. The writer of the letter, having given Guillaume and the painters of the "first generation" of tribal-art collectors credit for revealing Primitive "constructive principles," deplores the fact that what had been a stimulating element for creation had now become its "dissolvent." Citing the "Surrealist poets, dealers, and painters" whose "hallucinatory desires are heightened by contact with Idols," he accuses this second generation of having "completely distorted the intelligence of a style by placing it at the service of fleeting passions" and of having dragged it "into a form of academicism." This does not mean that "Negro art must suffer an eclipse.... It is ripe for the Louvre" because "it should be envisaged from the standpoint of formal perfection. If the Pahouin [Fang] form is its apogee, it is because they mark the highest degree of mastery and civilization." What the new generation should ask "from the Negroes is a lesson in sculptural knowledge, not clumsiness,...a state of universality and not the exotic and savage." Two months later, Waldemar George told his readers in *Formes* of a secret he had learned "from the promoter of tribal art in Europe and the United States": "Paul Guillaume is thinking of divesting himself of his important collection of African sculptures." If this

plan had been carried out, it is unlikely, despite George's wishes, that the beneficiary of it would have been the Louvre.

Paul Guillaume died in 1934. The following year, on March 18, "African Negro Art" opened at The Museum of Modern Art in New York (p. 164). Except for Barnes and Coray, the principal American and European collectors participated in it. Domenica Guillaume sent thirty-four objects. This, in terms of the number of entries, placed the Guillaume contribution in third place. First place, with almost twice that number, went to the Parisian dealer Charles Ratton.

Charles Ratton belongs to that "second generation of Negro art specialists" for which the author of "Le Crépuscule des idoles" reserved his harshest criticism. In the same way, by the somewhat broader aesthetic choices that he helped to bring about, he was part of the movement that led, beginning in 1930, to disenchantment with Guillaume. What distinguishes Ratton—who was arguably the last dealer and collector to be able to play a decisive role in the diffusion of African art and the revision of ideas concerning it—from his illustrious predecessor might be summed up as follows: first, the recognition of certain stylistic regions, hitherto underestimated or unfamiliar; second, the extension of the frame of reference to the American Indians and especially to the Oceanic world; and finally, the improvement of relations, if not with anthropologists, at least with museologists.

It was around 1923 that Charles Ratton, prompted by the painter Angel Zarraga, began to assemble a few African objects, the first of them being acquired from Antony Moris on the Rue Victor Massé in Montmartre.[116] At that time Ratton had two shops, one at 39 Rue Laffitte where he sold

Pavilion of French Equatorial Africa at the Exposition Coloniale, Paris, 1931. Photograph by M. Cloche

works from the European late Middle Ages, and the other at 76 Rue de Rennes where he offered antiquities, objects from Eastern and pre-Columbian excavations, ceramics and bronzes from the Far East, and a few pieces of tribal art. An advertisement in *La Révolution surréaliste* of October 1927 suggests that Ratton was already in contact with members of the Surrealist group. "Les Arts Anciens de l'Amerique," which was held the following year at the Musée des Arts Décoratifs, marks the convergence of a number of personalities who are no strangers to our subject. Among the lenders, in addition to Ratton, were Breton, Tual, Hein, and Vignier.

It was an assistant of Vignier's, Georges-Henri Rivière, whom Ratton met at his colleague's, who had been responsible for the arrangement of the pre-Columbian works in the rooms of the Pavillon de Marsan and the preparation, with Alfred Métraux, of the catalog. Georges Salles, Michel Leiris, André Schaeffner, and Georges Bataille had all collaborated with Rivière in different capacities. Having seen the quality of presentation of this exhibition, the Americanist Paul Rivet, who had just been named to replace Verneau as director of the Musée d'Ethnographie du Trocadéro, summoned Rivière to be his second-in-command there. In the first issue of *Documents*, a magazine of which Georges Bataille was general secretary and, with Rivet, Rivière, and Einstein, on the editorial board, appeared the renovation plan, drawn up by Rivière, for this decayed institution, which had become totally unsuited to its mission. While one of the points in the program urges "contacts with collectors and dealers capable of producing gifts, bequests, deposits, and loans," another clearly states that the vocation of the Musée d'Ethnographie is not that "of a fine-arts museum where objects would be classified under the aegis of aesthetics alone." Charles Ratton succeeded in softening the intransigence of such a principle, even if the number of his gifts (seventy objects between 1930 and 1939, ten of which were from Africa) was not directly responsible.

In 1930, for the Galerie Pigalle exhibition, Ratton, along with Tristan Tzara and Pierre Loeb,[117] selected nearly three hundred African objects from the best collections of the time. They were representative not only of the style already recognized but also of regions for which the Musée d'Ethnographie du Trocadéro possessed few or no examples: the kingdom of Benin, the eastern borders of Nigeria, Cameroon, Angola, and even Tanganyika. There were forty-five lenders, among them de Miré, Hein, Ratton, Tzara, the Galerie Percier, and Stephen-Chauvet. This exhibition, like the one at the Palais des Beaux-Arts in Brussels, confirmed Ratton's reputation beyond the circle of collectors.

In 1931, the year of the Exposition Coloniale, Ratton was present at both the Palais Permanent des Colonies, where sculptures from his collection had been hastily assembled along with others belonging to Carré, Hessel, and Lefèvre, and at the Trocadéro, for the Exposition Ethnographique des Colonies Françaises. On display, as a complement to the Treasure of Behanzin held by the museum, was the Fon group that Ratton had bought from Achille Lemoine, the heir of Colonel Dodds. Also, of the six public sales in 1931 where African objects were put up for auction, three were held with the presence of Ratton and Carré on the panel of experts: one on May 7 with 114 objects in the catalog, those on July 2 and 3 with 30 objects belonging to Breton and Eluard, and one on December 16 with 112 objects that were the property of de

Bird headdress. Baga. Guinea. Painted wood, 21¼" (54 cm) high. Musée de l'Homme, Paris

Miré (p. 520, bottom center) and of which some were considered absolute masterpieces. The preface to the catalog of this last sale ended with a confession by its author, Georges-Henri Rivière: "Would you like to know what is in the back of my mind?...A sort of vexation that the Trocadéro is not rich enough to buy this whole magnificent collection." Since only a few buyers in fact turned up, a number of objects were purchased by the organizers of the auction. Also in that same year, Ratton published *Masques africains*.

On June 15, 1932, announced by a special issue of *Cahiers d'Art*, the "Exposition de Bronzes et d'Ivoires du Royaume du Bénin" opened at the Musée d'Ethnographie. It was entirely organized by Ratton. Not only did he decide on the selection and draw up the catalog, but he even found financial means to help defray the costs to the museum. One hundred and thirty objects from some thirty public and private English, German, and French collections were exhibited. Among the lenders, in addition to Ratton with fourteen pieces, we find the names of Carré with twenty-five pieces, Bernheim, Flechtheim, Ascher, Loeb, Moris, Tzara, Derain, Eluard, and Jacques Lipchitz. It was on the occasion of this exhibition that the museum's "Treasure" was installed for a certain period of time. Twelve pre-Columbian, Oceanic, and African masterpieces were highlighted in an installation conceived by Lipchitz.

The following year, Ratton sent to the "All African" exhibition, held in Chicago from June 15 to October 30, more than a hundred pieces, which were up for sale.[118] In July of the same year, a selection from the collections of Ratton and Louis Carré was put on display in Carré's villa in Passy under the title

An assemblage of objects included in the Museum of Modern Art exhibition "African Negro Art," New York, 1935

"Sculptures et Objets de l'Afrique Noire, de l'Amérique Ancienne, de Mélanésie et de Polynésie." Ratton, in 1934, was to contribute a short essay, "The Ancient Bronzes of Black Africa," translated from the French by Samuel Beckett, to Nancy Cunard's monumental *Negro Anthology.*

Ratton attained recognition in New York in 1935 when, simultaneously with "African Art—Ratton's Collection" at the Pierre Matisse gallery, sixty-two of his African sculptures were included in the show at The Museum of Modern Art. The celebrated "Exposition Surréaliste d'Objets," held at Ratton's gallery a year later, included Oceanic but no African objects, an index, as it were, of Surrealist taste. Nevertheless, two years later, with the help of Man Ray and Eluard, Ratton offered a curious exhibition entitled "La Mode au Congo," in which headdresses and hair ornaments worn by African women were juxtaposed with photographs of European models adorned with them.

We have been able to give only a hasty outline of some of the more noteworthy of Ratton's activities during the late 1920s and the 1930s. By assembling works of exceptional quality or unquestionable historical value, he procured for his clients some of the masterpieces of African art. The pre–World War II collections of Jacob Epstein, Baron von der Heydt and Helena Rubinstein, among others, are testimonies to his taste.

With the splendid "African Negro Art" exhibition prepared by James Johnson Sweeney, with the help of Robert Goldwater and Ratton, a large number of tribal objects (some six hundred) made their appearance in a museum of modern art. In 1932, as we have seen, despite the "counter-aesthetic"[119] orientation a few years earlier of those who had reorganized the Trocadéro museum, "certain rare and beautiful pieces"[120] were transformed from indexes of another way of life into master-

pieces of world art. In 1933, *Minotaure,* the lavish art magazine of Skira and Tériade, devoted a whole issue to the Dakar-Djibouti expedition, which had just collected close to thirty-six hundred objects in Africa. Does this mean that the distance separating the defenders of pure ethnography from those of pure delight was steadily being reduced? Invoking this reconciliation of opposites would obviously be nothing but rhetorical artifice.

A few ethnographers, nevertheless, were to lay the foundations for an approach to the art of those societies that hitherto, for them, had had to be considered devoid of art in order to be thought more authentic. At the end of his long and meticulous monograph *Masques dogons* in 1938, Marcel Griaule, ruthless foe of "Negro fashionableness," arrives at some conclusions oddly similar to those at the end of *Negerplastik.* For him, the study of what is called the Society of Masks led to the emergence of "new facts concerning the development of African art or even of Art in general.... [Indeed], it is not rash to state that, in the minds of the Dogon, the aesthetic emotion and the expansion of death are closely linked." Could one go further in the objectification of the very means of creation? Between 1935 and 1938, Carl Kjersmeier, art lover and amateur ethnographer, published in four volumes a first typology of African art entitled *Les Centres de style de la sculpture nègre africaine.* In 1937–38, on the occasion of the exhibition "les Arts du Congo Belge," Frans Olbrechts provided a first glimpse of his famous map of the stylistic regions of the vast Congo. Already, behind the traditions of a group, he had discerned the existence of a workshop, the talent and skill of a master. Absent from this long history, only a few of whose moments we have been able to highlight here, the African artist finally arises from the anonymity in which he has been confined.[121]

—Translated from the French by John Shepley

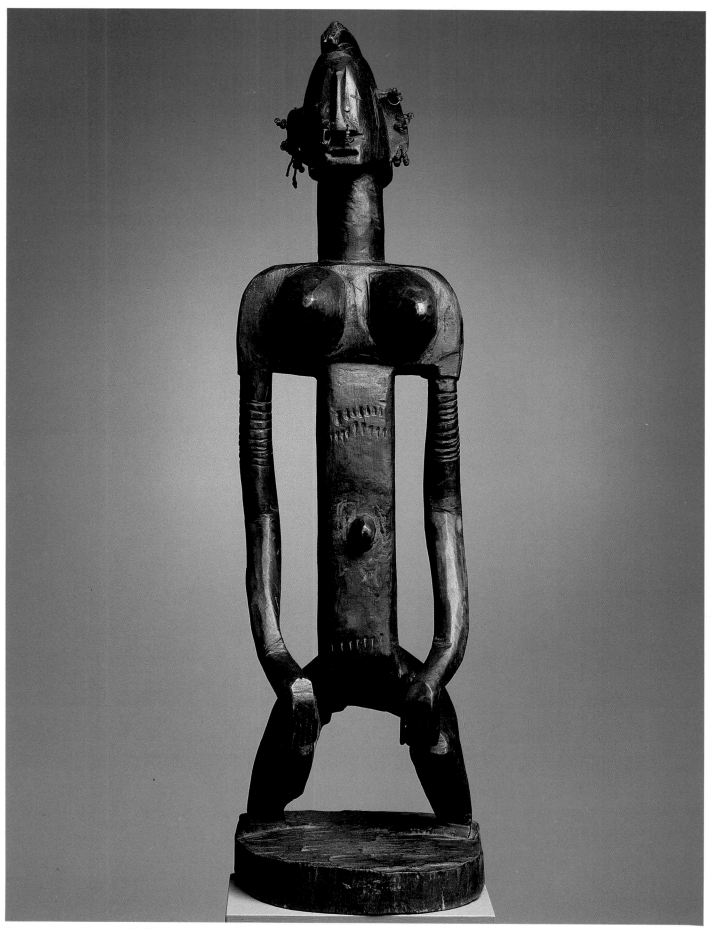

Figure. Bambara or Dogon. Mali. Wood and metal, 27⅛″ (69 cm) high. Private collection

Chart showing the dates of acquisition of African objects in the Musée d'Ethnographie du Trocadéro and the earliest appearances of objects from the respective peoples in the key publications listed at the bottom of the page.

MUSÉE D'ETHNOGRAPHIE/ DE L'HOMME						PEOPLES (IN GEOGRAPHICAL ORDER, NORTH TO SOUTH)	PUBLICATIONS									
BEFORE 1900	1900–07	1908–14	1915–20	1921–30	1931–33		1916	1917	1919	1925	1929 A	1929 B	1930	1931	1935	1938
	X					DOGON				X						
X						BAMBARA	X									
X						MALINKE/MARKA/BOZO				X						
	X					SENUFO/MINIANKA/NAFANA/KULANGO	X									
		X				BOBO/BWA/GURUNSI/KURUMBA										X
					X	MOSSI						X				
		X				LOBI						X				
X						BAULE/YAURE/GURO	X									
X						ANYI/ATTIE		X								
						ASANTE							X			
X						BALANTE										
	X					SUSU										
X						BAGA/NALU/LANDUMA			X							
X						BIJOGO						X				
	X					KONIAGI										
						MENDE								X		
	X					SHERBRO/KISSI						X				
					X	TOMA/BASSA/KPELLE								X		
					X	DAN/MANO/GIO/KONO			X							
	X					KRU/GUERE/KRAN/GREBO/BETE	X									
X						FON/EWE				X						
X						YORUBA			X							
						NUPE									X	
	X					COURT OF BENIN			X							
X						IGBO										X
						IBIBIO										X
						IJO										X
						CROSS RIVER COMPLEX						X				

1916 DE ZAYAS
de Zayas, Marius. *African Negro Art: Its Influence on Modern Art.* New York, Modern Gallery, 1916.

1917 APOLLINAIRE/GUILLAUME
Apollinaire, Guillaume, and Guillaume, Paul. *Sculptures nègres.* 24 photographies. Avertissement de G. Apollinaire et exposé de P. Guillaume. Paris, chez Paul Guillaume, 1917.

1919 LEVEL/CLOUZOT
Level, André, and Clouzot, Henri. *L'Art nègre et l'art océanien.* Paris, Devambez, éditeur, 1919.

1925 LEVEL/CLOUZOT
Level, André, and Clouzot, Henri. *Sculptures africaines et océaniennes, colonies françaises et Congo belge.* Paris, Librairie de France, [1925].

1929 PORTIER/PONCETTON
A Portier, A., and Poncetton, François. *Les Arts sauvages. Afrique.* Paris, Editions Albert Morancé, [1929].

1929 GUILLAUME/MUNRO
B Guillaume, Paul, and Munro, Thomas. *La Sculpture nègre primitive.* Paris, G. Grès, 1929. (Transl.

BEFORE 1900	1900–07	1908–14	1915–20	1921–30	1931–33	PEOPLES	1916	1917	1919	1925	1929 A	1929 B	1930	1931	1935	1938
						BENUE RIVER COMPLEX							X			
					X	DUALA/BASSA										X
					X	CAMEROON GRASSLANDS						X				
					X	SAO										
	X					SARA										
X						FANG	X									
X						KOTA	X									
X						MBETE										
					X	KWELE				X						
X						KUYU										X
X						TEKE	X									
				X		BEMBE			X							
X						SHIRA–PUNU/TSOGO/VUVI/ADUMA/NJAWI		X								
X						KONGO/VILI/WOYO		X								
				X		LULUA				X						
				X		LUBA				X						
					X	KUBA			X							
						MBALA					X					
						LEGA/MBOLE						X				
				X		SUKU/PENDE/YAKA					X					
						SONGYE							X			
X						CHOKWE					X					
X						YANGERE										
				X		YAKOMA										
	X					MANGBETU/ZANDE/NGBANDI										X
						MAKONDE						X				
X						ZULU										

of Guillaume, Paul, and Munro, Thomas, *Primitive Negro Sculpture.* New York, Harcourt, Brace & Co., and London, Jonathan Cape, Ltd., 1926.)

1930 GALERIE PIGALLE
Catalog of the *Exposition d'art africain et d'art océanien* [organisée par les Services d'art du Théâtre Pigalle]. Paris, Galerie Pigalle, 1930.

1931 RATTON
Ratton, Charles. *Masques africains.* Paris, Librairie des arts décoratifs A. Calavas, [1931].

1935 SWEENEY
Sweeney, James Johnson, ed. *African Negro Art.* Exhibition catalog. New York, The Museum of Modern Art, March 18–May 19, 1935.

1935/1938 KJERSMEIER
Kjersmeier, Carl. *Centres de style de la sculpture nègre africaine.* Paris, A. Morancé, and Copenhagen, Illums Bog-Afdeling & Fischers Forlag, 1935–38. 4 vols.

Chart by Jean-Louis Paudrat

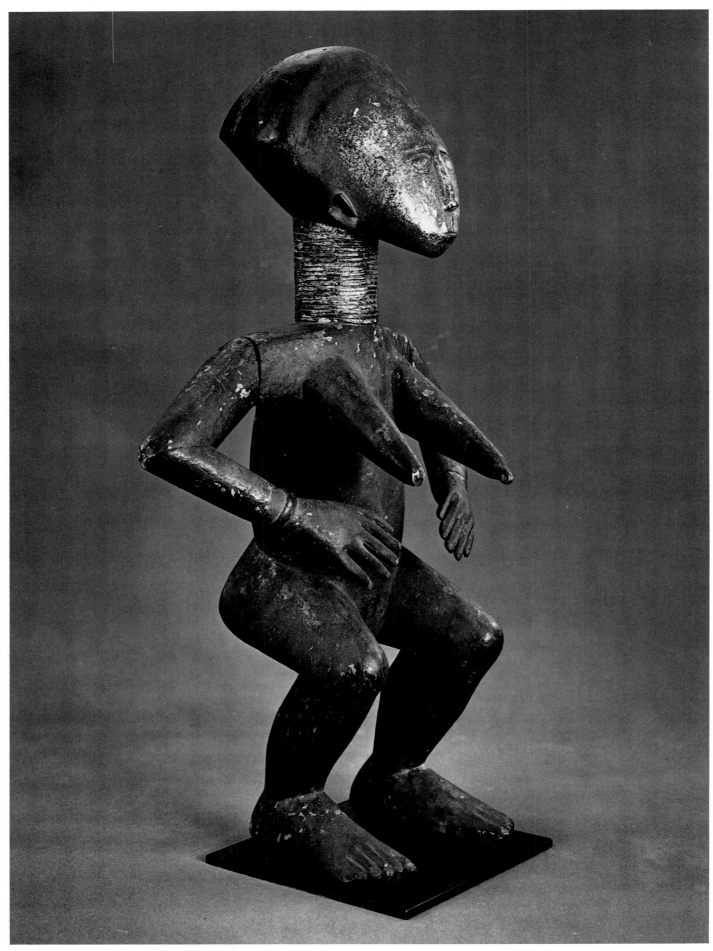

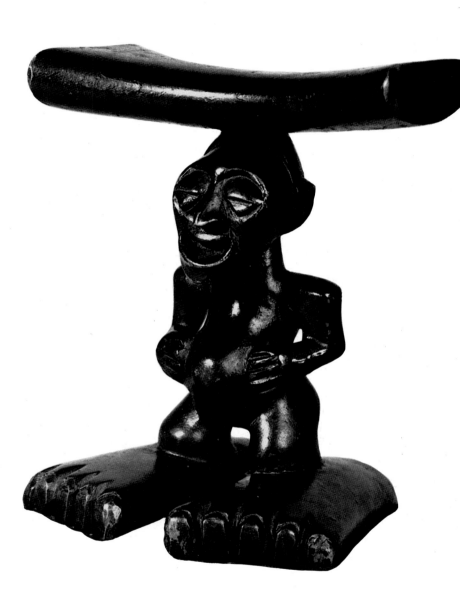

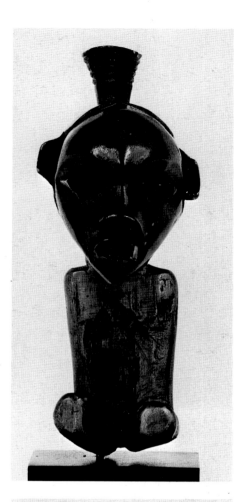

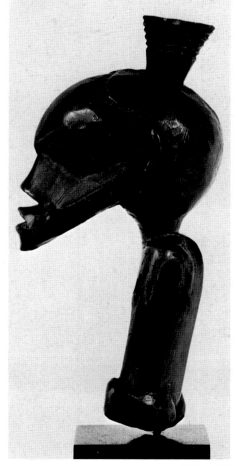

Above: Headrest. Songye. Zaire. Wood, 5½" (14 cm) high. Collection Merton D. Simpson

Above right and right: Fragment of a figure (two views). Lulua (?). Zaire. Wood, 4½" (11.5 cm) high. Collection Ernst Anspach, New York

Opposite: Figure. Eastern Akan. Ghana or Ivory Coast. Wood, 24" (61 cm) high. The Detroit Institute of Arts; Founders Society Purchase, Eleanor Clay Ford Fund for African Art

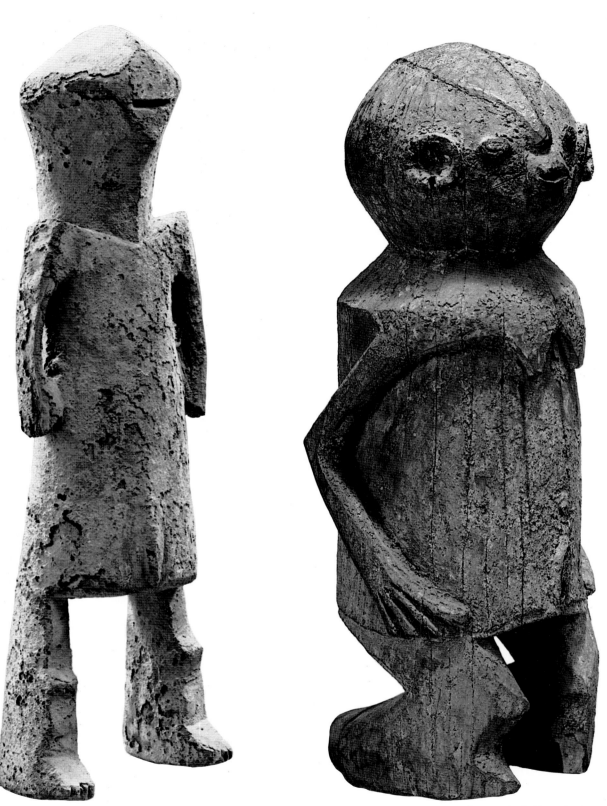

Figure. Keaka. Nigeria. Wood, 20⅛″ (51 cm) high.
Private collection

Figure. Keaka. Nigeria. Wood, 19¾″ (50 cm) high. Musée des Arts
Africains et Océaniens, Paris

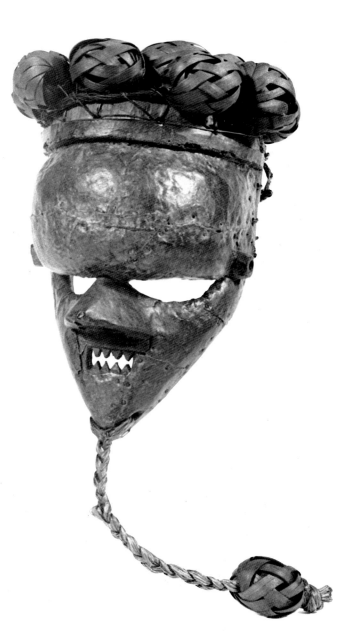

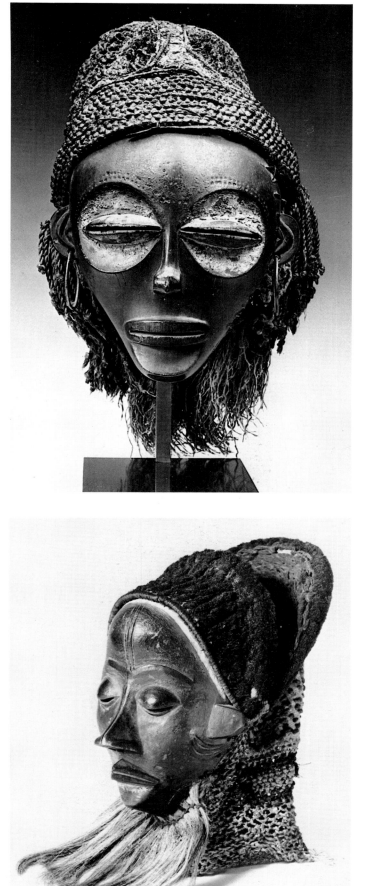

Above: Mask. Salampasu. Zaire. Wood, copper, and fiber, 13″ (33 cm) high. Museum für Völkerkunde, Berlin

Above right: Mask. Chokwe. Zaire or Angola. Wood and mixed media, 10⅝″ (27 cm) high. Private collection

Right: Mask. Pende. Zaire. Wood and fiber, 18⅛″ (46 cm) high. Private collection

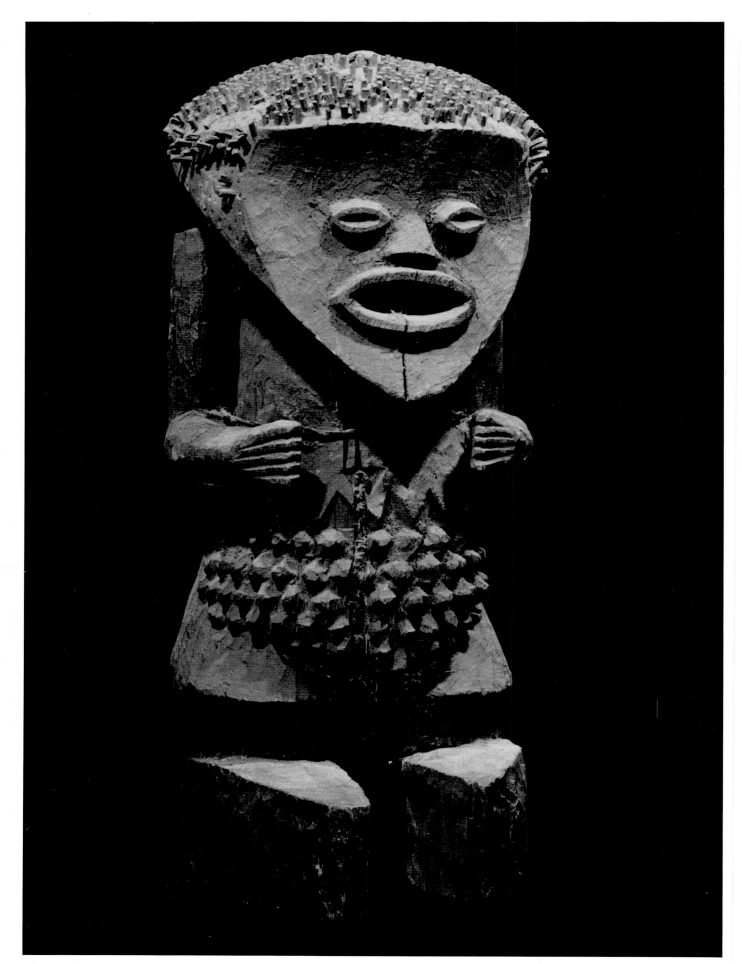

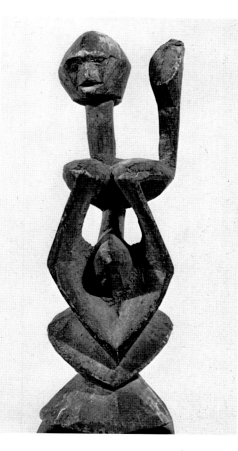

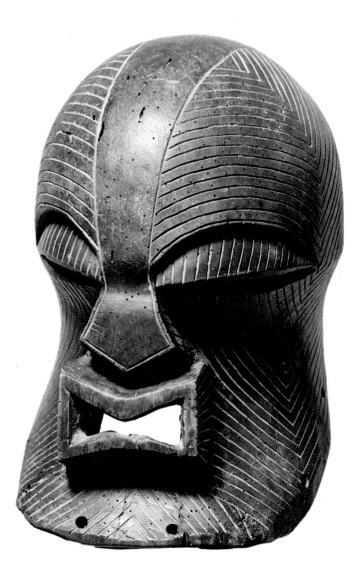

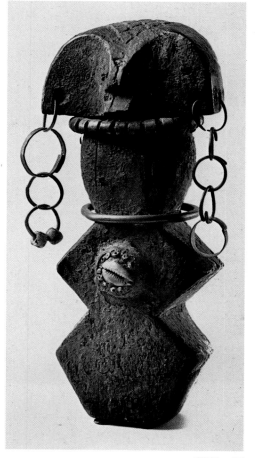

Above: Kifwebe mask. Songye. Zaire. Wood, 19″ (48.3 cm) high. Collection Alan L. Lieberman, St. Louis

Above right: Figure. Dogon. Mali. Wood, 10⅝″ (27 cm) high. Collection Dr. André, France

Right: Figure. Zande. Zaire. Wood, copper, beads, and shell, 7⅞″ (20 cm) high. Collection J. W. Mestach, Brussels

Opposite: Figure. Mambila. Nigeria. Wood, 17¾″ (45 cm) high. Musée Barbier-Müller, Geneva

NOTES

This is dedicated to the memory of my teacher, Jean Laude. My thanks to Judith Cousins and Krisztina Passuth and to Raoul Lehuard for the material they were kind enough to send me. My thanks also to my friends Pierre Pitrou and Georges D. Rodrigues for the help they have given me.

1. M. Besson, *L'Influence coloniale sur le décor de la vie française* (Paris, 1944); quoted by J. Laude, *La Peinture française et l'art nègre* (Paris, 1968), p. 542.
2. Rabelais, *Oeuvres complètes* (Paris, 1973), p. 798.
3. J. Laude, *Les Arts de l'Afrique noire* (Paris, 1979), p. 10.
4. After 1878 in the collections of the Musée d'Ethnographie.
5. M. Itzikovitz, "A propos d'un bronze abron," *Arts d'Afrique noire*, Winter 1976.
6. E.-T. Hamy, *Les Origines du Musée d'Ethnographie* (Paris, 1890), p. 49.
7. "Inauguration du buste du Dr. Hamy," in *L'Anthropologie* 21, 1 (January–February 1910).
8. A. A. Marche, "Voyage au Gabon et sur le fleuve Ogooué," in *Le Tour du monde*, 2d semester 1878, p. 415.
9. A. R. de Liesville, *Coup d'oeil sur l'Exposition Historique de l'art ancien* (Paris, 1879), p. 95 ff.
10. For the development of the Musée d'Ethnographie collection, we are following the inventory.
11. Catalog of the Musée Africain (Paris, 1879).
12. G. Schweinfurth, "Au coeur de l'Afrique," in *Le Tour du monde*, 1st and 2d semesters 1874.
13. On the West African expedition, see C. Coquery-Vidrovitch, *Brazza et la prise de possession du Congo* (Paris, 1969).
14. E. Rivière, *Notice sur la mission de l'Ouest Africain* (Paris, 1886).
15. C. Coquery-Vidrovitch, op. cit., p. 16.
16. It is reproduced in Savorgnan de Brazza, "Voyages dans l'Ouest Africain," in *Le Tour du monde*, 2d semester 1888, p. 39.
17. *Vente après décès d'une curieuse collection d'objets des îles de l'Océanie* (Paris, March 4, 1887).
18. See L. Rousselet, *L'Exposition Universelle de 1889* (Paris, 1890), and *Revue de l'Exposition Universelle de 1889* (Paris, 1889).
19. *Colonies Françaises et pays de protectorat à l'Exposition Universelle*, quoted by M.-N. Verger, *Présentation des objets de Côte d'Ivoire dans les expositions universelles et coloniales*, report, University of Paris I, 1982, p. 7.
20. Pol-Neveux, "Le village sénégalais," in *Revue de l'Exposition Universelle*, p. 71.
21. G. Tomel, "Le trône de Béhanzin," in *Le Monde illustré*, February 10, 1894, p. 87.
22. M. Delafosse, "Statues des rois de Dahomé...," in *La Nature*, March 24 and April 21, 1894.
23. M. Delafosse, "Sur les traces probables...," in *L'Anthropologie* (Paris, 1900), vol. 11, pp. 431–51.
24. L. G. Binger, "Du Niger au golfe de Guinée," in *Le Tour du monde*, 1st and 2d semesters 1891, pp. 1–128 and 33–144.
25. G. Schweinfurth, *Artes Africanae* (Leipzig/London, 1875).
26. F. Ratzel, *Völkerkunde* (Leipzig, 1885–88).
27. L. Frobenius, *Die Masken und Geheimbünde* (Halle, 1898).
28. On the Museum für Völkerkunde of Berlin, see A. Rumpf and I. Tunis, *Afrika Abteilung* (Berlin, n.d.), and K. Krieger, *Westafrikanische Plastik* (vols. 1, 2, 3) and *Westafrikanische Masken* (Berlin, 1960–69).
29. A. Bastian, *die Deutsche Expedition an der Loango Küste* (Jena, 1874–75).
30. M. L. Bastin, "Quelques Oeuvres tshokwe. Une Perspective historique," in *Antologia di Belle Arti* (Rome, 1981), 17/20.
31. See P. J. C. Dark, "An Introduction to Its Discovery and Collection," in *Art of Benin* (Chicago, 1962).
32. W. Fagg, *Merveilles de l'art nigérien* (Paris, 1963), pp. 9, 10.
33. Quoted by J. Laude, *La Peinture française*, p. 176.
34. W. Kandinsky and F. Marc, *L'Almanach du Blaue Reiter*, Lankheit edition (Paris, 1981), p. 169.
35. This and the following three paragraphs have been added to the text with Mr. Paudrat's permission. They are based on the research of Jean Wagner.
36. R. Goldwater, "L'Expérience occidentale de l'art nègre," in *Colloque sur l'art nègre* (Paris, 1967), vol. 1, p. 351.
37. D. Fraser, "The Discovery of Primitive Art," in *Anthropology and Art* (New York, 1971), p. 28.
38. Quoted by F. C. Legrand, *Le Symbolisme en Belgique* (Brussels, 1971), p. 142.
39. E. Bassani, "Carrà e l'arte 'negra,'" in *Critica d'Arte*, no. 130, June 1973, p. 10.
40. Jacob Epstein, *An Autobiography* (London, 1963); quoted by A. Wilkinson, *Gauguin to Moore* (Toronto, 1981), p. 168.
41. M. Vlaminck, *Portrait avant Décès* (Paris, 1943), p. 105.
42. R. Goldwater, *Primitivism in Modern Art*, rev. ed. (New York, 1967), p. 102, note 4.
43. R. Goldwater, ibid., p. 87.
44. R. Goldwater, ibid., p. 102, note 4.
45. A. Level, *Souvenirs d'un collectionneur* (Paris, 1959), p. 59.
46. J. Laude, *La Peinture française*, p. 323.
47. F. Fénéon, *Au-delà de l'Impressionnisme* (Paris, 1966), p. 27.
48. F. Fénéon, *Oeuvres plus que complètes* (Geneva/Paris, 1970), p. xxvii.
49. P. Guillaume, "Une Esthétique nouvelle, l'art nègre," in *Les Arts à Paris*, no. 4, May 15, 1919, p. 1.
50. G. Habasque in the catalog *Les Soirées de Paris* (Paris, 1958), notice 37, and J. Laude, *La Peinture française*, p. 322.
51. A. Lhote, "Ce Monde féerique de la plastique pure," in the catalog *Les Arts africains* (Paris, 1955), p. 9.
52. M. Vlaminck, op. cit., p. 105.
53. Ibid., p. 106.
54. The second appeared in "Un Masque mère, Maurice de Vlaminck et l'histoire de l'art noir à Paris," *Encyclopédie de la France d'outre-mer* (Paris, June 1947), no. 6, p. 12.
55. J.-P. Crespelle, *Vlaminck, fauve de la peinture* (Paris, 1958), p. 135.
56. The interview with P. Courthion, partially quoted by C. Wentinck, *Modern and Primitive Art* (Oxford, 1978), p. 17, has not been published. I wish to thank Pierre Courthion for kindly allowing me to consult it.
57. A. Warnod, "Matisse est de retour," in *Arts*, no. 26, July 27, 1946.
58. E. Tériade, "Matisse Speaks," in *Art News Annual*, no. 21, 1952, retranslated from English in *Henri Matisse: Ecrits et propos sur l'art* (Paris, 1972).
59. J. Laude, *La Peinture française*, p. 112.
60. Ibid., p. 111.
61. G. Stein, *Autobiographie d'Alice Toklas* (Paris, 1934), p. 71.
62. M. Jacob, *Chronique des temps héroïques* (Paris, 1956), p. 71; M. Jacob, *Naissance du Cubisme et autres* (Paris, 1932), quoted by J.-C. Blachère, *Le Modèle nègre* (Dakar, 1981), p. 32; R. Dorgelès, *Bouquet de Bohème* (Paris, 1947), p. 137.
63. Quoted by J. Laude, *La Peinture française*, p. 111.
64. G. Stein, op. cit., p. 71.
65. A. Malraux, *La Tête d'obsidienne* (Paris, 1974), pp. 17 ff.
66. C. Zervos, *Pablo Picasso* (Paris, 1942), vol. II, p. xlvii.
67. "Matisse Speaks," in *Henri Matisse*, op. cit., p. 121.
68. D.-H. Kahnweiler, *Juan Gris* (Paris, 1946), p. 156.
69. A. Level, op. cit., p. 59.
70. Information kindly communicated by Pierre Schneider, art critic and authority on the work of Matisse.
71. Reproduced in J. Laude, *La Peinture française*, fig. 80.
72. Reproduced ibid., fig. 17.
73. Interview with Jos Hessel by C. Zervos, in *Feuilles volantes/Cahiers d'art*, fasc. 4/5 (Paris, 1927), p. 2.
74. Photograph kindly provided by Michel Kellermann to The Museum of Modern Art.
75. On Brummer, see I. Devenyi, "Brummer Jozsef," in *Muveszet*, January 1968, p. 16; S. Leonard, *Henri Rousseau and Max Weber* (New York, 1970); A. Basler, *Henri Rousseau* (Paris, 1927); and W. H. Forsyth, "The Brummer Brothers: An Instinct for the Beautiful," *Art News*, October 1974.
76. A. de La Beaumelle, "Max Weber," in *Paris/New York* (Paris, 1977), p. 728.
77. On Coady, see J. K. Zilczer, *The Aesthetic Struggle in America, 1913–1918* (Ann Arbor, 1975).
78. See inf.
79. See A. Basler, op. cit.
80. B. and E. Göpel, *Leben und Meinungen des Malers Hans Purrmann* (Wiesbaden, 1961), pp. 70–71, 133–34.
81. M. Décaudin, "Guillaume Apollinaire devant l'art nègre," *Présence africaine*, no. 8, 1948, pp. 137 ff.; M. Adéma and M. Décaudin, *Album Apollinaire* (Paris, 1971), p. 141.
82. V. J. Holman, "French Reactions to African Art, 1900/1910" (master's thesis, London, 1980).
83. A. Salmon, *Souvenirs sans fin (première époque)* (Paris, 1955), p. 333.
84. J.-C. Blachère, *La Modèle nègre*, p. 31.
85. Ibid.
86. On the diffusion of African arts in Bohemia, see E. Herold, *Africké Umeni v Ceskoslovensku* (Prague, 1983).
87. On the group and the magazine, see Z. Volavkova, "La Revue mensuelle des arts," in *L'Année 1913* (Paris, 1971), vol. 2, pp. 989 ff.
88. D. H. Kahnweiler, *My Galleries and Painters* (London, 1971), docs. 13 and 14.
89. See in Apollinaire, *Les Petites flâneries de l'art*, (Montpellier, 1980), note 2 on p. 164.
90. See V. B. Mirimanov, "L'Epoque de la découverte de l'art nègre en Russie," *Quaderni Poro*, no. 3, June–July 1981, pp. 59 ff.
91. On Carl Einstein, see L. Meffre, "Carl Einstein et la problématique des avant-gardes dans les arts plastiques" (Ph.D. dissertation, Paris, 1980).
92. I. Devenyi, op. cit., p. 16.
93. L. Eglington, "Untimely passing of P. Guillaume Evokes Memories," *The Art News* 33, 4 (October 27, 1934) pp. 1–4.
94. A. Basler, "Monsieur Paul Guillaume et sa collection de tableaux," *L'Amour de l'art*, July 1929.
95. Quoted by J. Laude, *La Peinture française*, p. 117.
96. A. Savinio, *Souvenirs* (Palermo, 1976), p. 265, note 11.
97. See F. M. Naumann, "How, When, and Why Modern Art Came to New York," *Arts Magazine*, April 1980, pp. 96 ff., and F. Demé, "L'Approche de l'art africain aux Etats Unis d'Amérique, 1914/1935" (Master's thesis, Paris, 1982).
98. Quoted by H. Seckel in the catalog *Paris/New York* (Paris: Centre National d'Art et de Culture Georges Pompidou, 1977), p. 228.
99. A graduate of Harvard University, Paul B. Haviland (1880–1950) was one of the most energetic associates of Stieglitz at "291" from 1908 to 1915, being active as a photographer; member and Secretary of the Photo-Secession; associate editor of *Camera Work*; co-author with Marius de Zayas of *A Study of the Modern Evolution of Plastic Expression*, published in 1913; and one of the founders of the magazine *291*. His younger brother, Frank Burty Haviland (1886–1971) used only his first two names as a painter; a one-man show of his paintings and drawings was held at "291" from April 6 to May 6, 1914. He was already collecting Primitive art before World War I—and assembled an important collection that was dis-

persed at auction in 1936.

100. See invoice to Stieglitz, preserved in archives of the Beinecke Library, at Yale University.
101. G. Apollinaire, "Arts d'Afrique," *Paris-Journal*, June 1, 1914.
102. E. Lejeune, "Montparnasse à l'époque héroïque," *La Tribune de Genève*, February 8–9, 1964.
103. J. Bouret, "Une Amitié esthétique au début du siècle: Apollinaire et Paul Guillaume (1911–1918) d'après une correspondance inédite," *Gazette des Beaux-Arts*, December 1970.
104. J. Bouret, op. cit., p. 390.
105. Quoted by M. Bonnet, *André Breton, Naissance de l'aventure surréaliste* (Paris, 1975), p. 116.
106. *Les Arts à Paris*, no. 2, July 15, 1918, p. 10.
107. A. Salmon, *La Jeune Sculpture française* (Paris, 1919), p. 94.

108. R. Allard, "Ménalisme [sic]," *Le Nouveau Spectateur*, May 25, 1919, pp. 22–28.
109. M. de Zayas, *African Negro Art: Its Influence on Modern Art* (New York, 1916), p. 12.
110. Thus, in "L'Art du Congo Belge" (*Art et décoration*, 1920), "La Leçon de Tervueren" (*Bulletin de la vie artistique*, 1921), "A.E.F. [French Equatorial Africa] Sculptures et objets d'usage" (*La Renaissance des arts français et des industries de luxe*, 1922), and "La Décoration des tribus du Congo Belge" (*L'Amour de l'art*, 1923).
111. Quoted by M.-N. Verger, op. cit., p. 25.
112. Letter from Paul Guillaume in the archives of the Musée des Arts Décoratifs.
113. Quoted by J. M. Dunoyer, in *Le Monde*, November 7–8, 1965.
114. P. Guillaume, "The Discovery and Appreciation

of Primitive Negro Sculpture," in *Les Arts à Paris*, no. 12, May 1926, p. 13.
115. See plates 7, 10, and 19 in *African Negro Wood Sculpture* (New York, 1918), photographed by Charles Sheeler, with a preface by Marius de Zayas.
116. On Moris, see R. Lehuard, "La Collection du Père Moris," *Arts d'Afrique noire*, no. 46, Summer 1983.
117. T. Tzara, *Oeuvres complètes* (Paris, 1976), vol. 4, p. 674, note 2.
118. Information kindly supplied by Raoul Lehuard.
119. J. Jamin, "Objets trouvés des paradis perdus," in *Collections Passion* (Neuchâtel, 1982), p. 93.
120. Interview with Georges-Henri Rivière in *Chefs d'oeuvres du Musée de l'Homme* (Paris, 1965), p. 15.
121. See S. M. Vogel, "The Buli Master, and Other Hands," *Art in America*, May 1980, pp. 133 ff.

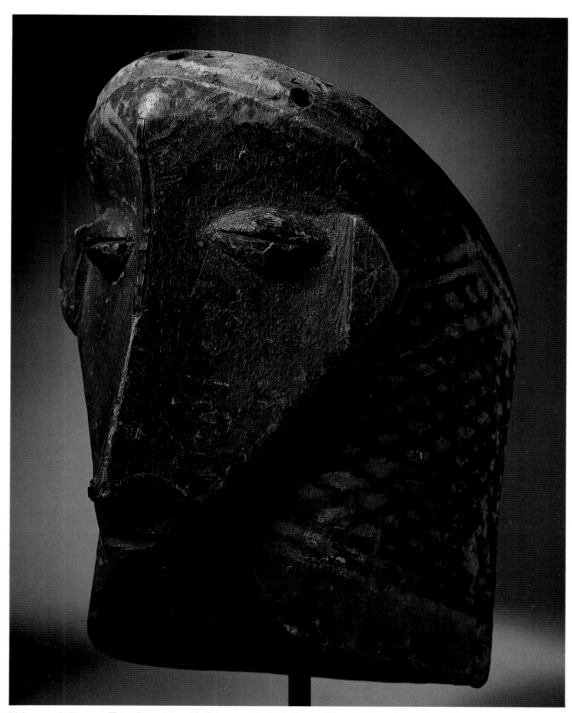

Helmet mask. Kasingo. Zaire. Painted wood, 15" (38.1 cm) high. Collection Mr. and Mrs. Kelley Rollings, Tucson

Paul Gauguin. Carved Door Frame from Gauguin's House in the Marquesas. c. 1899. Painted wood, left base: 15¾ x 60¼" (40 x 153 cm); left upright: 78¾ x 15⅝" (200 x 39.5 cm); lintel: 15⅜ x 95½" (39 x 242.5 cm); right upright: 62⅝ x 15¾" (159 x 40 cm); right base: 15¾ x 80¾" (40 x 205 cm). Left base, private collection; rest of door frame, Musée d'Orsay, Paris

PRIMITIVISM
IN MODERN ART

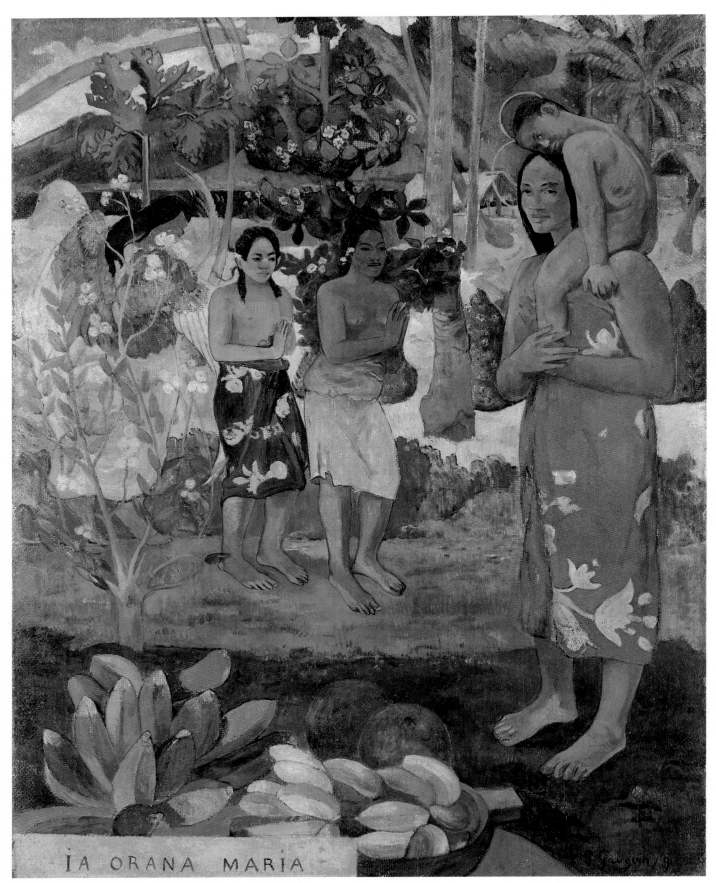

IA ORANA MARIA

Paul Gauguin. *We Hail Thee Mary.* 1891. Oil on canvas, 44¾ x 34½" (113.7 x 87.7 cm). The Metropolitan Museum of Art, New York; bequest of Sam Lewisohn

GAUGUIN

Kirk Varnedoe

aul Gauguin is the *primitif* of modernist primitivism, its original, seminal figure. Other artists before him may have known of the arts of Primitive societies, but Gauguin was the first to appreciate in such forms a significant, potentially transforming challenge to Western ways of depicting the world. In the compressed and oddly proportioned forms of folk art and exotic foreign objects he found not deficiency but independent, alternative force and creativity. This attitude, inverting the values of technique and progress that dominated Gauguin's century, guided his work and life.[1]

The facts of that life are the stuff of familiar legend. By nature incurably restless and dissatisfied, Gauguin was a loner, aware of his own mixed blood and dogged by nostalgia for happy childhood years on distant shores (his widowed mother raised him in Peru from the age of one to nine before returning to France in 1856). During the late 1880s, having quit a bourgeois career in finance and separated from his wife and children, Gauguin felt chafed again, by the limitations of the Impressionist world view and style that had first led him to the painter's life. As he reformed his painting, pushing toward more simplified drawing, flattened spatial effects, and bolder colors, he became increasingly ill at ease in urban society, at home only in rougher settings such as rural Brittany—where he could "live like a peasant" in crude clothes on slim means, and boast that he could "not be accused of enjoying life."[2] One attempt to leave France (in 1887) failed after grim toil in Panama and a brief idyll in Martinique. But in 1891 he made a decisive break, sailing away to live among "savages" in Tahiti (one of the Society Islands of Polynesia and a French protecto-

rate since 1843) to return only once to France (1893–95). In his last years he pushed still farther away, to the Marquesas Islands, where he died in 1903. In one of his last letters to a civilized world from which he was remote and alienated, he flailed out a characteristically bitter, defensive yet defiant self-estimation: "I am down, but not yet defeated. Is the Indian who smiles under torture defeated? No doubt about it, the savage is certainly better than we are. You were mistaken when you said I was wrong to say that I am a savage. For it is true: I am a savage. And civilized people suspect this, for in my works there is nothing so surprising and baffling as this 'savage-in-spite-of-myself' aspect. That is why it is so inimitable."[3]

In this temperamental antipathy to civilization, as well as in his attraction to non-Western arts, Gauguin might seem to be the indisputable precursor of the primitivism that became a central characteristic of twentieth-century creative life. But Gauguin's legend is a problematic one, and his contributions to modernist primitivism need redefining. Is there not pathetic overpleading in that final bravura? It does not take much looking to see that Gauguin's innovations in form and color actually depend more on advanced Western sources, such as Degas and Cézanne, than on any Primitive model. Even in his most "savage" visions, such as *Spirit of the Dead Watching* (p. 200), the sophistication of unusual color harmonies and the grace of line remain firmly linked to Western sensibilities of a distinctly unbarbaric kind. The ghosts of Manet and Ingres haunt this picture's composition more powerfully than do the hybrid exotic sources (part Egyptian, part Polynesian) from which the background figure seems to derive, just as the gentle arcadian spirit of Puvis de Chavannes is ever-present,

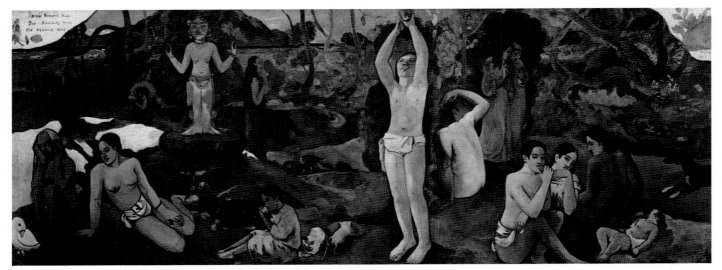

Paul Gauguin. *Where Do We Come From? Who Are We? Where Are We Going?* 1897. Oil on canvas, 54¾ x 147½" (139 x 374.6 cm). Museum of Fine Arts, Boston; Tompkins Collection, Arthur Gordon Tompkins Residuary Fund

fantasized (and non-Polynesian) idols notwithstanding, in Tahitian masterworks such as the murallike *Where Do We Come From? Who Are We? Where Are We Going?*

As for the exotic content of such works, it is not to be taken at face value. Patient separation of fact from deception has by now substantially tarnished the biographical legend, and has revealed how often the "primitive" in Gauguin's ideas and images was fabricated from sources in photo albums and guidebooks.[4] Measured against ideals of pure discovery or pure escape, Gauguin's primitivism must inevitably seem only a facade of half-truths.

There are better ways to assess the issue. At base, modern artistic primitivism is not so much a matter of new objects as of new ways of approaching them. It is above all an attitude. Gauguin's seminal importance lies in his ways of thinking and working, and most importantly it lies in his initiation of new routes of transaction between Primitive and modern creativity. Catalogs of external influences—pure or corrupt— on him, like fixed models of a "true" Primitive state he did or did not attain, do not get at the heart of the matter regarding Gauguin and primitivism. To understand and assess Gauguin's encounter with specific tribal arts and areas, we must first examine the general set of mind that made such encounters possible; and examine, too, the environment in which Gauguin's attitudes and actions were formed and took hold. In these more subtle areas lies a real primitivist structure, coherent and authentic in ways not generally recognized. Yet Gauguin's innovations, seen in this more complex, more accurate fashion, are again not purely original discoveries; they are closely linked to a much broader tradition of primitivism that both precedes and pervades the formation of Gauguin's aesthetic.

Primitivism in its basic form—the tendency to admire the virtues of early or less materially developed societies—has a long and diverse history within Western thought. Even in classical antiquity, Western literature contains laments for lost simplicity and praise for less-sophisticated societies.[5] In the sixteenth and seventeenth centuries, as exploration led to new contacts with unfamiliar races and societies, Europeans found

new fascination in human diversity, and a new awareness of the possible advantages of a life untouched by the conventions of European civilization. Beginning with Montaigne's satirical defense of cannibals in an essay of 1592, a whole tradition of thought and literature centered on the figure of the Noble Savage—an unspoiled being, innocent yet wise, sometimes ascetically hardened and in other versions gracefully sensual, whose purer virtues and simpler thoughts were held up as damning contrasts to the shallow and weakened artificiality of civilized Europe. This tradition became especially enriched in the eighteenth century as the philosophers of the Enlightenment formulated utopian visions of man's original happiness and goodness prior to civilization's restrictions and laced their arguments with optimistic references to the qualities found in the non-Western cultures European explorers were still discovering. Among the latest, but most famous, of these texts was Jean-Jacques Rousseau's *Discourse on the Origins of Inequality.* Rousseau indicted smug European beliefs in the value of progress and derided the benefits of organized society (on receiving a copy of the essay Voltaire responded, "Thanks for your letter against civilization"). Rousseau's praise for man's fuller life in an earlier, simpler state gave a newly cogent and emotional impetus to primitivist patterns of thought. It set the stage for a discovery, less than twenty years later, that seemed to confirm the dream of man's natural fulfillment prior to modern corruptions—the discovery of the island of Tahiti in 1767.

The accounts of Tahiti conveyed by its initial explorers offered (as we will see in greater detail further along) a vision of unblemished pleasure and natural happiness that seemed to many to undermine forever any claims for the superiority of modern European society. A primitivism fed by such "evidence," using a composite and often wholly fanciful Noble Savage as a device to critique Western mores, was a central aspect of advanced eighteenth-century thought in politics, philosophy, and religion. And while thinkers in these areas used an idea of Primitive man as a benchmark for assessing the bases of social structures, others scrutinized reports of newly discovered peoples for evidence concerning the biology and physiology of the human species. Not only the specific notion of the superiority of life outside civilization, but also these

general linkages between the study of foreign peoples and the analysis of man's essential nature, contributed to form a primitivist tradition that was one of the most characteristic and pervasive legacies of the intellectual ferment of the eighteenth century. The notion of Primitive art's virtues that motivated Gauguin had its roots in these patterns of thought, revitalized and evolving in his day. As progenitor of modern artistic primitivism, he is also inheritor of this larger tradition.

The inheritance is complex, beginning at its core with the very word "primitive." In French usage, the word has a large group of possible meanings, several of which would be important simultaneously for Gauguin. "Primitif" equally denotes, among other things: preliterate man; the idea of a beginning or original condition; and the irreducible foundation of a thing or experience. It thus may refer both to foreign peoples and to that which is most deeply innate within oneself. Such dual usage of the word, as a term for ranking societies and as a term of philosophy concerning human essences, made the concept of the *primitif* an especially charged part of the thought of Gauguin's time. As regards art in particular, in the late nineteenth century the label "primitive" had a broader application than is current today, designating early Renaissance art as readily as peasant crafts, Japanese prints as well as tribal artifacts; its connotations were more consonant with those of the terms "rustic" or "archaic" than would be the case today.[6] In the broadest sense, too, the term "primitive" as applied to other arts and cultures has never had a stable meaning, but has been intelligible only in relation to its changing opposites ("civilized," "modern," etc.). It has also characteristically been linked to other polarities that clarified its meaning and impact: heathen vs. Christian, natural vs. artificial, irrational vs. rational, etc., each in turn implying hierarchies of high and low, normative and aberrant, good and bad.[7] The popular image of Gauguin, even as inverter of these hierarchies, preserves such simplistic dualities: avant-garde artist against society, savage against civilization, and ultimately a man at odds within himself, struggling to assert a tougher, instinctually vital "native" persona over the weaknesses of his civilized sophistication. ("You must remember," he wrote his wife, "that there are two natures within me: the Indian [that is, the native American] and the sensitive. The sensitive has disappeared, which allows the Indian to proceed ahead straight and firmly.")[8]

Within the larger history of primitivist ideas, though, such dichotomies inevitably conceal more complex connections between their ostensibly opposite terms. Each civilization invents the "primitive" it needs, not just as an antithesis to its cultured sophistication, but also as a partial reflection of itself, compensating for or criticizing that civilization's doubts and ideals. Even as he robbed it, civilized man thought the Primitive world his cradle, often seeing strange new peoples as— for better and worse—unadulterated images of his essential, original self. The history of primitivism in European thought is marked in this way by a mixture of projected mythologies and collected evidence, and blends wishful invention with true discovery. It is a tradition not only of admiration for other societies, but of simultaneous and interwoven self-critique on the part of modern European society. The contrasts of Gauguin's legend—true savage and civilized artificer, avant-gardist and regressive, Indian and sensitive—are similarly not either/or choices, but paired terms. They embody tensions

that are characteristic not only of his own restless indecisiveness, but of the ambivalencies of fact and fiction, self-projection and self-critique, that had traditionally marked Western fascination with the Primitive world. Gauguin's primitivism, in a fashion consistent with this tradition, gains much of its energy not just by his flight from society, but also by projection of some of that society's central concerns, artistic and otherwise.

Nineteenth-century scientific and cultural thinkers typically believed that one should understand a thing—a person, a language, a civilization—in terms of its origins and organic growth. In the latter half of the century, the notion of "the primitive," in the sense of the original, beginning condition or form, preoccupied not only biologists but also social theorists, linguists, and psychologists (Darwin's *Origin of Species* is the prime, and most influential, example of such analysis). In France as elsewhere, all these various disciplines studied and compared the *"primitif,"* in prehistory, in childhood, and in tribal societies, as evidence for their arguments over man's limitations, potentials, and place in the natural order.

Paul Jamin. *An Abduction—The Stone Age*. 1889. Oil on canvas. Musée des Beaux-Arts, Reims

Gauguin's attitudes were shaped in this intellectual climate, and his appreciation of "primitive" creativity was part of a wave of transformation that affected these other studies as well. Especially relevant were the challenges, increasing at the end of the century, to biologically based notions of the "natural."[9]

Such established notions stemmed in large part from an evolutionary concept of man's essential and original animality —Darwinism itself, or variants of it. Extrapolating from and misapplying Darwin, an antiprimitivist pessimism, typified in Gauguin's day by Salon imagery of precivilized brutishness (e.g., Jamin's *An Abduction*), was ascendant in European thought in the 1860s and 1870s.[10] It rebutted with grim

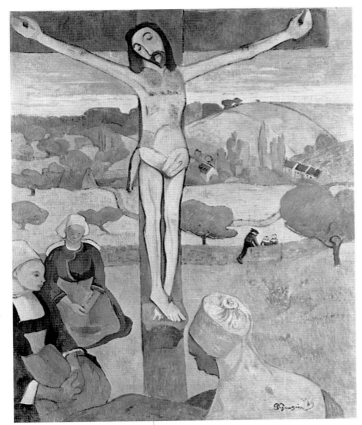

Paul Gauguin. *The Yellow Christ.* 1889. Oil on canvas, 36¼ x 28⅞" (92 x 73.3 cm). Albright-Knox Art Gallery, Buffalo

Paul Gauguin. *Breton Calvary.* 1889. Oil on canvas, 36¼ x 28¾" (92 x 73 cm). Musées Royaux des Beaux-Arts de Belgique, Brussels

"accuracy" all reveries of humanity's happy infancy in a Golden Age, supported racially determined hierarchies of culture, and buttressed concerns for man's latent animal barbarism (anxieties that were particularly current in France following the mob violence of the Commune uprising in 1871).[11]

Gauguin's idea of *sauvagerie* rejected this vision of man. It also ignored the directly opposite, optimistic ideals manifested in the 1890s by politically minded painters who dreamed that modern man could regain a utopian state of peaceful harmony with the natural order.[12] From the outset Gauguin's was a cultural primitivism concerned neither with a lost original state of nature nor with its possible future counterpart. He was instead attracted to places where the deep past seemed to survive in the present. The mystery that absorbed him resided in contemporary nonurban peoples whose lives, however free from modern artificiality, were nonetheless in the thrall of long-standing societal traditions. His initial attraction to the peasants of Brittany was not simply a nostalgia for agriculture, but a fascination with the arcane set of costumes, superstitions, and religious practices that made them seem atavistic foreigners in the midst of a modernizing France.[13] There, and later in Polynesia, such remnants of cultural determination, more than ideals of natural freedom, were what interested Gauguin.

This basic distinction, between longing for a state of nature and attraction to venerable cultural patterns, is often lost in the popular idea of all primitivism, including Gauguin's, as seeking a primal, empty innocence. Yet there is a crucial difference between retracing "natural," biological or animal roots of behavior (as in the Salon views of prehistory) and the

kind of interest in rustic custom and society Gauguin shows in such Breton images as *The Yellow Christ, Breton Calvary,* and *The Vision after the Sermon* (p.184). The former kind of regression searches for a given, original unity of man with the laws of organic nature, while the latter looks through folklore to the establishment of cultures that sets humanity apart. It is in this distinction that one can begin to see how Gauguin's primitivism, taking shape in the same period when he became increasingly dissatisfied with Impressionism, was part of an antinaturalist attitude—not just an aesthetic dispute with the imitation of nature's appearances, but also a broader rejection of biologically based or organicist thinking, a rejection characteristic of the avant-garde thought of his time.

Naturalist art honored the eye. It implicitly affirmed a faith in passive observation and in the evidence of the senses that had by the 1880s been the dogma of materialist science and philosophy for decades. Gauguin felt that Impressionism, by its apparent dependence on fugitive retinal sensations, was residually tied to the same aging principles. When Gauguin said the Impressionists worked "without freedom, retaining the bonds of verisimilitude," he was opposing a whole idea of the brain as slave to the senses. And when he criticized them for "searching around the eye and not in the mysterious center of thought," he divided organ from intellect in a way that pointed to a newly revived, alternative idea of the mind's innate, autonomous generative power.[14] This idea of mind before matter was central to a general rejection of biologically based views of man, but especially important for the possibility of a new attitude toward the Primitive. Each notion of the way art connected to experience—the waning "retinal"

idea as well as the emerging "mental" emphasis that Gauguin favored—correlated not only with larger ideas of the mind's workings, but also implicitly with evaluations, negative and positive, of the origins and progress of culture.

The naturalists' view of art as imitation, like the correlated concept of thought as received sensation, seemed to reduce representation to reflex. In this world view, all the representations humans made—including the signs of language and religion as well as those of pictorial depiction—were seen as essentially rooted in the mimicry of natural phenomena. When stated as an idea of the origins of culture, this concept gave a dim and unfavorable view of man's tentative beginnings and thereby all but precluded a primitivist admiration for earlier, less developed human productions. All human achievement was seen as having begun in inchoate oneness with nature, and as having historically grown, like a plant, through stages of steadily increasing organic complexity.

Late nineteenth-century thought increasingly rejected these assumptions underlying naturalism, and in doing so revalued the Primitive. As the new century approached, it was more and more broadly recognized that the ways human intelligence, society, and history worked were fundamentally un-"natural"—that is, operating under laws that had little to do with the way plants grew or reflexes twitched. Seeing and thinking, as newly conceived by certain branches of psychology, were held to depend less on perception and more on conception. The mind was newly portrayed not as the passive receptacle of received impressions from nature, but instead as an active, organizing agent that from the beginning imposed its order on the chaos of sensations.[15] Representation was thus seen more as an act than a response, one whose essence was construction rather than imitation. Correspondingly the origins of culture—language, religion, and art—were held to lie not in mimicry but in invention: in the primordial mind's expressive projection of sounds and forms that it then ordered into the elements of communication. In this fashion, the shift away from naturalist thinking opened the way to a new concept of the Primitive: not as the embodiment of man's former inadequacies and his bondage to nature, but as the bearer of his best potential, the essential spark of mind that definitively liberated him from the domain of beasts and plants.[16]

Gauguin was a man of scattered but goading intellectual ambitions, moving in circles that prided themselves on scientific, pseudoscientific, and philosophical rationales for a new art. He was more than aware of currents of change in the intellectual world at large, especially when they seemed to reinforce his preferences and desires. The primitivism he invested himself in need not be taken as an illustration, or even a reflection, of specific new theories; but it shares common origins, and notably parallel implications, with these wide-ranging and topical revisions in historical and scientific thought. The antinaturalist shift we have just discussed provided the environment from within which Gauguin enacted his invention. The manifesto of that innovation, fusing stylistic and conceptual transformations into a new artistic primitivism, is the 1889 canvas *The Vision after the Sermon (Jacob Wrestling with the Angel)* (p.184).

Just as Gauguin's initial Breton imagery had remained sty-listically indebted to Impressionism, so that imagery treated Breton character and culture thematically in a conventionally picturesque manner, as outgrowths of Brittany's distinctively severe and somber terrain. In the *Vision*, however, Gauguin joined a newly assertive sense of form—clearly more dependent on imagination than on the imitation of natural appearances—to a new, distinctly unearthly idea of the peasant subject. The drastically flattened vermilion landscape is a field of projection for the hallucination of pious women under the spell of a sermon. Gauguin wrote to van Gogh that this picture had a "rustic and superstitious" simplicity, and explained that it subsumed two worlds within it. The *Vision*, he said, juxtaposed a foreground world of the senses depicted naturally (*"les gens nature"*) to a landscape and struggle that "exists only in the imagination" of the women, literally supernatural (*"non nature"*), and disproportionately rendered. As the bluntly reduced design subsumed the visible and the visionary together, so the picture implicitly linked Gauguin's anti-naturalist, anti-Impressionist stylization to his perception of the transcendent intensity of the folk mind's inventions.[17]

While the *Vision* may seem at first sight a picture about religion, its basic subject, taken in the context of Gauguin's oeuvre, is clearly the Primitive mentality. This painting is the first clear announcement of Gauguin's belief in the kinship between the unsophisticated mind and the creativity of the modern artist. By joining caricatural formal simplification to the subject of folk imagination, the *Vision* did not indulge in mere mysticism, but revived a central primitivist tradition in an aggressively new and timely fashion. Ever since eighteenth-century philosophers such as Condillac and Rousseau associated simple lives with simplified thoughts, the study of less materially developed societies has been linked to the study of the mind. Primitive expressions have been thought to illuminate, in purer or more sharply defined form, the basic way the human mind works. In the Romantic legacy of Herder, this supposed linkage between "simpler" people and purified expression of mental fundamentals took the form of a specific veneration of folk culture as untutored artistry—evidence of innate, universal wellsprings of human creativity. This attitude recurred and evolved in such disparate artistic realms as Romantic "natural poetry" and Courbet's Realism (in his admiration for and borrowings from crude popular broadsides) until in Gauguin's day it became charged with a new importance for antinaturalist thought and art. In the late nineteenth century, the old Herder-like affection for simplicity's poetic value became reinforced with more scientific ideas of the significance and even innate superiority of simple forms of human expression. Progressive thinkers of the late nineteenth century increasingly rejected those evolutionary criteria of measurement that had automatically equated superiority with maximum complexity; for such thinkers, a new preference for the basic over the elaborate was a general point of faith. Moreover, as new scholarship has made convincingly clear, artists of Gauguin's generation found that their notions of the superior power of simplified forms—notions that were often tied to a belief in occult patterns of order behind the diversity of nature's appearances—were consonant with aspects of progressive psychological theory concerning the foundations of human experience. Psychology's view of the actively structuring mind looked on the rudimentary, non-imitative images made by children or untutored folk (includ-

ing even graffiti) as privileged keys to the basic structures of mental processes.[18] In this and other domains of the study of man, the *primitif*, in the sense of the earlier stage of development or the less complex form, was assigned a new, primary importance and worth.

The long-standing equation of simplicity with profundity, and of the uncivilized mind with purer creativity, was thus charged with fresh urgency for Gauguin's generation. New ideas from psychology merged with other currents, not only from the older primitivist tradition but also from a revived idealist philosophy and from occultism,[19] to feed broad-based dissatisfaction—generally with the values inherent in all biologically based and evolutionary ideas of human achievement, and specifically with the dominant ideals of elaborate mimesis in art. This intellectual shift provided the supporting and motivating context within which Gauguin, acting in his particular sphere of interest, also revived elements of long-standing tradition and gave them avant-garde inflections. He produced a hybrid construction that, in a charged climate ready to receive it, was pregnant with possibilities for a new artistic primitivism.

The formal simplifications and the theme of imaginative projection combine to make the *Vision* a manifesto of primitivism on all these conceptual and stylistic levels. Yet there is obviously nothing in what we would today call Primitive art, and nothing even in folk art, that could have provided a direct model for the picture. While Gauguin paid homage to the provincial art of Brittany (p. 182), he took only the most general stylistic encouragement from its rustic naiveté; and he mixed these admirations with a seemingly capricious attention to Oriental, South American, and early Western arts.[20] The *Vision* itself is a fusion of sources in Degas (the spatial overlay of the viewers and scene), popular *images d'Epinal* (the unmodeled and unmodulated hues), and Japanese prints (the branch, the wrestling group, and the overall compressed graphic power)—all catalyzed by the cloisonist style then being experimented with by Gauguin's companion, the younger painter Emile Bernard.[21]

This tendency to blend together diverse and disparate sources was not just a beginner's uncertainty. If anything, the tendency became even more marked as Gauguin's work matured. Such eclecticism was at the heart, in fact, of Gauguin's primitivism. He is a model of impurity, on at least two levels. First he received no simple "shock of the new" when he encountered Primitive objects, nor did he appreciate them primarily in terms of form. Instead he perceived these

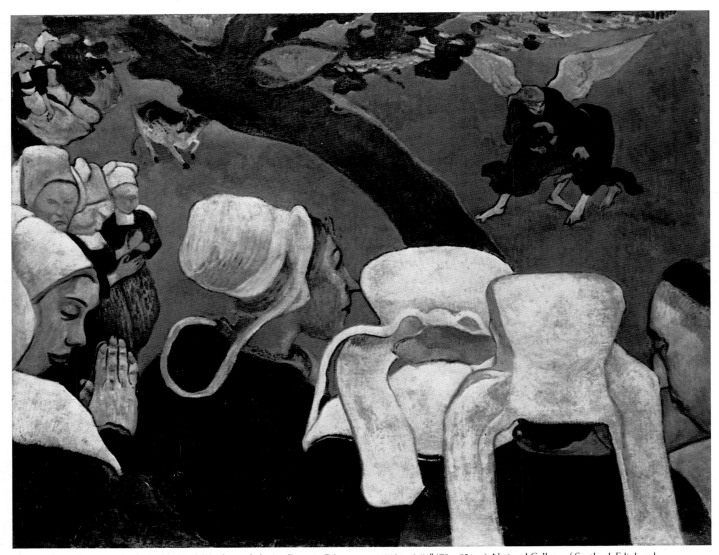

Paul Gauguin. *The Vision after the Sermon (Jacob Wrestling with the Angel)*. 1889. Oil on canvas, 28¾ x 36¼" (73 x 92 cm). National Gallery of Scotland, Edinburgh

objects and their styles from the outset with a set of presuppositions, desires, and expectations that had to do with the larger issues of mind and history we have been discussing. Second, when he did make use of Primitive objects he encountered, he did so by assimilating them into an unorthodox grab-bag of Western and non-Western stylistic associations. In both these respects he foreshadowed in varying degrees central characteristics of much twentieth-century artistic primitivism.

Gauguin's absorption of Japanese art, so evident in the *Vision*, typifies both the motivating preconceptions and the stylistic associations that shaped his primitivism. Gauguin saw Japanese art both as "primitive" and as linked to Western art, in an idiosyncratic and stimulating way. In his day, the art of Japan was generally thought of as "primitive" (despite some Western awareness of the complexities of Japan's society) because its elimination of shadows, modeling, and perspective seemed related to childlike perception and the drawings of the untutored.[22] But Gauguin extended its Western connections in a more radical way. He later described a little album in which he had purposefully assembled Japanese prints in a group with "low" comic art (caricatures by Daumier and Forain) and early Renaissance painting (reproductions of work from the school of Giotto). He recognized that all these things "appear to be so different", and he thus felt it important "to show that they are related." He praised the way Japanese draftsmen took shortcuts in depiction, and asserted that Hokusai rendered figures just as effectively as Raphael, but with "much simpler means." He then joined this appreciation for foreign abilities with a simultaneous call for serious attention to Western caricaturists as high artists; and also with an insistence on the superior power of those aspects of Giotto's style that others had traditionally seen as Giotto's "errors" of perspective and rendering. He attributed the Japanese accomplishments, and their kinship with these disparate Western arts, to "primeval qualities" of "honesty": "Drawing honestly," he explained, "does not mean affirming a thing which is true in nature, but instead using pictorial idioms which do not disguise one's thought."[23] The various styles of simplification—outside the dominant Western tradition (Hokusai), on lower levels within it (Daumier), and in the work of one of its founding fathers (Giotto)—were thus brought together by Gauguin as diverse evidences pointing to a single suppressed truth about the basic simplifying action of the mind in organizing vision into art. To subvert naturalism's reign, Gauguin formed an alliance of the outsider, the court jester, and the precursor, under the common device of simplification as the sign of innate, uncorrupted mental law.

Gauguin's little album of prints and reproductions reaffirms what we saw in *The Vision after the Sermon*: that an idea of the *primitif* within men—the basic structures of thought underlying representation—informed and helped justify his valuation of the Primitives among men. Both the album and the painting also suggest how a new attitude toward simplified foreign styles simultaneously encouraged Gauguin's destruction and inversion of hierarchies within his own tradition. In both cases, the linkages between notions of thought and appreciations of style, and between local and exotic stylistic models, make any simple idea of "influence" on Gauguin—in the sense of an external source offering him wholly new, unencumbered formal lessons—seem inadequate. It is not any

particular "influence" of foreign sources on Gauguin's style, but instead his more complex ways of thinking, that link him to the larger tradition of primitivism, and help to redefine his exemplary importance for some of the most potent aspects of twentieth-century art.

Primitivism in general derives its energies from differences and their cancellation. It creates a charged division by recognizing the significance of that which is distinctly *other*: the epoch, culture, or psyche perceived as challengingly different from—rather than merely inferior to—our own. Then, in a creative violation that ignores the dictates of history, class, and race, it provokes intercourse across that division, by intuiting points of affinity. Gauguin's "eclecticism" manifests this pattern. He demonstrates not only the creative transgressions of the primitivist artist's high-handed assimilation of non-Western styles, but also the key way in which a new valuation of "outsider" art inevitably provokes—and is in turn fostered by—an equally potent reassessment of hierarchies within our own traditions. Daumier meets Giotto in Japan. It is in this sense that Gauguin's artistic primitivism, as well as the modern lineage that flows from it, restates the legacy of primitivist thought we initially outlined: part discovery, part invention, part projection of a new idea of us into an external image of "them" for purposes of self-critique and internal reformation.

But conception is one thing and full realization another. The principles we have outlined here were formed by the end of Gauguin's Brittany period and reconfirmed throughout Gauguin's writings; yet ultimately their impact within his art was compromised. As a precursor, he confronted a potentially radical idea of the Primitive. But as a man of the late nineteenth century, he found it more often an occasion for introspective doubt than—as in the exceptional case of the *Vision*—a pretext for truly decisive change. Gauguin thus became a model of impurity in further, less fertile ways as well. His life and art are shot through with ambivalence, and an aura of shadowy ambiguity surrounds his preferred forms of Primitive beauty.

Gauguin's interest in the primacy of mind, for example, never won out over his equally powerful attraction to the "primitive" body. In the South Seas, where indolence shed the tinge of immoral sloth it had in Catholic Brittany, he was newly seduced by animality, as a dream of carnal indifference to civilization's shame and guilt. "Be in love, you will be happy" was the motto he carved beside the entrance to his house on the Marquesan island of Hiva Oa (pp. 176, 177). Many of the Polynesian images express little more than this pungent, if enervated, eroticism.

The indecision between mental and corporeal concepts of the Primitive recurs on other levels as well. Gauguin was ambivalent not only about *what* his works should communicate, but also about *how* they should do it. On the one hand, he wanted to address the intellect, and constructed a complex symbolism based on what he called "Maori mythology." On the other, he wanted the form and color of these works to affect their viewers "naturally"—with the unmediated sensual impact of music. For much of twentieth-century taste, this irresolution between what he called "literary" and "musical" aspects has seemed one of the artist's most damaging weaknesses.

Even on a purely formal level, the later Breton pictures and

the Polynesian pictures retreat from the single-minded bluntness essayed in the *Vision*. For all his ongoing talk of synthesis and simplicity, Gauguin's dominant visual idea of the Primitive came to be exotically heterogeneous and often disjointed. After 1891, his line and volume seem more truly indebted to Botticelli's elegance than to Hokusai's shorthand or Giotto's massiveness. Far from being constructed with the crude hues of popular broadsides, his mature works are duskily woven with oddly refined, even perverse color combinations. Gravely monotonous subcurrents of dark ochers, pinks, and purples are spiked by notes of lavish complementary astringency. Similarly, passages of absolute flatness recur only within a general fabric of unpredictably layered depth. The overall *non finito* of the later work finally communicates not a rough spontaneity, but a sophisticated decorative diversity. Delacroix, more than Daumier, seems to win the day.

These complexities are rooted in Gauguin's basic ambivalences about the nature of the "primitive" self he sought to realize in his art. When he looked inward, he found that his antipathy to bourgeois taste led him in contradictory directions: Admirer of the simple artisan, he nonetheless felt that all great art had been produced under mighty rulers, and recognized in himself a nostalgia for aristocracy (which may in part explain the dominant pattern of attraction, in his borrowings from non-Western sources, to the arts of court rather than tribal cultures). And though he recognized that his inner nature was divided between an "Indian" side and a "sensitive" side, he was apparently less aware of the confusion in his mind between Indian and cowboy as models of uncorrupted courage. Thus, while he practiced with bow and arrow on Brittany's beaches after seeing the Indians in Buffalo Bill's Paris show of 1889, he arrived in Tahiti wearing a cowboy hat over shoulder-length hair, in the image of the scout himself. At its earliest origin, the same kind of contradiction appears in Gauguin's shifting references to his South American ancestry. Though his pottery looked for inspiration to the high court cultures of ancient South America, he thought the ceramics he made confirmed him as a "savage from Peru"; and he referred to his ancestry in contradictory ways, sometimes linking himself to the Incas and sometimes to the Spanish colonizers, alternately identifying with the lost civilization and with the conquering grandee.[24]

His departure for Tahiti can appropriately be judged in very contradictory ways, each partially true to his personality. On the one hand, the trip was one of craven exploitation, to be seen as part of the unprecedented European imperialism that dominated his time. Gauguin's "flight from civilization" paralleled the explosion of French colonialism in certain obvious respects: Tahiti had just been transformed from a protectorate into a colony in 1881, and other destinations he considered (Tonkin, Madagascar) were even more topical points of French adventurism. His motivations for emigrating may also have had deeper connections with the imperialist spirit. Colonialism had promoted a taste for exotica in the Parisian literary and art-buying public, and Gauguin was certainly as aware of this as of the familiar colonist's privileges of more abundant "resources" (his own word) and cheaper overhead. Even on the level of psychic economy, his characteristic talk of the replenishment (e.g., "nourishing milk") and reinvigoration he sought in Primitive lands far from Western rottenness suggestively echoes official French rhetoric on colonization as

Paul Gauguin. *Self-Portrait, Jug.* 1889. Stoneware with transparent glaze, 7⅝ x 7" (19.3 x 18 cm). Museum of Decorative Art, Copenhagen

Stirrup-spout bottle. Moche. Peru. Ceramic, 12⅝" (32 cm) high. The Metropolitan Museum of Art, New York; gift of Nathan Cummings

the key to restoring national vitality and avoiding decadence.[25] Such contemporary inducements, added to the long-standing myth of Tahiti as the ultimate locus of sensual fulfillment and escape from care, undoubtedly conditioned Gauguin's idea that the island would be a colonist's paradise and a boon to his art. There is undeniably some justice in Pissarro's objection that Gauguin "is always poaching on someone's land; nowadays, he's pillaging the savages of Oceania."[26]

While such a critique tells the story, it misses the point.

Gauguin went to the South Seas not so much to "pillage the savages" as—in basic and quite literal senses he appears genuinely to have believed—to find himself. Consistent with a long-standing strain of Romantic primitivist thought, Gauguin saw the strength and wholeness of primal life not only as the privilege of simpler folk and foreign societies but as a birthright recoverable from within himself.[27] He was haughty, antisocial, and—though obviously already ego-directed to the point of recklessness—goaded by the belief that his true inner nature was being suffocated by circumstance, only awaiting release from bad surroundings and contrary impositions to shine forth. The decision to go to Tahiti thus restated on a deeper level the interchange Gauguin's primitivism initially proposed in stylistic terms, between external and internal discovery.

Gauguin identified primitivism with self-realization, not just because he thought Primitive peoples created or coupled in ways he envied, but on still more basic levels: because he believed that a move beyond or behind Western traditions of art-making and ways of living would lead him reflexively back into his own psyche; and that the proper outer simplification of his art and life would resolve inner confusions, literally to give form to his most basic identity. In his pre-Tahitian ceramics, for example, the "savage" quality emerges not so much from any specific borrowings of shape or glaze (though the South American and Oriental influences are clear) as from his psychic involvement in the physical processes. He shunned the facility of the potter's wheel and preserved the natural red of baked earth, because he felt that by making the material more resistant and by letting its innate life become expressive in the fire's test, the resultant object—troubled physiognomy and fervent hues—would best echo himself.[28]

His initial primitivizing expressed this instinctive attraction to an elemental, solid, and resisting simplicity he could both push against and identify with. Writing of his love for the "savage, primitive" quality of Brittany, he said, "When my wooden shoes echo against this granite ground, I hear the dull, muted, powerful sound I am looking for in painting."[29] In his thoughts of Polynesia, however, a less obdurate ideal of simplicity appeared: one of merger rather than resistance, of embrace by a softly nurturing environment. The characteristic Western idea of Primitive peoples as permanent children became internalized in fantasies of infantile regression. On the eve of the artist's departure his friend Octave Mirbeau wrote that Gauguin was motivated by "a nostalgia for those countries where his first dreams fell from the vine" and by a desire to return to "the things he left of himself out there." This was more than a casual confusion between the South Seas and the South America of the artist's childhood. Tahiti was to be a place where "nature is better adapted to his dream, where he hopes that the Pacific Ocean will have more tender caresses for him, with the old and certain love of a rediscovered ancestor."[30] The voyage out was a voyage in, and back.

Gauguin told a journalist that he was leaving France to make "simple, very simple art... to immerse myself in virgin nature, see no one but savages, live their life, with no other thought in mind but to render, the way a child would, the concepts formed in my brain, and to do this with nothing but the primitive means of art, the only means that are good and true."[31] The irony is that his destination was not a simple place, and no simple means could express it. The changes in

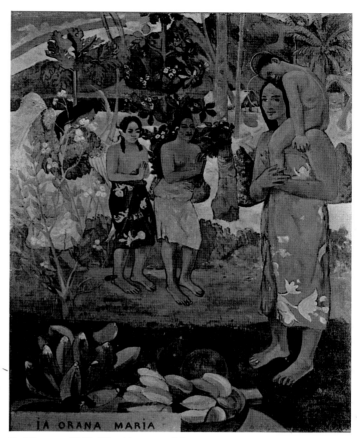

Paul Gauguin. *We Hail Thee Mary.* 1891. Oil on canvas, 44¾ x 34½" (113.7 x 87.7 cm). The Metropolitan Museum of Art, New York; bequest of Sam Lewisohn. For color reproduction see page 178

Relief (detail): The meeting with an Ajīvaka-monk, Borobudur, Java

Gauguin's art, like the inconsistencies and anomalies for which his primitivism is often criticized, must be seen in the light of Polynesia's meaning—not just as a personal fantasy, but as a multileveled reality. Tahiti represents the basic certainties Gauguin continually sought, and the irreducible ambiguities he inevitably confronted. In the island as in the Primitive in general, Gauguin found the mirror image not of the simple man he wanted to be, but of the complex, troubled, and questioning one he was.

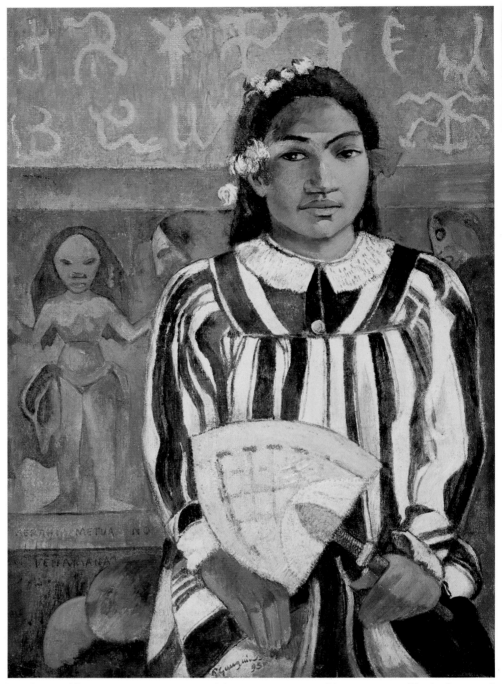

Paul Gauguin. *Tehamana Has Many Parents.* 1893. Oil on canvas, 30⅛ x 21⅜" (76.3 x 54.3 cm). The Art Institute of Chicago; anonymous gift

During the brief history of its contact with the West, Tahiti had become a powerful myth, layered over with contradictory associations. When it was discovered in 1767, it seemed to fulfill age-old dreams of "fortunate isles" beyond the horizon. This was an especially epochal event for a generation raised on the literature of the Noble Savage and newly sparked by Rousseau's praise of natural simplicity. The formerly admired tribesmen of North America had become tainted in the European mind by stories of hostile violence; and the Tahitians—"soft" Primitives of carefree tropical ease rather than "hard" Primitives of colder climates and warrior habits— were far better suited to fulfill eighteenth-century ideals of sensibility and sensual grace. Skimming over intimations of

darker traits such as cannibalism and infanticide, eager Europeans seized on reports that echoed the delight of the French discoverer, Antoine-Louis de Bougainville. He wrote in his shipboard journal:

Nature has placed it [Tahiti] in the most beautiful climate in the Universe, embellished with the most joyous aspects, enriched with all her gifts, covered with inhabitants that are handsome, tall, and strong. She herself has given them their laws. They follow these laws in peace, and form perhaps the happiest society that exists on the globe. Legislators and philosophers, come here and see, fully established, that which your imagination has not even been able to dream of....These people breathe only repose and the pleasures of the senses. Venus is the goddess one feels ever-present. The softness of

Inscribed tablet. Easter Island. Wood, 3½" (9 cm) high. National Museum of Natural History, Smithsonian Institution, Washington, D.C.

the climate, the beauty of the landscape, the fertility of the soil everywhere bathed by rivers and cascades, the purity of the air,...everything inspires voluptuousness. Thus did I name the place New Cythera [*La Nouvelle Cythère*, after the mythical erotic isle of Venus' birth], and the restraining protection of Minerva is just as necessary here as on that ancient isle, to defend oneself against the tempting influence of the climate and the mores of this society.[32]

Tahiti became instantly and enduringly synonymous with fantasies of sensual fulfillment; while philosophically—in such texts as Diderot's *Supplement to the Voyage of Bougainville*, which damned the Europeans for even touching the island and promulgated a mythical vision of the preternaturally wise, beautiful, and virtuously liberated Tahitians—Tahiti became a primary piece of evidence against civilization. The dream of this island became a fixture of the European imagination, as the epitome of simple sunlit happiness, and as the indictment of the artificiality of modern society's oppressive cares and conventions.[33]

Yet, like other symbols of a life of sensual indulgence, the island also quickly took on *vanitas* associations and was from the beginning evoked by poets and artists as a "tainted paradise" whose rewards, "physical, fitful, and transient," signified the ephemerality of earthly pleasures.[34] To this moral shading were soon added the concrete miseries of a swiftly increasing European presence: disease, depopulation, and cultural collapse. In less than a generation little remained of the society Bougainville had praised; and by the mid-nineteenth century Tahiti was notorious among all the South Seas islands as the one most wretchedly debased by "civilization."[35] With the rise of evolutionary speculation and newly systematized interest in early cultures, Tahiti became not so much the philosopher's delight as the scientist's despair: an enigma, standing as a ruined, barely legible page from a lost chapter of human history. On all these levels, Tahiti evoked remorse, and shadowy mystery.

So it echoed through the nineteenth century, the contradictions only intensifying with time. For a character in Balzac's *The Wild Ass's Skin*, a Tahitian girl's loincloth in a curio shop could transport the mind to a land of "genuine purity, the delights of innocence, so natural to man." But in Melville we find scourging critiques of the degradation of the Tahitians by missionaries; and in Henry Adams profound depression on

viewing the listless, alchoholic natives and melancholy atmosphere of decay in the capital, Papeete—only months before Gauguin's arrival. It bore, Adams said, "an expression of lost beatitude quite symbolic of paradise."[36]

The emblem of paradise, and of paradise lost, object simultaneously of longing and lament—by the 1890s Tahiti had become all this and more: still a central but now more deeply ambivalent piece of evidence for fundamental questions regarding man's origins and the mixture of progress and loss in his history. Those who have argued that Gauguin's vision was little influenced by Polynesia, and tells us little of worth about it, have not fully considered these complex aspects of Tahiti's reality, nor understood how Gauguin intended to do justice to them.

Gauguin's South Seas pictures do not conform to typical preconceptions of tropical paradises or simple Primitive art. From a very early Tahitian canvas such as *We Hail Thee Mary* (p. 178), the dominant contradictory impressions are already set: fruitlike hues of vibrant intensity combine to yield not joyous sunshine but a muted air of slightly suffocating and sad luxury; and finely delineated poses of high archaic elegance produce a ponderous rhythm of suspended narrative. It is, moreover, not difficult to recognize that many of the components of this vision derive neither from observation nor native art, but from scattered borrowings from the East and West (the archaic elegance of the background poses, for example, reflects a similar quality in their source, the reliefs of the Javanese Buddhist temple of Borobudur, p. 187). It would be quite another step, and a false one, to then conclude that these marks of stately order, of refinement and foreign style, indicate Gauguin's distance from a true response to Tahiti. On the contrary, they suggest the scope of his ambitions to respond: not just to his experience of the island in the 1890s, nor only to the allure and falsehoods of Tahiti's myths since 1767, but also to the larger questions of the Tahitians' role in human history. Rather than a stripping away toward some essential truth, his Tahitian primitivism emerged as a composite elaboration of this layered richness.

The portrait of his fourteen-year-old native mistress, Tehamana, for example, is built outward from intimate personal experience through the overlay of colonial history toward an enigmatic past. Modeled in earthen hue but cov-

ered in Western artifice (the tentlike garb that was a missionary legacy), she sits before a muted field of fantasized, vaguely Hindu figures and scrupulously copied pictograms—enormously enlarged characters from the Easter Island Rongorongo writing (p. 189) that has never been deciphered or successfully linked to any other script.[37] Child of pliant and available sensuality surrounded by signs of ancient, impenetrable intellectual mystery, she is Polynesia personified. The title, *Tehamana Has Many Parents*, refers both to this girl's multiple godparents (an anecdote Gauguin recounted in his writings) and by extension to the complex origins of her race. It typifies the way Gauguin extrapolated from his own experience of Tahiti metaphors for the larger questions inherent in this island and its people.[38]

Gauguin's larger vision of Polynesia was, like this picture, based on varying parts of experience, research, and speculation. The blurring of these levels is reflected in visual terms by the mingling and often disjointed juxtaposition of diverse styles and artistically alien motifs. This tendency toward the polyglot is emblematic of Gauguin's unwillingness and/or inability to settle for a simple and synthetic vision of Polynesia; and testifies to his ambitions to overlay upon his sensations of the Tahitian experience a diverse embroidery of

associations that would evoke the mysteries he intuited in Tahiti's past. Other visitors had remarked on the heavy-limbed stillness of the Tahitians, but found there only enervation, melancholy, or—as in the Pierre Loti novel of Tahiti Gauguin read before leaving France—a picturesquely mournful voluptuousness.[39] Yet for Gauguin the experience of the same passivity stirred thoughts of high art and lost grandeur. He wrote of the islanders: "Animal figures rigid as statues—something indescribably ancient, august, religious in the rhythm of their gestures, in their extraordinary immobility. In the dreaming eyes, the blurred surface of some unfathomable enigma."[40] These intimations of an unknown past woven into the present were what he set his art to capture.

The archaizing grace and slow rhythms of Gauguin's later style have been attributed to his Western, even Pre-Raphaelite sensibility, with no real connection to Tahiti.[41] But they also represent his attempt to evoke this echo of the immemorial in the native stillness, and his desire to associate this people with other, grander cultures. For example, at the Universal Exposition of 1889 Gauguin had been fascinated by the rigid mimes of Javanese dancers and their monotonously clanging gamelan accompaniment; others, sharing his interest, described the deep melancholy of lost glories the performances evoked, and

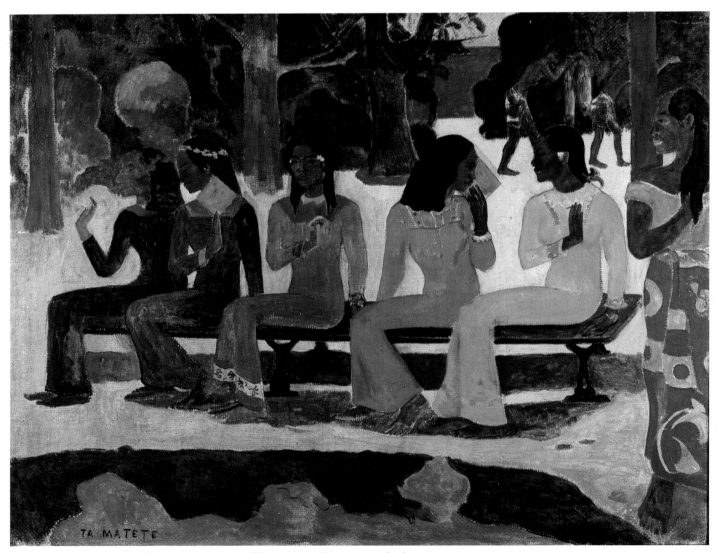

Paul Gauguin. *Market Day*. 1892. Oil on canvas, 28¾ x 36⅛" (73 x 91.5 cm). Kunstmuseum, Basel

compared the dancers to statues from the ancient Javanese temple of Borobudur.[42] Gauguin phrased his Tahitian pictures in these same musical terms, for parallel effect—by borrowing specific poses from Borobudur (e.g., p. 187) and by employing a generally static choreography of gestures and an unusual palette of repetitive colliding hues. Responding to a critique of monotony in these color contrasts, he wrote that the effect was often deliberate: "These repetitions of tones, of monotonous harmonies, in the musical sense of color—haven't they an analogy with those singsong Oriental chants in a shrill, twanging voice which accompanies the vibrant hues heard alongside them and enriches them by contrast?"[43]

Gauguin's recasting of Polynesians as Javanese, part poetic license used to express his experience of Tahiti's ancient rhythm, may also have reflected musings about the Tahitian past that would have had the sanction of ethnological theory. As recent scholarship has reminded us, Malaysia and particularly Java were frequent foci for theories of the origin of the South Sea island races. In such a context Gauguin's frequent use of Borobudur poses might not have been an arbitrary grafting, but an interpretive device motivated by a hypothetical reconstruction of lost history.[44] The same principle could be extended to a reconsideration of the ways Gauguin used Western art from photo albums as the basis for Tahitian scenes and mixed together local and foreign symbols.

Gauguin saw the Tahitians both as childlike and as immemorial, as remarkably simple and direct beings who nonetheless carried themselves with a mysterious grace that suggested innate aristocracy. For such a people, he felt complex pictorial constructions were appropriate. In those ambitions, he was moreover supported by a quasi-anthropological tradition. The obviously graceful and even courtly nature of Tahitian society had been one of the most striking aspects of the initial discoverers' reports. In conjunction with the isolation of the island and the absence of any record of their past, this culture provoked a debate that still continues. Long before Thor Heyerdahl's experimental voyages, and well before Gauguin's arrival, the language and customs of the islanders had been examined for correspondences that might link them to various continents and cultures—one notion even held the Polynesians to be a lost tribe of Israel.[45]

Gauguin's interest in such cultural syncretism—in the conjectural linking of the Tahitians to the traditions of other peoples—is obvious in his mixing of Maori mythology with symbols from Christianity and Buddhism. The early *We Hail Thee Mary* (p. 178) may only echo the cliché that simpler natives were truer Christians. But later, more ambitious splicings of foreign religious motifs with native figures leave no doubt that Gauguin connected the Polynesians not just with innocence but with ancient wisdom, in the spirit of theosophy.[46] His theosophical readings (evident from his written remarks) explained parallelisms in the world's great religions as signs of a lost unity of occult knowledge. When he studied the all-but-defunct Maori religion, its stories of genesis and its debate between male and female principles struck familiar chords that incited him to essay cross-cultural linkages with other religious systems.[47] In this context, the archaic stylistic inflections of Gauguin's South Seas style—an archaism recalling the art of ancient civilizations such as Persia and Egypt—may seem less idiosyncratic. The Egyptian air of a Tahitian genre scene, *Market Day*, based on an Eighteenth Dynasty

Paul Gauguin. *Studies of Maori Ornaments*. 1895–97(?). Pencil and india ink, 7⅞ x 5⅞" (20 x 15 cm). Private collection

tomb painting of which Gauguin owned a photograph, might in this fashion follow from Gauguin's association—in the manner of an Atlantis-type myth—of the Tahitian past with the great ancient societies.

This particular vision of the South Seas mystery affected not only what Gauguin imported from other cultures, but what he selected from Polynesian art. It has long been noted that he took little from this source, and similarly argued that these borrowings were of little consequence.[48] He apparently had no contact with or knowledge of Oceanic art before his departure from France in 1891. One photograph of objects purportedly from his collection did include two small tribal figures (p. 208), but these were African, and the date of their acquisition is uncertain.[49] Gauguin would have acquired them in Paris, either before 1891 or more likely during his return in 1893–95; either date would confirm the fact that he collected tribal art before the Fauve painters did. These figures had no demonstrable impact on his art, however, and nothing suggests he made any similar outreach toward Polynesian objects in Paris. Some Polynesian sculptures and objects were available to him in the Trocadéro museum of ethnology, but he apparently never saw them.[50] In any event he would certainly not have gone to Tahiti primarily for inspiration from its arts, which were few. Moreover, what he actually encountered of Oceanic art was almost never "live," but dependent on photographs, museums (Auckland and Noumea, on his voyages), and his discoveries in the haphazard curio collections and

Above: Paul Gauguin. *Study of a Tiki*. 1895–97(?). Pencil and india ink, 7⅞ x 5⅞" (20 x 15 cm). Private collection

Left: Figure. Oipuna, Puamau Valley, Hiva Oa, Marquesas Islands. Stone, 8' 6" (259 cm) high

shops of Tahiti.[51] One of the few drawings connected to Polynesian art *in situ*—a sketch of a stone figure on the island of Hiva Oa in the Marquesas—may also have been drawn from a photograph, before Gauguin saw the actual object.[52] All this seems to add up to a relatively desultory and piecemeal pattern of contact with the art of Oceanic tribal societies. Yet from these various contacts emerges a consistent, selective stylistic focus: a preference for Marquesan art that is tellingly appropriate to Gauguin's intentions.

Gauguin's primitivizing style lacks expressive violence and deformation, but not only out of mere timidity or misunderstanding in his encounter with Oceanic art. To anchor his hybrid vision of Polynesia he looked to other aspects of the South Seas art he knew. In concentrating on Marquesan ornament he chose an aesthetic he recognized as exceptional,[53] bearing dual associations of aristocracy and barbarism. This island's designs show a rich geometric and representational complexity governed by strict order, very different in feeling from the organic congestion and expressiveness of other South Seas arts, such as those of New Zealand or Papua New Guinea. Furthermore, the celebrated Marquesan tattoos (p. 198) Gauguin admired and copied had long been described as the mark of an aristocratic caste, and at the same time associated, like the similarly patterned human bone ornaments, with these islanders' reputation for special ferocity and cannibalism.[54] These designs, like those of the Marquesan war clubs (p. 198) he also copied, were refined in a way that satisfied Gauguin's sense of a grander order in Polynesia's cultural past. But, stemming from the islands that had been most ferocious and that had remained most resistant to the inroads of Western civilization, they evoked as well the dark side of the South Seas, the history of human sacrifice and bloody cruelty, that lent a savor of barbaric danger to the natives' grace, and augmented their mystery.

Gauguin wanted his art to convey the sensation of what he called *"un certain luxe barbare d'autrefois"*—a combination of splendor and savagery, luster and lurking shadows in the Polynesian heritage. His letters are full of indications, if proof were needed, that the clashing complementaries in his color schemes were intended to convey a musical mingling of violence, religious gravity, and childlike gaiety.[55] To this end, the melding of hieratic formal sophistication with intimations of horror in Marquesan art was ideal. The same general constellation of meanings finds expression in works like the *Idol with the Seashell* (p. 194), where the aloof dignity of the haloed, Buddha-like pose is offset by the disturbing inlay of flashing pointed teeth; or in *There Is the Marae*, where cheerful sunlight and lush flowers surround a *marae* (temple precinct) with a looming idol and a fence dressed out in skulls suggestive of human sacrifice. This latter fantasy of lushness

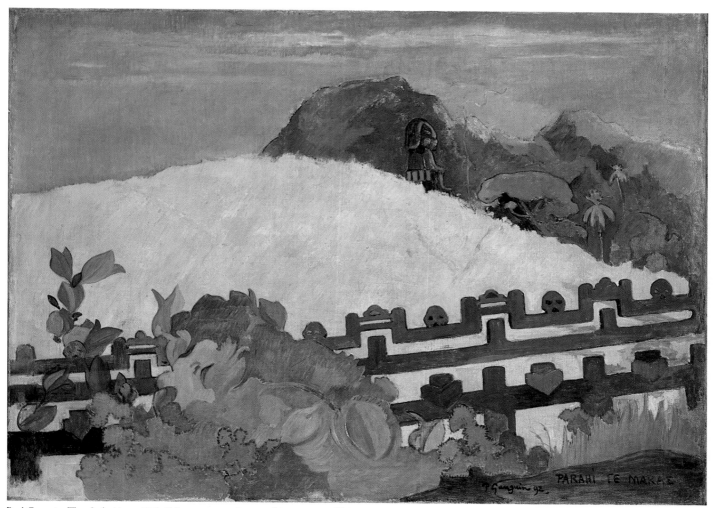

Paul Gauguin. *There Is the Marae.* 1892. Oil on canvas, 26¾ x 35¾" (68 x 91 cm). Philadelphia Museum of Art; gift of Mrs. Rodolphe Meyer de Schauensee

Paul Gauguin. Detail from *Studies of a Native Woman and Marquesan Ear Plug.* c. 1893. Pencil, pen and ink on parchment, 9⅜ x 12½" (23.8 x 31.7 cm). The Art Institute of Chicago; The David Adler Collection

Ear ornament. Marquesas Islands. Drawing from Karl von den Steinen, *Die Marquesaner und ihre Kunst,* 1925

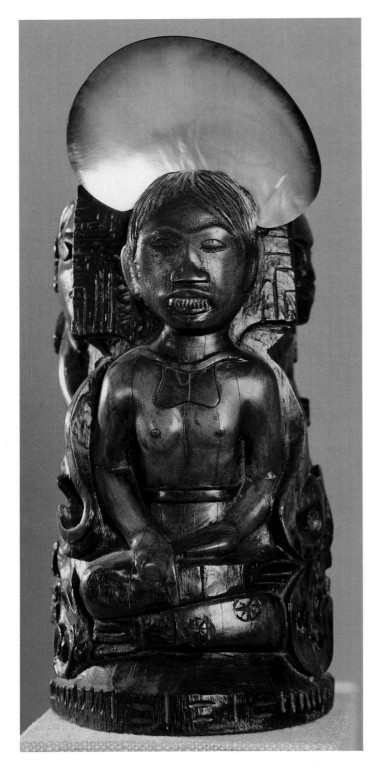

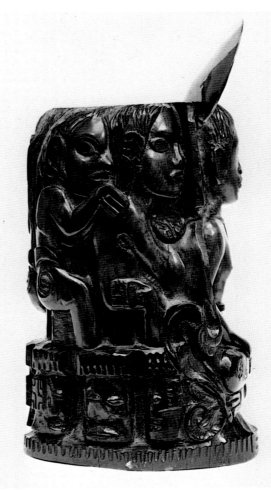

Left and above: Paul Gauguin. *Idol With the Seashell*. c. 1893. Wood, 10⅝″ (27 cm) high, 5½″ (14 cm) diameter. Musée d'Orsay, Paris

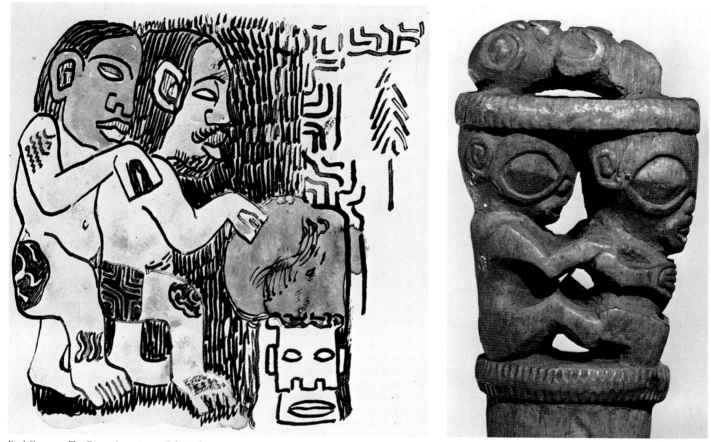

Paul Gauguin. *Two Figures* from *Ancien Culte Mahorie*. 1892–93. Watercolor, comp. 5 x 5" (12.8 x 12.8 cm). Cabinet des Dessins, Musée du Louvre, Paris

Paddle (detail). Marquesas Islands. Wood, 2½" (6.4 cm) high. The Trustees of the British Museum, London

and death was reconstructed by Gauguin from Marquesan objects. The idol is a Tiki, somewhat Egyptianized, but nonetheless embodying a rare instance of nearly strict accuracy in Gauguin's evocation of Polynesian sculpture—such Tiki were the only monumental figure sculptures in the Tahitian or Marquesan traditions. The fence design is an enlargement, considerably looser and more fantasized, from the forms of tiny bone ear ornaments (p. 193).[56]

The *Idol with the Shell* and *There Is the Marae*, along with the other similarly pieced-together hybrid images in Gauguin's Polynesian art, are fictions—not casual falsifications, but partly factual, partly hypothetical constructions intended to evoke the truths of imagination, and to heighten questions rather than resolve them. Those who read detailed meanings into their iconographies, like those who dismiss those iconographies as hopelessly muddled fantasies, take the works too literally. We need to accept their validity as speculative suggestion, and also to identify their general meaning in more basic terms. Gauguin's Oceanic primitivism dealt not just with his own psyche, nor only with the natives and their culture real or imagined, but with the questions that bound him and them together—the same questions of the origins of human creativity and communication initially suggested in his Brittany period.

This more basic interest in the Primitive emerges from specific works through layers of other meanings, personal and anthropological. The *Wood Cylinder with Christ on the Cross* (pp. 196, 197) and *Spirit of the Dead Watching* (p. 200), for example, seem opposed: the sculpture built from borrowed Oceanic

and traditional Western parts, and the painting from a modern French source and personal anecdote. Yet both work in parallel toward their related meanings: the *Cylinder* through religious symbolism to primary human experience; and the *Spirit* through contemporary experience to the origins of religion and symbols.

The *Cylinder* is the richest of Gauguin's carvings, and the most aggressively primitivizing. It typifies the antispatial bias (*horror vacui* as well as antiillusionist flatness) that guided his selection of Primitive decorative arts. The uppermost design on one face of the object makes pointedly clear Gauguin's preference for the more densely decorated, later style of Marquesan war club (p. 198) as opposed to the more "classic" and less richly worked form of the same implement (p. 198). On this same face, immediately below, a crucifixion appears, in which the extreme emaciation of the Christ, with its emphasis on the protruding ribs, may reflect Gauguin's attention to a type of Easter Island figure whose oddly accentuated rib cage easily if spuriously evokes connotations of martyred suffering (p. 196). The opposite face of the *Cylinder* contains a figure directly derived from another, later kind of Easter Island carving (p. 197), while elsewhere on the surface fragmentary body parts from Holbein's *Dead Christ* appear, packed within a field of faces, patterns, and pictographs from Easter Island script (p. 189).[57] Yet all this entangled symbolism connoting suffering and death is then subsumed into a primal image of resurgent life: the priapic column of the toa wood itself. After Rodin's *Balzac*, this is the most phallic form in late nineteenth-century sculpture.

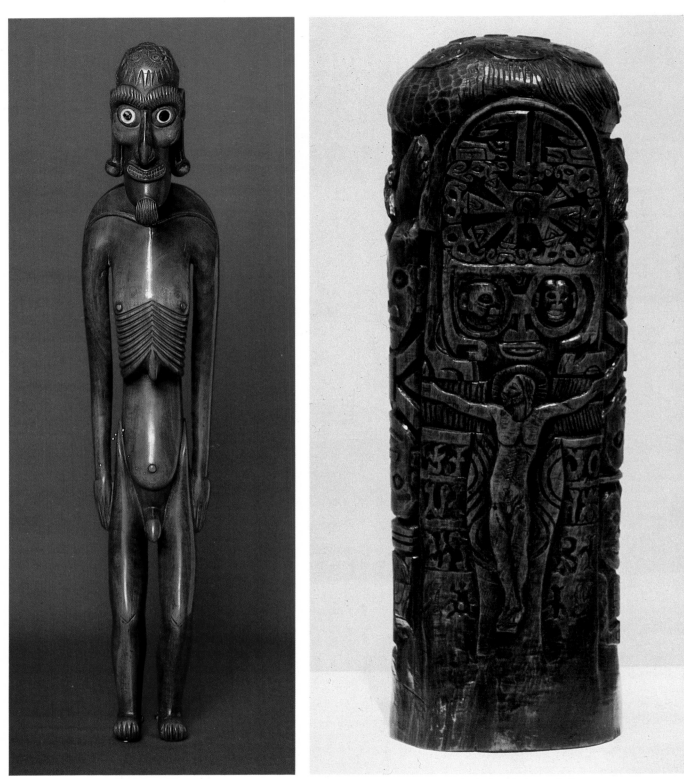

Figure. Easter Island. Wood, 18½″ (47 cm) high. The Trustees of the British Museum, London

Above and right: Paul Gauguin. *Wood Cylinder with Christ on the Cross* (two views). 1891–92. Wood, 19¾″ (50 cm) high. Private collection

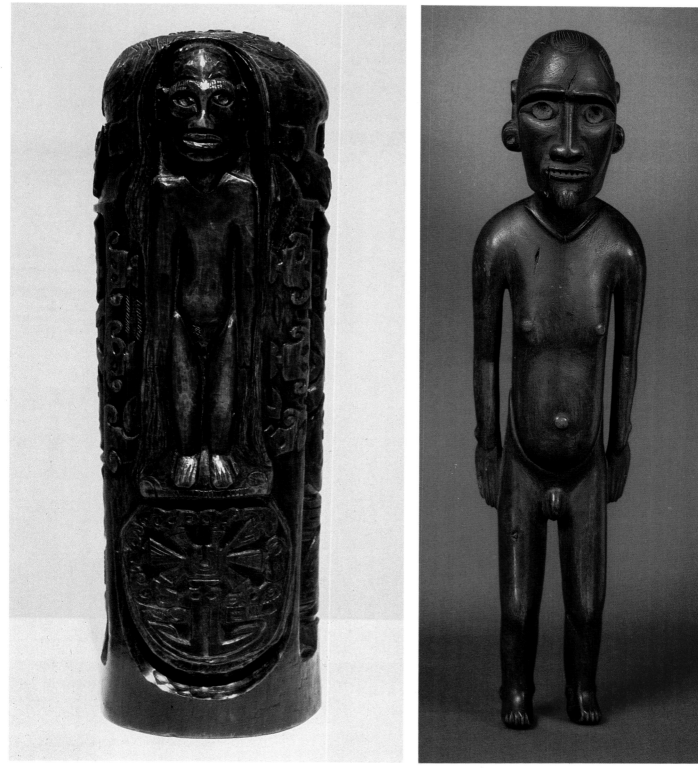

Figure. Easter Island. Wood, 16⅛" (41 cm) high. The Trustees of the British Museum, London

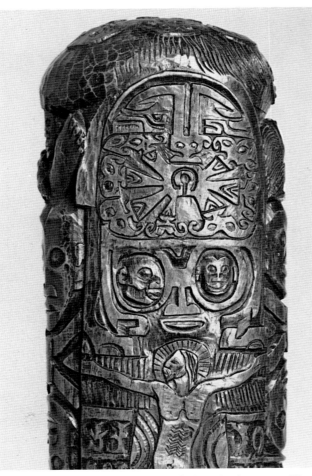

Paul Gauguin. *Wood Cylinder with Christ on the Cross* (detail). 1891–92. Wood, 19¾" (50 cm) high. Private collection

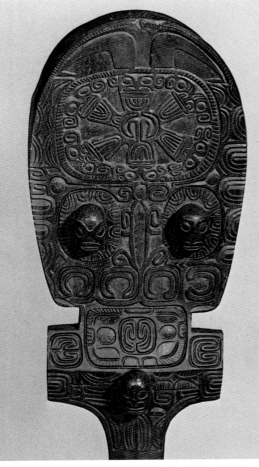

Club, detail (Later style). Marquesas Islands. Wood, 38⅜" (97.5 cm) high, overall. Bernice Pauahi Bishop Museum, Honolulu, J. L. Young Collection, purchased 1921

Tattoo design. Marquesas Islands. From Karl von den Steinen, *Die Marquesaner und ihre Kunst*, 1925

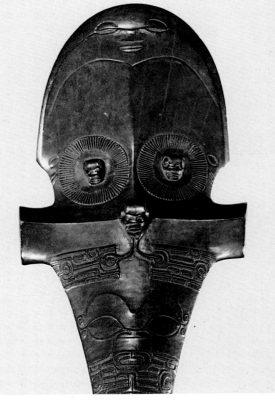

Club, detail (Classic style). Marquesas Islands. Wood, 52" (132 cm) high, overall. Collection Valerie Franklin, Beverly Hills

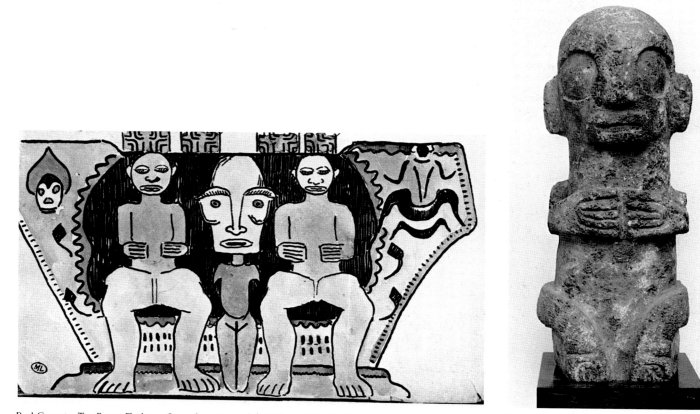

Paul Gauguin. *Two Figures Flanking a Statue,* from *Ancien Culte Mahorie.* 1892–93. Watercolor, comp. 4 x 6¾" (10.2 x 17.2 cm). Cabinet des Dessins, Musée du Louvre, Paris. For color reproduction see page 244

Figure. Marquesas Islands. Stone, 18⅛" (46 cm) high. Musée Barbier-Müller, Geneva

The primitivist meaning here lies less in Oceanic detailing than in the total form. Overlaying symbols of martyrdom on a root sign of procreation, the *Cylinder* likely evokes the idea of the underlying phallic origins of religion—a concept Gauguin discussed in his writings and suggested in other lingamlike carvings.[58] It joins resurrection with erection in a way that also embodies Gauguin's general association of the Primitive with life force, personal and cultural. He said he was attracted to the "sustenance and vital strength in the primitive arts," but found decadent Greek art disgusting or discouraging because it gave him "a vague feeling of death without the hope of rebirth"; and he wrote Odilon Redon that while death could be depicted in Europe as sinister and final, in Polynesia it would always be shown joined to new life.[59]

This fusion of physical and metaphysical urges toward renewed vitality was central to Gauguin's reaction against decadent Europe and his attraction to "primitive" life. The *Cylinder* embeds this specific sexual vitalism in another, more general meaning, also close to the core of Gauguin's fascination with the Polynesians: that of the primordial human origin of cultures. In the play between surface and underlying gestalt, the *Cylinder* leads the viewer from diverse cultural systems to recognition of their common source. This same theme has a redirected meaning when Gauguin considers it in reverse, beginning with a primary human event, in *Spirit of the Dead Watching* (p. 200).

The *Spirit* was a key canvas for Gauguin, and the several explanations he gave of its making were intended as exemplary guides to his creative process. He said it began only as a "slightly indecent" nude, a glimpse of Tehamana lying in the dark (in fact a variant of Manet's *Olympia,* inverted and exoticized to be more alluringly acquiescent). According to Gauguin, the picture then grew through piecemeal elaborations alternating naturalistic and anthropological accuracy (the flowered *pareu* skirt spread on the bed—ironically chosen as a typical Tahitian attribute, since its design and woven cloth were of European manufacture)[60] with varying degrees of antinaturalistic invented color associations (yellow to "suggest lamplight," purple for "terror"), finally to conclude with the addition of the peculiar background figure of the *tupapau* (this gnomelike specter, with frontal eye in profile head, has no specific model in Oceanic art and represents another of Gauguin's importations, here most likely from Egyptian sources). The *tupapau,* in Gauguin's account, then took priority over the original nude as the picture's main motif and determined the meaning of the scene: the native girl frightened, a spirit behind her.[61]

The resultant theme is the same one that fascinated Gauguin in *The Vision after the Sermon:* naive superstition overcoming perceptual reality. There coiffed in Breton religion, here the subject is literally laid bare, taken back beyond the suggestive spell of words to a moment of spontaneous projection caused by fear. Tehamana reenacts the primal terror reaction that had long been theorized as the source of Primitive animism, and thus ultimately of mythology.

Gauguin's writings show that histories of religion and languages were familiar to him and that he was aware of debate on the origins of these central human symbol systems. The *Spirit* echoes a classic hypothesis of the terrified primitive conjuring spirits in nature, thus initiating crude animistic or totemic

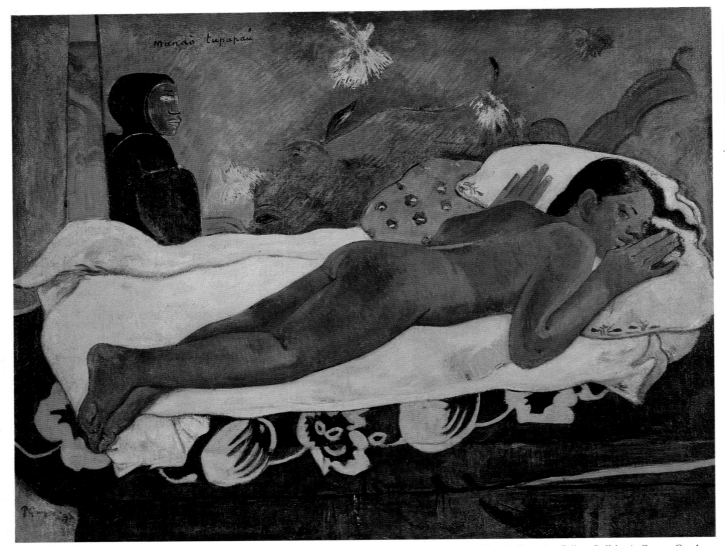

Paul Gauguin. *Spirit of the Dead Watching*. 1892. Oil on burlap mounted on canvas, 28½ x 36⅜" (72.4 x 92.4 cm). Albright-Knox Art Gallery, Buffalo; A. Conger Goodyear Collection

beliefs. From this initial fright sensation the rudimentary mentality was imagined to progress through alternating reaction and reflection, association and invention, toward more independent cultural symbols, and a full system of mythology. Gauguin's description of his elaboration of the *Spirit*, from initial sensory impression to symbolic art, follows a similar pattern and implicitly aligns his creative process with the primitive's construction from initial utterance to developed language.[62]

In the *Spirit* as in the *Vision*, the unsophisticated mind is a link inward to the basic processes of thought and backward to the origins of culture. In both instances, the Primitive mentality is shown as kin to Gauguin's in making the picture. But the *Vision's* association of caricatural simplicity with basic mental structures is not maintained here; and the *Spirit* makes no sharp division between *nature* and *non nature*, perception and projection. Instead it is complexly woven, as Gauguin insisted, from accretive layers of naturalistic and non-naturalistic elements, and finally centers on ambivalence. "The title has two meanings," Gauguin explained of the Tahitian words he chose; "either she thinks of the spirit, or the spirit thinks of her."[63] Typically, as he probed closer to the source, Gauguin became less concerned with simplicity and

more with ambiguity. The primitive's experience seamlessly melds the reality of the imagination with that of the senses; and Primitive language reveals not rock-bottom certainty but essential, original uncertainty—the words mean two different things, indicate two opposed realities.

The implicit theme in both the *Spirit* and its "genesis story" (Gauguin's account of its making) is the innate ambivalence of all representations humans make—myths, words, pictures—as mediators between nature and the mind, participating in both worlds. For an artist of the Symbolist generation, poised between naturalist fidelity to the senses and desire for separate symbolic access to the spirit, this oscillating ambiguity was irreducibly *primitif*, the ancestral mystery. For Gauguin, obsessed with finding his inborn originality yet indelibly printed with the influences of others, such a point of tension between the created and the imitated also held a tellingly personal metaphor.

The juncture of primitivism with an inquiry into the basic nature of signs, like the *Cylinder's* proto-Freudian identification of a primal sexual force with the fundaments of cultural diversity, is a potently modern idea. Again, however, Gauguin narrates these themes as subjects of shadowy Symbolist doubt rather than subsume them as incentives to dramatic artistic

change. Another generation, that of the Cubists, would find Primitive art a catalyst for more decisive breaks with imitation and more searching analyses of the bases of representation; and would use primitivism as an arm against the very ambiguities and half-light mysteries Gauguin found so absorbing.

This consideration returns us to the basic initial issue of Gauguin as the father of modernist primitivism. Revising ideas of what Gauguin actually intended and enacted, we have tried to redefine his primitivism in regard to his subjects, his society, and the larger way primitivism works as an aspect of the Western intellectual tradition. In all this there has been the implication that a new idea of Gauguin inevitably calls for a new idea of what followed from him; but this point needs further elucidation. It has often been argued that Gauguin's work is most fruitful for modern art when he forgets his self-conscious primitivism and just paints.[64] There is truth here, but it has been abused. This viewpoint has obscured and distorted some important aspects of the artist, and the time has come to redress the balance. As the analysis of the *Spirit*— and indeed the whole tenor of this discussion—suggests, Gauguin's importance as a source for twentieth-century artistic primitivism does not lie only in the selective use of his forms and colors by artists who immediately followed him. These are key points of comparison, but they do not exhaust the issue.

Modern artistic primitivism, as we stressed at the outset, is not exclusively a matter of new encounters with unfamiliar forms, but also of new attitudes brought to bear on such encounters. In this sense, Gauguin may be less premonitory in his successes than in his ambitions. He stands as the seminal translator, the conduit of personal invention through which the long tradition of primitivist thought is first projected into a modern attitude about the making of art. The contradictions, anomalies, and impurities that this entails may be marginal to Gauguin's painterly achievement, but they are close to the center of his interest for an assessment of the larger phenomenon of primitivism in modern art.

Gauguin has, for example, been held to be the type-figure of primitivism's regressive irrationality; and seen, therefore, as a child of the Romantic heritage. Yet the artist's writings could not be more explicit in affirming the ultimate importance of the rational. He closes one essay with the statement that all hope for progress belongs "to *Reason* alone" (his emphasis).[65] This is not irrelevant rhetoric. The insistence on reason makes sense in conjunction with primitivism if we recognize the eighteenth-century roots of both. Enlightenment philosophy used the term *rational* to designate the innate structure of thought; the opposite term is *empirical*. The duality concerns precisely the relationship between the mind's ordering power and the data of the senses we have seen addressed in Gauguin's work. His insistence on reason in his texts only further confirms that this idea of the innate, primal structure of the mind is as integral to his work as it was to the efflorescence of primitivism in the eighteenth century. Gauguin also recurrently used *rational* to define the basic truth that underlay the deceptive *literal* sense of things he admired, from the Bible to Cézanne's dicta. His use of the word is crucial to understanding the difference between the mystery he loved (the rational disguised by allegory, in the cover of the

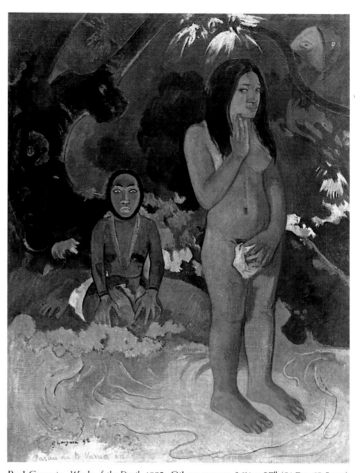

Paul Gauguin. *Words of the Devil*. 1892. Oil on canvas, 36⅛ x 27" (91.7 x 68.5 cm). National Gallery of Art, Washington, D.C.; gift of the W. Averell Harriman Foundation in memory of Marie N. Harriman

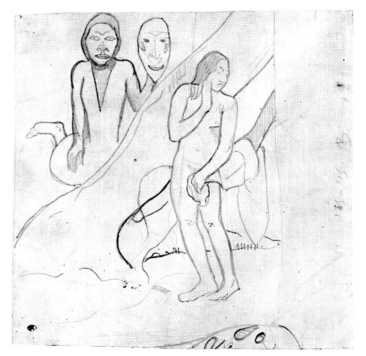

Paul Gauguin. *Study for Words of the Devil*. 1892. Pencil, 8¾ x 8½" (22.2 x 21.4 cm). Cabinet des Dessins, Musée du Louvre, Paris

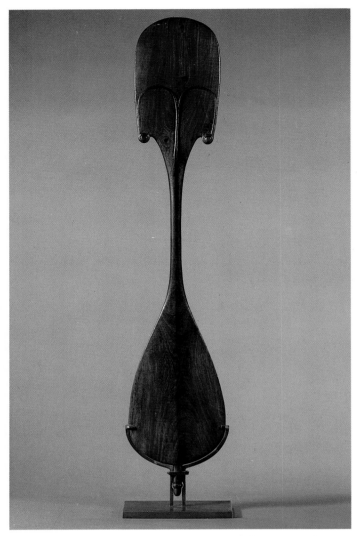

Dance staff. Easter Island. Wood, 27" (68.5 cm) high. Collection J. W. MESTACH, Brussels. Formerly collection JACOB EPSTEIN

literal) and the mystification he loathed (such as the Church's literal reading of Christ's miracles). He insisted that he himself worked "like the Bible" and that deeper rational meanings lay beneath the allegories he built to bedevil the literalists.[66]

There is more at issue here than a semantic argument about irrationality and reason. A revival of an Enlightenment view of the mind, separate from biological and historical considerations, was a key to progress in several fields of thought in the 1880s and 1890s. It was central to the emergence of modern cultural anthropology from the domain of skull measurements and racial stereotyping; and crucial as well, in the overthrow of etymology and comparative philology, for the emergence of modern linguistics.[67] Gauguin's primitivism is associated not only with the general wave of antinaturalism we discussed earlier, but with this specific transformation—in which old ideas, revived in a new context, took on radical modern implications. It is doubly important to locate Gauguin here, rather than only in a Romantic heritage, for the same period witnessed other forms of primitivism—folk movements with nationalist overtones—with more distinct ties to Romanticism and very different implications for the twentieth century.[68]

As Gauguin's primitivism is labeled irrational, so he is

thought to have rejected science. This too is false. He wrote of high hopes for progress, and for future spiritual regeneration informed by "this luminous spread of science, which today from West to East lights up all the modern world in a way so arresting, so prodigious in its effects."[69] His arguments from science are a jumble of borrowed bits from physiology and physics—from the central nervous system to antiparticle theories of atomic structure—linked to metaphysical notions from theosophy.[70] But they are not just his idiosyncrasies. Gauguin's idea that the ancients knew what modern scientists were just discovering is a correlate of his equation between "primitive" and modern art. Furthermore, such thinking has both ancestry and progeny. Primitivism before Gauguin had recurrently been joined with a progressive, reforming spirit. This pairing continues in a central strain of twentieth-century art, where the Primitive is held to be spiritually akin to the new man, and his forms commensurate with the look of the future. The affinity Gauguin sensed between primal and modern experience echoes in the proclamations of countless modern manifestos, that "we are the primitives of a new age."

The surprising affinity for science confirms what rationalism implied: that Gauguin is a better model for modern artistic primitivism when he is taken whole, ideas and art together, all contradictions included; and also that, considered in this way, he gives new meaning to the commonplace truth that primitivism is an integral aspect of the modernity it seems to reject. Gauguin's ways of thinking ask us to reevaluate the question of relationship between modernist artistic primitivism and developments in other domains, especially in the scientific study of man.

The revolution in modern man's approach to the arts of tribal societies, begun by Gauguin and brought to fruition by the artists of the early twentieth century, has resulted in a shift of these tribal objects from the domain of scientific data to that of aesthetic valuation, a conceptual shift equivalent to—and eventually echoed by—a displacement of these objects from the natural-history museum to the art museum. It might seem logical, then, to depict artistic primitivism as antithetical to scientific attitudes—either by celebrating twentieth-century artists' new valuation of Primitive art as victorious over the aesthetically "blind" limitations of an anthropological approach; or negatively, by faulting the modernist appreciation of tribal objects for imperialistically disregarding the ritual and societal contexts in which such forms have their true significance.

We cheat the complexities of history, however, if we suppose such an irreconcilable antipathy between subjective aesthetics and objective knowledge. The differences between the artist's view and the anthropologist's are obviously formidable, and the distance between the natural-history museum and the art museum constitutes a true gap. But the charged separation between such categories and such institutions only occurs within the equally important common ground both sides share as evolving expressions of the values of a larger Western culture. It is as crucial to understand the commonality as to isolate the antagonisms. In the case of something so central to the Western mind as its attitude toward Primitive man, it seems imperative that no aspect—especially one as consequential as modern artists' appropriation of tribal forms—be seen solely as isolated or polemic in its innovations.

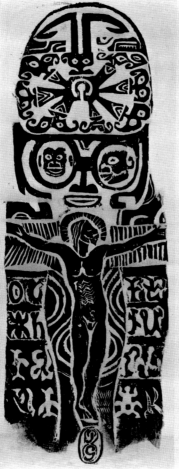

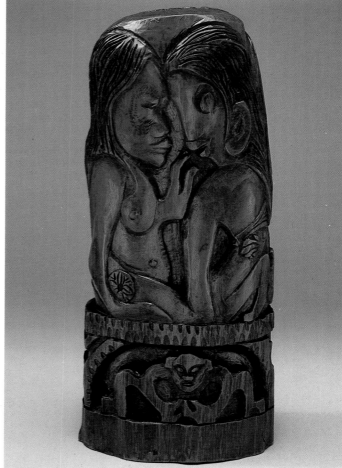

Paul Gauguin. *Christ on the Cross.* c. 1926 (posthumous impression). Woodcut, 15⅞ x 5⅜" (40.3 x 13.7 cm). The Metropolitan Museum of Art, New York; Harry Brisbane Dick Fund

Paul Gauguin. *Hina and Te Fatou.* 1892–93. Wood, 12⅞" (32.7 cm) high, 5⅝" (14.2 cm) diameter. Art Gallery of Ontario, Toronto; gift from the Volunteer Committee Fund

Gauguin initiated the shift of Primitive objects from the framework of natural science to that of artistic valuation in the very period when the foundations were elsewhere being laid for the modern "human sciences." The consonance of his innovative attitudes with the new tenor of these disciplines—linguistics, sociology, etc.—has already been outlined. His case as we have presented it argues that modern artistic primitivism is at its origin not driven by a regressive emotional intuition antithetical to scientific knowledge. The attitudes underlying modernist primitivism are instead significantly rooted in the rationalist, scientific spirit that emerged in a new systematization and independence of the study of human society and thought in the late nineteenth century.

Involved since the eighteenth century with the analysis of the fundaments of cognition and representation, primitivism has continued to be associated with these pursuits in modern art (perhaps most obviously in the Surrealists' probing of the unconscious and in the Abstract Expressionists' concern for universally communicative signs—both topics are given attention later in this volume). If we study modernist primitivism in art as isolated from other approaches to these central human issues—approaches in anthropology and psychology especially—our understanding will be impoverished.

Whether any given anthropologist has an eye for aesthetics or any given artist reads particular scientific books is not the issue. Even without such direct points of contact, innovations in artistic practice and in the natural and human sciences may be grounded in a shared nexus of broader assumptions, motivating ideas, and historical events. This does not mean that science's objectivity is reducible to changes in styles of thought, and it certainly does not mean that the primitivizing artist is simply an illustrator of new anthropological ideas. It is central to what we have observed about primitivism itself that these two ways of approaching the Primitive—aesthetic and scientific—should be independently separate, valid on their own different terms, yet joined by telling points of mutuality. Primitivism centers on a charged and fruitful relationship between differences and affinities. As a way of thinking about human diversity, it first abolishes hierarchies and allows a plurality of valid, independent, and truly different ways of constructing the world. Then it finds its energy in violating the gaps thus established, by asserting affinities that are fundamental to human thought and especially to modern creativity. This process has operated between our culture and others; now we need to apply it within our own traditions, to revise our notion of the way art, science, and the human sciences belong together in the study of primitivism—each a valid independent way of knowing, all interrelated on fundamental levels. If we ignore either the differences or the affinities, if we imagine hierarchies or polarities where interdependence and intercourse are central, then we misunderstand what Gauguin represents, and miss the power of primitivism as idea and art.

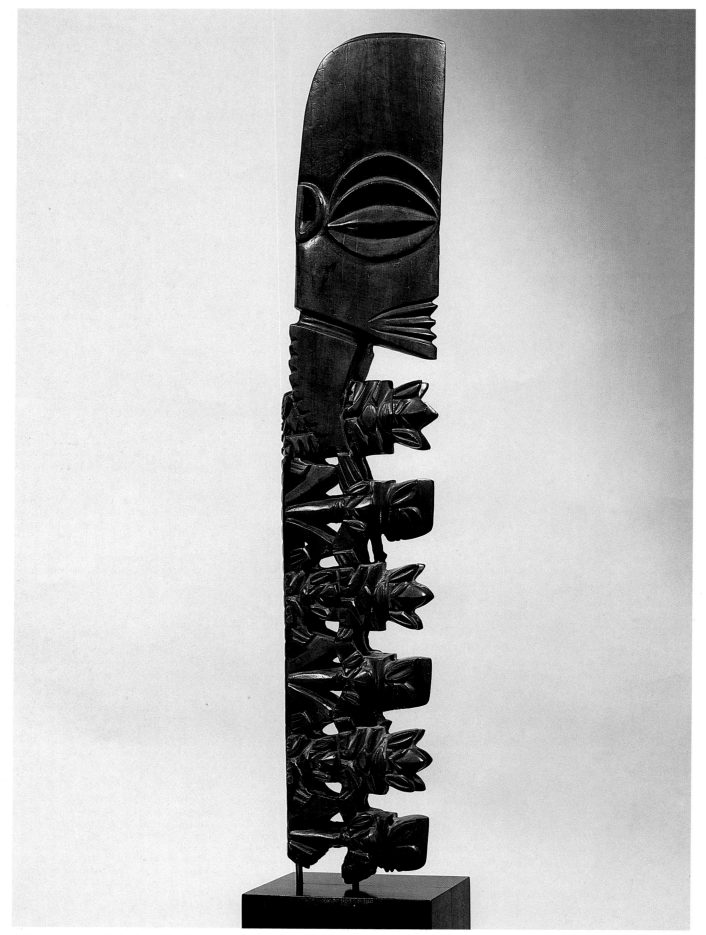

Staff god. Rarotonga, Cook Islands. Wood, 31¼″ (79.4 cm) high. Robert and Lisa Sainsbury Collection, University of East Anglia, Norwich

NOTES

1. In the preparation of this essay, I have depended on the kind cooperation of several colleagues and friends. Professor Jehanne Teilhet-Fisk generously advanced me printer's proofs of the work that has since been published as *Paradise Reviewed* (Ann Arbor: UMI Research Press, 1983). Professor Richard Field kindly answered questions and provided me with copies of his work when I had difficulty in obtaining the relevant articles. My two research assistants, Patricia Berman and Joan Pachner, worked tirelessly and were of tremendous help. I also express my gratitude to Elyn Zimmerman, Sam Varnedoe, and Adam Gopnik, all of whom read versions of this essay repeatedly and made highly valuable suggestions. For numerous key suggestions and corrections in the final version, I am indebted to William Rubin.

2. "Je suis au bord de la mer dans une auberge de pêcheurs près d'un village de 150 habitants, je vis là comme un paysan sous le nom de sauvage. Et j'ai travaillé journellement avec un pantalon de toile ...Je dépense 1 fr par jour pour ma nourriture et deux sous de tabac. Donc on ne peut me reprocher de jouir de la vie." Paul Gauguin to Mette Gauguin, undated letter of late June 1889; Maurice Malingue, *Lettres de Gauguin* (Paris: Grasset, 1946), p. 160. Translation from Daniel Guerin, ed., *The Writings of a Savage, Paul Gauguin* (New York: Viking, 1978), p. 29.

3. "Je suis par terre, mais pas encore vaincu. L'indien qui sourit dans le supplice est-il vaincu? Décidément le sauvage est meilleur que nous. Tu t'est trompé un jour en disant que j'avais tort de dire que je suis un sauvage. Cela est cependant vrai: je suis un sauvage. Et les civilisés le pressentent; car dans mes oeuvres il n'y a rien qui surprenne, déroute, si ce n'est ce 'malgré-moi-le-sauvage.' C'est pourquoi c'est inimitable." Paul Gauguin to Charles Morice, April 1903; Malingue, op. cit., p. 319. Translation from Guerin, op. cit., p. 293.

4. Two of the standard and still most helpful accounts of Gauguin are by Robert Goldwater, in *Paul Gauguin* (New York: Abrams, 1957) and *Primitivism in Modern Art* (New York: Vintage, 1967). Major contributions to unraveling Gauguin's legend have been made by Bengt Danielsson, *Gauguin in the South Seas* (New York: Doubleday, 1966) and Richard Field, "Plagiaire ou créateur?" in *Gauguin* (Paris: Hachette, 1961). Gauguin's borrowing of specific sections of his *Noa-Noa* manuscript were first pinpointed by René Huyghe in "La Clef de Noa Noa," in *Ancien Culte Mahorie* (Paris: La Palme, 1951). The crucial beginning of systematic identification of Gauguin's artistic borrowings was made by Bernard Dorival, "Sources of the Art of Gauguin from Java, Egypt, and Ancient Greece," *Burlington Magazine* 93, no. 577 (April 1951), pp. 118–22.

5. Arthur Lovejoy and George Boas, *Primitivism and Related Ideas in Antiquity* (New York: Octagon, 1980), reprinted from the original 1935 edition of Johns Hopkins Press.

6. The use of the word "primitive" as a term of artistic categorization constitutes a subject beyond the scope of the present essay. Any broader survey would include such earlier phenomena as the radical regressives within J.-L. David's studio, known as *les barbus*, and periodic archaizing movements such as that of the Nazarenes. For a survey of changing nineteenth-century attitudes toward the artistic "primitives" of the early Renaissance, see Francis Haskell, *Rediscoveries in Art* (Ithaca: Cornell University Press, 1980).

7. Hayden White, "The Forms of Wildness: Archaeology of an Idea," in Edward Dudley and Maximillian Novak, eds., *The Wild Man Within: An Image in Western Thought from the Renaissance to Romanticism* (Pittsburgh: University of Pittsburgh Press, 1972):

"The notion of 'wildness' (or in its latinate form 'savagery') belongs to a set of culturally self-authenticating devices which includes, among others, the ideas of 'madness' and 'heresy' as well. These terms are used not merely to designate a specific condition or state of being but also to confirm the value of their dialectical antitheses: 'civilization,' 'sanity,' and 'orthodoxy' respectively...[in] the historical career of such concepts...[they are] complexes of symbols, the referents of which shift and change in response to the changing patterns of human behavior which they are meant to sustain" (pp. 4–5).

8. "Il faut te souvenir qu'il y a deux natures chez moi: l'Indien et la sensitive. La sensitive a disparu ce qui permet à l'Indien de marcher tout droit et fermement." Gauguin to Mette, February 1888; Malingue, op. cit., p. 126.

9. See Lovejoy and Boas, *Primitivism and Related Ideas in Antiquity*; and also George Boas, "Primitivism," in Philip Weiner, ed., *Dictionary of the History of Ideas* (New York: Scribner's, 1973), vol. 3, pp. 557ff.; Hoxie Neal Fairchild, *The Noble Savage: a Study in Romantic Naturalism* (New York: Columbia, 1928); Lois Whitney, *Primitivism and the Idea of Progress* (Baltimore: Johns Hopkins, 1934); and Frank Manuel and Fritzie Manuel, *Utopian Thought in the Western World* (Cambridge, Mass.: Belknap, 1979), esp. pp. 425ff. For another and highly relevant perspective, see T.K. Penniman, *A Hundred Years of Anthropology* (London: Duckworth, 1965).

10. The assault on evolutionary optimism had actually begun much before Darwin, as historicist and materialist values of the nineteenth century countered the more ahistorical utopian thought of the eighteenth century. See Penniman, *A Hundred Years of Anthropology*; and George W. Stocking, *Race, Culture, and Evolution* (Chicago: University of Chicago Press, 1982), esp. "French Anthropology in 1800." On the intellectual background of racism, see George L. Mosse, *Toward the Final Solution* (New York: Harper, 1978). For Darwin in France, see Yvette Conry, *Introduction du Darwinisme en France au XIXᵉ siècle* (Paris: Vrin, 1974).

11. Another useful semantic investigation, equally beyond the scope of the present essay (see note 6), would be to trace the use of terms such as *sauvage, barbare*, etc., in their frequent political usage. Especially following the burning of major monuments in Paris during the repression of the Commune, the "dangerous classes" were often labeled as regressive forms of life, incapable of civilization. Such social anxieties fed the popularity of theories such as those of Lombroso, which held biological atavism to be a cause of criminality. For Lombroso and related questions see Stephen Jay Gould, *The Mismeasure of Man* (New York: Norton, 1981), as well as Mosse, *Toward the Final Solution*.

12. Neo-Impressionism was often associated with anarchist ideals, and these in turn with a revival of the Fourierist ideals of a golden age or "temps d'harmonie." See Donald Egbert, *Social Radicalism and the Arts: Western Europe* (New York: Knopf, 1970) and Eugenia Herbert, *The Artist and Social Reform: France and Belgium, 1885–1898* (New Haven: Yale University Press, 1961).

13. For background on Brittany's place in French society and imagination, see Fred Orton and Griselda Pollock, "Les Données Bretonnantes la prairie de la représentation," *Art History* 3, no. 3 (September 1980), pp. 314–44.

14. "Ils étudient la couleur exclusivement en tant qu'effet décoratif, mais sans liberté, conservant les entraves de la vraisemblance....ils cherchent autour de l'oeil et non au centre mystérieux de la pensée." From *Diverses Choses*, cited by Rotonchamp in *Gauguin* (Paris: 1925), and by Cachin in *Gauguin* (Paris: Livre de Poche, 1968), p. 257. Translation in Guerin, op. cit., p. 140.

15. In relation both to psychological and to language theory, an extremely stimulating piece of scholarship has connected Gauguin and the Symbolist aesthetic to developments in science: Filiz Eda Burhan, "Vision and Visionaries: Nineteenth Century Psychological Theory, the Occult Sciences, and the Formation of the Symbolist Aesthetic in France" (Ph.D. diss., Princeton University, 1979). Burhan points out how many of the idealist premises expounded by Symbolist artists and critics can be traced to elements in such "naturalist" thinkers as Helmholtz and Taine. I am especially indebted to her section on "Theories of Original Language and the Concept of Symbolic Primitivism" for informing the assertions I make in the present section and for focusing my attention on the implications of the Symbolists' use of the "art is a language" metaphor.

16. This broad-based shift in thinking can be traced through the work of early modern pioneers in several major fields, most relevantly anthropology but also linguistic theory. See Robert Lowie, *The History of Ethnological Theory* (New York: Farrar and Rinehart, 1937), and Penniman, op. cit. For language, see Ernst Cassirer, *The Philosophy of Symbolic Forms* (New Haven: Yale University Press, 1955); Otto Jespersen, *Language* (New York: Norton, n.d.); and Jonathan Culler, *Ferdinand de Saussure* (New York: Penguin, 1977). In psychology the obvious connection would be to William James's increased stress on inner structuring over received data, in *Principles of Psychology* of 1890. For James in context see Nicholas Pastore, *Selective History of Theories of Visual Perception, 1650–1950* (New York: Oxford University Press, 1971).

17. See the extensive discussion of this linkage, and its connections to mystic theories of creation, in Burhan's chapter on *The Vision after the Sermon*, op. cit., pp. 227–337. Burhan associates the picture with Gauguin's art theories in a broader fashion and argues for it as a symbolic self-portrait. The connection between the modern mind and the Primitive mentality is implicit in Bastian's work on *Elementargedanken* that find their expression in *Volkergedanken*, in works like *Beitrage zur vergleichenden Psychologie: die Seele und ihrer Erscheinungenswesen in der Ethnographie*, 1868, and *Wie das Volk 'denkt*, 1892. Penniman, op. cit., pp. 110–12, summarizes the belief—which among other things led to the creation of the Museum für Völkerkunde in Berlin in 1886—in "the psychic unity of mankind." Modern artistic primitivism walks a fine line between affirming such a belief and maintaining that tribal man and the artist share a distinctly separate kind of mentality, more along the lines of Lévy-Bruhl's insistence, in the twentieth century, on the gulf that divides the Primitive view of the world from the rational one. Lévy-Bruhl's view of the prerational consciousness of tribal man is also challenged from within anthropology by the theories of Claude Lévi-Strauss, which argue for structures of high logical organization underlying Primitive myth and society. The two concepts—one valuing Primitive man for his distance from Western concepts of logic, and the other arguing for Primitive man's covert parity even in Western logical terms—have produced a rich dialogue in primitivist thought in the twentieth century, and each finds its counterpart in art. The relationship between Lévi-Strauss's approach and recent primitivizing art is treated by me in a later essay in this volume.

18. Burhan, op. cit., gives intensive attention to attitudes toward the art of children in the late nineteenth century, and specifically connects these to Symbolist aesthetics; see pp. 242–59. She expands and specifies the linkages suggested by Goldwater in his review of "The Evaluation of the Art of Primitive Peoples," in *Primitivism and Modern Art*. For another expansion and updating of Goldwater's work on changes in the nineteenth- and early twentieth-century evaluations of Primitive art, see Joseph Masheck, "Raw Art: 'Primitive' Authenticity and German Expressionism," *Res* 4, Autumn 1982,

pp. 93–117. On Courbet's primitivism, see Meyer Schapiro, "Courbet and Popular Imagery: An Essay on Realism and Naivete," *Journal of the Warburg and Courtauld Institutes* 4 (1940–41), pp. 164–91. On the Romantic background of interest in naive art, see Aaron Sheon, "The Discovery of Graffiti," *Art Journal* 36, no. 1 (Autumn 1976), pp. 16–22.

19. On the interrelation between scientific theory and the occult, see especially Burhan, op. cit. Burhan expands and clarifies the work on occult ideals and the resurgence of Schopenhauerian idealism, in H. Rookmaker, *Gauguin and Nineteenth Century Art Theory* (Amsterdam: Swets and Zeitlinger, 1972).

20. For identification of diverse early inspirations from South America and the Orient, see Merete Bodelsen, *Gauguin's Ceramics* (London: Faber and Faber, 1964), and Christopher Gray, *Sculpture and Ceramics of Paul Gauguin* (Baltimore: Johns Hopkins, 1963).

21. On the relation of the *Vision* to Degas's café-concert scenes, see Mark Roskill, *Gauguin, van Gogh, and the Impressionist Circle* (Greenwich, Conn.: New York Graphic Society, 1970). For the picture in the context of Gauguin's association with Bernard and cloisonism, see Bogomila Welsh-Ovcharov, *Vincent van Gogh and the Birth of Cloisonism* (Toronto: Art Gallery of Ontario, 1981).

22. Elisa Evett, "The Late Nineteenth-Century European Critical Response to Japanese Art: Primitivist Leanings," *Art History* 6, no. 1 (March 1983), pp. 82–106. For broader work on the same topic, see Evett, *The Critical Reception of Japanese Art in Late Nineteenth Century Europe* (Ann Arbor: UMI Research Press, 1982).

23. From the manuscript *Diverses Choses*, in Guerin, op. cit., pp. 132–33. A variant version of the same account appears in *Avant et après*.

24. Gauguin's inner conflicts have often been noted before, most specifically by Wayne Andersen in *Gauguin's Paradise Lost* (New York: Viking, 1971) and in his introduction to Guerin, op. cit. Gauguin wrote in *Cahier pour Aline*, "Les grands monuments ont été faits sous le règne des Potentats. Je crois que les grandes choses aussi ne seront faites qu'avec des Potentats... Intuitivement, d'instinct sans réflexion, j'aime la noblesse... Je suis don (d'instinct et sans savoir pourquoi) ARISTO" (see facsimile, Paris: Société des Amis de la Bibliothèque d'Art et d'Archaeologie de l'Université de Paris, 1963). When he told his life story in *Avant et après*, he asserted that there were two races in him (p. 89), and in the same text claimed descent from a Borgia of Aragon, Viceroy of Peru, whereas he had previously referred to himself as "un sauvage de Pérou" (letter to Schuffenecker, July 8, 1888, Malingue, op. cit., p. 133).

Evidence of Gauguin's interest in Buffalo Bill appears in a letter to Bernard of February 1889, in Malingue, op. cit., p. 157. Later, in August 1890, Gauguin wrote Bernard, "J'ai fait quelques flèches et je m'exercise sur le sable à les lancer comme chez Buffalo Bill. Voilà le soi-disant Jésus-Christ" (*Lettres de Paul Gauguin à Emile Bernard* [Geneva: Cailler, n.d.], p. 117). The cryptic and probably self-mocking last line here reminds one that the sensations of a dual nature—martyr and messiah—are equally built into Gauguin's frequent identification of himself with the (equally long-haired) savior, in self-portraits. Jehanne Teilhet-Fisk, in *Paradise Reviewed* (Ann Arbor: UMI Research Press, 1983), p. 29, notes Gauguin's affectation of long hair but associates this exclusively with Gauguin's wish to associate himself with the savages in the Wild West Show. The hat described by Jenot, which Gauguin wore getting off the ship in Tahiti, suggests more the complete image of Buffalo Bill, whose hair was also long. The description is "cheveux poivre et sel tombant en nappe sur les épaules au-dessous d'un vaste chapeau de feutre brun à larges bords, à la cowboy." Jenot also mentions that he had brought a Winchester rifle with him. "Le Premier Séjour de

Gauguin à Tahiti d'après le manuscrit Jenot," in G. Wildenstein, ed., *Gauguin, sa vie, son oeuvre* (Paris: Gazettte des Beaux-Arts, 1958), pp. 117, 124.

25. Gauguin's use of the word *ressources* is in the context of discussing Madagascar as a point of emigration where there were "plus des ressources comme types, religion, mysticisme, symbolisme." Malingue, op. cit., p. 198. As regards exploitation, there is also the remark to Bernard, "Je suis un peu de l'avis de Vincent, l'avenir est aux peintres des tropiques, qui n'ont pas encore été peints, et il faut du nouveau comme motifs pour le public, stupide acheteur." From Arles, 1889, in *Lettres de Paul Gauguin à Emile Bernard*, pp. 70–71.

For a brief overview of the dramatic expansion of European imperialism after a nadir c. 1870, see Carlton J. Hayes, *A Generation of Materialism 1871–1900* (New York: Harper and Row, 1941). For more specific treatments in relation to France: Thomas Power, *Jules Ferry and the Renaissance of French Imperialism* (New York: King's Crown Press, 1944); Stephen Roberts, *The History of French Colonial Policy 1870–1925* (London: Frank Cass, 1963); and Brunschwig, *French Colonialism 1871–1914, Myths and Realities* (London: Pall Mall, 1960). Power notes that "Two events seemed to revive French interest in Polynesia. With the consideration of the project for the Panama canal, Tahiti suddenly acquired a new potential importance as a base... Coincidentally, the French were alarmed by the accession of a new native ruler in 1877, for his wife was the daughter of an Englishman." This fear of possible English influence brought the French to start pressing for colony status in 1879. At that time French business was one-tenth of the island's trade; by 1884, it was one-half.

Power also notes (p. 184, note 203) arguments like that of Arthur Bordier in *La Colonisation scientifique et les colonies françaises* (1881), proposing a strengthening of the French race by fusion with colonial races, to forestall depopulation of France. This in turn has echoes in two directions. First, it parallels the rhetoric adopted by the Ferry government, encouraging Frenchmen to believe that, following their defeat and subjugation on the Continent (by Germany), aggressive external activity was needed to recover and sustain national élan. Also, it recalls the notion of the archracist Gobineau, who argued in his *Essai sur l'inégalité des races humaines* (1854) that the European races would have to blend their superior civilizing and reasoning abilities with the greater instinctual sense of rhythm and art in the "inferior" races. All this provides a context that should affect our reading of Gauguin's search for "reinvigoration" in Tahiti.

Gauguin's attitude is classically stated in his odd inversion of the Hercules vs. Antaeus myth, in which Antaeus needed to touch the ground to gain strength. He wrote Bernard before leaving that "L'Occident est pourri en ce moment et tout ce qui est Hercule peut comme Antée prendre des forces nouvelles en touchant le sol de là-bas. Et on revient un ou deux ans après, solide." Malingue, op. cit., p. 193.

26. "Il est toujours à braconner sur les terrains d'autrui; aujourd'hui, il pille les sauvages de l'Océanie!" Camille Pissarro to Lucien Pissarro, November 23, 1893; John Rewald, ed., *Camille Pissarro, Lettres à son fils Lucien* (Paris, 1950), p. 217.

27. On this tradition of "psychologically oriented primitivism" see Edith A. Runge, *Primitivism and Related Ideas in Sturm und Drang Literature* (Baltimore: Johns Hopkins, 1946), esp. p. ix.

28. Gauguin wrote Bernard in regard to a vase he had given to Madeleine Bernard. "C'est une chose bien sauvage, mais qui est plus l'expression de moi-même que les dessins des petites filles... Le pot est bien froid et cependant il a supporté intérieurement une chaleur de 1600 degrés. En le regardant bien on pourrait peut-être trouver comme à son auteur un peu de cette chaleur." Letter without date,

December 1888; Malingue, op. cit., p. 155. In describing his self-portrait he had evoked the color in similar terms: "figurez-vous un vague souvenir de la poterie tordue par le grand feu! Tous les rouges, les violets, rayés par les éclats de feu comme une fournaise rayonnant aux yeux, siège des luttes de la pensée du peintre." Letter to Schuffenecker, October 8, 1888; Malingue, op. cit., p. 141. See also his discussion of grave colors and suffering in hell, in regard to ceramic, in "Notes sur l'art à l'Exposition Universelle," *Le Moderniste illustré*, July 4 and 11, 1889.

29. "Vous êtes Parisianiste. Et à moi la campagne. J'aime la Bretagne. J'y trouve la sauvage, le primitif. Quand mes sabots résonnent sur ce sol de granit, j'entends le ton sourd, mat et puissant que je cherche en peinture." Letter to Schuffenecker, February 1888; Malingue, op. cit., p. 322.

30. "Et voilà la nostalgie lui revient de ces pays où s'égrenèrent ses premiers songes. Il voudrait revivre, solitaire, quelques années, parmi les choses qu'il a laissées de lui, là-bas... à Tahiti, où la nature s'adapte mieux à son rêve, où il espère que l'Océan pacifique aura pour lui des caresses plus tendres, un vieil et sûr amour d'ancêtre retrouvé." Octave Mirbeau, from *L'Echo de Paris*, February 19, 1891—a clipping Gauguin pasted into his *Cahier pour Aline*. The idea that the Tahitian voyage was a regression to Gauguin's own infancy has been advanced by several writers. The most prominent and extended analysis of the artist in these terms is Andersen's *Gauguin's Paradise Lost*. Field has also written that "his vision of Tahiti was inextricably tied to his needs to objectify his own past or subconscious," in *Gauguin and Exotic Art* (University of California at Santa Cruz, Center for South Pacific Studies, n.d.). Both authors draw attention to themes of the mother, and of birth, death, and return, in Polynesian imagery.

31. Gauguin quoted by Jules Huret in "Paul Gauguin Discussing His Paintings," *L'Echo de Paris*, February 23, 1891. Guerin, op. cit., p. 50.

32. Bougainville's *Voyage autour du monde*, cited in Jean-Etienne Martin-Allanic, *Bougainville navigateur et les découvertes de son temps* (Paris: Presses Universitaires de France, 1964), pp. 683, 668. On the ancient idea of "fortunate isles," see Lovejoy and Boas, *Primitivism and Related Ideas in Antiquity*, e.g., p. 290.

33. Diderot's *Supplément au voyage de Bougainville* was first printed in 1796, though written earlier. See Diderot, *Oeuvres*, Editions Gallimard, 1951. Essential for Tahiti's history are the discoverers' chronicles: first by the Englishman Wallis, in John Hawkesworth, *An Account of the Voyages Undertaken by Order of His Former Majesty...*; and then Bougainville's *Voyage autour du monde*. These accounts are both quite balanced in their assessment of Tahiti, and full of reports of native venality and hostility that were ignored in the formation of the Tahitian myth. These discoverers' accounts are also riddled with premonitory incidents of conflict, including murder and armed intimidation, between the Western sailors and the islanders. Diderot and other mythifiers of Tahiti likely did not read Bougainville's own accounts. Most Frenchmen had formed their opinions long before Bougainville's *Voyage* was published, on the basis of newspaper accounts and the testimony of others who sailed with the explorer. See for example the early article on Tahiti dealt with in L. David Hammond, ed., *News from New Cythera* (Minneapolis: University of Minnesota Press, 1970). Tahiti figures prominently in several of the general books listed above, note 9.

34. Bernard Smith, *European Vision and the South Pacific*, p. 31: "Tahiti was seen from the beginning by poets and artists as a tainted paradise—its pleasures fitful, physical, and transient." Also, on p. 27: "Tahiti proved that there was once a golden age; Tahiti also proved it had long passed away. The island entered into the more serious and reflective levels of European art and thought not as the symbol of

the normality of human happiness but as a symbol of its transience." On p. 70 Smith continues to remark on Tahiti's role, not only in declining old-fashioned primitivism, but in new evolutionary speculation.

35. See the comments of Power, op. cit., on Polynesia as "perhaps the worst example of French colonial rule" (p. 74). The sad history of missionary battle, forcible suppression of uprisings, etc., is outlined in Louis Henrique, *Les Colonies françaises* (Paris: Quantin, 1889), vol. 4. Some savor of the battles at issues can also be gathered from Henri Lutteroth, *O-Taiti, histoire et enquête* (Paris: Chez Paulin, 1843), where the equivocal role of the Belgian Moerenhout is discussed. Moerenhout's own text, *Voyage aux îles de Grand Océan* (Paris: Arthur Bertrand, 1837), is the tome Gauguin used as his source for Tahitian history and mythology; it makes clear that by the 1830s the fabric of native culture had already collapsed. See also Roberts, *The History of French Colonial Policy*, esp. pp. 510–14, for a damning review of European effect on the island. Referring to the passage of fifteen governors in the thirty-six-year period from the 1843 protectorate to 1879 negotiations for colony status, Roberts notes: "The administration was such that it kept the [Society Islands] stagnant, destroyed native life almost entirely, and introduced the word *tracasserie* as a synonym for French colonial efforts." (After 1880, there were thirty-one governors in forty years.)

36. For the Balzac citation I am grateful to William Rubin, who in turn first heard the reference from Meyer Schapiro. The relevant passage is in *The Wild Ass's Skin* (New York: Penguin, 1977), pp. 37–38. The revelant Melville novel is *Omoo*; see especially the chapters "A Missionary's Sermon; with Some Reflections," and "Tahiti As It Is." The Adams citation is from Worthington Ford, ed., *Letters of Henry Adams* (New York: Houghton Mifflin, 1930), p. 468. Adams's letters of February 6 and February 23, 1891, are rich evocations of Papeete as Gauguin found it, worth consulting *in toto*.

37. Goldwater identified the script in *Primitivism and Modern Art*, p. 70. This odd writing was not known at all until 1864, and debate continues over its origins and meanings. See the discussion of Rongorongo, in this painting and its role as a cryptological "hot topic" in the 1890s, in Teilhet-Fisk, op. cit., p. 88. For Rongorongo in a broader context, see Ernst Doblhofer, *Voices in Stone* (London: Palladin, 1973). The fabricated statue in the background of Gauguin's painting may reflect some knowledge of the argument that Rongorongo closely resembles Indus languages (see Doblhofer, pp. 301ff.).

38. On the proper reading of the Tahitian title *Merahi Metua No Tehamana*, see Bengt Danielsson, "Gauguin's Tahitian Titles," *Burlington Magazine* 109, no. 769 (April 1967), p. 231.

In *Gauguin* (Art Institute of Chicago, 1959), the notes by Samuel Wagstaff on this painting cite the following passage from Gauguin's *Noa-Noa*: "Now that I can understand Tehura [another name for the same *vahine*], in whom her ancestors sleep and sometimes dream, I strive to see and think through this child, and to find again in her traces of the far away past which socially is dead indeed, but still persists in vague memories." Teilhet-Fisk, op. cit., p. 88, extends the question of ancestors back to a more specific genesis reference but ultimately stresses the picture's references to the Tahiti of the 1890s.

39. Henry Adams put it bluntly: "They are still, silent, rather sad in expression.... I never saw a people that seemed so hopelessly bored as the Tahitians...The melancholy of it quite oppresses me" (op. cit., pp. 466–67).

Pierre Loti was the *nom de plume* of Julien Viaud. His novel of Tahiti, *Rarahu*, 1881, was one of a series of his exotic travel romances. Later published as *Le Mariage de Loti*, the autobiographical tale of love with a *vahine* and sad return to Europe reads almost like a scenario for Gauguin's first voyage. Gauguin disliked the prettiness and superficiality of Loti's dolorously perfumed prose (see Guerin, op. cit., pp. 138, 218); yet if we set his pictures, or *Noa-Noa*, between *Rarahu* and Victor Segalen's *Les Immémoriaux*, we find a consistent strain of French exoticism of the South Seas as a place of sad pleasures and mournful cultural disappearance. For an assessment of the musical aspect of Loti, his relation to Chateaubriand, and to the reaction against Zola, see Roland Lebel, *Histoire de la littérature coloniale en France* (Paris: Larose, 1931), p. 69.

40. "Figures animales d'une rigidité statuaire: je ne sais quoi d'ancien, d'auguste, religieux dans le rythme de leur geste, dans leur immobilité rare. Dans les yeux qui rêvent, la surface trouble d'un énigme insondable." Letter to André Fontainas, March 1899, Malingue, op. cit., p. 288. Translation from Guerin, op. cit., p. 184.

41. This is the position of Goldwater in *Primitivism in Modern Art*, reconfirmed by Field in *Gauguin and Exotic Art*: "It still remains fundamental to the understanding of his painting, sculpture and graphics that the borrowings or incorporation of primitive motifs are amazingly few and that the assimilation of their expressive, angular, and nonnaturalistic elements into Gauguin's art is even less manifest. Goldwater clearly summarized Gauguin's position by emphatically relating his work to nineteenth-century attitudes toward flat, ornamental, archaic, and non-European styles...."

42. "...ces danses javanaises qui, dans leur monotonie même et dans la lenteur hiératique de leurs mouvements, nous donnent l'impression de rites primitifs conservés à travers les âges. Il y a là les restes d'un art subtil et raffiné qui fait songer aux frises du temple de Borobudur...Un oeil d'artiste ne saurait rester indifférent à ces cadences bizarres, à ces attitudes, à ces gestes, à ces inflexions de mains, à ces renversements, à ces déhanchements de corps, qui remontent aux origines mêmes de bouddhisme." Louis Gonse, "L'Art à l'Exposition—l'Orient," *L'Illustration*, October 19, 1889. Also, Frantz Jourdain, "Le Kampong Javanais à l'Exposition Universelle," *L'Illustration*, July 6, 1889: "Les danseuses...n'évoquent-elles tout un passé mort?une mélopée monotone et mélancolique qui ne manque ni de charme ni de poésie." Gauguin wrote Bernard: "Dans le village de Java il y a des danses hindoues. Tout l'art de l'Inde se trouve là et les photographies j'ai du Cambodge se retrouvent là textuellement." Undated, March 1889; Malingue, op. cit., p. 157.

43. "Ces répétitions de tons, d'accords monotones, au sens musical de la couleur, n'auraient-elles pas une analogie avec ces mélopées orientales chantées d'une voix aigre, accompagnement des notes vibrantes qui les avoisinent, les enrichissant par opposition..." Letter to André Fontainas, March 1899, Malingue, op. cit., p. 287. Translation from Guerin, op. cit., p. 184.

44. This is the thesis of Teilhet-Fisk, op. cit. (e.g., p. 42), who employs it as a point of departure for more specific interpretive speculations on the Buddhist references in Gauguin's borrowings. In a book Gauguin could well have known, Henrique's *Les Colonies françaises* (1889), the theories of Elisée Reclus and M. E. Raoul on the Malaysian origins of the Polynesian are reviewed (vol. 4, p. 23), with special reference to Java. And in *Avant et après*, Gauguin specifically cites Reclus's geographical writings (which were an innovative combination of geology and ethnology) as a source for a description of the Marquesan Islands. On the other hand, it seems certain Gauguin did not accept the old notion of a migration from Java to Polynesia. His sarcastic comments on such theories in *Avant et après* are not recantations (as Teilhet-Fisk suggests they are), but, taken in context, are calls for a reorientation of thought about the connections between the two cultures. Gauguin seems to support the idea of a great Oceanic race (of which Java and Polynesia would be offshoots) that was associated with the theory of a lost Austral continent—of which the South Sea isles would be remaining mountain peaks. Gauguin's subscription to this deluge theory of the origins of Tahiti is clear from his description of the Tahitian peaks in the opening lines of *Noa-Noa*. The idea of separate centers of invention, each correlated by common ideas and symbols, is central to Gauguin's anti-Darwinian syncretist thinking, and implicitly rejects a model of diffusion by direct copying and mechanical transmission alone. This emphasis on his part is quite timely. Penniman explains (op. cit., p. 177) that "The whole atmosphere of social studies, whether of material culture or of sociology, religion, and law, was charged [in the late nineteenth century] with inquiries into the customs of primitive peoples, in an attempt to discover the origins and development of civilization...The majority of investigators approached their problems psychologically, assuming that the intellect and emotions of the peoples of the earth differed in degree rather than in kind..." On pp. 110–12, Penniman reviews the work of Bastian on primitive psychology, and his anti-Darwinian interests; Bastian felt that all humanity was bound together by basic original and fundamental thoughts. Gauguin's ideas echo this pattern of thinking on human origins and diversity.

45. In *Noa-Noa*, Gauguin noted "old memories of great chiefs (a race that had such a feudal system)." Guerin, op. cit., p. 81. Smith, op. cit., discussed how eighteenth-century shifts in ideas led to the belief that "Perhaps the clue to the origin of art and indeed of civilization...is not to be found by digging up the buried monuments of Greece and Italy but by studying life as lived in the islands of the Pacific" (p. 92). For the "lost tribe" idea distantly echoed, see John LaFarge, *Reminiscences of the South Seas* (New York: Doubleday, 1912), p. 317.

46. Teilhet-Fisk, op. cit., links theosophical leanings and stylistic mergers: "As his theosophy demanded the synthesizing of religion, Gauguin's art demanded the synthesizing of styles..." (p. 145). Gauguin's connections to theosophical literature are reviewed by Andersen in his introduction to Guerin, op. cit., p. xx. The crucial Gauguin document in this regard is the manuscript *L'Esprit moderne et le catholicisme*, in the St. Louis Art Museum.

47. This kind of exercise in comparative religion occurred almost inevitably in discussions of the South Seas islanders, even if only at the level of quasi-involuntary metaphor. Moerenhout's account of Maori religion in *Voyage aux îles de Grand Océan* is peppered with constant references of this kind. Smith, op. cit., analyzes the phenomenon of religious associations with the Polynesians, and the general pattern of assimilating the unknown in terms of the known in Western thought's confrontation with Polynesia.

48. See note 41 above.

49. Christopher Gray, in *Sculpture and Ceramics of Paul Gauguin*, p. 316, published a detail from a photograph initially published in 1909 as illustrating works by Gauguin. While in 1909 these figures were attributed to Gauguin, Gray rightly identifies them as African sculptures. In a lecture of 1966, unfortunately without supporting reference, Robert Goldwater refers to "au moins deux exemplaires du Congo" in Gauguin's possession around 1891. (See Goldwater, "L'Expérience occidentale de l'art nègre," in *Colloque sur l'art nègre*, Dakar: Société Africaine de Culture, 1966, vol. 1, p. 351.) While Goldwater's reference is presumably to the same figures reproduced by Gray, nothing is known of Goldwater's evidence or reasoning for the date he assigns. I am grateful to Jean-Louis

Paudrat for bringing Goldwater's remarks about these objects to my attention.

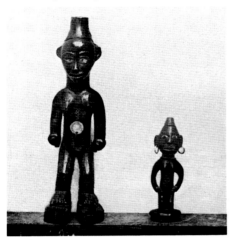

Detail of a photograph published 1909 in *Zolotoye runo*... showing objects purportedly by Gauguin. Attributed by Christopher Gray to the Emile Schuffenecker Collection, Paris

50. William Rubin has surveyed the records of the Trocadéro collection and has identified several Marquesan Tiki in wood and stone that were accessioned by the museum in the late 1880s, as well as a few Hawaiian sculptures.

51. Field discusses the visit to Auckland in "Plagiaire ou créateur?" p. 148. Teilhet-Fisk makes further identifications of his drawings after Maori art in the museum there, op. cit., pp. 107–10.

52. In connection with a forthcoming work on Gauguin, Alan Wilkinson has recently undertaken field research in Polynesia and, in conjunction with Gilles Artur, has identified a large stone Tiki in the Marquesas Islands (p. 192) which he believes to be the one drawn by Gauguin. I am extremely grateful to Mr. Artur for providing a photograph of this work and for allowing its publication in the present context.

53. In *Avant et après*, Gauguin praises the "sens inouï de la décoration" of the Marquesans, their ability to cover any surface no matter how awkward, leaving no "vide choquant et disparate." He marveled particularly at the interchange between facial features and pattern in their designs. By contrast, Gauguin frequently used the term "Papuan," referring to the art of the Papuan Gulf area of New Guinea, as a synonym for extreme coarseness; see Guerin, op. cit., pp. 186, 187, and 221.

54. On the general associations of the Marquesan Islands, see Melville's novel *Typee*. Loti's *Rarahu* also included reference to the cannibalism reputedly still practiced there. The Marquesas had other associations as well, to which Gauguin could have been exposed before his first departure for Tahiti; see van Gogh's lament for the destruction of the islands by the white man, apropos of a recent book on the islands, in his letter to Bernard (B5 [5]), from Arles, May 1888. *The Letters of Vincent van Gogh*, (Boston: New York Graphic Society, 1978), vol. 3, p. 483.

On Marquesan art, see Karl von den Steinen, *Die Marquesaner und ihre Kunst*, 2 vols. (Berlin: Dietrich Reimer, 1925). More specifically, see Willowdean C. Handy, *Tatooing in the Marquesas* (Honolulu: Bernice Bishop Museum, 1922), which includes a select bibliography. Handy reviews the history of thinking about the designs. Confusion about the riches needed to be tatooed began with an account of 1804, followed by others that associated the marks with nobility. See also Handy, *L'Art des Iles Marquises* (Paris: Les Editions d'Art et d'Histoire, 1938), p. 22.

55. "J'ai voulu avec un simple nu suggérer un certain luxe barbare d'autrefois [describing the canvas *Nevermore*, 1897, now in the Courtauld Institute, London]. Le tout est noyé dans des couleurs volontairement sombres et tristes...." Letter to Daniel de Monfried, February 14, 1897; Malingue, op. cit., p. 101.

56. See the poem "Parahi Te Marae" in *Noa Noa* (Paris: Editions G. Cres, 1924), p. 101; and the description of this picture by Charles Morice, p. 16. For the comparison of the fence with a Marquesan ear ornament, see Alan Wilkinson, *Gauguin to Moore: Primitivism in Modern Sculpture* (Toronto: Art Gallery of Ontario, 1981), p. 60.

57. On the *Cylinder*, see Wilkinson, op. cit., pp. 38–41; Ziva Amishai-Maisels, "Gauguin's Early Tahitian Idols," *Art Bulletin* 60, no. 2 (June 1978), pp. 331–41; and Teilhet-Fisk, op. cit., pp. 128–33. William Rubin believes that the sculpture's two main figures—Christ with ribs protruding, and the more fleshed-out figure on the other side—already embody the opposition between images of mortality and vitality that conveys the *Cylinder's* most basic meaning.

58. In *L'Esprit moderne et le catholicisme*, Gauguin pursues comparative analyses of several religions, specifically in relation to the connection between crucifixion symbolism and phallic deities. Discussing Mexican gods, Gauguin asserts that the Christian crown of thorns was not originally a symbol of suffering, but a derivative from the tree of life. He continues: "Dans son *ascension* Witoba est dépeint comme une figure cruciforme étendue dans l'espace, avec les marques des clous sur sa main, ce qui indique la divinité virile assez puissante pour ressusciter de nouveau, et les clous sont les symboles de sa force pubescente. Cette vue est confirmée par le fait dans le Dekkan, Witoba est envisagé comme un avatar de Siva la Lingaïque comme le Dieu qui se leva de nouveau, ou était ce que le Rituel appelle re-dressé. Il ne peut y avoir aucun doute qu'Orion a été jadis un type *phallique* avec les trois étoiles pour l'emblème mâle." P. 48 of the transcript provided by the St. Louis Art Museum.

59. "You will always find sustenance and vital strength in the primitive arts (in the arts of fully developed civilizations, nothing, except repetition). When I studied the Egyptians I always found in my brain a healthy element of something else, whereas my studies of Greek art, especially decadent Greek art, either disgusted or discouraged me, giving me a vague feeling of death without the hope of rebirth." *Diverses Choses*, in Guerin, op. cit., p. 131.

The letter to Redon is from Le Pouldu, (September?) 1890, referring to a Redon image of death: "En Europe, cette mort avec sa queue de serpent est vraisemblable, mais à Tahiti, il faut la voir avec les racines qui repoussent toutes les fleurs." Malingue, op. cit., p. 323.

60. Danielsson, *Gauguin in the South Seas*, p. 85, remarks on the dress of the Tahitians in the 1890s, and identifies the flower-patterned woven cotton cloth of the typical *pareu* skirt as being of European manufacture. This is the kind of cloth that was often produced by textile manufacturing centers such as Manchester, for export use only—hence the lack of consonance with European designs of the day, despite the European origin of the cloth. The origin of the bold, proto-Matisse flowered designs that are so much a part of Gauguin's vision of Tahiti remains obscure. However, Adrienne Kaeppler of the Smithsonian Institution has kindly informed us that Tahiti did have a tradition of plant-pattern designs, in two senses. The traditional native *tapa* cloth, from which the *pareu* was originally made, was often printed with a fern pattern, by dipping ferns in red dye and pressing them directly on the cloth. Furthermore, early in the nineteenth century the missionary influence led to the adoption of a type of quilting in which large red

designs were appliquéd onto white cloth (or the reverse) in flower patterns. In a personal communication of September 10, 1983, Colin Newbury, of the Institute of Commonwealth Studies of Oxford University, points to various published evidence that printed muslin cloth and *pareu* were being imported from England and France at least by 1865. Bengt Danielsson, in a similar communication of October 4, 1983, cites a letter written in Tahiti by C. F. Gordon Cumming on December 2, 1877, describing at length the native "pareos" as cloth from Manchester, "prepared expressly for these isles, and of the most wonderful patterns. It is wonderful what a variety of patterns can be produced," the same writer continues, "not one of which has ever been seen in England." (C. F. Gordon Cumming, *A Lady's Cruise in a French Man-of-War* [London: William Blackwood and Sons, 1882], p. 288.) Mr. Danielsson, who has devoted considerable study to the problem and has amassed a photo archive of Tahitian dress, concludes that the printed cloth began to be imported in the 1850s, with an eye to matching and replacing the traditional *pareu* made from bark cloth. Apparently the flowered designs that Gauguin favored were of a type popular in Tahiti in the 1890s; but there is no evidence that such designs were traditional in the imported cloth. Photographs from the 1850s show *pareu* in printed cloth of geometric design. Mr. Danielsson believes that Gauguin may well have invented the particular floral patterns he depicted; efforts to match exactly the patterns seen in Gauguin's Tahitian paintings with patterns recorded in photos of the day have been unavailing. I am grateful to M. Danielsson for his extremely kind and informative reply to my inquiries; and also to Mr. Newbury, to Douglas Newton of the Metropolitan Museum, and to Adrienne Kaeppler, for generously responding to my inquiries on this matter.

61. Field, in *Paul Gauguin: The Paintings of the First Voyage to Tahiti* (New York: Garland, 1977), pp. 109–15, discusses the various versions of Gauguin's description of *Manao Tupapau*, commenting on previous interpretations of the texts by Goldwater and Rey. Among other issues, Gauguin's dependence on Poe's "Philosophy of Composition" is discussed. Field concludes that the "full-blown essay on *Manao Tupapau* in *Cahier pour Aline* was an amalgamation of the actual Tahitian experience, the formal analysis as first set forth in the two letters of December 1892, and the literary overlay that reflects the ideas of Poe whom Gauguin apparently had just been reading."

62. The idea that the "affect of fear is the beginning of all religion" is traced at least to Hume, and had a strong momentum in Enlightenment thought; see Ernst Cassirer, *The Philosophy of the Enlightenment* (Princeton: Princeton University Press, 1968), pp. 106–07. For Gauguin on comparative religious histories, see *L'Esprit moderne et le catholicisme*.

In *Avant et après*, p. 55, a long passage asks how languages first originated, and examines the question of similarities among languages (translated in Guerin, op. cit., pp. 270–71). This occurs in the same context with Gauguin's rebuttal of immigration theories of Polynesian origins (see note 44). In his exchange with August Strindberg in 1895, Gauguin used an elaborate linguistic (he called it "philological") analogy to compare the Eves of Europe and Oceania, contrasting a developed "langue à flexion" with ruder tongues, "isolés ou soudés sans nul souci du poli." This suggests more than a passing acquaintance with linguistic theory, for the three terms Gauguin uses are those set up by August Schleicher in his *Sprachvergleichende Untersuchungen* (1848–50): inflected (à flexions), agglutinative (soudés), and isolating (isolés). Gauguin's letter to Strindberg is in Malingue, op. cit., pp. 263–64. See Cassirer, *Philosophy of Symbolic Forms*, vol. 1, pp 164–65, for Schleicher's categories.

Cassirer's discussion (beginning p. 186) of theories of progression of representation through three stages—mimetic, analogical, and symbolic—gives the framework for reading Gauguin's account as a paradigm of primal thought. For the relations of language and myth, see Cassirer, vol. 2. In a succinct condensation, Cassirer's *Language and Myth* (New York: Dover, 1953) surveys the connection. On the origins of the first word in the primal imagination of a frightening figure, see pp. 42–43. Cassirer summarizes: "It is evident that myth and language play similar roles in the evolution of thought from momentary experience to enduring conceptions, from sense impression to formulation, and that their respective functions are mutually conditioned" (p. 43). And earlier: "The same function which the image of the god performs [referring to Usener's idea of the 'momentary god' of native fear, espoused in 1896]...may be ascribed to the uttered forms of language....As soon as the spark has jumped across, as soon as the tension of the moment has found its discharge in the word or mythological image, a sort of turning point has occurred in human mentality" (p. 36). See the same volume on "The Successive Phases of Religious Thought," pp. 62–83.

63. Gauguin first mentions the double meaning of the title in letters of December 8, 1892, to Mette (Malingue, op. cit., pp. 61–62) and Daniel de Monfried (*Lettres de Gauguin à Daniel de Monfried* [Paris: George Falaize, n.d.], pp. 61–62). On titles, see Danielsson, "Gauguin's Tahitian Titles," pp. 228–33. In regard to the passage from subjective certainty to the inherent ambiguity of words as central to Primitive experience, see Cassirer, *Philosophy of Symbolic Forms*, vol. 1, p. 178.

64. See, for example, Rey's point of view that Gauguin only needed explanations of symbolism as a sec-

ondary justification for his instinct to pure form, and that such trappings are dispensable for us (in Field's discussion, note 60 above). This seems equally the point of view of Françoise Cachin, who sees Gauguin at his best as an observer, only undermined by his intellectual confusions: "Il faut bien convenir que c'est dans l'observation et non dans une convention ambitieux que Gauguin retrouve sa grandeur." *Gauguin* (Paris: Livre de Poche, 1968), p. 289.

65. C'est donc à la *Raison* seul qu'appartient dèsormais le progrès..." *L'Esprit moderne et la catholicisme*, p. 94.

66. For examples of Gauguin's use of the rational vs. literal distinction, see Guerin, op. cit., pp. 136, 142, 143; for the idea of the Bible's working in parables, p. 147. For the idea that Gauguin himself worked as the Bible worked, see the letter to Fontainas of August 1899, in Malingue, op. cit., p. 293.

67. The revival of eighteenth-century ideas is implicated in the major shift from diachronic to synchronic ways of thinking in the human sciences: in the work of Durkheim and his followers, in Franz Boas's work leading up to the original *The Mind of Primitive Man* of 1911, and in the work of Michel Bréal and Ferdinand de Saussure leading up to Saussure's revolutions in sign theory. See Penniman, op. cit., and Stocking, op. cit., on transformations in anthropology and ethnology in the late nineteenth century. Especially focused on the Enlightenment revival are the essays of Hans Aarsleff in *From Locke to Saussure* (Minneapolis: University of Minnesota Press, 1982), most pointedly in "Bréal vs. Schleicher: Reorientation in Linguistics during the Latter Half of the Nineteenth Century," pp. 293–334. Aarsleff shows that a preference for earlier, more "rudimentary" language forms was not Gauguin's alone in this period (see Gauguin's letter to Strindberg, note 61).

68. Full discussion of this important issue of *völkisch* primitivism is beyond the scope of this essay. See partial consideration of the Northern artistic currents of this movement in Varnedoe, ed., *Northern Light: Realism and Symbolism in Scandinavian Painting, 1880–1910* (New York: Brooklyn Museum, 1982); and excellent historical treatments in George Mosse, *The Nationalization of the Masses* (New York: New American Library, 1975), and *The Crisis of German Ideology* (New York: Schocken, 1981); and in Fritz Stern, *The Politics of Cultural Despair* (Berkeley: University of California Press, 1961).

69. "...cette étincelle, cette propagation lumineuse, immense, de la science, qui aujourd'hui d'occident en orient illumine tout le monde moderne d'une façon déjà si saisissante, si prodigieuse d'effets..." *L'Esprit moderne et le catholicisme*, p. 77.

70. For the discussions of the central nervous system and the atom, see *L'Esprit moderne et le catholicisme*, pp. 15–16. Both of these are what one would call today antireductionist arguments against mechanistic materialism in physics and biology. Gauguin's statements against science, as in his letter to Charles Morice of April 1903 (Malingue, op. cit., p. 319), are rejections of a mode of materialist science then being overthrown from within science itself by discoveries in areas such as radiation. Gauguin's words to Morice—"Nous venons de subir en art une très grande période d'égarement causée par la physique, chimie mécanique et étude de la nature"—are entirely consistent with his welcoming of emergent modern science. Curiously enough, one might once again juxtapose Gauguin and Henry Adams as men of their time, if we compare Gauguin's witnessing of the death of old science to Adams's observations on the same phenomenon in his famous essay on the electric dynamo in Paris, in *The Education of Henry Adams*.

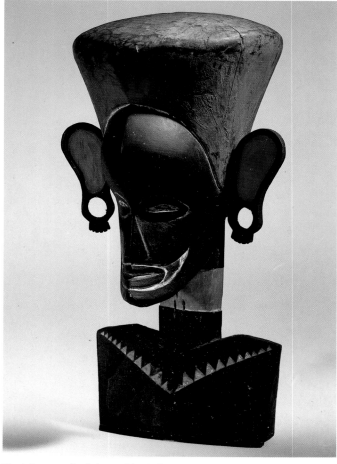

Head. Bougainville, Solomon Islands. Painted wood, 17" (43.2 cm) high. Museum für Völkerkunde, Basel

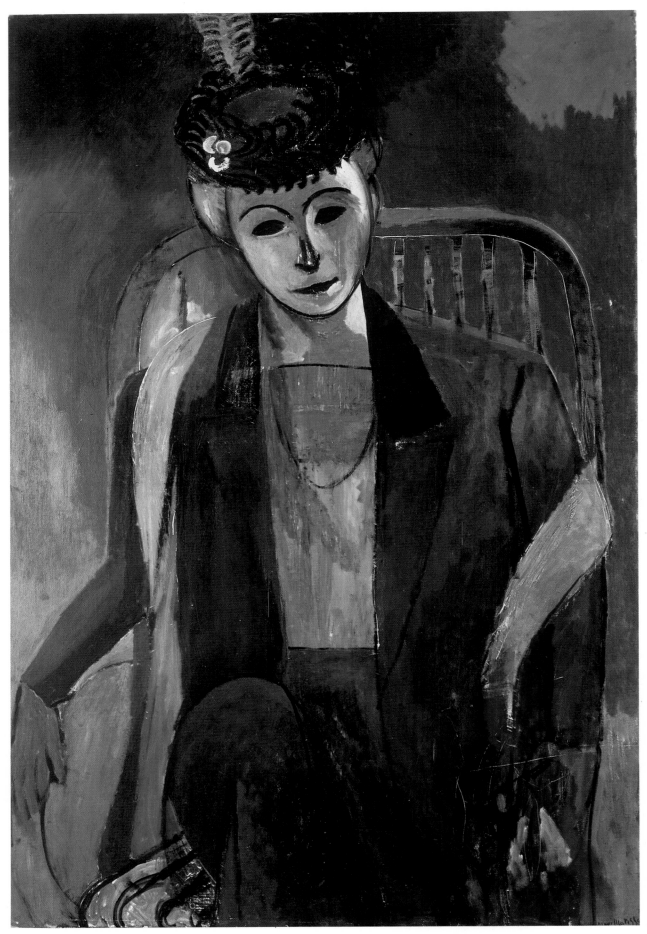

Henri Matisse. *Portrait of Madame Matisse.* 1913. Oil on canvas, 57⅝ x 38¼" (146.4 x 97.1 cm). The Hermitage Museum, Leningrad

MATISSE AND THE FAUVES

Jack D. Flam

It is generally said that Primitive or tribal art was "discovered" sometime around 1905 by a group of French artists who later became known as the Fauves—Matisse, Derain, and Vlaminck. The precise time, circumstances, and effects of that discovery, however, have been the subject of considerable argument, and several factual points and central issues regarding it have not been dealt with adequately.[1] In this essay, I shall firmly establish mid-1906 as the date and discuss the circumstances surrounding the discovery in the light of several issues that are important for an understanding of its significance.

Intellectual and cultural preparation for the discovery of Primitive art preceded by at least a century apprehension of the potential offered by its expressive and plastic means. In fact, tribal art was one of the last of the non-European arts to engage the attention of European artists, and the French artists' interest in tribal art was a relatively late development in the European cult of the Primitive. For tribal art possessed a number of characteristics that made it seem even more remote than other non-Western arts from European sensibility, and (as discussed in the Introduction, pp. 11–13) it was only after some radical changes had been effected within the European tradition that tribal art could profitably be studied by European artists.

Tribal objects as such did not lend themselves to direct appropriation by painters. Tribal sculpture was comprised almost entirely of single figures carved directly in wood, thus using what was at the turn of the century considered a "primitive" material, worked by a "primitive" technique (direct carving).[2] Whereas motifs and pictorial devices from Japanese prints or Southeast Asian reliefs could be adapted to the needs of European painters in a fairly direct way, neither the motifs nor the structural principles of tribal art could easily be assimilated within Western traditions based on Renaissance conventions of pictorial space and canons of the figure going back to antiquity. Not only was tribal art comprised largely of single figures, but the figures themselves also presented the most radical restructuring of the human body that Western artists had yet confronted. Compared to Senufo, Fang, or even Baule figures, for example, an Old Kingdom Egyptian statue, an Archaic Greek Kouros, or an Indian Yaksha figure seems relatively naturalistic and anatomically determined. In African objects, which were generally the first tribal forms to influence French artists, the human body was often radically reinvented by the carver.[3] The usual African proportions—very large head, large torso, prominent genitals, relatively small limbs—are what might be called "social" rather than anatomical proportions.[4] Emphasis is placed on the plastic rather than on the anatomical organization of the figure, which bears only an indirect relationship to the muscle and bone structure, or the actual look, of the human body. The poses of these figures were also difficult to assimilate into European imagery. This was because of their lack of specific action, their symmetry, and their implied removal from space, time, and—perhaps most crucially—gravity. Most sculpture tacitly acknowledges the force of gravity, either by submitting to or struggling against it; and most figurative painting, no matter how stylized, creates a space within which the force of gravity is at least implicitly acknowledged. In most African sculptures—with their small size, symmetrical, bent-kneed poses, and frequent lack of a base—gravity, time, and surrounding space are simply not taken into account.[5] Since

211

African wooden figures are essentially portable objects—in contrast to the monumental or architectural sculpture common to most of Europe and Asia—their removal from time is reinforced by their dissociation from a specific place.

The subject matter of African art was also not understood. It appeared to have no narrative content, unlike Chinese or Japanese art, the development of which could be charted historically, and which also had, as well as a frequent narrative component, a repertory of attributes and symbols that were fairly well known. The figures in African art, on the other hand, were not engaged in any recognizable activity but were represented outside man's ordinary pursuits, ordinary time, and usual space. Thus, aside from what was regarded as their "deformed, hideous,"[6] and hence "barbaric" quality, they evoked a strong sense of mystery.

African art was also removed from time in another important sense, for at the beginning of the century its historical development was unknown, so that it seemed to exist in a kind of temporal vacuum. Its anonymous creators and their uncharted cultures had thus been able to escape the tyranny of nineteenth-century historicism—although in popular evolutionary thought they were nevertheless believed to represent the "beginning" of man's development.[7]

But early in the twentieth century, the very characteristics of African art that had previously barred it from access to Western sensibility began increasingly to correspond to needs and tendencies that were being felt in Europe. Around 1906, progressive painters were seeking alternatives to an imagery burdened with optical effects, circumstantial details of the material world, and narrative. This coincided with a deep interest in new ways of combining the ideal and the real, and of synthesizing the conceptual and the perceptual. The two main historical sources of these interests were the art of certain of the Post-Impressionists, who had successfully—if unsystematically—attempted just such a synthesis, and various exotic and nonnaturalistic arts, pictorial (Japanese prints and Persian miniatures) and sculptural (Egyptian, ancient Near Eastern, and pre-Roman Iberian stone carvings).[8]

Gauguin was the only major artist who had actually lived for an extended time in places where Primitive art was made. Its influence on his woodcuts and sculptures was sometimes quite direct, but on his paintings only rare and usually indirect, for in them the pictorial conventions of European art—and the exotic court arts—were predominant.[9] This was remarked by Maillol, who observed that Gauguin "should have sculpted as he painted, by drawing upon nature as well, instead of making women with large heads and tiny legs. He had two ideas, one in painting and another in sculpture: he was split in two."[10]

In fact, this dichotomy between sculpture (the medium of most Primitive art) and painting (the preeminent form of European expression) characterized much of the early contact with Primitive art. The exoticism of Gauguin's paintings probably had little impact upon his contemporaries, but his sculptures and woodcuts were to provide significant primitivist models for artists of the succeeding generation, in Germany as well as in France. The large retrospective of his work at the 1906 Salon d'Automne acted as an important catalyst. It led to a marked interest in the straightforward, simple style of woodcuts, and within the next year several of the younger artists—notably Derain, Matisse, and Picasso—tried their hand at direct carving in ways recalling Gauguin.

By contrast, any role that Cézanne played in the "discovery" of Primitive art was entirely indirect. Cézanne himself expressed no interest in exotic or tribal cultures; yet, if Gauguin helped open the younger artists' eyes to the expressive qualities of Primitive art, it was Cézanne who helped make them receptive to its plastic qualities.

The so-called Fauve style, which reached its culmination between mid-1905 and mid-1906, was essentially pictorial and perceptual. It was a late phase of Post-Impressionism, in which purely optical effects were given greater emphasis than sculptural forms, and color took precedence over modeling. By the spring of 1906, however, the Fauve painters had become increasingly desirous of giving greater stability to their pictures and achieving a more even balance between color and modeling. This new interest in sculptural form (which was paralleled in the work of Picasso) was most clearly marked in the work of Matisse but was also evident in that of Derain and, to a lesser degree, of Vlaminck.[11]

The guiding light for this new balance between surface design and modeling was Cézanne. His drastic simplifications of form and his ability to achieve sculptural effects through faceted planes of color opened up new possibilities for the younger artists and presented them with both a challenge and a dilemma. For while Cézanne pointed the way to a new vision, the almost overwhelming force of his art and its potential influence also created a kind of impasse. It was here that the example of African art could become especially useful. Although African art, like some Post-Impressionist painting, placed strong emphasis on abstract structure and conceptual, rather than perceptual form, it did not occupy the same territory. African art was even less optical, less literally descriptive, and more overtly symbolic than that of the Post-Impressionists. And because its iconographic content and its history were unknown, it not only provided a way of circumventing Post-Impressionism but also opened up a path beyond history and inherited cultural traditions.

The latter point is important, for in allowing the young artists to move beyond the constraints of history, tribal art also provided them with an antidote to their sense of artistic belatedness—the feeling that they were working at the end of a tradition whose possibilities had already been explored, thus blocking the way to their own originality.[12] At a time when the influence of the great Post-Impressionists seemed to impede their progress within the European tradition, and most of the exotic, non-Western arts had already been exploited, African art offered the possibility of a new beginning.[13]

Much ink has been spilled over the question of precisely who first "discovered" tribal art and rescued it from the obscurity of the ethnographical museums—as if such a "discovery" were analogous to the notion of priority that we commonly associate with scientific discovery. In fact, there was no single "discoverer." As in all cases in which we deal with artistic influence, we must consider complex networks of reaction and counterreaction. When we speak of the "discovery" of Primitive art, we refer to the time at which artists began to see tribal objects as being more than mere curiosities of purely ethnographic interest, and perceived in them characteristics they

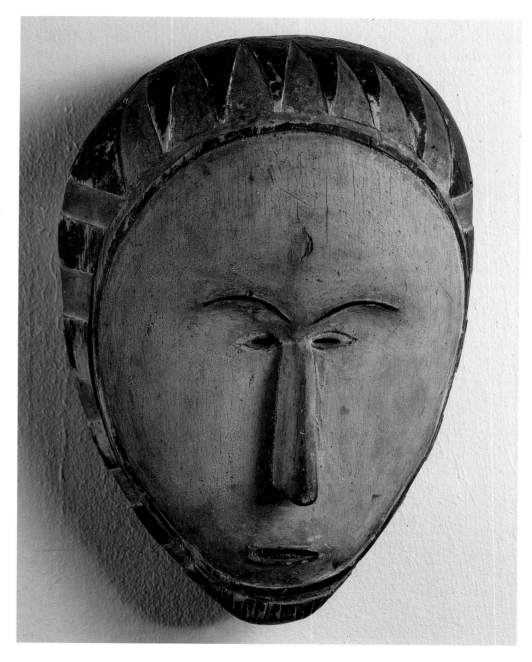

Left: Mask. Fang. Gabon. Painted wood, 18⅞" (48 cm) high. Musée National d'Art Moderne, Centre National d'Art et de Culture Georges Pompidou, Paris. Formerly collections MAURICE DE VLAMINCK, ANDRÉ DERAIN

Below: Maurice de Vlaminck. *Bathers.* 1908. Oil on canvas, 35 x 45⅝" (88.9 x 115.9 cm). Private collection, Switzerland

could assimilate into their own art. Thus, when we address the notion of a "discoverer" of tribal art, we must ask ourselves just what it was that the discoverer himself was looking for, what he thought he had discovered, and what use he was able to make of his discovery.

The earliest and most persistent claim to having been the lone "discoverer" was made by Maurice Vlaminck, and his right to that distinction is still given great credence.[14] According to his own somewhat contradictory accounts, he first became aware of the aesthetic value of African art sometime between 1903 and 1905.[15] From his various statements, the following history can be constructed:

After having painted out-of-doors on a hot, bright day, Vlaminck stopped at a bistro in Argenteuil for some refreshment. As he stood drinking, he noticed on a shelf behind the bar three African objects. Two of them, painted red, yellow-

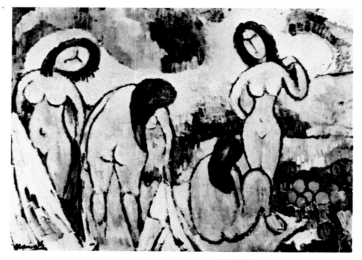

ocher, and white, were Yoruba pieces from Dahomey, and a third, unpainted and quite dark, was from the Ivory Coast.[16] So struck was he by the force of these objects that he persuaded the owner to let him have them in exchange for buying the house a round of drinks.

Shortly afterward, Vlaminck showed these works to a friend of his father's, who in turn gave him three more African objects—two statues and a large whitish Fang mask (p. 213), which the man's wife had found revolting and had threatened to throw into the trash. When Derain later saw this mask hanging above Vlaminck's bed, he was deeply impressed and offered twenty francs for it. Vlaminck refused, but a week later, being short of cash, he sold it to Derain for fifty francs. According to Vlaminck, Derain then took the mask to his studio on the Rue Tourlaque, and it was there that Picasso and Matisse saw it and were supposedly first incited to enthusiasm for tribal art.[17]

Vlaminck stated that he had already seen African sculptures on several visits to the Trocadéro museum with Derain, but he had then regarded them merely as "barbaric fetishes" of no particular aesthetic interest.[18] In the bistro at Argenteuil, however, he reacted quite differently. So shaken was he by the

African objects there that he later regarded the incident as a "revelation," a word possibly borrowed from Picasso.[19]

Vlaminck was apparently quite fond of telling embroidered versions of this story, and it eventually became the most frequently cited account of the discovery of Primitive art. In addition to his own published writings, Vlaminck appears to have been the source of other accounts that attributed to him not only a key role in the "discovery" of tribal art but also in opening the eyes of Matisse and Picasso to it.[20] In one of the most elaborate of these versions, Francis Carco relates that Vlaminck showed an African sculpture to Derain, remarking that it was "almost as beautiful" as the Venus de Milo. Derain then supposedly replied that it was "*as* beautiful" as the Venus. The two men then decided to show the sculpture to Picasso, Vlaminck once again saying that it was "almost as beautiful," and Derain repeating that it was "as beautiful," as the Venus de Milo. Picasso is then alleged to have topped them both by declaring that it was "even *more* beautiful."[21]

As Jean Laude has pointed out, Vlaminck's memoirs are replete with self-deception, contradiction, and outright lies.[22] The question of priority was obviously very important to Vlaminck. His supposedly crucial role in the "discovery" of

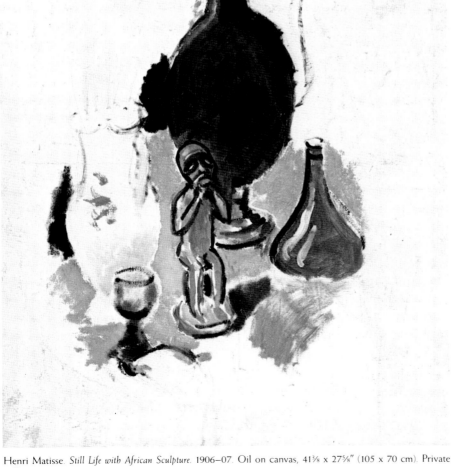

Henri Matisse. *Still Life with African Sculpture.* 1906–07. Oil on canvas, 41⅜ x 27⅝" (105 x 70 cm). Private collection

Figure. Vili. People's Republic of the Congo. Wood, 9⅜" (24 cm) high. Private collection. Formerly collection HENRI MATISSE

African art, which was subsequently to be so significant for the development of modern art, was a stratagem to aggrandize the part he had played in that larger history. If we examine his accounts, we quickly realize that what most impressed Vlaminck in the bar at Argenteuil was precisely the same "barbarism" that he had felt when he had seen the African objects in the Trocadéro museum. In that setting, however, the objects had been sealed off in glass cases and presented as "curiosities." His frame of mind was evidently quite different at Argenteuil, where the interior of the bar would have been cool and dark, in contrast to the bright sunlight and intense heat in which he had just spent several hours painting. He was tired, his defenses were down, and he was drinking; he was surrounded by sailors and workingmen, not accompanied by a sophisticated colleague. By his own account, what then struck him was not the plastic originality of the African sculptures but their instinctive expressiveness.[23]

Furthermore, although painted sculpture is relatively rare in Africa, two of the three pieces that Vlaminck professed to have seen on that occasion were polychrome Yoruba works from Dahomey, with a general range of color not too far from the one he was using in his own painting at the time. In other words, what initially most impressed Vlaminck was an affirmation of the van Gogh–inspired expressionist direction that his own art had already taken, and a reinforcement of a Gauguin-inspired interest in the exotic and mysterious.[24]

Vlaminck's interest in African art was really only another manifestation of the general feeling for primitivism that was current at the time. (In fact, before the Fauve period Vlaminck himself had been interested in, and collected, examples of popular and folk art, such as puppets and *images d'Épinal*, which he later intimated might have prepared him for an appreciation of African art.[25]) His subsequent inspiration by African art bears out this contention, for although the expressive possibilities in what he perceived as the extreme emotionality and instinctive expressiveness of that art may have served as a kind of general catalyst for greater freedom in his work,[26] it had virtually no discernible influence upon it. For one thing, Vlaminck was primarily a landscape painter, and the possibilities of Primitive art were most clearly assimilable to the handling of the human figure. One of the few instances in which any sort of African influence can be seen is in his *Bathers* of 1908 (p. 213). In this, the faces of the two frontal figures appear to have a strong—in fact, embarrassingly literal and banal—resemblance to the Fang mask he had sold to Derain two years earlier. Compared to the contemporary work of Derain, Matisse, or Picasso, however, this painting is most noteworthy for the rather poor understanding it reflects of either Cézanne or Primitive art.

Aside from the contradictions contained in Vlaminck's differing accounts of his "discovery," and in those of others for which he was the source, there are important discrepancies regarding the date of the event. It is variously either undated,[27] given as 1903,[28] or, in his most elaborate account, said to have been in 1905[29]—the date usually accepted in subsequent literature. It appears, however, that the actual date was neither 1903 nor 1905, but 1906—around the time that Matisse, for very different reasons, was also becoming much interested in African art.

The evidence for the 1906 date is as follows. First, Derain did not move into his Rue Tourlaque studio until the autumn of

André Derain. *Crouching Man.* 1907. Stone, 13 x 10¼ x 11⅛" (33 x 26 x 28.3 cm). Museum des 20. Jahrhunderts, Vienna

1906.[30] Thus, if Derain brought the Fang mask he purchased from Vlaminck to that studio shortly after acquiring it, the date could not have been in 1905.[31] Further, Matisse, who as we know from reliable sources first became seriously interested in African sculpture in 1906, later implied that Derain had bought the famous Fang mask from Vlaminck *after* Matisse himself had purchased his first African piece in the autumn of 1906.[32]

The 1906 date also accords better with some significant circumstantial evidence. It explains some of the apparent discrepancies in accounts by such writers as André Salmon and Max Jacob, who associated Picasso's introduction to Primitive art with Derain,[33] and it explains why Derain's response to African art in his own work did not occur until the autumn of 1906.[34] It suggests that Derain became eager to acquire Vlaminck's Fang mask because he had already seen the 1906 Gauguin retrospective and begun to understand the potential value of Primitive art.[35] It also seems plausible that Vlaminck's appreciation of African art related precisely to the conflict between the perceptual and the conceptual that was preoccupying the Fauve painters in 1906—a problem that they felt more acutely then than they had the year before, when they first became concerned with freeing themselves from Neo-Impressionism.

Placing Vlaminck's discovery in 1906 also impels us to reevaluate the role that Derain played in Vlaminck's preparation for appreciating African art. There is evidence that the two men had discussed African art in some detail before the summer of 1906, and that Vlaminck had been prepared for his revelation by conversations and correspondence on the subject with Derain. Of particular importance in this context is a letter from Derain to Vlaminck, which is simply dated "*Londres, 7 mars,*" without the year.[36] Derain mentions his visit to

the "*Musée nègre*" (the British Museum's ethnographic collections) and writes of his experience there:

It is amazing, disquieting in expression. But there is a double reason behind this surfeit of expression: the forms issue from full outdoor light and are meant to function in full outdoor light.

This is the thing to which we should pay attention in terms of what, in a parallel way, we can deduce from it.

It is thus understood that the relations of volumes can express a light or the coincidence of light with this or that form.[37]

Goldwater, who dated this letter to 1910, gave it as an example of the sort of admiration for Primitive art that "did not come about before the time of the cubists...."[38] But Laude has convincingly shown that the letter is earlier than 1910 and was probably written in 1906—in any case, not later than 1907.[39] If, as seems likely, it was written in March 1906, then it precedes Vlaminck's "discovery" by several months and gives evidence that Derain's interest in African art as a possible source of inspiration preceded his purchase of the Fang mask from Vlaminck. Since it was probably Derain, who frequently went to museums, who had initiated the two friends' visits to the Trocadéro,[40] we are further led to speculate that it may have been he who first aroused Vlaminck's interest in African art, even though the latter was the first to acquire African objects. In any event, we do know that Derain, like Vlaminck, had several years earlier expressed interest in "primitive" art of another sort. "I should like to study the art of children," he had written to Vlaminck in 1902. "Truth is doubtless there."[41]

Also of particular interest in Derain's 1906 letter from London is his reference to "volumes," and his remark earlier in the same letter that "it is absolutely necessary to break out of the circle in which the Realists have enclosed us."[42] This clearly relates Derain's interest in tribal art to the main concerns of his painting at this time: a search for greater plasticity and a need to move away from the "realist," perceptual basis of the 1905 Fauve style. It is not unreasonable to assume that these concerns may also have contributed to his desire to acquire the Fang mask from Vlaminck in the fall of 1906.

Matisse seems to have come upon African tribal sculpture at about the same time as Vlaminck, and the motivations and consequences of his discovery are far more interesting and important. His interest in African art appears to date from the spring of 1906—around the time of his first visit to North Africa, in March of that year.[43] He may well have seen such sculpture before then, since it had been on public exhibition in the Musée d'Ethnographie in Paris for over two decades, and Matisse, like Derain, was a great frequenter of museums. In any case, it had not had any effect upon him, for until 1906 there was no way in which he could relate it to his own work.[44]

By the beginning of 1906, however, several factors had opened Matisse's eyes to the expressive and plastic qualities of African sculpture. At that time, he was the only vanguard painter with a profound and consistent understanding of Cézanne. Picasso's sense of the Master of Aix was still fragmentary, and Braque and Derain would begin fully to grasp the lessons of his art only during the ensuing year. Matisse, on the other hand, had purchased from Vollard a small, powerful *Three Bathers* by Cézanne as early as 1899. For several years, he had discussed the intricacies of Cézanne's paintings with his colleagues, and Cézanne had been the strongest single influ-

ence on his work since the turn of the century. Matisse's so-called Fauve period, which ended in the winter of 1906–07, was a relatively brief transitional phase between his earlier, directly perceptual—essentially Post-Impressionist—work and his more synthetic later styles. It was not until toward the end of his Fauve period, when his painting once again became more sculptural and his colors generally less intense, that Matisse was able to revaluate his own earlier responses to Cézanne and, in doing so, make indirect use of tribal art. Whereas for Vlaminck that art was associated primarily with emotional or romantic primitivism, akin to the attitude of Gauguin, for Matisse African art suggested new plastic possibilities for sculpture and, through it, for painting—and a new way of dealing with the heritage of Cézanne.

Unlike Vlaminck's aggrandizement of his own importance by insisting that it was he who introduced Matisse and Picasso to African art, Matisse's claims were not only more modestly stated and dispassionate but are also verifiable by disinterested third parties. In *The Autobiography of Alice B. Toklas*, published in 1933, long after she and Matisse had ceased to be friends, Gertrude Stein states unequivocally that Matisse had "introduced Picasso to Negro sculpture," and that "it was Matisse who was first influenced, not so much in his painting but in his sculpture, by the african statues and it was Matisse who drew Picasso's attention to it just after Picasso had finished painting Gertrude Stein's portrait."[45]

Matisse himself later elaborated upon this account in an unpublished 1941 interview:

I came to [African sculpture] directly. I often used to pass through the Rue de Rennes in front of a curio shop called "Le Père Sauvage,"[46] and I saw a variety of things in the display case. There was a whole corner of little wooden statues of Negro origin. I was astonished to see how they were conceived from the point of view of sculptural language; how it was close to the Egyptians. That is to say that compared to European sculpture, which always took its point of departure from musculature and started from the description of the object, these Negro statues were made in terms of their material, according to invented planes and proportions.

Derain in his studio, winter 1908–09. Photograph published in G. Burgess, "The Wild Men of Paris," *Architectural Record*, 1910

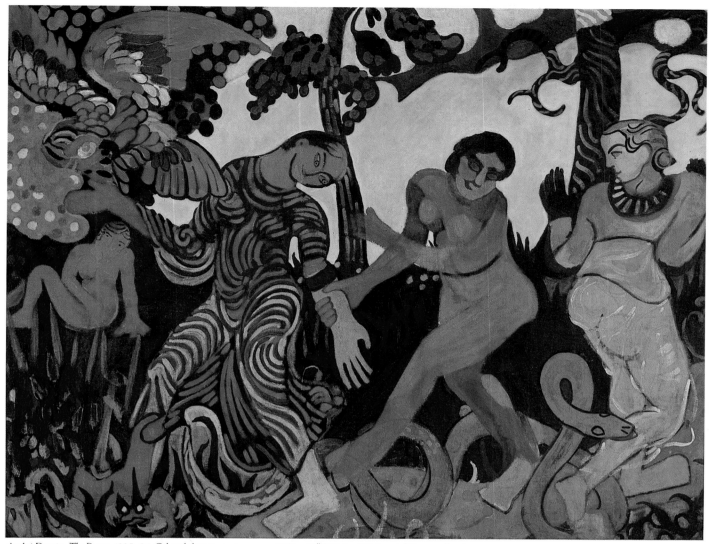

André Derain. *The Dance*. 1905–06. Oil and distemper on canvas, 70¾ x 90" (179.5 x 228.6 cm). Private collection

I often used to look at them, stopping each time I went past, without any intention of buying one, and then one fine day I went in and I bought one for fifty francs.

I went to Gertrude Stein's house on the Rue de Fleurus. I showed her the statue, then Picasso arrived. We chatted. It was then that Picasso became aware of Negro sculpture. That's why Gertrude Stein speaks of it.

Derain bought a large mask. It became of interest to the group of advanced painters.[47]

When Picasso himself recalled his first encounter with African art, he too asserted that it was Matisse who first showed it to him, and even noted that Matisse had talked about Egyptian art at that time, although when Picasso became interested in Primitive art the following spring, he saw it in a very different way.[48]

It has often been said that the Fauves were not really influenced by Primitive art in their own work. According to Ettlinger, for example, "It should be stressed that Matisse and the Fauves, their enthusiasm apart, learned little if anything directly from African art, as Guillaume Apollinaire pointed

out as early as 1907."[49] In the case of Derain, and especially of Matisse, this is simply not true, as we shall see; the influence of African art upon them coincided with the end of their Fauvism.

As was remarked earlier, in considering the question of the "discovery" of Primitive art one must take into account what the discoverers were looking for, what they thought they had discovered, and what use they were able to make of their discovery. Vlaminck, as we have seen, was seeking instinctive expressiveness and a kind of "barbaric" wildness, and that is what he found. But beyond a certain sentimental romanticism—and here Ettlinger is quite right—he seems to have learned little directly from African art.

Derain, on the other hand, did attempt to make use of what he saw. His point of departure, like that of Vlaminck, was Gauguin—but Gauguin the sculptor rather than Gauguin the painter—and the influence is most evident in the sculptures he executed early in 1907. Not surprisingly, however, Derain had more difficulty in assimilating into his paintings the structural features of African art.

As Ron Johnson was first to point out, Derain began his earliest direct carvings in the fall of 1906, probably in

André Derain. *Bathers*. 1907. Oil on canvas, 52 x 76¾" (132.1 x 194.8 cm). The Museum of Modern Art, New York; William S. Paley and Abby Aldrich Rockefeller Funds

response to the Gauguin retrospective at the Salon d'Au-tomne, which included a number of Gauguin's wood carvings and sculptures.[50] It has often been remarked that Derain's use of direct carving in the sculptures he executed between the fall of 1906 and October 1907 owed a good deal to Gauguin's example. Equally significant, however, is the fact that Derain did many of his carvings not in wood, as had Gauguin, but in the more resistant medium of stone, although in order to do so he had to use "blocks of building stone appropriated from the front steps of the Derain family house" at Châtou.[51] His choice of stone was a conservative one, since for several millennia stone had been the preferred medium of European sculpture, and its use thus gave a certain inherent legitimacy to his undertaking. Further, the more resistant medium enabled Derain to avoid slavish imitation of either Gauguin or the Primitive carvers. Stone also provided a material whose sur-face could be left relatively rough without looking merely unfinished, and the rough surface of Derain's stone sculptures reinforces a general impression of their "primitiveness."

Although sculptures such as *The Twins* and the *Standing Woman*[52] are fairly naturalistic in their poses (and the volup-tuous *Standing Woman* is closer in pose, modeling, and material to the sculpture of India than to that of Africa or Oceania), the heads in both works are simplified in an Archaic manner. Indeed, the head of the *Standing Woman* suggests a curious mixture of Archaic Greek influence and the visage of Derain's own Fang mask—a melange that indicates again how unradical, almost "archaic," the features of that mask are.

The most famous, most influential, and probably most interesting of Derain's sculptures is the *Crouching Man* (p. 215), which is said to have directly influenced Brancusi's *Kiss*.[53] The blockiness of this work, the compactness of its forms, and the contrast between the pent-up energy of the figure and the cubic geometry of the stone make this Derain's most original and affecting piece of sculpture. It is also fre-quently cited as demonstrating the influence of tribal art on Derain's sculpture.[54] Such details as the large hands, the geometric rendering of the fingers, and the overall com-pactness of the sculpture have been related to stone figures from the Marquesas as well as to the sculpture of Gauguin.[55] But the figure's self-contained inwardness is, both physically and psychologically, quite unlike that of Marquesas sculpture or of Primitive art in general. In fact, as Johnson has pointed out, this emphasis upon an inner state clearly relates the figure to Symbolist art.[56] Further, the cubic form of *Crouching Man* and the angular, high-relief carving of the anatomical details, as well as the material itself, relate it more to Aztec than to tribal sculpture.

The two documented sculptures by Derain that do seem to show a direct influence of tribal art have unfortunately been lost. Both appear in a photograph of the artist taken in the winter of 1908–09 and published by Gelett Burgess in 1910 (p. 216).[57] The sculpture that Derain holds in his arms in the photograph is his small *Cat*, which was carved in wood and painted "mostly green with touches of red on the face."[58] The size, shape, and coloration of this piece recall Picasso's small

André Derain. *Bathers*. 1908. Oil on canvas, 70⅝ x 91¼" (179.4 x 231.7 cm). National Gallery, Prague

1907 sculptures,[59] as well as the cylindrical carvings of Gauguin. The larger carving seen in the lower right foreground is even more striking in its overt resemblance to tribal art—so much so that it could almost be called an imitation or pastiche of a tribal object—its head resembling certain Fang masks, and its body a Polynesian Tiki.[60]

In Derain's primitivist paintings, the relationships to tribal art are more tenuous. In *The Dance* (p. 217), completed in 1906 from sketches begun the previous year, a painting which was quite obviously done as a response to the canvases of Gauguin, Derain employed a curious hodgepodge of stylistic elements. The right-hand figure seems to recall in its type the same sort of East Asian forms that Gauguin had used in his paintings, and that has echoes in Derain's *Standing Woman*, while its pose is taken directly from the figure of the Negress at the right in Delacroix's *Women of Algiers*.[61] The figure in the center foreground is—given the picture's stylistic vocabulary—relatively naturalistic, apart from its bright red coloring. The foreground figure at the left is a curious amalgam in which the contortions of the body and the swirling, linear forms of the drapery are more suggestive of such Romanesque works as the famous figure of Isaiah at Souillac than they are of tribal art.[62]

A similar Gauguinesque eclecticism, Gauguin-inspired curvilinearity, and crowding of the forms into the frontal plane are also evident in the two wooden panels that Derain carved in 1906–07 to decorate a bed.[63] The face of the woman in the smaller panel, which is reminiscent of Gauguin's Tahitian

women, might be said to bear a relation to the face of Derain's Fang mask, but if so, it is a tenuous one indeed.

Probably the work most frequently cited as demonstrating a direct link between Derain's painting and tribal sculpture is his *Bathers* of 1907.[64] On the basis of the simplified face of the central figure, Derain has been called "the first painter to combine in a single work the influences of both Cézanne and Negro art,"[65] a judgment that has often been cited.[66] This assertion, however, is clearly unacceptable, for there is no African influence, direct or indirect, in this face or anywhere else in the painting. Although the planes of the figure's head and neck are simplified, the nature of the simplification and the pose of head and neck are quite un-African. Rather, they reflect a general archaizing tendency, not unlike that in Matisse's sculpted heads of 1906 discussed below. Elsewhere in Derain's picture, the drawing of the figures is based on a rather carefully and logically delineated articulation of the anatomy. The contrapostal poses are well within the received tradition and seem to be based on studio drawings done directly from the live model. Quite superficial, likewise, are the obvious references to Cézanne. Despite the Cézanne-like coloring, the vaguely Cézannesque brushstroke, and a certain angularity in the drawing and modeling, these figures are so literal, so static, and so entirely separated from the background against which they are placed, that they have almost nothing in common with the inner dynamics of the Cézanne Bather paintings from which they derive.[67] Not until the following year did Derain manage successfully to combine

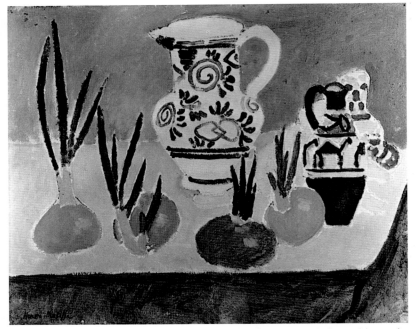

Henri Matisse. *Still Life with Geranium Plant.* 1906. Oil on canvas, 38½ x 31½" (97.8 x 80 cm). The Art Institute of Chicago; Joseph Winterbotham Collection

Henri Matisse. *Pink Onions.* 1906. Oil on canvas, 18⅛ x 21⅝" (46 x 54.9 cm). Statens Museum for Kunst, Copenhagen; J. Rump Collection

"Cézanne and Negro art." In his 1908 *Bathers*, now in Prague (p. 219), the three upper heads bear at least some relation to African masks, while the interaction between the figures and the background, as well as some of the poses, is clearly Cézannesque. But by 1908 Picasso had already achieved a much more radical combination of Cézanne and tribal art, so neither of Derain's *Bathers* can be considered "a true forerunner of Cubism."[68]

The photograph of Derain (p. 216) from the winter of 1908–09, discussed above, sets forth perhaps more clearly than any other document of the period the various components of the artistic problems current at the time. The small primitivist *Cat* Derain holds in his arms and the standing figure at the lower right, with its "tribal art" features, show just how un-African really are the two stone sculptures seen beside him, the *Standing Woman* and the *Crouching Man* on which it rests. On the wall above, looking out over the room like a personal icon or the shrine of a household deity, is a reproduction of Cézanne's *Five Bathers* of 1885–87, now in the Kunstmuseum of Basel (Venturi 542). The juxtaposition of these objects is an embodiment of Derain's preoccupations since 1906, when he began to seek a way to combine the nonperceptual solidity of tribal sculpture with the intense color and sometimes violent emotions of his Fauve paintings. Although he realized that one way to achieve this synthesis was by reinterpreting the reductive and sculptural qualities of Cézanne's figures in terms of the more radical forms of Primitive art, this was a goal he was not able to attain. "Even in 1907," as John Elderfield has noted, "Derain, though full of admiration for African sculpture, was unable fully to use its lessons in his work."[69] What he *was* able to achieve through the combination of Primitive art and Post-Impressionism was a modest extension of the synthesis that Gauguin had better realized several years earlier. In spite of the concern with sculptural modeling and the need to break away from realism

that Derain expressed in his March 1906 letter to Vlaminck, his strongest and most original works seem, in fact, to have been those he painted perceptually, directly from nature. When he tried to give his art a stronger conceptual basis, his paintings tended to become dry and somewhat lifeless. Ironically, his pioneering role notwithstanding, tribal art and other conceptual styles—most notably Cubism—ultimately had a less than vitalizing effect on his work, which after 1906 never again achieved the force and originality that it had during his Fauve years.

The interviews that Gelett Burgess conducted during the winter of 1908–09 provide a convenient point of departure for our discussion of Matisse. It was Matisse who gave Burgess the names of the seven artists that he subsequently interviewed;[70] and it was Matisse whom Burgess considered to have been the first to appreciate the plastic values of African sculpture: "Since Matisse pointed out their 'volumes' all the Fauves have been ransacking the curio shops for Negro art."[71] Moreover, Burgess also recognized the underlying aesthetic revolution that was implicit in the discovery of Primitive art. "I had mused over the art of the Niger and of Dahomey," Burgess wrote toward the beginning of his essay, "I had gazed at Hindu monstrosities, Asian mysteries and many other primitive grotesques; and it had come over me that there was a rationale of ugliness as there was a rationale of beauty; that, perhaps, one was but the negative of the other, an image reversed, which might have its own value and esoteric meaning. Man had painted and carved grim and obscene things when the world was young. Was this revival a sign of some second childhood of the race, or a true rebirth of art?" He continued a couple of paragraphs later: "It was Matisse who took the first step into the undiscovered land of the ugly."[72]

Seen from the perspective of today, Burgess's remarks, with

their lumping together of such diverse forms of art as "primitive grotesques," appear quaint and not too dissimilar from other disparaging writings of the period. But Burgess, who was himself a painter, seems to have been sincerely seeking enlightenment about the current artistic situation,[73] and his observation about a new aesthetic of ugliness touches upon one of the most important relationships between Primitive art and modern painting. Burgess seems to have realized that in the new artistic revolution taking place in Paris, old notions of beauty were being superseded by new values. In 1906, Matisse was the leader of this revolution, and tribal sculpture, of which he then became aware, was to prove an important catalyst for the realization of his goals.

During the summer of 1906, between his return from North Africa and his first purchase of an African sculpture, Matisse was looking for nothing less than a new aesthetic basis for his art. He was seeking to synthesize the art of Cézanne—which at that time he understood better than did any other painter—with the art of Gauguin and a general primitivism such as could be found in folk and children's art (and perhaps also in the painting of Henri Rousseau, who had been included in the "Fauve" Salon d'Automne of 1905).[74] These two modes corresponded to very different ways of handling form and space. The first involved sculptural relief modeling and tangible, but nonperspectival, space; the second, flat bright colors and a decorative flatness in the rendering of figures, objects, and background. The polarity between these modes can be seen in two pairs of paintings that Matisse did at Collioure shortly after this return from North Africa: the *Still Life with Geranium Plant* and the *Pink Onions*, and the two versions of *The Young Sailor*.

The two still lifes include arrangements of similar objects—pink onions, North African folk pottery, and a terra-cotta version of Matisse's sculpture, *Woman Leaning on Her Hands*, of 1905. The formal differences between the two paintings are so strong, however, that at first one hardly recognizes this. *Still Life with Geranium Plant*, the earlier of the two, is decidedly more traditional in its rendering. It is painted from a single viewpoint (as evidenced by the insistent perspective of the table and the objects upon it), has clear indications of cast shadow, and a strong sense of atmospheric space. The handling of the contours, the brushstroke, and the use of *passage* are, at the same time, Cézannesque. The matrix of the image, as in Cézanne's paintings, is still rooted in sensory perception, and the representation on the whole is fairly naturalistic.

In the *Pink Onions*, on the other hand, the objects are simplified and flattened like those in a child's drawing.[75] They are placed in an abstract space, unrelated to a specific viewpoint, devoid of atmosphere, and without light and shadow. Here, Matisse has employed a simplified, primitivist technique to diminish the sense of actuality and emphasize the symbolic relationships among the objects. The onions seem virtually to be growing through the sandy, earthlike surface of the table, and the spirals on the large vase function as a symbolic articulation of the force of this growth. The female figure and the camels on the vase complete the quartet of symbols—woman, animal, spiral, plant growth. This subtle, restrained, and wholly pictorial kind of symbolism, in which objects and the way they are rendered are inseparable functions of their "meaning," is one of the most striking innovations in Matisse's art during the summer of 1906.

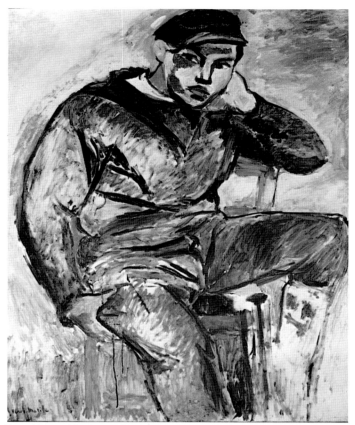

Henri Matisse. *The Young Sailor I.* 1906. Oil on canvas, 39½ x 31" (100.3 x 78.7 cm). Private collection

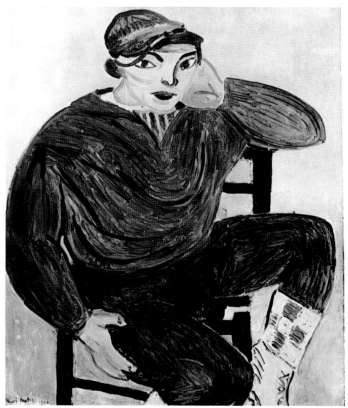

Henri Matisse. *The Young Sailor II.* 1906. Oil on canvas, 39⅜ x 31⅞" (100 x 81 cm). Private collection

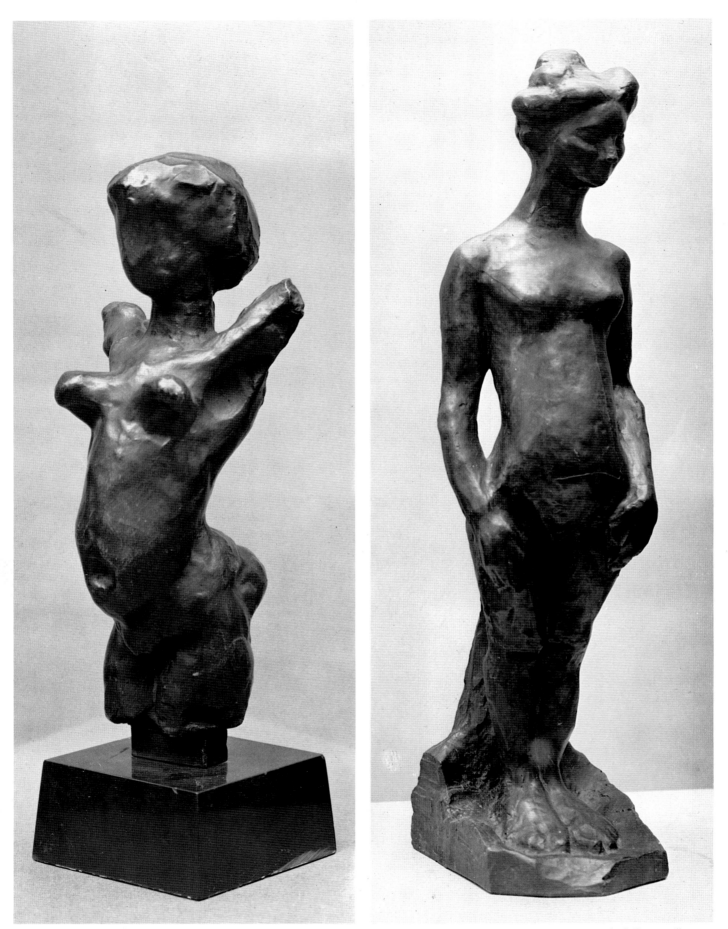

Henri Matisse. *La Vie*. 1906. Bronze, 9⅛" (23.2 cm) high. The Metropolitan Museum of Art, New York; Alfred Stieglitz Collection

Henri Matisse. *Standing Nude*. 1906. Bronze, 19" (48.2 cm) high. Private collection

A similar polarity between Cézannism and primitivism can be seen in the two versions of *The Young Sailor*. The first version has a somewhat harsh, aggressive intensity (not unlike Matisse's *Self-Portrait* of the same period in the Statens Museum for Kunst, Copenhagen); the rendering combines vestiges of his Fauve style with a decidedly Cézannesque handling of color, brushstroke, and spatial construction. The second version, which followed shortly afterward, was not done directly from the model, but from the first painting. This was in accordance with a procedure that Matisse had begun about 1904, and which he would continue in the future in numerous pairs of paintings based on the same motif.[76] His first rendering of a theme would be perceptual; the second version, a picture based on that picture, would be more synthetic. In this way, he was able to retain his intense contact with nature and at the same time distance himself somewhat from wholly perceptual rendering. Leo Stein remembered well this early instance of such a procedure: "One summer he brought back from the country a study of a young fisherman, and also a free copy of it with extreme deformations. At first he pretended that this had been made by the letter carrier of Collioure, but finally admitted that it was an experiment of his own. It was the first thing he did with forced deformations."[77] Stein's term "forced deformations" is an apt one. Up until then, the deformations in Matisse's work had come directly from his visual and emotional response to what he was painting; they were done in the heat of battle. Here, on the other hand, the picture has been consciously synthesized and intellectually willed. The first version of *The Young Sailor* reflects the excite-ment provoked by direct encounter with the motif—what Matisse referred to as the shock of confrontation;[78] the second version is a meditation on that encounter and a render-ing of it in conceptual terms. By working in this way, Matisse was able to gain a necessary distance from the sensate basis of his previous painting, and also from the powerful influence of Cézanne. In *The Young Sailor II*, instead of setting down his sensations stroke by stroke and emphasizing the ruggedness and angularity of the subject, he translated the raw stuff of life into an elegant, gracefully curvilinear, broadly patterned whole. There is something almost childlike in the straightfor-ward simplicity of the drawing and the flat, bright planes of color; yet at the same time, the painting shows a sophisticated understanding of Gauguin's synthetism. Significantly, Matisse dated only the second version of *The Young Sailor*, as if to imply that this is where he stood in 1906.

Matisse nevertheless seems to have had mixed feelings about the direction in which his new simplifications and incipient primitivism were taking him, if we judge from his half-serious disavowal of the two most radically flattened works done that summer, which he attributed to a mythical provincial postman. These disavowals may in part have been indications of the unsureness and even embarrassment that many artists feel when first showing their most radical work; but they are also, I think, an indication of Matisse's uneasiness at the apparent naiveté that those works manifested. For his new manner was, in effect, a negation of the great tradition of Renaissance painting in which he had been trained. As Picasso very astutely remarked, what Matisse really wanted to achieve

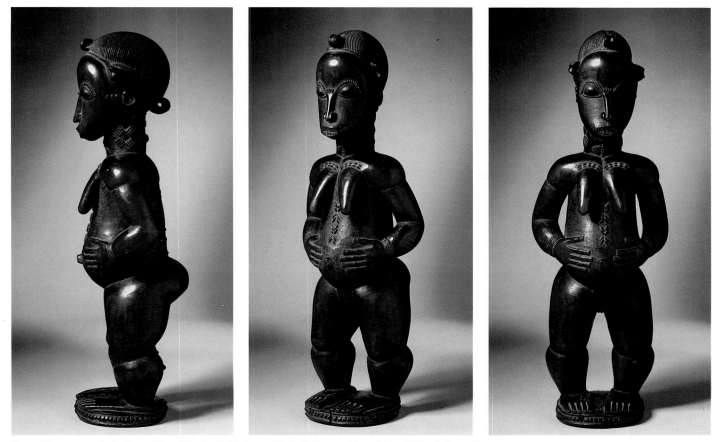

Figure (three views). Baule. Ivory Coast. Wood, 18¾" (47.6 cm) high. Collection Mr. and Mrs. Kelley Rollings, Tucson

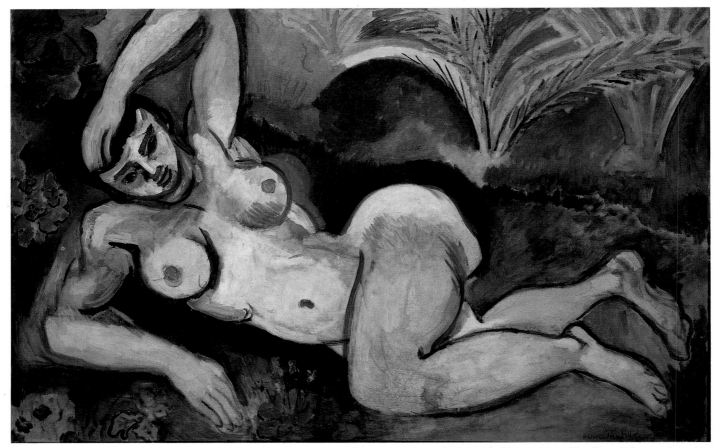

Henri Matisse. *The Blue Nude (Souvenir of Biskra)*. 1907. Oil on canvas, 36¼ x 55⅛" (92.1 x 140.1 cm). The Baltimore Museum of Art; The Cone Collection, formed by Dr. Claribel Cone and Miss Etta Cone of Baltimore, Maryland

at this time was the straightforward simplicity of children's art.[79] The primitive and exotic arts in which he had become interested may have served to give Matisse the sanction of a confirmation from outside his own tradition for his most innovative plastic discoveries.

Matisse's intensified interest in sculpture during the summer of 1906 also appears to have been provoked by his interest in African sculpture. The *Standing Nude* (p. 222), for which his daughter modeled, represents an extreme departure from his earlier sculpture, which had been based upon the articulation of muscle masses and contrapposto poses similar to those in his paintings. In the *Standing Nude*, the stance is nearly symmetrical, the neck elongated, the head disproportionately large, and the hands are kept close to the body, as in Baule sculpture (p. 223). The small torso with a head called *La Vie* (p. 222), with its protruding breasts, outthrust arms, exaggerated buttocks, and large head, also recalls certain features of African figurines.[80]

When Matisse returned to Paris that fall, his interest in African art had finally become strong enough for him to acquire a small African sculpture. Not long afterward—possibly toward the end of 1906—he began the only still life in which he represented an actual African sculpture (p. 214). That he left the work unfinished may perhaps indicate a mistrust of the exotic for its own sake, as well as his awareness of the need to work toward a synthesis. It was not the mere representation or imitation of African sculptures that would be

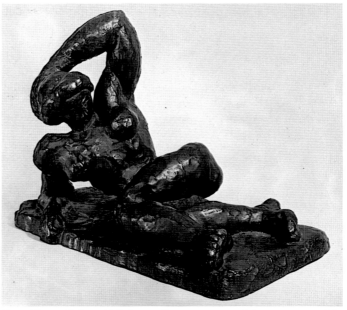

Henri Matisse. *Reclining Nude I*. 1907. Bronze, 13½ x 19¾" (34.3 x 50.2 cm). The Museum of Modern Art, New York; acquired through the Lillie P. Bliss Bequest

most meaningful to Matisse, but rather the creation, in his own handling of the human figure, of freely invented, African-inspired formal structures. This development was not long in coming; when he returned to Collioure early in 1907, he began work on one of his major sculptures, *Reclining Nude I*, and shortly afterward he painted *The Blue Nude (Souvenir of Biskra)*, which marked a crucial turning point in his art.

Heretofore, most of Matisse's sculpture had been done from the live model. The modeling had been based on a combination of tactile and visual notations which defined surfaces that followed the underlying thrust of the anatomical structure. In 1906, in the *Reclining Figure with Chemise*,[81] he had created a sculptural version of one of the recumbent figures in the center of the *Joy of Life*—a three-dimensional realization of the very intangibly rendered figure in the painting. That sculpture, like its prototype in the painting, employed the same general pose as the well-known antique sculpture, the *Sleeping Ariadne* (which later would so haunt the paintings of Giorgio de Chirico). The pose, with legs drawn up and one arm bent above the head, had since the late fifteenth century been used also to represent Venus and other erotic figures and to signify sensuality.[82] The motif had persisted into the nineteenth century, when Ingres had used it for some of his Odalisques, and the academic painter Cabanel had adapted a similar pose for his *Birth of Venus*. Matisse's elaboration of this pose early in 1907, both in the *Reclining Nude I* and *The Blue Nude*, was evidence of his desire to create not only a modern equivalent of the ancient Venus but even more significantly, as we shall see, a kind of "African" Venus. The meaning that the sculpture held for him as a personal symbol is indicated by the frequency with which he incorporated it as an important motif in his paintings.[83]

The *Reclining Nude I* was not done directly from the model but from memory and imagination, which gave Matisse greater freedom in his restructuring of the human body. Several features were rendered according to what he had called the "invented planes and proportions" of African sculpture and have an African inflection. The relatively large head, spherical breasts, and bulbous buttocks recall common features of African sculpture, as does the strong emphasis on the mass of the various body parts, and the way in which those volumes act in counterpoint to, rather than in harmony with, the articulation of the figure's anatomy. Thus, although the pose of this sculpture is a traditional European one, its formal rendering shows a subtle but very real response to the imaginative restructuring of the human figure that Matisse admired in African art.

The Blue Nude was begun after the *Reclining Nude I* had been worked on for some time (and had almost been destroyed in a studio mishap).[84] With its Cézanne-like tonality and willed awkwardness, it is the first major painting that Matisse executed after the death of Cézanne the preceding October. In a sense, it is both a kind of homage to Cézanne and a statement of the new freedom from his conventions that Matisse was able to achieve, in part because of his study of African sculpture. In this painting, the restructuring of the body is carried even further than in the *Reclining Nude*, and the use of African-inspired elements in the articulation of the forms is even stronger—although, as in almost all Matisse's works, the

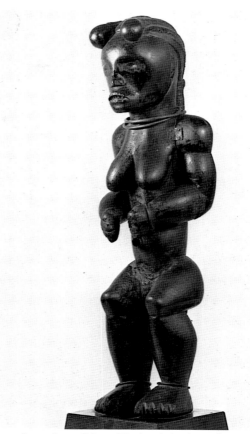

Reliquary figure. Fang. Gabon. Wood and metal, 25½" (64.8 cm) high. The Metropolitan Museum of Art, New York; The Michael C. Rockefeller Memorial Collection, gift of Nelson A. Rockefeller. Formerly collections ANDRÉ DERAIN, JACOB EPSTEIN

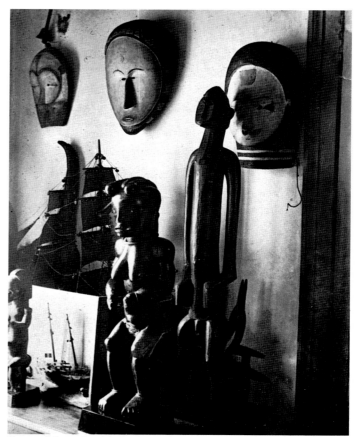

Corner of the studio of André Derain, Paris, c. 1912–13.

outside influences are so thoroughly and subtly synthesized that one must look very carefully to find them.

The numerous liberties that Matisse took in the reorganization of the woman's body in *The Blue Nude* come ultimately, if indirectly, from African sculpture. The upper and lower parts of the torso, for example, are turned so extremely in relation to each other that they almost appear to belong to different figures. From the waist up, the body is seen full front, as if from eye level, while the lower part of the torso is seen as if the figure were turned on her belly and viewed from above. The deformations here are more extreme and less anatomically determined than the liberties that Cézanne had previously taken in his rendering of the human body, and are more like the structure of African figures.

Certain specific details of *The Blue Nude* also seem to have been influenced by African sculpture. The bulbous breasts, the close-cropped, spherical head (devoid of the flowing hair or the chignon characteristic of European models), and the elongated torso all recall common features of African sculpture. The exaggerated "shelf" of the buttocks also resembles a form that is especially frequent in Baule and Fang sculptures, which were very common in Paris at the time (p. 223).[85]

In *The Blue Nude*, Matisse also pushed further the symbolic possibilities that he had begun to explore the previous year. In order to focus and control the image, he used his recollection of the oasis at Biskra in Algeria, which gave the painting a North African subject as well as a Black African formal inflec-tion.[86] The picture is not a literal memory of anything that Matisse had seen, but rather a symbolic image of the powerful effect that his experience of Africa had had upon his imagination. He later remembered Biskra as "a superb oasis, a lovely and fresh thing in the middle of the desert, with a great deal of water which snaked through the palm trees, through the gardens, with their very green leaves, which is somewhat astonishing when one comes to it through the desert."[87] As a personification of the voluptuous growth that had so impressed Matisse in North Africa, *The Blue Nude* became an embodiment of the force of life itself—a visual equivalent of André Gide's exultant evocation of that same oasis a few years earlier: "This African earth ... now awakening from winter, drunk with water, bursting with new juices; it laughed with this frenzied springtime whose echoing reverberation I perceived also within myself."[88]

In keeping with the underlying theme of the springtime earth, the painting has an extraordinary dynamism. The composition is based on a series of echoing arcs and curves that relate the figure to the surrounding landscape and thus emphasize formally, as well as in terms of its subject, the indissoluble exchange of energy between woman and earth. What holds the image together, in addition to the continuous "rhyming" of the curves of the woman's body and the landscape around her, is the paint application: the figure radiates force outward into the pentimenti that echo and give amplitude to the arms, upper breasts, buttocks, and legs. Seen

Henri Matisse. *Decorative Figure*. 1908. Bronze, 28¾" (73 cm) high. Hirshhorn Museum and Sculpture Garden, Smithsonian Institution, Washington, D.C.

Henri Matisse. *Two Negresses*. 1908. Bronze, 18½ x 10½ x 7½" (47 x 26.6 x 19 cm). The Baltimore Museum of Art; The Cone Collection, formed by Dr. Claribel Cone and Miss Etta Cone of Baltimore, Maryland

neither from a single viewpoint nor fixed in a single place, the figure is rendered with a dynamism and fluidity greater than in any of Matisse's previous works. The rich interplay between figure and ground, and between image and paint surface, conveys a sense of the materialization and erosion of the space itself. It also suggests temporal flux: reality is apprehended in terms of energy interacting with matter; the generative form of the woman, at once contained by and bursting from the earth around her, seems actually to bring the forms around her into existence. The metaphors of the subject and its formal embodiment are inseparable. It is here, rather than in Derain's *Bathers*, that we see the first painting "to combine in a single work the influences of both Cézanne and Negro art."[89] *The Blue Nude* was thus an important step not only in Matisse's formal development but also in the development of his symbolic repertoire. It anticipates the primitivist figure compositions, such as the *Bathers with a Turtle* and eventually the *Dance*, which would occupy him over the next few years.[90]

In its evocation of an "African" Venus, *The Blue Nude*—like the *Reclining Nude I*—also announced a new aesthetic in the representation of the female body. The aggressive "ugliness" of *The Blue Nude*, which was an important part of its expressive means, typified the new aesthetic of "African" or "barbarous" beauty that was later noted by Gelett Burgess—and also by Picasso, if we accept the story that he declared the African figure to be more beautiful than the Venus de Milo. Indeed, *The Blue Nude*, which was quite clearly meant as an "anti-Salon nude," offered a kind of challenge not only to such well-known paintings as Cabanel's *Birth of Venus*[91] but even to Ingres's *Grande Odalisque* and Manet's *Olympia*, which had just been hung together in the Louvre.[92]

"A nude woman, ugly, spread out on opaque blue grass under some palm trees," Louis Vauxcelles wrote of *The Blue*

Henri Matisse. *The Back III*. 1916–17. Bronze, 6'2½" x 44" x 6" (189.2 x 111.8 x 15.2 cm). The Museum of Modern Art, New York; Mrs. Simon Guggenheim Fund

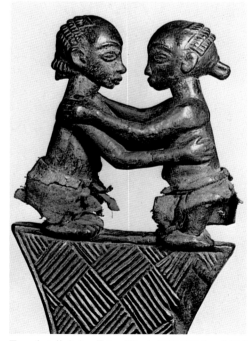

Top of staff. Luba. Zaire. Wood, 53¼" (135.2 cm) high, overall. Buffalo Museum of Science

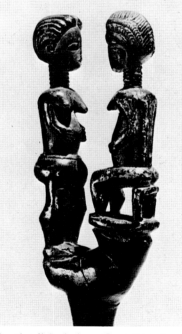

Top of staff. Baule. Ivory Coast. Painted wood, 10¾" (27.3 cm) high, overall. Private collection

Mask. Bangwa. Cameroon. Wood, 7⅞" (20 cm) high. Private collection. Formerly collection TRISTAN TZARA

Nude.[93] Matisse defended the painting in a response whose rationale would be echoed by Braque and others,[94] saying, "If I met such a woman in the street, I should run away in terror. Above all I do not create a woman, *I make a picture*."[95] This focus on the formal means rather than the subject of the picture also underlay Matisse's esteem for the qualities of African sculpture, with its "invented planes and proportions." Max Weber remembered that when, a year or so later, Matisse showed his students African pieces from his collection, "he would take a figure in his hands, and point out to us the authentic and instinctive sculpturesque qualities, such as the marvelous workmanship, the unique sense of proportion, the subtle palpitating fullness of the form and equilibrium in them."[96]

The most important response to *The Blue Nude* was not that of critics or writers, but that of other painters.[97] Although the influence of Cézanne was widely felt at the 1907 Indépendants, at which *The Blue Nude* was exhibited, Matisse alone had gone beyond mere imitation of Cézanne. Picasso, especially, was deeply impressed by the painting, and it may have stimulated his own evolving ideas in working out what would become the *Demoiselles d'Avignon*—much more so than either the *Joy of Life*, with which he was in effect competing, or Derain's dryly Cézannesque *Bathers*, which was also exhibited at the 1907 Indépendants. Although Picasso is said to have been initially spurred on to execute a large, multifigured composition partly in response to Matisse's *Joy of Life*, by the spring of 1907, when he actually started his painting, *The Blue Nude*, with its vigorous brushstroke, multiple viewpoints, dynamic space, extreme anatomical distortions, and "ugliness," would no doubt have been much more interesting to him. Indeed, the primitivism of *The Blue Nude*, an "African"

Henri Matisse. *Jeannette V.* 1916. Bronze, 23 x 7¾ x 11½" (58.4 x 19.7 x 29.3 cm). Art Gallery of Ontario, Toronto; purchase

painting, would much better have suited the effect for which Picasso was striving in his own paintings of early 1907. Although he did not use African forms (or the lessons of Cézanne) in his art until after Matisse had done so, Picasso eventually adapted them in a more radical way. *The Blue Nude,* with its purposeful crudeness and assertive primitivism, was one of a number of influences that encouraged Picasso to work in a manner rougher and bolder than any he had employed before.[98] The painting may also have had a role in inspiring Picasso to take another look at African sculpture, this time in the Trocadéro museum, after which visit he repainted the two so-called "African" figures at the right side of the *Demoiselles.*[99]

Because Picasso's use of African sources was seemingly more overt than Matisse's, and because Picasso was inspired by some more radical and abstract African objects than those that influenced Matisse, it was he who from this point forward seems to have taken the lead in the "Africanizing" of French painting. Matisse, nonetheless, continued to draw upon tribal forms and structural concepts in both his painting and his sculpture. But because the basis of his art continued to be essentially perceptual, these sources and other conceptual influences tended to be so highly synthesized that in their diluted state they are often not readily apparent.

In December 1907, Guillaume Apollinaire published an article on Matisse in which he remarked his interest in the exotic arts, including "the statues of African Negroes proportioned according to the passions which inspired them." He went on to say that "although curious to know the artistic capacities of all human races, Henri Matisse remains above all devoted to the European sense of beauty."[100] This has been interpreted as affirming that Matisse had "learned little if anything directly from African art."[101] But in fact, by the end of 1907, the aesthetic revolution in which African art, and Matisse, played such an important role was on its way to becoming an aspect of the "European sense of beauty," at least among many advanced artists.

From 1907 until the end of World War I, the most radical and imaginative use of Primitive art was made by Picasso and Brancusi. Many of the onetime Fauve painters continued to be serious collectors of Primitive art, but it had little perceptible effect on their work. Vlaminck, who remained a passionate collector of African art, spent most of the rest of his life painting stormy landscapes. Derain, who also continued to collect, and who held on to some of his African objects until the end of his life, also made little subsequent use of African art, except for a few more or less literal quotations such as

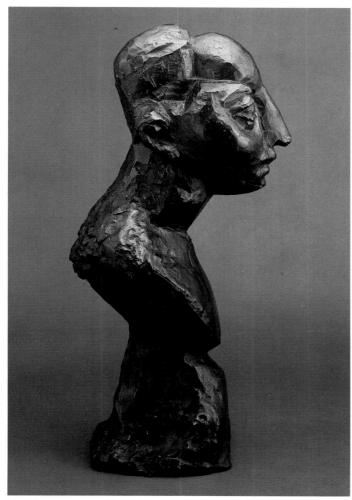

Henri Matisse. *Jeannette V.* 1916. Bronze, 23 x 7¾ x 11½" (58.4 x 19.7 x 29.3 cm). Art Gallery of Ontario, Toronto; purchase

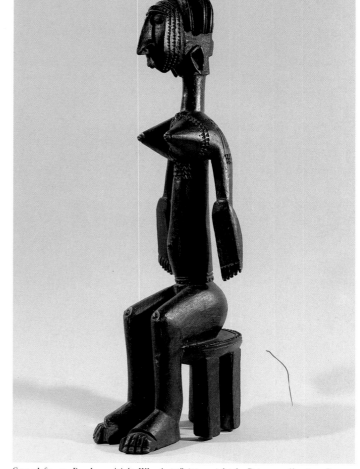

Seated figure. Bambara. Mali. Wood, 24" (61 cm) high. Private collection, France. Formerly collection HENRI MATISSE.

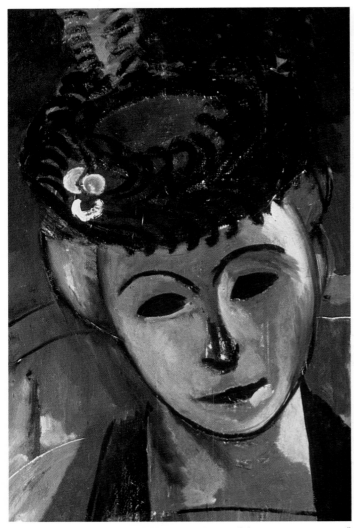

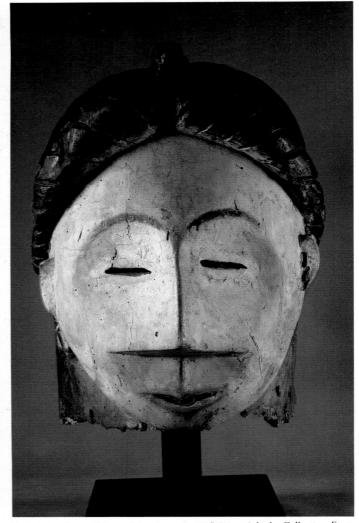

Henri Matisse. *Portrait of Madame Matisse* (detail). 1913. Oil on canvas, 57⅝ x 38¼" (146.4 x 97.1 cm). The Hermitage Museum, Leningrad

Mask. Shira-Punu. Gabon. Painted wood, 12¼" (31 cm) high. Collection Ernst Winizki, Zurich

those cited by Laude.[102]

Once again, Matisse was an exception. The large head and globular breasts of his *Decorative Figure* of 1908 (p. 226) indicate a general "Africanizing" tendency, which is made even more explicit in the *Two Negresses* (p. 226), based on a magazine photograph of two Tuareg girls.[103] The striking sensuality of the girls in that photograph may have given Matisse the impetus to choose it as a source, but such use is in line with his general desire at the time to work three-dimensionally from photographs, in order to distance himself from nature and to reverse the procedure of working from the three- to the two-dimensional that he had been engaged in with his paintings. The other sculptures that Matisse did from photographs, the *Crouching Nude* of 1908 and *La Serpentine* of 1909, were done from rather ordinary photographs of artist's models, like those to be found in publications such as *Le Nu esthétique*.[104] The photograph of the two Tuareg girls, on the other hand, was probably chosen to reinforce the "négritude" with which Matisse wanted to invest the sculpture.

The *Two Negresses* is the only sculpture that Matisse did of more than one figure. It may have been suggested in part by Picasso's very sculptural *Two Nudes* of 1906 (p. 248), which, however, derives from Iberian rather than African art. It may also have been inspired by African sculptures that sometimes

represent facing female figures—though Luba sculptures such as the one reproduced here (p. 227) were very likely not seen in Paris at the time. Although the poses in the *Two Negresses* follow those in the photograph fairly closely, the whole sense of the image has been completely transformed. The rendering of the two figures owes a good deal to African, especially Baule, sculpture, particularly in the relation of torsos to buttocks, the treatment of the breasts, and the hairdos (p. 223).

African influence is more readily discernible in the last head of the Jeannette series, *Jeannette V* (pp. 228, 229), which is usually dated between 1910 and 1913 but actually dates from 1916.[105] One source of inspiration for this most radically distilled head in the series was almost certainly the fine Bambara seated figure (p. 229) that Matisse had recently purchased,[106] and which is represented on the mantelpiece in the left-hand panel of the *Three Sisters* triptych of 1916–17 in the Barnes Foundation. Stripped of the melancholy charm of the first three Jeannette heads and of the energetic wit of the fourth, the *Jeannette V* conveys an extraordinary sense of psychological nakedness. The Primitive, indeed primal, quality of this piece rivals that of its Bambara prototype.

The Back III (p. 227), done at about the same time as the *Jeannette V*, shows an African influence in a more diffuse way. Here, as in the figures in the contemporaneous *Bathers by a*

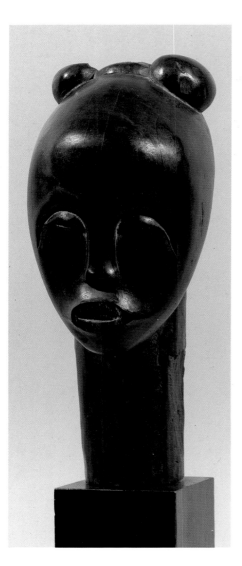

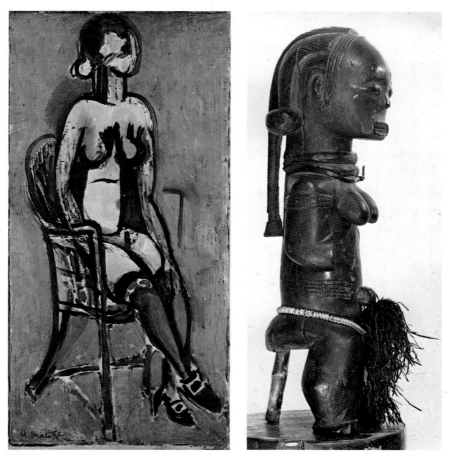

Left: Reliquary head. Fang. Gabon. Wood, 13¾" (35 cm) high. Private collection. Formerly collection MAURICE DE VLAMINCK

Above: Henri Matisse. *Seated Woman.* 1915. Oil on canvas, 27⅛ x 13¾" (69 x 35 cm). Private collection

Right: Reliquary figure. Fang. Gabon. Wood and mixed media, 10" (25.5 cm) high. Private collection, Paris

River,[107] African art may have helped Matisse to formulate a response to the Cubist fracturing of form without relying on actual Cubist devices. This sculpture is one of several interesting stylistic tropes, dating from 1913 to 1917, in which Matisse used an original synthesis of tribal forms and Cézannesque elements to respond to and at the same time resist the innovations of the Cubists. In comparison with the two earlier Backs, the stance of the figure in *The Back III* is more architectonic than anatomical, the parts of the body are related by linear and planar rhythms rather than by musculature, and the sense of gravity is barely felt. The relative largeness of the head and the strong vertical emphasis given by the spinal column are also indirect reflections of elements that Matisse had seen in African sculpture. Indeed, this work probably constitutes Matisse's most subtle translation of the sculptural principles of African art in his own sculpture.

The effects of African forms on Matisse's paintings during the decade following the initial discovery of Primitive art are also fairly persistent. In some cases, as in the standing figure in the two versions of *Le Luxe* of 1907, specific features such as the relationships between the upper torso, elongated neck, and large head resemble the general proportions of African sculpture. In subsequent years, the general idea of "invented planes and proportions" became an integral part of Matisse's working

procedure when dealing with the human figure, but in several instances overt allusions were made to specific kinds of African art.

In the great 1913 *Portrait of Madame Matisse,* the face (page left) recalls Gabonese masks, and André Salmon was not far from the mark when he criticized it for looking like "a mask of wood, smeared with chalk...a figure in a nightmare."[108] The symmetry and simplification of the features, the obviously masklike treatment of the eyes, and even the shape of the hair and hat quite clearly recall the features and coloration of Fang and white Shira-Punu masks, which are meant to represent spirits or ghosts.

The previously unpublished *Seated Woman* (above), datable to 1915,[109] also makes a clear allusion, I believe, to Gabonese art—in this case, to Fang figure sculpture, which it closely resembles in several details. The head and hairdo, the neck, the shoulders, the breasts, the arms, and the upper torso are so like those of Fang sculpture that this painting, in fact, exemplifies the most direct use that Matisse ever made of African forms in his painting. The contrast between the austerity of the woman's body and the provocative sensuality of the garter on her thigh makes the woman seem simultaneously like a heathen idol and a coquette, creating a marvelously ambiguous effect.

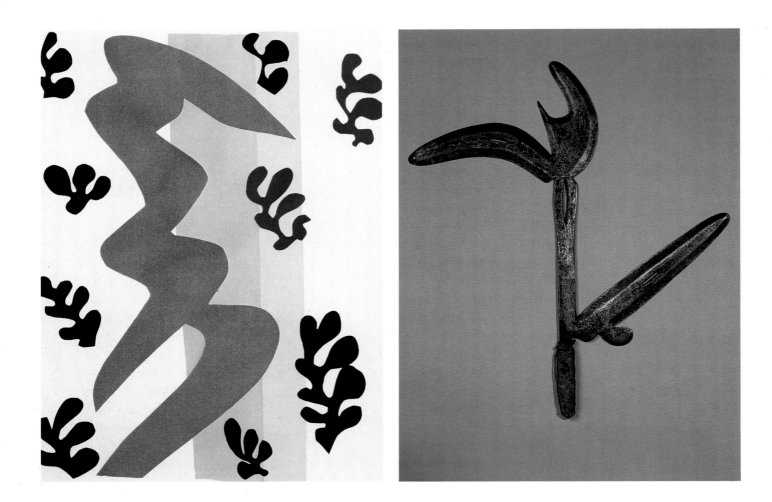

Finally, in the late cutouts, the last great synthesis of his art, Matisse once again turned to African forms and objects as a source of inspiration. In a wonderful visual pun, the figure of *The Knife Thrower* composition in *Jazz* (above) himself assumes a form reminiscent of an African throwing knife. One of the most ambitious of all the large cutout compositions, *The Negress* (p. 236), was not only inspired by a Negro subject, the dancer Josephine Baker, but also elliptically alludes to the formal vocabulary of African sculpture—the "négritude" of form and subject thus mutually reinforcing each other in a way that recalls the *Two Negresses* of 1908. In some of the cutout compositions, African masks are more or less directly represented.[110] But whereas in Matisse's earlier paintings and sculpture the influences of tribal art had mainly come from Africa, in the cutouts the influence of Oceanic art is also visible.

The echoes of Oceanic art in the cutouts provide an interesting contrast with Matisse's earlier use of African forms. In his paintings and sculptures, what he learned from African art had been reflected principally in his handling of the human figure. In the cutouts of the mid-1940s, Melanesian decorative forms seem to have aided him in the creation of an abstract, dematerialized space, characterized by an allover decorative patterning based on the repetition of similar shapes. The abstract space of these cutouts was very different from the space in his paintings, and their motifs often involved imagery directly related to Matisse's memories of the South Seas.

Above left: Henri Matisse. *The Knife Thrower* (detail) from the portfolio *Jazz*. 1947. Colored stencil, 16 x 25¾" (40.6 x 65.3 cm). The Museum of Modern Art, New York; gift of the artist

Above right: Throwing knife. Zande. Zaire. Iron, 18¾" (47.6 cm) high. Collection Norman and Shelly Dinhofer, New York

Opposite left: Henri Matisse. *Composition Green Background*. 1947. Cut and pasted paper, 41½ x 16" (105.4 x 40.7 cm). Private collection

Opposite right: Shield. Asmat. Irian Jaya (formerly Netherlands New Guinea). Painted wood and fiber, 6'4" (193 cm) high. Collection SERGE BRIGNONI, Bern

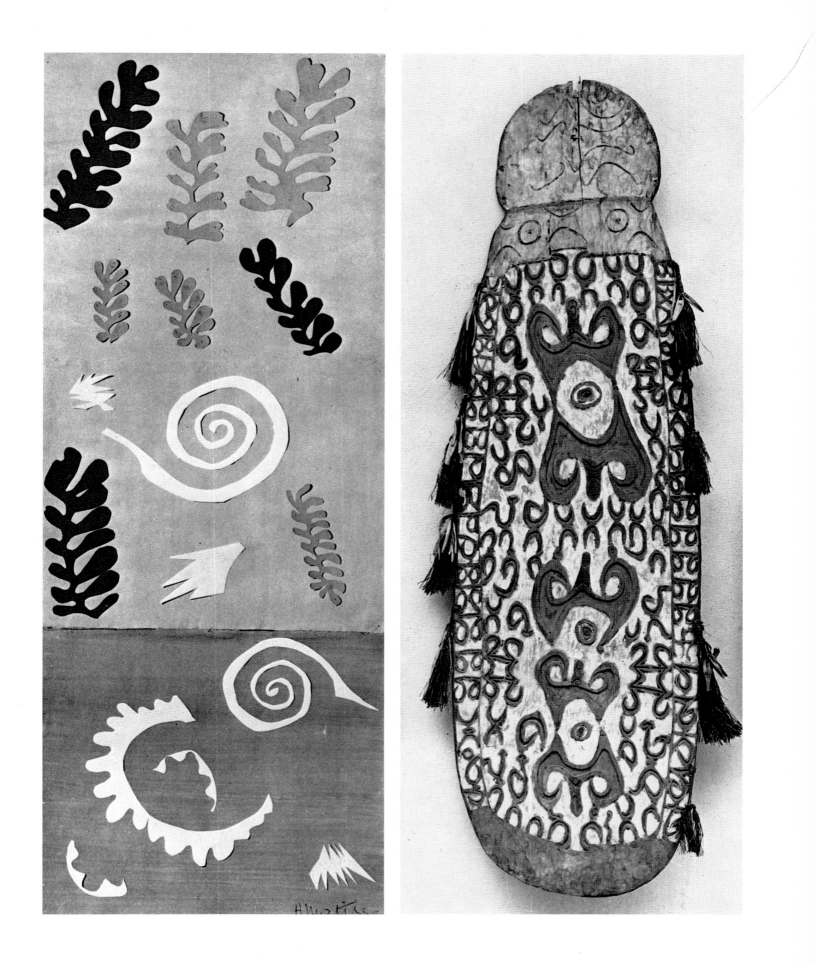

Left: Mask. Namau. Gulf Province, Papua New Guinea. Painted bark cloth and cane, 8' (244 cm) high. National Museum of Ireland, Dublin

Henri Matisse. Front-cover design for Baudelaire's *Les Fleurs du mal.* 1947. Pen and ink, 10¾ x 8⅜" (27.2 x 21.1 cm). The Hermitage Museum, Leningrad

Henri Matisse. *Oceania, the Sky.* 1946. Serigraph, c. 65″ x 12′5⅝″ (165 x 380 cm). Musée National d'Art Moderne, Centre National d'Art et de Culture Georges Pompidou, Paris

In 1930, at a time of uncertainty in his art and life, Matisse had visited Tahiti. Although he made little immediate use of his Tahitian experiences in his art, he was deeply impressed by the light, the color, the lush vegetation, and the abundant marine life he saw there,[111] and recollections of these remained with him to the end of his life. In the mid-1940s, he began to combine his impressions of Oceanic flora and fauna with some of the formal characteristics of Oceanic decorative art—as in the allover patterning and abstract space of the two *Oceania* compositions that he did in 1946 as maquettes for wall hangings.[112] This abstract, decorative tendency became even more marked in some of the later cutouts, whose curvilinear designs quite clearly seem to have been inspired by Melanesian objects. This is especially apparent in works done around 1947, in which the decoration of Melanesian shields (p. 233) and masks (page opposite) is often recalled.[113]

Just as Matisse's experience of African art had helped him to reformulate certain characteristics of his imagery in 1906, so the example of Oceanic art seems to have helped him to achieve another new synthesis some forty years later. Then, as at the time of his earlier "discovery," tribal art suggested new and original solutions to the formal and expressive problems with which he was preoccupied.

Referring to the early days of the discovery of African art, Gertrude Stein very shrewdly pointed out that Picasso and Matisse were affected by African sculpture in different ways: Picasso "more in his vision than in his imagination," and Matisse "more in his imagination than in his vision."[114] Whether this analysis will hold up under careful and systematic analysis is open to question, but it is nevertheless true that Matisse's visual imagination was profoundly affected by his experiences of both African and Oceanic art. Their example and their influence stayed with him to the end of his life.

Tapa. Lake Sentani, Irian Jaya (formerly Netherlands New Guinea). Painted bark cloth, 34⅝″ (88 cm) high. Private collection. Formerly collection HENRI MATISSE

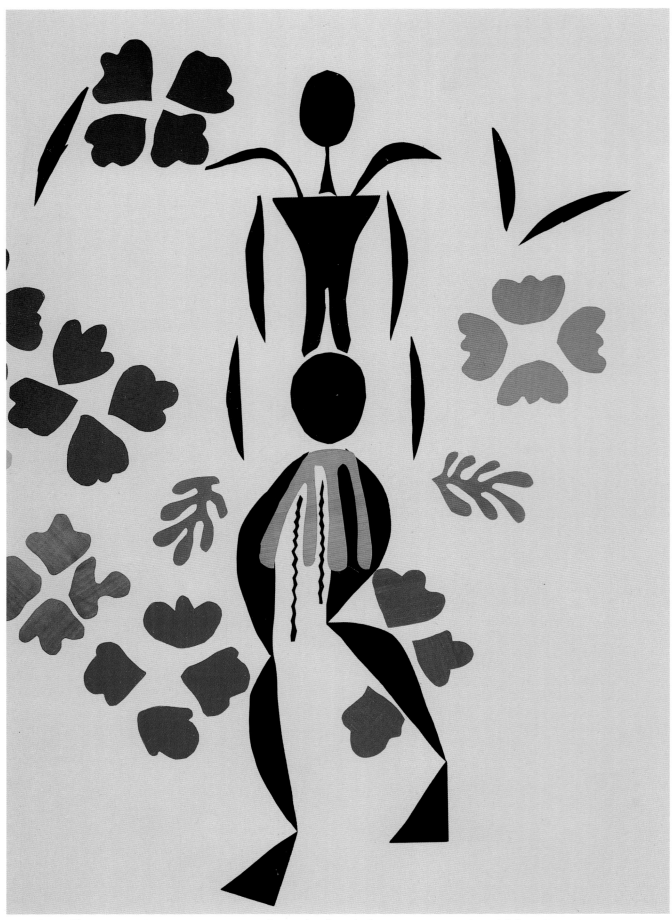

Henri Matisse. *The Negress* (detail). 1952. Paper on canvas (collage), 14'10¾" x 20'5½" (453.9 x 623.3 cm). National Gallery of Art, Washington, D.C.; Ailsa Mellon Bruce Fund

NOTES

This essay is dedicated to the memory of Douglas F. Fraser, who twenty-odd years ago guided my own discovery of Primitive art.

1. For an overview of scholarship on this issue, see: Robert Goldwater, *Primitivism in Modern Art* (rev. ed., New York, 1967), especially pp. 86–103; Douglas F. Fraser, "The Discovery of Primitive Art," *Arts Yearbook 1* (New York, 1957) pp. 119–33; Edward Fry, *Cubism* (New York and Toronto, 1966), pp. 47–48; Jean Laude, *La Peinture française (1905–1914) et "l'Art nègre"* (Paris, 1968), especially pp. 83–239; Ellen G. Oppler, *Fauvism Reexamined* (New York and London, 1976), pp. 125–78; Alan G. Wilkinson, *Gauguin to Moore: Primitivism in Modern Sculpture* (Toronto, 1981). In subsequent notes, these works will be referred to simply by their authors' surnames.

2. This was expressed, for example, by Baudelaire in his essay on the Salon of 1846: *"The origin of sculpture is lost in the mists of time; thus it is a Carib art.* We find, in fact, that all races bring real skill to the carving of fetishes long before they embark upon the art of painting...." (Jonathan Mayne, ed., *Art in Paris, 1845–1862: Salons and Other Exhibitions Reviewed by Charles Baudelaire*, London and New York, 1965, p. 111).

3. African art was initially more influential than Oceanic art in Paris, partly because of its greater sculptural plasticity and partly because of the large colonial holdings of the French in Africa. As J. B. Donne has pointed out ("African Art and Paris Studios, 1905–20," in M. Greenlagh and V. Megaw, eds., *Art and Society*, New York, 1978, pp. 105–20), almost all the primitive art collected by French artists at this time came from French territories. In the second volume of Elie Faure's *Histoire de l'art* (*L'Art médiéval*, Paris, 1911), which seems to be the first general history of art in which Primitive art is given a prominent place, much more attention is given to African than to Oceanic art; in fact, Faure's discussion of Oceania is limited to the art of Polynesia (where the French had colonies), which is more sculptural than Melanesian art.

4. See Raymond Firth, "The Social Framework of Primitive Art," in *Elements of Social Organization* (Boston, 1951), p. 175.

5. The nongravitational nature of African art posed a difficult problem for European artists, since the Western traditions of optical, illusionistic space and gravitationally oriented figures were so interwoven. In paintings like Picasso's *Full-Length Nude* of 1907 (Pierre Daix and Joan Rosselet, *Picasso: The Cubist Years, 1907–1916*, Boston, 1979, no. 40), features related to African sculpture are imposed on a figure that stands like a model in an *académie* drawing. Even in the *Nude with Raised Arms* (ibid., no. 53), in which the standing pose is less natural, one still senses the pull of gravity. A similar sense of gravity is also present in some of Picasso's primitivizing sculptures of 1907 (e.g., Wilkinson, pp. 103, 109, and Roland Penrose, *The Sculpture of Picasso*, New York, 1967, p. 55) and sharply distinguishes them from actual tribal art.

6. Gelett Burgess, "The Wild Men of Paris," *Architectural Record* (New York), May 1910, p. 406.

7. For discussions of the evolutionary bias of early studies of Primitive art, see Goldwater, pp. 19–22, and Fraser, pp. 119–20. Even Faure, in the generally sympathetic chapter "Les Tropiques" in *L'Art médiéval*, revealed such a bias: "To find a primitive art that retains its sap and can impart new and strong emotions to sensibilities that have preserved or regained their first ingenuousness, we must go to those peoples who have remained primitives" (*Mediaeval Art*, trans. Walter Pach, Garden City, 1937, p. 166). As late as 1920, Vlaminck declared that African art was "the only art one can look at

without being overwhelmed by the explanations, the admirations, the praises of a literature that explains the art of the present, of the past, of the future," and he remarked on its "virginal" quality ("Opinions sur l'art nègre," *Action* [Paris], 3, April 1920, p. 26).

8. The growing interest in nonnaturalistic arts was reflected in the number of large exhibitions devoted to them in Paris during the years in which Fauvism developed: Islamic art at the Louvre in 1903; French Primitives at the Louvre in 1904; Japanese art at the Salon d'Automne in 1905; ancient Iberian art at the Louvre in 1906; and Russian art (organized by Diaghilev and including some thirty-six icons) at the Salon d'Automne that same year. The pictorial values that were most admired in those arts, moreover, where not only clearly related to those that would be emphasized by the modernists in the following years, but they were also similar to the values that were most admired in the works of the major Post-Impressionists, who were also given major exhibitions during this period: van Gogh at the 1905 Salon des Indépendants; Gauguin at Vollard's gallery in 1903 and the Salon d'Automne in 1906; Cézanne at the

Objects belonging to Henri Matisse in his apartment, Hôtel Régina, Nice, assembled after his death

1904 Salon d'Automne (only five paintings, but including three Bathers) and the 1907 Salon d'Automne.

The conceptual basis common to both the exotic arts and the art of Gauguin and, to some extent, Seurat became increasingly apparent during the early years of the century, and similar criteria were often applied to both. In his introduction to the catalog of the great French Primitives exhibition of 1904, for example, Georges Lafenestre wrote of the "sincerity of emotion" of the early French artists and of their ability to mix the real and the ideal (*Exposition des primitifs français au palais du Louvre ...*, Paris, 1904, p. xviii). Even their *"incorrections"* and *"gaucheries,"* he asserted, were justified by their "legitimate expression of sincere feeling" (ibid., p. xix)—a phrase that might have been used to defend the art of van Gogh, Gauguin, or Cézanne (and was, in fact, used for Rousseau).

During the summer of 1904, the Neo-Impressionist painter Henri-Edmond Cross, in a letter to Charles Angrand, wrote about the French Primitives. After praising the paintings of Monet, he went on to say: "When I tell you that I was equally bowled over, if not more so, by an art which is exactly the reverse of that, you will recognize in me the eternal debate. I went this morning to the show of French primitives...What a marvelous and transporting art! The difficult problem of transposing the real on the imaginary is resolved here, and by such simple means: one of several *rapports* of happy and various tints in a beautiful unity suffices for the realization of the most sumptuous harmonies" (letter of July 7, 1904, cited in Catherine C. Bock, *Henri Matisse and Neo-Impressionism,*

1898–1908, Ann Arbor, 1981, p. 67).

9. See Rubin, Introduction, p. 7, and Varnedoe, "Gauguin," passim.

10. Judith Cladel, *Maillol, sa vie, son oeuvre* (Paris, 1937), as cited in the catalog of the exhibition "Arts primitifs dans les ateliers d'artistes," Paris, Musée de l'Homme, 1967.

11. See also Derain's 1906 letter to Vlaminck, discussed below, pp. 215–16.

12. For Matisse's recollections of this period, see Jack D. Flam, *Matisse on Art* (London, 1973), pp. 55, 102, 126.

13. Interestingly, Vlaminck later associated the reliance upon tribal forms with artists who were "powerless to express themselves in the language of their fathers" (*Poliment*, Paris, 1931, p. 130). In 1945, Matisse remarked that "in order to protect himself from the spell of the work of his immediate predecessors whom he admires, an artist can search for new sources of inspiration in the production of diverse civilizations, according to his own affinities" (Flam, *Matisse on Art*, p. 102).

14. See Charles Wentinck, *Modern Art and Primitive Art* (Oxford, 1979), pp. 16–17.

15. Vlaminck's accounts are in *Tournant dangereux: Souvenirs de ma vie* (Paris, 1929), pp. 88–89; *Poliment,* pp. 129–30; and *Portraits avant décès* (Paris, 1943), pp. 105–07—his most detailed account, on which the following is largely based.

16. In *Poliment* and *Tournant dangereux*, only two pieces are mentioned.

17. *Portraits avant décès*, p. 107, and a letter of 1944 to M. A. Leblond (cited by Laude, p. 104).

18. *Portraits avant décès*, p. 106.

19. Ibid.; see also Laude, p. 104.

20. See Laude, pp. 100–06.

21. "De Montmartre au Quartier Latin," in *Mémoires d'une autre vie* (Geneva, 1942), pp. 209–10.

22. Laude, p. 103.

23. In *Portraits avant décès* (p. 106), Vlaminck uses the phrase "cette expression d'un art instinctif." As William Rubin has pointed out (in conversation, September 17, 1983), Vlaminck's experience makes an interesting contrast with Picasso's. Whereas Vlaminck was not deeply impressed by African art until he saw it *outside* the museum, Picasso did not fully grasp its implications until he saw it *inside* the museum.

24. Guillaume Apollinaire remarked as early as 1912 that Vlaminck "no doubt found in these grotesque and grossly mystical works analogies with the woodcuts and sculptures that Gauguin had executed" and noted that Gauguin had himself taken inspiration from "Breton calvaries or from the savage sculptures of Oceania, where he had retired in order to escape from European civilization" ("Art et curiosité, les commencements du cubisme," *Le Temps*, Paris, October 14, 1912; reprinted in Apollinaire, *Chroniques d'art, 1902–1918*, Paris, 1960, p. 264).

25. *Tournant dangereux,* p. 88; *Portraits avant décès,* p. 106. See also John Elderfield, *The "Wild Beasts": Fauvism and Its Affinities* (New York, 1976), p. 109.

26. *Portraits avant décès*, p. 106.

27. *Tournant dangereux,* pp. 88–89. Goldwater, p. 86, asserts that "judging from its context we may place it in the year 1904, and certainly not before 1903."

28. *Poliment,* pp. 129–30.

29. *Portraits avant décès*, pp. 105–07.

30. Oppler, p. 155, note 3.

31. Cf. Vlaminck's accounts of Derain's purchase, note 17 above.

32. See note 47 below.

33. See Laude, pp. 101–03.

34. There is no trace of African influence in either Derain's painting or his sculpture until the autumn of 1906 at the earliest.

35. The 1906 Salon d'Automne opened on October 6 and closed on November 15.

36. *Lettres à Vlaminck* (Paris, 1955), pp. 196–97. The letter was sent from 65 Blenheim Crescent, Hol-

land Park, London.

37. Ibid., p. 197.

38. Goldwater, p. 89.

39. Laude, p. 176. Oppler, p. 159, note 2, says the letter "*must* be dated 1906, not 1910," but does not say why she rules out a date of 1907.

40. See Oppler, p. 156.

41. *Lettres à Vlaminck*, p. 63.

42. Ibid., p. 196.

43. Goldwater, p. 87, says that Matisse's collection of African sculpture was "perhaps begun as early as 1904, and certainly before 1906," but I have found no evidence for this claim. Alfred H. Barr, Jr., in discussing the 1908 sculpture *Two Negresses*, states that Matisse had then been collecting African Negro sculpture "for two or three years" but does not document this assertion (*Matisse: His Art and His Public*, New York, 1951, p. 159).

44. A similar phenomenon had existed in Matisse's relationship to Cézanne. We now know that, contrary to all accounts in the Matisse literature, he had seen paintings by Cézanne as early as 1895, but it was not until four or five years later that he was able to make use of them. Matisse mentioned this in a 1941 interview with Pierre Courthion, which M. Courthion very kindly related to me in conversation, December 11, 1979. Matisse had a similar delayed reaction to the Islamic art that he saw exhibited at the Louvre in 1903.

45. *The Autobiography of Alice B. Toklas* (New York, 1961), p. 63. See also Stein's *Picasso* (London, 1938), p. 22: "Upon his return from ...Gosol...he became acquainted with Matisse through whom he came to know African sculpture."

46. "Le Père Sauvage," also known as "le négrier de la rue de Rennes," was Emile Heymann, who owned a shop called "Au Vieux Rouet." See Paudrat, p. 139; also D. H. Kahnweiler, *Juan Gris, sa vie, son oeuvre* (Paris, 1946), pp. 155–56, and Laude, p. 102.

47. Communicated to me by Pierre Courthion (see note 44). A mistranslated and otherwise grossly inaccurate version is given by Wentinck, *Modern Art and Primitive Art*, p. 17. In a 1951 "statement" assembled by Tériade, Matisse mentions buying an African head "for a few francs" (see Flam, *Matisse on Art*, p. 134). Since the statement put together by Tériade ("Matisse Speaks," *Art News*, November 1951, pp. 40–71) is a pastiche in English of several earlier accounts, its accuracy on certain points is questionable.

48. Cf. André Malraux, *Picasso's Mask* (New York, 1976), pp. 10–11.

49. "German Expressionism and Primitive Art," *Burlington Magazine*, 110, April 1968, pp. 191–92. In fact, Apollinaire did not "point out" anything of the kind but merely said that Matisse "remains above all devoted to the European sense of beauty" ("Henri Matisse," *La Phalange*, December 1907, as given in English translation in Barr, *Matisse: His Art and His Public*, p. 102). D. H. Kahnweiler ("L'Art nègre et le cubisme," in *Confessions esthétiques*, Paris, 1963, p. 223), also held that Matisse was not influenced by African art.

50. Unpublished essay on Derain's sculpture (1969), p. 2. I should like to thank Mr. Johnson for letting me make use of this essay, and William Rubin for calling it to my attention.

51. Interview conducted by Edward F. Fry, March 26, 1963 (see his "Cubism 1907–1908: An Early Eyewitness Account," *Art Bulletin* 48, March 1966, p. 73 and note 59).

52. Reproduced in Elderfield, *The "Wild Beasts,"* p. 111.

53. Reproduced ibid.; see Johnson, pp. 8–9, and Wilkinson, p. 124.

54. See Johnson, p. 5, where a direct connection is made. Burgess, "The Wild Men of Paris," quoted by Elderfield, *The "Wild Beasts,"* p. 111, Laude, p. 180, and Wilkinson, p. 124, imply such a relationship.

55. Johnson, p. 5.

56. Ibid.

57. "The Wild Men of Paris," p. 414.

58. Johnson, p. 4, citing an interview with Mme Derain in 1969.

59. See, e.g., reproductions in Wilkinson, pp. 105, 107, and 113.

60. To my knowledge, this sculpture does not appear anywhere in the Derain literature. In assuming that it was by Derain, I have taken into account its hybrid style (as far as this can be made out in the not very clear photograph) and Burgess's remark (p. 406) that in addition to "his African carvings, horrid little black gods and goddesses with conical breasts, deformed, hideous," Derain also had his own "imitations of them in wood and plaster."

61. See Elderfield, *The "Wild Beasts,"* p. 107 and p. 157, note 44.

62. See Rubin (p. 254). Picasso told him that Romanesque sculpture was considered "primitive" at the turn of the century.

63. Whereabouts unknown; reproduced by Elderfield, *The "Wild Beasts,"* p. 107.

64. The *Bathers* was probably done in 1907, about the same time as Matisse's *Blue Nude*. Oppler, p. 289, identifies it with the canvas that Hans Purrmann recalled had been done by Derain in "friendly competition with Matisse as to who could paint the best figure in blue" (Barr, *Matisse: His Art and His Public*, p. 533, note 3 to p. 94), and she suggests that Purrmann was mistaken in saying that it had been destroyed. Elderfield (*The "Wild Beasts,"* p. 158, note 75) does not accept this identification, pointing out that despite the prominence of blue throughout the *Bathers*, none of the figures is blue.

65. John Golding, *Cubism: A History and an Analysis* (London, 1968), p. 139.

66. See Elderfield, *The "Wild Beasts,"* p. 120, and Wilkinson, p. 124.

67. William Rubin ("Cézannism and the Beginnings of Cubism," in *Cézanne: The Late Work*, New York, 1977, pp. 156–57) also discusses the Cézannesque elements of this painting (particularly the sense of sculptural plasticity in the figures) and emphasizes Derain's "immense importance in 1907 as a bridge between Cézanne and the vanguard painters." Rubin believes that Picasso's sense of rivalry in undertaking the *Demoiselles* in spring 1907 was piqued even more by Derain's *Bathers*, shown that spring, than by Matisse's *Joy of Life*, shown the preceding year.

68. Golding, *Cubism*, p. 139. For Picasso's amalgamation of Cézanne and tribal arts see Rubin, "From Narrative to 'Iconic' in Picasso: The Buried Allegory in *Bread and Fruitdish on a Table* and the Role of *Les Demoiselles d'Avignon*," *The Art Bulletin*, December 1983, pp. 615–49.

69. Elderfield, *The "Wild Beasts,"* p. 109.

70. "The Wild Men of Paris," pp. 401–14. Among the seven, Braque, Derain, Czóbel, Friesz, and Metzinger had been associated with the Fauve movement; the others were Herbin and Picasso.

71. Ibid., p. 410.

72. Ibid., p. 402.

73. See Fry, "Cubism 1907–1908," p. 70.

74. See note 75 below.

75. Barr (*Matisse: His Art and His Public*, p. 77) suggests that Matisse, who is said at first to have told his friend Jean Puy when showing him this painting that it had been done by the Collioure postman, "may have had at the back of his mind the work of another petty official, Henri Rousseau," whose work Matisse could have associated with the "technique, simple to the point of naïveté," that he had used in the *Pink Onions*. The connection of this painting with Rousseau's still lifes seems to me, however, very tenuous.

76. For example, the two versions of the *Still Life with a Purro*, 1904, or the two versions of *Le Luxe*, 1907.

77. "More Adventures," published in *Appreciation: Painting, Poetry and Prose* (New York, 1947), reprinted in *Four Americans in Paris: The Collections of Gertrude Stein and Her Family* (New York, 1970), p. 98. Note the

78. Pierre Courthion, in conversation (see note 44 above).

79. Dore Ashton, ed., *Picasso on Art* (New York, 1970), p. 164. Picasso's understanding of Matisse's aims is indicated by the fact that when he and Matisse exchanged pictures at about this time, Picasso chose the portrait *Marguerite*, done in 1906 or 1907, which is even more willfully simplified and childlike than the *Pink Onions* or *The Young Sailor II* (see Barr, *Matisse: His Art and His Public*, pp. 85 and 94; repr. p. 332).

80. Matisse's interest in various Archaic arts as well as in Primitive sculpture is reflected in the small heads he did that summer, in which emphasis is given to exaggerated facial features and to planar rather than muscular construction; in these, the predominant influences seem to be Greek, Etruscan, Celtic, and ancient Iberian rather than African. See reproductions in Alicia Legg, *The Sculpture of Matisse* (New York, 1972), p. 14.

81. Reproduced ibid., p. 18.

82. See Lawrence Gowing, *Matisse* (London, 1979), p. 77. One of the striking instances of this pose is in Titian's *Bacchanale*, now in the Prado. See also Kenneth Clark, *The Nude* (New York, 1956), pp. 294–95, and Millard Meiss, "Sleep in Venice: Ancient Myths and Renaissance Proclivities," *Proceedings of the American Philosophical Society* (vol. 110, 1966), reprinted in *The Painter's Choice: Problems in the Interpretation of Renaissance Art* (New York, 1976), pp. 215–17.

83. Enumerated in Barr, *Matisse: His Art and His Public*, p. 100.

84. See ibid., p. 94, for an account of this accident.

85. See Donne, "African Art and Paris Studios," passim.

86. Although North Africa is, of course, very different from Black Africa, Matisse later referred to his experiences there as being experiences of "Africa" (communicated by Pierre Courthion, December 11, 1979).

87. Ibid.

88. *The Immoralist* (1902), translated by Richard Howard (New York, 1970), p. 45 (translation modified here).

89. See notes 65 and 66 above.

90. The relationship between Matisse's *Bathers with a Turtle* and Picasso's contemporaneous *Three Women*—both of which have "primitive," primeval themes—is dealt with in my forthcoming book on Matisse. These two works are excellent examples of how close the underlying subjects of the two painters often were at this time, despite their very different formal means.

91. It was a response also to a painting as recent as Raphael Collin's *Paresse*, exhibited at the Salon of the Société des Artistes Français in 1906, in which the pose and placement of the figure are very close to that in *The Blue Nude*.

92. For details see Jean Puy, "Souvenirs" (*Le Point*, no. 21, July 1939), p. 36 (132).

93. "Le Salon des Indépendants," *Gil Blas*, March 20, 1907, p. 1.

94. See Burgess, "The Wild Men of Paris," pp. 405, 413–14.

95. "Notes of a Painter on His Drawing," *Le Point*, no. 21, July 1939, p. 14 (110); translated in Flam, *Matisse on Art*, p. 82.

96. Transcript of lecture given at The Museum of Modern Art, New York, dated October 22, 1951 (courtesy of the Archives of American Art).

97. After *Les Demoiselles* was finished, Picasso in fact alluded to the pose of *The Blue Nude* in his Reclining Nude series and related works (see Daix and Rosselet, *Picasso*, nos. 76, 77, and 79–83). This dialogue soon became quite intense. Later in the year, Braque painted his own *Large Nude*, partly inspired by Picasso's *Demoiselles* and partly by Matisse's *The Blue Nude*, which the Braque painting closely follows in pose and rendering. In the fall,

Matisse responded with his own *Standing Nude*, now in the Tate Gallery.

98. See below, Rubin, pp. 255–57.
99. For the chronology of the *Demoiselles*, see Rubin, "From Narrative to 'Iconic' in Picasso."
100. "Henri Matisse, *La Phalange* (vol. 2, 18, December 15, 1907), pp. 481–85 (English translation in Barr, *Matisse: His Art and His Public*, pp. 101–02).
101. Ettlinger, "German Expressionism and Primitive Art," pp. 191–92 (see note 49 above).
102. For details of the collections of Derain and Vlaminck see Laude, pp. 113–24. A generalized African influence can be seen in such works as Derain's *The Last Supper* (c. 1913) in the Art Institute of Chicago, in which some of the heads are "Africanized," albeit through a Cubist vision.
103. See Albert Elsen, *The Sculpture of Matisse* (New York, 1972), p. 84.
104. For the photographs from which the *Crouching Nude* and *La Serpentine* were done, see John Elderfield, *Matisse in the Collection of The Museum of Modern Art* (New York, 1978), p. 190, figs. 43 and 46.
105. Pierre Matisse (in conversation, June 22, 1983) has confirmed that Matisse did the *Jeannette V* at the same time as *The Back III*; its *terminus ante quem* is related to its appearance in the *Still Life with Plaster Bust* in The Barnes Foundation, which although persistently misdated to 1912 in fact dates to 1916.
106. Pierre Matisse (ibid.) remembers that Matisse acquired this piece around the beginning of World War I, c. 1915. It is listed as belonging to Matisse in Paul Guillaume and Guillaume Apollinaire, *Sculptures nègres* (Paris, 1917), pl. V.

Rubin reads the Bambara figure in a manner quite opposed to my sense of it, stressing delicacy and ritual grace where I see a primal quality relating it to *Jeannette V.* The latter sculpture, Rubin feels, relates more closely to Cameroon masks (p. 228) of the type Matisse might have seen on his visit to Munich in 1910.
107. Art Institute of Chicago; repr. Barr, *Matisse: His Art and His Public*, p. 408.
108. "Le Salon," *Montjoie!*, 1, November–December 1913, p. 4.
109. The painting appears in a photograph of Matisse in his studio taken early in 1916; reproduced in Elderfield, *Matisse in the Collection of The Museum of Modern Art*, p. 209, fig. 90.
110. See, for example, J. Cowart, J. Flam, D. Fourcade, and J. H. Neff, *Henri Matisse: Paper Cut-Outs* (St. Louis and Detroit, 1977), nos. 32, 70, 108.
111. See Matisse's accounts of his Tahitian experiences in Flam, *Matisse on Art*, pp. 110 and 145. Shortly after his return from Tahiti, he executed two sculptures, the *Tiari* and the *Venus in a Shell* (reproduced in Elderfield, *Matisse in the Collection of The Museum of Modern Art*, pp. 137–39), both of which contain visual metaphors of tropical vegetation. The woman's head in the *Tiari* is suggested by the form of the exotic plant for which the work is named. In the *Venus in a Shell*, the woman and the shell evoke the image of a plant growing in a dish. As late as 1953, in the last year of his life, echoes of his Tahitian voyage still reverberate in Matisse's *Memory of Oceania* (reproduced ibid., p. 168).
112. Cowart, Flam, et al., *Henri Matisse: Paper Cut-Outs*, nos. 55 and 56.
113. See ibid., nos. 61, 62, 63, 64, 66, and the installation photograph on pp. 132–33. Matisse also collected Oceanic objects and owned a New Ireland Uli figure, a large figure from the New Hebrides, and a Tapa painting from Lake Sentani in New Guinea (p. 235) which makes an interesting comparison with the design he did for a door grille for the Albert D. Lasker mausoleum (reproduced ibid., p. 265, fig. 72).
114. *The Autobiography of Alice B. Toklas*, p. 63.

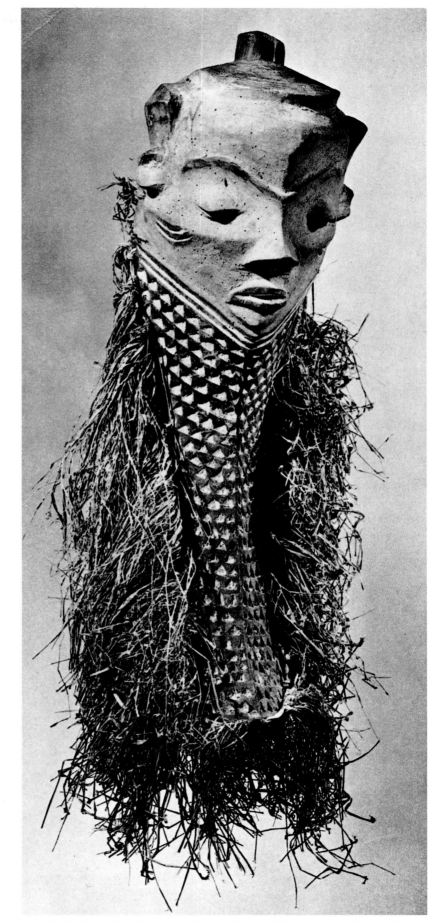

Mask. Pende. Zaire. Painted wood and fiber, 23⅝" (60 cm) high. Private collection. Formerly collection HENRI MATISSE

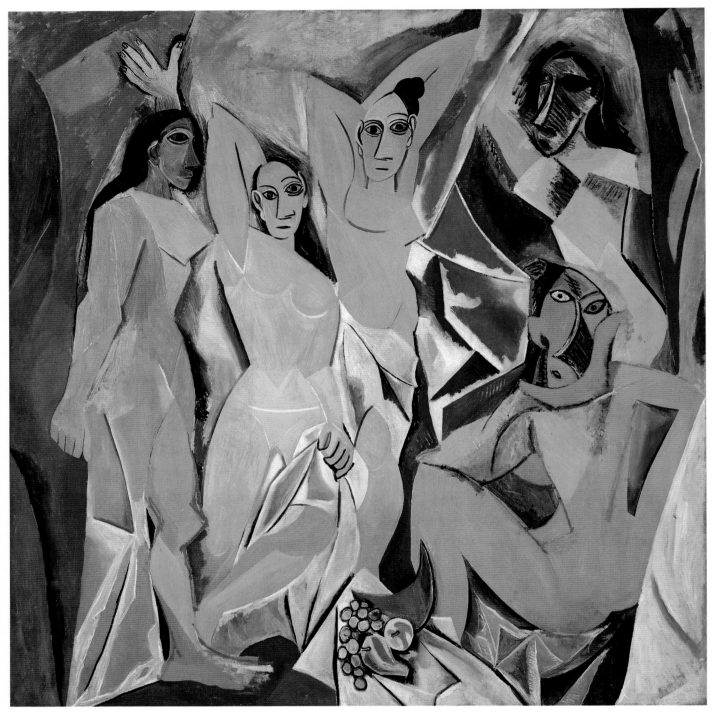

Pablo Picasso. *Les Demoiselles d'Avignon.* 1907. Oil on canvas, 96 x 92" (243.9 x 233.7 cm). The Museum of Modern Art, New York; acquired through the Lillie P. Bliss Bequest

PICASSO

William Rubin

In no other artist's career has primitivism played so pivotal and historically consequential a role as in Picasso's.[1] It was critical (though in diminishing proportions) in three periods of redirection in his work: between his return from Gosol in 1906 and the resolution of his early Cubist style in winter 1908–09; during the formation—in the context of collage and construction sculpture—of Synthetic Cubism in 1912–13; and in the new directions of both his modeled and constructed sculpture in the early thirties. Overarching these particular interventions were primitivist instincts that represented an abiding strain in Picasso's psychology. They could only have been reinforced by the continuous presence of tribal objects in his studios from 1907 until his death.

Picasso's empathy toward tribal art was so profound and apparent that the earliest critics identified him as the key protagonist of twentieth-century primitivism despite the knowledge that Matisse, Derain, Vlaminck, and perhaps others had "discovered" African sculpture before he did.[2] So deep, indeed, was this affinity perceived to be that it engendered a myth ascribing African blood to Picasso, presumably through Spanish-Moorish descent[3]—a way of associating Cubism to Africa that was retroactively extended to Cézanne.[4] But it is on the psychological rather than the racial plane—Picasso's superstitiousness, exaggerated fear of death, and early competitive relationship with his father—that the roots of his special sympathy with Primitive art are to be found. As Picasso's father was a professional painter, the son's instinct for challenge and revolt, which surely began on a psychosexual level, transmuted easily into attitudes toward art.

Picasso's childhood was bourgeois and conventional. The family was dominated by his tall, exceedingly handsome father, who was not only an able painter but a respected professor in the Fine Arts Academy of Barcelona. His painting, though not academic, was as traditional as the values with which he tried to imbue his children. The young Picasso's First Communion (1895–96)[5] gives us a good sense of the physical impressiveness of his father, in the context of precisely the kind of subject that displayed the latter's bien-pensant beliefs and attitudes. In the illusionistic bravura of this set piece, for which his father posed, young Pablo defeated him at his own game, so to speak. That it was executed by a fourteen-year-old boy reflects not only Picasso's prodigious talent, but his precocious oedipal triumph. (His father, it is said, "laid down his brushes" at seeing pictures such as these.) Strengthened by an unusually profound bond with his mother (reflected in his early adoption of her family name, Picasso, in place of his father's, Ruiz), the young artist was to carry the repudiation of his father's world a step further in the form of the bohemian vie d'artiste he took up as soon as he left home.

All this is perfectly banal, and would have remained so had not Picasso intuited that a lasting symbolic defeat of his father and what he stood for would have to be accomplished not by surpassing him in an art that encapsulated his values, but by rejecting that art in favor of something personal and unique; not, therefore, by hypertrophying his remarkable talent—for talent was at once the backbone and measure of traditional and salon-type painting—but by sacrificing it. Talent was among the screens obscuring the fact that nineteenth-century illusionism had degenerated into a rhetorical and sentimental art. By embracing primitivism in 1906, Picasso short-circuited the continuity of these inherited conventions, and his year-long exploration of increasingly remote and alien aesthetic correlatives permitted him to rediscover pictorial authenticity for himself.

Picasso's primitivism marked a broadening of the Western language of art, erasing distinctions between "high" and "low." It also constituted a commitment to conception and invention (that is, genius) as over and against skill and virtuosity (talent).

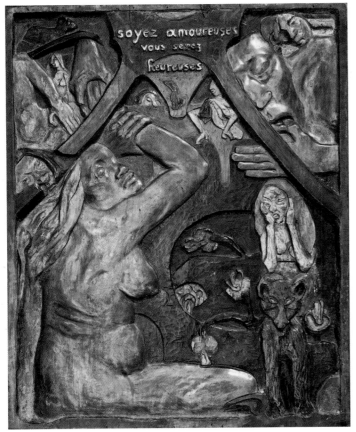

Paul Gauguin. *Be in Love, and You Will Be Happy.* 1889. Carved, polished, and polychromed lindenwood, with original frame, 47 x 38" (119.4 x 96.5 cm). Museum of Fine Arts, Boston; Arthur Tracy Cabot Fund

The choice of the latter option was in itself nothing new by the time Picasso exercised it. But in the work of no other modernist who elected it were the talent sacrificed so prodigious or the new conceptions so radical, so alien to accepted ideas. Picasso's father was not around to be shocked when the young painter's primitivism culminated in *Les Demoiselles d'Avignon,*[6] but Picasso had long since psychologically equated Professor Ruiz with the whole community of artists, indeed, with the bourgeois world.

Picasso's preprimitivist painting—from the stylistic mélanges of 1900–01 through the often bathetic Blue and early Rose Period pictures—constituted, to be sure, a commitment to a certain modernism. But little in these paintings would have amounted to real heresy in his father's eyes. They were still dependent on bravura talent (though admittedly of a different sort than he had exercised as a child prodigy), and they were suffused with a different but equal sentimentality. The distance that separates Picasso's largely Symbolist-inspired "soft" modernism of 1901–05 from the art of his father is slight as compared to that which separates it from the *Demoiselles.*

In the introductory chapter, primitivism was described as an antibourgeois, countercultural force. Picasso's instincts in this direction may be discerned prior to 1906 in his celebration of society's outsiders—the poor, the blind, the old, the

rejected and dispirited entertainers (or various combinations of the above). But whatever critique of society these pictures represent, it is proposed in terms of storytelling rather than those of painting itself. Only at the inception of Picasso's primitivism upon his return from Gosol does the real pictorial critique begin—in work that was for the first time wholly identifiable with the young artist's robust personality.

We have already seen that the primitivist critique was, in its beginnings, literary and philosophical. Even in its incipient modernist pictorial form, the work of Gauguin, it remained largely a matter of symbols and ideas. And it is in this *fin de siècle* primitivism that Picasso's took root. Yet by the end of 1907, he had not only recapitulated the Symbolist generation's exploration of Archaic[7] and exotic objects, but had endowed primitivism almost single-handedly with a new, twentieth-century definition. This was anchored in tribal (rather than exotic court) objects—heretofore considered just curiosities—and involved an appreciation of both their affective "magical" force and their plasticity.

What I have said about Picasso's psychology might apply to any number of modernists whose syndromatic reactions against tradition and authority took the form of *épater les bourgeois.* But Picasso's deepest aspirations went far beyond a middle-class scion's taste for revolt. He was convinced not only that the art of his childhood—along with the religious, ethical, and sexual beliefs embodied in it—was no longer viable, but that it was incumbent on him to provide new alternatives. Only an artist who had been able so early and so easily to imitate the sort of painting his father championed could have so readily called its bluff, could have so soon become aware that something was profoundly wrong with what it said and the way it said it. Precisely *what* was wrong would only become entirely clear to Picasso in the "shock" and "revelation" he experienced before the tribal masks and "fetishes" in the Musée d'Ethnographie du Trocadéro: "At that moment," he said later, "I realized what painting was all about."[8]

"That moment," an epiphany of June 1907 discussed in detail below, was made possible, however, only by a year-long evolution triggered by a Louvre exhibition of Archaic Iberian reliefs from Osuna.[9] This inspired Picasso's "Iberian" style, which fully took root the following fall.[10] It constituted the first important stage of his primitivism. But this Iberianism had already been prepared for by his exploration of Egyptian sculpture, which he had been studying in the Louvre since 1903. (An Egyptian relief is probably echoed in the hieratic gesture of his *Woman with a Fan* of 1905.) And the seeds of his primitivism could be said to have been sown even earlier—however delayed the germination that was to follow—in his 1901 contacts with Gauguin's art through his friendship with the Spanish sculptor Paco Durrio.

The path of Picasso's interests from Gauguin (whose own primitivist models were primarily in Archaic court art) to Archaic art itself (Egyptian and Iberian sculpture) and then to Primitive art (African and Oceanic sculpture) would have been easily interpreted early in the century—and was probably so understood by Picasso himself—as a journey back in time, to the beginnings of art. This apprehension prevailed despite the fact that tribal objects are much more recent than any of the non-Classical arts at which Picasso had been looking—a chronology not understood when Picasso was

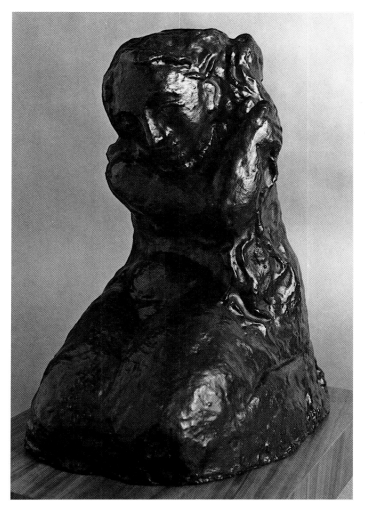

Pablo Picasso. *Woman Combing Her Hair.* 1906. Bronze, 16½ x 10¼ x 12⅝" (42 x 26 x 32 cm). The Baltimore Museum of Art; The Cone Collection, formed by Dr. Claribel Cone and Miss Etta Cone of Baltimore, Maryland

in Picasso's work begin in 1901 when he and Sabartés visited Durrio. "There was much talk about Gauguin, Tahiti, and the poem *Noa-Noa*, about Charles Morice, and a thousand other things."¹⁵ Durrio possessed a number of Gauguin's works and knew Charles Morice, who soon gave Picasso a copy (now apparently lost) of his publication of *Noa-Noa*, in the margins of which Picasso made at least two drawings.¹⁶ Gauguin, Johnson demonstrates, made a sufficiently "deep impression on Picasso that he modelled his first sculpture, a *Seated Woman* (Z. II,² 668, 1901), on ideas drawn from Gauguin's *Portrait Vase of Mme Schuffenecker* (1889)." Johnson would be the first to agree, however, that there is nothing Primitive or even Archaic about the Gauguin object in question. And although an ink study by Picasso related to it (Z. VI, 364) has an archaizing quality, the same is not true of Picasso's wholly Rodinesque *Seated Woman*, of which only the motif relates to Gauguin. Johnson also posits a connection between Picasso's sculpture *Woman Combing Her Hair*, of early 1906, and Gauguin's relief *Be in Love and You Will Be Happy* (1889). Spies mentions the same Gauguin panel in connection with the relief *Head of a Woman* (Spies 8) made somewhat later in 1906.¹⁷ If, however, Picasso borrowed the bent arm position of *Woman Combing Her Hair* from Gauguin's relief, the style of the sculpture—and of the drawings related to it—shows him rejecting precisely those archaizing aspects that are to be found in Gauguin's panel in favor of the classical contrapposto he had learned in art school.¹⁸

These few "Gauguinesque" Picassos of 1901 to early 1906 did not anticipate the artist's subsequent primitivism. Such Gauguin influences as were to feed into Picasso's remarkable stylistic metamorphosis of later 1906 through 1907 are discernible in his work only *after* his exposure to the Iberian

young. As late as 1920, André Salmon, a charter member (1903) of "la bande à Picasso," could mistakenly write that "a number of the most beautiful pieces [of African art] that have come down to us are much older than the Christian era." He even discerned an "influence of the carvers of 'fetishes'" upon Egyptian (and through it, upon Archaic Greek) art. Given the modern artists' concern with the fundamental principles of construction, Salmon concluded, they were fated "to pass from the Egyptians [back] to the Negroes."¹¹ This scrambled art history was but the other side of the same counterfeit coin that led certain anthropologists wrongly to speculate that African art had been influenced by Egyptian sculpture.¹² Needless to say, none of the African pieces Picasso saw in his first few years of fascination with "art nègre" were more than just decades old, though the origins of their traditional styles obviously go back several centuries at least.¹³ But old or new, the tribal works were associated by Picasso's generation with the earliest phases of civilization, in accordance with a highly simplistic model of world history.

Ron Johnson has rightly emphasized the importance of Picasso's very early contact with Gauguin,¹⁴ whose influence forms the background of Picasso's primitivism and continues right into the earlier phases of the *Demoiselles*. Allusions to Gauguin

Pablo Picasso. *Exotic Figures* (detail of *La Parisienne and Exotic Figures*). 1906(?). India ink, 11⅞ x 16⅝" (30 x 42 cm). Musée Picasso, Paris

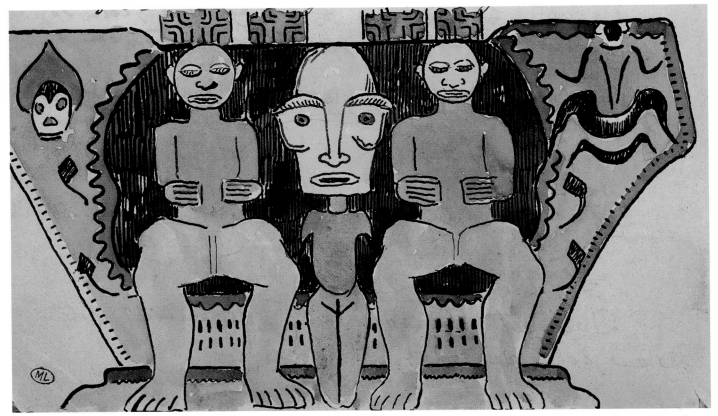

Paul Gauguin. *Two Figures Flanking a Statue*, from *Ancien Culte Mahorie*. 1892–93. Watercolor, comp. 4 x 6¾" (10.2 x 17.2 cm). Cabinet des Dessins, Musée du Louvre, Paris

Opposite: Pablo Picasso. *Two Seated Women*. 1906–07. Gouache, 9⅞ x 12⅝" (25 x 32 cm). Private collection

sculptures in the spring of 1906. That experience no doubt positioned Picasso for the very different reading he would give Gauguin's art when he visited the latter's large memorial retrospective at the Salon d'Automne upon his return from Gosol.

Apart perhaps from a sketch of a Tahitian beauty—juxtaposed, with Picasso's characteristic malice, to a fantasy of (her?) decrepitude in old age (p. 243)[19]—the Gauguin memorial exhibition directly inspired, I believe, an entirely unusual gouache, *Two Seated Women*, which thus far has attracted little attention. In his catalog of Picasso's Cubist work, Daix characterizes this gouache as "totally isolated" in the artist's oeuvre (as, in most ways, it is), and he dates it with reservations "1909."[20] Daix's doubts about his dating reflect the fact that while the picture's grays, browns, and greens recall 1909, there is nothing in the space, morphology, and configuration of the work that makes particular sense in that year.

I am convinced that the very uniqueness of *Two Seated Women* follows from the fact that it was to some extent a paraphrase, experimental or celebratory, of an equally unusual watercolor by Gauguin, *Two Figures Flanking a Statue*, which was exhibited in the Gauguin retrospective.[21] *Two Seated Women* conflates this watercolor with aspects of Gauguin's *Market Day* (p. 190) and his sculpture *Oviri* (p. 246), both also

shown in the 1906 exhibition. The mirror-image symmetry of *Two Seated Women*, wholly unexpected in Picasso, is a peculiarity that suggests a particular model—and the configuration of Gauguin's *Two Figures Flanking a Statue* is a perfect one. As Gauguin made this watercolor specifically as an illustration for his *Ancien Culte Mahorie* not long after his arrival in Tahiti (he considered Tahitians to be Maoris; see p. 191), its purpose would explain his own exceptional use of a symmetrical and hieratic configuration, as well as the details, which were intended to suggest Marquesan Tikis and ornaments.

In late 1906, however, Picasso had yet to see any Polynesian art, and he therefore not surprisingly accepted only the generally Archaic aspects of the Gauguin watercolor—symmetry, frontality, hieratic gestures and postures—while rejecting all that is specifically Oceanic in it. He replaced the head of the Tiki-like idol in the center of the Gauguin with symmetrically arranged ferns and flowers (the two blossoms of which take the place of the idol's eyes) and put them in a vase that substitutes for the idol's body. Picasso retained the simple and schematized heads, hands, and feet of Gauguin's native women even while changing their positions. And the scalloped forms of the lower corners of Gauguin's watercolor are perhaps reflected in the areas reserved for the chairs on which Picasso's women sit[22] Instead of the Marquesan posi-

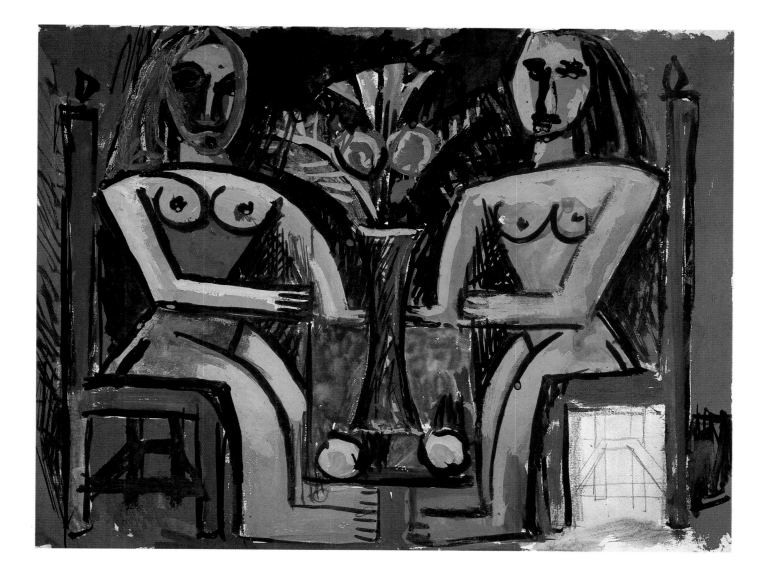

tioning of the hands and arms used by Gauguin, Picasso went "Egyptian," turning the shoulders into the picture plane in "memory image" fashion while showing the legs in profile. Each of Picasso's figures has one hand placed on the altarlike table, the other suspended in a ritual gesture that is a "primitivist" counterpart to that of the *Woman with a Fan.*

Picasso's combination of almost frontal faces and frontal shoulders with profile legs in *Two Seated Figures* recalls in particular the woman at the center of the bench in *Market Day,* and also recalls the peculiar posture of *Oviri.* If *Oviri* is a less direct model in this respect, Picasso's interest in this sculpture was nevertheless reinforced, I believe, by the motif of its nonsupporting legs, which he would easily have associated with the *Dying Slave* of Michelangelo (p. 246), a figure that had profoundly moved him from the time of his first visits to the Louvre. (Picasso spoke to me about his strong feeling for the *Dying Slave* while we were looking at a full-size plaster cast of it that stood in the corner of his sculpture studio.)[23] This figure's left arm, thrust over its head, is bent back in a manner that would be repeatedly echoed in Picasso's work, and the relaxed lower body seems only half supported, an effect more intense in the "memory image" posture of *Oviri. Oviri* also recalls the equivocal half-sitting, half-standing position produced by the bent knee in much tribal sculpture. Conflated

with the Michelangelo and other sources, *Oviri* feeds directly into the center-left Iberian woman of the *Demoiselles.* The peculiar posture of the latter, whose contradictory aspects were extensively discussed by Leo Steinberg,[24] includes the raised bent arm of the Michelangelo. That aspect of the posture has traditionally and with justice been associated with its many models in Cézanne (as in *Five Bathers,* V. 542), who himself adapted it from Michelangelo. Picasso, however, would have been familiar with the Michelangelo for years before he knew its echoes in the work of Cézanne.[25]

That the demoiselle in question conflates the work of Michelangelo as well as that of Cézanne and Gauguin is sustained by the sexual equivocalness and conflict at the heart of Picasso's picture. The Neo-Platonic struggle between materiality and pure idea in the Michelangelo can easily be read on the more mundane plane of sexuality versus love, and the very androgynousness of Michelangelo's figure facilitated its association with a female. The raised crooked arm is, of course, directly connected with erotic revelation in Cézanne (as in *The Temptation of St. Anthony,* V. 103). But Picasso's conflation of it with the Michelangelo as well as the Gauguin only enriched these associations; in the later forms of Picasso's "Africanism," as in *Three Women,* this gesture assumes a recognizably Michelangelesque sculptural power.

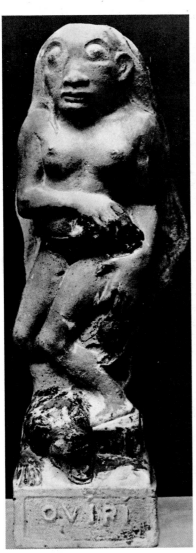

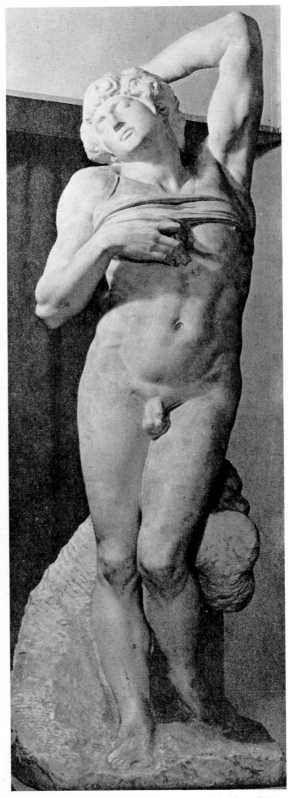

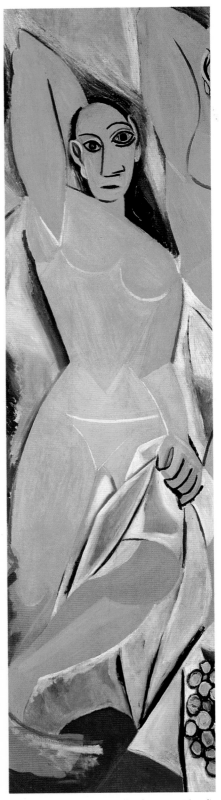

Paul Gauguin. *Oviri*. c. 1891–93. Terra-cotta, 29⅛" (74 cm) high. Private collection, Paris

Michelangelo Buonarroti. *Dying Slave*. 1513–16. Marble, 89" (226 cm) high. Musée du Louvre, Paris

Pablo Picasso. *Les Demoiselles d'Avignon* (detail). 1907. Oil on canvas, 96 x 92" (243.9 x 233.7 cm). The Museum of Modern Art, New York; acquired through the Lillie P. Bliss Bequest

The influence of the Iberian reliefs from Osuna that Picasso saw at the Louvre is first signaled marginally in work executed by Picasso in Gosol in the summer of 1906, but it becomes fully evident only in the pictures executed after Picasso's return to Paris.[26] Picasso's taste for the Archaic, however, had already been evident at the beginning of 1906, to the extent that Greek Kouroi—striding, frontal statues of male nudes given to victors at the Olympic games—are secondary sources (after Cézanne) in *Boy Leading a Horse*, the mood and execution of which also signaled the coming shift from the sentimental to the plastic. The Archaic visages in the Osuna reliefs, with their stylized features and hairdos and their simply modeled surfaces, are certainly at the origin of the masklike faces in Picasso's work of that autumn. The classic illustration, for a variety of reasons, is the repainted face in the *Portrait of Gertrude Stein*. One need only compare the style of Miss Stein's face with that of her dress—the bodice especially—and her chair to see, quite literally, how much Picasso's art had changed since his departure from Paris the previous spring. Stein claims variously to have posed as many as ninety-two times that winter and spring before Picasso left for Gosol, but he could not get the likeness to satisfy him and, shortly before leaving Paris, he wiped out the face completely.

Picasso's repainting of Stein's face in Iberian form the following autumn was done from memory. Hence the picture bridges his crucial leap from a perceptual to a conceptual mode of working (see pp. 11–13). This can be seen in retrospect as having opened the way for what two years later would become Cubism. However different Picasso's Iberianism of 1906–07 was from his Africanism of 1907–08, or from his early Cubism of 1908–09, one principle was to remain inviolate. As Salmon—who may well have heard it from Picasso—later put it, "The great law that dominates the new aesthetic is the following: conception overrides perception."[27]

Two Nudes (p. 248), painted toward the end of 1906, has been called "the culmination of the 'Iberian' phase," but it is simply the culmination of the first, or "sculpturesque," period of Picasso's Iberianism—that of the immediate post-Gosol months. During the first five months of the following year, the Iberian forms would flatten, becoming not only less sculptural but rougher, simpler, more angular and schematic. A major impetus in this direction seems to have been provided by Picasso's acquisition, in March 1907, of two Iberian heads from Cerro de los Santos, which unbeknown to him had been stolen from the Louvre.[28] Though Archaic, these heads were cruder and seemingly more "primitive" than the Osuna reliefs (especially the Cerro male head, p. 251, one side of which was significantly damaged).[29]

Picasso's figure types of late 1906, as exemplified by *Two Nudes*, were of squat proportions not earlier seen in his work. These proportions and the masklike faces—especially the heavy-lidded almost lozenge-shaped eyes—reflected the continued influence of the Osuna objects, though the quality of bulk in the bulbous and awkward figures is indebted to Cézanne. In the handling of the feet of the right-hand figure of *Two Nudes*, Picasso made a break with verisimilitude unprecedented in his art. In order to assure a more architecturally stable support for the nude's massive trunk, Picasso flattened her feet and omitted the front contour of her lower right leg where it joins the foot. He thus sacrificed the sense of

Man attacked by a lion. Iberian. Osuna. End of 6th–3rd century B.C. Stone (detail of a bas-relief), 16⅛" (41 cm) high. Museo Arqueologico Nacional, Madrid

Pablo Picasso. *Portrait of Gertrude Stein*. 1905–06. Oil on canvas, 39¼ x 32" (99.6 x 81.3 cm). The Metropolitan Museum of Art, New York; bequest of Gertrude Stein

a dynamic relationship between the figure and the ground on which it stands—an abiding convention of Western art since it was first convincingly established by Masaccio, who turned the weight of the body through the ankle into a foot that seemingly pressed against a resistant surface. The gravity-free manner in which the weighty right-hand nude relates to the ground beneath her recalls the Italian Primitives, Giotto in particular, as well as the inorganic stance of African figure sculptures, of which Picasso had by now seen some examples.[30] While *Two Nudes* is not "primitive" in the same sense as the work of the two following years, it shows a simplicity and numbing rawness in its facture—particularly in the rough hatching on the arms and the scrubby brushwork of the background—and a willful awkwardness in its drawing that mark it as an important step in that direction.

Picasso's Iberianism—along with the artist's interest in Gauguin and Egyptian art—constitutes the first, or Archaic, phase of his primitivism. The later stages of that Iberianism may be studied within the framework of the integration of *Les Demoiselles d'Avignon*, which saw both the culmination of the Archaic phase of Picasso's primitivism and the first appearance of the tribal influence that succeeded it. As it would be difficult to do justice to this picture's art-historical sources and implications in even a book-length text, I shall attempt to limit my discussion here as much as possible to the role of primitivism in the picture—admittedly a somewhat inorganic isolation from among intertwined art-historical themes and influences.

Contrary to the chronology cherished for many years (a chronology largely due to Kahnweiler's *Weg zum Kubismus*), Picasso did not begin the ensemble sketches for the *Demoi-*

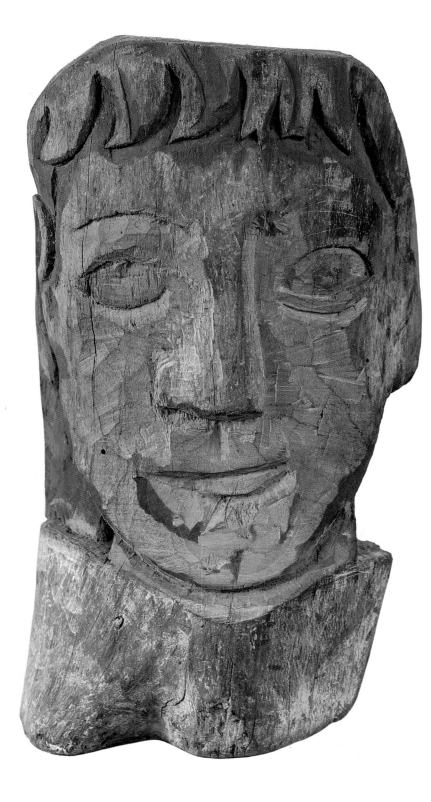

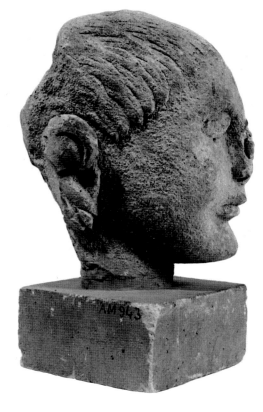

Above: Pablo Picasso. *Head.* 1907. Wood and paint, 15⅜ x 9⅞ x 4¾″ (39 x 25 x 12 cm). Collection Jacqueline Picasso, Mougins

Left: Head. Iberian. Cerro de los Santos. 5th–3rd century B.C. Stone, 8¼″ (21 cm) high. Musée des Antiquités Nationales, Saint-Germain-en-Laye. For another view of this work, see page 251.

selles—not to mention the canvas itself—until well into 1907. The impression fostered by Kahnweiler was of a painting upon which Picasso had worked for some six to eight months, beginning late in 1906. Unable to resolve its putative stylistic contradictions, he supposedly abandoned it unfinished by early summer 1907. The right side of the picture—its final phases—also constituted, for Kahnweiler, the "beginning of Cubism."

I hope that I have elsewhere satisfactorily laid to rest this matrix of art-historical myths.[31] Studies for the *Demoiselles'* composition as a whole date only from March 1907; and the painting was executed in its first, Iberian form in late May/early June of that year. Later in June, and probably into early July, Picasso made a number of changes in the work, possibly, as we shall see, on two separate occasions. The picture was complete by early July 1907. (Cubism was developed by Braque and Picasso only in the latter half of 1908; and Kahnweiler did not annex the *Demoiselles* to it until 1920.)

The earliest large ensemble study for the *Demoiselles* (below) dates from late February or early March 1907, probably not long before Picasso purchased the Cerro de los Santos heads. His Iberianism had been less and less sculptural since *Two Nudes*, and it is therefore not surprising that neither this seven-figure charcoal-and-pastel drawing in the Basel Museum nor the paintings of individual figures associated with it have much modeling. Their light/dark relationships are often abrupt,

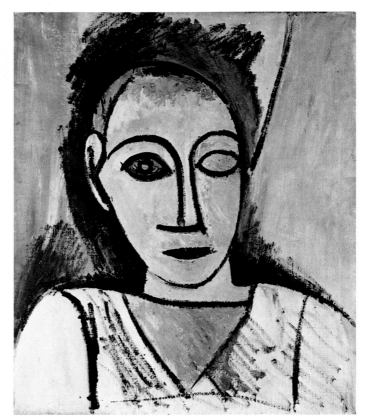

Pablo Picasso. *Medical Student, Sailor, and Five Nudes in a Bordello (Study for Les Demoiselles d'Avignon).* 1907. Charcoal and pastel, 18⅞ x 25" (47.7 x 63.5 cm). Kunstmuseum Basel, Kupferstichkabinett

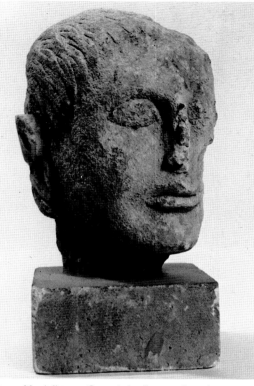

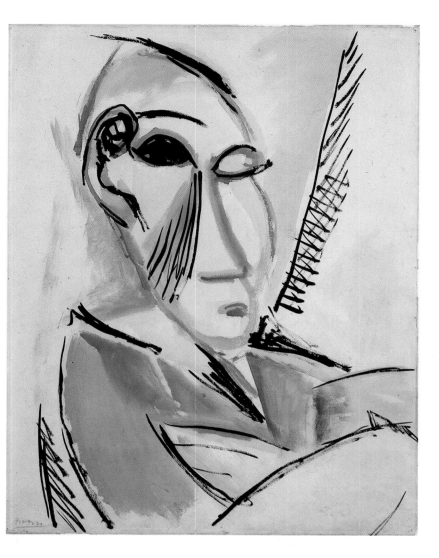

Above: Head. Iberian. Cerro de los Santos. 5th–3rd century B.C. Stone, 8¼" (21 cm) high. Musée des Antiquités Nationales, Saint-Germain-en-Laye. For another view of this work, see page 249.

Opposite above: Pablo Picasso. *Bust of a Sailor*. 1907. Oil on canvas, 21¾ x 18⅛" (55 x 46 cm). Musée Picasso, Paris

Right: Pablo Picasso. *Head of the Medical Student (Study for Les Demoiselles d'Avignon)*. 1907. Gouache and watercolor, 23¾ x 18½" (60.3 x 47 cm). The Museum of Modern Art, New York; A. Conger Goodyear Fund

even brutal, and in subsequent studies take the form of striations and hatchings that Picasso would associate—but only some months later—with African and Oceanic scarification marks and body painting.

If the little bronze sculpture-in-the-round, *Head of a Woman* (p. 248), belongs to the culmination of the first phase of Iberianism (as exemplified by *Two Nudes*), the work that relates to this last Iberian phase is quite logically a relief: *Head* (p. 249). The spirit of this raw and challenging piece, carved awkwardly in wood and offhandedly painted, immediately recalls that of the male head from Cerro, from which it derives its seemingly "primitive" facture and the slightly caricatural cast of its figuration.[32] The Cerro head, as Golding remarked long ago,[33] is also certainly related to such subsequent Iberian studies for the *Demoiselles* as the watercolor bust of the medical student (above right) in its large, peculiar scroll-like ear, the asymmetry of its eyes,[34] and the general coarseness of its facture. The long striations used for the shadow of the nose in Picasso's watercolor (which have affinities to the hairdo patterns of the Cerro sculpture) constitute an extrapolated form of the graphic shorthand known as hatching, the more typical examples of which in this same work suggest the shading of the drapery edge that rises in the upper right. The angular, primitivistic nature of this hatching (a word that derives etymologically from the cuts of an ax) led some critics to associate it with wood carving and, by this

declension, with the scarification marks and striation patterns of African sculpture. It is clear, however, that such bold striated patterns existed in Picasso's work well before his June "revelation" about tribal art at the Trocadéro, and were essentially his own primitivization of a traditional method of shading. After Picasso became interested in African sculpture, such patterning was, indeed, conflated with his recollections of scarification marks on African masks and figure sculptures, of the parallel copper strips of the Hongwe reliquary figures (p. 266), and of the so-called "tear patterns" (p. 302) and the parallel incised lines (p. 270) of Kota reliquary figures.

The hundreds of drawings and paintings related to the integration of the *Demoiselles* are yet to be fully collated,[35] but the outlines of its development are clear. The inception and implementation of the image from its first sketches through the achievement in late May or early June of a "completed" picture (of which only the two central maidens, the still life, and some other passages remain) are to be associated with the last, least sculptural, most schematic and angular phase of Picasso's Iberian period (which also saw his great *Self-Portrait* in Prague). By March 1907, this Iberianism had produced a project showing the reception room of a bordello (page opposite) in which a seated sailor is surrounded by five nude prostitutes in varying postures while a medical student (alternately shown carrying a book or skull) enters from the left.[36] By mid-May, following a host of studies in a variety of media,

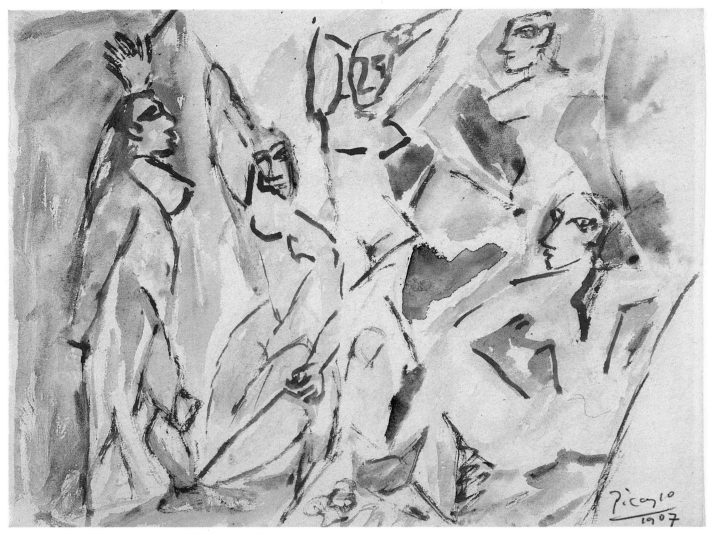

Pablo Picasso. *Five Nudes (Study for Les Demoiselles d'Avignon)*. 1907. Watercolor, 6¾ x 8¾" (17.2 x 22.2 cm). Philadelphia Museum of Art, A. E. Gallatin Collection

this gave way to what was to have been the final conception, as seen in the late Iberian watercolor of the Philadelphia Museum (above), in which the two male figures are eliminated and the format of the picture is altered in the direction of the vertical.[37] The "first campaign" of work on the canvas itself—which produced a "completed" picture that was a slightly flattened and more vertical version of the late Iberian watercolor—dates from late May and/or early June. But Picasso was evidently dissatisfied with the results and, in later June and/or early July, made a number of changes on the left and right side of the painting. It is in terms of *these* changes—their psychological motivations and their expressive and plastic character—that the inception of the tribal phase of Picasso's primitivism can be understood.

Why was Picasso dissatisfied with the Iberian version of the painting? I am convinced that in the course of transforming his conception from an essentially narrative (i.e., anecdotal) image into a more "iconic" one (more frontal, more spatially compressed, and comparatively abstracted from time and place), Picasso had sacrificed certain implications of the original storytelling bordello scene that had been carried in that

earlier context by the association of the *filles* with the sailor and medical student. Picasso's subsequent intuitive decision to introduce a range of different types of figuration into the *Demoiselles* effectively recaptured some of these meanings through the medium of style rather than illustration, and recaptured them on a more profound if more generalized level consistent with the "iconic" form the picture had taken on. The center, left-, and right-hand demoiselles communicate progressively darkening insights into the nature of femininity. I believe that once Picasso had left narrative communication behind, his picture *required* these differences in style precisely in order to span the polarity from Eros to Thanatos—from the allure of the female body to "the horror" of it—implied, as we shall see, in his original conceit. Picasso's transformation of the *Demoiselles* from a narrative to an "iconic" picture must be seen as taking place within a broad and continuing progression toward a static, frontal, and concentrated type of image that marks the elaboration and reworking of all of the four most ambitious of Picasso's 1905–09 paintings, and is paradigmatic for the development of his art from the Rose into the early Cubist period.

The "iconicizing" of the *Demoiselles* was at the heart of those innovations in style and symbolic content that confirm the

picture as an art-historical turning point. But for reasons rather different from those traditionally given. The *Demoiselles*, as I have observed, is not "the first Cubist painting."[38] Indeed, while marking the final stage of Picasso's transition from a perceptual to a conceptual way of working, and suggesting something of the shallow relief space that would characterize Cubism, this great and radical work pointed mostly in directions opposite to Cubism's character and structure—although it cleared the path for its development. The *Demoiselles* obliterated the vestiges of nineteenth-century painting still operative in Fauvism, the vanguard style of the immediately preceding years; it is thus more a "breakaway" painting with respect to late nineteenth-century modernism—and post-Medieval Western painting in general—than a "breakthrough" painting with regard to Cubism in particular. The first Cubist paintings were Braque's L'Estaque landscapes of the summer of 1908 and Picasso's revisions later that year of *Three Women* and *Carnaval au bistrot* (in the form of *Bread and Fruitdish on a Table*); yet the pivotal position of the *Demoiselles* makes it crucial to an understanding of early Cubism.

Since the 1920s, the *Demoiselles* had been interpreted primarily in formal terms—and seen through the wrong end of the telescope, so to speak, as the point of departure for Cubism. This not only discouraged studies dealing with the real beginnings of the Cubist style,[39] but led to a profound misinterpretation of the *Demoiselles*. The situation was virtually single-handedly reversed by Steinberg's 1972 article on the picture,[40] which encouraged what might be described as a new literature on the *Demoiselles*. Steinberg laid to rest the popular belief that Picasso's conversion of the *Demoiselles* was propelled primarily by a proto-Cubist interest in abstraction. The image's pictorial metamorphosis, he demonstrated, was

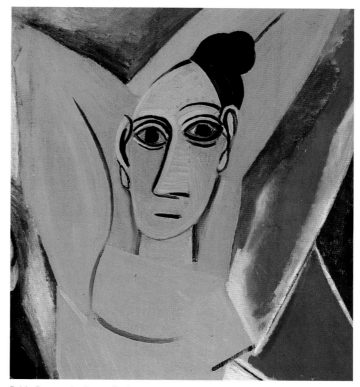

Pablo Picasso. *Les Demoiselles d'Avignon* (detail). 1907. Oil on canvas, 96 x 92" (243.9 x 233.7 cm). The Museum of Modern Art, New York; acquired through the Lillie P. Bliss Bequest

consistently motivated by a desire for an increasingly profound and intense projection of what had been Picasso's expressive concerns right from the first sketches: his complex and contradictory feelings about women. Steinberg marshaled many convincing arguments to confirm the changes in the painting as functions of "the trauma of sexual encounter."

The "African" figures on the right of the *Demoiselles* were, however, viewed by Steinberg exclusively as embodiments of "sheer sexual energy, as the image of a life force." This is consistent with his view of the picture as a whole as an image of "orgiastic immersion" and "Dionysian release." In this respect, I am obliged to consider Steinberg's characterization too narrow, as I believe that the two "African" figures (and, to a lesser extent, what I call the Gauguinesque "Oceanic" demoiselle[41] on the left) were as much, if not more, inspired by the fear of death as by the life force. Indeed, in a Freudian sense, the shadow of mortality would be implicit in any picture that was a "sexual metaphor," as Steinberg called the *Demoiselles*. But I am convinced that it was also present very explicitly in the painting's first project, in Picasso's deliberate pairing of the medical student and sailor—and that this dread of death survives in a more vivid, if generalized, form in the final image. The thanatophobic dimension of the *Demoiselles* has needed elucidation, I believe, not only because it confirms the last state of the painting as a deepening rather than an abandonment of the picture's original program, and clarifies the value of the iconic (as against the narrative) mode in achieving this end, but also because it throws fresh light on the conundrum of Primitive influence.

The cohabitation of Eros and Thanatos in the *Demoiselles* recalls a particular component of Picasso's psychology: his deep-seated fear and loathing of the female body—which existed side by side with his craving for and ecstatic idealiza-

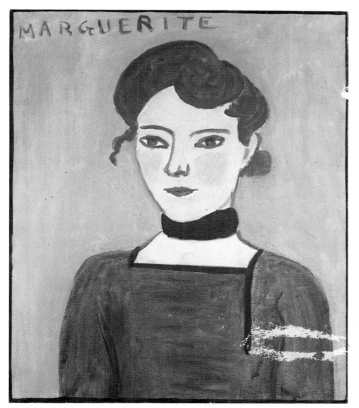

Henri Matisse. *Marguerite*. 1907. Oil on canvas, 25⅝ x 21¼" (65 x 54 cm). Musée du Louvre, Paris; Donation Pablo Picasso

tion of it. This dichotomous attitude was time and again evidenced in Picasso's art as it was in his behavior; it is parodied in his admitted treatment of women as "either goddesses or doormats." To be sure, comparable attraction/repulsion syndromes are commonplace in male psychology. But in the *Demoiselles*, as often in the work of a great artist, such inherently banal material is so amplified by the spirit of genius that it emerges as a new insight—all the more universal for being so commonplace.

Picasso's feelings of revulsion for the female body were projected in the first state of the *Demoiselles* through a narrative specificity that turned on the danger of venereal disease, at that time often fatal (Picasso had frequented bordellos for many years). This is the real meaning of the confrontation of the sailor and the medical student (who carries a skull) in the first project.[42] The identities, props, and postures of the male figures do more than just enhance the narrative particularization of time, place, and transaction in the bordello. The image lends itself to many readings, but insofar as the sailor represents one who gets the pox in a brothel and the medical student one who cures it, their pairing reflected a little-reported but very important symptomatic aspect of Picasso's makeup—his exaggerated concern for and fascination with venereal disease, as reflected in his 1902 visits to the Hôpital Saint-Lazare to study prostitutes being treated for syphilis.[43] This motivation has not gone totally unnoticed. Mary Mathews Gedo, although overlooking the reciprocal symbolism in the pairing of the male figures, hazarded that "the skull [carried by the medical student] may refer to the fact that somewhere, sometime during his youthful amatory career, Picasso himself had contracted a venereal infection."[44] To postulate Picasso's having been diseased is hardly necessary, however; nor is there any firm evidence for such a suggestion. It more than suffices that the painter deeply feared such potentially fatal contagion.

The final painting no longer contains a specific narrative reference to Picasso's dread of disease and death. There, this dread is subsumed in a broader, more universal fear of mortality that is communicated through more direct pictorial means. We sense the thanatophobia in the primordial horror evoked by the monstrously distorted heads of the two whores on the right of the picture, so opposite to those of the comparatively gracious Iberian courtesans in the center. One can hardly imagine the fear, shock, and awe these heads must have imparted in 1907, given the vividness with which we still experience them. These "African" faces express more, I believe, than just the "barbaric" character of pure sexuality invoked by Steinberg; in the first instance, their violence alludes to Woman as Destroyer—vestiges of Symbolist *femmes fatales*—but they finally conjure something that transcends our sense of civilized experience, something ominous and monstrous such as Conrad's Kurtz discovered in the heart of darkness.

It is precisely because Picasso was looking for new solutions to the direct communication of these primordial terrors, and not because tribal art supposedly offered a proto-Cubist morphology, that he seized upon it at that particular moment as a source of inspiration. To the extent, therefore, that the right-hand demoiselles were inspired by ideas

about tribal art prompted by Picasso's Trocadéro visit, their images open outward toward the collective implications of masking as elucidated by Lévi-Strauss. Insofar, however, as those visages were in fact arrived at by Picasso's search for plastic correlatives in exorcising his private psychological demons, they constitute a form of visual abreaction, and lead us inward to the Freudian sense of masking, in which an emotion too painful to confront directly (here the artist's fear of death through disease) is dealt with by substituting a "cover" image.

Despite his assertions to the contrary, which began in earnest during World War II, Picasso had seen some examples of "art nègre," as we have already noted, for at least six months before he absorbed it into the fabric of the *Demoiselles*. But it had not registered with him—any more than had his early confrontations with Rousseau—because it did not then relate to his needs. Picasso's "revelation" at the Trocadéro was said by Zervos, and others who saw no reflection of "art nègre" in the *Demoiselles*, to have taken place in late July 1907, *after* Picasso completed the picture. But it was surely in June, after he had completed *only the first (Iberian) version* of the *Demoiselles*, from which the two central figures remain. Indeed, the artist himself spoke of the *Demoiselles* in relation to "art nègre" in his 1937 conversations with André Malraux.[45]

Picasso had gone that day to look at the plaster casts of Romanesque sculpture in the Musée de Sculpture Comparée, which occupied one wing of the Palais du Trocadéro. He had been there before, and the fact that he was drawn back to an art considered "primitive" in those years is probably symptomatic—another case of Picasso's famous "prescience," here exercised in regard to the kinds of solutions his instinct told him were needed to resolve his dissatisfaction with the *Demoiselles*. He had, however, never before visited the Musée d'Ethnographie, which occupied the other wing of the Trocadéro, and as he described it, his entering that wing was virtually serendipitous. In retrospect, however, it seems a logical continuation of the search that had taken him to the Musée de Sculpture Comparée. Further, though Picasso described himself as virtually stumbling upon the ethnological material,[46] the configuration of the building was such that he had to exit entirely from one museum to enter the other.

On entering the Musée d'Ethnographie, he would have had to pass through the large rotunda gallery devoted, at that time, to both African and Oceanic sculpture, where large mannikins in ritual or warlike postures were displayed in masks and costumes. His various descriptions of the dankness, evil smell, poor installation, and general seediness of the place[47] probably apply more to the individual galleries than to the rotunda. The African gallery would seem to have been in particularly bad shape at the time (see Paudrat's description of it, pp. 141–42), and more confusingly installed than we see it in photographs made in 1895 (pp. 126, 322). Access to this gallery was directly from the rotunda, and except for brief if evidently frequent periods, it was open to the public.[48] A stairway connected it directly to the Oceanic gallery (pp. 258, 286), which was probably in better shape as it had been "officially" closed since almost the time of its original installation—though Paris's leading museum guide showed it as regularly open. "Closed" simply meant that one could enter it only with the assent—or in the company—of the guard.[49]

Picasso's accounts of this visit (and several that followed)[50]

suggest that he was able to wander quite freely. His first instinct, given his disgust with the place itself, was to flee. But something would not let him take his eyes off the tribal material, and he remained. When he finally left, it was with a feeling of relief. He thought at first it was just the fresh air, but he realized almost instantly that it was because something not altogether comfortable or pleasant—indeed, something profoundly disturbing—had been happening to him inside.[51] The words he would use and reuse with Malraux, myself, and others—"shock," "revelation," "charge," and "force"—make clear that he had experienced both a trauma and an epiphany.

Insofar as the trauma related to the uncertain state of his recent psychological probing—the virtual self-analysis which had engaged him ever since he had undertaken the *summa* of his life and work that became the *Demoiselles*—it was the "magical" conception of art as catharsis that first claimed Picasso in the masks and figure sculptures he saw. He was later at pains to point this out—in part, perhaps, because his view of tribal art had traditionally been misinterpreted as purely formalistic.[52] He did, however, also respond to the reductive, ideographic character of the works he saw (which he would describe to Salmon as "raisonnable," i.e., logical, in a conceptual sense), as well as to the aesthetic particulars of certain objects, as his drawings of 1907 and 1908 make perfectly clear. Picasso's dualistic attitude toward the objects that he called both "magicaux" and "raisonnables" involved no contradiction, however. The first word described their function and their force; the other, the logic of their various reductive and ideographic (as opposed to descriptive) modes of representation.[53]

Picasso's admittedly galvanic reaction to his Trocadéro visit was surely the inspiration for the "second campaign" of work on the *Demoiselles*, which thus would have resulted from a renewed and more extensive confrontation with tribal art at precisely the moment he was casting about for an adequate visual idea to embody his dark forebodings and private terrors. Not by accident did he later characterize the *Demoiselles* as his "first exorcism picture." "For me the [tribal] masks were not just sculptures," Picasso told Malraux. "They were magical objects...intercessors...against everything—against unknown, threatening spirits....They were weapons—to keep people from being ruled by spirits, to help free themselves." "*If we give a form to these spirits*," he said (in a perfect definition of what I have called "visual abreaction"), "*we become free.*"[54]

My conviction that the Trocadéro visit preceded the repainting of the two right-hand demoiselles follows in part from aspects of these figures that cannot be adequately explained by Picasso's experience of a handful of objects from the French territories in Africa, such as those he had seen in the studios of Derain, Vlaminck, and Matisse during the preceding six to eight months. By 1907, the Trocadéro possessed a large number and wide variety of African and Oceanic objects, a survey of which I have made with the collaboration of my colleague Judith Cousins; regrettably only a small fraction of this material can be reproduced here (the acquisition dates of these objects are included in the captions). The Trocadéro not only offered Picasso a large number of more stylistically varied works than he saw in his fellow artists' collections but,

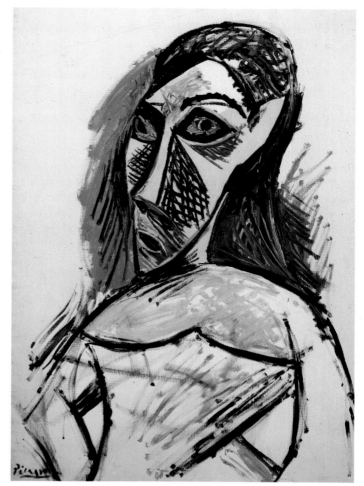

Pablo Picasso. *Bust of a Woman.* 1907. Oil on canvas, 31⅞ x 23⅝" (81 x 60 cm). Private collection, Switzerland

more important, presented them in a different context. To see a few sculptures in an artist's studio is to see them in a situation of aesthetic delectation. Viewed this way, "art nègre" clearly did not impress Picasso between autumn 1906 and June 1907.[55] Then suddenly we find him regarding these masks and "fetishes" by a compelling, new light that is relevant to what he is trying to get at in the *Demoiselles*. He now begins to think in terms of "exorcism," "intercession," and "magic." What could be more logical than that this "revelation" should have taken place in an ethnological museum, where the isolated masks and statuettes of the artists' studios give way to mannikin figures in full ceremonial regalia surrounded by artifacts evoking their cultures and accompanied by labels that declare their ritual function?

Although the magical, exorcistic roots of art constituted the central feature of Picasso's "revelation," there is another aspect of the "African" figures in the *Demoiselles* that leads me to relate them to the Trocadéro visit—and that is, ironically, their "Oceanic" coloring. (African objects are most frequently unpainted and when colored tend to be muted in hue—except for the folkloristic palette of the Yoruba; this is consistent with their fundamentally sculptural plasticity, as against the essentially pictorial character of most Oceanic sculpture.) While the tactility and morphologies of the right-hand demoiselles' masklike faces are clearly, if only elliptically, reminiscent of Africa, their highly saturated colors, juxtaposed in brash—even brutal—combinations, strongly suggest the raw and

often grating juxtapositions of orange, blue, white, and yellow in certain Oceanic objects. These color combinations are not, however, related to objects from Tahiti, the Marquesas, or New Caledonia, which Parisian artists could have acquired in 1906-07, but to those from other areas such as the New Hebrides (a joint British-French protectorate) and New Guinea, from which sculpture was not yet commercially available in France, though a number of such intensely colored pieces had entered the Trocadéro in the nineteenth century.[56] Impetus to sudden stylistic change is often associated in Picasso with seeing a challenging, unfamiliar art that speaks directly to his thinking and feeling at the time. Given the sudden rupture in his development represented by the right-hand figures of the *Demoiselles*, a trigger has certainly to be assumed—and there is not only no better but *no other* candidate for this than the Trocadéro visit that the artist himself called a "shock" and a "revelation."

The unprecedented *brut* coloring and slashing painterly attack of the right side of the *Demoiselles* (and paintings related to it, p. 255) have sometimes been wrongly associated with Fauvism. But the latter remained throughout its development essentially decorative in its color harmonies, which were consistently anchored to the triad of the primary hues. Moreover, the manner in which this color was applied—even at its most "wild" (as in Vlaminck's *Woodcutter*)—was a far cry from the slashing boldness, the almost bodily physicality, of some brushwork in the *Demoiselles*. Nor can Picasso's new color be associated with Gauguin's decorative palette or the more Expressionist chromatics of Brücke painters such as Nolde and Kirchner, whose characteristic color gamuts in any case post-date the *Demoiselles* by more than a year (though it is possible

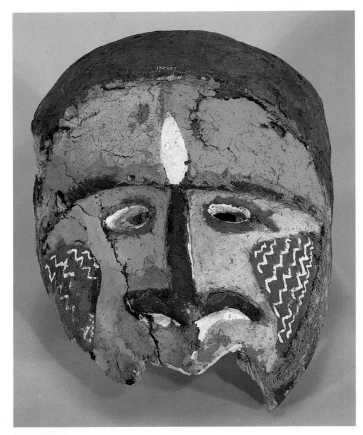

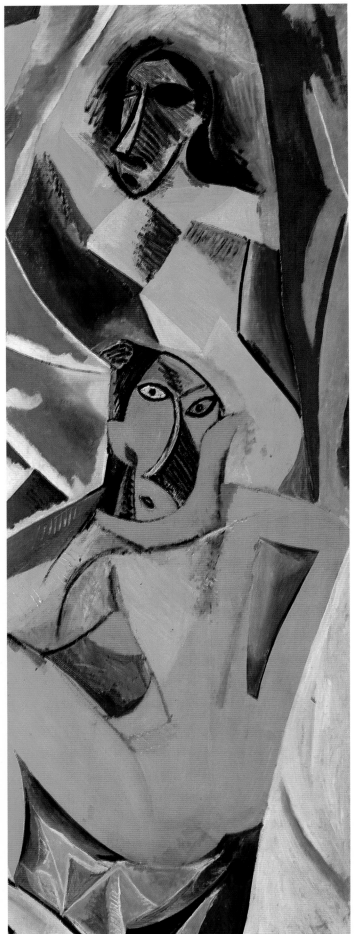

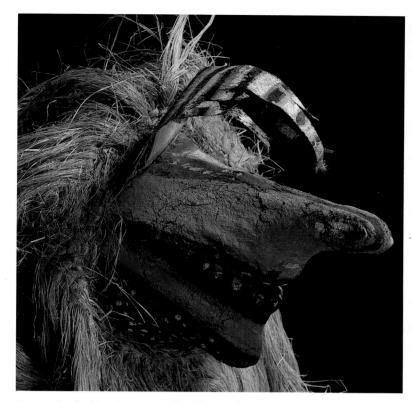

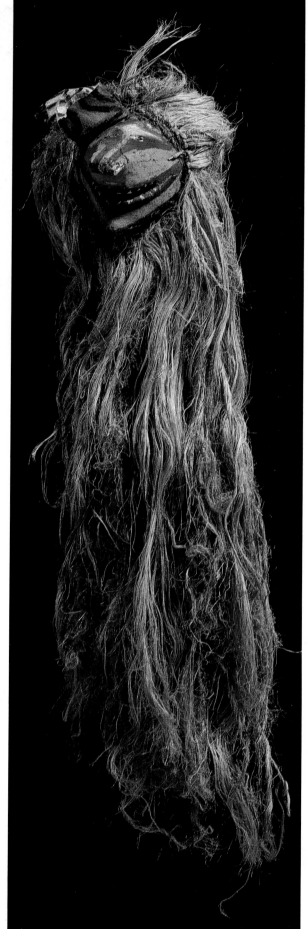

Above and right: Mask (two views). Oba, Vanuatu (formerly the New Hebrides). Painted tree bark and fiber, 5⅞" (15 cm) high. Musée de l'Homme, Paris; acquired 1894

Opposite left: Mask. Malekula, Vanuatu (formerly the New Hebrides). Painted palmwood, 25" (63.5 cm) high. Field Museum of Natural History, Chicago

Opposite right: Pablo Picasso. *Les Demoiselles d'Avignon* (detail). 1907. Oil on canvas, 96 x 92" (243.9 x 233.7 cm). The Museum of Modern Art, New York; acquired through the Lillie P. Bliss Bequest

that a certain rawness in their color too derived from South Seas sources). The Expressionists favored remote tertiary and quaternary hues, which endowed their pictures with precisely that "sicklied o'er" psychological ambiance, that sense of *angst*, which they were trying to obtain. Picasso's robust new "primitive" coloring of 1907 stays closer to primary and secondary hues than does that of the Germans, but not as close to the primaries as that of the Fauves. The particular oranges, blues, reds, yellows, and whites he uses in the *Demoiselles* and related studies are unlike those of the French painters; not only are they usually even more saturated, but the chromatic intervals that separate adjoining colors have a brutal dissonance that is entirely antidecorative.

There is no model for this in Western art. But it was anticipated in some of the Oceanic art that was in the Trocadéro collection at the time of Picasso's visit. The New Hebrides mask illustrated on this page, for example, is made up of raw oranges, blues, and whites close to those of the *Demoiselles*, while its exaggerated nose and grimacing grin— though far from having been imitated by Picasso—accord with a kind of "horrific" expressionism he initiated. It was this Picassoesque expressionism (which he would himself revive in the period 1925 to World War II) rather than German Expressionism (as was often mistakenly assumed) that was to inspire Pollock and de Kooning in the early forties, and to lead directly to the grimacing "smile" on the face of de Kooning's *Woman I.*

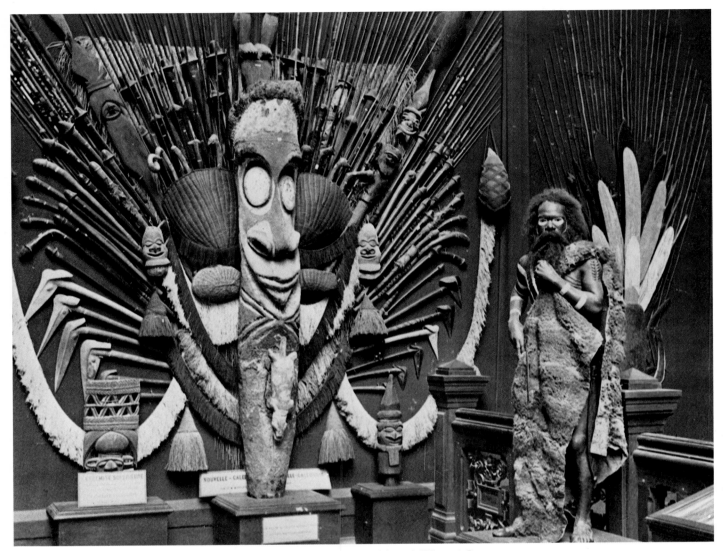

Installation of a corner of the Oceanic Room, Musée d'Ethnographie du Trocadéro (now Musée de l'Homme), Paris, 1895

If there was no Western precedent for the palette of the right side of the *Demoiselles*, neither was there one for the morphologies of its masklike heads. Their "distortions" complement the *brut* coloring, and together these qualities endow the figures with precisely the sense of awe, shock, and horror that seems to have been cathartically necessary for Picasso in order to liberate himself from his sexually inspired fear of disease and death; they provide as well a telling foil for the image of the attractive female, as represented by the *Demoiselles'* center figures.[57] The "horrific" heads of the right-hand figures have been associated with tribal masks—African in particular— ever since the picture was painted. Indeed, their insistently sculptural character and some particulars of their morphologies are distinctly African in spirit. Yet the "Oceanic" color that Picasso applied to these "African" heads is in perfect expressive harmony with them. Picasso cared nothing, of course, about mixing cues and recollections from unrelated cultures. Aesthetic unity is not, after all, a question of the artist's sources, but of his work, and Picasso's mixture of "African" plasticity with "Oceanic" coloring on the right side

of the *Demoiselles* was genial.

Beyond hazy assumptions (often incorrect) that tribal sculptures related to concerns such as fertility and death, Picasso and his early twentieth-century colleagues knew nothing of their real context, function, or meaning. Their ignorance was an advantage insofar as it freed them to interpret the objects in manners suited to their personal concerns. And this ignorance or vagueness, needless to say, extended to geography. In common with other artists of his generation, Picasso did not always distinguish, even later in life, between African and Oceanic tribal art. Both were subsumed under the term "art nègre."[58] To the extent, however, that a distinction was made, "Oceanic" usually tended to signify for Paris artists of Picasso's generation, Matisse for example, a conflation of the Polynesian environment (even more than its art), its extrapolations in Gauguin's work, and the premises (primarily literary) of the French "myth of the primitive" that had inspired Gauguin. Thus, along with a darkling substratum of mysterious ritual, "Oceanic" generally implied the luxuriant, unthreatening natural environment of Polynesia as celebrated

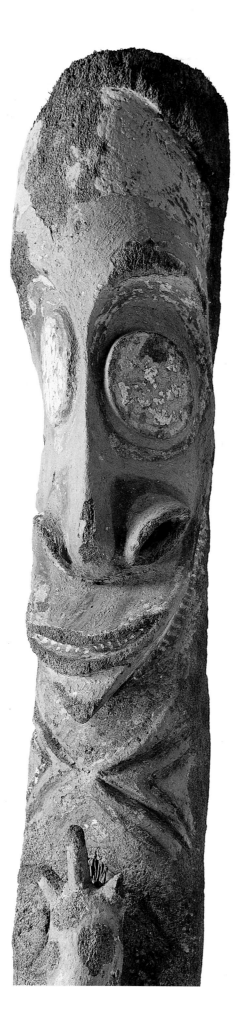

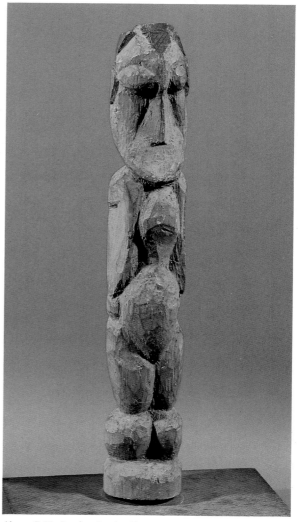

Above: Pablo Picasso. *Standing Figure.* 1907. Painted wood, 14½ x 2⅜ x 2⅜" (37 x 6 x 6 cm), on base 15¾ x 8¼ x 4" (40 x 21 x 10.2 cm). Private collection

Left: Grade Society figure (detail). Malekula, Vanuatu (formerly the New Hebrides). Painted tree fern, 8' 10¼" (270 cm) high, overall. Musée de l'Homme, Paris; acquired 1890

in Bougainville's *Voyage autour du monde.*

Such connotations did not surround the word "African," which evoked something more fetishistic, magical, and, above all, potentially malefic—far closer in mood to Conrad's *Heart of Darkness* than to Gauguin's *Noa-Noa.*[59] The archetypal "night journey" of the soul recounted in *Heart of Darkness* by means of the metaphor of Kurtz's voyage to the interior of the Congo seems to me close in spirit to Picasso's descent into his psyche during the elaboration of the *Demoiselles.* Indeed, Picasso's radical primitivizing of the *Demoiselles* might well be considered a pictorial realization of Conrad's words, "The mind of man is capable of everything—because everything is in it, all the past as well as all the future." Certainly the "African" figures on the right of Picasso's painting were meant to express something alien, menacing, and virtually unutterable about "the primitive" such as Kurtz discovered in the recesses of his own unconscious when, in the heart of the Congo, he released himself from the constraints of "civilization"—something he could express at the moment of his death only as "the horror" of it.

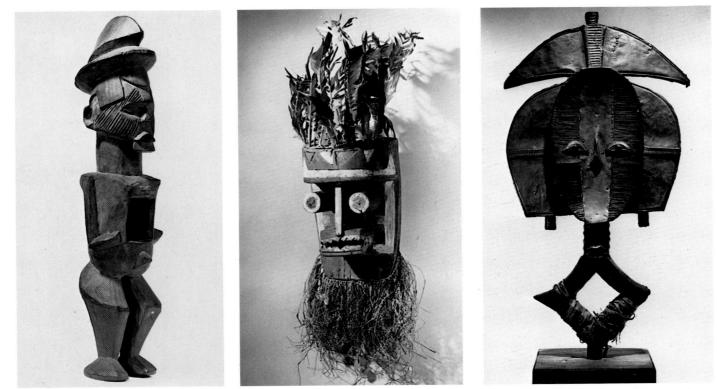

Figure. Teke. People's Republic of the Congo. Wood, 11¾" (29.9 cm) high. Musée de l'Homme, Paris; acquired 1904

Mask. Grebo. Sassandra, Ivory Coast. Painted wood, feathers, and mixed media, 11⅜" (29 cm) high. Musée de l'Homme, Paris; acquired 1900

Reliquary figure. Kota. People's Republic of the Congo. Wood, copper, and brass, 19⅝" (50 cm) high. Musée de l'Homme, Paris; acquired 1883 (see page 337, note 84)

The role of "art nègre" in the *Demoiselles* was much talked about early on by friends of Picasso such as Salmon, Stein, and Wilhelm Uhde. So popular did this "explanation" of the picture eventually become that the *Demoiselles'* "postludes" began being titled *African Dancer* or *African Head*—as if Picasso had literally made images of Africans or, at the very least, had imitated African figures or masks. By the beginning of World War I, this sort of "criticism" had become hypertrophied in the press, both in Paris and New York, in part as the result of the activities of the Mexican-born caricaturist, artist, entrepreneur, and, above all, propagandist Marius de Zayas who, among other things, acted as go-between for Stieglitz and Paul Guillaume in organizing the celebrated exhibition of African art at "291" in 1914.[60] De Zayas saw the whole of modernist abstraction as the "offspring" of Negro art,[61] which he also claimed in 1916 as the "point of departure" for the "complete evolution" of Picasso's thinking and feeling from 1907 on.[62] He later evidently identified himself to Alfred Barr as Picasso's interlocutor for the now famous text Barr reprinted as a 1923 "statement made in Spanish to Marius de Zayas,"[63] but which is, in fact, an edited version of observations made by Picasso to Florent Fels.[64] It is not without significance that one of Picasso's remarks to Fels that de Zayas excised—precisely because it contradicted his own theories about the role of "art nègre"—was the artist's statement that "the African sculptures that hang around almost everywhere in my studios are more witnesses than models."[65] There is no question that the kind of speculations fueled by de Zayas and others angered Picasso, and led to remarks on his part downplaying (and later denying) the role of "art nègre"[66]—to the point that

from World War II onward, Picasso consistently claimed not only to have seen no tribal art prior to painting the *Demoiselles*, but that his celebrated visit to the Trocadéro had followed rather than preceded the painting's execution. As if further to deflate the "African" explanation, Picasso also then first publicly alluded to the very real and until then wholly unobserved role of Iberian art in the *Demoiselles*.[67]

Quite apart from the data of the painting itself, however, the collective testimony of friends who knew him during its execution, combined with Picasso's own remarks linking it to "art nègre" in his 1937 conversation with Malraux, makes it clear that Picasso's later comments were a kind of strategy (as I have explained elsewhere)[68] designed to counter prevailing theories and to put discussion of the *Demoiselles* and, indeed, the whole "African" period into some sort of perspective. While Picasso had seen some African objects on occasional studio visits (to Matisse, Derain, and Vlaminck) during the six months prior to undertaking the *Demoiselles*, and while the Trocadéro visit clearly took place *during* and not after its execution, neither in this picture nor in any other painting, drawing, or sculpture did Picasso literally copy or imitate any tribal object. Nor was tribal sculpture—contrary to popular assumptions—to have anything comparable to the role of Cézanne's painting in the development of Cubism. This does not mean that recollections of tribal objects were not occasionally points of departure for Picasso's work. But when that happens, what really interests us even more than his source— if it can be divined—is how Picasso metamorphosed it. Beyond the sense of the magical (i.e., psychological and spiritual) force of tribal art, Picasso was impressed by aspects of its conceptual structure, principles that he could abstract

Mask. Susu. Guinea. Cloth, metal, and fiber, 23⅝" (60 cm) high. Musée de l'Homme, Paris, acquired 1901

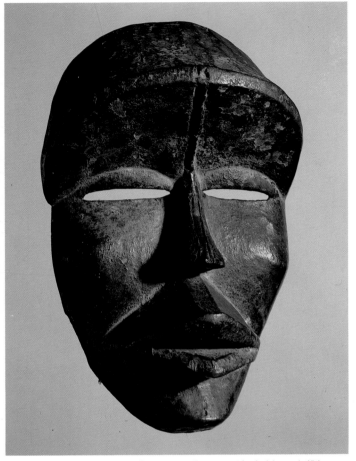

Pablo Picasso. *Les Demoiselles d'Avignon* (detail). 1907. Oil on canvas, 96 x 92" (243.9 x 233.7 cm). The Museum of Modern Art, New York; acquired through the Lillie P. Bliss Bequest

Mask. Dan. Ivory Coast or Liberia. Wood, 9⅝" (24.5 cm) high. Musée de l'Homme, Paris, gift of Baron von der Heydt; acquired 1952

from their sources and use to his own ends. In fact, neither of the two "African" heads on the right of the *Demoiselles* nor the one on the far left that I have called Gauguin-esque/"Oceanic" resembles any African or Oceanic mask Picasso could have seen in Paris in 1907 in the studios of his friends or at the Trocadéro museum.[69]

Proceeding from oversimplified conceptions as to how Picasso worked, scholars have, nevertheless, associated four particular types of tribal masks with the *Demoiselles*. Not one of these, however, would have been accessible to Picasso in 1907. Alfred Barr, for example, proposed a relationship[70] (afterward cited by Laude[71] and others) between the head on the upper right of the picture—indeed, the most masklike and "African" of the faces—with a type of mask from the Etoumbi region of the (then) French Congo (facing page). This remains a most interesting juxtaposition, even if it must be "demoted" from an influence to an affinity because none of the three masks of this type known to exist came out of Africa before 1929.[72] In fact, no objects at all from this particular region are known to have reached Paris until after 1907. Let us even imagine, however, that by some accident of history one such rare Etoumbi region mask *had* been brought to Paris by some sailor or colonial. Even then, the chances of Picasso's having seen it appear nil. We know that no such mask was (or is) in the Trocadéro museum, and we know that this was not at all the type of object collected by his three painter friends (who then probably had no more than thirty African sculp-

tures, only some of them masks, between them).[73] These four sources constitute the whole of Picasso's visual experience of tribal art *up to and through* the execution of the *Demoiselles*. As Picasso began collecting tribal objects only *after* he completed the *Demoiselles*,[74] he had not yet started visiting shops handling them, only one of which in any case—Emile Heymann's Au Vieux Rouet—was established by 1907. As I have explained earlier, such similarities as were signaled by Barr do not necessarily imply artistic contact between the authors of the objects. All artists who represent the figure through conceptual signs rather than through description share a commonality of problems and, hence to some extent, of solutions.

In comparing the Etoumbi region mask with the upper-right demoiselle, Laude, for example, emphasized the long triangular nose of the mask. This he saw as the source of a type of nose common in Picasso's heads of later 1907 and early 1908, which the French call the *quart-de-brie* (wedge of brie cheese) nose. But when we look at the other noses in Picasso's "African"-period works, at least those wide enough to merit the term *quart-de-brie*, we see that in most of them the triangle is formed less by the nose itself—that is, by the front of the nose, as in the upper-right demoiselle and the Etoumbi mask—than by the profile contour of the nose *in combination with its shadow* (pp. 255, 291). This formulation had been anticipated in a number of the heads associated with the Iberian phase of the *Demoiselles* (p. 251) realized prior to Picasso's Trocadéro visit. The rude hatching through which

such Iberian imagery was realized is ultimately at the origin of the parallel complementary red and green stripes that "shade" the upper-right demoiselle's nose. Thus the very origin of the so-called *quart-de-brie* nose was pictorial rather than sculptural—a primitivizing of a two-dimensional shading device.

This should remind us of a point often forgotten in the quest by certain critics for Primitive models in Picasso's work, namely, that these putative models are sculptures while the *Demoiselles* is a painting, so that a whole series of different aesthetic conventions apply. In primitivizing the conventions of painting, Picasso unquestionably merged them with recollections of surface-design aspects of the tribal art he had seen—incised scarification patterns, for example. But taken in its entirety, Picasso's primitivizing in the *Demoiselles* presupposed his absorption of the whole Western pictorial tradition. Indeed, appearances to the contrary notwithstanding, modern painting is in general more informed by Western illusionism than by anything else, for its revolutionary changes *operate precisely on that body of received ideas*. Hence, for example, Matisse's frequent flattening of the image so as to drain it of evident sculptural values is nevertheless done in such a way as to retain these values by implication. This results in an image with a plastic expressiveness whose vestigial illusionism renders it very different from pre-Renaissance styles such as the Egyptian, which were flat from their inception. This would not apply, at least in the same manner, to Picasso's (or Brancusi's) sculpture. But in its 1907–08 phase, that sculpture, most of which was left unfinished, has only oblique relationships to tribal objects—and then, as we shall see, as much to Oceanic as to African models.

The second of the four kinds of masks scholars have associated with the *Demoiselles* is the type of Dan mask Golding reproduced in his classic article on the *Demoiselles*,[75] in which he compared it with the head of the darkling maiden on the extreme left. He did not, of course, imply that this particular mask (facing page), which is in the collection of the Musée de l'Homme, was *the* mask Picasso saw. And, indeed, this particular mask only entered the Trocadéro in 1952. But such resemblance as the face of Picasso's figure might have to this or any other Dan mask would have to have been entirely fortuitous, as no Dan masks were to be seen in Paris until some years after the *Demoiselles* was painted. The "pacification" of the interior regions of the Ivory Coast where the Dan live began only in 1908, in the face of fierce opposition. Some Dan masks may have made their way to French ports in the years just prior to World War I, but despite their later ubiquity, the overwhelming majority arrived only during the *entre-deux-guerres*. One Dan mask was reproduced in Level and Clouzot in 1919,[76] but the earliest to enter the Trocadéro collection arrived only in 1931.

Golding's association of the left-hand figure's head to Africa notwithstanding, I have always considered this visage to be essentially Gauguinesque in character, and probably, through Gauguin, more indebted to Oceanic or Egyptian art than to anything African. Although this demoiselle's head shares many of the Iberian characteristics of the picture's two central heads, its more summary and more geometrical contouring, more sculptural modeling, and dark color render it more

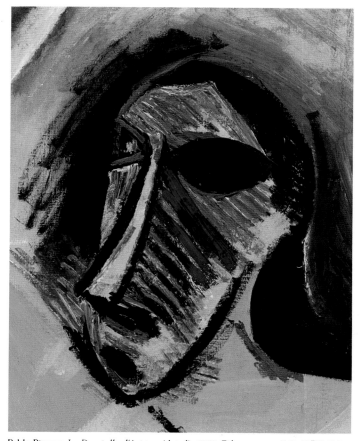

Pablo Picasso. *Les Demoiselles d'Avignon* (detail). 1907. Oil on canvas, 96 x 92" (243.9 x 233.7 cm). The Museum of Modern Art, New York; acquired through the Lillie P. Bliss Bequest

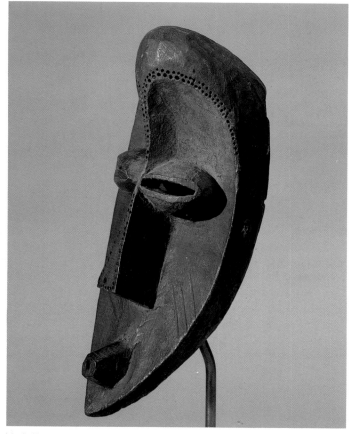

Mask. Etoumbi region, People's Republic of the Congo. Wood, 14" (35.6 cm) high. Musée Barbier-Müller, Geneva

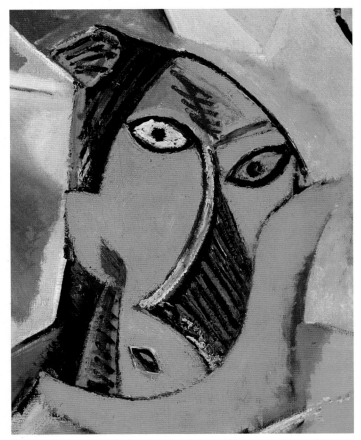

Pablo Picasso. *Les Demoiselles d'Avignon* (detail). 1907. Oil on canvas, 96 x 92" (243.9 x 233.7 cm). The Museum of Modern Art, New York; acquired through the Lillie P. Bliss Bequest

masklike, and as Golding observed, the head and neck seem clearly detached, both stylistically and in hue, from the body. While the upper parts of the two figures in the center show no signs of repainting, the neck, head, hair, left hand, and parts of the body of the left-hand demoiselle were unquestionably reworked after Picasso had completed the painting in its original, Iberian form. It is possible that this was done at the same time he repainted the two demoiselles on the right, but I believe that it took place at a somewhat earlier moment—and that there were thus *two* periods of repainting, the visit to the Trocadéro probably falling between them. Two reprises seem to be suggested, although somewhat confusingly, in Salmon's *La Jeune Peinture française*, the only really significant early account by an eyewitness to the painting's progress.[77]

Gauguin's *Spirit of the Dead Watching* (p. 200), which Picasso probably knew only in lithographic form (though its elements are also present in *Noa-Noa*), contains a half-idol, half-human Tupapau (a female ancestor spirit), which is situated on the extreme left and is represented in absolute right profile, but with a frontal eye—all of which characteristics are shared by Picasso's left-hand demoiselle. And although the face of the latter is more masklike and more Iberian, the Gauguin figure, with its conflation of Archaic influences—Egyptian, in particular—seems to me as close to the Picasso as any African or Oceanic mask. Indeed, there are *no* masks that, viewed in profile, show frontal eyes; this is a *pictorial* convention, and is fundamental to Egyptian painting and to other forms of Archaic art from which Gauguin borrowed ideas. On the poetic and psychological plane, the *Spirit of the Dead Watching* is even

more relevant to the *Demoiselles*. It shows a troubled young girl at the age of sexual awakening reclining on a bed (Gauguin described this figure as "slightly indecent," and she is not unrelated to the heroine of his loss-of-innocence paraphrase, *Nevermore*). Her "fear" or "dread" (Gauguin's words) is related to the imagined Tupapau, hence to death. The combination of Eros and Thanatos in Gauguin's picture is especially apt to the exploration of the identical polarity that I find at the heart of the *Demoiselles*.

An Oceanic (as opposed to African) inspiration for the *Demoiselles* was one of Ron Johnson's theses, and in this regard he saw as a possible source for the picture a mask from the Torres Strait (p. 315) that had been published as being in Picasso's collection.[78] Picasso's mask does not, however, have the sinister look of the tortoise-shell[79] masks of this region, which usually have the elongated visage of the powerful wooden one we reproduce on page 108. Picasso's is, in fact, far more imaginative, with its small superposed second head and seashell "cap." But its round features are in no way related to the faces in the *Demoiselles*, and its primarily pale green and secondarily dark red coloring is equally alien to the picture. Moreover, though this cannot be proved, Picasso's mask was understood among his friends to have been acquired in the 1920s;[80] indeed, Charles Ratton, dean of French dealers in tribal art, told me that so far as he knew, no Torres Strait masks were available in Paris before that time.

Perhaps the most extraordinary masks to have been associated with the *Demoiselles* are the remarkably abstract Kifwebe

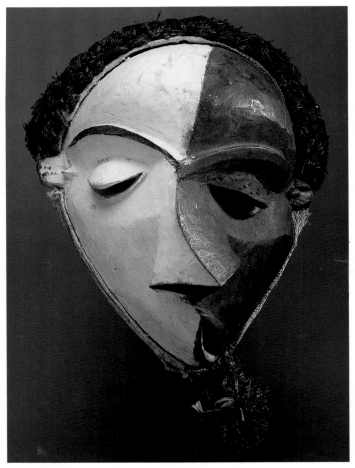

Mbuya (sickness) mask. Pende. Zaire. Painted wood, fiber, and cloth, 10½" (26.6 cm) high. Musée Royal de l'Afrique Centrale, Tervuren, Belgium

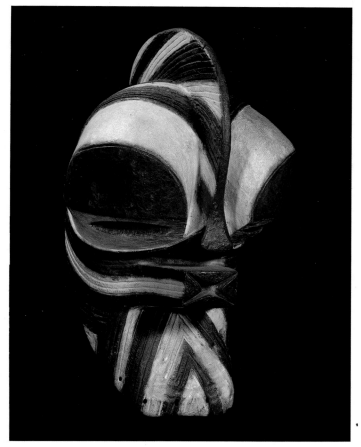

Kifwebe mask. Songye. Zaire. Painted wood, c. 19⅝" (50 cm) high. Collection J. W. MESTACH, Brussels

masks of the Songye people (above and p. 16). Warren Robbins, Senior Scholar and Founding Director emeritus of the National Museum of African Art (Smithsonian Institution), is among those who have identified these masks—normally characterized by bold distortions and large projecting mouths—with the head of the seated demoiselle in the lower right of Picasso's picture.[81] But it is impossible that Picasso could have seen such a mask as early as 1907. Even today the Musée de l'Homme possesses only one, which did not enter its collection until 1967. Moreover, Ratton told me that the first Kifwebe mask he ever saw (it was in the very late 1920s) was the one subsequently shown in 1935 in The Museum of Modern Art's exhibition "African Negro Art," illustrated on page 16. Material from the then Belgian Congo, Ratton observed, especially from the interior areas, where the Songye live, remained extremely rare on the Parisian markets until after World War II. Even in Belgium, which in 1908 had taken over the Congo Free State—thitherto virtually the private property of Leopold II—Songye Kifwebe masks were rare early in the century. The first to enter Le Musée Royal de l'Afrique Centrale at Tervuren—which has the largest holding of Kifwebe masks—arrived only in 1911.[82]

Like most African objects, Kifwebe masks are symmetrical, and it is usually the mouth (which often engulfs the chin), rather than the nose, that projects most radically. In the head of the lower-right demoiselle, the mouth is small, displaced to the side, and diagonal rather than horizontal; it is rather the immense scalloped nose and the asymmetrically placed, differently colored eyes that carry—along with the saturated

orange and blue hues—the expressionistic charge. The physical and psychological violence expressed in this face is in keeping with the increased torsion to which the position of the figure was subjected as the work progressed. In the early sketches (Z. XXVI, 4) she is shown entirely from the back, facing inward. Then her head begins turning left toward the picture plane, first in profil perdu (p. 250), then pure profile, then in three-quarters view toward the spectator (p. 252). But all the while her body faces directly inward. In the final version, the forms reflect with an almost perverse realism the violence of Picasso's having twisted her head 180° against the always static torso—as if literally wringing her neck. Insofar as scalloped noses with brutal shading, and asymmetrical eyes were already present, though in less extreme form, in Iberian studies for the Demoiselles, the role of the objects Picasso saw on this first visit to the Trocadéro was obviously less that of providing plastic ideas than of sanctioning his even more radical progress along a path he was already breaking. Neither the rawest color of Oceanic art nor the boldest distortions of African sculpture approach the kind of expressionist violence Picasso generated in the seated figure of the Demoiselles.

Although Picasso could not have seen masks such as the Songye Kifwebes, or the one from the Etoumbi region (p. 263), the resemblances nevertheless interest us in terms of affinities. As such, they measure the depth of the artist's grasp of the informing principles of African sculpture as a whole. Nor do these masks mark the limits of Picasso's "prescience" with regard to African solutions. Indeed, the stylized asymmetry of certain Pende masks (facing page) provides an even more analogous example—involving parallelisms of content as well—insofar as these masques de maladie are not only closer to the plastic character of the seated demoiselle's face, but represent persons suffering from advanced states of syphilis, among other disfiguring diseases. As in the case of the other masks, however, Picasso could not have seen a masque de maladie in Paris in 1907. No Pende masks entered the Trocadéro until the 1920s, and even today it has no masque de maladie. A much less Picasso-like Ivory Coast sickness mask (misconstrued as a "masque de guerre") did, however, figure in the collection of André Level in 1917. But this would surely not have been accessible to Picasso a decade earlier.[83] We should keep in mind, moreover, that even the most violent distortions in the African masques de maladie were based upon facial disfigurements that existed in reality; the artist essentially imposed his people's traditional stylization upon physical data. Picasso's distortions, on the contrary, were an invented projection of an internal, psychological state. Their characteristics, moreover, are exaggerated versions of asymmetries visible in the early projects for the Demoiselles, executed before his experience of tribal art at the Trocadéro.

The resemblances between the heads in the Demoiselles and the masks that have been compared to them in art-historical studies are thus all fortuitous—reflections of affinities between arts that communicate through conceptual signs rather than through pictorial conventions directly derived from seeing. Yet the fact that so many more such affinities may be found between Picasso's art and that of the tribal peoples than is the case with the work of other pioneer modernists reflects, on Picasso's part, a profound identity of spirit with the tribal peoples as well as a generalized assimilation of the principles and character of their art.

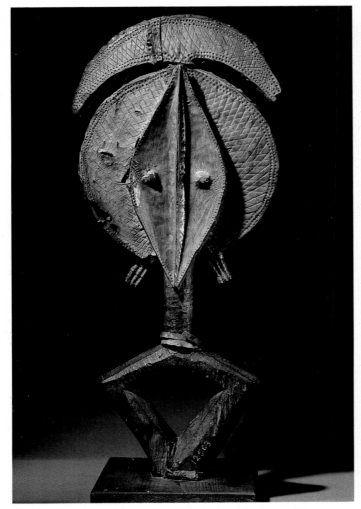

Reliquary figure. Kota. Gabon or People's Republic of the Congo. Wood, copper, and brass, 15¾" (40 cm) high. Musée de l'Homme, Paris; acquired 1884

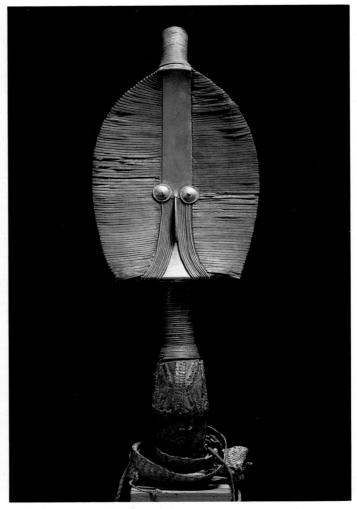

Reliquary figure. Hongwe. Gabon. Wood, copper, brass, and fiber, 19⅜" (49 cm) high. Musée de l'Homme, Paris; acquired 1886

Though the three "masked" demoiselles of Picasso's picture have little direct relation—except for scarification markings—to any masks Picasso could have seen at the time, they bear affinities, at least in the daring of their abstraction (as well as in aspects of their surface patterning), to a type of tribal object that was indeed visible very early at the Trocadéro and available even before the turn of the century in the curio shops, namely, the copper-covered reliquary guardian figures of the Kota and Hongwe peoples. The Kota figures, which both Barr and Golding had associated with the *Demoiselles*, are found in an impressive variety, of which we can give only a slight sampling (pp. 270, 301, 302, 498); some of this range was already evident in those in the Trocadéro at the time of Picasso's visit (above). Their heads range from quite realistic visages streaked symmetrically by diagonals that are not scar marks and are sometimes called stylized "tears" to exceedingly abstract conceptions where the face consists of nothing but a relieved vertical running centrally from top to bottom between two hemispheric eyes (p. 268). Others contain a wide variety of parallel line designs that derive from scarification patterns. The shapes of the heads usually are roughly oval (sometimes slightly pointed at the top or bottom or both), extended occasionally into stylized lozenges.[84]

The heads of the Hongwe reliquary figures, on the con-

trary, adhere to a single prototype: a pointed oval cut horizontally at the bottom (above right and p. 352). In these Hongwe sculptures, the concave curve along the horizontal axis of the face is sometimes exquisitely balanced against a less marked concave curvature along the vertical one. The hallmark of the Hongwe visages is a pattern of multiple thin strips of copper projecting horizontally and sometimes diagonally from the central axis. This no doubt reminded Picasso of hatchmarks, and many of his studies of 1907–08 show such African patterning subsumed in the shading on his figures, as in the views of André Salmon's back (p. 285). Here again, the assimilation of a particular tribal type depended on the proximity of its effects to the notation Picasso was already developing in the course of his radical post-Gosol simplifications.

Taken together, the Kota and Hongwe reliquary figures—certainly the most abstract of the tribal sculptures Picasso encountered—constitute, along with Baga figures (p. 276) and Fang masks (p. 290) and reliquary heads (p. 292), the most important African prototypes for his art from June 1907 until the summer of the following year. The painter owned two Kota reliquary figures[85] (p. 301), and though there is no documentation, photographic or otherwise, as to when he acquired them, the simplicity, rawness, indeed the very medi-

ocrity of both of them—quite apart from their influence on his work in 1907—suggest that they were among the earliest tribal objects he acquired.[86] By the start of World War I, Paul Guillaume possessed some very fine Kotas (p. 152), but Picasso seems not to have reached for these (in part, no doubt, because they were very expensive).[87]

The lozenge-shaped lower supports for the heads of the Kota reliquary guardians are usually taken—wrongly, the specialists tell us[88]—as legs. And the readings by the modern artists were no exception. If we imagine them as legs, the reliquary figure as a whole suggests a dancer—as we see in the little leaping personage in Klee's *Idols* (p. 499)—whose heels are together and whose knees are splayed out in profile below the frontal head. Picasso was evidently sufficiently fascinated by this bent knee position to explore it in a large drawing (p. 268), which was extrapolated in paintings such as *Nude with Raised Arms* known generically as "Dancing Figures" or "African Dancers" (pp. 269, 271).

In this period Picasso worked conceptually, without models, so that in making the drawing on page 268, his inspiration was triggered rather by a generalized recollection of Kota reliquary figures than by any individual object. Unlike Klee, who retained the lozenge shape of the "legs" of the Kota figures by keeping the ankles together, Picasso was interested only in the radically bent knee, and in that only as a starting point. In the upper right figure of the drawing on page 268 the feet are together, but even there the legs are treated asymmetrically—an asymmetry that would mark all the paintings

derived from this motif (where even the bent knee is largely abandoned), thus putting these paintings at a still greater remove from the reliquary figures. In this unusual sheet of drawings, we see Picasso exploring a transformation of the flat, planar disposition of Kota figures' "legs" into formulations that assimilate the bent-knee position to rudimentary forms of Western perspective space. This shallow, "collapsed" relief space—the detritus of premodern Western space—had just been established in the *Demoiselles*, and constituted the first step toward the Cubist space that followed it.

If the legs of Picasso's "Dancing Figures" thus bear an indirect relation to Kota reliquary guardians, the position of their arms, raised and bent over their heads, corresponds to that of the central figure in the *Demoiselles* and was thus already part of Picasso's vocabulary during his late Iberian phase (Z. XXVI, 190); indeed, it was probably extrapolated from Cézanne's *Bathers*. Such types of African caryatids as he could have seen in 1907[89] (p. 289) obviously interested him, as the drawing on page 288 attests, but they can hardly be counted a source for the raised-arms positions of the "Dancers." Moreover, the most marked characteristic of Picasso's "Dancing Figures"—a sense of energetic, indeed convulsive, movement conveyed not only by the postures but by the bold and rapid facture—is entirely antithetical to the stasis of tribal art (however much that movement might relate to the artist's imaginings with regard to tribal dances).[90] This may be what led Lucy Lippard to observe that while the *Nude with Raised Arms* is "often taken as the ultimate instance of African influ-

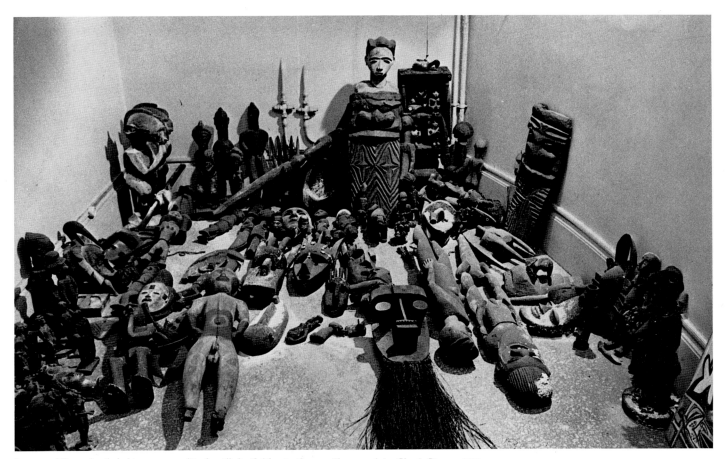

A group of Picasso's tribal objects as stored in the villa La Californie, Cannes. Photograph by Claude Picasso, 1974

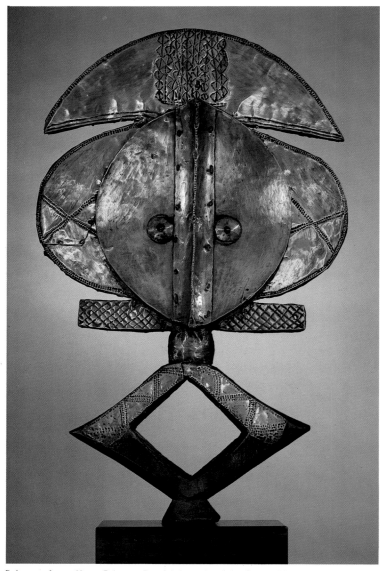

Reliquary figure. Kota. Gabon or People's Republic of the Congo. Wood, copper, and brass, 22½" (57.2 cm) high. Private collection

Pablo Picasso. *Sheet of Studies*. 1907. Charcoal, sight 23⅝ x 15¾" (60 x 40 cm). Private collection, France. Charcoal *Portrait of André Salmon* (verso) reproduced page 284

ence, in fact it demonstrates the relative superficiality of Picasso's borrowings from the African."[91] I would amend this by substituting "indirectness" and "fragmentariness" for "superficiality"—on the plane of "borrowings." The power of Picasso's imagination and his instinct for manipulation and metamorphosis were such that the kind of direct borrowing from the Primitive we see occasionally in other artists, or the integral representation of tribal objects as in Expressionist art, would be hard to imagine in his painting.

More important, however, than any visible borrowings was Picasso's sense of tribal objects as charged with intense emotion, with a magical force capable of deeply affecting us. This went hand in hand with his understanding of the reductive conceptual principles that underlie African representation. On this level, Picasso's debt to African art was not superficial but profound. In the drawing above, the presence of Picasso's hand, which rises from the bottom of the sheet as if magically commanding the activities of the figures, is an important link to the Primitive tradition. Picasso had already developed a sense of the artist's hand as a kind of thaumaturgic wand. In

Boy Leading a Horse of 1906, the unbridled animal seems to follow the boy as if mesmerized by the power of his gesture. Although oversimplified and perhaps anthropologically incorrect, Picasso's assumptions about tribal usages—the laying on of the shaman's or medicine man's hands, for example—could only have reinforced his personal sense of the magical. And as the "fetishes" were religious objects, the notion of art-making and of religion became fused in a consciousness of the force of the artist-shaman's hand. In the drawing above, one of the earliest of Picasso's many representations of his own hand, he makes this explicit by the "lines of force" that emanate from it. His hand is repeated in another position in the center of the drawing, where again the emanating lines of force suggest that the hand magically "commands" the movement of the figures, thus paralleling metaphorically the reality of Picasso's hand as the agent of their creation. The representation of the artist's hand in isolation—found from the cave painters to Pollock (p. 645)—is always an allusion to the notion of image-making as a supernatural, ritual power, which is the conception that overwhelmed Picasso in his "revelation" at the Trocadéro.

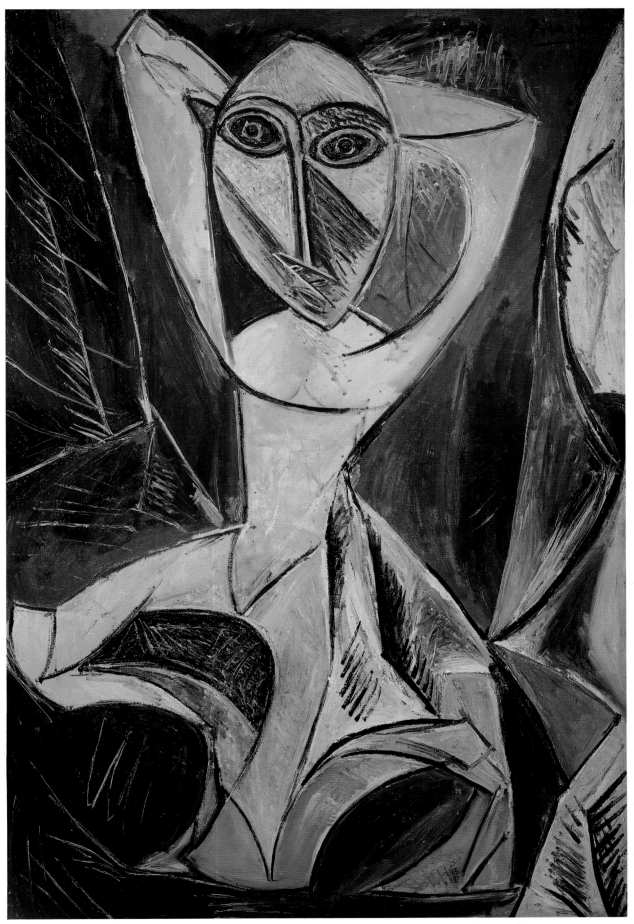

Pablo Picasso. *Nude with Raised Arms (The Dancer of Avignon)*. 1907. Oil on canvas, 59⅛ x 39½" (150.3 x 100.3 cm). Private collection

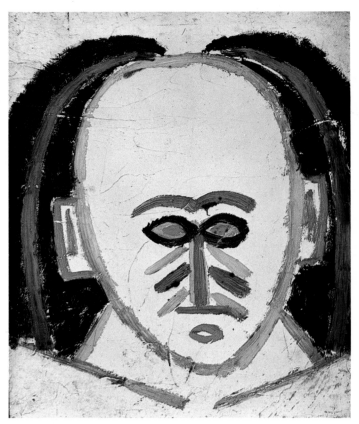

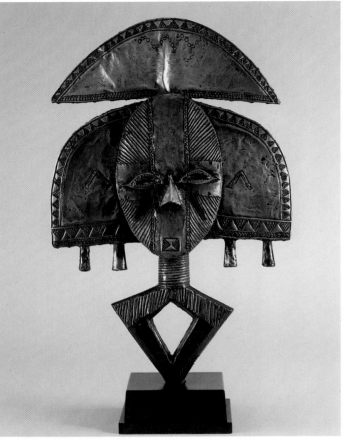

Pablo Picasso. *Head*. 1907. Oil on canvas, 7 x 5⅝" (17.8 x 14.3 cm). Collection Claude Picasso, Paris

Reliquary figure. Kota. People's Republic of the Congo. Wood, copper, and brass, 25" (63.5 cm) high. Collection Merton D. Simpson

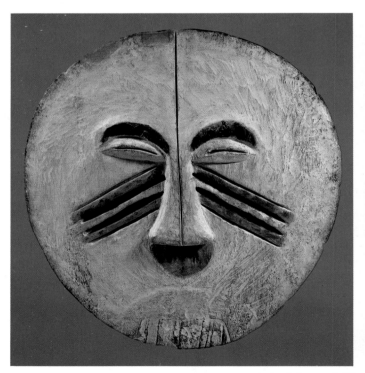

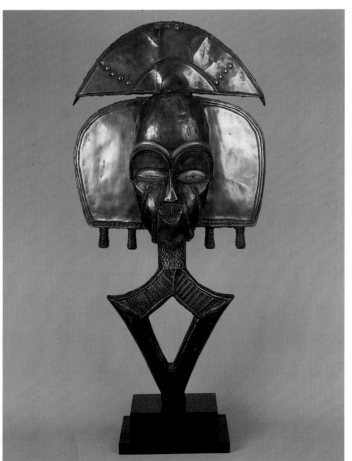

Mask. Mbole (?). Zaire. Painted wood, 19⅝" (24.5 cm) high. Collection J. W. Mestach, Brussels

Right: Reliquary figure. Kota. Gabon. Wood, copper, and brass, 29½" (75 cm) high. Private collection, Switzerland

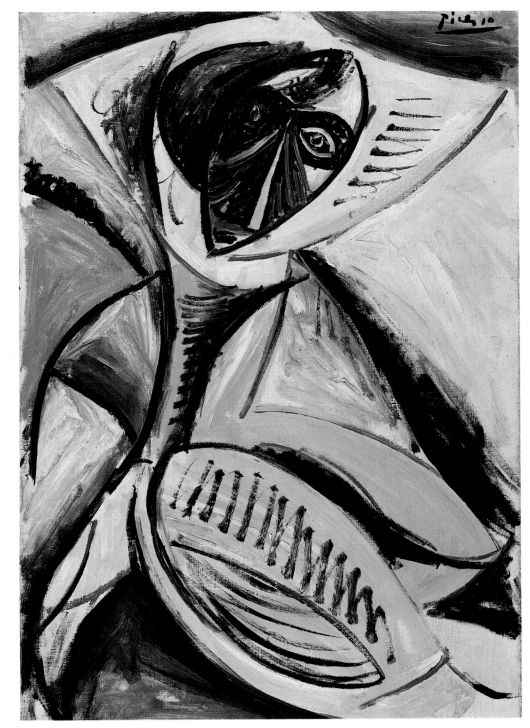

Pablo Picasso. *Nude with Raised Arms*. 1907.
Oil on canvas, 24⅞ x 16¾" (63 x 42.5 cm).
Thyssen-Bornemisza Collection, Lugano,
Switzerland

Picasso's characteristic distancing from his sources in Primitive art may be seen in a variety of drawings of 1907, of which I shall treat three examples: a sketch clearly inspired by Bambara antelope dance headdresses (p. 272); an altogether unusual drawing I shall call *Mask and Heads* (p. 274); and a project for a sculpture inspired by "Nimba-headed" figures of the Baga people (pp. 277–79).

Given the variegated, fanciful, and sometimes highly abstract forms that antelope crests took in the hands of African sculptors (p. 272), it is interesting that Picasso's study should move in the directions both of greater realism and greater simplification—almost as if a Bambara antelope had

been reworked in the more rigorously geometrical spirit of Dogon sculptors (p. 273). Indeed, the spare geometricity of the Dogon style presents the closest affinity with what would become the early Cubism of late 1908–09. It is often said, to be sure, that Dogon sculpture was unknown to the Cubists, and it is true that certain types of Dogon work—not to say the best-quality objects—began coming to France only after the Dakar-Djibouti mission of 1931–33. Nevertheless, there were a number of Dogon pieces at the Trocadéro at the time of Picasso's 1907 visit, including a large typically geometrical figure (p. 273, left) that was actually photographed in the Trocadéro's galleries in 1909 by the Czech Cubist Josef Capek.

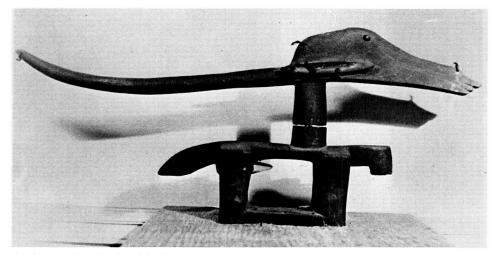

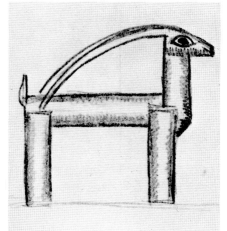

Antelope headdress. Bambara. Mali. Wood and cotton, 11⅜" (29 cm) high. Private collection, Paris

Pablo Picasso. *Two Antelopes* (detail). 1907. Pencil, 6½ x 8½" (16.5 x 21.5 cm). Private collection

As the lesson of such works depended on their style rather than their quality (recall Picasso's remark that "You don't need the masterpiece to get the idea"), Dogon sculpture must be considered along with the then better known tribal genres as implementing the background of Picasso's "Africanism."

The extreme simplicity of Picasso's antelope no doubt responds in part to the fact that Picasso envisioned executing it in wood, and he was still a novice at carving. But the treatment of the legs as discrete cylinders repeating the cylinder of the neck was certainly an aesthetic decision, taken in the spirit of African reductionism. It was basically a question of appropriating this reductionist principle and of intensifying and extending it; this became the paradigm of Picasso's response to tribal art. He may well have seen, for example, as early as 1907, the kind of Bambara figure from Kahnweiler's collection reproduced on page 280.[92] The treatment of the

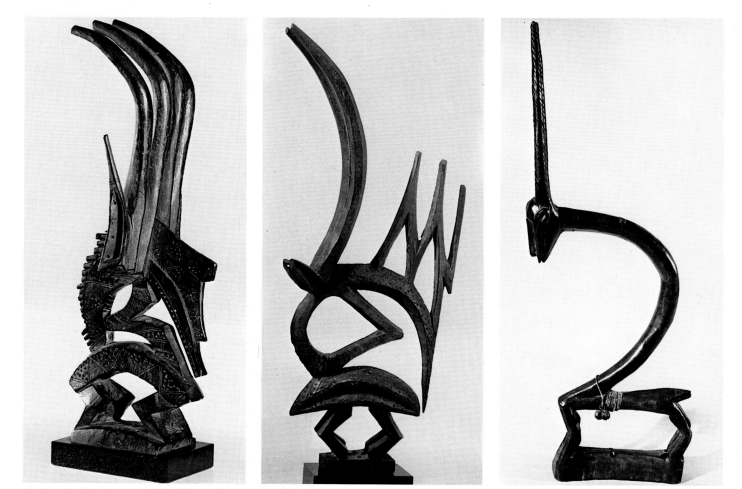

Antelope headdress. Bambara. Mali. Wood, 21½" (54.6 cm) high. Collection Valerie Franklin, Beverly Hills

Antelope headdress. Bambara. Mali. Wood, 23¾" (60.3 cm) high. Private collection

Antelope headdress. Bambara. Mali. Wood, fiber, and metal, 31" (78.8 cm) high. Private collection

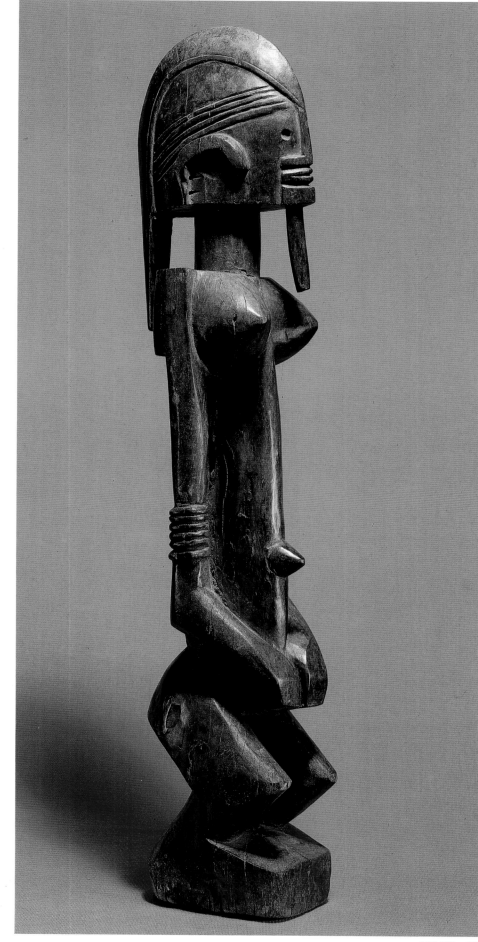

Above: Figure. Dogon. Mali. Wood, 23⅝" (60 cm)
high. Musée de l'Homme, Paris; acquired 1906

Right: Figure. Dogon. Mali. Wood, 25⅛" (64 cm)
high. Musée de l'Homme, Paris; acquired 1935

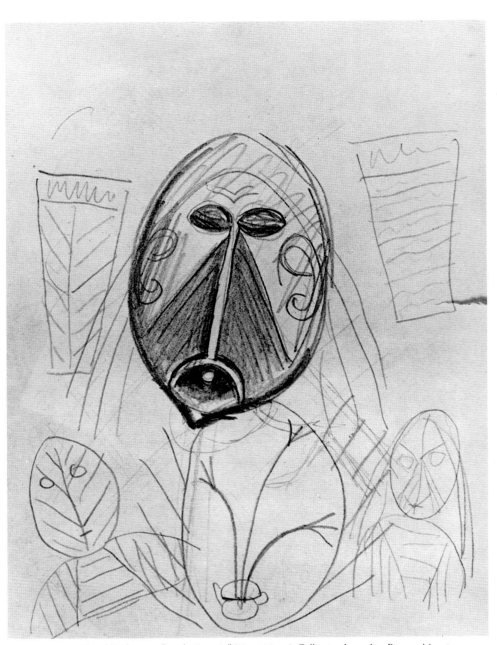

Pablo Picasso. *Mask and Heads.* 1907. Pencil, 8⅝ x 6⅜″ (22 x 16.3 cm). Collection Jacqueline Picasso, Mougins

shoulders and upper arms as a semicircle in this work would certainly have interested Picasso. But it was characteristic of him to press such ideas even further by reducing the shoulders, arms, and hands to a complete circle, and then to set this against an equally geometrical triangular torso (p. 280).

Mask and Heads (above) is one of the most unusual of Picasso's "primitive" drawings of 1907. It is built around a large, powerful head resembling a mask that Laude assumed was based on an African work ("vraisemblement congolais").[93] But one searches in vain for any mask, African or Oceanic, that resembles it. Indeed, it is a mistake to assume that Picasso would base his imagery directly on a particular prototype.[94] When questioned by Pierre Daix about this drawing, Picasso denied that it was inspired by a tribal object, saying that he had invented it from his imagination[95]—and this was surely the case. But as the imagination springs from the same unconscious that is the storehouse of visual memories and "forgot-

ten" images, it is not surprising that different aspects of this "mask" evoke, at least obliquely, bits and pieces of recognizable styles. The ears—the most clearly identifiable of its motifs—are in fact not inspired by tribal art at all. They are a more rounded, symmetrical version of the scroll-like ear of the Iberian head in Picasso's possession, the ear of which is echoed in less stylized form in the Iberian watercolor study for the *Demoiselles* (p. 251). The striated triangular shadow areas to the sides of the nose of this "mask" had already been anticipated in his Iberian studies, such as the watercolor just mentioned, though the rigorousness of the pattern here presupposes Picasso's recollections of tribal scarification patterns and the symmetrical so-called "tears" of certain Kota reliquary figures. On the other hand, the form of the mouth, virtually an extension of the long thin nose, is Melanesian rather than African in character.

More interesting if less arresting than the central image in

Nimba mask. Baga. Guinea. Wood, 47¼" (120 cm) high. Musée de l'Homme, Paris; acquired 1902

Mask and Heads is the evidence surrounding it of the "automatic" character of Picasso's drawing, which almost instantaneously records the chain of his mental associations, suggesting that Picasso's thought, as Tzara put it, "is made in the hand."[96] In the lower left, Picasso has inverted the patterning of diagonals that descends from the nose of his "mask" so as to create a head that is also a leaf. This leaf-head, which prefigures Klee, leads by the same associative logic to the even more fantastical and larger head at the bottom-center of the drawing, whose "mouth" is a horizontal flower pot, whose nose and cheeks are plant stems, and whose eyes are tiny palm or papyrus fronds—double-duty elements that remind us of his transformation of the idol in the Gauguin watercolor (pp. 244, 245). In the context of such imagery, the trapezoidal objects in the upper left and right of *Mask and Heads* might be taken as vases—and Zervos so titled a separate study of the one on the left (Z. XXVI, 160). But given the exoticism of the

imagery, these two forms were probably also, if not primarily, intended as tribal shields. In drawings such as this, one interpretation does not exclude another. On the contrary, the multiple identities of the motifs and the associational linkages between them tell us more about the processes of Picasso's mind, and the nature of his assimilation of tribal material, than do his paintings of this period. In the latter we *sense* the richly textured, many-leveled fabric of his imagery, but in the drawings we *see* it more discretely.

Among the 1907 drawings that can be linked to tribal sculpture, none are more revealing of Picasso's ways of thinking and working than those related to Nimba, assumed at the time to be the Baga people's goddess of fertility.[97] In Baga art, the Nimba-type head is associated with huge dance masks (above and pp. 324, 327), and with smaller figure sculptures that have human bodies (p. 276). There is no question that Picasso saw the dance mask illustrated above during his visits

to the Trocadéro; in 1907 it was the only such object in the Musée d'Ethnographie. This mask shares some but not all of the characteristics of "classic" Nimbas: the long arched head is cantilevered forward, its projection intensified by an extraordinarily large nose; the head culminates in a low crest, slightly hollowed out, which passes from the forehead almost to the back of the neck. The latter, a long cylinder, separates the head from the bust, which is characterized by large but flattened breasts, below which project the four supports held by the dancer.[98] When in use, a large raffia dress, which descended from just below the breasts, covered the dancer entirely, though he could see out through small holes bored between the breasts.

While the Nimba mask was used exclusively for dances and thus was seen in movement, the smaller, integral "Nimba-headed" figures were stationary objects whose purpose is not known; in 1907, the Trocadéro owned one of these as well. They were also among the types of smaller objects occasionally available in the curio shops, and it is very probable that the pair of "Nimba-headed" figures Picasso owned (in rear of

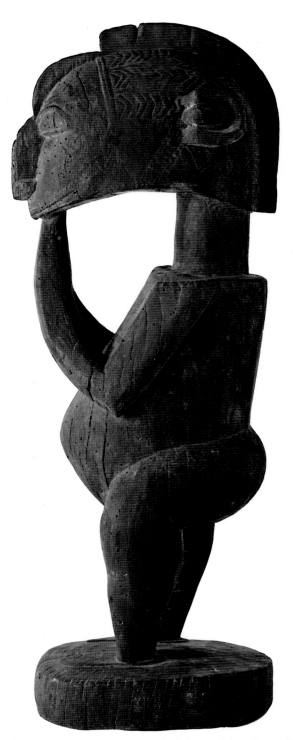

Figure. Baga. Guinea. Wood, 24" (61 cm) high. Collection Paloma Picasso. Formerly collection PABLO PICASSO

photo, p. 267, and above) were purchased by him at the time he made the drawings in question.

The large pencil drawing of a head (page opposite, upper left) which—with a similar less-developed study (Z. VI, 907)—is probably Picasso's first elaboration of a Nimba-derived motif, is already quite distanced from what we are considering its source of inspiration. Nevertheless, Reinhold Hohl's argument that its crest, a chain of almost semicircular forms, relates to a Nimba is ultimately persuasive.[99] Hohl, however, associated Picasso's crest simply to the long crest of the Trocadéro Nimba mask, which encircles its coiffure, as

Figure. Baga. Guinea. Wood and cloth, 35" (89 cm) high. Musée de l'Homme, Paris; acquired 1904

Pablo Picasso. *Head*. 1907. Pencil 19¼ x 25⅜″ (49 x 64.5 cm). Collection Jacqueline Picasso, Mougins

Pablo Picasso. *Head*. 1907. Conté crayon and charcoal, 25⅝ x 19¾″ (65 x 50 cm). Collection Bernard Picasso, Paris

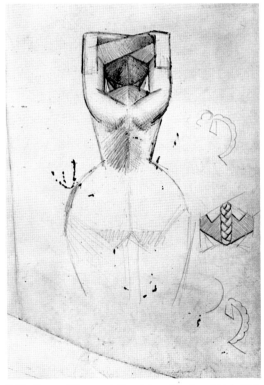

Pablo Picasso. *Woman with Raised Arms Seen from Behind*. 1907. Pencil, 18⅞ x 12½″ (48 x 31.6 cm). Collection Marina Picasso

Pablo Picasso. *Woman in a Long Dress*. 1907. India ink, 25⅜ x 19½″ (64.5 x 49.4 cm.) Collection Jacqueline Picasso, Mougins

does the more ornamental one in *Head*. Yet the Nimba crest is straight-edged. It appears to me that while Picasso retained the *idea* of a crest from either the Trocadéro mask or from the smaller "Nimba-headed" figures, the rhythm of near semicircles that characterize its appearance in *Head* was extrapolated not from a Nimba crest, but from the sequence formed by the rounded nose and the curved forehead with its echoing projection—a rhythm we see in his own "Nimba-headed" figures in profile. Such a sequence cannot be disengaged from the Baga mask or figure then at the Trocadéro. His own Nimbas also clearly provided the prototype for the nose in *Head*.

Head, however, is in no sense a copy of a Nimba. When Picasso was inspired by motifs in tribal art, he extrapolated, metamorphosed, and fused them—in effect creating his own version of tribal art. A good example of this is *Woman in a Long Dress* (p. 277, lower left), where a careful look shows that the familiar chain of semicircles again forms the extremity of the subject's coiffure. Were further proof necessary for the "African" inspiration of this motif, we would need only to consider the "undressed" version of the woman in the same drawing, which shows how she might look as an "African"

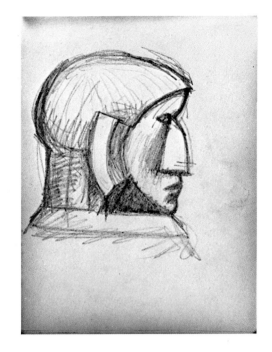

Above: Pablo Picasso. *Head in Profile*. 1907. Pencil, 8¼ x 5⅜" (21 x 13.5 cm). Musée Picasso, Paris

Left: Pablo Picasso. *Standing Nude in Profile.* 1907. Pastel and gouache, 24⅝ x 18⅞" (62.5 x 48 cm). Musée Picasso, Paris

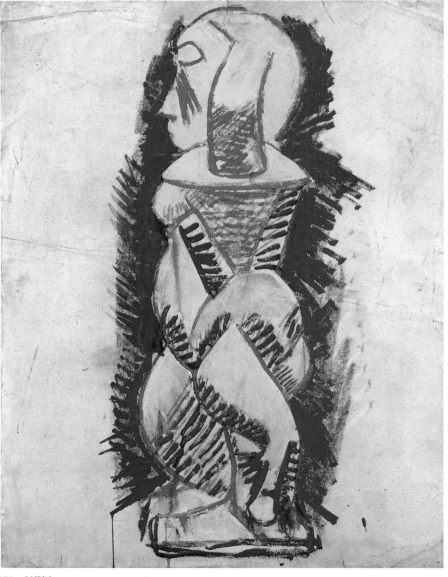

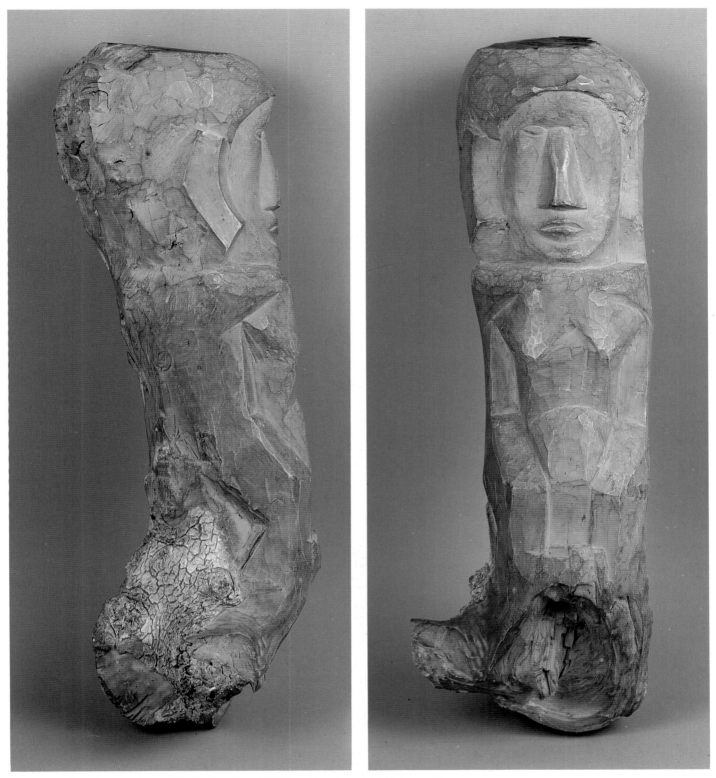

Pablo Picasso. *Figure* (two views). 1907. Wood, 13⅞ x 4¾ x 4⅛" (35.2 x 12.2 x 10.5 cm). Musée Picasso, Paris

sculpture. Indeed, there are few more obvious examples than the latter of Picasso's use of hatching as the equivalent of ax or chisel cuts in marking the geometrically precise planes suggested by African objects. A further insight into the associative nature of Picasso's invention is offered in Hohl's observations regarding the pencil study *Woman with Raised Arms Seen from Behind* (p. 277, lower right), where a separately worked detail of the woman's braid is assimilated to a "Nimba crest" by

juxtaposition with fragments of the coiffure from *Head*.

The metamorphosis of *Head* and its variants culminated in the exquisite if unfinished carving *Figure* (above). That Picasso had all along envisioned the making of a wood sculpture is confirmed by the fact that the profile in *Head* was accompanied by a front-view companion study (p. 277, upper right). Picasso clearly began his wood sculptures of 1907 by transferring such outline drawings to the faces of a wood

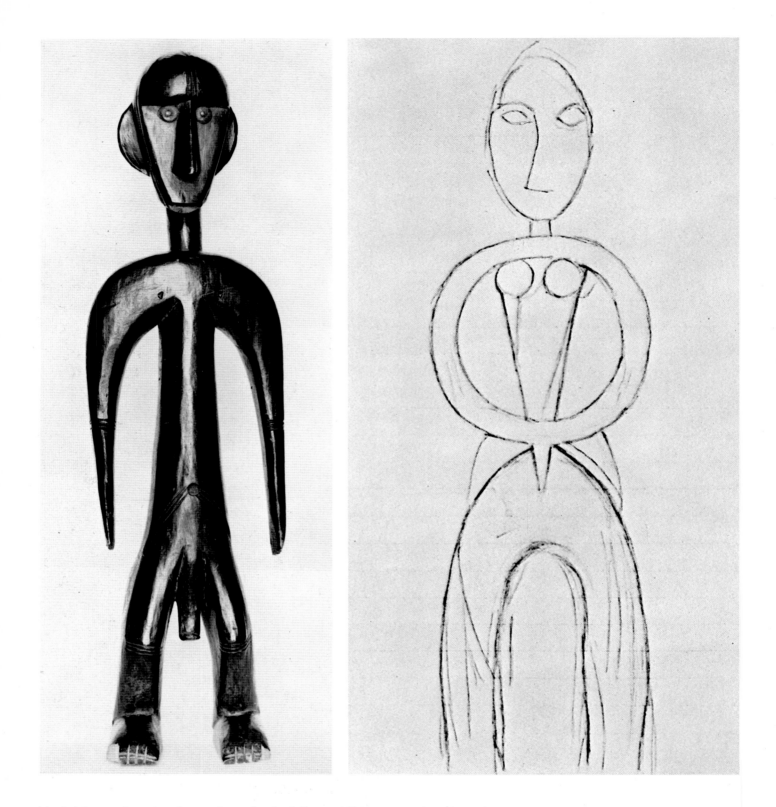

block (a procedure manifest in the unfinished *Caryatid Figure*, p. 289, where traces of the orange outline drawing are still preserved). By the time Picasso actually began carving *Figure*, he had eliminated the crest (or "braid") and slightly minimized the salience of the nose and lips, as is already anticipated in a notebook sketch for the head of the sculpture (p. 278), which probably just preceded its carving. Although we cannot be sure of Picasso's intentions for the top and rear of the head of *Figure*, as that part of the sculpture is unfinished, the notebook sketch indicates that the Nimba-inspired motifs still visible in *Head* would have totally disappeared.

Above left: Figure. Bambara. Mali. Wood, 23¼" (59 cm) high. Private collection, France

Above right: Pablo Picasso. *Standing Nude.* 1907. Pencil, 8⅞ x 6¾" (22.5 x 17 cm). Private collection

Opposite: Mask. Fang. Gabon. Wood, paint, and fiber, 20½" (52 cm) high. Fondation Olfert Dapper

Guillaume Apollinaire in the studio of Picasso, Boulevard de Clichy. Photograph taken between spring 1910 and spring 1912

There is perhaps no more remarkable indication of the associational character of Picasso's imagery than the fact that his large, caricatural charcoal portrait of his friend André Salmon (p. 284), one of the earliest proponents of tribal art, should have been executed on the verso of the very sheet on which Picasso had explored the bent-knee position inspired by Kota reliquary figures. Though Salmon is overshadowed in the literature on Picasso's early years by the artist's two other poet friends, Max Jacob and Guillaume Apollinaire, he played an important role in Picasso's life around this time. Not the least interesting aspect of this followed from his interest in tribal art, which may have developed a year or two before Picasso's or Apollinaire's.[100] Once Picasso had had his Trocadéro "revelation," and begun buying and studying tribal material, it was Salmon—along with Apollinaire—who served as his principal interlocutor on the subject. Nevertheless, Salmon tells of having himself only fully understood certain of these

objects after Picasso had talked to him about them, had pointed out their "logic" and "purity"[101] (a "purity of expression," Picasso would later tell Sabartés, "which Western art never attained").[102] Unlike Apollinaire, who though he later collected and wrote about African sculpture (pp. 144–47), hardly remarked on its relationship to Cubism,[103] Salmon not only championed tribal art for itself but as an inspiration for contemporary artists. He was the first to write about it in connection with Picasso: "Already [in the *Demoiselles*] Picasso was passionate about the Negro sculptors, whom he placed far above the Egyptians. Polynesian or Dahomean images appeared 'reasonable' [*raisonnable*] to him...The sorcerer's apprentice constantly consulted [*interrogeait*] the Oceanic and African magicians."[104] For all its wrongheaded theories regarding the relation of African, Egyptian, and Greek art (ideas nevertheless widely entertained at the time), Salmon's article "L'Art nègre" was sufficiently appreciated to be pub-

Figure (Tiki). Marquesas Islands. Wood, 28⅜″ (72 cm) high. Private collection. Formerly collection PABLO PICASSO

Pablo Picasso. *Portrait of André Salmon*. 1907. Charcoal, sight, 23⅝ x 15¾" (60 x 40 cm). Private collection, France

Photograph of André Salmon published as frontispiece in André Salmon, *Propos d'atelier*, 1922

lished in *The Burlington Magazine*.[105] Its frequent references to plastic qualities—as well as the magical qualities that Apollinaire emphasized—should remind us that the aesthetic aspect of tribal art had also intrigued Picasso.[106]

Salmon's early observations about tribal art are scattered and fragmentary, but while the more comprehensive "L'Art nègre" appeared only in 1920, it probably still reflected his conversations with Picasso of many years earlier. In one of its principal passages, Salmon identifies tribal art as a form of "realism," a reality based on truth to feeling rather than appearances—not unlike an observation Picasso himself made to me.[107] "The carver of idols," Salmon wrote,

is unquestionably the most scrupulous of realists...His diligence and fidelity in the study of human perfection do not arise from the base fetishism of imitation, which leads academically minded Europeans to rejoice when they can confound a painting with a mirror. The African and his rival the Polynesian draw all their inspiration from human perfection without ever subordinating the work of art to it. As realists, they direct scrupulous attention to the construction of a harmonious whole...[the] plastic translation of emotion, taken preferably at its most intense instant (from which we may argue that even psychology is not lacking in Negro art).

Picasso's portrait of Salmon was intended as a starting point for a wood sculpture. "During the same period [that of the *Demoiselles*]," Salmon recounts, "Picasso executed a charcoal portrait of me that was a preparatory study for a small wood sculpture yet to be executed..."[108] While the Kota sketches on the verso of that same sheet progressed, in Picasso's characteristic manner, away from their African sources, the development of the Salmon portrait—no doubt by reason of Salmon's passion for "art nègre"—reversed the process. Its subsequent metamorphoses (facing page)[109] show Picasso converting Salmon into a sort of tribal sculpture.

The Salmon portrait brings us to a consideration of the role of caricature—indeed, of popular art in general[110]—in Picasso's responses to tribal art. Picasso had made many brilliant and amusing caricatures and caricatural drawings in the years prior to 1907. They bear witness to his remarkable gifts in that direction. Some of these were true caricatures of people (and of pictures);[111] others were fantasies, often pornographic, or "grotesques." I know of no caricatural drawing prior to the Salmon portrait, however, that was both executed on large-size drawing paper (most are in the notebooks) and intended as a study for a work in a "serious" medium.

Picasso's powers as a caricaturist consistently played a role in the remarkable likenesses he was able to achieve, even in his most abstract styles—as I observed some years ago with regard to his 1910 Cubist portraits.[112] The ability to isolate the essentials of an individual's facial structure and expression permitted him to evoke remarkable likenesses of Vollard, of Uhde, and of Kahnweiler in contexts of such abstractness that much else in the pictures remains unreadable.[113] It is evident that Picasso considered the conceptual nature of caricature—which fosters hierarchies of representation based on ideas and feelings rather than on verisimilitude—to be very closely related to the lessons he had been deriving from Primitive art. Nor is it surprising that some of the early viewers of the *Demoiselles*, such as the critic Félix Fénéon, should have responded to that painting as a derivative of caricature.

Pablo Picasso. Studies for the *Portrait of André Salmon*. 1907. Ink, 12¾ x 15¾" (32.5 x 40 cm). Collection Jacqueline Picasso, Mougins

Pablo Picasso. *Portrait of André Salmon* (final state). 1907–08. India ink, 24¾ x 19⅞" (63 x 48 cm). Collection Jacqueline Picasso, Mougins

Indeed, Fénéon—who would later become a collector of tribal art—advised the young Picasso to devote himself to caricature. Recounting this later to Roland Penrose, Picasso remarked that "this was not so stupid since all good portraits are in some degree caricatures."[114] The affinity between Picasso's caricatures and his primitivist and Cubist figuration is easier to grasp when we realize that, as studies in perception have recently demonstrated,

caricatures' external forms in some way mirror the internal structure of our mental representations, the idealized and schematicized internal imagery that our minds use to "pre-sort" and structure perception. The "mind's eye"…in effect sees caricatures, not portraits…Our conceptual systems *knows* that it uses exaggerations, simplifications, and generalizations to encode our knowledge of appearances, and can recognize these deviations when confronted with a cartoon or caricature.[115]

Not surprisingly, one discovers that the "low art" of Picasso's caricatures starts fusing with his "high art" at precisely the moment his primitivism begins: with the repainting of Gertrude Stein's face in the Iberian manner on his return from Gosol. As Adam Gopnick observes in a brilliant recent study of this subject,

A likeness [the Stein portrait] that began…in the grand manner, is transformed through the use of primitive forms into a study in physiognomic identification through distortion. The forms which Picasso selects from the vocabulary of Iberian art—the oversized eyes, the magnified and thrust-out brows—are precisely those physiognomic features which any "how-to" book still encourages the beginning caricaturist to emphasize. What Picasso has done is to invent a kind of creole, *a language which assimilates an alien vocabulary to a familiar syntax*…The move from low to high, the victory of the notebook over the easel, is accomplished through the Trojan horse of primitivism.[116]

In the portrait of Salmon, Picasso starts with caricature—and gradually assimilates it to the graphic vocabulary of his primitivism. The relaxed drawing of "the imperturbable evangelist of primitivism"[117] shows him frontally, holding a book (like a stand-in for Picasso's medical student/self-portrait in the early studies for the *Demoiselles*) and a pipe, his head turned in a

three-quarters view so as better to expose his long nose and prominent jaw. As Picasso begins to play with this image in the upper left of the multiple study illustrated on this page, he turns Salmon's body in profile and then considers him from the back. The "fishbone" hatch marks leading from Salmon's spine—by now Picasso's scarification-like shorthand for "primitive" sculpture—indicate the direction the portrait is taking. The wave of Salmon's hair is simplified into a jutting crest which, given the elongation of the skull on one side and the face on the other, creates something like a Pharaonic profile. This crest will drop down, as Picasso proceeds, to become a jutting brow, and by the time the artist has arrived at his definitive conception (above), the project for a sculpture looks more "tribal" than caricatural. The original sinuous contrapposto of the Salmon portrait has given way to a blocky, flat-footed image of an aged nude whose frontality and symmetry are alleviated only by a slight turning of the head.

Picasso's conversion of a young man into an old one—a not uncommon form of his malicious wit—reenacts a kind of metamorphosis the artist was familiar with in the celebrated

so-called caricatures of Leonardo.[118] Along the way, some of Salmon's attributes are dropped (the wave of hair gives way to baldness); many are retained (the long nose and jutting chin); and still others added (the large and prominent ears). Salmon's conversion into a "tribal sculpture" was a project at which Picasso worked quite hard; there are many variant drawings. In the course of this transformation, Salmon ceased to be Salmon and became, as was the case with so many of Picasso's subjects (though notably not Gertrude Stein), entirely a creature of the artist.

That Picasso never advanced to the stage of carving "Salmon" is hardly surprising. For every sculpture he actually started, far many more projects for sculptures remained literally on the drawing board. There are many reasons for this, beginning with questions of time and patience. Picasso was interested in sculptural *ideas*. Their attendant problems could be solved on paper in minutes—and at that point Picasso usually lost interest. He clearly hated the effort that went into carving or otherwise realizing his ideas three-dimensionally. Execution was an annoying and time-consuming matter that would eventually be largely left to others. By standards of a Brancusi, Picasso was lazy—and little concerned with the nature of sculptural materials or the finessing of their surfaces. Though he was the most revolutionary and inventive of modern sculptors, whose work—at least in quantitative (i.e., stylistic and conceptual) terms—has altered the history of art more than Donatello's, Bernini's, or Michelangelo's, Picasso's accomplishments in this area oblige a study based more on

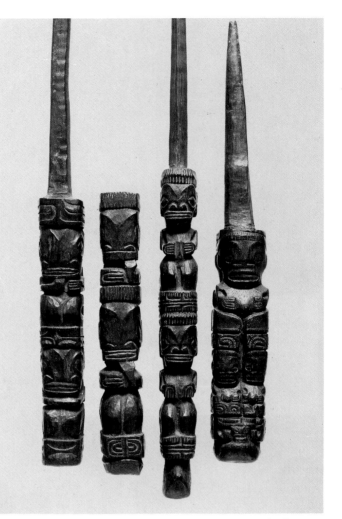

Fan handles. Marquesas Islands. Wood, 10⅞" (27.5 cm) high, tallest. The University Museum, University of Pennsylvania, Philadelphia

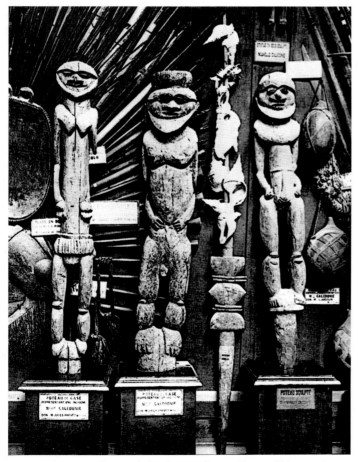

Section of the installation of the Oceanic Room, Musée d'Ethnographie du Trocadéro (now Musée de l'Homme), Paris, 1895

drawings than on objects. The latter function primarily as verifications of the concepts explored on paper. Even when Picasso used the relatively less laborious technique of modeling—in his sculptures of the thirties and thereafter—he telescoped the time and effort involved by employing found objects to rapidly bulk out his forms. That these objects also added a poetic, sometimes surreal element to many of his sculptures takes nothing from the fact that for Picasso they started as shortcuts to the three-dimensional realization of what were, in the first instance, graphic images.[119]

Such considerations should weigh heavily in treating Picasso's 1907 carvings—that phase of his work most visibly related to his primitivism. No text on these sculptures alludes to the fact that his handful of 1907 objects represents but a fraction of the sculptures conceived and developed that year in his drawings. Indeed, it is only rarely observed[120] that of those which progressed to the three-dimensional stage (pp. 259, 279, 289), the majority remain in differing degrees unfinished. With the exception of the Iberian-style relief (p. 249) executed in the spring of 1907,[121] there is no firm context for placing these objects in any particular season of 1907; nor has

Pablo Picasso. *Doll*. 1907. Painted wood with metal eyes, 10¼″ (26 cm) high. Art Gallery of Ontario, Toronto; purchase

Figure. Marquesas Islands. Wood, hair, bark cloth, and shells, 19⅝″ (50 cm) high. Musée de l'Homme, Paris; acquired 1887

there been any scholarly discussion of this question. In view, however, of the affinities of these works not simply with African but with Oceanic sculpture (which we have no compelling reason to think Picasso saw before his Trocadéro visit in June),[122] I am disposed to give all these objects to the second half of 1907.

The small carving of a *Standing Figure* (p. 259) is typical of the composite character of these sculptures as far as sources are concerned. Its head contains distinct echoes, in its elongation and outward curve, of the big, predominately red Grade Society fernwood sculpture from the New Hebrides that was the centerpiece of the Trocadéro's Oceanic room (pp. 258, 259); the arms, legs, and body proportions of the Picasso are closer to African carving. Johnson, comparing *Standing Figure* to Gauguin's *Saint Orang*, sees it as revealing the Post-Impressionist's "direct influence" on Picasso.[123] If so, it was more a question of Gauguin's interest in wood sculpture (which would have been brought home to Picasso with particular force by the retrospective the previous autumn) than of the actual character, forms, or finish of his carvings—except insofar as they themselves subsumed aspects of Polynesian sculpture. The yellowish color of *Standing Figure* is seen by Johnson as "possibly an ironic reference to Gauguin's *Saint Orang* and

Yellow Christ." If that is true, these associations are certainly mingled with the recollections of the painted New Hebrides and New Guinea objects at the Trocadéro (as well, perhaps, as some painted Yoruba carvings he could have seen there, at his painter friends,' or at Heymann's shop).

Johnson is certainly correct, however, when he cites Picasso's *Doll* (above left) as representing probably "the most direct influence of tribal art on [the artist's] carvings of 1907." He notes that the stylized hands and mouth, squat body proportions, large head, and goggle eyes are very close to the figures on Marquesan fan handles. In fact, *Doll* could represent a typically Picassoesque metamorphosis of any one of the many types of Polynesian Tikis (p. 283 and above) then at the Trocadéro. Johnson further observes that the small hole in the back of this piece indicates that it was intended to be hung, like Picasso's New Caledonian figures (p. 299), on the wall—"one of the more revolutionary steps in breaking down distinctions between painting and sculpture in mode of display." Although *Doll* was evidently painted in red, green, and blue, the color has since been largely lost.[124]

Standing Figure and *Doll* are among the few sculptures-in-the-round from this period that were completed. Only the front of *Figure* (p. 279)—the Nimba-related sculpture dis-

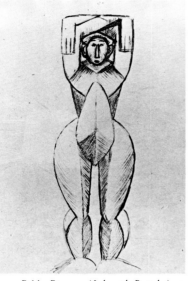

Above: Pablo Picasso. *Nude with Raised Arms.* 1907. Pen and brown ink, 10½ x 7¾" (26.7 x 19.6 cm). Musée Picasso, Paris

Right: Pablo Picasso. *Studies for Caryatid Figures.* 1907. Pencil, 8⅞ x 6⅞" (22.4 x 17.4 cm). Private collection

cussed earlier—was carved, though that part was smoothly finished. Picasso abandoned *Caryatid Figure* (facing page), the largest of his 1907 wood pieces, at the roughing-out stage; much of the front, sides, and back of the piece of wooden beam from which it was worked remains only partially carved, with the outlines in orange paint Picasso inscribed as guides still intact.

Johnson speaks of *Caryatid Figure* as "roughly executed" and compares it to the *Demoiselles* in its effect of "brutalization, a kind of savage sexuality." I am sure, however, that this figure, though conceived with angular contours, was intended to be smoothly finished, in the spirit of the female caryatids in the sketch reproduced above, the lower right of which is obviously the project for *Caryatid Figure*. Certainly it was to have had a smoother, less chipped and brutal surface than it now possesses. Indeed, Picasso himself confirmed to Werner Spies that he considered the ax-hewn project unfinished.[125] This said, its present state, which gives it an expressionist

character alien to tribal art, may have ended by pleasing Picasso, who would otherwise probably have thrown it away. The source for *Caryatid Figure* was obviously African rather than classical (as in Modigliani's *Caryatid,* p. 422), and as the now well-known Luba caryatid stools (p. 423) would not have been visible in Paris in those years, the African models must be sought in those of the Ivory Coast, or in the type of Senufo drum-support figures that were already making their way to France. Although Picasso's studies do not directly resemble any of these, they share their frontal, iconic character as well as the motif of the symmetrical and vertical forearms.

Opposite left: Pablo Picasso. *Caryatid Figure.* 1907. Painted wood, 31⅞ x 9⅛ x 8¼" (81 x 23.2 x 21 cm). Musée Picasso, Paris

Opposite top right: Drum. Senufo. Ivory Coast. Wood and hide, 48⅜" (122.9 cm) high. Private collection

Opposite bottom right: Figure. Ivory Coast. Wood. Published in Marius de Zayas, *African Negro Art: Its Influence on Modern Art,* 1916

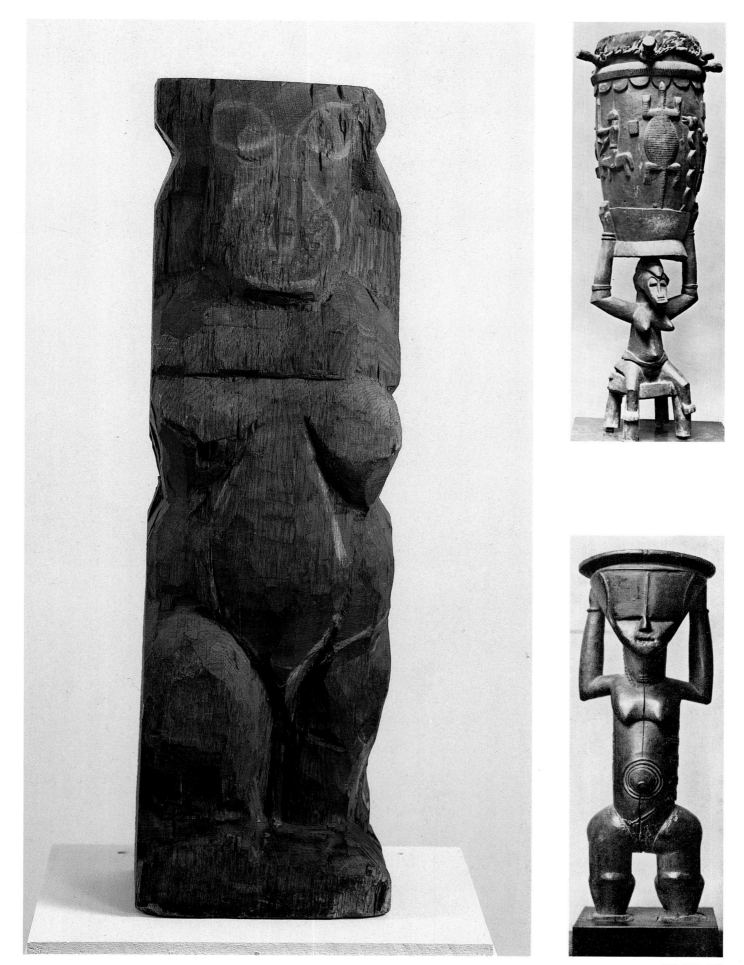

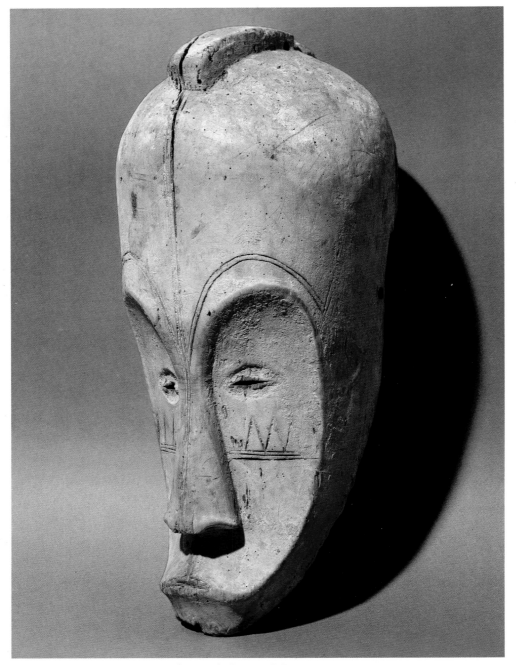

Mask. Fang. Gabon. Painted wood, 19⅝" (50 cm) high. Vérité Collection, Paris

Two characteristics of Picasso's 1907 painting that persisted into 1908—blocky, symmetrical torsos and concave faces—have a decided kinship with tribal art. Physiognomies that combine a wide convex forehead and a long, tapering, concave lower face, such as we see in *Woman's Head* of early 1908, descend from the upper right-hand head in the *Demoiselles*, and also unquestionably answer to Fang sculpture (above and p. 292). As a source of vanguard interest in the prewar years, Fang sculpture compares in importance with Kota reliquary figures. Fang masks were owned by Picasso (p. 300), Braque (p. 307), Derain, and other artists; Fang reliquary guardian figures (p. 293) and heads were rarer and much sought after; Picasso owned a figure, and the fierce head on the bottom of page 292, which Einstein reproduced, was probably known to Picasso in the years just before World War I.[126] Fang-inspired concave facial types continue in Picasso's work well into 1908,

as shown in the *Study for Friendship* (p. 292), indeed, right into *Three Women*, whose repainted version of the following winter would mark the end of Picasso's "Africanism." A rather idiosyncratic form of concavity can be found in *Studies for the Head of a Peasant Woman* that Picasso executed in late summer 1908 during his stay at La Rue des Bois. The profile versions of the head in the lower center and right of the sheet on page 295, however, recall less the concavity of Fang masks (which usually had convex foreheads) than that of Bambara masks (also on p. 295) of a type probably visible then in France.[127]

The solid, closed, reductive, and symmetrical character of the *Peasant Woman*, taken in her entirety, confirms the African inspiration of Picasso's figure paintings at La Rue des Bois. The landscapes executed there, however, have another filiation. For these, there was naturally no model in Primitive art, and the counterpart role fell to Henri Rousseau.

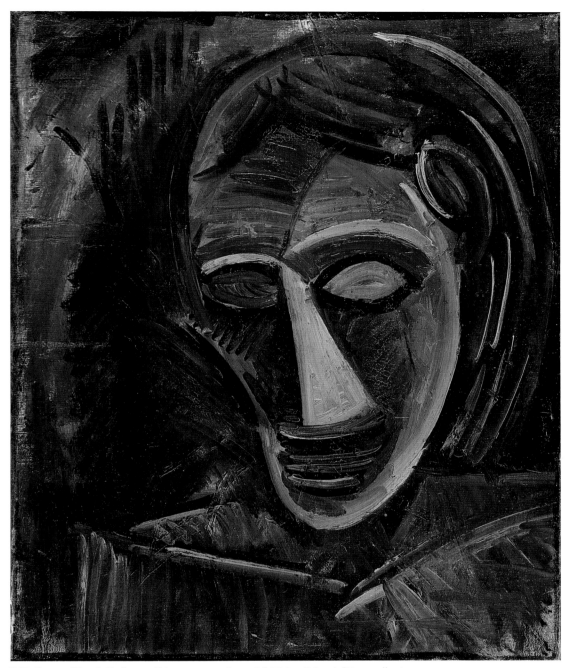

Pablo Picasso. *Woman's Head*. 1908. Oil on canvas, 28⅞ x 23¾" (73.3 x 60.3 cm). Private collection

Though Picasso had seen Rousseau's work much earlier (almost surely in 1901 but without question in 1905),[128] it becomes influential in his work only in 1908, when it fitted his purposes. Rousseau's painting seems to have been of some interest to Matisse and Derain in 1906, in terms of a kind of generalized primitivism that prevailed following the showing of *Le Lion ayant faim*...in the Salon d'Automne a year earlier.[129] As an agent of simplification—the way it may have functioned in Matisse's *Marguerite* (p. 253), which Picasso had chosen in an exchange of paintings in 1907 while still in his Iberian style[130]—Rousseau's work not only provided Picasso with prototypes for highly stylized, "geometrized" landscapes, but with a paradigm of plastic order and serenity such as could only have made sense for him at a time when the more violent and expressionistic effects—the brutal coloring and the brash, energetic brushwork—of his 1907 "African" paintings

were giving way to a more monumental, more classically contained and stable art. This tendency culminated in the smoother, more "controlled" brushwork and a more monochrome (greens, browns, and grays) palette of the repainted version of *Three Women*,[131] the transitional masterpiece that assimilated the vestiges of Picasso's "Africanism" into early Cubism.

It seems perfectly logical, at least in retrospect, that Rousseau's influence on Picasso should have crested while the latter was still in his "African" period, prior to his renewed interest in and deeper understanding of Cézanne's art, which were prompted by Picasso's seeing the early Cubist Braques that led him entirely to repaint *Three Women*. Rousseau's archaism, which was closer to tribal art than was anything in Cézanne, thus acted as a bridge between "art nègre" and the Cézanne-Braque influences that increasingly determined Picasso's

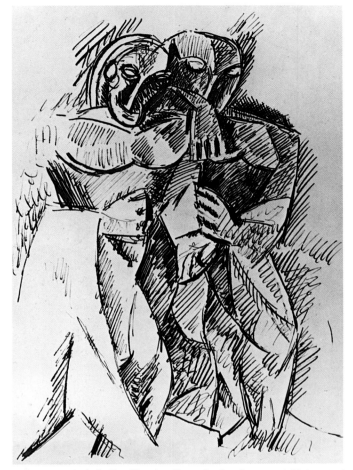

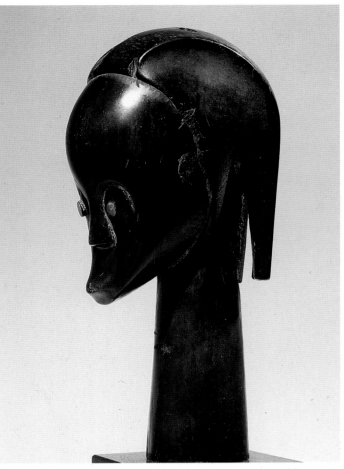

Pablo Picasso. *Study for Friendship*. 1908. Pen and india ink, 19⅛ x 12⅛" (48.4 x 31.6 cm). Musée Picasso, Paris

Reliquary head. Fang. Gabon. Wood, 9⅞" (25 cm) high. University of East Anglia, Norwich; Robert and Lisa Sainsbury Collection

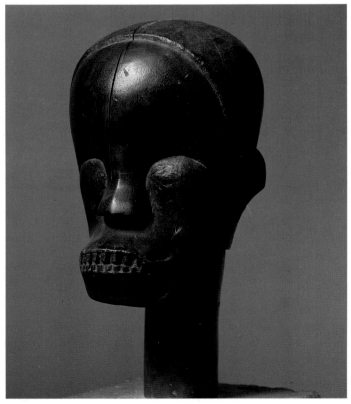

course once he returned to Paris from La Rue des Bois. By the end of 1908, only the faceting of Picasso's early Cubism (p. 297)—which recalls the planification of some tribal sculpture even as it primitivizes Cézanne—remained from his earlier battery of "African" effects.

Many of Picasso's friends of this period found a comparable simplicity and "innocence" in the work of Rousseau and tribal artists; they were felt to share a sense of the sacred in their approach to their work: "The Douanier," wrote Salmon, "painted his ambitious compositions the way the black image-maker carved his religious images." Salmon also, however, compared Rousseau to Giotto and Uccello, adding that "we cherished [him] not for barbarism, but for his science."[132] In fact, it is only if at all in relation to the Italian Primitives, hence in terms of the nineteenth-century connotations of *primitif*, that the latter word has any significance in regard to the Douanier.

Rousseau himself was not interested in tribal art, nor is it in any way reflected in his painting. He considered himself resolutely contemporary, and in most ways he was. His famous *mot* to Picasso has been widely quoted, but invariably taken simply as a joke: "You, Pablo, and I," he said, "are the two greatest artists of the age; you in the Egyptian style and I in the modern." What he said was not illogical, however, if we consider the context. By the end of the nineteenth century, the word "Egyptian" had become a surrogate for "primitive" in

Head. Fang. Gabon or Equatorial Guinea. Wood, 10⅝" (27 cm) high. The Philadelphia Museum of Art; The Louise and Walter Arensberg Collection

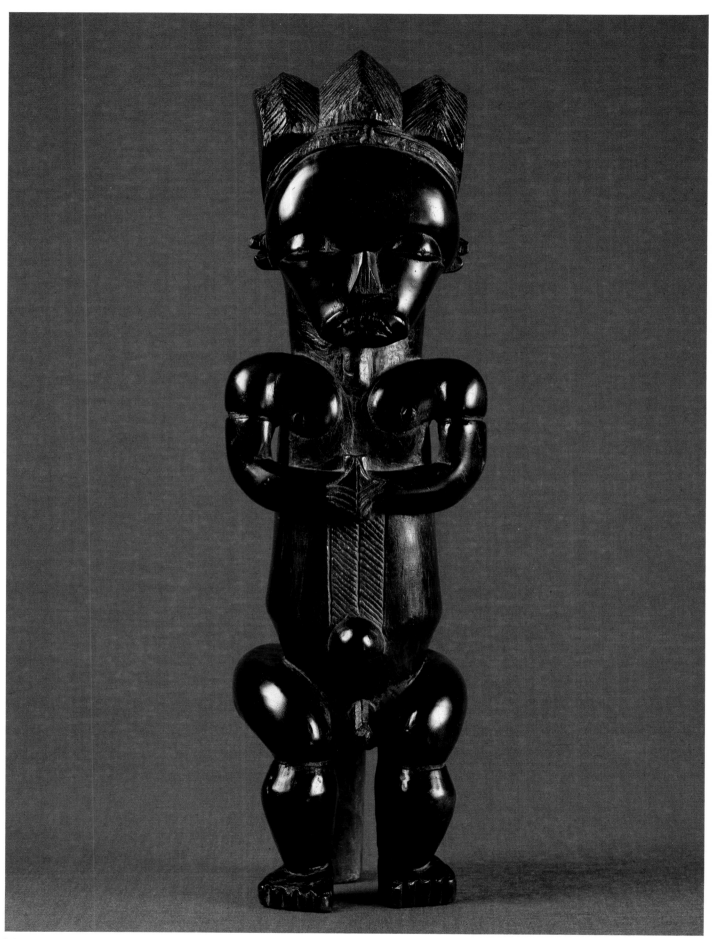

Reliquary figure. Fang. Gabon or Equatorial Guinea. Wood, 20⅞" (53 cm) high. Private collection

Pablo Picasso. *Peasant Woman.* 1908. Charcoal, 24⅝ x 19⅛" (62.5 x 48.3 cm). Collection Jacqueline Picasso, Mougins

critical jargon (and remained so until the latter took on its tribal connotation in the years just prior to World War I). It was applied quite readily to any art that tended toward the exotic, the highly stylized, the static, simple, geometrical, or frontal. In his letters, van Gogh had used "primitive" to describe Egyptian art, and the reader will recall that Matisse had talked about Egyptian art when he first showed Picasso an African carving; a few years later, Lipchitz would purchase his first African object under the impression that it was Egyptian.[133]

In the light of such confusion, it is quite understandable that Louis Vauxcelles's autumn 1908 review of Braque's first Cubist pictures should speak of the painter's "obsession with the style of Cézanne and with the recollection of the static art of the Egyptians."[134] Vauxcelles would have been correct, of

course, had he paired Cézanne with African art, which Braque was already collecting.[135] But in 1908 the art of Africa and Oceania was little known even in vanguard critical circles, and Vauxcelles was obviously unaware of Braque's interest in it. Considering that Rousseau was familiar with Picasso's primitivism—especially the *Demoiselles*, in which the head on the left, though in profile, contains as in Egyptian art a frontal eye—it is not so surprising that he characterized Picasso's work as "Egyptian."

As for his own modernity, the Douanier thought of it, I believe, largely in terms of motifs: airplanes, ocean liners, the Eiffel Tower, soccer games, factories—many of which would be taken up in the Cubism of his young friend Robert Delaunay. To be sure, Rousseau "the primitive" has been misleadingly treated as *sui generis*, or even worse, as the

Pablo Picasso. *Studies for the Head of a Peasant Woman.* 1908. Charcoal, 24¾ x 19⅞"
(62.7 x 48 cm). Collection Marina Picasso

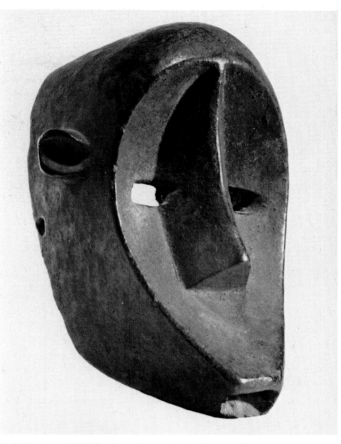

Mask. Bambara. Mali. Wood, 9⅜" (24 cm) high. Private collection, Italy

Pablo Picasso. *Standing Nudes and Study of a Foot.* 1908. Pen and india ink and
watercolor, 11⅞ x 9" (30 x 22.6 cm). Musée Picasso, Paris

founder of a school of *naïfs* that produced such painters as
Vavin and Bombois. In fact, his Symbolist poetic preoccupa-
tions, exotic iconography, and flat-lit, archaizing, decorative
style identify him quite logically with the Post-Impressionist
generation, to which he belonged chronologically in any
case. And it is not illogical that in the years when the styles of
Cézanne, Gauguin, Seurat, and van Gogh were variously
influencing the young Fauve and Cubist painters, the art of the
Douanier should also have been of interest—especially as the
four leaders of Post-Impressionism (Seurat, van Gogh,
Gauguin, and Cézanne) were already dead, while Rousseau
was established by 1908 as an active member of the young
painters' circle.

Rousseau's celebration by Picasso and his poet friends
aside, the championing of the Douanier became the self-
imposed lifetime task of two former students of Matisse, the
American painter Max Weber[136] and the Hungarian-born
sculptor turned art dealer, Joseph Brummer. In the shop on the
Boulevard Raspail that Brummer established toward 1908, one
encountered the Douanier's canvases face to face with tribal
art, of which Brummer became the principal dealer in the
period from 1908 to World War I (pp. 143–48).

The addition of Brummer's shop to that of Heymann on the
Rue de Rennes, where Matisse bought his first African sculp-
tures, significantly expanded opportunities to obtain tribal
art, which was otherwise available in Paris only here and there
in curio shops and stands at the flea market. This raises the
vexing question of the makeup of Picasso's personal collection

in the crucial period from 1907 until World War I. While it is possible to characterize Picasso's early collecting in a general way—and I have done so in the Introduction (pp. 14–17)—it is difficult to be specific about the work he owned during this period because of the sparsity of documentation. We do possess, however, some information, and further conclusions may be drawn from Picasso's work itself.

We have already observed that Picasso was probably shown his first African sculpture by Matisse on the occasion of a visit to Gertrude Stein in autumn 1906.[137] Matisse later spoke of his conversation with Picasso about it, and many writers have concluded that Picasso's "Africanism" dates from that occasion.[138] But there is not the slightest support for such a conclusion in Picasso's work during the next half year. The lack of importance Picasso himself attributed to that meeting at Gertrude Stein's[139] would be all the more understandable if Paudrat is correct in thinking (p. 141) that the object Matisse showed Picasso there was the unchallenging Vili figurine Matisse introduced not long afterward into a painting that remains unfinished (p. 214).[140] Matisse's conception of African sculpture, based primarily on the more conservative, "classic" Baule, Yombe, Yoruba, Vili, and Punu objects, led him to equate it with Egyptian art.[141] Picasso, who was drawn to the more abstract and imaginative Baga, Kota, and Hongwe objects, disliked Matisse's equation.[142] With a few exceptions,[143] what most interested Picasso in African sculpture was precisely what distinguished it from Egyptian art.

As I have already suggested, using the example of Rousseau's influence, Picasso did not get involved with the art of others until its trajectory crossed his own on an operational level, until it raised or answered questions that interested him—or could be cannibalized by him. Immersed as he was in his extrapolations of Iberian art during the autumn of 1906, he was either not ready for or, more likely, not particularly engaged by the objects he saw in those months in the studios of Matisse, Derain, and Vlaminck. Salmon, to be sure, has Picasso collecting tribal work in 1906. But Salmon wrote this many years later, and was often contradictory regarding dates.[144] Hence, in the absence of confirming documentation, or any reflection of tribal art in Picasso's work of winter 1906–07, this statement cannot be taken as strong evidence of his having collected it that early. I am therefore inclined to credit Picasso's assertion to me that he began buying tribal objects only after finishing the *Demoiselles* (i.e., in early summer 1907). His excitement about owning such objects, "charged" as he told me with a mysterious "force," could only have developed after his "revelation" about their magical nature.

With a single (possible) exception (which shows no Primitive art), there are no known photographs of Picasso's studio prior to late 1908.[145] Short of clues that may yet turn up among documents in the Picasso archive, there is scant evidence concerning the artist's earliest acquisitions of "art nègre."[146] In view, however, of Picasso's statement to me, there is no reason to doubt Kahnweiler's recollection that he saw a Marquesan Tiki in the studio before the end of 1907.

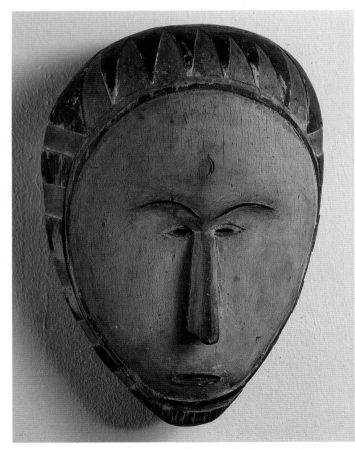

Mask. Fang. Gabon. Painted wood, 18⅞" (48 cm) high. Musée National d'Art Moderne, Centre National d'Art et de Culture Georges Pompidou, Paris. Formerly collections MAURICE DE VLAMINCK, ANDRÉ DERAIN

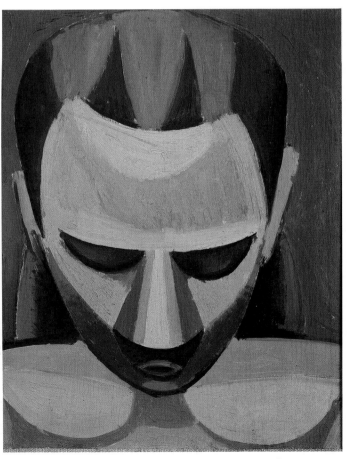

Pablo Picasso. *Head of a Man.* 1908. Oil on wood, 10⅝ x 8¼" (27 x 21 cm). Kunstmuseum Bern; Hermann und Margrit Rupf-Stiftung

This Tiki (p. 283) is the only object of great quality that we can be sure Picasso owned prior to World War I, and it may well have been purchased from Heymann.[147] That his initial Oceanic acquisition should have been Polynesian is most logical, for such Tikis have a sculptural plasticity that distinguishes them from Melanesian art but is comparable to that of Africa—and this was a moment of great sculptural concern for Picasso. His pictorial, Melanesian objects (p. 315) were largely acquired after 1920, when his own art moved in related directions.[148] Not surprisingly, in view of its quality, Picasso's Tiki remained in his studio through the years when many of his early "art nègre" acquisitions were shut away. We see it in a beautiful, previously unpublished photograph of Apollinaire at Picasso's c. 1911 (p. 282) and in numerous images of the studios in later years.[149]

Most of Picasso's early tribal objects, he told me, were purchased on promenades with Fernande, especially Sunday walks in the flea market. His estate contains a large number of obviously old but rather poor masks and figures that might well have been acquired on those promenades, but we cannot confirm their dates of purchase.[150] I find it hard to believe he would have sought out such objects after World War I, years during which the choice of tribal material was rapidly expanding, and during which he obtained most of his finer pieces, some of them by exchange for his own work. The acquisition of his many poor examples—which constitute the core of Picasso's "collection"[151]—makes more sense at a time when "art nègre" was a novelty for him, and when his own aims and

Pablo Picasso. *Standing Nude Seen from the Back.* 1908. Gouache and pencil, 24⅞ x 19" (63 x 48 cm). Private collection, promised gift to The Museum of Modern Art, New York

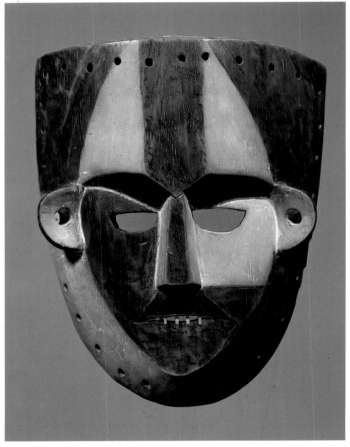

Mask. Boa. Zaire. Painted wood, 10" (25.5 cm) high. Collection J. W. MESTACH, Brussels

needs led him to discover useful concepts in routine objects (see pp. 18–20). Some of this poor tribal material is visible among the objects in the photographs taken by Claude Picasso at La Californie (p. 267). Tzara had looked over this mass of objects toward 1955 and was surprised by its mediocrity.[152] But he evidently did not understand how and why Picasso accumulated "art nègre."

It should also be kept in mind that in the years prior to World War I truly fine tribal objects were not inexpensive, and in 1907–12 Picasso's art was too difficult to bring much immediate financial success. By the time of World War I, Paul Guillaume reportedly sold an African object for 30,000 francs, or $6,000 (over $60,000 in today's dollars),[153] which was then around half the going price for an important Cézanne at Vollard's.[154] Picasso was, moreover, a thrifty buyer of tribal objects, despite his passion for them; and his well-known reluctance to part with money evidently had a bearing on the quality of his acquisitions, at least before the later 1920s. As late as 1918, when he was already becoming fashionably successful and had accumulated a certain wealth, we find him writing to Gertrude Stein, who had found some interesting tribal objects in Nîmes and proposed that Picasso purchase them: "…I would be happy to have them if they're not expensive." And ten days later: "Offer the fellow a hundred francs for the two of them." The deal in which Stein served as intermediary evidently went through, and Picasso liked the objects. The carvings, he writes her, "m'ont plus" (I retain his spelling), and he indicates that he is enclosing "avec cete letre" the hundred francs "que je vous doits pour les negres."[155] It is

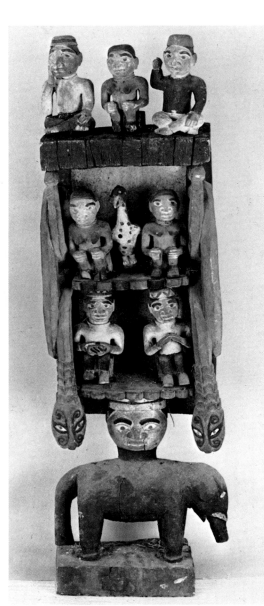

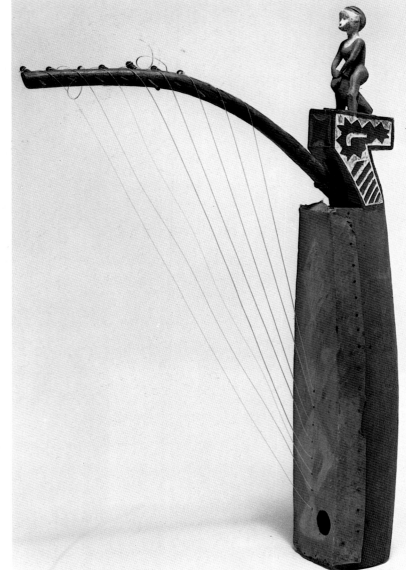

Composite group. Yombe. People's Republic of the Congo, Cabinda, or Zaire. Painted wood, 29¾" (75.5 cm) high. Collection Marina Picasso. Formerly collection PABLO PICASSO

Harp. Punu (also possibly Lele, Myene, or Fang). Gabon. Painted wood, 31½" (80 cm) high. Shown as restored. Collection Jacqueline Picasso, Mougins. Formerly collection PABLO PICASSO

very probable that Picasso enjoyed finding bargains, and he seems especially to have enjoyed what he called "chasses aux nègres" whenever he traveled to port cities where tribal sculptures were liable to be found.

The ordinariness of most of Picasso's early tribal objects is largely confirmed by the first studio photograph that shows them (facing page). It was taken in the Bateau-Lavoir late in 1908.[156] So far as is known, none of the tribal sculptures shown in it were seen in Picasso's studios or apartments after World War I. But knowing the artist's reluctance to part with such objects—indeed, his superstitious, almost fetishistic possessiveness with respect to them[157]—I guessed they might turn up in his estate. The two New Caledonian objects hanging on the wall have been selected by the Musée Picasso. I found the two African pieces shown on the table in the

photograph among the studio claptrap and miscellany in the lots of two of the heirs. Together with the Tiki, which was exceptional in its quality, these four constitute the inventory of what we can be *sure* Picasso owned in 1908.

The two New Caledonian figures are by today's standards rather routine, though no worse than their counterparts in the Trocadéro collection (p. 286), and they were probably fairly rare objects in 1907–08 Paris. The larger one can be made out to the left of Kahnweiler's head in Picasso's 1910 portrait of him (p. 310), so that this figure, at least, continued to be visible in Picasso's quarters after he had moved from the Bateau-Lavoir to his apartment on the Boulevard de Clichy.

On the famous drop-leaf table in the 1908 photograph is a curious African sculpture from the Loango coast (then the French Congo) of a type generally identified as Yombe; it is a

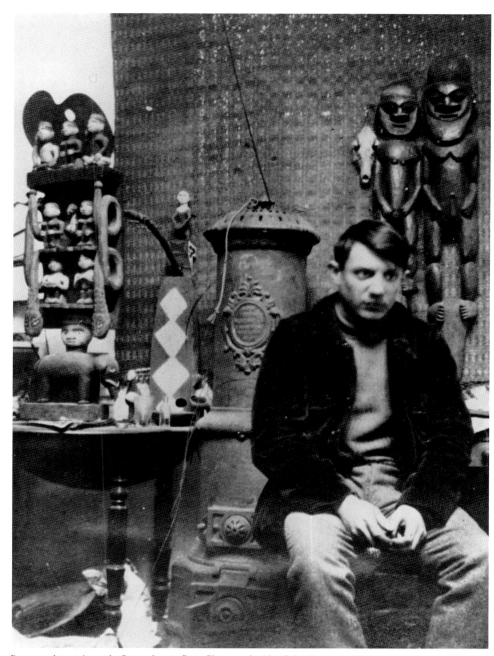

Picasso in his studio in the Bateau-Lavoir, Paris. Photographed for Gelett Burgess, 1908

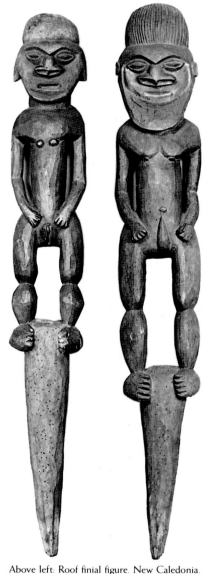

Above left: Roof finial figure. New Caledonia. Wood, 46½" (118 cm) high. Musée Picasso, Paris. Formerly collection PABLO PICASSO

Above right: Roof finial figure. New Caledonia. Wood, 49⅝" (126 cm) high. Musée Picasso, Paris. Formerly collection PABLO PICASSO. For color reproduction see page 310.

multitiered object with coiling snakes on an elephant socle. Of the six or seven such objects I have seen—including the one that entered the Trocadéro in 1900 and may have influenced Picasso's choice here—all were made as ornamental supports for ceremonial hand drums.[158] This is clearly not the case with Picasso's object, which could never have supported a drum (nothing is missing at the top, nor is there any logical place where the drum could have been attached). As his object is therefore a variant not made for traditional purposes, we may surmise that it was a "special order" by a colonial (a conclusion supported by the presence of Europeans among the figures). Hence, this construction falls into the category of "tourist objects," which includes a significant number of the earliest works to turn up in the West.[159] As there is little plastic interest or magical "force" in this construction—the

folkloristic style of which is reminiscent of much Yoruba sculpture—I must conclude that Picasso was amused by its almost circuslike whimsy.

To the right of the Yombe construction in the photograph is a Punu harp from Gabon, crested by a small female figure tapping a drum held between her legs. With its parallel diagonals and curiously serrated decoration above the resonating box—the front of which is covered with colored lozenges that would have recalled Harlequin's costume to Picasso—this musical instrument was probably a handsome object before its deterioration, which included the loss of the female figure at the top (it is shown on the page opposite as restored). A number of the figures had in fact fallen off the Yombe construction, but I was able to have them put back according to their positions in the photograph.

Ramon Pichot in Picasso's studio, Boulevard de Clichy, Paris, 1910

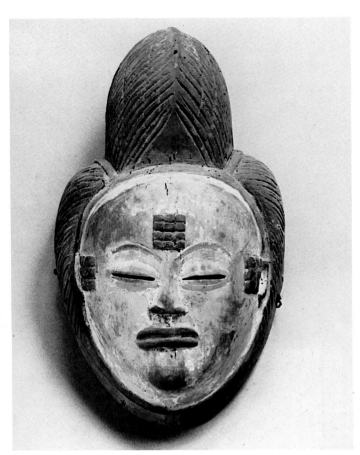

Mask. Shira-Punu. Gabon or People's Republic of the Congo. Painted wood, 11″ (28 cm) high. Musée Picasso, Paris. Formerly collection PABLO PICASSO

The 1908 photograph shows only one corner of Picasso's little studio, however, and we must assume that, in addition to the Tiki, other tribal objects were already to be found in it. It is very probable, for example, that Picasso had already purchased his white-faced Shira-Punu mask, which, as Fernande emphasized its importance,[160] was probably among his first purchases. The earliest documentation of it, however, is in a photograph of 1910 that shows Picasso's friend Ramon Pichot in the Boulevard de Clichy studio, where the mask hangs to the right of two oil paintings, a landscape of Horta by Picasso's childhood pal Manuel Pallerés, and a painting by himself. Such Shira-Punu masks were among the first objects to have been bought by the Fauves (whose collecting anticipated that of Picasso by more than six months); not only was the stylized "orientalism" of these masks easy to appreciate and readily assimilable to the inherited Gauguinesque concept of the Primitive, but their average quality ran particularly high, and they were evidently readily available on the Paris market.

Among the other likely candidates for Picasso's "collection" in its earliest years, aside from the two small Baga figures already mentioned in connection with *Head*, is one or both of his copper-covered Kota reliquary figures (top of facing page). This contention is supported first by the indications of interest in such objects in Picasso's work itself, especially in 1907 (see above, p. 268); second, by an observation about their originality made to me by Picasso;[161] and third, by the fact that both of the Kota reliquary figures Picasso owned are markedly inferior in quality to those available at Paul Guillaume's and

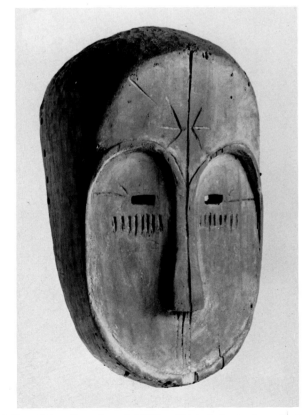

Mask. Fang. Gabon. Painted wood, 13″ (33 cm) high. Collection Jacqueline Picasso, Mougins. Formerly collection PABLO PICASSO

Reliquary figure. Kota. Gabon or People's Republic of the Congo. Wood and metal. Private collection. Formerly collection PABLO PICASSO. Photographed by Claude Picasso in the villa La Californie, Cannes, 1974

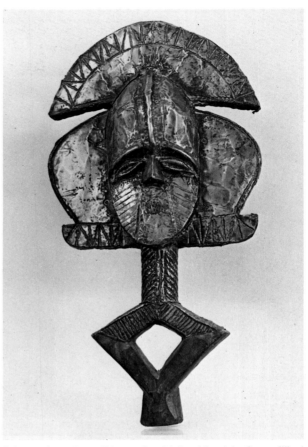

Reliquary figure. Kota. Gabon or People's Republic of the Congo. Wood, copper, and brass, 22¼" (56.5 cm) high. Collection Marina Picasso. Formerly collection PABLO PICASSO

Daniel-Henry Kahnweiler and his wife in their apartment, Rue George Sand, Paris, 1912–13

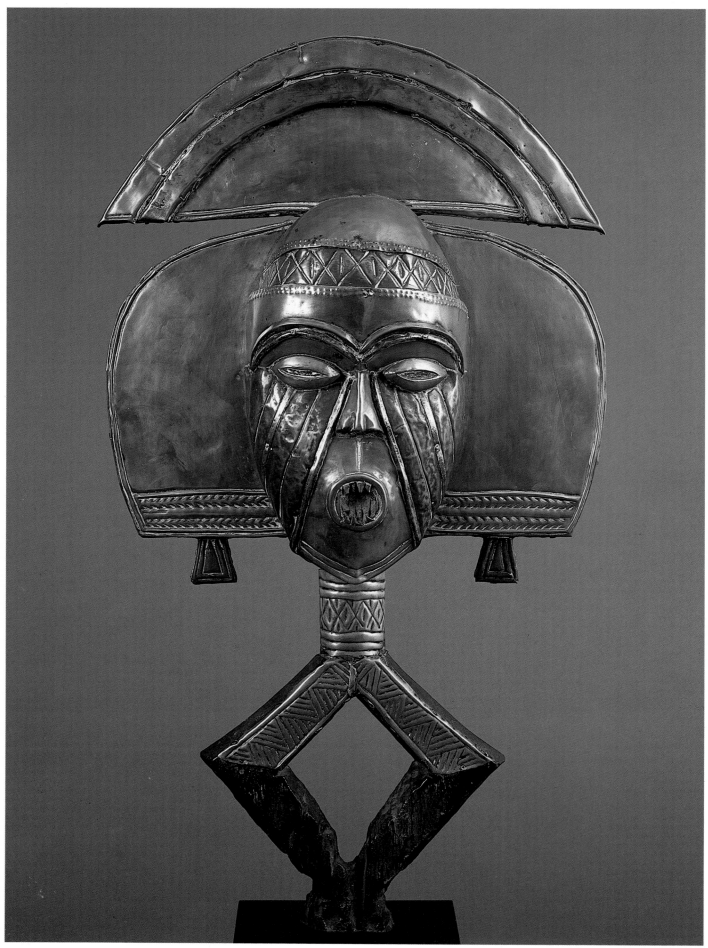

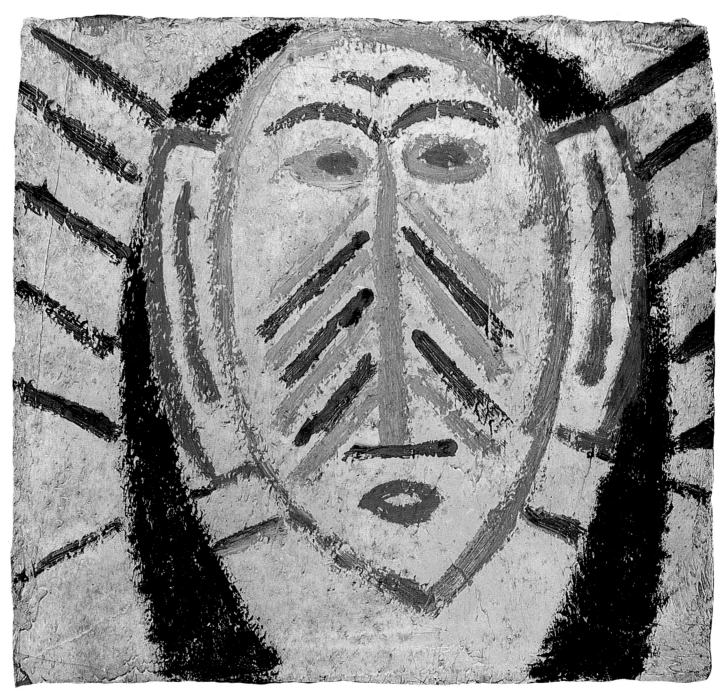

Above: Pablo Picasso. *Head.* 1907. Oil and sand on panel, 6⅞ x 5½" (17.5 x 14 cm). Collection Claude Picasso, Paris

Opposite: Reliquary figure. Kota. Gabon. Wood, copper, and brass, 26¾" (68 cm) high. Private collection

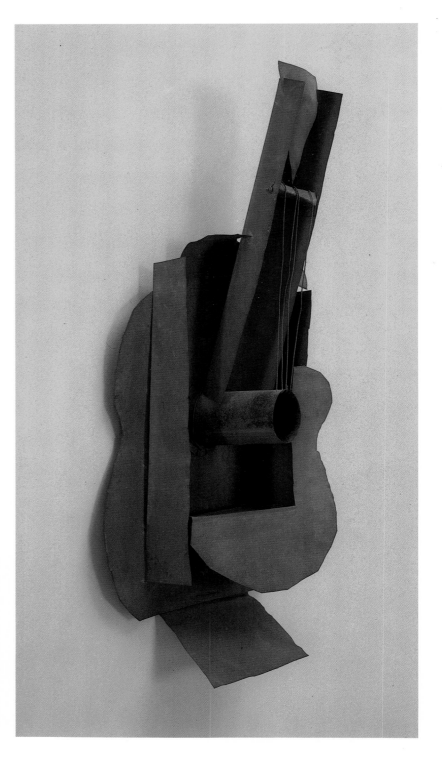

Right: Pablo Picasso. *Guitar.* 1912. Sheet metal and wire, 30½ x 13¾ x 7⅝″ (77.5 x 35 x 19.3 cm). The Museum of Modern Art, New York; gift of the artist

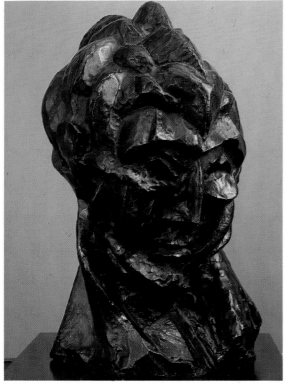

Pablo Picasso. *Head of Fernande.* 1909. Bronze, 16¼″ (41.3 cm) high. Private collection, Switzerland

other Paris dealers by the years just prior to World War I.[162] The first purchased by Picasso is probably the crude one (p. 301, left) photographed in the room of La Californie in which many of Picasso's tribal objects were stored. Picasso's other Kota reliquary figure (p. 301, right), more typical of the genre and more *travaillé*, cannot by today's standards be considered more than an "honest" example. Both are less handsome than some of those (p. 266) already in the Trocadéro collection by 1907. (A quite imposing Kota reliquary figure, published in 1982 as having been Picasso's—indeed, as having been in his collection at the time he painted the *Demoiselles*—has no connection with him whatever).[163] Of the two objects published as "Collection Picasso" by Clouzot and Level in 1919,[164]

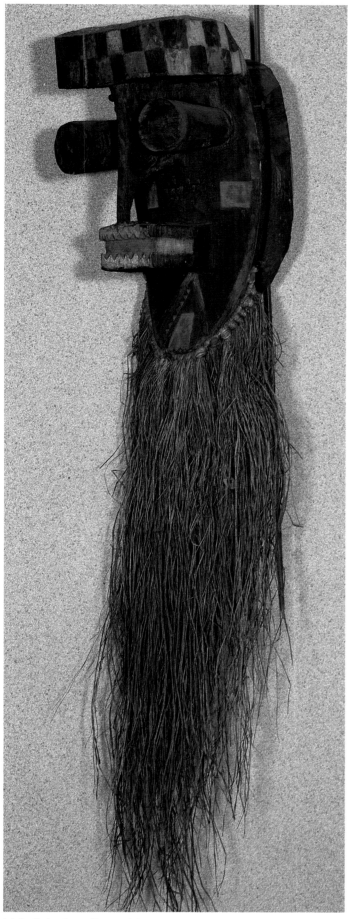

the Fang mask (p. 300) was probably acquired—in view of Picasso's taste for one-upmanship—before the better one Braque had owned by 1911 at the latest (p. 306). There is no way even to guess when Picasso acquired the Guere mask reproduced in Clouzot and Level.[165]

By far the most interesting of the African objects probably purchased by Picasso in the prewar years was the finer of his two Grebo masks (left), which may have been obtained during his "chasse aux nègres" with Braque in Marseilles in the second week of August 1912. In a postcard to Kahnweiler, Braque speaks of having shown Picasso around the city and having "bought up all the African objects" ("...avoir acheté tous les nègres").[166] A sketch in Picasso's notebooks, dated August 9 of that year (p. 307), shows what is probably an African mask under the café table in the lower right. Edward Fry, who pointed this out, has identified the mask as Picasso's Grebo, which he assumed was acquired then.[167] But despite the summariness of the sketch, it is clear that the mask which is represented—if, indeed, a mask is what Picasso intended to show—little resembles either of Picasso's two Grebo objects. As Picasso's finer Grebo mask is shown on the wall of the apartment at Montrouge in a drawing of 1917 (below), the trip to Marseilles provides a logical but far from obligatory date for Picasso's having purchased it. Even assuming this date to be correct would not necessarily confirm anything (contrary to Fry's assumptions)[168] with respect to the date of the *Guitar*, a sculpture influenced, as we know, by one or both of Picasso's Grebo masks (then wrongly known as Wobe), for Picasso would almost certainly have *already* been in possession of his inferior one (p. 20). The latter is precisely the type of mediocre, little-used object one could find very early in the century, when Grebo masks were among the more available

Mask. Grebo. Ivory Coast or Liberia. Painted wood and fiber, 14½" (37 cm) high. Collection Claude Picasso, Paris. Formerly collection PABLO PICASSO

Pablo Picasso. *Dining Room of the Artist at Montrouge*. 1917. Pencil, 11 x 9" (27.2 x 22.6 cm). Musée Picasso, Paris

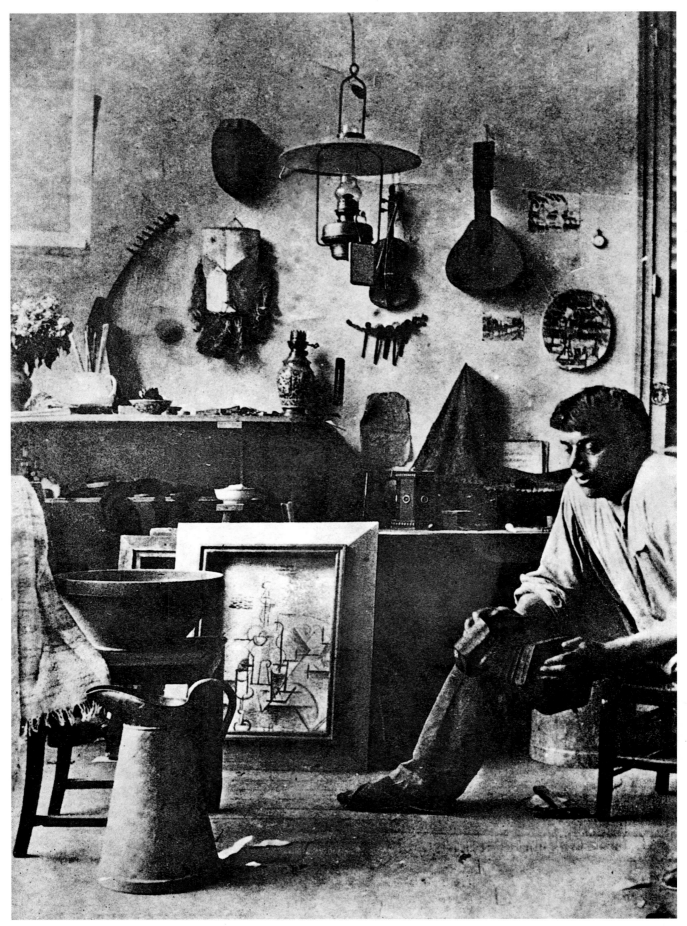

Georges Braque in his studio, Paris, 1911

Mask. Fang. Gabon. Painted wood and fiber, 12½" (32 cm) high. Collection Mr. and Mrs. Claude Laurens, Paris. Formerly collection GEORGES BRAQUE

Though Braque is rarely mentioned in connection with "art nègre," primarily because none of the forms in his pictorial vocabulary recall tribal art, even obliquely, Braque was nevertheless an avid collector in his early years (see p. 143) and did not mince words in regard to African art's importance for him: "The African masks...opened a new horizon to me. They made it possible for me to make contact with instinctive things, with uninhibited feeling that went against the false tradition [late Western illusionism] which I hated."[171]

The lovely photograph of Braque in his studio in 1911 shows his handsome Fang mask on the wall and one of his Cubist paintings on the floor. Nothing visibly relates the two, yet the conceptual principles of reductive abstraction and ideographic representation that govern the mask are operant, albeit in quite another spirit, in the painting. If one can apprehend the tenuous and obviously elliptical relation between these works, one grasps the nature of Braque's rapport with tribal art. His appreciation of it was, however, more formalistic and, in that sense, more limited than Picasso's. Unlike the Spanish artist, he was not interested in the magical "charge" or mysterious "force" of these objects. Braque, as Picasso later asserted, "did not really understand 'art nègre' because he was not superstitious."[172] Nor did Braque appreciate the mélange of materials, so characteristic of tribal art,

Pablo Picasso. *Souvenir de Marseille*. 1912. India ink, 7½ x 5⅜" (13.5 x 9 cm). Musée Picasso, Paris

types.[169] Picasso would never have purchased such a routine Grebo *after* having acquired the one on page 305; nor is the poor one the kind of object that might have been presented to him later as a gift.

Given the unknowns of the situation, we cannot be sure which of Picasso's Grebo masks relates more directly to the *Guitar*, if indeed one does more than the other.[170] Since both Kahnweiler (p. 301) and Apollinaire (p. 312) owned Grebo masks prior to World War I, and both began collecting later than Picasso, the probability is that Picasso acquired his routine Grebo mask sometime between later 1907 and 1912, and then perhaps improved his representation of the type with a purchase at Marseilles in 1912 (though nothing prevents him from having acquired the finer one in Paris during these same years).

As the nature of the Grebo masks' impact on the conception of the *Guitar* was discussed at some length in the Introduction (pp. 18–20), I shall not repeat it here. It should be noted, however, that this was precisely the kind of "invisible" influence that defined the relation of Braque's Cubism to tribal art.

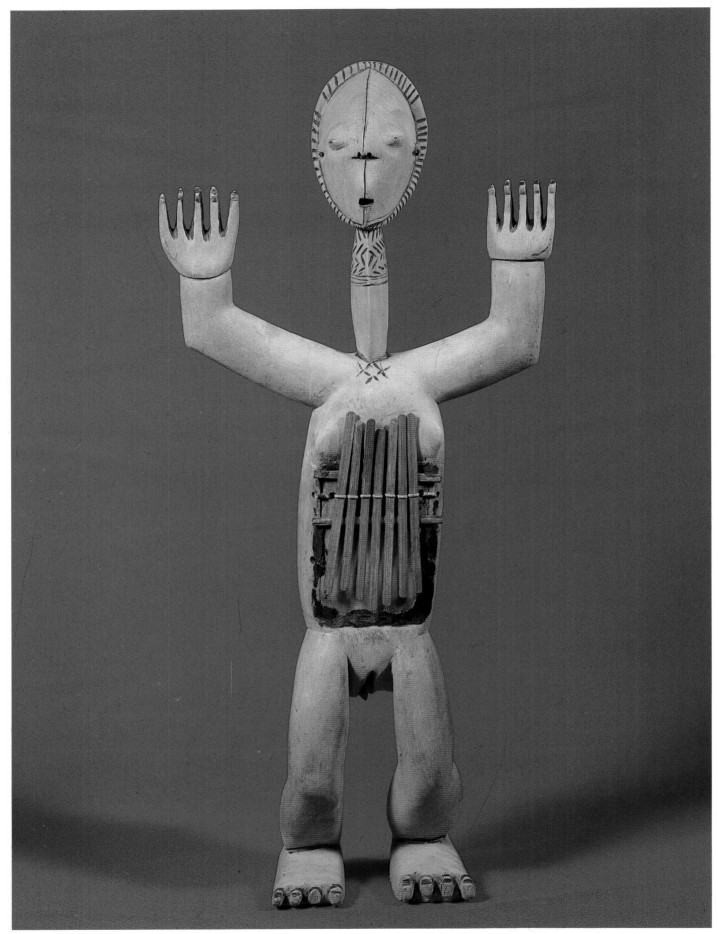

Sanza. Zande. Zaire. Wood, bamboo, and resin, 26″ (66 cm) high. Musée Royal de l'Afrique Centrale, Tervuren

Harp. Mangbetu. Zaire. Wood, animal skin, and cord, 33⅝" (85.5 cm) high. Collection J. W. MESTACH, Brussels

Friction drum. New Ireland. Wood, 20⅞" (53 cm) high. Collection J. W. MESTACH, Brussels.

that forms the background for Picasso's inventions of collage and construction.[173]

The 1911 photograph of Braque also attests to the ubiquity of musical instruments, both modern and tribal, in Cubist studios. Both Picasso and Braque loved guitars, violins, lutes, and zithers not for their sounds but for the beauty of their abstract and "lyrical" forms. Picasso, whose sense of fantasy and instinct for metamorphosis far exceeded Braque's, tended consistently to think of such instruments as analogues for the human torso or face.[174] The frequent anthropomorphism of African instruments could only have reinforced his thinking. (Oceanic instruments are often figural in quality, though usually in the form of animals or monsters, as in the friction drums from New Ireland.)

As Picasso's Cubism moved in 1910 from a language of solidly modeled bas-relief forms to a "painterly" style in which fragments of increasingly transparent motifs hovered in an uncertain and immeasurable luminous space, any rapport his work could have had with tribal sculpture, indeed with sculpture of any sort, necessarily became more tenuous. From 1909 until 1912, the only link I can find between his work and tribal art is the common denominator of their conceptualism. The utterly pictorial nature of high Analytic Cubism rendered it, both in style and in spirit, alien not only to tribal art, but to the more factual, tangible, "raisonnable" Cubism of 1909,[175] to say nothing of Picasso's "African" work of 1907–08.

During 1910–11 Picasso nevertheless continued to value his tribal art; most of the early studio photos, which date from those years, show it on the walls, tables, and floors. But while the conceptual analysis that African art had fostered continued to provide the dialectical underpinning of Picasso's and Braque's progress, the solutions to the pictorial problems they confronted could no longer be directly influenced by tribal sculpture. A style in which Cubism's solid forms were dissolving in a manner that recalled Cézanne's late watercolors and oils more than the paintings of his solid, "architectural" middle period, could hardly accommodate the kind of sculptural ideas Picasso had earlier absorbed from tribal objects.

Roof finial figure (detail). New Caledonia. Wood, 49⅝" (126 cm) high, overall. Musée Picasso, Paris. Formerly collection PABLO PICASSO. For complete view, see page 299.

Pablo Picasso. *Portrait of Daniel-Henry Kahnweiler* (detail). 1910. Oil on canvas, 39⅝ x 25⅝" (100.6 x 72.8 cm). The Art Institute of Chicago; gift of Mrs. Gilbert W. Chapman in memory of Charles B. Goodspeed

Pablo Picasso. *Portrait of Daniel-Henry Kahnweiler* (detail). 1910. Oil on canvas, 39⅝ x 25⅝" (100.6 x 72.8 cm). The Art Institute of Chicago; gift of Mrs. Gilbert W. Chapman in memory of Charles B. Goodspeed

The background of the portrait of Kahnweiler provides an interesting measure of this aesthetic distance. So abstract is the style that the two tribal objects on the wall behind the sitter—the finer of Picasso's two New Caledonian pieces to the left and an unidentifiable mask to the right—would probably never have been noticed had not Picasso himself alluded to them.[176] The upper part of the New Caledonian figure can be firmly identified because of its crownlike hairdo (arrows), though not by the face, which has been "analyzed" to the point of unrecognizability; the bottom of this figure dissolves into a matrix of abstract forms that derive from other objects in the visual field, such as the liqueur glass which can be made out where the figure's midsection would have appeared.

The mask on the other side of the wall behind Kahnweiler (above) is indicated by planes derived from one of its outer contours, its triangular beard and long nose, and a horizontal panel across the forehead not unlike the one on Picasso's better Grebo mask (p. 305).[177] So much do these fragmentary

310 *RUBIN*

planes dissolve into their neighbors through *passage* that one cannot guess what kind of mask was actually hanging there, let alone identify it with any that is known to have been in Picasso's possession. The very transparency of which the *passage* is a pictorial function was seized upon by Kahnweiler much later and made the focal point of a confused and confusing text,[178] whose aim was to show that the thrust of African influence on Picasso's art was not in the period of the *Demoiselles*, but precisely in that of high Cubism. To this end he attributed to Ivory Coast masks, and to the forms of Ivory Coast masks (Grebo in particular), a "transparency" that they demonstrably do not have.[179]

The illusionistic transparency of the high Analytic Cubist style created a unity residing more in its continuum of light than in the forms that emerge and submerge within that light, and Picasso obviously realized that this did not lend itself to sculpture. After fashioning the *Head of Fernande* of 1909 (p. 304), he abstained from sculpture until late 1912, when under

Antoine Pevsner. *Mask*. 1923. Celluloid and metal, 13 x 7⅞ x 7⅞" (33 x 20 x 20 cm). Musée National d'Art Moderne, Centre National d'Art et de Culture Georges Pompidou, Paris

the impact of collage a new, more factual form of nonillusionistic Cubism was emerging. If there is any sculptural counterpart to the high Analytic Cubism of 1910–11, it is to be found not in the work of Picasso but (later) in that of Pevsner. The translucent planes of Pevsner's celluloid reliefs were no doubt extrapolated from that Cubism, to which they owe their abstractness, their brownish tonality, and their partial transparency. Indeed, it is not hard to imagine Pevsner's *Mask* as a realization of ideas implicit in Picasso's treatment of the mask hanging on the wall in the Kahnweiler portrait. Kahnweiler's later theories notwithstanding, such "transparency" as one can attribute to a Grebo (or any other tribal) mask is not optical but conceptual, and takes the form—as in Picasso's *Guitar*—of a "cutaway" rather than an illusionistic method of indicating the positioning of planes in depth.

It is thus not by chance that Picasso's Analytic Cubism had generated little sculpture—none at all except in the earlier "tactile," 1909 phase. It seems at first a paradox that Picasso's

painting of late 1908 to spring 1910—given its ultimately sculptural plasticity—should have produced so little three-dimensional work while the antisculptural, flat patterning of the Synthetic Cubism that emerged in 1912 should lead to some of Picasso's greatest sculptures. But this paradox is illusory, and to understand why Picasso returned to sculpture in 1912—and why his work then and in the following year was once again to relate directly to tribal art—is to grasp the nature of the profound revolution Picasso wrought in the art of sculpture.

In the *Head of Fernande* (p. 304) of autumn 1909, Picasso had created a sculptural counterpart to his early Analytic Cubism. But he evidently realized that this re-creation of the forms used in his paintings amounted ironically to but a sculptural illusion of a pictorial device. When we compare the *Head of Fernande* with the paintings of 1909, such as *Woman with*

View of Guillaume Apollinaire's library, Paris. Photographed c. 1954. For another photograph, see page 144.

Pears,[180] we discover that there is greater sculptural plasticity in the paintings than in the sculpture; the latter lacks an intense sense of material weight and density (such as Brancusi, for example, would bring to his sculpture). This results from the fact that the *Head of Fernande* was not conceived essentially in terms of mass, but as a relief turned in 360 degrees—a cylindrical surface illusioning the ridged surfaces of the artist's painted forms. The greater plasticity of the paintings was partly a question of Picasso's ability to light each plane so as maximally to enhance the quality of its relief. As the light in

the paintings was pure illusion, that light could be (and was) made wholly inconsistent in logical terms in order to enhance the plasticity of the forms. Natural light being uncontrollable, constrained as it is by the laws of physics, the same possibility was not available for sculpture.[181] *Head of Fernande* constituted a dead end, and Picasso seems to have recognized it.[182] It demonstrated that an illusionistically modeled Rodinesque[183] approach to representation—itself the last phase of a plastic tradition that went back to the ancient world—could not engender a truly sculptural counterpart for Cubist painting.

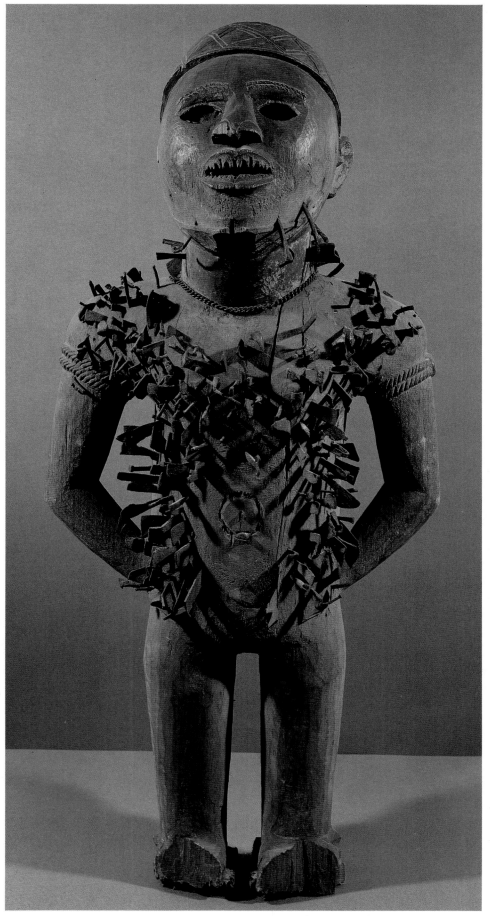

Fetish figure. Yombe or Woyo. Zaire, People's Republic of the Congo, or Cabinda. Wood and metal, 39⅜" (100 cm) high. Private collection. Formerly collection GUILLAUME APOLLINAIRE

Mask. Guere. Ivory Coast. Wood, fiber, shell casings, and mixed media, c. 12" (30.5 cm) high. Private collection

Given the setback constituted by the *Head of Fernande*, it is not surprising that Picasso made no sculpture for three years. When he resumed in autumn 1912 with the *Guitar*,[184] it was because the name of the game had changed. Now he would create a relief art that would give the tangibility of real objects to images which in his paintings had become flat, bodiless forms—just the reverse of the situation that obtained in 1909. The mass, weight, and density central to traditional sculpture were no longer to be issues. And the new sculpture would be made of materials dissociated from that tradition, materials heretofore considered "unworthy" of high art,[185] its style would be antivirtuosic, and the objects would look both homely and homemade. Indeed, compared to the *Head of Fernande*, the *Guitar* is distinctly unprepossessing. But it bodied forth a concept that revolutionized sculpture: the substitution of additive construction for the technique of modeling and carving of the "monolith" tradition.[186] This made possible the invention of planar and linear "open-work" configurations in sculptures that constituted conceptually encoded objects in themselves rather than sculptural illusions of objects.

As I observed in the Introduction, *Guitar* and other of

Picasso's Cubist reliefs and constructions share characteristics with certain types of tribal art. It is obviously impossible to determine how much this commonality of materials and modes of figuration was fortuitous and how much the tribal objects actually stimulated Picasso's ideas—if sometimes only subliminally. At the very least, there are many parallels. Many of the tribal objects Picasso preferred were revetted with copper or tin or incorporated bits and pieces of various found objects, thus contradicting Western traditions governing both the hierarchy and unity of sculptural materials.

Ivory Coast masks, which were among the most common African objects in Paris early in the century, not infrequently incorporated found materials. The Guere carver who articulated his mask with cartridge shells charged his object with a ready-made material symbolic at once of private and collective power, material as alien to the bronzes of the Benin court as Picasso's found materials would prove to the Rodinesque tradition of Western sculpture. Like the found matter of the Guere artist, Picasso's assemblage inclusions are somewhat "serendipitous," and are both private and public in their implications. His oilcloth, pebbles, string, cardboard,

Mask. Torres Strait, Papua New Guinea. Painted metal, hair, shell, and mixed media, 19¼"(49 cm) high. Collection Claude Picasso, Paris. Formerly collection PABLO PICASSO

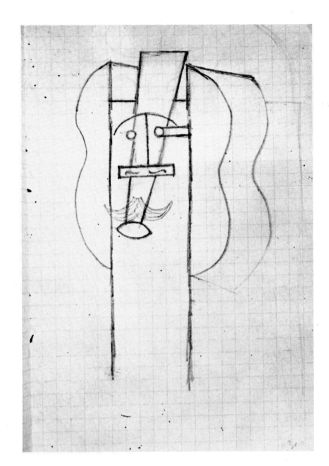

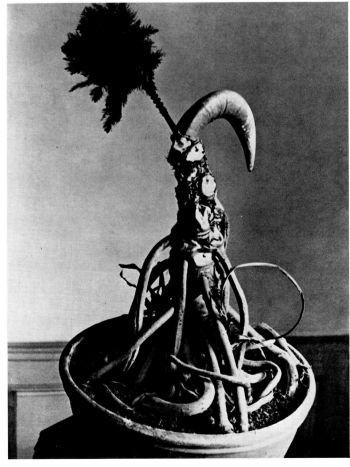

broomstick, wire, nails, garden tools, rubber gloves, and colanders each have a set of associations we share collectively. But for Picasso they almost always also had a secret metaphoric value. (He once spoke to me for twenty minutes of his feelings about the tasseled furniture fringes so common in Cubist paintings and *papiers-collés,* one of which was literally digested into the painted wood still-life construction in the Tate Gallery.)[187] Like the Guere artist with his cartridge shells the significance of which is altered when they become the hairdo and beard of his mask, Picasso magically transforms a tennis ball into the bulging eye of a warrior.[188] Or he pits his own powers against those of a tribal artist by using an Easter Islander's sculptured arm as a found object in *Woman in a Long Dress* (p. 330).

Many tribal objects share a simplicity, sincerity, awkwardness, and winning absence of presumptuousness with Picasso's collage constructions, which among all his creations Picasso prized especially—perhaps for these very reasons. To be sure, few of Picasso's constructions or assemblages resemble tribal objects, but from time to time he signals his consciousness of the latter by a quasi-parodistic gesture. I take this to be the meaning of the "fetish" he created by adding a horn and a feather duster to a mass of philodendron roots.

Above left: Pablo Picasso. *Study for a Head.* 1913. Pencil, 5½ x 3⅝" (14 x 9 cm). Musée Picasso, Paris

Above right: Pablo Picasso. *Study for a Head.* 1913. Pencil, 5½ x 3⅝" (14 x 9 cm). Musée Picasso, Paris

Left: Pablo Picasso. *Object.* 1931. Flowerpot, roots, horn, and red feather-duster. Probably destroyed

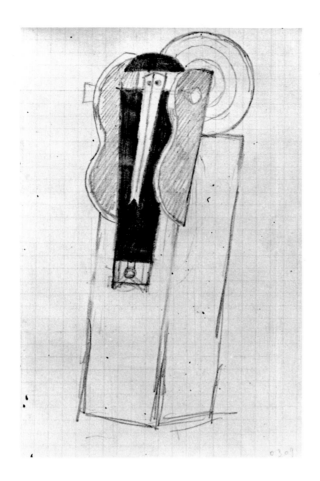

Not long after executing the metal version of the *Guitar*, Picasso embarked upon a series of sketches for sculptures and assemblages in which, for the first time since 1908, we find unquestionable if always oblique references to tribal objects. These drawings are introduced by a study of an elongated head that narrows to terminate in a chinless mouth, recalling the contours of Fang masks and Bambara animal masks (p. 319, top). As Picasso takes a guitar apart in his mind, he imagines the tapering fingerboard bent downward so that it can serve as a nose in relation to the sound box of the instrument, which has become a head (page opposite). This fingerboard-nose then becomes identified with the entire elongated head that related to the Fang and animal masks, and leads finally to an extraordinary project for a *Head* (left). This construction, had it ever been realized, would have started from a wooden box; the front plane of a guitar's sound box, cut in two and turned at right angles, would have been attached to its upper forward edges to form the sides of the face, with a segment of the tapered fingerboard affixed between them as a nose. Behind the plane of the face, on the very top of the box, a disk with concentric circles was foreseen; Picasso actually did use such a disk a year later as a bell for his "clarinet" in the construction *Mandolin and Clarinet*.

Left: Pablo Picasso. *Head*. 1913. Pencil, 5½ x 3⅝" (14 x 9 cm). Musée Picasso, Paris

Below left: Mask. Dogon. Mali. Wood, 13" (33 cm) high. Folch Collection, Barcelona

Below right: Pablo Picasso. *Head*. 1958. Wood, nails, buttons, painted plaster, and painted synthetic resin, 19⅞ x 8¾ x 8" (50.4 x 22 x 20 cm). The Museum of Modern Art, New York; gift of Jacqueline Picasso

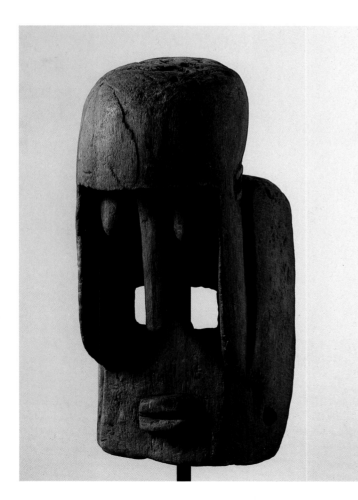

Helmet mask. Baule. Ivory Coast. Wood, 30¼" (77 cm) high. Private collection, Paris

Such associations to Fang or Bambara animal masks as may have informed the study to the right disappeared, in any case, as Picasso's project developed, much as the vestiges of Picasso's interest in Nimba figures had vanished by the final state of *Figure* (p. 279). Picasso made no effort, however, to eliminate or disguise his sources when he used an animal mask as a model for the head of the horse in his costume for *Parade* (below). The source is made quite clear in a drawing in which two studies for the horse's head are juxtaposed to early conceits for a manager's costume. The latter, as will be remembered, ended as a Cubist construction that incorporated allusions to architecture and machinery. One cannot help feeling that Picasso was making a point by associating to these symbols of modernity a costume incorporating a direct allusion to a very different source of Cubist thinking—the tribal mask.[189]

In the late 1920s Picasso experienced a new burst of creativity in sculpture, which began with the "drawing in air" wire pieces of 1928–29, progeny in part of the wire strings of the 1912 *Guitar.* These new pieces, fashioned by Julio Gonzalez from Picasso's drawings, were antipodal to tribal art in their openness—that is, their rejection of any vestige of solid forms, modeled or carved. In the course of expanding the possibilities of metal sculpture, however, Picasso introduced, during 1930–31, ideas that once again revealed affinities (and perhaps even echoes) of his love of tribal sculpture. These links became even more marked when in the winter of 1931–32 Picasso returned to sculpture based on solid forms in the extraordinary series of large heads of Marie-Thérèse Walter.

Pablo Picasso. *Studies of Costumes for Parade.* 1917. Watercolor and pencil, 8⅛ x 11" (20.5 x 28 cm). Musée Picasso, Paris

Pablo Picasso. The Horse in *Parade.* 1917. Photograph by Oumansky and Novak. Private collection

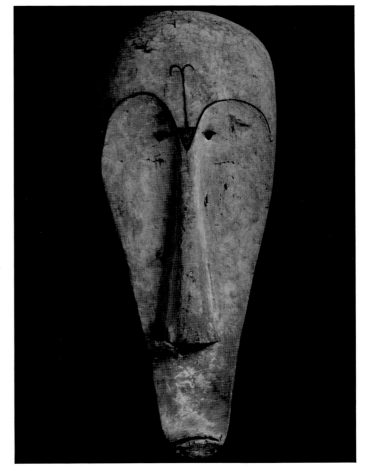

Pablo Picasso. *Head of a Woman*. 1912. India ink, 7½ x 5⅜″ (13.5 x 9 cm). Musée Picasso, Paris

Mask. Fang. Cameroon. Painted wood, 30¾″ (78 cm) high. Museum für Völkerkunde, Berlin

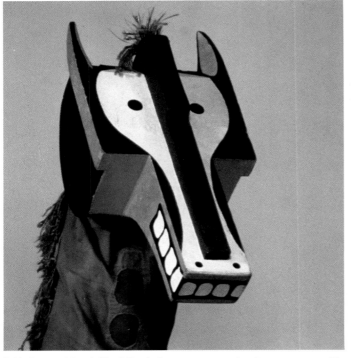

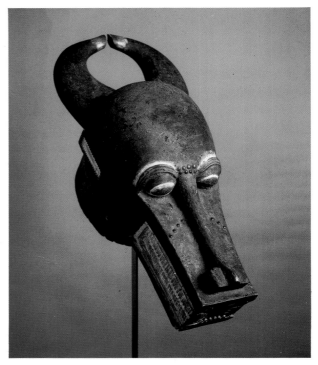

Pablo Picasso. Horse's Head, *Parade*. Reconstruction and realization supervised by Kermit Love. The Joffrey Ballet's production, 1974. (Danced by Eric Dirk)

Helmet mask. Baule. Ivory Coast. Wood, 28″ (71 cm) high. Musée d'Art Moderne, Troyes; gift of Pierre and Denise Lévy

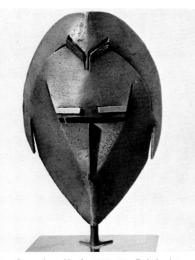

Julio Gonzalez. *Head*. 1929–30. Polished iron, 10⅝″ (27 cm) high. Private collection. Formerly collection Alex Maguy, Paris

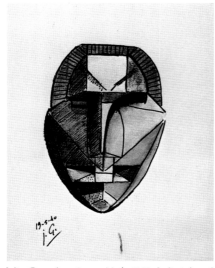

Julio Gonzalez. *Austere Mask*. 1940. India ink and wash, 12½ x 9⅜″ (31.7 x 23.8 cm). Collection Carmen Martinez and Viviane Grimminger, Paris

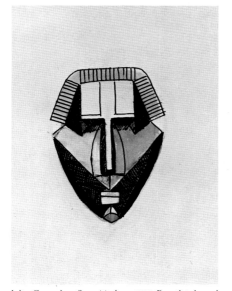

Julio Gonzalez. *Stern Mask*. c. 1939. Pencil, ink, and wash, 12¾ x 9½″ (32.4 x 24.2 cm). The Trustees of the Tate Gallery, London

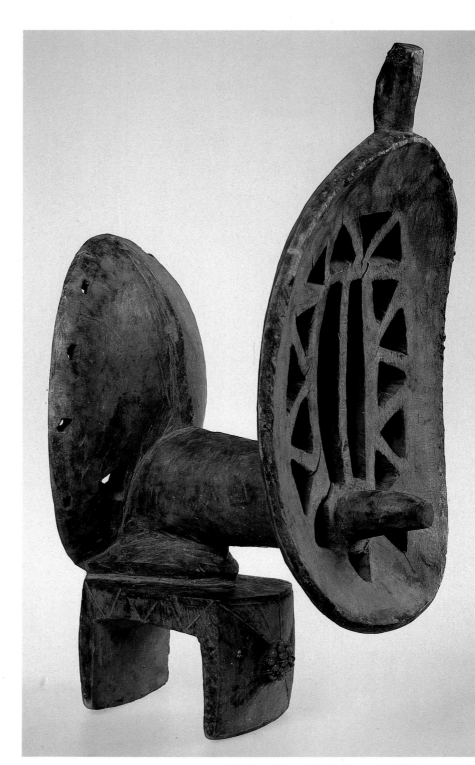

Mask. Jukun. Nigeria. Wood 10¼″ (26 cm) high. Museum für Völkerkunde, Berlin. (See page 79, note 112)

There is already in 1930 a striking affinity between Picasso's iron, brass, and bronze *Head* and a Jukun type of African mask. Both are based upon the radical forward projection of the frontmost plane of the head. In the Picasso, this concave and vertical projecting form is a sign for a mouth;[190] in the Jukun mask to which we compare it, the perforated concave oval is a decorative elaboration, apparently developed over many years, of the shape of the horns in the masks of the neighboring Mama peoples (p. 610). Here we are certainly

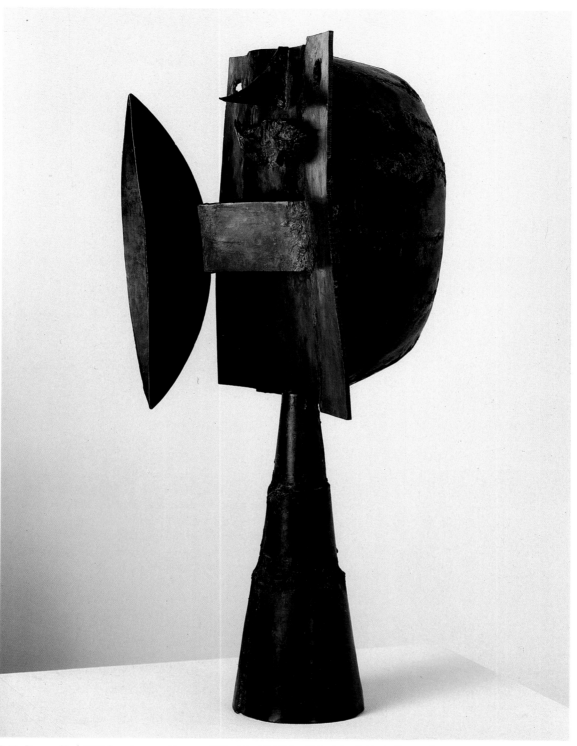

Pablo Picasso. *Head.* 1930. Iron, brass, and bronze, 32⅞ x 16 x 14" (83.5 x 40.5 x 36 cm). Musée Picasso, Paris

dealing with an affinity rather than an influence, for Picasso could not have seen even a photograph of such a Jukun mask before making this sculpture.[191] However, the pointed concave oval that constitutes the projecting mouth in Picasso's *Head* is also, taken alone, reminiscent of one of his longtime favorites among tribal sculptures, the Kota reliquary figure. (Giacometti had arrived at a very similar form for the torso of a c. 1926–27 plaster figure, p. 528, made directly under the influence of a Kota object obtained from a friend.)[192]

That these copper-covered Kota reliquary figures were again on Picasso's mind in 1930–31 is further suggested by the presence of the concave oval he used as the plane of the face in *Head of a Woman* (p. 323), which is in fact a "portrait" of Olga Picasso,[193] as well as by the elongated lozenge that supports the head—much as do the lozenges of the reliquaries. One is tempted to speculate that Picasso found himself thinking of these reliquaries for two reasons, both of which relate to possible associations with Olga (who was not only the subject

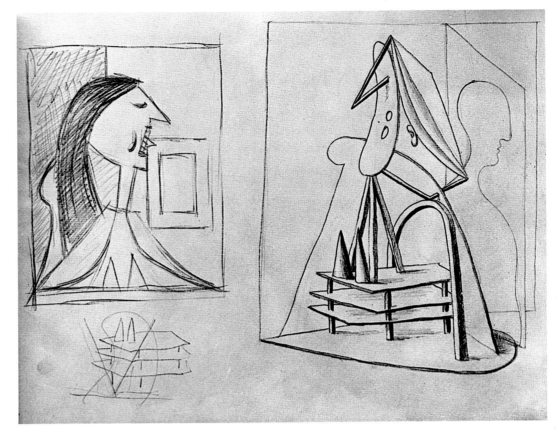

Pablo Picasso. *Study for Bust of a Woman with Self-Portrait and a Sculpture.* 1929. Pencil, 9¼ x 12" (23.4 x 30.5 cm). Musée Picasso, Paris

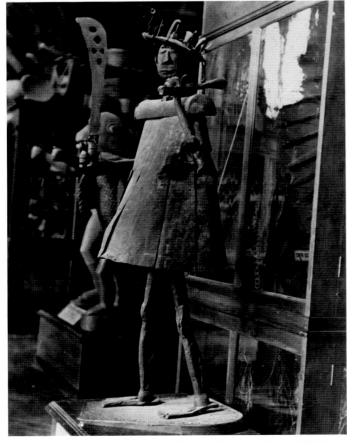

Figure. Fon. People's Republic of Benin (formerly Dahomey). Metal, 65" (165 cm) high. Musée de l'Homme, Paris; acquired 1894. Photograph of installation in the Musée d'Ethnographie du Trocadéro, Paris, 1895

of *Head of a Woman* but also, in all likelihood, the inspiration for *Head*). These are the metallic coverings of the reliquary figures and the lozenge shapes of their supports.

First let us recall that Picasso, like some other modern artists, had "misread" the lozenges of the reliquary guardians as legs, which thus suggested "dancing figures." Hence the reliquary figures would be logical associations to Olga, who had been a professional ballerina. Even in the years of Picasso's happiness with Olga (1917 to 1924), his drawings and paintings of her usually emphasized the hardness and leanness of her dancer's body and her angular *danseuse noble* features.

As relations between the two became exacerbated beginning in 1925, Picasso's images of Olga became less classical and realistic, tending to a kind of surreal distortion[194] that culminated in 1929–31 in a variety of conceptions that portray her as a kind of bone-hard, sharp-edged predatory monster.[195] Olga had not been able to adjust to sharing Picasso's life with Marie-Thérèse—and had become increasingly distracted. On his vacations from her in the late twenties, she would pop up unexpectedly anywhere—on the beach, in the streets—and cover Picasso with invective. Many of Picasso's images of Olga from the late twenties portray very graphically his changing feelings. It has long been recognized, for example, that the screaming female with hair flying back and pointed tongue projecting in *Bust of a Woman with Self-Portrait* (1929, Z. VII, 248) represents Olga; here Picasso portrays his own reaction to being "engueulé" by Olga as one of detached calm (the metaphor of the Self-Portrait shown on the wall). Elsewhere, Picasso's images of Olga reflect annoyance, anger, and even fear. Olga's increasing alienation probably led her eventually to threaten Picasso's life,[196] and this no doubt

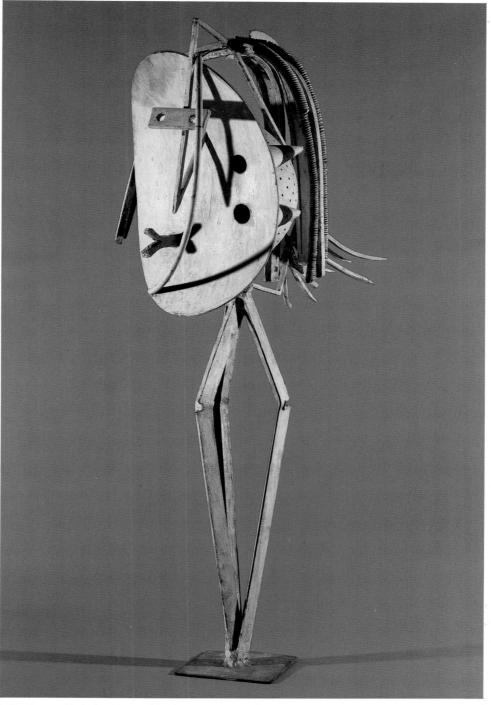

Pablo Picasso. *Head of a Woman* (Olga Picasso). 1930–31. Painted iron, sheet metal, springs, and found objects (colanders), 39⅜ x 14½ x 23¼" (100 x 37 x 59 cm). Musée Picasso, Paris

inspired her portrayal as Charlotte Corday in *Woman with Stiletto (Death of Marat)* of 1931.

The sense of Olga's body as hard, angular, and aggressive—as it is summarized in the celebrated *Seated Bather* of 1930 (Z. VII, 306)—quite appropriately suggested the use of metal for the sculptural images inspired by her, a choice that reinforces the association to Kota reliquary figures, which were alone among Picasso's tribal objects of any size in being metal.[197] *Head of a Woman* is easily identified as Olga because of the pronglike "hairs" flying back from her head (as in *Bust of a Woman with Self-Portrait*), and by the elegant lozenge that

supports the head, which is at once a long "neck" and a suggestion of a ballerina's attenuated legs. Indeed, the association between the *Head of a Woman* and *Bust of a Woman with Self-Portrait* is confirmed by a notebook drawing (facing page) that juxtaposes studies of the two works. Among the metal sculptures of this period, *Head of a Woman* has a certain grace and lyricism despite its hardness and angularity. *Head* relates more closely in spirit to the violent painted images of Olga; the projecting pointed oval that literally represents her exaggerated "gueule" suggests by implication the torrents of abuse she heaped on the artist.

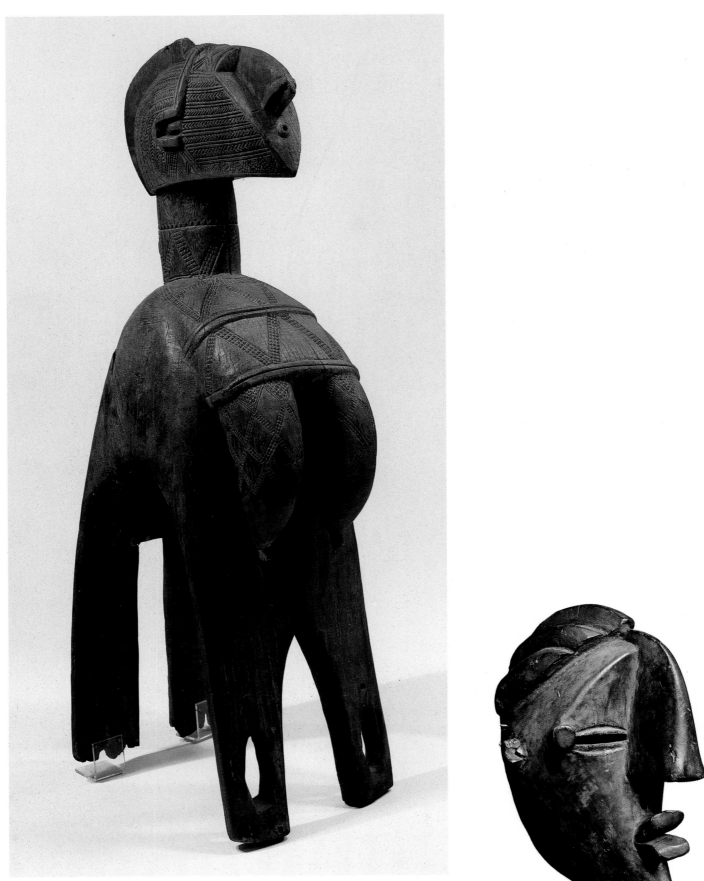

Nimba mask. Baga. Guinea. Wood, 42½" (108 cm) high. Museum Rietberg, Zurich

Mask. Lwalwa. Zaire. Wood, 13⅜" (34 cm) high. Private collection

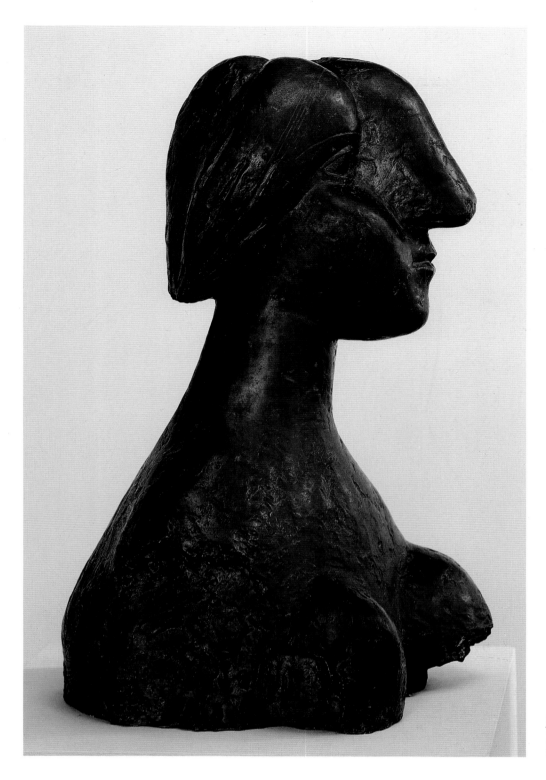

Pablo Picasso. *Bust of a Woman* (Marie-Thérèse Walter). 1931. Bronze, 27 x 16½ x 17⅛" (68.5 x 42 x 43.5 cm). Musée Picasso, Paris

Picasso's choice of sculptural materials was always more inspired by their aptness for communicating the artist's specific sentiments toward his subject than by any possibilities inherent in the materials themselves, or any related interest in aesthetic problem-solving. If his feelings about Olga led to the use of metal in the sculptures just discussed, his shift to modeling in clay and plaster for the series of monumental heads of 1931–32 was dictated by his feelings for Marie-Thérèse. Both groups of sculptures have counterparts in Picasso's collection of tribal art, correlatives that were among the earliest primitive objects to interest him. If the sculptures of

Olga relate to the metal-covered Kota reliquary figures, the monumental heads of Marie-Thérèse were executed under the sign of Nimba (p. 327), Baga goddess of fertility.[198]

The method of execution in the metal sculptures inspired by Olga was impersonal insofar as they were actually realized by Gonzalez.[199] In *Head of a Woman*, Olga was further distanced from the artist to the extent that she was literally turned into an object by the incorporation—in some instances without transformation—of recognizable colanders, springs, and nails. On the other hand, Picasso's love of the soft, pneumatic, sensual forms of Marie-Thérèse, and his

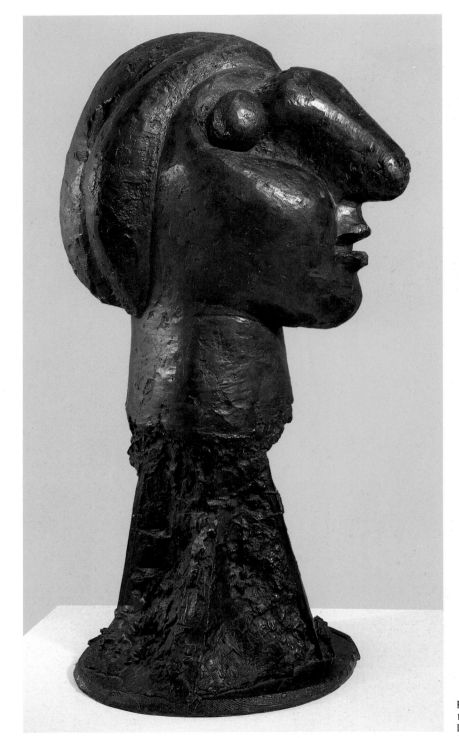

Pablo Picasso. *Head of a Woman* (Marie-Thérèse Walter).
1931–32. Bronze, 33½ x 14½ x 19″ (85 x 37 x 48 cm). Galerie
Louise Leiris, Paris

sense of intimacy with her body, led him back to a method in which the material of the sculpture (clay) was pressed and squeezed by his own hand.

We do not know precisely when and how Picasso acquired his very handsome, classic Nimba mask (opposite), but it was evidently in the later twenties.[200] He likely had already long possessed his Baga figures,[201] one of which is reproduced on page 276; indeed, we have seen that they were probably among his first purchases, contemporary with the 1907 drawings related to Nimba (p. 277). At the beginning of the century, the much larger and heavier Nimba masks were extremely rare, and though Picasso saw the one in the Tro-

cadéro museum (p. 275), he almost certainly had no opportunity to purchase such a mask until after World War I.

Picasso's acquisition of the shoulder mask at the right after the inception of his long-term relationship with Marie-Thérèse in 1925 has a certain appropriateness about it. Marie-Thérèse was for Picasso the incarnation of sensuality and, by extension, of fertility. The full shapes, salient nose, and large prominent breasts of classic Nimbas would have certainly reminded Picasso of Marie-Thérèse even if he had not been aware—as, indeed, he was[202]—of the mask's cult associations to fertility. It is not by chance that Picasso's Nimba stood like a clan totem in the entrance of the château at Boisgeloup where

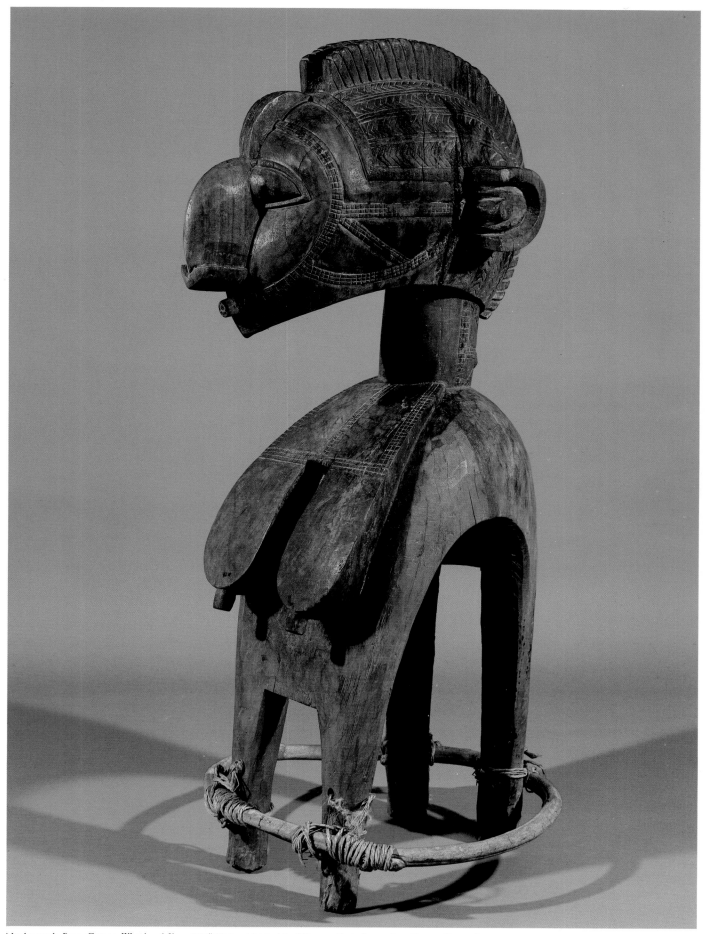

Nimba mask. Baga. Guinea. Wood and fiber, 49⅝" (126 cm) high. Musé Picasso, Paris. Formerly collection PABLO PICASSO

Pablo Picasso. *Girl before a Mirror* (detail). 1932. Oil on canvas, 64 x 51¼" (162.3 x 130.2 cm). The Museum of Modern Art, New York; gift of Mrs. Simon Guggenheim

Pablo Picasso. *Bust of a Woman* (detail). 1960. Oil on canvas, 36¼ x 28¾" (92 x 73 cm). Collection Jacqueline Picasso, Mougins

he executed the large plaster busts and heads of Marie-Thérèse.[203] When Brassaï, who went there to photograph these sculptures, described them as "resembling some barbarian goddess," he may well have had Picasso's Nimba in mind.

The "carry-over" from Picasso's Nimba to his sculptural work of that moment is strongest in *Bust of a Woman* (p. 325) and *Head of a Woman* (p. 326). As was customary for him, the

motif was assimilated in a highly personal way. Of the two sculptures, *Bust of a Woman* is closer to the Nimba masks because of the suggestion of Marie-Thérèse's sumptuous breasts, though the almost continuous silhouette from the hairdo through the forehead and the large nose has closer affinities with the type of Nimba mask in the Rietberg Museum (p. 324) than the classic one owned by Picasso. Given the semicircular projection on its forehead, the latter is more closely echoed—at least in the upper contours of its silhouette—by *Head of a Woman*. (Picasso may also have seen a large-nosed Lwalwa mask such as is reproduced on page 324, though such masks were extremely rare in France before World War II.)

The very particular language of forms in classic Nimba masks is charged with secondary sexual connotations that Picasso would not only absorb but extend. Such connotations, however, enter tribal art in a less conscious, less intuitive or individual manner than in Picasso's work. The curved profile of the Nimba's nose, in combination with its singularly narrow front view, has inescapable connotations of the *mons veneris* and female sex, especially in conjunction with the unusual little button mouth projecting just below it. The eroticism of the Nimba seems to have inspired Picasso to enrich and complicate these associations in *Head of a Woman*, where he imprints upon the sumptuous female aspects of Marie-Thérèse an allusion to his male genitals, in the form of the phallic nose that projects between a pair of globelike eyes.

In relating Marie-Thérèse to a tribal mask representing an African goddess, Picasso had translated the image of the woman he loved to a virtually mythic level. This universalizing of his sentiments would be echoed in quite a different way shortly afterward in his image of Marie-Thérèse in the *Girl before a Mirror*. The formulation here, which includes a lavender profile within the intense yellow front view completing the oval of the face, had in its origins Cubist stylizations of the shadowed area of facial features. By the 1920s, however, Picasso was investing this originally formal discovery with a variety of poetic associations. Yet only in *Girl before a Mirror* did he explore it in universal, quasi-mythic terms. In Meyer Schapiro's extraordinary appreciation of this picture, he speaks of the cool lavender profile as a "moon crescent" and the yellow front face as "like the sun."[204] Schapiro's "symbolism" of "the sun and the moon" shows Picasso reaching into the recesses of his own imagination for precisely the kind of cosmic imagery we see in such tribal objects as the Northwest Coast mask illustrated at the right.

This mask has been sliced near the center in such a way that its resultant cross-section, which is painted black, is read as a profile contained within the essentially frontal structure of the mask. Northwest Coast and Eskimo masks often divide integrally frontal faces more conventionally into dark and light halves, which allude to opposites such as the sun and moon, day and night, or the sunlit and dark sides of the moon. These "split-beings," or transformed beings, of Northwest Coast mythology are inevitably associated with the cosmic,[205] but as in all such oppositions, they are also projections of the underlying duality in human psychology and sexuality. Picasso could almost certainly never have seen a "sliced" mask like the one we reproduce, but it nevertheless points up the

Mask. Kwakiutl. British Columbia. Painted wood, 13⅜″ (34 cm) high. Museum für Völkerkunde, Berlin

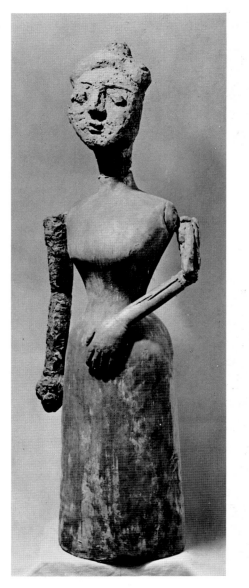

Left: Pablo Picasso. Drawing after an Easter Island arm and hand given to Picasso by Pierre Loeb before 1940. Published in Pierre Loeb, *Voyages à travers la peinture*, 1945

Below left: Pablo Picasso. *Woman in a Long Dress.* 1943. Bronze, 63⅜ x 19¾ x 14⅜" (161 x 50 x 36.5 cm). Private collection

Below: Picasso in his studio at the villa La Californie, Cannes, with bronze cast of Rurutu sculpture. Photograph by Edward Quinn, c. 1960

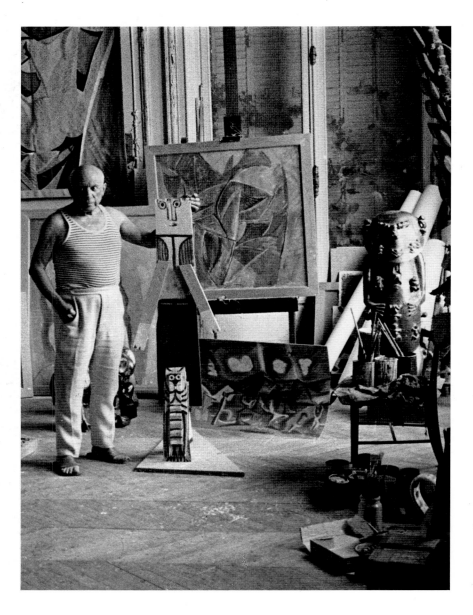

affinity of his poetic thought in *Girl before a Mirror* to the mythic universals that the tribal objects illustrate. More likely as sources for Picasso are the images of a circular sun and quarter moon shown personified, that is, with "faces," in some manuscripts of the late Middle Ages.[206] That both Luna and Sol, astral embodiments of the female and male principles, should be combined in the face of Marie-Thérèse in this painting may be understood as an extension of the kind of poetry that led Picasso to fuse phallic and feminine forms in *Head of a Woman* (p. 326). Consciously or not, they suggest

his desire for union, both psychic and corporeal, with his beloved.

Picasso's art of 1930–32 marks the last distinctly primitivist phase of his work. But he continued until his death to cherish tribal objects and to acquire them. Indeed, some of the best objects in his collection—such as the powerful Sepik River figure (p. 48) and a striking Lega mask, now lost[207]—were acquired in the thirties and after. Sometime toward the beginning of World War II, Picasso admired a wooden arm from Easter Island at the gallery of Pierre Loeb, and Loeb promptly

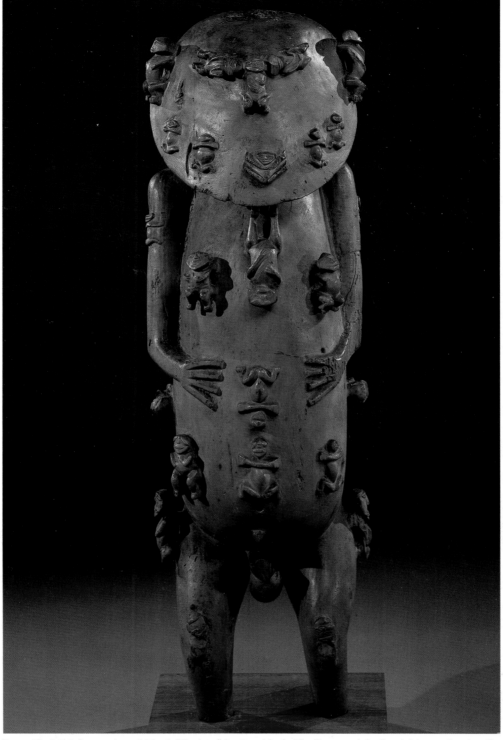

Figure (God A'a). Rurutu, Austral Islands. Wood, 44″ (111.7 cm) high. The Trustees of the British Museum, London. For another view of this object, see page 581.

made him a gift of it.[208] In 1942, after Loeb had fled occupied Paris, he received a message from a friend (who had telephoned the artist with news of Loeb) that Picasso was "at that moment" holding the wooden arm in his hand.[209] Indeed, he was just then executing the sketches of the Easter Island object, which he was about to employ as an "objet trouvé" to form the left arm of the *Woman in a Long Dress*, a life-size figure built around a discarded tailor's dummy (facing page).

Two objects that would figure prominently in Picasso's studios in his later years have rather special provenances. The

first is a bronze cast of the celebrated god A'a from Rurutu in the Austral Islands. Visiting Roland Penrose's studio in 1950, Picasso had seen a plaster cast of this extraordinary sculpture—perhaps the greatest tribal object in the British Museum—and was bowled over by it; to be sure, it had already been much admired by the Surrealists and had served, sixteen years earlier, as a model for Victor Brauner's *Force of Concentration of M.K.* (p. 581). Penrose had acquired the plaster from the British Museum for the exhibition "40,000 Years of Modern Art."[210] The museum had actually inherited the mold

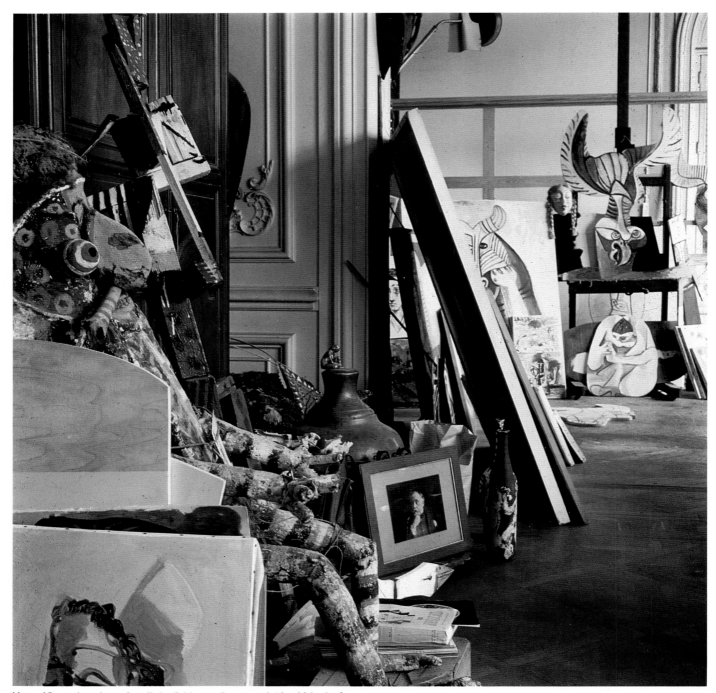

View of Picasso's studio in the villa La Californie, Cannes, with New Hebrides figure, c. 1955

as well as the original piece in the nineteenth century from the London Missionary Society, which had made many casts of the god A'a in order to demonstrate as widely as possible to its supporters "how hideous heathen idols could be."[211] An extra plaster was run off for Picasso, who used it to make his own bronze.

On a visit to Matisse at the Hôtel Régina in Nice, Picasso had admired a New Hebrides body mask with arms and legs (above and opposite) that Matisse had received as a gift from a friend who was a ship's captain.[212] (The object thus did not reflect Matisse's own taste in tribal art—indeed, it was alien to it.) In its fantastical character, the figure was destined to please Picasso; when he admired it, Matisse made it a gift. Delivered

to Picasso by Pierre Matisse after his father's death, it presided for years over a studio in La Californie.

It is often assumed that the major impact of "art nègre" on Picasso concerned the formation of Cubism—a judgment based upon the mistaken assumption that the *Demoiselles* was a Cubist painting. In fact, tribal art had but a residual role in Analytic Cubism, a role centering on the conceptualizing of visual data. This was the only aspect of "art nègre" that two so different artists as Braque and Picasso could have shared. The African plasticity and Oceanic color by which Picasso was moved—like his rediscovery of art-making as a "magical"

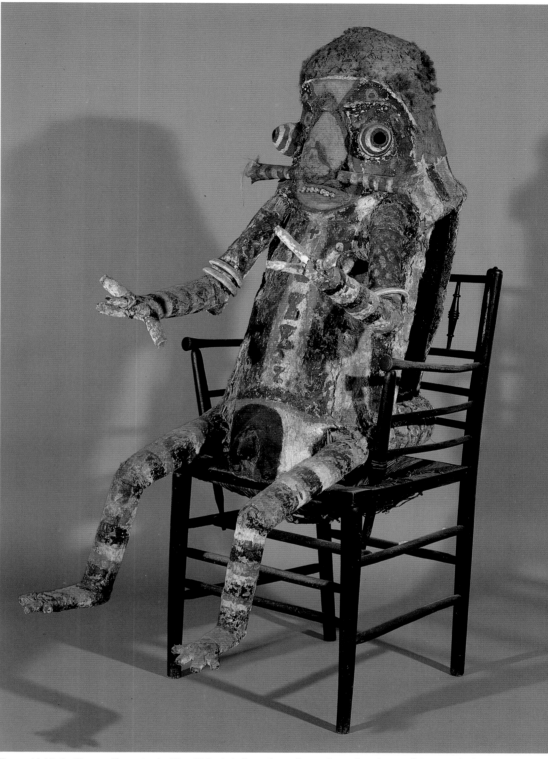

Figure. Malekula, Vanuatu (formerly the New Hebrides). Painted tree fern and mixed media, 44⅞" (114 cm) high, excluding chair. Musée Picasso, Paris. Formerly collections HENRI MATISSE, PABLO PICASSO

act—belong to his pre-Cubist art of 1907–08. Once Picasso and Braque began working in tandem in the winter of 1908–09, Picasso's art took on a more detached, classical mood, which would be characteristic of Analytic Cubism, the spirit of which had little in common with Picasso's immediately preceding "African" work. It was precisely this form of classicism that was jettisoned in his second primitivist phase, which produced collage and assemblage—anticlassical tech-

niques in which Braque pointedly did not participate. These new methods, which had much in common with aspects of tribal art, continued to be guarantors of the adventurousness and open-endedness of Picasso's art, keeping him in the forefront of the modernist vanguard for what turned out to be over forty years from the inception of his primitivism in 1906, and making him, in his old age, the loneliest of modern art's long-distance runners.

NOTES

As Picasso's work is discussed extensively in the Introduction (pp. 14–21, 51–55, 59–61, 64, 73), I shall assume the reader's familiarity with those earlier passages with regard to the exposition in this chapter.

1. The role of primitivism was equally pivotal in the career of Max Ernst, but less consequential for the history of art as a whole.

2. This holds generally for such early witnesses as Apollinaire, Salmon, and Stein and becomes increasingly the case in the second decade of the century with writers such as de Zayas.

3. This was something Picasso told me in the course of a discussion precipitated by his questioning me on the current situation of blacks in America. I have no idea who propagated this notion nor how widespread it was. Picasso seemed to have been charmed by the idea.

4. As exemplified by Robert J. Coady, art editor of *The Soil* magazine, and director of the Washington Square and Coady galleries in New York City (1914–19), who wrote in 1917: "Cézanne was not French. It was the Negro blood of his mother that gave his canvases most of their qualities" (Judith Zilczer, "The Aesthetic Struggle in America, 1913–1918: Abstract Art and Theory in the Stieglitz Circle" [Ph.D. diss., University of Delaware, 1975], p. 151).

5. Illustrated in William Rubin, ed., *Picasso: A Retrospective*, exhibition catalog (The Museum of Modern Art, New York, 1980), p. 14.

6. Picasso's father died on May 3, 1913, but never saw the *Demoiselles* or any other "African" period paintings and probably never saw a Cubist painting. In the latter case, the sole exception could have been the portrait of Manuel Pallarès executed in Barcelona during Picasso's brief stopover in Barcelona on his way to Horta (spring–summer 1909). If Picasso's father saw this picture, there is no record of his reaction.

7. For my use of this term see pp. 3–5.

8. The full sentence, taken from Françoise Gilot and Carlton Lake (*Life with Picasso* [New York, Toronto, London: McGraw-Hill, 1964], p. 226), runs: "At that moment I realized that this was what painting was all about." I have chosen this version of Picasso's account as coming closer to my notes of my own conversation with him—in which he covered the same ground—than the version of André Malraux (*Picasso's Mask*, trans. June Guicharnaud with Jacques Guicharnaud, from *La Tête d'obsidienne* [Paris: Gallimard, 1974]; New York: Holt, Rinehart and Winston, 1976, p. 11) in which Picasso says, "I understood why I was a painter."

9. The series of bas-reliefs that were placed on view in the spring of 1906 (or as early as the end of 1905, according to Pierre Daix, *La Vie de Peintre de Picasso* [Paris: Editions du Seuil, 1977], p. 72) had been excavated from the Iberian fortress at Osuna by a French mission in 1903. The results of these excavations were first published in 1906 by Arthur Engel and Pierre Paris (*Une Forteresse ibérique à Osuna* [Paris: Imprimerie Nationale, 1906]). The book and the coincidental Louvre installation provided much stimulus for awakening enthusiasm for Iberian sculpture at that time.

10. There is some difference of opinion as to how far Picasso had proceeded into his sculptural, early Iberian phase while still at Gosol, though his Iberianism certainly began there. Some critics (Barr, Leymarie) placed *Woman with Loaves* (Philadelphia Museum of Art)—the head of which was reworked in the new, masklike style—entirely at Gosol. I believe that, like the Stein portrait, the head in the Philadelphia picture was repainted after Picasso's return to Paris.

11. See André Salmon's "L'Art nègre" (1920), in his *Propos d'ateliers* (Paris: G. Grès et Cie, 1922), pp. 116, 123, 128.

12. See pp. 75–76 note 32.

13. This is the assumption of most Africanists, though as observed above (p. 77 note 68), we know little of what happens before the mid-nineteenth century. What we do know—from rare preserved and excavated material (Nok, Djenné, Benin), some of which goes back more than ten centuries — is that some aspects of tribal art are already forecast.

14. Ron Johnson, "Primitivism in the Early Sculpture of Picasso," *Arts Magazine* 49, no. 10 (June 1975), pp. 64–68.

15. Cited ibid., p. 64.

16. Picasso had told Pierre Daix of this, but the volume did not turn up in his estate.

17. In Werner Spies and Christine Piot, *Picasso: Das plastische Werk*, exhibition catalog (Nationalgalerie, Berlin, October 7–November 27, 1983, and Kunsthalle, Düsseldorf, December 11, 1983–January 29, 1984), p. 33.

18. For this reason, I remain skeptical about Johnson's proposed relationship between the Gauguin panel and *Woman Combing Her Hair*.

19. This is just a guess on my part, based upon Picasso's fantasies of disgust regarding aged women and the "Vanitas" character of certain juxtapositions of young and old women throughout his imagery.

20. Pierre Daix and Joan Rosselet, *Le Cubisme de Picasso: Catalogue raisonné de l'oeuvre 1907–1916* (Neuchâtel: Ides et Calendes, 1979), p. 247, cat. no. 304. A rough pencil sketch on its verso also relates to studies for *The Harvesters* of early 1907.

21. Though not listed as such in the catalog of the 1906 Gauguin retrospective, *Two Figures Flanking a Statue* seemed to me so much to anticipate Picasso's gouache that I felt Picasso had to have seen it. Geneviève Monnier, curator in the Department of Drawings of the Louvre, who kindly checked the watercolor, tells me that *Ancien Culte Mahorie*, of which it was the centerpiece, has a sticker indicating it was shown in the 1906 Salon d'Automne retrospective.

22. I suspect that the section under the chair on the left was originally left blank, as is still the case on the right. Picasso seems to have returned to the gouache to explore the curious foreshortened representation of the legs of the chair that we now see on the left. This spatial representation is clearly at odds with the laterality prevailing elsewhere in the image. The jarring effect it creates probably explains why Picasso left blank the corresponding section on the right.

23. The two full-size plaster casts (after Michelangelo's marble *Bound Slave* and *Dying Slave* in the Louvre) in Picasso's studio were relative newcomers, his early admiration for the originals notwithstanding. The casts had apparently been in the Château Grimaldi, which housed the Antibes Museum, when Picasso began working there in 1946, and were given to him by Romuald Dor de la Souchère, curator of the museum, just after he had settled into the villa Notre-Dame-de-Vie at Mougins in 1961. (Roland Penrose, *Picasso: His Life and Work*, rev. ed. [New York, Evanston, San Francisco, London: Icon Editions, 1973], p. 452 (first published London: Victor Gollancz, 1958).

24. "The Philosophical Brothel, Part 1," *Art News* 71, no. 5 (September 1972), pp. 24, 29 notes 15–20.

25. In my notes, Picasso says that he had loved the Michelangelo statue since his youth. It is not clear from the context, however, whether he meant replicas he would have seen in art schools in Spain or the original, which—as was evident from the conversation—he saw on his first trip to Paris. A photograph showing the "Salle Michelange" in the Louvre, in 1906, is reproduced in Gertrude Berthold's *Cézanne und die alten Meister* (Stuttgart:

W. Kohlhammer, 1958), illustration 88. Michelangelo's *Slaves*, according to Berthold (pp. 49, 59 note 41), were in place by 1877 in this gallery, built to replace the "old" Michelangelo gallery where the sculptures stood until 1875.

26. See above, note 10.

27. "L'Art nègre" (as in note 11), p. 125.

28. Picasso had purchased them from Géry Pieret (also referred to as Géry-Piéret, Gérard Pieret, Guy Pieret, etc.), Apollinaire's secretary. See John Golding, *Cubism: A History and an Analysis 1907–1914*, 2d ed. (London: Faber and Faber, 1968), p. 53 note 1 (first published London: Faber and Faber, 1959).

29. For a reproduction of the female head Picasso had purchased from Géry Pieret, which seems to have interested him much less than the one we reproduce in this text, see John Golding, "The Demoiselles d'Avignon," *The Burlington Magazine* 100, no. 662 (May 1958), p. 158, fig. 24. Herewith a few other examples of the Cerro sculptures:

Two heads. Iberian. Cerro de los Santos. 5th–3rd century B.C. Stone; left: 9" (23 cm) high; right: 8⅝" (22 cm) high. Museo Arqueologico Nacional, Madrid

30. He had seen a handful of pieces in the studios of Matisse, Derain, and (probably) Vlaminck beginning in early autumn 1906.

31. See William Rubin, "From Narrative to 'Iconic' in Picasso: The Buried Allegory in *Bread and Fruitdish on a Table* and the Role of *Les Demoiselles d'Avignon*," *The Art Bulletin* 65, no. 4 (December 1983), pp. 615–49.

32. For more on caricature see text below, pp. 284–86.

33. Golding, *Cubism: A History and an Analysis* (as in note 28), pp. 53–54.

34. The asymmetry of the Cerro sculpture is almost entirely a result of the damage sustained by one side of the face. This seems to have fascinated the profoundly superstitious Picasso, who probably connected the lone remaining eye to popular beliefs about the *"borgne"* with the "evil eye." The asymmetry in the eyes of the sailor (*Bust of a Sailor*, p. 250) and the medical student (*Head of a Medical Student*, p. 251) cannot, however, be directly equated with the more obviously literary implications of one-eyed figures such as *Celestina* (1903).

35. In collaboration with Michèle Richet, Marie-Laure Bernadac, and Hélène Seckel of the Musée Picasso, Pierre Daix and I are hoping to correlate all the sketches, published and unpublished, related to the *Demoiselles* in order to trace precisely the development of the painting and its chronology. Our conclusions will be published in the catalog of the exhibition "Autour des *Demoiselles d'Avignon*," scheduled at the Musée Picasso in 1986.

36. In the Basel sketch (p. 250), the final version of the first state, the medical student carries a book rather than a skull. There are, however, many studies (e.g., Z. XXVI, 45) that show he was originally conceived holding a skull, and Picasso described him in that form to Kahnweiler, Barr, and me.

37. For a detailed discussion of this see my "From

Narrative to 'Iconic' in Picasso" (as in note 31).

38. Ibid. See especially appendix 5: "The *Demoiselles* and Cubism."

39. The failure of students of Picasso and of Cubism to focus on the period between summer 1908 and summer 1909 is reflected in the virtual absence in the literature until relatively recent years of discussion (or even reproductions) of the two major monuments of Picasso's early Cubism: *Three Women* (The Hermitage, Leningrad) and *Bread and Fruitdish on a Table* (Kunstmuseum, Basel).

40. "The Philosophical Brothel," published in two parts in *Art News*, September 1972, pp. 22–29 (part 1), and October 1972, pp. 38–47 (part 2). All subsequent citations from Steinberg in the main text are from this article.

41. For a discussion of this figure see my "From Narrative to 'Iconic' in Picasso" (as in note 31), pp. 627–32, and especially app. 6: "The Left-Hand Figure in the *Demoiselles*."

42. See note 36.

43. In the course of a number of protracted visits to Picasso's villa, I discussed a variety of subjects with him. The frequency of Picasso's references to venereal disease (often, to be sure, of a humorous nature) struck me as noteworthy. Among his friends, Picasso was long known to have had an exaggerated, obsessive fear of death. As he was a frequenter of brothels in his early years, that anxiety might well have intensified an understandable fear of fatal venereal disease. In Picasso's art, images with references relating directly or elliptically to venereal disease are surely more common than in the work of any other major painter. A survey of them would take an article in itself.

44. Mary Mathews Gedo, *Picasso: Art as Autobiography* (Chicago and London: University of Chicago Press, 1980), pp. 75–80, 270–72, and "Art as Exorcism: Picasso's 'Demoiselles d'Avignon,'" *Arts Magazine* 55, no. 2 (October 1980), pp. 70–83.
 Gedo focused on the sailor (whom she supposes to symbolize both Picasso's early childhood self and his youthful initiation to the brothels), the medical student, and the prostitutes—particularly the association between physicians and diseased prostitutes—and, interpreting them as reflecting aspects of Picasso's own history, formulated the hypothesis that the initial conception of the *Demoiselles* responded to Picasso's own "double-edged experiences as both objective observer and subjective victim of diseased prostitutes." Thus, the presence of the skull might refer to the possibility that Picasso had himself contracted a venereal infection, presumably syphilis, perhaps from Fernande Olivier. (Gedo, citing the gossip and notoriously inaccurate Pierre Cabanne, remarks that Fernande was rumored to have had a history of promiscuity and actually to have prostituted herself when she had previously lived with another artist.) Elsewhere in *Art as Autobiography* (pp. 53, 267), Gedo, referring to the prevalence of the motif of blindness in Picasso's work of 1903 and the many interpretations as to its origin, speculates that this motif "originated in Picasso's guilt and anxiety over the damaging effects of a veneral disease he had contracted." In this, she invokes John Berger (*The Success and Failure of Picasso* [New York: Pantheon, 1980]), pp. 43–44 (repr. of 1965 ed., Harmondsworth, England: Penguin), who saw the artist as "probably... suffering from venereal disease" and fearing blindness "as the result of his disease."

45. *La Tête d'obsidienne*, pp. 17–19. Malraux's account of his conversation with Picasso is based on notes from a 1937 meeting. As I have already observed, Picasso covered much of the same territory with me. On the second of the two occasions that I was able to get him to talk about the *Demoiselles*, he mentioned that his 1907 visit to the Trocadéro had been profoundly moving. In the context of

the conversation, however, the remark could as well have referred in general to the "African" pictures of 1907–08 as to the *Demoiselles* in particular. As my notes correspond in a general way to what Picasso says more eloquently about the *Demoiselles* in Malraux's account of his conversation, I have permitted myself to use his text, although some passages in *La Tête d'obsidienne* have been rumored to be Malraux's inventions in whole or in part.

46. In my transcription of my conversations with Picasso he describes his first visit to the Musée d'Ethnographie as virtually the result of pushing the wrong door, yet he elsewhere alluded to Derain's having advised him to visit that museum.

47. "...c'était dégoûtant. Le marché aux Puces. L'odeur" (*La Tête d'obsidienne*, p. 17).

48. As there were, for some periods of time, only two guards for the Musée d'Ethnographie, the absence or illness of one would have sufficed for closing all areas except the Rotunda gallery at the entrance.

49. One commentator writes in 1910 of the principal Oceanic gallery as having been officially closed for fourteen years, though the leading guide of the period, Joanne's *Les Musées de Paris* of 1903, shows it as open (as does a revised edition of 1905). The resolution of such conundrums may lie in the indications given by Baedecker during this period. The guards seem to have profited from a system not unknown even today in certain churches, monuments, and provincial museums. Baedecker lists the Oceanic gallery as officially closed, but indicates that one could visit the museum, even at normally closed hours, for a "pourboire"—or, as the English edition quaintly puts it, "by feeing the guardian." Not subject to closing, during regular hours at least, was the large Rotunda gallery near the entrance, which was devoted to a selection of African and Oceanic material. That access to untended areas of the museum was a somewhat casual matter is attested by the inordinate number of thefts the Trocadéro suffered; in his characterization of the museum (in "L'ethnographie en France et à l'étranger," *Revue de Paris*, 20ᵉ année, V [September–October 1913], pp. 537–60, 815–37), Marcel Mauss signaled "notable thefts."

50. Picasso indicated to me that he had returned more than once to the Musée d'Ethnographie in his early years, and on one or more of these return visits he was accompanied by friends; on the first visit he was alone. There is a clear indication that one of these return visits was in the company of Apollinaire (Ekaterini Samaltanou-Tsiakma, "Guillaume Apollinaire: Catalyst for Primitivism, for Picabia and Duchamp" [Ph.D. diss., University of Virginia, 1981], pp. 31–37). From my notes, it seems that the last time Picasso visited the Trocadéro was in the 1930s, for the opening of some special event (which may have been the 1933 exhibition of material gathered by the Dakar-Djibouti mission, of which his close friend Michel Leiris was a member).

51. In my notes it is clear that Picasso received the full force of his "revelation" *just after* he had exited from the museum.

52. Just as Picasso's late-in-life assertion that he had not seen tribal art until after completing the *Demoiselles* was, in a sense, a compensatory strategy in relation to ideas that had developed around the picture (see "From Narrative to 'Iconic' in Picasso," as in note 31, app. 7: "Picasso's Equivocations with Respect to *Art Nègre*"), so his repeated references to the magical quality of tribal objects (in conversations with Christian Zervos, Françoise Gilot, André Malraux, me, and no doubt others) were directed to overcoming the widespread view (as epitomized in Goldwater, *Primitivism in Modern Art* [New York: Random House, Vintage Books, 1967; rev. and enl. ed. of

Primitivism in Modern Painting, 1938], pp. 144–63) that his interest in this art was essentially formalist. Picasso's emphasis, however, should not lead us to the notion that his interest was only magical. Quite apart from the tenor of his remarks to Salmon (Picasso found African art "raisonnable" ["L'Art nègre," as in note 11], and "Picasso had 'meditated on geometry,' choosing as guides the savage artists" ["Histoire anecdotique du cubisme," in *La Jeune Peinture française* (Paris: Société des Trente, Albert Messein, 1912), p. 46], and some observations to me touching on the inventiveness of tribal objects and their materials regrettably only paraphrased in my notes, it is evident from material explored in this chapter that Picasso's feeling for tribal objects was many-faceted. *What artists talk about is not necessarily to be equated with what they do.*

53. Lydia Gasman's chapter on Picasso and magic in her dissertation "Mystery, Magic and Love in Picasso, 1925–1938" (Columbia University, 1981, a revised and expanded version of which will be published in 1985 by Yale University Press) provides a brilliant accumulation of material reinforcing the notion of Picasso's magical attitude toward tribal objects. As against what Goldwater referred to as Picasso's "intellectual primitivism," she proposes the term "magical primitivism." While my own sense of Picasso's reaction to tribal objects is considerably closer to Gasman's than to Goldwater's views, "intellectual" and "magical" primitivism, taken together, suggest a dichotomy that falsifies, I believe, Picasso's way of thinking and working. Gasman seems to see "intellectual primitivism" and "magical primitivism" as alternative and alternating modes: "To be sure, Picasso as 'magician' did not replace the cool Picasso searching for innovating forms and conceptions in the newly discovered primitive treasures. This 'intellectual primitivism' was as earnest as his 'magical primitivism' and it paralleled the modernistic primitivism of his contemporaries. 'One is not a sorcerer all day long!' he exclaimed to Malraux" (p. 472). Picasso did not have two different mind-sets in regard to tribal material. What Goldwater refers to as "intellectual primitivism" relates to what Picasso meant when he told Salmon that African art was "raisonnable," that is, that the tribal sculpture was subject to the reasoning faculty, hence logical and conceptual; the remark thus treated the ideographic mode of figuration in Primitive objects. "Magical primitivism," inspired by many statements by Picasso, and now reinforced by much other supportive material gathered by Gasman, deals with Picasso's psychological attitudes and relates to his generalized interpretation of what the objects meant to tribal peoples. Thus the two "primitivisms" are really aspects of a single unified approach. When, for instance, Picasso discussed his Grebo mask with me in terms of essentially formal problems of figuration, he was not in any way suspending his sense of the object as a magical intercessor.
 The material in Gasman's thesis makes up for Goldwater's failure to have dealt with French ethnological thinking in a manner comparable to the way he treated German and English anthropology. Her text is full of much relevant material drawn from Marcel Mauss and others that gives us an excellent sense of the distinctive French ethnology in the intellectual air early in the century. I take exception only to her hints that Picasso might have read Mauss's 1903–04 essay on magic, or that Lévy-Bruhl's 1910 text on magic in Primitive art "would have caught Picasso's attention." Quite apart from the state of Picasso's French in the first decade of the century, these are not the kind of things he read. Gasman's exposition of the parallelism between Picasso's and Mauss's thinking is a fascinating instance of the zeitgeist at work. But it remains simply a parallelism. More-

over, had Picasso in fact read Mauss's early essay, his experience at the Trocadéro would hardly have been a "revelation." Once he had had that revelation, he had no need to read Mauss.

54. *La Tête d'obsidienne* (as in note 8), p. 18. Italics mine.

55. This is not only testified to by the absence of any visible influence of African art in Picasso's work during that period, but is implicit in the remarks he made about the African piece Matisse showed him at Gertrude Stein's apartment. See below, pp. 260, 296, and notes 138, 139.

56. Present curators of the Musée de l'Homme tell me that virtually every mask and figure sculpture, and a majority of the arms and utensils, were on view in the early installations of the museum (a view supported by the crowded character of the presentations in the 1895 photographs). The New Hebrides mask illustrated on page 257 is one of two very similar ones that came to the museum in 1894; at least one—and probably both—were on view during Picasso's first visit.

57. However they may appear to those unfamiliar with Picasso's Iberian style, there is no question that the central women were intended to appear attractive and sexually appealing. This is evident in their coloring, their seductive postures, the lyric character of their contouring, and their relatively undistorted features. As the picture progressed to completion they became all the more engaging by contrast with the figures on both sides, which developed in the direction of the menacing and the monstrous.

58. See p. 74 note 11.

59. Both *Noa-Noa* (which means "very fragrant") and *Heart of Darkness* were based on direct experiences of the tropics at about the same moment and were published about the same time. Gauguin arrived in Tahiti in June 1891, just one year after Conrad made his long voyage up the Congo River. *Noa-Noa* was published in modified form in 1901; *Heart of Darkness*, serialized in 1899, appeared in book form in 1902.

I have compared Conrad's novella with *Noa-Noa* as providing an excellent idea of the contrast between European views of Africa and of Polynesia. Picasso could not then, of course, have read *Heart of Darkness*, which was published in French as *Au coeur des ténèbres* only in 1926. But French attitudes toward Africa in the first years of the century—influenced by earlier commentaries on Stanley's explorations as well as subsequent *récits de voyages*, and colored even more by the heavy losses the French were then suffering in their Central African military adventures—were very different from their views of their Pacific possessions, and Picasso, an avid newspaper and magazine reader, certainly absorbed the moods and feelings in the Paris air. Francine Ndiaye, curator of African art at the Musée de l'Homme, tells me that French writers on Africa not infrequently cite *Heart of Darkness* because there is no counterpart to it in French literature. Indeed, Malraux embeds the phrase "coeur des ténèbres" in his discussion of Picasso and African art (*La Tête d'obsidienne*, p. 158) in an obvious salute to the earlier novelist.

60. The objects in that show were chosen by Guillaume, but all the arrangements for it were made by de Zayas. For his role, see Francis M. Naumann, introduction and notes to "How, When, and Why Modern Art Came to New York" by Marius de Zayas, *Arts Magazine* 54, no. 8 (April 1980), pp. 96–126.

61. Marius de Zayas, *African Art: Its Influence on Modern Art* (New York: The Modern Gallery, 1916), p. 41. This book has been a constant embarrassment to de Zayas's admirers not only because—its title notwithstanding—it says virtually nothing about the influence of African art on modern art, but because of its pervasive crackpot racism. Despite de Zayas's admiration for African sculpture, he considered Africans to be cases of arrested

development:

Analyzing the art of the different human races, one can see that each race has a determined conception of representation, and that the degree of the development of their art toward naturalism is in direct relation to the intellectual development of the race that produces it…The small amount of direct imitation—the almost abstract form of the plastic representation of the African Negro—is nothing more than the logical result of the conditional state of this brain…[p. 7]. They [the Negro race] remain in a mental state very similar to that of the children of the white race. Their life is purely sensorial. Like the white child they are egocentrists [p. 10]. It can be said that the cerebral condition of the Negro savage is particularly primitive, and that his brain keeps the conditional state of the first state of the evolution of the human race…[p. 10]. The reason of the stationary state of the mental faculties of the savage Negro is due to his natural and social milieu…The Negro is therefore incapable of any intellectual sentiment properly speaking, and he looks but for the satisfaction of the physical needs…[p. 13]. Though the eye of the Negro sees form in its natural aspect, the state of his brain is unable to understand it and retain it in his memory under that aspect…He does not reason, and does not make comparisons to obtain relative values, because he does not possess the faculty of analysis [p. 32].

62. "Cubism?" (an exchange), *Arts and Decoration*, April 1916, pp. 284–86, 308. Cited in Naumann, "How, When, and Why" (as in note 60), p. 104.

63. Alfred H. Barr, Jr., ed., *Picasso: Forty Years of His Art* (with two statements by the artist), exhibition catalog (The Museum of Modern Art, New York, in collaboration with The Art Institute of Chicago, 1939), pp. 9–12, 200. The 1923 statement was published under the title "Picasso Speaks" in *The Arts* 3, no. 5 (May 1923), pp. 315–26. Barr's reprinting of "Picasso Speaks" in *Picasso: Forty Years of His Art* as an interview given by the artist to de Zayas is the first instance of de Zayas's name being identified with this particular statement. In fact, when it was first published, in May 1923, an accompanying note by the editor of *The Arts* merely specified that "Picasso gave this interview to *The Arts* in Spanish, and subsequently authenticated the Spanish text which we herewith translate" (p. 315), without any reference to de Zayas. Even as late as 1936, no such pairing of de Zayas and "Picasso Speaks" is to be found either in Merle Armitage's little book (reproducing the 1923 interview and a later statement by Picasso) or in the letter Armitage wrote to Barr to bring the book to his attention.

64. An additional problem concerns the bibliographical entry (in *Picasso: Forty Years of His Art*, p. 200) that states, "A French version [of this interview], with additional paragraphs dealing with…Rousseau, negro art, and literature, appeared in Florent Fels, *Propos d'artistes*, Paris, Renaissance du Livre, 1925, pp. 139–45." What has not been taken into account here (and elsewhere for that matter) is the existence of an earlier text of the interview of Picasso by Florent Fels, published in *Les Nouvelles littéraires, artistiques et scientifiques*, no. 42 (August 4, 1923), p. 2, under the title "Propos d'artistes: Picasso," which—rather than the so-called de Zayas's "Picasso Speaks"—most likely constitutes the source of the version published by Fels in his *Propos d'artistes* of 1925.

Fels further explained the genesis of the "longue interview" published by *Les Nouvelles littéraires* in another text on Picasso in his later book of essays (*Le Roman de l'art vivant* [Paris, 1959], pp. 172–75), stating that he had had numerous conversations with Picasso (whose studio he first visited when the artist lived on the Rue Schoelcher, 1913–16, then on the Rue La Boétie beginning in October or November 1918). Picasso said to Fels in the 1923 interview, "Je vous ai

déjà dit que je ne pouvais plus rien dire de 'l'art nègre.' Vous avez répondu pour moi, en une précédente enquête: 'L'art nègre, connais pas.'" This is a reference to the "Opinions sur l'art nègre," published in *Action*, April 1920, and additional evidence of their familiarity in those years.

65. Picasso's remark to Fels comes directly after the above statement: "C'est qu'il ['l'art nègre'] m'est devenu trop familier, les statues africaines qui traînent un peu partout chez moi, sont plus des témoins que des exemples" (*Les Nouvelles littéraires*, as in note 64, p. 2).

66. Picasso made this very clear to Pierre Daix, who recounted it to me.

67. Christian Zervos, *Pablo Picasso: Oeuvres de 1906 à 1912*, vol. 2, pt. 1 (Paris: Editions "Cahiers d'Art," 1942), pp. xxxvii–iii, 10. See also James Johnson Sweeney, "Picasso and Iberian Sculpture," *The Art Bulletin* 23, no. 3 (September 1941), pp. 191–98.

68. "From Narrative to 'Iconic' in Picasso" (as in note 31), app. 7: "Picasso's Equivocations with Respect to *Art Nègre*."

69. The nearest relationship is that of the head of the standing figure on the right—not to masks but to the heads of Fang reliquary figures. This resemblance, however, is rather elliptical as compared with its similarities to masks Picasso could *not* have seen (p. 263). Though there was at least one Fang figure at the Trocadéro when Picasso made his first visit, his heads take on a decidedly Fang physiognomy only toward early 1908 (pp. 290–91). Picasso owned a Fang reliquary figure quite early, certainly no later than around 1910; it can be seen silhouetted against the studio window in an unpublished, undated photograph in the archives of the Musée Picasso that was taken in the Boulevard de Clichy studio to which Picasso moved in September or October 1909 (he remained there until autumn 1912).

70. Alfred H. Barr, Jr., *Picasso: Fifty Years of His Art* (New York: The Museum of Modern Art, 1946), pp. 55, 257.

71. Jean Laude, *La Peinture française (1905–1914) et "l'Art nègre"* (Paris: Klincksieck, 1968), pp. 254–55.

72. See page 78 note 82.

73. Matisse seems to have had the most tribal objects, some twenty, by 1907. There is no indication that Vlaminck or Derain had more than four or five each at that date.

74. He stated this to me very clearly and, for reasons explained below (p. 296), I see no basis for doubting him.

75. Golding, "The 'Demoiselles d'Avignon'" (as in note 29), p. 57, fig. 19.

76. Henri Clouzot and André Level, *L'Art nègre et l'art océanien* (Paris: Devambez, 1919), pl. xxxvi: "Masque lunaire," Côte d'Ivoire, Collection André Level, 25 cm.

77. André Salmon, "Histoire anecdotique du cubisme" (as in note 52), pp. 42–50.

78. Ron Johnson, "Picasso's 'Demoiselles d'Avignon' and the Theatre of the Absurd," *Arts Magazine* 55, no. 2 (October 1980), pp. 104–05. The Torres Strait mask was published by Christian Zervos as being in Picasso's collection in "L'Art nègre," *Cahiers d'art* 2, no. 7–8 (1927), p. 231.

79. These are the characteristic masks of the region; they are, however, rare and extremely expensive, and it is doubtful that Picasso would have purchased one even if it had been offered him. An excellent one was in the collection of his friend Georges Salles in the 1930s; this mask was later purchased by Kenneth Clark and has been wrongly described by a representative of his heirs as having been in Picasso's collection.

80. This was communicated to me by Pierre Daix.

81. In lectures at the National Gallery ("Picasso, Cubism and African Art," February 28, 1982) and elsewhere.

82. Letter to me from Ms. Huguette van Geluwe of the Musée Royal de l'Afrique Centrale, Ter-

vuren. She refers here to the so-called "full" Kifwebes with protuberant features, which are the masks at issue.

83. Even today there are precious few *masques de maladie* in French collections; such masks are rare in commerce, and Charles Ratton observes that before the change in taste that followed World War II they were considered too ugly to be salable. The type of mask illustrated on page 264 is, according to Susan Vogel, largely inspired by the advanced stages of syphilis or gangosa. This particular Pende sickness mask, which I came upon in the reserves of the Tervuren museum, is at once more beautiful and more abstract than the norm; it was taken from Africa only in 1954, and while its age cannot be fixed, its fabrication in all likelihood postdates that of the *Demoiselles*.

Level claimed to have begun collecting in 1904, but this claim has been questioned. However that may be, there is no indication that he met Picasso before 1908—a year after the *Demoiselles*. (In his *Souvenirs d'un collectionneur*, Level stated that he became acquainted with Picasso in 1908 in the course of a visit to the artist at 13 Rue de Ravignan and his succeeding purchase of the *Family of Saltimbanques* for the collection of La Peau de l'Ours. See André Level, *Souvenirs d'un collectionneur* [published posthumously, Paris: Alain C. Mazo, 1959], p. 23. Nor is there any basis for assuming that Level owned the mask in question a whole decade before publishing it. Finally, his Ivory Coast *masque de maladie* has much less resemblance to the head of the seated figure in the *Demoiselles* than we find in some Pende masks.

84. Our attribution of certain kinds of metal-covered reliquary guardian figures from Gabon and the Congo to the Kota follows a long-established but mistaken convention that was initiated and then abandoned by the French colonial administration. As Leon Siroto pointed out to this author, many of the first known figures of this kind were made by the Ndasa and the Wumbu, peoples who spoke languages related to that of the Kota to their north. These true Kota, however, did not share their style of sculpture. Since then scholars have learned that many, if not most, of the substyles within this corpus originated among the Mbamba, a people who, although living next to the Kota-speakers, differ markedly from them in history, language, and social organization.

Applied strips under the eyes of some Kota metal-covered figures from the Mossendjo region do not correspond to scarification (not practiced by the Kota); they tend to be interpreted by certain laymen and dealers as tears. This notion, which runs counter to the value system and iconography of the society concerned, finds no support in ethnography. According to Siroto, the motive might derive from small vertical tattoo marks formerly in fashion (one finds them in some images from other peoples to the northwest), or, just as likely, from a decorative choice.

85. These are no doubt what are referred to on the inadquate list referred to above (p. 76 note 56) under no. 69: "Masques [sic], Plat cuivre et bois, effigie funéraire, Gabon, Bakota. Ht. 50 [cm.]." In fact we cannot be sure whether Picasso owned more than the two Kota reliquary figures that I have discovered in the estate (p. 301). One heir, Bernard Picasso, has been unresponsive to scholars in general and to the Museum in particular; hence it is not possible to check his holdings.

86. Had Picasso purchased his Kota figures in the twenties or later, they would certainly have been much finer, first because a greater selection was available, second because at that time Picasso loosened his pursestrings to some extent in his purchases of tribal material. The object on the upper left of page 301 is of a crudeness that more characterizes the material being offered at the very beginning of the century, prior to the

activities of Brummer and Guillaume.

In answering a question of mine about Matisse's having shown him an African object at Gertrude Stein's, Picasso took issue with Matisse; in so doing, he also indicated that he was drawn to African objects different from those that interested Matisse, African objects that made Matisse's equation of African and Egyptian objects wrongheaded or foolish. (Though I was unable to remember Picasso's exact words, my notes indicate that he said something to this effect "scoffingly"). Picasso then mentioned some of the objects he liked. In so doing, he may have used some conventional appellations such as Nimba or Kota. But as I knew virtually nothing about African art at the time, I would have missed them. In my notes, however, I paraphrase Picasso talking about "small metal figures, very abstract" and "big-nosed masks." In retrospect, I believe that these cannot be other than the Kota reliquary guardian figures and the "Nimba-headed" figures and/or Nimba masks of the Baga. These two types of object can be directly connected to the work of 1907 (pp. 268–69, 276–77). That fact, in combination with Picasso's observations, makes it virtually certain that they were among the earliest objects to interest him, hence almost certainly among the earliest objects he collected (though the earliest document showing the Baga figures in his studios or apartments is in a photograph of Olga (Archives of the Musée Picasso) used for the portrait of her in 1917 [Z. III, 83]).

87. In the years prior to World War I, Guillaume's (and presumably Heymann's and Brummer's) fine Kota reliquary figures were surprisingly expensive—in part, perhaps, because they were mistakenly represented as objects many centuries old. Paudrat (p. 154) notes that the two reliquary figures Guillaume sent on consignment to Stieglitz for the 1914 exhibition, were priced at three thousand francs each, that is, six times more than he asked for de Chirico's *Song of Love*, one of that painter's masterpieces (worth today at least ten times the price of a superb Kota reliquary figure).

There is a mistaken impression among collectors and historians that fine tribal objects were very inexpensive early in the century. One could, of course, buy poor conventional material for very little—as one can today as well. But the top examples were extremely expensive, and still are (though no longer in comparison to the masterpieces of modern art; indeed, in terms of the latter's prices, tribal masterpieces, though they usually cost in the hundreds of thousands of dollars, are relatively low).

88. The first acquaintance of art historians with metal-covered reliquary guardian figures attributed to the Kota led them to interpret arbitrarily the lozenge-shaped base as conventional legs. This is incorrect. Some later studies based on "Kota" informants (E. Andersson, "Contributions à l'ethnographie des Kuta" I, *Studia Ethnographica Upsaliensia* 6, 1953, p. 340) and stylistic comparisons (L. Siroto, "Notes on the Bakota, Pangwe, and Balumbo Sculpture of the Gabon and the Middle Congo," in *Masterpieces of African Art*, exhibition catalog [Brooklyn Museum, October 21, 1954–January 2, 1955], pp. 26–30) reason more closely that the form probably represented arms. Photographs of integral reliquaries usually show the lower part of the lozenge buried in the shrine, hence not visible.

89. There is not the slightest indication that the nowcelebrated Luba caryatid stools were available in France during the first decade of the century (and they were certainly not to be found in the collection of the Musée d'Ethnographie). This notwithstanding, some writers have been tempted to associate them with the work of Paris artists of that time (Manfred Schneckenburger, for

instance, in *Welt Kulturen und moderne Kunst*, exhibition catalog [Munich, Haus der Kunst, June 16–September 30, 1972], pp. 492–93, makes precisely such an association with Modigliani's painted caryatid of c. 1910). I have chosen my examples from French territorial regions, whose sculptural material was already in circulation in Paris.

90. The convulsive movement and projection of limbs in Picasso's dancing figures have no relation to any African or Oceanic art he could have seen, or, indeed, to what can be made out in early engravings of tribal dance ceremonies such as can be seen in *Le Tour du monde* and other popular magazines Picasso saw. I think there is no doubt that he fantasized about such ceremonies and, to the extent he imagined dances, thought of the dance figures as expressing great violence and energy, more along the lines of the ejaculatory gestures common in Martha Graham's choreography than the regular and contained movements we see in films of African dances.

91. "Heroic Years from Humble Treasures: Notes on African and Modern Art," *Art International* 10, no. 7 (September 1966), reprinted in *Changing: Essays in Art Criticism* (New York: Dutton, 1971), p. 38.

92. Though the Bambara figure reproduced on page 280 was in Kahnweiler's collection at the time of his death (and is visible on top of a bookcase, in a photograph of 1913 of Kahnweiler's home, Rue George Sand [reproduced in Daniel-Henry Kahnweiler and Francis Crémieux, *My Galleries and Painters*, Documents of Twentieth Century Art series, trans. from the French by Helen Weaver, introduction by John Russell (New York: Viking, 1971), between pp. 15 and 17]), there is no way of knowing whether he had it as early as 1907. It is, however, a type of object that might well have been purchased at that early a time.

93. Laude, *Le Peinture française* (as in note 71), p. 253.

94. There is no drawing or painting by Picasso that is directly copied from any tribal object.

95. Communicated to me by Daix in conversation.

96. *Artes*, Antwerp, no. 3–4, 1947–48, p. 3, cited in Lydia Gasman, "Mystery, Magic and Love in Picasso" (as in note 53), p. 456.

97. Michel Leiris told me that Picasso certainly knew that his Nimba mask (p. 327) represented a goddess of fertility, and in general, the "Nimbaheaded" figures (p. 276) of the Baga were also—though wrongly—interpreted this way.

According to Leon Siroto, "Our present knowledge prevents us from inferring any more than a stylistic relationship between the Giant Nimba mask and the statues, male and female, that show an identical treatment of the head. Old accounts tell us that such statues were important to certain Baga communities, but they do not mention Nimba masks in this connection. The field study of Baga iconography has been greatly neglected" (communication to me, 1984).

98. Presumably owing to the immense weight of these masks, it is sometimes said that they were supported by more than one dancer under the raffia skirt. In fact, by a combination of support by the head and lifting on the circular hoop around the "legs" (still preserved in Picasso's mask, p. 327) a single dancer could and did control the mask.

99. Reinhold Hohl, catalog text for no. 52 (sheet with drawings from early summer 1907) in *Pablo Picasso: Eine Ausstellung zum hundertsten Geburtstag, Werke aus der Sammlung Marina Picasso*, exhibition catalog, ed. Werner Spies (Munich, Haus der Kunst, February 13–April 20, 1981; Cologne, Josef-Haubrich-Kunsthalle in collaboration with Museum Ludwig, August 11–October 11, 1981; Frankfurt am Main, Städt Galerie im Städelschen Kunstinstitut, October 21, 1981–January 10, 1982), pp. 235–36.

100. At different points Salmon indicates an awareness

of tribal art in both 1905 and 1906. If this was the case, his interest would have anticipated Picasso's 1907 involvement by a year or two. Since Salmon elsewhere wrongly dates the latter in 1906, it is possible—indeed probable—that his early dates are mistaken and were based upon what we now know to be a mythical 1905 date widely described as the moment of the modernist "discovery" of tribal art.

101. "L'Art nègre" (as in note 11), p. 124.

102. Picasso told Sabartés, "On n'a jamais dépassé la sculpture primitive" (Jaime Sabartés, Picasso, portraits et souvenirs, trans. from the Spanish by Paule-Marie Grand and André Chastel [Paris: Louis Carré, Maximilien Vox, 1946], p. 223).

103. In Apollinaire's The Cubist Painters, there is but one brief reference to tribal art—mentioned in the same breath with Egyptian art. See Guillaume Apollinaire, Méditations esthétiques—Les Peintres cubistes (Paris: Eugène Figuière et Cie, 1913), pp. 16–17: "Ajoutons que cette imagination: la quatrième dimension, n'a été que la manifestation des aspirations, des inquiétudes d'un grand nombre de jeunes artistes regardant les sculptures égyptiennes, nègres et océaniennes." The passage suggests that it resulted, in part, from the author's interview with Matisse ("Henri Matisse," La Phalange, no. 2, December 15–18, 1907, reprinted as "Matisse interrogé par Apollinaire" in Henri Matisse: Écrits et propos sur l'art, ed. Dominique Fourcade [Paris: Collection Savoir, Hermann, 1972], pp. 56–57: "Je n'ai jamais évité l'influence des autres...Par conséquent toutes les écritures plastiques: les Égyptiens hiératiques, les Grecs affinés, les Cambodgiens voluptueux, les productions des anciens Péruviens, les statuettes des nègres africains proportionnées selon les passions qui les ont inspirées peuvent intéresser un artiste et l'aider à développer sa personnalité"—rather than in relation to Picasso.

For an analysis of Apollinaire's role in the spread of primitivism, see Samaltanou-Tsiakma, Guillaume Apollinaire: Catalyst for Primitivism (as in note 50), passim, and pp. 48–50, for her comments on the tendency of the time to associate Negro and Egyptian sculpture with the "fourth dimension."

104. André Salmon, "Histoire anecdotique du cubisme" (as in note 52), pp. 43, 44.

105. André Salmon, "Negro Art," trans. D. Brinton, The Burlington Magazine, no. 205, April 1920, pp. 164–72.

106. The necessary critique of the traditional view of Picasso's primitivism (as advanced by Goldwater), of which Gasman's impressive text is the epitome, may be resulting in a swing of the pendulum too far in the other direction. Much of this writing is based on words (citations from Picasso and various authors) rather than on direct confrontation of the work of art. Unlike Matisse, Picasso rarely spoke about formal questions. Even his references to Cubism were in a poetic vein (see my Picasso in the Collection of The Museum of Modern Art, exhibition catalog [The Museum of Modern Art, New York, 1972], pp. 72, 206 note 3). Yet the work shows that Picasso was very much engaged in the resolution of formal problems—and we should not lose sight of this in regard to his primitivism.

107. In my notes, I paraphrase Picasso as saying: "The greatest realism is the closest correspondence between the marks the artist makes—whatever their style—and the nature...of his most intense feeling." In other words, realism is not a question of illusion or illustration but of communication.

108. André Salmon, "La Semaine artistique. Cubisme: Exposition Metzinger (Galerie Rosenberg)," L'Europe Nouvelle, 2ème année, no. 3 (January 18, 1919), pp. 139–40.

109. I have no space here to illustrate a number of variant studies, among them Zervos VI, 966, and XXVI, 180.

110. Though I focus here on caricature, we should keep in mind that—as the bric-a-brac, old magazines, etc. that Picasso kept around him (and used in papiers collés and constructions) attest—he was a lover of "low" art.

111. For example, his parody at once of Manet's Olympia and Cézanne's L'Après-midi à Naples in Christian Zervos, Pablo Picasso (Paris: Editions "Cahiers d'art," vol. 6, supp. to vols. 1–5, 1954), no. 343.

112. Rubin, Picasso in the Collection (as in note 106), p. 66.

113. Not until Picasso himself alluded to the presence of one of his New Caledonian figures (long known to scholars through the Burgess photograph) in the upper left of the Kahnweiler portrait was it recognized in the configuration (see p. 310). For Picasso's remark to John Richardson, see below, note 176.

114. Roland Penrose, Picasso: His Life and Work (London: Victor Gollancz, 1958), p. 126.

115. Adam Gopnik, "High and Low: Caricature, Primitivism, and the Cubist Portrait," Art Journal 43, no. 4 (Winter 1983), pp. 371–76.

116. Ibid., p. 374.

117. Ibid., p. 375.

118. As for instance the sheets showing the contrasted profiles of a stern old warrior and an epicene youth with wavy hair (reproduced on plates 24, 127, 141 in Arthur E. Popham, The Drawings of Leonardo [New York: Reynal & Hitchcock, 1945].

On an occasion when Picasso, Jacqueline, and I were looking at some of his early caricatures left with him by a dealer (which Picasso feared had been stolen from the Barcelona Museum), I asked him if he knew the so-called caricatures of Puvis de Chavannes. He replied in the negative but said he liked those of Leonardo.

119. This method was subsequently used to more purely poetic and iconographic ends in the sculptures of Max Ernst.

120. So far as I know, this point has been made only by Spies, Picasso: Das plastische Werk (as in note 17), pp. 37–47.

121. This work has been identified by Spies with the winter 1906–07 (Werner Spies, Sculpture by Picasso [with a Catalogue of the Works], trans. from the German Picasso: Das plastische Werk by J. Maxwell Brownjohn [New York: Abrams, 1971], p. 301, fig. 11). But the resemblance of its hair pattern—to say nothing of its brut manner—with the Cerro head Picasso acquired only in spring 1907 (see p. 249) obliges me to attribute it to that time.

122. For Picasso to have seen Oceanic sculpture before then, he would have had to see it in the collections of Matisse, Derain, or Vlaminck. No discussion of their early acquisitions mentions Oceanic art. Inasmuch, however, as the term "art nègre" covered Oceanic as well as African art, and as confusion between the two was commonplace, we cannot exclude the possibility.

123. Johnson, "Primitivism in the Early Sculpture of Picasso" (as in note 14), pp. 66, 67.

124. When Johnson inspected the piece, only traces remained, perhaps because it was actually played with as a doll by the child to whom it was given (later Mme André Masson). Today there seems even less trace of these colors on the subject.

125. Spies, Sculpture by Picasso (as in note 121), p. 23.

126. This head is said to have been purchased by Arensberg from Frank Burty Haviland, who was a friend of Picasso, Brancusi, and, through de Zayas, the members of the Guillaume circle. Picasso's Fang figure can be seen silhouetted against the window of his Boulevard de Clichy studio in a photo of c. 1911 (Musée Picasso).

127. By 1908, a considerable number of Bambara objects could be found in France, although there is no documentation of the presence there of the specific type of mask illustrated on page 295.

128. See "From Narrative to 'Iconic' in Picasso" (as in note 31), pp. 620–22.

129. Daix (letter to me of December 15, 1982) insists on an interest in the Douanier on Matisse's part as early as 1905, and cites Barr (Matisse: His Art and His Public [New York: The Museum of Modern Art, 1951], p. 77) in regard to the possible association between Matisse's 1906 Pink Onions and the still lifes of Rousseau.

It is evident that the art of Rousseau played at least a certain role in the step toward the simplification and reduction of means that mark Matisse's transition from Fauvism to his own personal style in later 1906 (the difference, essentially, between the two versions of The Sailor). This role was, however, subordinate to that of Gauguin, Cézanne, and the various "primitive" arts Matisse was already collecting.

For me the work that best illustrates Matisse's generalized primitivism of winter 1906–07 is Marguerite (p. 253), which Picasso would select in an exchange of works between the two artists shortly after its execution. Some critics have interpreted Picasso's choice of this seemingly awkward, simple, and naive Matisse portrait as an attempt to show up Matisse by having in his (Picasso's) own studio a picture that could be taken to be a poor Matisse. In fact, one has only to compare the head of Marguerite in this quite extraordinary little picture to Picasso's post-Gosol work, indeed, to the Iberian heads in the center of the Demoiselles, to see why Picasso might have preferred it to other Matisses. Matisse's Marguerite belongs to a moment (early 1907) when, for the Fauves, the "primitive" meant a variety of "archaic," often exotic styles, "art nègre," Gauguin, and Rousseau, while for Picasso it meant primarily the Archaic Iberian, and secondarily Gauguin. Only later, more than a year after his June 1907 revelation regarding "art nègre," was Picasso's work influenced by Rousseau; once again the Douanier's work functioned as it had for Matisse, as a simplifying agent in the context of a major stylistic transition. Daix correctly sees the interest of both Matisse and Picasso in the work of Rousseau as "following quite naturally from their interest in 'primitive' arts."

130. The affinity of the last phase of Picasso's Iberianism (early spring 1907) with the style of Matisse's Marguerite is underlined by the comparison of the latter with one of the central heads of the Demoiselles on page 253. The two works are no more than a few months apart at most.

131. For a discussion of the reworking of Three Women, see this author's essay "Cézannism and the Beginnings of Cubism," in Cézanne: The Late Work, ed. William Rubin (New York: The Museum of Modern Art, 1977), pp. 184–88.

132. "L'Art nègre" (as in note 11), p. 119.

133. For Lipchitz's account of this, see below, Wilkinson, p. 425.

134. Louis Vauxcelles, "Exposition Braque: Chez Kahnweiler, 28 rue Vignon," Gil Blas, November 14, 1908, repr. in Edward F. Fry, Cubism (London: Thames and Hudson, 1966), p. 50.

135. There is no question that Braque owned a number of African sculptures by 1908. However, the suggestion by Habasque, cited by Paudrat (pp. 139, 174 note 50), according to which Braque would have purchased his first African object in 1905, is highly suspect. This would have made him anticipate Matisse as a collector, when, in fact, it was probably Matisse's collecting (begun in 1906) that served as Braque's model. The commonplace attribution of such "firsts" to 1905 follows from the fact that for many decades 1905 has been considered the year in which Matisse, Derain, and Vlaminck had begun collecting. We now know that year to be 1906.

136. See Sandra E. Leonard, Henri Rousseau and Max Weber (New York: Richard L. Feigen, 1970).

137. For further discussion of this, see Paudrat (pp. 139–41) and Flam (pp. 216–17 above).

138. This is the position, for example, of Laude, and most writers have followed his lead. This view is inspired by Tériade's 1951 version of Matisse's account of the events at Gertrude Stein's apartment in autumn 1906. In this interview ("Matisse Speaks," *Art News Annual* 21, 1952, repr. in Jack D. Flam, *Matisse on Art* [London: Phaidon, 1973], p. 134), when Matisse shows Picasso the African object (most probably the Vili figure on p. 214; see above, Paudrat, p. 141), Picasso is said to have been "astonished" by it. The Tériade interview, which Flam has characterized to me privately as "unreliable," deprives Matisse of his usual discretion; Flam considers this "a corrupt text." He judges the 1942 Courthion interview more reliable. Both he and Paudrat have had access to unpublished parts of that interview "lu et approuvé" by Matisse. In this interview Matisse merely says: "Picasso est arrivé, nous avons causé. C'est là que Picasso a remarqué la sculpture nègre. C'est pourquoi Gertrude Stein en parle" (my gratitude to Flam for this information). See also Flam (p. 238, notes 44, 47).

It is evident that if Picasso had been "astonished" by the African object (all the more unlikely if it was indeed the Vili figure), Picasso would have become interested in African art then. In fact, he did not begin collecting—nor is there any sign of the influence of tribal art in his work—for some half a year afterward.

139. When I asked about this meeting, Picasso described seeing Matisse's African object as of no special importance, having already made the point that his "revelation" took place later (and responded to very different kinds of African and Oceanic objects).

140. The exact date of this unfinished painting is unknown, but the style suggests to me the winter 1906–07, which would accord with Matisse's interest in the Vili figure at that time. There is no documentation for the picture's date, and Pierre Schneider, in his forthcoming book on Matisse, will date it 1907–08.

141. As observed in the Introduction, Matisse's taste in African art was conservative. The "classic" objects he preferred could be (and were) more readily associated with Egyptian art than the Baga, Kota, and Grebo objects central to Picasso's taste.

142. In my notes (see above, note 86), Picasso scorns Matisse's equation of the African and Egyptian and says something to the effect (this is paraphrased): "Matisse didn't know what was really good in African art."

143. Picasso did own and admire a white Shira-Punu mask, a Shango mask, and some other objects in the more "classic" taste shared by Matisse. It should also be observed that—at least later, at some time after the period at issue—Matisse acquired two Baga figures as well as a New Ireland sculpture, objects that are far from "classic." However, Lydia Delectorskaya made the point to me emphatically that the New Hebrides Megapode spirit mask that was given to Matisse by a friend (p. 333), and which Matisse gave to Picasso, did *not* represent Matisse's taste in tribal art.

144. Thus, in "Histoire anecdotique du cubisme" (as in note 52), pp. 41–61 (*La Jeune Peinture française,* according to Fry, *Cubism,* as in note 134, p. 90, was written by April 1912 and published in the autumn), Salmon implied that the *Demoiselles* (referred to as the "grande toile") was begun following the completion of *Boy with a Pipe* (the painting dates from late 1905) and described it as containing six figures. In *L'Art vivant,* 1920, pp. 109–18, he is unspecific about its beginnings, alluding to both "aux environs de 1908" and "dès 1906," whereas in his article on the "Exposition Metzinger" in *L'Europe nouvelle,* January 1919, p. 139, the "grand toile" is ascribed to "un peu après 1906." In *Souvenirs sans fin,* Salmon misdates Picasso's 1907 portrait of him to 1906 (Paris: Gal-

limard, 1961, p 185).

145. The single possible exception is a photograph published by Christian Zervos without a date but showing Picasso's studio, 13 Rue Ravignan, and the date "1907" written in beside the two drawings and one of the paintings shown in the photograph ("Oeuvres et images inédites de la jeunesse de Picasso," *Cahiers d'art* 25, no. 2 [1950], p. 278). Werner Spies (in *Picasso: Das plastische Werk* [as in note 17], p. 42) reproduces a photograph from Claude Picasso's archives that but for the lack of any dates inscribed is identical with Zervos's, which he assigns to "um 1907."

146. In working with the curators of the Musée Picasso on the projected exhibition "Autour des *Demoiselles d'Avignon,*" I have seen all the photographs in their archives that show tribal sculptures. The Musée Picasso will publish these photographs later. Given their small number and their post–Bateau-Lavoir dates, they do not tell us a great deal about Picasso's early acquisitions. The Musée Picasso archives do, however, contain letters and other material from these years (still being reviewed by the archivist), which may throw further light on Picasso's early purchases of tribal work.

147. Heymann was, in 1907, the only dealer specializing in tribal art. At some point before Picasso's purchasing the Tiki, a photograph of it was supplied to the German ethnologist Karl von den Steinen, who published it later in his monumental compendium of Marquesan art (*Die Marquesaner und ihre Kunst* [Berlin, 1928], vol. 3, n.p., fig. 13a and b) as "in dealers' hands." Since von den Steinen received the photo from a dealer—and it had to be a dealer whom he sought out knowing that he handled tribal art—it is hard to see who this could be besides Heymann.

148. As Melanesian objects are less sculptural, more fantastic and "surreal," it is not surprising that Picasso's purchase of such objects as his Torres Strait mask (p. 315) should have been made in the 1920s and 1930s, when Picasso's own work evolved in directions related to Surrealism.

149. David Douglas Duncan, *The Private World of Picasso* (New York: Harper and Brothers, 1958), pp. 36–37, 41, 67, 72, 109; *Besuche bei Picasso* (photographs by Siegfried and Angela Rosengart) (Lucerne: Galerie Rosengart, 1973), p. 17.

150. No documentation would exist for purchases at the flea market. It is possible that some documents (e.g., offering letters) will turn up in the Musée Picasso archives that can be associated with objects that have come down to us, but there is small likelihood of this, in part because the tribal and geographical appellations used by dealers before World War I are almost invariably incorrect—which makes the matching of objects and references to them exceedingly difficult.

151. See above, page 14, for my reservations in regard to calling Picasso's group of tribal objects a "collection."

152. Laude, *La Peinture française* (as in note 71), pp. 116–17 note 92. Laude does not specify the date but says only that Tzara saw the objects in Picasso's studio "à Antibes." It was most likely at his villa La Californie in Cannes (and not Antibes, where Picasso never had a studio) that Tzara saw Picasso's tribal objects, which had been stored in boxes until he moved into La Californie in 1955.

153. Mention of sales of single pieces for as high as 30,000 francs is made by Frederick W. Eddy in the *Sunday World,* October 29, 1916, in his review of the exhibition of African negro sculpture organized by Marius de Zayas for The Modern Gallery, cited in Naumann, introduction and notes to "How, When, and Why" (as in note 60), p. 110.

154. According to John Rewald, the Meyer family paid Vollard ten thousand dollars each for large, important Cézannes (now in The National Gallery, Washington, D.C.) around 1912 and again in

1917.

155. In the correspondence which Gertrude Stein bequeathed to Yale University and which is now preserved in the Beinecke Rare Book and Manuscript Library, there are six letters and one postcard from Picasso to Gertrude Stein (who at that time was living in Nîmes), dating from December 1917 (?) to June 8, 1918, that concern his wishes in having her purchase "statues nègres" for him. I am indebted to Margaret Potter for bringing this correspondence to my attention.

156. This is the generally accepted date, though it is possible that the photograph was taken early in 1909. See Edward F. Fry, "Cubism 1907–1908: An Early Eyewitness Account," *The Art Bulletin* 48, no. 1 (March 1966), pp. 70–73.

157. There is no question that Picasso's possessiveness with regard to these objects had to do with what he called their magical "charge." Giving an object that belonged to his intimate life to some other person would have been understood by the superstitious artist as, in effect, giving that person a kind of power over him. To my knowledge, no object that Picasso possessed was ever given away or sold—though he would have been more likely to part with something acquired late in life (and quite readily, something given to him) than with his early acquisitions.

158. For an illustration of one such object, see R. S. Wassing, *African Art: Its Background and Traditions,* trans. D. Imber (New York: Abrams, 1968), p. 46.

159. On the basis of visits to the reserves of the major European ethnological museums, I would say that a large minority (if not a majority) of the earliest acquired tribal objects were not used ritually. How many of these were unused because they were made for colonials, sailors, or ethnologists is impossible to say.

160. Fernande Olivier, *Picasso et ses amis* (Paris: Stock, 1933), p. 170 (the period 1910–14): "Picasso aimait particulièrement un petit masque de femme à qui la peinture blanche du visage, ressortant sur la couleur bois de la coiffure, donnait une expression étrangement douce."

161. This was in the conversation in which he denigrated Matisse's view of African art and singled out as (paraphrased) "inventive" some "small metal figures, very abstract" and "big-nosed masks." This remark (see note 86), I believe, must be associated with Kota reliquary figures and Baga Nimba masks and figures.

162. An example of the quality of the latter is the reliquary figure consigned to Stieglitz by Guillaume shown in the installation photograph on page 152.

163. *Primitive Art Newsletter* 5, no. 6 (June 1982), p. 7.

164. Clouzot and Level, *L'Art nègre et l'art océanien* (as in note 76), pl. XX: Masque pahouin [Fang], 35 cm; and pl. XXXIV: Masque Côte d'Ivoire [Guere], 25 cm, both listed as "Collection Picasso."

165. It is possible, but highly doubtful, that some document related to these masks will turn up in the archives. Both are of a type known to be in circulation prior to 1914. A Guere of the type owned by Picasso (Clouzot and Level, ibid., pl. XXXIV), so similar to his that it is probably by the same hand, was put on sale by de Zayas (who undoubtedly got it from Guillaume) in The Modern Gallery, New York, in 1916. It is illustrated in Naumann "How, When, and Why" (as in note 60), no. 73.

166. Cited in "Braque 1912–1918: Repères chronologiques," in *Georges Braque: Les Papiers Collés,* exhibition catalog Musée National d'Art Moderne, Centre Georges Pompidou, Paris, June 17–September 27, 1982, p. 180.

167. Edward F. Fry, "Les Dimensions du modernisme" (transcript of a series of four lectures given in May–June 1982 at the Musée National d'Art Moderne, Centre Georges Pompidou, Paris) in *CNAC Magazine* (published by the Centre

National d'Art et de Culture Georges Pompidou), no. 16, July–August 1983, p. 18.

168. Fry assumed that the purported "discovery" of a "Wobé" (Grebo) mask in Marseilles inspired the solution of the sound hole of the *Guitar.* But aside from the fact that Picasso almost certainly already possessed his less-good Grebo, he surely knew others in the Trocadéro, the collection of Kahnweiler, and elsewhere. Grebo masks were among the more familiar types of mask in Paris in the first decade of the century.

169. Jacques Kerchache, who had an opportunity to study the mask on page 20, confirmed this fact to me.

170. As the concept of cylindrical eyes is common to all Grebo masks of this type, and as Picasso abstracted the concept, a purely one-to-one relationship cannot be established between the objects.

171. Dora Vallier, "Braque, la peinture et nous," *Cahiers d'art,* 29, no. 1–2 (October 1954), p. 14.

172. Malraux, *La Tête d'obsidienne* (as in note 8), p. 19.

173. The word "collage" is often used for *papiers collés* as well as the gluing together of alien materials (oilcloth on canvas as in Picasso's *Still Life with Chair Caning*) and the assembling of diverse materials (the mariner's rope used as a frame in that same pioneer work). But *papier collé,* insofar as it maintains a unity of materials, is more classical than other forms of collage, and should be distinguished from them. It is characteristic for Braque's classicism and conservatism that he worked *only* in *papier collé.* Collage in all other forms—which are those with affinities to tribal art—is entirely the invention of Picasso.

174. The analogy is much less common in Braque's work, and is never carried as far. On the occasion that Picasso gave me the *Guitar* for The Museum, he propped it up in a chair like a seated figure and had Jacqueline photograph it that way.

175. The more sculptural, tactile, "factual" Cubism of late 1908 through 1909, though removed from tribal art as compared to Picasso's work of 1907–08, is still much closer to it than the pictorial forms of High Analytic Cubism where the nature of the reductionism is further from what Picasso meant by the "realism" of tribal art. In 1911–12, another kind of realism takes over (see Rubin's *Picasso in the Collection* [as in note 106], p. 72, for the artist on the "reality" in High Cubism).

176. See John Richardson, ed., *Picasso: An American Tribute,* exhibition catalog (New York: Public Education Association, 1962), n.p.

177. Despite this similarity, the other forms of this illusioned mask make it quite clear that this could not have been the Grebo on page 305.

178. Daniel-Henry Kahnweiler, "L'Art nègre et le cubisme," *Présence africaine,* no. 3, 1948, pp. 367–77.

179. Kahnweiler has here confused the ideographically *reduced* (of tribal art) with the *cutaway* (of Cubism).

180. Illustrated in Rubin, *Picasso in the Collection* (as in note 106), p. 60.

181. The lack of control that this implied obviously became clear to Picasso at this point, and virtually none of his later sculpture, its range and variety notwithstanding, depended on this Impressionist-inspired, post-Rodinesque play of pictorial light.

182. My notes contain, in paraphrase, a sentence in which Picasso says, "It was pointless to go on with this kind of sculpture." For years I have debated as to precisely what he meant. He was clearly disappointed in aspects of the modeled *Head of Fernande,* and the remark may simply reflect fatigue at something that turned out to be a dead end.

183. Goldwater long ago rightly characterized *Head of Fernande* as "Rodin's art of the hollow and the lump" (*What is Modern Sculpture?* [New York: The Museum of Modern Art, 1970], p. 42).

184. I accept Fry's emendation for the date of the (maquette of) *Guitar* (fall 1912 instead of early in the year, as Picasso had suggested).

185. See Introduction, p. 64.

186. See Introduction, pp. 18–20.

187. Illustrated in Spies, *Sculpture by Picasso* (as in note 121), p. 53.

188. Illustrated ibid., pp. 132, 133.

189. My point here is that Picasso was certainly conscious of the fact that early Cubism had two important immediate sources, the principal one, Cézanne's painting, being inflected by the ideographic reductionism of tribal art.

190. Though this is not readily apparent because the mouth has been enlarged and turned vertically, there can be no question of the identification of this feature. The nose is a triangle projecting from near the top center of the facial rectangle, the eyes are round holes flanking the nose.

191. My search has turned up no reproductions of masks of this type that could possibly have been available in scholarly circles—not to say in artists'—in Paris before 1930.

192. This was the Kota reliquary guardian figure that Giacometti had purchased from Serge Brignoni (see below, Krauss: p. 528 note 13).

193. This identification, earlier clear to me through affinities of *Head of a Woman* (p. 323) with the "bone" Bathers known to be Olga, is confirmed by the sketch on page 322, in which there is a "mirror image" identification of an early form of *Head of a Woman* (on right of sketch) with an image of Olga screaming (Picasso so identified her to Penrose) very much as she appears in *Bust of a Woman with Self-Portrait,* 1929 (*Picasso: A Retrospective* [as in note 5], p. 272).

194. The first of these is *The Embrace,* 1925 (ibid., p. 257).

195. Eg., *Seated Bather,* 1930 (ibid., p. 279).

196. Penrose mentioned to me—though requesting a discretion no longer necessary (Picasso was still alive)—that in Olga's most distracted moments she had threatened Picasso's life.

197. This statement is based on having seen about seventy of Picasso's hundred-odd tribal objects, and having studied photographs of some of the rest.

Metal and metal-covered tribal objects of any size are relatively rare. While Picasso might have owned one more Kota reliquary figure than we estimate, it is hard to imagine what other metal or metal-clad objects of any size he might have possessed in the early years, aside from Marka masks—and I have found no record of his owning one.

198. The large-size female Nimba mask—as opposed to the "Nimba-headed" Baga figures, which are found in both sexes (see above, note 97)—was widely understood as symbolizing seasonal rebirth and human procreation. Generally, Picasso paid little attention to ethnological particulars, but Michel Leiris assured me that Picasso knew the significance of the Nimba figure as popularly interpreted.

199. Gonzalez had begun to realize Picasso's metal sculptures, mostly from drawings, in 1928. The realization of *Head of a Woman* (p. 323) became, for Gonzalez, the linchpin of his new career as a vanguard metal sculptor. Most of his important work relates to Picasso's openwork "drawing-in-air" sculptures. Gonzalez also executed, however, a series of "Masks" (p. 320), less obligated to Picasso in their inspiration, which reflected Gonzalez's own interest in tribal art.

200. I have in my notes a reference to Picasso's having acquired it in 1928, but I have lost track of the source. Jacques Kerchache points out that it was exhibited in the Exposition d'Art Africain et d'Art Océanien at the Galerie du Théâtre Pigalle, Paris, 1930 (no. 18 of the catalog), as "Collection Pablo Picasso."

201. See above, p. 276.

202. See above, note 97.

203. "This [Nimba]," Penrose observes (*Picasso: His Life and Work* [as in note 114], p. 242), "found its echo in the monumental plaster heads in the stables across the courtyard."

For Picasso, the malleable character of the clay in which these sculptures were modeled, and of the plaster, in which they were reworked, was (as I suggested in the text) an important expressive dimension of their makeup. The plasters, despite their large size, have an appearance of weightlessness and buoyancy that speaks of Marie-Thérèse's image in Picasso's mind (as literalized in *Bather with Beach Ball,* 1932; see Rubin, *Picasso: A Retrospective* [as in note 5], p. 295). The bronzes lose a great deal of this, and Picasso knew it, as the following citation confirms (from [Gyula Halàsz] Brassaï, *Picasso and Company,* trans. from the French *Conversations avec Picasso* by Francis Price [Garden City, New York: Doubleday, 1966], p. 51):

Picasso: They [the modeled sculptures of the early 1930s] really were more beautiful in plaster. At first I wouldn't even hear of having them cast in bronze. But Sabartés kept saying, "Plaster is perishable...You have to have something solid... Bronze is forever..." He's the one who persuaded me to have them done in metal. And at last, I gave in. What do you think of them?
Brassaï: Some of them have lost in the change. Especially your monumental heads.

204. "A *Life* Round Table on Modern Art" (held in penthouse of Museum of Modern Art and reported by Russell W. Davenport in collaboration with Winthrop Sargent) *Life Magazine,* October 11, 1948, p. 64.

205. My gratitude to Dr. George MacDonald, director of the National Museum of Man, National Museums of Canada, for answering my questions about the iconography of Northwest Coast objects.

206. As observed by Meyer Schapiro in conversation with me.

207. Illustrated in *Arts primitifs dans les ateliers d'artistes,* exhibition catalog, introductory texts by Gaëtan Picon and Jean Laude (Musée de l'Homme, Paris, 1967), pl. 41.

208. Pierre Loeb, "Une main," in *Voyages à travers la peinture* (Paris: Bordas, 1946), pp. 29–30: "Je ne m'en serais jamais séparé, mais Picasso la vit et la désira."

Arm with hand. Easter Island. Wood, c. 17½" (44.4 cm) long. Private collection. Formerly collection PABLO PICASSO. Detail of a photograph by Brassaï, 1943

209. Ibid., p. 30.

210. "40,000 Years of Modern Art: A Comparison of Primitive and Modern Art," The Institute of Contemporary Arts, London, 1949.

211. Letter to me from Roland Penrose, September 30, 1982.

212. This is the "Temes Malau" or "Megapode Spirit." The mask, the top part of which is missing in the Matisse/Picasso example, is normally some eight feet high. For a sketch of a complete mask, see Thomas Harnett Harrison, *Savage Civilization* (New York: Knopf, 1937), p. 340 (my gratitude to Douglas Newton for this reference).

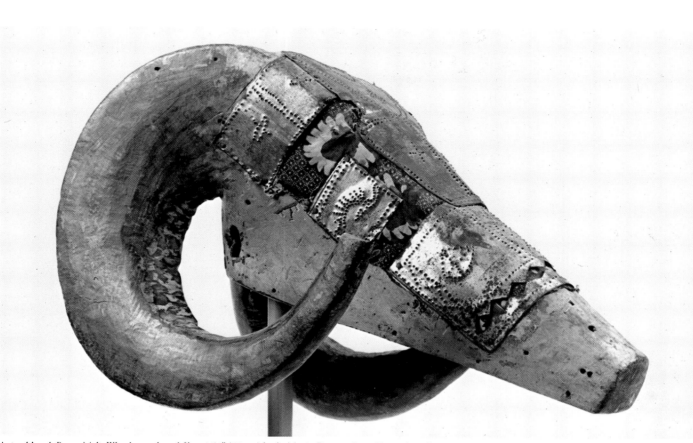

Animal head. Bozo. Mali. Wood, metal, and fiber, 11¾" (30 cm) high. Musée Picasso, Paris. Formerly collection PABLO PICASSO

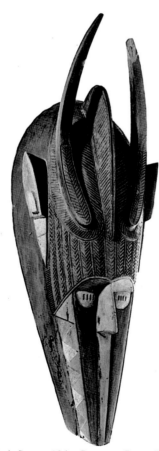

Mask. Baga or Nalu. Guinea or Guinea-Bissau. Wood, c. 30" (76.2 cm) high. Collection Jacqueline Picasso, Mougins. Formerly collection PABLO PICASSO

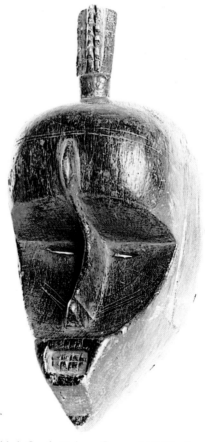

Mask. Senufo (?). Ivory Coast or Mali. Wood, c. 11" (28 cm) high. Collection Jacqueline Picasso, Mougins. Formerly collection PABLO PICASSO

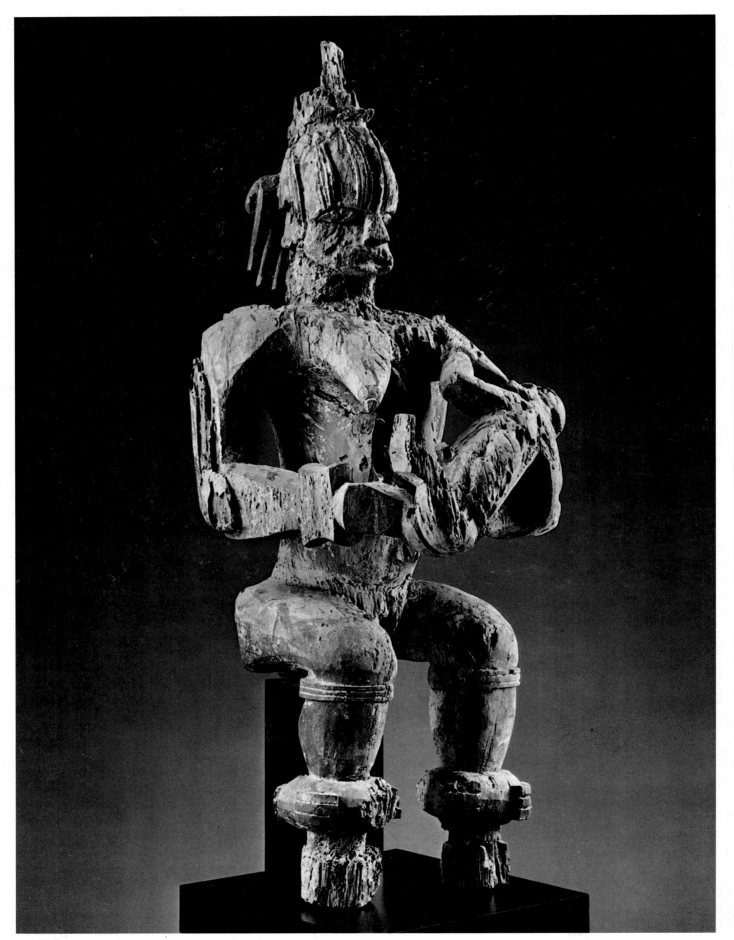

Mother and child. Urhobo. Nigeria. Wood, 57⅛″ (145 cm) high. Collection Philippe Guimiot

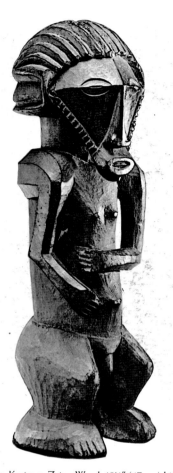

Figure. Kasingo. Zaire. Wood, 18½" (47 cm) high. Collection Gustave and Franyo Schindler, New York

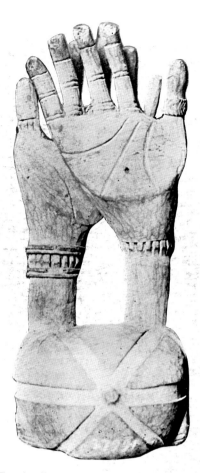

Top of staff. Akan or Ewe. Ghana, Ivory Coast, or Togo. Wood. Published in Marius de Zayas, *African Negro Art: Its Influence on Modern Art*, 1916

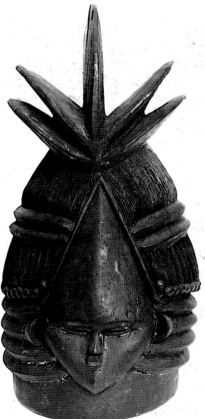

Helmet mask, Janus-faced. Mende. Liberia or Sierra Leone. Wood, 19¼" (49 cm) high. Museum voor Land- en Volkenkunde, Rotterdam

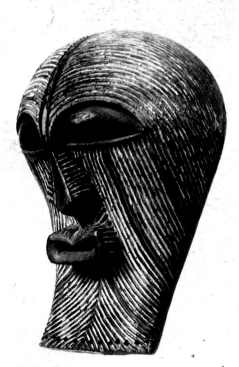

Kifwebe mask. Songye. Zaire. Painted wood, 22" (55.9 cm) high. Collection Jack Naiman, New York.

DATE DUE

11/24 - 3pm		
3/12 - 9:50am MR		
3/13 - 9:30am cml		
3/14/01 9:30am LL		
3/15/01 9.30 am RW		
3/16/01 9:30 am RW		
3/18/01 KH 7 p.m.		
3/19/01 8.30a.m RW		
3/26/05 11:00pm		
~~10/26/05 4:0~~		
10/27/05 4 pm		
10/28/05 5:50 pm		
10/30/05 2:30 pm 4:00pm		
11/1/05 4:00pm		
11/9/05		
11/11/05 4:30pm		
11/19/05 4:00pm		
JA 2 0 '06 DE 1 5 '06		

GAYLORD